Lee Miller

By the same Author

Becoming Modern: The Life of Mina Loy

Lee Miller

Carolyn Burke

BLOOMSBURY

First published in Great Britain 2005
This paperback edition published 2006
Copyright © 2005 by Carolyn Burke

The moral right of the author has been asserted

Bloomsbury Publishing Plc, 36 Soho Square, London, W1D 3QY

First published in the United States by Alfred A. Knopf,
a dvision of Random House, Inc., New York

A CIP catalogue record for this book is available from the British Library

ISBN 978 0 7475 8119 2

10 9 8 7 6 5 4 3 2

All papers used by Bloomsbury Publishing are natural,
recyclable products made from wood grown in well-managed forests.
The manufacturing processes conform to the
environmental regulations of the country of origin.

Printed in Great Britain by Clays Ltd, St Ives plc

www.bloomsbury.com/carolynburke

For Valda

I want to have the utopian combination of security and freedom, and emotionally I need to be completely absorbed in some work or in a man I love. I think the first is to take or make freedom, which will give me the opportunity to become concentrated again & just hope that some sort of security follows & even if it doesn't the struggle will keep me awake and alive.

—Lee Miller to Aziz Eloui Bey, November 17, 1938

I keep saying to everyone, "I didn't waste a minute, all my life—I had a wonderful time," but I know, myself, now that if I had it over again I'd be even more free with my ideas, with my body and my affections.

—Lee Miller to Roland Penrose, September 9, 1947

Contents

Part Three: **Madame Eloui Bey**

Part Four: **Lee Miller, War Correspondent**

Part Five: **Lady Penrose**

Introduction

Lee Miller was one of the most remarkable, and underrecognized, photographers of the last century. At their best, her images put head, eye, and heart on one line of sight—to borrow a phrase from her friend Henri Cartier-Bresson. Like him, Lee Miller captured those decisive moments when reality seems to compose itself for the camera, when the visual world speaks. But because she did not pursue a conventional career, her reputation, until recently, has been eclipsed by her legend, and the famous men who helped construct it.

While it is true that Lee Miller's early work in Paris recalls that of her lover Man Ray, it was uniquely her own—full of startling perspectives and witty surprises. In Egypt, her home in the mid-1930s, her unforced Surrealist eye saw familiar and unfamiliar sights through the skewed lens of her expatriation. In the 1940s, her World War II coverage for *Vogue* conveyed the urgency of combat, the horror of the death camps, and the war's impact on ordinary lives—the collateral damage that gripped her long after it came to a close.

That Lee Miller was also one of the most beautiful women of the twentieth century has made it difficult to evaluate her work in its own right. Her astounding good looks seem to get in the way. For many, her beauty is at war with her accomplishment, as if the mind resists the thought of a dazzling woman who is a first-rate photographer.

One might even say that there are too many portraits of Lee Miller by better-known artists. Edward Steichen launched her as a model; Man Ray photographed her, whole and in parts, as his perversely enchanting muse; Jean

Cocteau cast her as the spellbinding classical statue in his film *Blood of a Poet;* Picasso painted six portraits of her as a Provençal wench whose bare breasts inspire reveries of sexual freedom; Roland Penrose charted his erotic relations with her in a series of paintings that range from ecstatic to melancholy.

Mesmerized by her features, we look at Lee Miller but not into her. We think of her as a timeless icon. To this day, her life inspires features in the same glossy magazines for which she posed—articles explaining how to re-create her "look." This approach turns the real woman into a screen on which beholders project their fantasies. Looking at her this way perpetuates the legend of Lee Miller as "an American free spirit wrapped in the body of a Greek goddess" (in the words of her friend John Phillips) while underplaying her élan, the imaginative and moral energy that magnetized those who knew her, often to their cost.

In Lee Miller's time, her admirers were equally spellbound by her beauty, but they also saw her as an incarnation of the modern woman—in the United States of the twenties, as a quintessential flapper; in Paris of the thirties, as a subversive *garçonne* or a maddeningly free *femme surréaliste*—one who sparked creativity in others but played the role of muse only when it suited her, and sought, despite her lovers' objections, to keep her energy for herself.

Breaking free of conventional roles for women, whether in traditional or avant-garde circles, Lee Miller stirred up trouble for herself and those who loved her. Like screenwriter Anita Loos and actress Louise Brooks (whose careers she followed), she helped reshape women's aspirations through her embrace of popular culture, starting with her appearances in *Vogue* after her accidental discovery, in 1927, by Condé Nast. At the same time, she pursued a self-directed training in art, stage design, photography, and, later, politics, all of which inform the incisive dispatches she wrote in the 1940s in her unex-pected, and defining, role as *Vogue*'s war correspondent.

Lee Miller's movement from model to combat photojournalist is perhaps the most remarkable metamorphosis in a life full of self-reinvention. "Who else has written equally well about GIs and Picasso?" the head of U.K. *Vogue* asked when she returned to London after the war. "Who else can get in at the death in St.-Malo and the rebirth of the fashion salons? Who else can swing from the Siegfried line one week to the new hip line the next?"

Two portraits of Lee Miller, emphasizing hats rather than hemlines, sug-gest her significance in her own time. The first, a drawing by Georges Lepape, appeared on the cover of *Vogue* a month before her twentieth birthday. Posed against Manhattan's night sky, she stares into the future from beneath her hel-metlike cloche hat—the incarnation of what it meant to be "moderne."

Nearly two decades later, *Vogue* ran a striking shot of Lee Miller in uni-form wearing a U.S. Army helmet: one can read in her eyes the imprint of the wounded and dying soldiers she had just photographed, for her first illustrated report on the Normandy invasion. These images suggest her exceptional range.

The woman who inspired artists to depict her as the quintessential flapper became the photographer whose war images, like those of her colleague Margaret Bourke-White, still have the power to set our hair on end.

Yet if I were to choose one image to represent her, it might be the self-portrait she called *LM* par *LM*—Lee Miller *by* Lee Miller. Taken after she moved into her Montparnasse studio in 1930, near Man Ray's yet at a slight distance, it differs from his better-known portraits of her in its unposed quality, the way it reveals how it felt to be alone with herself. *LM* par *LM* lets us see the softness she rarely showed to others, since even then, she behaved as if she were one of the guys, an American *garçonne*.

Reading Lee Miller's letters, one learns that her sense of herself, shaped by psychic wounds sustained in childhood, was far from confident. Beneath her defiant pose, she experienced the doubts that were papered over in her ever-expanding search for freedom. The unstable balancing act between her quest for fulfillment, personal and creative, and her need for love registered in the alcoholism and depression of her later years, when early trauma and the aftereffects of combat returned to haunt her.

Lee Miller's life can be seen as segmented—a set of phases through which she moved as if going from one role to another in a number of wildly different movies. When one stands at a distance from the ways she caught the world's attention—as *Vogue* model, avant-garde muse, stylish portraitist, photojournalist, and unexpectedly, gourmet cook—her restless desire for change occupies the foreground.

But if one changes the focus to see her close-up, themes emerge from beneath the surface of her variousness. Continuities reveal themselves. To borrow a metaphor from photography, the biographer needs a set of different lenses, focused now at a distance for the big picture, now at close range for detail. A flexible vantage point helps us grasp a life in its multiple contexts, but also to feel the subject's inwardness, the emotional and aesthetic imperatives at work even as she seized each chance to reinvent herself.

To understand someone who met the world visually, we must also look through her eyes—and in the case of Lee Miller, note her compositions' expressive use of space. In each phase of her work, she took photographs characterized by her feel for the medium as a way to speak bodily truths that otherwise remain silent. Her archive guides us in this reading, one that tells the tale of a life that was multiple, yet marked by fault lines revealed at times of stress, leaving traces on her most mysteriously moving photographs.

At the same time, she was extraordinarily able to respond to what came her way, to meet reality on its own ground. Lee Miller's gift for being in the moment created compositions that say, simply, this is how it was—as if in the onrush of life, she caught the essence of each scene or person in her viewfinder. Her images have the feel of fortuitous encounters.

Appropriately, it was chance, or synchronicity, that brought us together. I

met Lee Miller in 1977, when I happened to sit beside her at a public event in Paris. We began to talk. The conversation continued the next day. She told me about her life in Poughkeepsie, Manhattan, Paris, and Egypt, then about the war and its aftermath. I knew right away that I wanted to write about her after the completion of my project at that time, a life of her friend Mina Loy. Years later, seeing Lee's war images—in which her surrealist imagination meets a shattered reality head-on—impelled me to pursue the idea. The encouragement of her son, Antony Penrose, who opened the Lee Miller Archive to me, made it possible for me to do so.

Since then, I have interviewed scores of her friends, family, and associates, many of whom are still puzzled by her life's discontinuities; worked in archives in the United States, Britain, and France; read widely on all areas of her life; and corresponded with specialists on related projects—often returning to the Lee Miller Archive to verify details and refine interpretations. It has been moving to handle the diverse documents held there and encountered elsewhere—a favorite book from her childhood, *The Goop Directory;* a notebook filled with adolescent musings; emergency guides to London during the Blitz; the yellow cotton Jewish star she took as a souvenir after the liberation of Paris—and to pore over her correspondence, the eloquent, teasing letters she signed "Lovelee." As I pieced together her life from these materials and from work by others, it sometimes felt as if I were assembling a puzzle from which pieces were missing.

Eerily, it seemed as if Lee Miller's past had entered my present when I read in a 1937 letter to Roland Penrose that she saw her life as a jigsaw puzzle, one whose pieces "don't match in shape or design"; trying to compose a new shape with these mismatched bits, she wondered if she were "ever meant to fit together." This metaphor (Miller loved puzzles of all kinds) recurs in descriptions of her state of mind: "I feel about as popular as a leper and as rational as a scattered jigsaw puzzle," she wrote in 1945, when in despair about the future of Europe, and her own.

It was difficult to understand her turn to gourmet cooking in the 1950s, after she settled in London, married Penrose, and stopped working as a full-time photographer. Lee chose cookery "for therapeutic reasons," her friend Bettina McNulty explained, "to put her wartime experiences behind her and to share the results of her efforts with her wide circle." After trying her more outrageous Surrealist-inspired recipes, I understood that cooking provided some of the sensual and artistic immediacy she had found in photography. An intensely social person, Lee created in her kitchen a vibrant conviviality, a world she sustained and, to some extent, composed to her liking—though when dinner finally appeared, she and her guests were often in their cups.

In the end, Lee Miller could not fit the pieces of her life into a coherent pattern. Few of us can. It is the work of the biographer to complete the pattern

while indicating the convergences and discrepancies, the matching up of the scattered bits. Looking when possible through her eyes—in the case of a great photographer, a transformative experience—this life of Lee Miller relates her baffled search for integration within herself, with those she loved, and with her time, even as she took every opportunity to defy and confound its conventions. Despite her attitude toward photography (she believed, as did many of her contemporaries, that it was a technique, not an art), Lee Miller produced a body of work that continues to surprise us, revealing moments of composure in the midst of chaos, boldly aligning head, eye, and heart.

Part One

Elizabeth

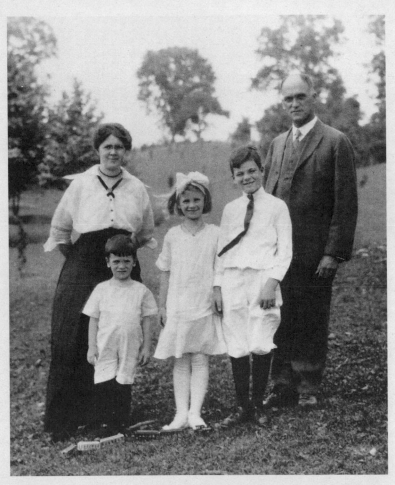

Florence, Erik, Elizabeth, John, and Theodore Miller, 1914 (Theodore Miller)

Chapter 1

A Poughkeepsie Girlhood

(1907–15)

On April 23, 1907, Theodore Miller entered the birth of his daughter, Elizabeth, in his diary, noting the time of day (4:15 p.m.), the place (the Miller home, 40 South Clinton Street, Poughkeepsie, New York), her weight (seven pounds), and the names of those in attendance (Dr. Gribbon and Nurse Ferguson). His firstborn, Elizabeth's brother John, had come into the world two years earlier, but the little girl—Li Li, then Te Te, Bettie, and in her twentieth year, Lee—would always be her father's favorite. Her blue eyes and blond curls enchanted him. Whatever name she went by, she was his Elizabeth, whose growth he would continue to document, one might almost say obsessively.

By the time Elizabeth was born, Theodore Miller was the superintendent of Poughkeepsie's largest employer, the DeLaval Separator Company (its machines separated heavier liquids from lighter ones). An ambitious man of thirty-five who was on his way to becoming one of the town's elite, he had married three years earlier after securing his position at DeLaval's recently enlarged plant on the bank of the Hudson River. Florence Miller, his wife, is not mentioned in the diary entry, as if her part in the arrival of their daughter could not be reckoned among the facts and figures that gave him his grip on

the world. Perhaps it was taken for granted. Like most men of his time, Theodore believed that a woman's place was at home, a man's with the new world of science and technology—the forces that enabled entrepreneurs like himself and the country as a whole to move forward.

Theodore always said that he came of a long line of mechanics. A tall, erect man with penetrating blue eyes, he might have stepped out of a Horatio Alger novel. Born in 1872 in the aptly named Mechanicsville, Ohio, he grew up in Richmond, Indiana, at that time the largest Quaker settlement in the country. Although the Millers were not Quakers, he thought well of this sect despite his opposition to formal religion and, in adulthood, his atheism. More important to him than the Society of Friends and the Inner Light were facts. As a youth he had worked in a roller-skate-wheel factory, then a machine shop where he operated lathes. Earning his qualification in mechanical engineering through a correspondence course reinforced the idea that hard work led not only to self-improvement but also to material rewards.

When telling his children about his rise in the world, Theodore emphasized the Miller self-reliance. His ancestors included Hessian mercenaries who had fought for the British in the Revolutionary War; his father was famous as the man who laid seven thousand bricks a day when helping to build Antioch College; his older brother, Fred, was an engineer widely known as the editor of the *American Machinist*. Theodore's career illustrated the belief that a self-confident man could try his hand at anything. In his twenties he had worked in New Jersey at a U.S. Navy shipyard, in Brooklyn at a typewriter factory, in Mexico at the Monterrey Steel Works, and in Utica, New York, at the Drop Forge and Tool Company, where he became general manager. So intent upon making his way that he did not think about marriage until he turned thirty, he then proposed to Florence MacDonald, the fair-haired Canadian nurse who had cared for him during his treatment for typhoid at Utica Hospital.

It was typical of their union that the children heard more about the Millers than about the MacDonalds. Florence told them little of her background except that her people were Scots-Irish settlers from Brockville, Ontario, where she was born in 1881, and that her parents had died when she was a girl, after which she went to live with relatives. Only later did they learn that the MacDonalds had been defeated by their hard, rocky land, and that Florence had had little education apart from nurse's training. Then, nursing was one of the few paths open to women from poor families. There were more opportunities in the United States than at home but the work required dedication. Florence would have earned little more than room and board at the training hospital in Utica—except for the hope that once certified, she could work anywhere. Theodore Miller may have won her heart, but he was also a good catch.

Their life together as members of Poughkeepsie's bourgeoisie began when

they married in 1904, after he had settled into his position at DeLaval. It would have required an adjustment on Florence's part to manage a household staffed with servants, including some from the town's black community. In the few family photographs taken before 1904 Florence is a shy, slender young woman. She was happy to trade her white cap and nurse's uniform for the large-brimmed hats and flowing gowns of the 1900s, to collect bric-a-brac for her new house, and in time, once her children were at school, to educate herself.

Although Florence took her turn giving the tea parties expected of the Poughkeepsie ladies with whom she mingled, some insecurity prevented her from enjoying these occasions. She fussed about details. Unsure which of Poughkeepsie's many Protestant churches to attend, she tried them all. Traces of her time as a nurse were still discernible in her bathroom, where white tiles and a doctor's scale implied that cleanliness was next to godliness. Florence retained a horror of germs and a reverence for doctors. She was also in awe of her husband, who was nearly ten years older and the mainstay of their comfortable life.

The Millers often told their children a story from their early days in Poughkeepsie. Because of Theodore's position, the local chapter of the Daughters of the American Revolution invited his bride to join this ultraconservative organization. Florence filled in the genealogical forms required of new members. Her husband's Hessian forebears, who had fought against the revolution that gave the group its name, raised a few eyebrows, but as soon as the membership committee saw that she was Canadian, the invitation was withdrawn. Having been treated as less than loyal Americans, the Millers turned the incident into a joke. And since it was impossible to infiltrate the old families whose cupolaed mansions overlooked the Hudson, they made the best of the matter by establishing themselves as citizens of the new century.

Depending upon whom you were talking to, Poughkeepsie in the 1900s was either a declining regional capital or an industrial center ready to take advantage of its strategic location. Both accounts were accurate. To the town's more progressive citizens, its values seemed Victorian. Yet at the same time, institutions like Vassar College—located two miles east of town—were trying out new ideas about women's social and intellectual potential, and forward-looking businesses like DeLaval, a Swedish firm, were rethinking the relations between civic and professional life. Many Poughkeepsians believed they lived at the center of things. The New York Central's trains sped north along the Hudson to Albany and south to New York City, the bridge across the river encouraged trips west to New Paltz and the Catskills, the Dutchess Turnpike ran east past rich farmlands to Connecticut.

Since the eighteenth century, the "river families," the old guard of Dutchess County, had looked down from their hilltop estates on the villages along the Hudson's shores as if they were the fiefs in some American version of feudalism. Poughkeepsie, a town of twenty-four thousand when Elizabeth was born, had always been something of an exception. Its inhabitants prided themselves on their town's history as a seventeenth-century Dutch settlement and an early state capital, the site of New York's ratification convention for the U.S. Constitution, and from the 1860s on, the hub of swift railroad connections to the north and west. Although the symbol of the new century, the Twentieth Century Limited, flew past Poughkeepsie on its way from New York to Chicago, the city's position halfway between New York and Albany was thought to ensure its influence—provided the town fathers could agree on what was meant by progress and how to go about implementing it.

Prominent Poughkeepsians looked to technology as the way to be "up-to-date." At a time when civic leaders all over the United States indulged in boosterism to enhance their town's reputation at the expense of neighboring ones, they proclaimed Poughkeepsie's superiority over its rivals, Syracuse and Albany. Yet in reality it had grown very little since the 1870s, a number of businesses having failed or gone elsewhere. Industries clustered along the Hudson in former times had included shipbuilders, dye mills, a brewery, and an ironworks, many of which had been replaced by larger, more modern concerns like DeLaval and Queen Undermuslins, a manufacturer of women's underwear. What was good for these businesses was good for Poughkeepsie, town officials said, as were recent municipal gains like electric lights, telephones, and macadam paving. But there were those who said that they had been right to decline Thomas Edison's offer to make Poughkeepsie the first fully electrified American city, after which he bestowed the honor upon Newburgh.

In Theodore Miller's espousal of modern technology, he spoke for the "progressives," those who favored any and all improvements. His credentials— a professional engineer's license, membership in the American Society of Mechanical Engineers, and his new post—so impressed members of the town's preeminent social group for men, the Amrita Club, that they made him a member within months of his arrival in 1903. There he met local aristocrats like the Roosevelts and those who were on their way to positions of influence in banking, commerce, and politics. By the time Elizabeth was born, Theodore was known as the forward-looking manager of DeLaval's large workforce or, alternately, as its benevolent dictator.

DeLaval had opened the plant in 1892 for the manufacture of its centrifugal cream separator (which separated cream from milk), then enlarged it the year before Miller was hired to quell labor unrest. A history of Poughkeepsie published in 1905 hails DeLaval as the town's most advanced industry, functioning with electricity "driven by a dynamo driven by the only turbine engine so far installed in the city." Over the years, new applications were developed

for DeLaval's machines. Theodore oversaw the production of machinery designed to clean industrial oils and varnishes, prepare blood plasma, and perform other tasks based on the principle of separating solids from liquids. The company was known as a good place to work. Theodore paid higher wages than were being paid in the rest of the county, instituted a forty-eight-hour workweek, and set up employee benefits including a restaurant, insurance, and profit sharing. To a labor force that had known harsh conditions elsewhere, he seemed a humane employer.

Nonetheless, good labor relations depended upon the employees' knowing their place. The noblesse oblige attitude that prevailed in social circles—the river families' distant patronage of their inferiors—operated at DeLaval. Theodore's position, which would lead to his serving on the boards of civic institutions, planning commissions, and local banks, presupposed absolute control of his workers. The women employees whom he fondled did not complain of harassment, the members of ethnic groups—Italians, Poles, and other minorities, mostly Catholic—did little in the face of the "Wasp" values that kept them from advancing, and the few members of the town's black community thought themselves lucky to have jobs. Theodore's strict rule over his five hundred employees was taken for granted.

In this respect his ideas about the workforce were only somewhat more liberal than those of his cronies at the Amrita Club, which barred from membership Jews, Catholics, and blacks. Members invited their wives and daughters to a New Year's Day tea dance, but the rest of the time women were excluded. Much of Poughkeepsie's growth was decided at the Amrita Club's dinner table, which was served by the best cook in town. Like the rest of Dutchess County, the city fathers were Republicans, but in this respect as in others (such as his atheism), Theodore demonstrated his independence of mind by voting Democratic. Despite these eccentricities, his preeminence was not disputed.

During the last decades of the nineteenth century, civic leaders had sought to express the town's standing in monumental public buildings. In 1912, when the Amrita Club's elegant new premises were completed, members concluded that they too belonged to the country's elite—since McKim, Mead and White, the architects of New York's Harvard Club, had designed their Colonial Revival headquarters. The new building, the mayor declaimed, symbolized "the orderly progress of a community" by incorporating modern conveniences into a design recalling the town's colonial beginnings. Poughkeepsie was "the 'City Beautiful,' " according to the board of trade. Greek Revival banks, Gothic churches, and Renaissance palazzo department stores lent a sense of history; the mansard roofs of Vassar's Main Building evoked the Tuileries Palace, the Eastman Business College's turrets recalled Oxbridge. Young men entering the portals of the new YMCA, whose façade evoked a Medicean palace, would emerge "the better for that beauty," the town fathers told themselves.

The young men of the day, most of whom hoped to make their way as Theodore Miller had, no doubt felt the better for time spent out of doors rather than inside the edifices intended to civilize them. Few could afford the train trip to New York, where increasingly people of Miller's standing would go for entertainment; many were intimidated by the idea of the big city. Young people took part in a round of local activities that began in autumn with trips to apple orchards for cider, winter carnivals, ice skating and boating on the frozen Hudson, fishing in April when the shad ran downriver, and in warmer months, garden parties and socials beneath the flowering fruit trees or among the azaleas.

The social calendar peaked in June when rowing crews from the Ivy League colleges came to train for the Intercollegiate Regatta. Poughkeepsians spoke proudly of having won out over Saratoga Springs, the home of the regatta until 1898—when the broad four-mile stretch of the Hudson north of town was deemed more appropriate than Lake Saratoga. Thousands of rowing enthusiasts came by train to stroll along the river, watch the rowers, and boost the local economy. The crews and their supporters occupied all the rooms in the area. Young men in boater hats strolled around town in the company of ladies with upswept hairdos; romances flourished. For a month the river was a watery stage crisscrossed by ferryboats full of rowing buffs and lined by viewing stands on specially fitted railroad cars.

This spectacle enchanted the local girls and decided the futures of a number of Vassar students, some of whom settled in Poughkeepsie. Elizabeth Miller had no such fate in mind for herself. She would always refer to her hometown as "P'ok"—as in *poke*, to prod, pry, or meddle, and *pokey*, as in cramped, frumpy, or, in slang, a prison—and she would do anything to *épater* the local bourgeoisie. Once she knew something about the Old World always being evoked in "P'ok," Europe became her destination. By the end of her life, when she had lived abroad for fifty years, she had assimilated the Surrealists' antibourgeois stance and accepted her odd status as the wife of Sir Roland Penrose—this after having been born into privilege, American style, and turning her back on what Poughkeepsie had to offer.

Yet the geography of Lee Miller's escapes—to New York, Paris, Cairo, and then to the movable country of the avant-garde—was mapped onto the landscape of Dutchess County as its opposite. Despite her hometown's narrow-mindedess, it amused her to sign her name (as she did on a Caribbean cruise) as Lady Penrose of Poughkeepsie, New York.

∞

The Millers lived until 1912 in the comfortable frame house on South Clinton Street where Elizabeth was born. Theodore liked the location near the center

of town, Florence walked to the local shops beneath the flowering cherry trees and Japanese maples that lined the street, an Italian organ-grinder played his spirited tunes outside their door, and the fife-and-drum band passed, waving banners, on the Fourth of July. After the birth of Elizabeth's younger brother, Erik, in 1910, her parents talked of moving to the country. Wherever they lived, Elizabeth always saw Erik as *her* playmate, a loyal sidekick ready to do her bidding. The Millers arranged to limit their family to the three children, another choice thought by some to show a progressive spirit.

Yet each parent's marked attachment to the child of the opposite sex struck some of their contemporaries as unusual. Florence preferred her firstborn. She dressed John in girls' clothing and tied bows in his hair until he was six, when she reluctantly agreed to trim his curls—a year after Theodore had himself cut Elizabeth's long fine hair and commemorated the event with before-and-after photographs. In a kind of reversed symmetry, Elizabeth often wore boys' clothing. Theodore so obviously preferred his daughter that John not unreasonably formed the opinion that girls had all the luck: they won their fathers' attention and didn't have to do chores. The two older children would share little except a passionate interest in machinery and what the family called their strong-mindedness. In most respects, they were opposites.

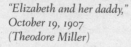

"Elizabeth and her daddy,"
October 19, 1907
(Theodore Miller)

From an early age Elizabeth disdained dolls, except when required to pose with one for Theodore, who used his camera to document her childhood on all occasions. He photographed himself holding John while both watched Florence with three-week-old Elizabeth, his little girl swathed in stiff white garments ("Elizabeth as a starched daisy"), himself holding her aloft at six months ("Elizabeth and her daddy"), John and his sister eating "in their pelts" on a hot day. No one thought much of his nude photos of Elizabeth at eighteen months, although it must have been hard to make her sit still on her wicker chair for both profile and rear views. The family albums hold many more shots of Theodore's daughter, all meticulously captioned in purple ink, than of his sons.

Theodore had many more occasions for picturesque shots after their move in 1912 to Cedar Hill Farm, four miles south of town. The property, which covered 165 acres, became a vast playground for the children. They lived first at Cedar Hill cottage, then in a two-story frame house. Over the next eight years, as Elizabeth grew up, her father enclosed the porch, added rooms, and built a playhouse behind the house with a bronze bell in the belfry to summon the children. Theodore's code worked according to birth order, one ring repeated three times for John, two rings for Elizabeth, three for Erik. Once Theodore gave John his own tools, the playhouse became John's shop. The younger children watched him build a locomotive that ran on a track equipped with a switch to avoid collisions and that had eight brass wheels that Theodore had specially cast. They sustained skinned knees from the inevitable wrecks as the train raced on its wooden tracks down the hill behind the house, across the flat land, and up the opposite hillside. Until John transferred his love of trains to airplanes, all three looked forward to their future as engineers.

Elizabeth habitually played boys' games. Delighted when John allowed her to ride his train, she developed such an interest in locomotives that she disappeared one day when the family was about to begin a train trip. Her parents worried until the conductor appeared to explain that she had gone to inspect the engine. Much of her play involved tinkering with things and taking them apart out of curiosity, a trait encouraged by her father. With John and Erik she built a waterwheel beside the stream that ran through the property—where they picnicked, swam, and picked watercress in the summer. She learned the rudiments of photography from Theodore, who gave her a box camera—at a time when Kodak ads enticed young customers to adopt the Brownie as the latest, and most creative, kind of toy. She climbed trees, camped, went riding and fishing with white bows in her flyaway blond hair—her mother's attempt to keep her from being a tomboy.

The children saw their father as a cross between a wizard and an inventor. While remodeling the farmhouse, he added running water, a heating system, and electricity, but what impressed them even more were gadgets of his own

design: a new kind of nutcracker, a light that came on when the cupboard was opened, a sealed photo lab set up in a converted bathroom. Theodore taught John to use either hand for certain tasks to make him ambidextrous and encouraged the children to write with both hands, as he did—an interest adopted by Elizabeth, with the result that her handwriting varies as much as his does. Theodore's respect for facts—the time, the weather, one's digestion, or how one had slept—implied that such matters were bedrock. What counted was what one could measure or record.

Inventors were national heroes while the Miller children were growing up. The proximity of Locust Grove, the richly landscaped property that had been the home of Samuel Morse, maintained its owner's reputation as an American Leonardo. That the inventor of the telegraph and Morse code had also been a leading nineteenth-century artist and an agriculturalist provided another example of masculine omnicompetence. His Italianate villa, said to be connected telegraphically to the major sites of North America, sat at the end of a curving drive that led to a romantic "French" garden. Locust Grove was more patrician than Cedar Hill Farm, and Theodore Miller was a man of the new age. Yet in some ways his vision of a healthy setting for his children's development harked back to the values with which his generation had been raised.

Since Theodore spent his days at the DeLaval plant, it made sense to have the property farmed by others. Through Florence's relatives, Theodore contacted the man his children would call Uncle Ephraim Miller, though he was not a relative. Ephraim traveled from Canada to Poughkeepsie with his wife, four daughters, and livestock to run the farm, which he did in the manner current in his homeland. They made all their own food except for staples, used flails to harvest grain, and lived according to the tenets of his Methodist faith. The girls played enthusiastically with Elizabeth and her brothers except on Sundays, when they walked the four miles to town to attend church. Theodore disapproved of what he called Ephraim's backwardness—his lack of interest in modern equipment—but until some years later, when he replaced Ephraim with a more forward-looking manager, the children had playmates with whom they formed an extended family.

During the long winters, when the family was often snowbound, Florence read them instructive stories like Margaret Sidney's *Five Little Peppers and How They Grew*. They were better off than the fatherless Pepper children, yet it sometimes seemed as if their home on Cedar Hill Farm resembled the little brown house of this impoverished but cheerful group. At first, before Theodore added a bathroom, they too heated water on a coal stove and bathed in the kitchen. Unlike the Pepper parents, however, their father was a force to be reckoned with, and their mother was not obliged to take in sewing. Nor could anyone imagine Elizabeth imitating industrious Polly Pepper by coaxing cakes out of brown flour and old raisins. The Peppers' rags-to-riches saga (a

millionaire railroad director, Mr. King, becomes their benefactor) sketched out an alternative to the Horatio Alger model, one in which all were so unvaryingly kind that their elevation to a more aristocratic way of life did little to change them.

Elizabeth preferred a series in a different vein, the Goop books. Ostensibly created to tell children what not to do, Gelett Burgess's unruly Goops sent up the moralism of nineteenth-century children's stories and, in the process, made bad behavior look delicious. (Burgess betrayed his sympathy for his big-headed imps in one series title, *Goops and How to Be Them*.) Infantile crimes like Talking While Eating, Whining, Sulking, and Not Minding Mother were portrayed as reprehensible, yet one guesses from the subtitle of a later edition, his manuals "for impolite infants, depicting the characteristics of many naughty and thoughtless children," did more to inspire Goop-emulation than to persuade children to its opposite. *The Goop Directory*, which Elizabeth kept in her adult library, attributed infantile indiscretions to familiarly named children: one Eliza Puddingfoot, found guilty of Cheating at Play, is shunned by all but so dominates the illustration that one cannot feel sorry for her.

Unlike the recently departed Mr. Pepper, Theodore was a major presence in the children's lives. He interested himself and them in pastimes befitting a man of his position—like Teddy Roosevelt, he disappeared for several weeks each fall to hunt deer and bear, which he brought home as trophies. He was gregarious and loved to travel, at first by train, then in the big Buick sedan he bought in 1917. The children peered through its cut-glass panels as they toured with their parents during summer holidays, when they went to the mountains and seashore, or to visit their prosperous Uncle Fred, whose island estate on the Delaware River impressed them more than Morse's house at Locust Grove.

The Millers also attended performances at Poughkeepsie's Collingwood Opera House, where under the auspices of high culture, they saw everything from farce to vaudeville. The children were taken there to experience the novelty of the day, the "motion pictures" used as curtain-raisers before more high-class events. They were also initiated into Theodore's passion for the stereoscope—a photographic camera and viewer that purveyed with a startling depth and detail images of exotic places, technological marvels, and humorous or titillating scenarios. What the children did not see, presumably, were the stereoscopic poses of naked women widely available at the turn of the century and still popular at gentlemen-only venues like the Amrita Club. It was one thing to gaze at the prickly texture of pineapple plants in Hawaii and quite another to contemplate bare-breasted harem girls recumbent on their couches.

Theodore often told the children about his upbringing. As a boy he had never defied his father. He saw himself as a strict but reasonable parent: if the children talked back or otherwise misbehaved, they were sent to their rooms. Elizabeth's remarks about Erik's table manners resulted in angry retorts by Flo-

rence, who told her not to criticize the little boy, then sent her upstairs to con-
template her goopishness: she had not only hurt her brother's feelings but set
a bad example. Theodore told the children that they could do as they pleased
as long as it didn't harm anyone. Good behavior was based on ethical princi-
ples. In his view his large collection of books on atheism made more sense
than the Bible. Organized religions produced fanatics who believed in mira-
cles or unyielding throwbacks like Uncle Ephraim. As a concession to Flo-
rence the family attended the Unitarian church, which had the merit of not
greatly challenging Theodore's outlook while also maintaining contact with
Protestant doctrine.

In later years Theodore met once a week with the Episcopalian minister,
to whom he referred as his spiritual adviser, but as if to balance his influence,
often invited him to dinner with the head of Vassar's astronomy department.
Since his sister Elizabeth had married a Quaker missionary, Theodore made an
exception for this sect. Little Elizabeth listened attentively to her aunt's stories
of life in Japan when the Binfords came to visit, and dressed for photo sessions
in the kimono and obi brought as gifts, along with swords and armor for her
brothers. These glimpses of other lives, combined with evenings spent looking
through the stereoscope viewer at faraway lands—Hawaii, India, or Japan,
where the Binfords lived—inspired a precocious wanderlust.

John lost interest in trains after his father took him to see Glenn Curtiss,
a contemporary of the Wright Brothers who in 1910 landed his flying machine
near their farm to refuel. The experience so impressed the little boy that he
vowed to become a pilot. Elizabeth, still enchanted by terrestrial engines, dis-
covered a source of inspiration other than her father in an equally unlikely
place. Decades later, recalling her first motion picture—"a thrill-packed reel of
a spark-shedding locomotive dashing through tunnels and over trestles"—she
could still feel its dizzying speed and see the "head of the train glar[ing] at its
own tail" as it curved around a chasm. "Nothing whatever stayed still," she
wrote, "and I pulled eight dollars worth of fringe from the rail of our loge, in my
whooping, joyful frenzy."

What inspired her rapture was not the film's engineer but a character who
documented their ride as it happened—"the intrepid cameraman himself who
wore his cap backwards, and was paid 'danger money.'" In this retrospective
account of her seven-year-old self, the child's identification with her on-screen
hero is one with an intoxicating sense of forward motion. It is an intense vis-
ceral memory for a little girl who years later as a photographer would neither
stay still nor receive her due in fame or "danger money."

<center>∾</center>

Something of a spark-shedding locomotive herself, Elizabeth led an
untrameled life compared to other girls. Brought up as her daddy's darling, she

was used to roaming over the farm, alone or with her brothers, and to getting her way. She was also confident in her powers of judgment and determined to discover how things worked, especially if they were men's business. Above all, she was drawn to the conjoining of motion and materiality in machines—whether DeLaval's separators, which broke matter into its constituent parts, the locomotives of the New York Central line, or her father's well-appointed touring cars. These engines stirred the little girl's imagination—in which she too was full of energy and sufficient unto herself, like the train curling back on its own beginning. Recalling the ourobouros (the snake biting its tail—an archetype of nature's continuity), this strong figure conveys the child's sense of autonomy.

From her mother's perspective, however, Elizabeth was unladylike. Florence wanted her to look more like the girl of the family. After her marriage Florence had cut a fashionable figure—until three pregnancies and the Millers' removal to the farm combined to increase her girth. When Elizabeth was little, Florence dressed her as a small version of herself in a miniature nurse's uniform. On the principle that while her behavior was unruly she could at least dress properly, for special occasions Elizabeth wore white lace frocks and embroidered jackets, or a white alpaca coat with matching muff, gloves,

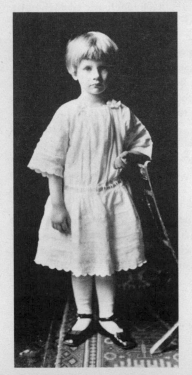

Elizabeth on her fourth birthday
(Theodore Miller)

hat, and hairbow. In photo albums she appears alternately in her overalls and gumboots and in the delicate feminine garments of her mother's choosing.

While Elizabeth's early life was happy, it is hard to know what to make of her parents' relationship. On the one hand, Theodore was as much a domestic tyrant as an industrial one; Florence deferred to him, tacitly accepting his liaisons with other women. On the other hand, she was not without influence. After he initiated her into his passion for photography, Florence agreed to pose in the nude. This unusual request seems not to have alarmed her, no doubt because he explained that such portraits were "Art." They were for his own enjoyment, and nudism was, in any case, a progressive practice. Such things were taken for granted in the family.

Theodore regularly made trips to DeLaval's home office in Stockholm. One winter, after his return, the neighbors thought he had gone mad when they saw him sliding down the snow-covered hills on a pair of curved boards; until then, skis were unknown in Poughkeepsie. The children caught on quickly after he made skis for them by steaming boards to turn up the ends. In addition to the skis, he came home with great respect for Swedish manufacturing. In Stockholm DeLaval was thought a genius, in the same company as Alfred Nobel. Theodore also looked with interest on the early stages of the Swedish social welfare program and the gradual rise of the Social Democrats, although their policies regarding workers' rights differed from his own. Although Sweden had come late to modernization, its industrial breakthrough predisposed him in the country's favor.

When Swedish friends visited Poughkeepsie, they often brought presents for the Miller children. Family photos show Elizabeth dressed as a Swedish girl or holding a Swedish doll. During the Millers' visit to Sweden in July 1913, they spent several idyllic days at a DeLaval associate's summer home on Lake Mälaren with an attractive young couple, the Kajerdts, who later came to the United States to work with the company's American branch. When in Poughkeepsie, the couple often visited the Millers. Astrid Kajerdt (who had no children of her own) took a fancy to Elizabeth, whose blond good looks may have reminded her of home. Her affection was reciprocated—so much so that Elizabeth looked forward to staying with the Kajerdts in Brooklyn while Florence recovered from an illness.

Mrs. Kajerdt wrote to Florence about Elizabeth's impressions—when they went into the subway she asked whether night had fallen—and her ability to "take things so natural and feel quite at home with everything and everybody." They fed the squirrels in the park, rode on a merry-go-round, and inspected Abraham and Straus's toy department. Elizabeth made new friends—the boy upstairs and Mrs. Kajerdt's brother-in-law, "Uncle Bob," who took his meals with the family. Everyone enjoyed her, Astrid wrote: "It is strange how a child can make you young again. She really is the most impor-

tant person in the house at present, but I will try my best not to let the gentlemen spoil her."

This visit marked the end of Elizabeth's sense of security and, in some ways, her childhood—at the age of seven. One day when Astrid went shopping, she left the girl in the care of a male friend, "Uncle Bob" or a nephew who was also staying with the Kajerdts on leave from his tour of duty as a sailor. The details of what happened are unclear. Mrs. Kajerdt's correspondence ended abruptly; Theodore's diaries are mute on the subject even though Elizabeth was rushed to Poughkeepsie. At nine her brother John did not know the word *rape,* but he later surmised that Elizabeth's caretaker had raped her during Mrs. Kajerdt's absence. Given the secrecy surrounding such matters it is no wonder that John had to piece together the story, which was never explained.

For Elizabeth the experience was so unexpected, so traumatic, and so impossible to process that its impact must be inferred from the patterns of her later life. During rape, integrity is ruptured, trust in the world undone. The act deprives the victim of her autonomy whether or not she can defend herself. Often a kind of numbing ensues. The helpless person may experience an altered state of consciousness in which the attack seems unreal: "as though she is observing from outside her body, or as though the whole experience is a bad dream from which she will shortly awaken." Judging by Lee Miller's adult life, she never quite awoke from this nightmare. The damage done to her seven-year-old self stayed with her, even though she later made use of her ability to observe as if objectively what was happening to her body.

If rape is also understood as a violation of inwardness, "the most sacred and private repository of the self," its impact on a young child—whose self is a work in progress—is all the more terrifying. Maya Angelou, raped by a family friend at about the same age, called the episode "a breaking and entering when even the senses are torn apart." Decades later, Lee Miller put her outraged emotions into her compositions—where enigmatic doorways hint at damage to the house of the self, or look to a space beyond loss and trauma.

Although there are many uncertainties about this turning point in Elizabeth's life, its impact is apparent in Theodore's photographs. In one of them, most likely taken before her stay in Brooklyn, she stands between John and Erik, with her parents planted protectively behind them. Wearing a white summer dress, matching shoes and stockings, and a large bow in her hair, she smiles confidently. The embrace of her family is taken for granted. In another photo, made less than a year later, Elizabeth stands alone with one arm propped against the support of the playhouse. She wears shapeless overalls, her hair is

slicked back and bowless, her expression at once depressed and angry. Barely eight, she seems quite unlike her self from the previous year. Much later, John observed that his sister never fully assimilated the trauma. "It changed her whole life and attitude," he reflected—adding as an afterthought, "she went wild."

After her return home Elizabeth's recovery was still uncharted. Reestablishing a sense of trust after rape depends to a large extent on family members' attitudes. Nothing in Theodore's commitment to the certainty of facts could have prepared him for this emergency, nor did nurse's training at the turn of the century include advice on the subject. The Millers turned not to a spiritual adviser but to a doctor, probably a psychiatrist. They understood him to say that they must tell Elizabeth that the damage was not permanent, since sex was one thing and love another. This applied Freudianism sounded up-to-date, but had the effect of separating body from spirit, the senses from the emotions.

The task of attending to their daughter's physical condition fell to Florence, who realized that the rape had not only changed Elizabeth's attitude but had left her with a disease, which was soon diagnosed as gonorrhea. In the first decades of the century, public health officials warned that an epidemic of such complaints threatened the country; Dr. Prince Morrow, an expert on "the diseases of vice," warned that syphilis and gonorrhea had invaded the habitations of virtue. Although polite discourse did not permit discussion of such matters, sexually transmitted diseases constituted a grave problem—both ethically, since innocent females contracted these diseases unknowingly, and in their effect on the body politic. Gonorrhea was, Morrow believed, the single most powerful factor in depopulation: 50 percent of infected women became sterile. Moreover, the treatments then available could have disastrous consequences. "The flower of our land, our young women," another expert wrote, "are being mutilated and unsexed by surgical life-saving measures because of these diseases."

Since no one in Poughkeepsie could know the cause of Elizabeth's illness, her case had to be handled discreetly—which meant continued isolation during her recovery. Florence took her to Vassar Hospital several times a week for the next year. Before sulfa drugs, the treatment for gonorrhea in females consisted of an antiseptic sitz bath followed by the "irrigation" of the bladder with a solution of potassium permanganate (the ominous-sounding equipment included a glass catheter, douche can, and rubber tubing), after which the patient was douched with a mixture of boric acid, carbolic acid, and several oils. As if this were not enough, the cervix had to be probed twice a week with cotton-wool swabs to remove secretions, then daubed with a solution of "picric acid in glycerine."

Florence administered these treatments in her immaculate white bath-

room. Although the boys were not supposed to know what was happening, John heard his sister cry out when their mother performed the irrigations, and he watched her sterilize the fixtures to keep the disease from spreading. Whatever Elizabeth touched, bathtub, basin, or toilet seat, had to be scoured with dichloride of mercury, a strong disinfectant. It is not difficult to imagine the effect of this routine on the little girl, or to understand how her mother, rather than comforting her, unwittingly made the situation worse.

In the cases with the best outcomes, trauma victims undergo stages in recovery. Regaining a sense of control over one's body is vital, but daily irrigations and frequent "inoculations" over the course of the year must have made it seem—to a seven-year-old—that she would never regain the freedom she had enjoyed before the attack. Nor would the capacity for trust be reestablished, since the rape occurred at the home of friends. It is likely that Elizabeth learned to dissociate herself from the event (since her father had said that sex was separate from love) and from its aftermath, the feelings of guilt, blame, and anger. Whatever Florence actually said, the treatments she administered made her daughter feel that she had been contaminated. In the parlance of the day, she was "damaged goods." It is from this time that Lee's tendency to see herself as split between good and bad selves may be dated.

∞

One morning in 1915, two weeks before Elizabeth's eighth birthday and Theodore's next trip to Sweden, he announced that he would be taking a different kind of portrait, to be called "December Morn"—although it was April. Thinking perhaps that he was carrying out the doctor's orders or hoping to make his daughter feel more comfortable with her body, perhaps wanting to mark the close of this horrible year, he told her not to dress up. She was to pose outside in her birthday suit. In this photo the child stands naked, except for her slippers, in the snowbanks beside the house. Trying not to shiver, which would have spoiled the picture, she looks ill at ease, yet somehow proud of herself.

Today, Theodore's blend of therapy and "Art" seems peculiar—especially when one realizes that his inspiration was Paul Chabas's *September Morn*, a painting of a nubile nude emerging from a pool that provoked a national scandal when it was shown in New York the year before. For a time, this titillating artwork (now owned by the Metropolitan Museum) was as famous, or notorious, as the *Mona Lisa*.

From our perspective, we wonder whether Theodore, too, saw his daughter as damaged goods—her innocence despoiled yet preserved in his imagination, her image held for his private view in stereoscopic slides and annotated

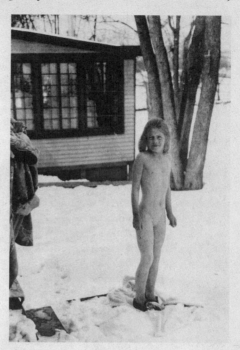

December Morn, *April 14, 1915*
(*Theodore Miller*)

albums. Then, the family accepted his hobby as a form of art. Florence, who often supervised photography sessions, did not object to their effect on Elizabeth. And despite her many lovers in later life, Lee would always rely on her father. Erik observed: "He was the only man she could feel comfortable with and really love."

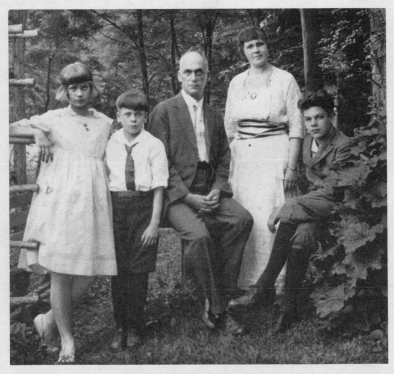

The Millers, 1920 (Theodore Miller)

Chapter 2

Never Jam Today

(1915–25)

If Theodore hoped to reassure Elizabeth by casting her as his prepubescent muse, this peculiar "treatment" deepened their bond while further objectifying her. The rape and its aftermath, occasional bouts of gonorrhea, became an unmentionable part of her life. During a flare-up twelve years later, she wrote obliquely of their impact in a journal addressed to an imaginary reader—who is asked to sympathize, yet held at arm's length. Her confession, she noted with the self-absorption of a nineteen-year-old, was "something to hand down to posterity."

"Of my dark and supposedly lurid past," she began, "I will say almost nothing. . . . I will content myself this time in saying that anything you hear about me is probably true." Her "sordidly experienced life" could be seen as a pattern initiated by a random cause—just as in novels, events resulting "from the circumstantial placing of individuals" could generate a "natural and probable occurrence." This pattern, she went on, has been "true to life—to *my* life!"

But generalities offered little comfort: she could not bring herself to name her distress. And the effort to accept objective theories about the "circumstantial placing of individuals" was so great that after formulating this account, Elizabeth burst into tears. "I was the nearest to suicide I have ever

been," she wrote later—overwhelmed by a sense of "sheer hopelessness, acti-
vated by that swollen awkward feeling which ha[s] followed me from child-
hood." This awkward feeling suggests the stored bodily memory of the rape
and the ensuing treatments—a discomfort that sometimes surfaced like a
threat to her being.

∞

From the end of Elizabeth's childhood at seven to her departure from home at
nineteen, her moods dominated the household. Florence often lost patience
with her; Theodore usually responded by taking his daughter's side in family
squabbles. Her wishes were indulged, her health constantly monitored. While
John was given tasks like mowing the lawn as well as his daily chores, Eliza-
beth was treated like a princess. The little boy couldn't understand why she
didn't have to do women's work but could spend her time reading, drawing,
and looking at albums of film stars or dreaming about the scripts in which she
would shine as an actress.

The few girls who lived nearby, most of whom attended a Vassar prep
school called Putnam Hall, were invited to keep Elizabeth company. When
she had recovered from the trauma, her parents sent her to Governor Clinton
School to start first grade, where she chose as her best friend a lively eight-
year-old named Miriam Hicks, nicknamed Minnow. Elizabeth took to running
away as an alternative to venting her temper at home. On these occasions her
father drove straight to Minnow's house and waited outside until her mood
had changed.

One wonders what Theodore made of Elizabeth's turn from boys' games to
more "feminine" activities—whether he saw it as natural or as a consequence
of her precocious sexual knowledge. (Typically, he did not commit thoughts or
feelings to paper but made factual notes, such as "Elizabeth had tantrums,
threw things in her room.") The psychiatrist the Millers consulted may have
said that they could expect a stormy period right through her adolescence. The
trauma had sexualized her at an early age—seven being considered the start of
latency, a period in child development when eros is thought to lie dormant.
From this perspective, her tantrums expressed her buried rage. But the
episode was never mentioned, except when Theodore repeated the doctor's
remark that sex and love were not the same.

Florence continued to practice the pastimes befitting a woman of her sta-
tion: bridge, gourmet cooking, and churchgoing. She enrolled Elizabeth at
Sunday school, for piano lessons, and for dance classes at Miss Rutherford's,
where the offspring of the local elite studied tap, ballet, and ballroom dancing.
For the next three years her mother also took her to New York for treatments
with a Dr. Robinson. (Theodore's diaries record the dates of these trips but

nothing more.) In order to keep watch on Elizabeth, Florence chose not to accompany her husband on his next trip to Sweden.

Under her mother's attentive eye, the little girl indulged in pastimes like jewelry making and other crafts, and with her brothers, enjoyed the pleasures of country life. She rode Ginny, the donkey, around the farm, lolled in the hammock or swung on the swings Theodore hung from the birch trees, and camped, swam, and fished with John and Erik during the summer. In winter months she skated on the frozen pond or at nearby Lake Upton—activities recorded by Theodore, whose desire to document the children's days was accepted as something fathers did, like hunting and fishing.

Theodore's fascination with the camera and his love of gadgets came together in his passion for photography. In these years, he initiated his family into a pastime that had, for the past decade, been encouraged by Eastman Kodak, the pride of Rochester. Kodak urged middle-class families to record their lives: "Bring your vacation home in a Kodak," the company exhorted; "There are no Game Laws for those who hunt with a Kodak," proclaimed an ad aimed at outdoorsmen. The "better" magazines all featured well-dressed women photographing foreigners encountered on their holidays or memorializing Christmas at home; the Kodak Girl, a subdeb version of modern womanhood, appeared with her camera in publicity campaigns emphasizing her sense of adventure—but also her amateur status.

While Theodore often used a box camera, he preferred the stereoscope, which took a pair of pictures set slightly apart so that the two images formed one when seen through a viewer. In 1916, he began experimenting with techniques for projecting the twin images on a screen, using a revolving shutter to get "the true stereoscopic effect, the important point being to get both projections focused alike." Although John continued to prefer airplanes to photography, Elizabeth and Erik loved to watch images of themselves appear as if by magic as Theodore took prints from the

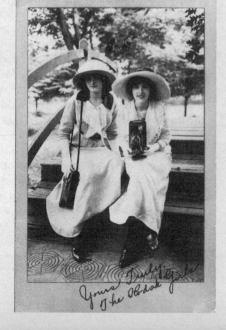

Publicity card for the Kodak Girls, Eastman Kodak's role models for budding female photographers

chemical bath in his darkroom. They enjoyed their closeness to him in this private space, and at night, when he entertained the family with slide shows of faraway lands shown in deep perspective.

Peering intently through the stereoscope viewer, Lee got her eye in at an early age. Some of these devices were held like opera glasses. Others enhanced the sense of a theatrical experience by shielding the spectator's eyes under a slight overhang: one entered this private space to gaze at the Eiffel Tower or the fronds of date palms beside the Pyramids. The stereoscope, a pastime combining home entertainment with educational instruction (commercial slide sets included courses of study), gave the little girl a precocious visual training and the desire to visit the foreign lands at which she gazed.

Formal education did not interest her, however, nor could she accept the discipline required at local institutions of learning. From an early age, Elizabeth picked up information by more amusing methods, like the stereoscope, her stamp collection, and the chemistry set Theodore gave her one Christmas, with which she performed a series of disastrous experiments. Since she wanted to be entertained while learning, the regimented teaching methods at Governor Clinton did not suit her. Teachers thought her more than a little spoiled; classmates called her a show-off. As she grew up, Elizabeth took delight in being provocative. One afternoon she had her braids cut off, then appeared at school with a fashionable bob. "That one, she had a mind of her own," recalled Miss Freer, whose sixth-grade English classes had the merit of providing her with an excuse to read as much as she liked.

Theodore's interests provided an alternative to formal education. At dinner the family debated the ideas of Henry George, the economic visionary who, he believed, offered the solution to social injustice. Toward the end of the nineteenth century Georgism had influenced a wide range of people, from artists and revolutionaries like Tolstoy and Sun Yat-sen to wheat farmers in the United States, Canada, and Australia. Prominent Americans like William Jennings Bryan favored George's principle of a single tax on landowners, which eliminated taxation on wage earners and the landless. Theodore agreed that the land belonged to the people. Once landowners could no longer profit from speculation, the natural order would be restored, and all classes would benefit.

No one at the dinner table noticed the contradictions between Georgism and the ideas of Henry Ford, another of Theodore's favorites. Although both men rejected the aristocracy of inherited wealth and looked to a more democratic future, their differences were profound. But this was of no concern to Theodore. Ford's vision of motorcars for the multitude was heroic; his mass-production techniques, socially useful. And his recent decision to give factory workers a living wage while reducing their hours had already proved good business practice, since workers could then buy the very Model Ts they were turning out every twenty-four seconds.

The man whose career inspired the whole family was Thomas Edison, the

holder of more than a thousand patents for his inventions—among them the microphone, the phonograph, and the incandescent bulb. The cover of *Success*, an illustrated magazine that publicized national heroes, featured a reflective Edison in the laboratory where he worked on such projects as a motion picture projector synchronized with a phonograph—an early form of "talkies." Edison also devised a new power source, the alkaline storage battery. By the mid-1910s, Edison's batteries were powering submarines, electric motorcars, and the starter for the Model T.

Elizabeth learned about perspective by peering through her father's stereoscope viewer, shown with his slides of the Millers and of Lee at twenty-one.

Another of his projects intrigued Theodore. Edison's workshop had tried to develop a magnetic separator to extract iron from low-grade ores. Although the effort had been abandoned, the parallel with DeLaval's use of its separators was striking.

Theodore, it was generally agreed, was a man of the future. He espoused health habits considered eccentric by some and progressive by others, such as birth control, a diet of whole foods, and exposure to the sun's rays through the practice of nudism—practices in which Florence joined him. While these opinions made him seem advanced, he also enjoyed the reputation as one of Poughkeepsie's most influential citizens. The children looked to their father as the household Edison, whose inventions made life more interesting. His purchase of the first electric blankets seemed to prove his wisdom, especially in cooler months, when the family still slept on the sleeping porch.

The Millers' lives were not much affected by the hostilities in Europe even when Poughkeepsie was swept up in the wave of patriotism that overwhelmed the country after the United States entered the war in 1917. The children followed its progress in the newspaper; each class at Governor Clinton formed a military company. John used an army manual to drill his company (they took first prize) and wore his Boy Scout uniform to sell war bonds. Having recently been subjected to sewing lessons by Florence, Elizabeth knitted socks for the refugees and posed in her Red Cross nurse's uniform—one of the rare occasions when she could be said to take after her mother. She played war games with Erik but did not succumb to war fever, nor did she join her parents at victory meetings or the timely performance of George Bernard Shaw's *Arms and the Man,* held in town at the Collingwood Opera House.

The Collingwood, which combined the functions of civic meeting place

and temple of culture, ran anti-German propaganda films on Friday and Saturday nights, when the Millers took the children to Poughkeepsie. These melodramas portrayed the enemy as fiends who took pleasure in ruining the innocent. "Dishevelled girls staggered from the private quarters of the Crown Prince of Germany who raped his way across Belgium," Lee recalled of such programs, "while his officers tortured civilians behind haystacks. The Kaiser himself was busy gloating over Zeppelin raids," she went on, "the chopped-off hands of little children and 'the worse-than-death' fate of nuns and nurses. Oh! how gloaty was the gloating, how lecherous the leer and oh, how pure the innocent."

On December 8, 1917, the Millers took Elizabeth to the Collingwood to see Sarah Bernhardt's latest farewell tour. The experience, her first theatrical event, so marked her imagination that she could still visualize it decades later. With John and her parents she walked through the crowded lobby, past the fountain banked with flowers, and into the vast semidark opera house to their loge. High above them, on the great dome and decorated ceiling representing the firmament, Italianate gods lolled on billowing clouds. Straight ahead loomed the huge stage, framed like an enormous painting by its eighty-foot proscenium arch, and all around, the audience arranged in tiers and balconies. That night the house was full of Vassar girls and soberly dressed notables, whose decision not to wear evening clothes "portended a change of feeling," an onlooker wrote—as if the town agreed "to show Mme. Bernhardt that we are taking the war seriously."

The curtain-raiser, a one-reel silent, starred Elizabeth's hero—the cameraman who took pictures while hanging out the train window to earn his "danger money." Next came the slightly risqué *tableaux vivants,* which featured immobile nudes impersonating abstractions or statuary, with titles like Motherhood, Columbia, and Venus de Milo. A quivering light played over these feminine icons, Lee recalled with a touch of sarcasm, but to her eyes, already accustomed to her father's nude studies, "It was just more ART."

The Divine Sarah, although over seventy and missing a leg, exceeded expectations by enacting the death of Cleopatra on her chaise longue. Then, following the mayor's exhortations on behalf of the Red Cross drive, she leaned against a pillar to play Portia in *The Merchant of Venice.* Watching the actress declaim "was of considerable morbid interest to me," Lee recalled. "Though I understood no French, her Portia, pleading, seemed urgent." Bernhardt had come to the United States to fan prowar sentiment: she represented what the Allies were fighting for, and her transformation from horizontal to vertical seemed miraculous.

The entire audience leapt to their feet at the end of the performance. Everyone applauded as the actress returned again and again to the stage, even though few apart from the Vassar contingent had understood what she said.

This triumph of mind over body, the reviewer wrote, joined with the prevailing spirit of patriotism to inspire all those who were present. At the end of the evening the accompanist played the Marseillaise, the Vassar girls sang from the balcony, and members of the audience wiped tears from their eyes. Bernhardt, "as full of life and as active as many women are at 30," had given Poughkeepsie a triumph.

Elizabeth was ten when she saw this stirring program. Yet in 1956, as she drafted these recollections for a *Vogue* article, "What They See in Cinema," she placed the experience several years before it happened. Given that her memory was excellent, one may suppose that such errors are not accidents. "What They See in Cinema" links visceral memories of that December night in 1917 with other evenings at the Collingwood when she watched the "worse-than-death fate" befall the kaiser's victims—images that must have evoked her own victimization at age seven—while its ironic tone holds the "dishevelled girls" at arm's length, as if the scene were too painful to examine head-on.

That same weekend saw the opening of *Arms and the Girl,* a popular "photoplay" inspired by G. B. Shaw's success. The film met the demand for uplifting entertainment by depicting innocent femininity as a weapon against masculine beastliness: Billie Burke, a guileless American, saves a gallant compatriot from execution by pretending that they are engaged, then marries her "fiancé" on the orders of a cruel German general. Its mixed message implied that while society gave women a limited scope for heroism, feminine virtue would nonetheless triumph.

In the 1910s, photoplays, as movies were called, were *the* modern form of entertainment, combining technical innovations with lively artistic effects. Elizabeth often escaped to the movies with Minnow—who, in addition to sharing her love of the cinema, got free passes from her father. Although Elizabeth would always admire Bernhardt's bravery, it was hard for a young girl to imitate a seventy-year-old tragedienne. But it *was* possible to think of imitating Billie Burke's spirited film heroine, or Geraldine Farrar, who, Lee wrote, "besieged Orleans as Joan of Arc, with noble Wallace Reid by her side." Cecil B. DeMille's *Joan the Woman* (more prowar propaganda) was "as grand as Delacroix," she went on. "It's pretty good going to be awed, educated and entertained simultaneously," she added, recalling her ten-year-old self's enthusiasms.

In 1918, after the armistice, filmmakers returned to less uplifting, but equally entertaining, subjects—like sex. Elizabeth and Minnow admired the former Ziegfeld Follies dancer Mae Murray, who starred in such classic silent films as *Jazzmania* and Erich von Stroheim's *Merry Widow.* Reading about her

"bee-stung lips" in the fan magazines, they pursed their own in imitation. Other Hollywood heroines included the diva-turned-film-star Lina Cavalieri, who "thumbed-down handsome gladiators and orgied through ancient history," Lee wrote, and during their teenage years, the young "flappers" Colleen Moore and Louise Brooks.

While the girls also admired noble Wallace Reid and smoldering Rudolph Valentino, their Hollywood pantheon soon included more writers and directors than actors—since they wrote the stories that thrilled the masses. Unchaperoned, Elizabeth and Minnow watched the orgies of destruction in *The Ten Commandments* and *The Last Days of Pompeii,* whose sources in the Bible and in history justified their on-screen saturnalia. Such large-scale misbehavior was inspiring, as was the silent movies' sexual innuendo. The girls practiced lipreading to learn "what the bride really said at the altar." The cinema, Lee observed dryly, "offers us variety in vicarious living."

Rather than act in the movies, the two friends decided to write for them. To this end, they studied *Photoplay,* a popular movie magazine, as if it were a textbook. It was exciting to learn that Wallace Reid had entered a sanatorium after becoming addicted to morphine, and that Valentino had been charged with bigamy following his marriage to Natacha Rambova, who was said to have him under her spell. Another of their heroes, Allan Dwan, who had been an engineer before becoming a director, was known to be practical: "You will never hear Allan Dwan prate about 'My Art,'" *Photoplay* explained. "He believes in the photoplay as an art and as an industry, but he doesn't waste time telling everybody about it."

Elizabeth and Minnow were even more interested in the women who achieved recognition as writers. While the *Photoplay* columnist Adela Rogers St. John had an insider's knowledge of Hollywood, they planned to emulate Anita Loos, who began writing for D. W. Griffiths as a fifteen-year-old and would go on to write the book *Gentlemen Prefer Blondes.* Loos had worked with both Griffiths and Dwan on vehicles for Douglas Fairbanks; her recent successes included *Wild and Wooly, A Virtuous Vamp,* and *The Perfect Woman,* but she was even better known for her dark bob—at a time when most women, especially in Poughkeepsie, had long tresses. Loos became their model. Their scripts, which combined elements of the films they saw and the Hollywood lore they devoured, "were full of naked sinners on bearskin rugs," Minnow mused, but "they made us happy."

Reflecting on her early love of motion pictures, Lee concluded that what had moved her was the occasional "flash of poetry." "Often it is born of motion, alone," she went on. "It might be the way an arm moves, a shadow falls, or some dust settles." This poetic quality was, moreover, an accident: "neither study, sincerity, taste nor trying can synthesize or pin it down."

Years later, as Lee peered through her camera at people, buildings, and

landscapes, flashes of poetry often revealed themselves—like a private viewing space, the apparatus itself helped to capture the quality of motion. But as a teenager desperate to escape from Poughkeepsie, she feared that despite her artistic temperament, she had no definable talent. English teachers did little to encourage her desire to write. The few school assignments remaining among her papers include two poems written in completely different styles, as if she were trying on voices just as she tried different kinds of handwriting and different identities: she submitted these verses as "Betty" Miller.

The more traditional of the two, "A Song," exhorts her fourteen-year-old self to "Do good, since thou still liveth, / Love, it is not too late. / Do good, for the joy it giveth, / Put from thy heart all hate." The speaker tells the self strain-ing between contradictory emotions to resolve them in work, the nature of which remains vague, but ends the poem on a positive note: "Live, for thy life's not long / Dream, for thy dreams are real. / On thy lips let there be a song / Of Life, of Work, an ideal." Beneath the moralizing rhymes and antiquated dic-tion, Elizabeth's belief in the reality of dreams—Art?—is discernible to a sym-pathetic reader.

Her other poem, "Chinese Shawls," abandons Victorian sentiment to focus a self-consciously Beardsley-esque composition—three shawls arranged on "a chest of lacquer red." Their colors—"black, with poison green," "pow-dered Chinese gold," and "Night-black and paper-white"—suggest a Green-wich Village studio of the 1910s, and since the meter is more relaxed than in "A Song," one may suppose that art for art's sake came more easily than moral uplift.

About this time, Elizabeth also wrote a story, "Distributing Letters," whose characters are Jean, "the pretty and popular daughter" of Judge Ashford; Jean's older brother; and their father. Jean's mother having conveniently died when she was eleven, "Jean was very much spoiled by her father"—who, in spite of being a town notable, "could do nothing with her, for she had a will of her own." Each morning at breakfast she receives anonymous letters from a watchful critic, the most recent of which begins, "At the tennis match your white hat was very smart and becoming, but your new dress would be much better if it were several inches longer." The writer also taxes her with "making eyes," behavior that "marks you as not being well-bred, which is a shame on your father." By the end of the story, Jean's brother realizes that Judge Ashford is the author of these missives and agrees to join him in curing her faults.

In the opinion of Elizabeth's teacher (who gave the story an 83), "Distrib-uting Letters" lacked unity. To a more sympathetic reader, the tale is transpar-ent. At fourteen, Elizabeth felt caught between doing her own looking and being scrutinized for properly feminine behavior. She had a will of her own that she wanted to exercise. But as the daughter of a prominent family, her attempts to be active in the world were proof that she was not what she

seemed. A nagging voice insisted that despite the smart white outfit, she was not "well-bred."

∞

Given her lack of success at school, Elizabeth's career as the next Anita Loos seemed uncertain. In the meantime, the local newspapers announced the establishment of a community theater. Although the "little theater" movement had been popular across the country before the war, Poughkeepsie was the first large city to commit resources to this kind of cultural venture. The new Community Theatre planned to produce plays of a high standard (in keeping with its Anglophile spelling), thereby avoiding the "vulgarity of some Broadway successes."

Gertrude Buck, the force behind the project, was an energetic Vassar English professor whose students already staged, directed, and acted in the plays produced in her theater workshop—an innovation at a time when most drama courses consisted of play reading. Her hands-on approach offered a model for the community. The Vassar Brothers Institute trustees gave the use of their premises rent-free, prominent residents became subscribers, and the head of the First National Bank signed on as chairman.

The plan was to present a new play for children on successive Saturday afternoons each month, followed by an adult play in the evening. Elizabeth auditioned and won a part in a stage version of Lewis Carroll's *Alice in Wonderland*. Cast as the absentminded White Queen, whose opening lines— "bread-and-butter, bread-and-butter"—never failed to produce laughter, she had difficulty keeping a straight face at rehearsals, especially when telling Alice that one might have "jam to-morrow and jam yesterday—but never jam *to-day*." She managed to stay in character and celebrated her fourteenth birthday onstage.

When Elizabeth returned to school on Monday mornings, the White Queen's declaration that she could do sums but could not manage subtraction "under *any* circumstances" may have come to mind. Her scapegrace antics infuriated teachers while entertaining classmates. Cooking class struck her as a particular waste of time. One day as she and Minnow were washing the dishes, she began flicking water at the others. The teacher complained to the principal and had her expelled.

The Millers visited several private schools before choosing the new Quaker establishment, Oakwood, as the institution of learning most likely to instill discipline in their mischievous daughter. Townspeople were proud of having attracted Oakwood to the area: it was thought to cap Poughkeepsie's reputation as a center of learning. The first coeducational boarding school in the United States, Oakwood was run on strict principles. Theodore decided

that John and Elizabeth would both board there, even though the school was a short walk from their new house in Kingswood Park. He could afford the fees, and he admired the principal, an ambitious man named William Reagan, who said that the Quaker ethic would benefit both children.

Although classes were coed, boys and girls were allowed to socialize for only one hour on Sundays. Fads like dancing, jazz, and short hair were deemed immoral; swear words and personal adornments were forbidden. The high point of the week came when the whole school assembled to hear Mr. Reagan read aloud from Dickens. No other amusements were allowed. When Elizabeth complained to Theodore, he wrote her a teasing letter: as his "Queen of Hearts" she must maintain her reputation, for it was "the King who suffered for [her] sins or shortcomings." Pleased, nonetheless, by the design she sent him for a perpetual-motion machine, he continued, "The only good thing about the general scheme is that they furnish some mental exercise and teach boys, and on rare occasions girls, to inquire into the whys and wherefores of mechanics."

But Oakwood's curriculum did not provide the mental exercise Elizabeth craved. When she lamented her domestic science class and her cake's failure to rise, Theodore consoled her with the hope that future culinary experiments would be more successful. Two years of Quaker discipline turned Elizabeth into a headstrong sixteen-year-old who spent much of her ingenuity cultivating her reputation as her own perpetual-motion machine. Proud to be known as a bad influence, she used swear words deliberately and devised practical jokes. With her dormitory mates she strewed sugar on the floor outside their room so that they could hear the woman who came to do bed checks, but when "Old Sugarfoot" discovered the ruse and told Mr. Reagan, the principal informed Theodore that Elizabeth was no longer welcome at Oakwood.

One can read equal parts of parental concern, pride, and identification in her father's response to her defiance. Theodore decided to further Elizabeth's education by taking her to Puerto Rico. This trip would not only be a vacation, he told his sister, "but being rather disturbers ourselves, it serve[s] the double purpose of giving the balance of the family a rest." On board their ship, he photographed Elizabeth touring the power plant with the engineer, contacting other vessels from the wireless station, and gazing at flying fish from the bow. Their tour of the island provided more opportunities for lessons: they inspected San Juan's fortress, a factory, a hydroelectric plant, sugar mills, and plantations. While Elizabeth was surprised to see bananas growing upside down, her father noted with approval the use of a centrifugal separator to extract crystallized sugar from molasses and registered their ascent to the island's highest point on his barometer. Theodore photographed everything with both single view and stereoscopic cameras, since he planned to treat the family to a slide show—most of it starring Elizabeth.

Ten days in Puerto Rico may have been meant to compensate in advance for her next school year—at St. Mary's in Peekskill, a Catholic school for girls whose teaching methods were stricter than Oakwood's. Elizabeth begged Minnow to send her reading matter, shared each week's allotment with her roommates, and tried not to finish before the next chapter arrived. As at Oakwood, she became the class ringleader, making outrageous remarks and thinking up practical jokes to inspire her followers. She contrived to have an unsuspecting classmate swallow a capsule containing diagnostic dye; when the girl's urine came out blue, she had hysterics. In May 1924, Elizabeth and two other girls stayed out late and were caught smoking. Summoned to Peekskill by the mother superior, Theodore learned that "Elizabeth had misbehaved," he noted without further comment.

He brought his daughter home to a household in crisis. Florence quarreled with Elizabeth about her future and blamed Theodore for spoiling her. She worried even more about John, who had ended his freshman year at Antioch after one month because, in his view, while the teachers preached socialism, they did not appreciate his thoughts on Henry George. At nineteen John was tall, handsome, and, unlike his sister, well behaved. However, while he was still determined to become an aviator, he also liked to wear women's clothing. Only Erik seemed to be growing up normally. (Looking back at this time, Erik said that he had been fortunate to have been born last, since his parents were too preoccupied with his brother and sister to pay attention to him.)

The children knew that things were wrong with Florence when they heard her crying, yet Theodore said nothing about her distress. What they did not know at the time was that after years of accepting his affairs with other women, she had herself fallen in love and could not decide whether to leave: divorce meant scandal, and she had a lot to lose. In June, Theodore dealt with the situation by giving Florence a new Ford. One morning she prepared breakfast as usual, went into the garage, locked herself in the car, and turned on the engine. Theodore broke down the door in time to save her. As if unable to empathize, he noted only that on her return from the hospital, Florence hurled a chair at their bed and hit the wall, "where a great dent was made in the plaster." When she again threatened suicide, he took her to a New York specialist, then back to the hospital, where she remained until August. His diary records the facts but says nothing about his feelings or those of the children.

Something had to be found to occupy Elizabeth. Theodore gave her a Remington portable and enrolled her at the Eastman Business College, on the theory that if she learned typing, she would never starve. But Eastman, a Poughkeepsie institution with a reputation for turning out good secretaries, was only a stopgap for a lively seventeen-year-old who needed to complete her education. To make matters worse, Minnow had already graduated from high school. Elizabeth did not like to show the frustration she felt beneath her

bravado, nor could she admit her fear that she would never find anything meaningful to do.

Florence came home in time to celebrate her twentieth wedding anniversary. A few days before the family picnic intended to symbolize the return of domestic harmony, she began treatment in New York with the well-known Freudian doctor A. A. Brill, which continued several times a week for a year, despite Theodore's objections. Elizabeth stayed at home for the next few months and often accompanied her mother on the train to town. While it was a mixed blessing to travel as her companion, Florence's illness gave both a reason to get away.

Brill had trained with Freud after studying medicine at Columbia University: he returned to the United States in 1912 to start practice as the first American psychoanalyst. By 1924, when Florence became ill, he had translated many of Freud's books and was the best-known specialist in the treatment of nervous disorders. Brill's credentials were impeccable. He taught at Columbia Medical School, ran Bronx Hospital's Department of Neurology, and was said to understand women.

Seeing a psychoanalyst was, nonetheless, an unusual thing to do. Brill may have been the doctor Theodore and Florence consulted after the attack on their daughter. On the other hand, it is unlikely that Brill would have told them that sex and love were two different things. Given the general public's reductive understanding of psychoanalysis, Brill took care to explain that what Freud understood by sex was much broader than people thought. It encompassed what was meant by *love* and *eros,* and while sex was a central part of a relationship, unhappy women lacked love more than they did its physical counterpart.

Brill's methods—he had patients tell their dreams and free-associate— would have been novel for Florence, who was not used to having her thoughts, conscious or unconscious, taken seriously. If she identified her relationship with her daughter as one of the causes of her distress, Brill's views on the anxiety he found to be prevalent in teenage girls may have helped her to understand their difficulties. "It is at these ages," he believed, "that the girl becomes aware of the sex urge but cannot as yet place her emotions properly." Brill may also have helped Florence become aware of her rivalry with Elizabeth, who had become a head-turning beauty—the epitome of the sexually curious, emancipated flapper. One wonders how much of Florence's understanding she shared with her daughter, and whether Elizabeth sympathized with her mother's unhappiness.

In November Theodore agreed that Florence could decide between him and the other man. His willingness to respect her decision may have been exactly what she wanted, since she chose to remain married, and with Brill's advice, found other interests. By the following year, Florence was acting in

local theater, reading Shakespeare at Vassar as a special student, and staying overnight in New York to see plays after sessions with Dr. Brill.

Once her mother's condition had stabilized, Elizabeth could return to school—provided one would agree to take her. She completed her last year of formal education as a day girl at Putnam Hall. Hoping that she too might be allowed to do as she wished, she dreamed of living in Europe and, through her reading, explored all possible means of escape.

After school she often browsed through books on subjects as diverse as poetry, drama, graphology, and anthropology at Lindmark's, the used-book shop near the Hudson. Jack Lindmark, the owner, wore knickers to work, he said, because it was easier to squat among his collection of 200,000 volumes in these old-fashioned trousers. Elizabeth and Minnow loved the bookshop's bohemian atmosphere: Lindmark's, a contemporary wrote, was "filled with the sorrowful voice of Ophelia and the sonorous tones of Scrooge mingled with the signs of the Prisoner of Chillon and the merry conversation of Robin Hood." To the girls, what mattered was that Jack and his wife, Ray, were from New York and took an interest in their young clients. They should always wear fine undergarments, Ray teased, since one never knew when one might be in an accident; Jack said that whatever they wore, they were "sitting on a million dollars."

About this time, Elizabeth befriended another pair of local freethinkers, Frank and Helen Stout, whom she met soon after they came to Poughkeepsie to direct the Community Theatre. For some time she had been seeing the latest New York plays with her parents, often reading them in advance at Lindmark's, and while she still dreamed of writing for the movies, she looked to the theater as a mirror of the larger world. The Stouts encouraged her to take drama seriously.

Elizabeth made her adult acting debut in a staged version of *The Girl from the Marshcroft,* by the Swedish novelist Selma Lagerlöf. Lagerlöf, then famous as the first woman to win a Nobel Prize, denounced the narrowness of Swedish folkways in her tale of a country girl "more sinned against than sinning," the *Evening Star* explained. The stage version, featuring authentic Swedish costumes and dances, was faithful to Lagerlöf's ending. After the heroine bears a child to the master of the household where she is in service, a wealthy young man sympathizes with "her struggle against the severe code established for women" and rejects his rich fiancée to wed this modest heroine. Whatever associations this production may have set off in Elizabeth's mind, she brought comic relief to her role as the fiancée's sister, charming the audience with a spirited polka.

Interpretive dance (at that time a branch of "art" theater) attracted girls of Elizabeth's age, since it was said to give grace to one's gestures and improve the figure. Miss Rutherford, whose shapely form proved the theory, told her pupils

tales of her life on the New York stage. Before marrying into the old Pough-keepsie family in whose house she taught gymnastics, ballroom dancing, and tap, she had been Marilyn Miller's understudy at the Ziegfeld Follies. The Rutherford Dance Studio was as unusual as its director. On the outside, the house resembled a steamboat, but once inside, ordinary girls became ephemeral creatures in tutus whose reflections multiplied along the ballroom's mirrored walls. Dance, Miss Rutherford explained, was a calling.

In 1923 the opera house reopened as the Bardavon, with a revamped inte-rior and the latest cinematic equipment, after having been bought a few years earlier by a group of businessmen who saw the opportunity to invest in enter-tainment. While its name gestured to Stratford-upon-Avon, the corporation planned to show everything from films and Broadway tryouts to grand opera. The highlight of the season came on January 15 when the Denishawn company presented its free-form dramatic dances (the name amalgamated those of its founders, Ruth St. Denis and Ted Shawn). Few were sure how to describe what they did except to say that these interpretive (or "figure" or "aesthetic") dances were performed barefoot in exotic costumes, and that they resembled moving *tableaux vivants*. The company's style was familiar to Elizabeth from the Hollywood epics she loved, since D. W. Griffiths had employed Den-ishawn dancers to evoke his imaginary Babylons.

That night the program featured one of St. Denis's "music visualizations," as well as a snake-encircled Shawn writhing to Satie in his Cretan "dance-drama," *Gnossienne,* and both principals in Shawn's smoldering *Valse Direc-toire.* The whole company, including several who would go on to establish a unique style of American dance—Martha Graham, Doris Humphrey, and Charles Weidman—performed Shawn's lavishly costumed Toltec spectacle, *Xochitl:* in his huge cape of orange feathers Shawn pursued Martha Graham as Xochitl, the Salome-like dancer whom he all but rapes before claiming her as his empress. Perhaps the most unusual company member that season was a sixteen-year-old named Louise Brooks, whose large dark eyes gave her an exotic look despite her fashionable Anita Loos–style bob.

Up to this point, Elizabeth's dance performances had been restricted to posing in her hootchy-kootchy dress for Theodore and dancing in the chorus of *Kat-cha-koo,* a musical comedy staged in town. She decided to work harder on dance lessons. It was unthinkable to move to New York to study at the Den-ishawn School as Louise Brooks had done before joining the company, but it *was* possible to learn interpretive dance in Poughkeepsie. In June she danced in the Community Theatre's open-air production of *Midsummer Night's Dream,* with the chorus in the airy Grecian garb favored by St. Denis and Isadora Duncan. The following year she went to New York with Florence for the gala in honor of Anna Pavlova at the Metropolitan Opera—where the great ballerina accepted her tributes in a simple white gown.

But to a rebellious seventeen-year-old dreaming of a career in the arts—whether moving pictures, theater, or dance was unclear—swooning divas like St. Denis and Pavlova were passé, the heroines of her mother's generation. Elizabeth wanted to be modern, which meant being active, energetic, unhindered by small-town, middle-class expectations. Women had won the vote in 1920. It remained to be seen what they would do with their freedom.

Elizabeth's teenage years coincided with the first half of the 1920s, when an upheaval in the mores of young people preoccupied the country. Critics blamed this permissiveness on the end of the war, the returned soldiers' hedonism, the movies, and, once Prohibition was enacted, the thrill of clandestine drinking—since to drink meant to break the law and consort with bootleggers and other lowlife. Others pointed to the changes in women's lives. Middle-class girls left home to work in the cities even though their parents could support them; those who stayed home enjoyed greater freedom from surveillance due to the motorcar.

It was more difficult to explain the rise of the flapper. Some said that she had been created by F. Scott Fitzgerald, whose first novel, *This Side of Paradise,* imagined a new kind of American girl based on Zelda Sayre, the southern belle he married soon after its publication in 1920. The cover of Fitzgerald's next book, *Flappers and Philosophers,* showed a puzzled group of citizens watching a barber wielding his shears on the head of a young woman—the rite of passage celebrated in his *Saturday Evening Post* story "Bernice Bobs Her Hair." Fitzgerald's preeminence in the matter was soon challenged by writers like Dorothy Speare, the author of *Dancers in the Dark,* and Warner Fabian, whose 1923 *Flaming Youth* spawned the phrase for this turbulent decade. Some said that the flapper had been created by Hollywood, which not only filmed Fitzgerald's and Fabian's books but churned out sensational dramas of its own, including *Naughty but Nice, Flirting with Love,* and *The Perfect Flapper.*

Wherever the flapper came from, her bold carelessness marked Elizabeth's vision of how she meant to live: this brazen young woman's stance declared, "I do not want to be respectable because respectable girls are not attractive," in the words of Zelda Fitzgerald, its prototype. Yet being a flapper was sometimes only a matter of style. Although Zelda soon announced the demise of the flapper due to the widespread adoption of her accoutrements—short skirt, cloche hat, rolled stockings, one-piece bathing suit, rouge, "and a great deal of audacity"—Elizabeth rebobbed her marcelled waves and had them cut in bangs, like Louise Brooks; later, she and Florence purchased man-tailored flapper outfits and posed in them for Theodore. In these pictures, her

mother, caught up in her own way in hopes for greater freedom, seems unaware of the incongruity of dressing like her daughter—who was trying on the flapper's stance along with her clothes.

The flapper's philosophy included flirting, taking life lightly, and refusing to go in for the moral uplift required of girls in previous generations. But it also meant cultivating her mind. Contrary to popular belief, the modern girl was neither flippant nor cynical, Scott Fitzgerald insisted; she was simply intent on exercising her intelligence. Unlike her parents, she understood that "the accent [had] shifted from chemical purity to breadth of viewpoint, intellectual charm, and piquant cleverness." The flapper might not be well educated, but her curiosity attracted her to a range of subjects. "She refused to be bored," Zelda quipped, "chiefly because she wasn't boring."

Yet Hollywood flappers rarely did anything but celebrate their own high spirits. Colleen Moore, the star of *Flaming Youth*; Clara Bow, the "It" girl; and Louise Brooks, the dancer-turned-movie-star, all flaunted their youthful self-assurance in films meant to demonstrate their sex appeal as well as their talent for living. "An artist in her particular field," Zelda reflected, the flapper claimed as her domain "the art of being—being young, being lovely, being an object."

While Elizabeth shared the flapper's talent for being (and being an object), she wanted to be an artist in her own right. Well trained as her father's muse, she would continue in this role when it suited her to collaborate with those whose worship of her beauty conferred on her the power to win their hearts. She would be young and lovely, but on her own terms. And while she often spoke without regard for consequences, her boldness disguised an emotional reticence. Of the consummate flapper, Zelda wrote in 1925, "you always know what she thinks, but she does all her feeling alone." She might have been describing Elizabeth.

Elizabeth and Theodore Miller on the SS Minehaha, *New York, May 29, 1925*

Chapter 3

Circulating Around

(1925–26)

Elizabeth's year at Putnam Hall passed without incident. She studied French, directed the Drama Society's end-of-year play, and—unexpectedly—passed all her courses, yet showed no interest in college, not even as a place to meet men. Boys her age let her know that in their opinion she had as much "It" as Clara Bow. But eighteen-year-olds were callow. What she wanted was to live in Paris among the bohemians she read about in novels and saw dramatized on Broadway in plays like *Kiki*, the tale of a gamine who becomes a sprightly chorus girl.

As Elizabeth was completing her education, she found inspiration closer to home—in Anita Loos's *Gentlemen Prefer Blondes*, published that spring. Like their counterparts all over the country, Putnam Hall girls did their best to imitate its heroine, Lorelei Lee, whose sugar daddy sends her to Europe to broaden her mind. Lorelei's self-possession is surpassed only by her ability to coax diamonds out of skinflints; the novel ends with her marriage to the millionaire who promises to back her film career. Loos's best seller underscored Zelda Fitzgerald's quip about the flapper's philosophy: girls like Lorelei were "merely applying business methods to being young."

∞

While Lorelei was broadening her mind and portfolio, Elizabeth was plotting her departure from Poughkeepsie. Her French teacher, an impoverished Polish countess known as Madame Kohoszynska, planned to spend the summer in France with her companion. As her chaperones, they could introduce Elizabeth to Europe and settle her in the finishing school in Nice where Madame Kohoszynska was to teach during the summer. Ever indulgent with his only daughter, Theodore agreed.

On May 29, 1925, Florence, Theodore, Erik, and Elizabeth spent the night in a New York hotel before nearly missing her early morning departure on the wonderfully named SS *Minehaha*. Her family watched Elizabeth race up the gangplank, looking fashionable but subdued in her paisley dress, calf-length coat, and cloche hat. Once on French soil, she took charge. Madame Kohoszynska could not manage enough French to order a taxi and, when they settled in Paris, failed to notice the unusual number of men entering and leaving their hotel—which proved to be a *maison de passe*, a hotel used as a brothel. "It took my chaperones five days to catch on, but I thought it was divine," Lee recalled. "I was either hanging out of the window watching the clients," she went on, "or watching the shoes being changed in the corridor with amazing frequency." She had found what she was looking for. "I loved everything," she recalled fifty years later. "I felt everything opening up in front of me."

That summer Paris resembled a series of gleaming stage sets built to display the union of art and industry. The city's historic monuments served as backdrops for the 1925 International Exhibition of Modern Decorative and Industrial Arts, the first major exhibition of Art Deco, as the style came to be known. Its eye-catching pavilions were everywhere. National displays from all of Europe lined the Seine; luxury boutiques stretched from the Left Bank across the Pont Alexandre III, where visitors saw the latest designs in crystal, polished metals, and richly embroidered fabrics. Lalique's glass fixtures shimmered at different spots throughout the city; Sonia Delaunay's Simultanist *robes-poèmes* wed bright primary colors to Cubist shapes (one could order a car to match); Paul Poiret showed his new fashions on three lyrically named barges, *Amours*, *Délices*, and *Orgues*. "One look at Paris," Lee recalled, "and I said, 'This is mine—this is my home.'"

Showing remarkable self-assurance for an eighteen-year-old, she told Madame Kohoszynska that she would *not* be going to Nice, wired her parents that she wanted to study art in Paris, and, like Kiki, found herself a maid's room. Theodore, who may have seen this as Elizabeth's chance to prove herself, agreed to the plan and upped her allowance by the sum he had been paying the chaperone. *La vie de bohème* was what she had been seeking. Artists

were always broke, Lee recalled later, "but it didn't matter. We lived off each other toward the end of the month." Shared resources, casual romances, and "intermingling nationalities" delighted her, and the occasional visiting Americans who hired her as their guide to bohemian Paris took her to the best restaurants—though not in the style of Lorelei's protectors.

Elizabeth also persuaded Theodore to pay her fees at one of the first schools to teach stage design, L'Ecole Medgyès pour la Technique du Théâtre—under the direction of the Hungarian artist Ladislas Medgyès. This decision made sense. Unlike the Montparnasse art academies frequented by most foreigners, the Medgyès School trained students in the applied arts of lighting, costume, and design. Several Medgyès graduates had already distinguished themselves in the New York theater. What Theodore did not know was that in the drama world Medgyès was considered a revolutionary.

His reputation derived in part from his paintings, which combined the intense coloration of the German Expressionists with bright abstract patterning. But Medgyès was also something of a "play-boy," in the view of Frank Crowninshield, the urbane *Vanity Fair* editor who visited the school and met Elizabeth there that autumn. "If you will roll together six of the gayest of contemporary Parisian masters—Picasso, Van Dongen, Laurencin, Cocteau, Pascin and Soudeikin," Crowninshield noted, "you will have Medgyès . . . who thinks of art as a beguiling adventure."

It took an adventurous spirit to pick one's way through the jumble of miniature sets, masks, and marionettes in his studio, where animated conversations went on in several languages. Treating students as apprentice designers, Medgyès put them to work in contemporary productions and encouraged them to approach the stage not as a room with the fourth wall removed, but as an evocation of what one saw with the mind's eye.

For the rest of the year Elizabeth studied with Medgyès and his colleagues, the directors Charles Dullin and Louis Jouvet—both champions of experimental drama. Their teacher, Jacques Copeau, had staged antirealist dramas at his theater, Le Vieux-Colombier, where he used the play of colored lights to sculpt the stage. Medgyès taught his students to evoke form in the same spirit: the bare stage, modeled by shifting lights, he explained, would put the emphasis back on the play. In his ideal theater, shadows would be projected onto screens set at angles, and the impression of depth created through the manipulation of objects backstage. The class admired his model of this dream stage, a five-sided space overarched by a ten-sided dome to reflect light. The problem was not creating new stages, he said, but finding plays that mirrored life—that were "as gay, as sad, as tragic, as alive, as this game we are all playing."

Paris became Elizabeth's university. She learned the cobblestone streets of the Latin Quarter, the patrician St. Germain des Près area, and the historic sites of French drama—the imposing Comédie Française just beyond the

arcaded rue de Rivoli, the baroque Opéra sitting like a dowager at the end of its avenue, the colonnaded Odéon Theater near the Luxembourg Gardens, where nannies perambulating their charges mingled with lovers holding hands. The cold, rainy skies did not bother her. There was always a café nearby, a glass of hot wine, an art students' party. That autumn, the Dadaists were reinventing themselves as Surrealists under the leadership of André Breton, Jean Cocteau was memorializing his dead lover in *Orphée,* Picasso was becoming dissatisfied with his fame and his marriage, Gertrude Stein was entertaining in the rue de Fleurus, and Hemingway was completing *The Sun Also Rises,* whose heroine, Brett Ashley, would replace Lorelei Lee as an inspiration for girls like Elizabeth. While she would meet these luminaries in a few years, in 1925 her social world was confined to her fellow students and the drama circles she came to know through Medgyès.

Her teacher envisioned his own theater as a magical space, a scenery-less music hall with sets made of mirrors and actors of spun glass. "Like marionettes, they would be more intelligent than humans," he explained. "They would not mind sacrificing their personal vanity for the artistic effect." To objections that only serious drama suited his futuristic stage, he replied that one could easily create a Chaplinesque aura with props—ladders, platforms, and barrels were all that was needed to make people laugh.

Lee described this period of her life as particularly happy. Medgyès found her employment at the school and recommended her for a job at an "art theater"—as Left Bank venues like Le Vieux-Colombier were called to distinguish them from the commercial theaters. Having already trained her eye with photography, she soon learned to visualize plays onstage and to apply her aptitude for solving technical problems. "Every once in a while I quite surprise myself by my actual intelligence," she admitted, although only one completed project by Elisabeth Miller (her name spelled as if she were French) was listed in the 1926 school brochure. For the first time in her irregular education, she was absorbing what Medgyès called *métier*—a professional attitude toward one's craft—and learning to focus her eye while awakening to the promise of a larger life through art.

With their teacher, Medgyès's students also critiqued the more traditional "well-made plays" at the Right Bank theaters—farces by playwrights like Henri Bernstein, whose *Le Venin* dramatized the passions of a man caught between his wife and his mistress, and Alfred Savoir, whose *Deux Amis* staged the tale of a son who condones his mother's affair with his best friend—because she is "first of all, a woman." In such plays, an observer wrote, sex was just "an appetite in which man is revealed as funny." But Americans in the grip of "the inevitable Puritanism, repression, and sentimentalism" were often disturbed by the Parisian blend of frankness and sensuality.

Like many girls on their own in Paris for the first time, Elizabeth tried to

make up for any residual puritanism. Accepting sexual advances proved that she was emancipated; it was sometimes easier to acquiesce than to say no. The following year, looking back on "all the various and nasty affairs" she had had in her teens, Elizabeth concluded that she had "never been . . . really loved." One wonders whether she was thinking of Medgyès, with whom she probably began a liaison despite the difference in their ages—or because of it. Their names for each other suggest a playful complicity. Her teacher was "Maestro," she was "Souris" (Mouse)—though her determination to do as she pleased was hardly mouselike. He admired her mind, she thought, but was particularly fond of her breasts. Although we may conclude that Medgyès abused his position, relations of this sort—combining authority with intimacy—were familiar to her. Their relationship did not strike her as odd.

It was with mixed feelings that Elizabeth read a letter from Florence announcing her arrival in Paris on October 5, 1925. Within a short time, Florence cabled Theodore to come at once, adding "Elizabeth unaware." Elizabeth's behavior changed once he joined them: she and her mother shopped for clothes at the couturiers'; they toured Paris, went to the theater, and dined at fine restaurants. To allay her parents' suspicions, Elizabeth introduced them to Medgyès, who sent flowers to Souris's mother and invited the family to a tea dance. As men of the world, the Maestro and Theodore understood each other.

Theodore left to see his DeLaval associates in Stockholm; Florence took the precaution of staying in Paris until the end of the year. Elizabeth completed her studies with her mother as chaperone while presumably finding time for clandestine trysts. In January, Florence and Elizabeth made the return voyage on the *Suffren*.

Theodore was waiting for them at the French Line pier on January 23, 1926, an unusually cold day even by New York standards. In the time it took to collect their luggage and drive to Poughkeepsie, Elizabeth's spirits sank. The next day she could not get up. When her condition was diagnosed as congested lungs, she stayed in bed for a month, too feverish to interest herself in her father's testimony in Washington in favor of the metric system or his talks at the local YMCA on youth's need to prepare for work. Her father worried about her health—a doctor came daily—but did not connect her collapse to her homecoming after seven months in Paris.

∞

Toward the end of February Theodore wrote in his diary, "Elizabeth has so far recovered as to be up and around the house." What would come next was unclear. Young women of her class did not need to work; her time in Paris had not prepared her for anything, although to her mind it opened the door to a more spacious vision of life.

*Hallie Flanagan, director of Vassar's
Experimental Theatre*

There was a solution nearby. Poughkeepsie shared Vassar's view of itself as the best women's college in the country. Vassar girls came from good families; their intellectual achievements did not seem to lessen their chances in marriage. Yalies and Harvardians squired these young women around town and sampled cakes with them in the local tea shops. Moreover, in 1926, Vassar's trustees approved a new course of study called Euthenics, which aimed "to raise motherhood to a profession worthy of [woman's] finest talents" by offering classes called Husband and Wife, Motherhood, and the Family as an Economic Unit. While many faculty members argued that Euthenics travestied Vassar's commitment to women's minds, the program reassured parents who looked less than favorably on their daughters' desires for independence.

Vassar was responding to a national change in attitudes. A 1923 survey of its students had shown that in contrast to prewar years, when most looked forward to professions, 90 percent now called marriage the biggest of all careers. Women were marrying more frequently and much younger than in the first part of the century. Popular magazines praised domesticity; newspapers quoted the new experts like psychologist John B. Watson, for whom "sex adjustment" represented a female's best chance for fulfillment. Only a small number of Vassar students hoped to combine work with public service, a vision that Mary McCarthy, a student there in the 1920s, called the Vassar girl's wish "to play a part in the theatre of world events."

While Elizabeth had been studying stagecraft in Paris, Vassar had also begun a program called Dramatic Production, or "D.P." Henry MacCracken, the president, had opposed the Euthenics program, which he saw as a step back from the kind of progressive education he favored. Having lost the war over Euthenics, he planned to inaugurate an opportunity of a new kind, based

in the theater. In 1925 MacCracken hired Hallie Flanagan, one of the first women graduates of George Pierce Baker's highly respected Workshop 47 at Harvard, to direct a similar drama program at Vassar. Students would write, stage, and direct their own plays as well as selected classic and contemporary ones; interested townspeople could take part. Flanagan's work at Vassar's Experimental Theatre would contribute to her being chosen by President Roosevelt to head the Works Progress Administration's Federal Theatre Project in the 1930s. In 1925, she was already much admired by theater buffs like Mac-Cracken, who expected her to play a major role in Vassar's modernization.

If nothing else Vassar offered a daily reason to leave home. Because at this point, Elizabeth saw her future in the theater, she summoned the energy to enroll in D.P. as a special student in March—a move that may have exacerbated Florence's unacknowledged rivalry with her daughter since she too was studying theater, in Vassar's program for townspeople. While being the child of a prominent Poughkeepsian may have smoothed Elizabeth's way, it is likely that Flanagan took her on Medgyès's recommendation. Her new student was knowledgeable about trends in European scenography and could provide an introduction to the Maestro, whom Flanagan hoped to meet the following year.

Elizabeth's new teacher, who saw the theater as a progressive social force, urged students to take a professional attitude. Perhaps because she compared her to Medgyès, Elizabeth did not warm to her new mentor, a diminutive redhead who behaved like a powerhouse. Flanagan was, she noted in the diary she began after starting classes, "more interested in Medgyès and what I might tell class of his work—and work with others, than in my studying in her drama production class." Flattered by the attention just the same, Elizabeth accepted her invitation to lecture to the class on the contemporary European theater.

Flanagan also put her in charge of lighting for the workshop's production of *King's Ward,* a romance set in medieval Portugal. Elizabeth researched the settings in Vassar's Gothic library before organizing her crew, including two electricians and six Vassar seniors. The only onstage scenery was a Moorish door; the mood had to be evoked by the lights. Her design, a series of images projected onto a curtain, required long hours in the theater to adjust the lights. "Swearing mentally and spiritually at the false connection on the lighting circuit," Elizabeth wrote, she clambered into the light loft while juggling electric wires "without the slightest knowledge of the system," but with faith in the hereditary Miller ingenuity. The audience applauded the lighting after each performance. Elizabeth wrote that she had acquitted herself "with honour and glory, even though Flanagan gave most of the credit to Medgyès." (She added dryly, "Thank god for any natural cleverness!")

The success of *King's Ward* brought her to the attention of the Vassar Community Theatre leaders Frank and Helen Stout, who greeted her as a

peer. They persuaded her to do the lighting for their next play, *Overtones*, and gave her a small part in the production, to be presented at the Women's City and Country Club on March 26. She was suddenly too busy to miss Paris. After the performance she went to sleep in her makeup and awoke at noon the next day, physically and emotionally exhausted.

Campus life did not appeal to her, nor did Vassar students—with the exception of the girls from D.P. with whom she went to New York to see plays. During the week they flocked to her parents' house in Kingwood Park to smoke in her bedroom on the sly, indulge in "lewd conversation," and hear about life in the Latin Quarter. But the glamour surrounding the college in the eyes of new students was not apparent to one who had grown up nearby. A night in a Vassar dormitory after working on a play was a "somber thing," Elizabeth wrote, nor did she like "breakfasting in a noisy gloomy clammy cold dining hall with a hundred other cross sleepy girls." Social pretensions were rife. The next production was "arty in the perfection of manner so pleasing to college dramatic groups." However, of another Vassar proclivity, erotic friendships, Elizabeth noted that a certain M. E. Clifford was "enough to make a lesbian of one." She wondered whether she might herself "go queer."

After her return from Paris, Elizabeth underwent treatment for recurrent gonorrhea—daily douches supervised by her mother and weekly trips to the doctor for inoculations to strengthen her resistance. His "inoculation torture" often produced cramps, fever, and nausea, which reinforced her sense that she was damaged goods; the enforced intimacy of douches in Florence's bathroom led to quarrels and, occasionally, "an almost closeness to mother." However much Elizabeth fancied the idea of herself as sexually free, she had to accept the need, for the moment, of "a virgin life." This condition had the advantage of allowing her to flirt with impunity. Her diary entries for March 1926 note "passionate love proposals" from boys her age, "flirtation and refusal with two Frenchmen," dinner with a seductive friend astounded by her chastity, and telephone sex with a theatergoer named Harold ("Hope he acquired erection," she wrote; "I was sufficiently naked, also soapy and wet").

Harold also accompanied Elizabeth to art galleries in New York and Greenwich Village hangouts like Romany Marie's, where they engaged in "analytical conversation." Despite these efforts, her opinion of his intellect was not high. She gave him some light reading, *Gentlemen Prefer Blondes* and a recent success about a well-mannered adventuress, *The Diary of a Young Lady of Fashion*. Wondering why she was still corresponding with the Maestro, she considered the effect of her beauty on him while imagining his response to a change in her breasts: "Medgyès will be sorely grieved—tho why now should it interest him? thus does my new found virginity affect me!"

Daydreams about Paris and her future there returned to plague her. Since there was no point in confiding in her Vassar friends or in Harold, she scrawled

the occasional poem in her notebook. In one of these, distinguished chiefly by its self-deprecation, she dismissed her private "thots" (thoughts) as "callow." The poem, which is addressed to an unnamed but judgmental reader ("you that talk of places far across the sea"), concludes that such a person wouldn't even want "to know / About those most precious thots / Hidden deep below." Despite this inner critic, the last lines express one heartfelt thought: "Would that I might trade my all, for Paris fog and rain!"

∞

Seven months in Paris had made Vassar seem tame and Poughkeepsie unbearable. Elizabeth looked to New York for something more inspiring; as usual, Theodore underwrote the process of exploration. During the winter and spring of 1926 she attended fifteen productions—staged by the Theater Guild, the Moscow Art Theater, the Actors' Theater, the Provincetown Players, and the Metropolitan Opera. She scrutinized the plays she saw for more generous views of life, but also as correlatives of her inner turmoil.

When Elizabeth took the train to New York on days she didn't have classes, there was a price to pay: Florence often accompanied her. Her mother liked to discuss plays, even though they rarely agreed on the merits of contemporary drama's emphasis on psychosocial issues. Florence preferred the classics; Elizabeth worshipped Eugene O'Neill. *Desire Under the Elms,* she thought, dramatized the "inhibitions, repressions, & prohibitions" of the kind she struggled with in private. Plays about the sexual tension of American life made her feel "the squirmings of uncivilized ideas which we are supposed to have outgrown." Although the psychological drama then popular in New York was not poetic in the Medgyès style, such plays, she wrote, left her "nervous, tense, and hard from the unexpected stirring of all my primitive emotions."

Strong emotions dominated the stage that season. One of the first plays Elizabeth saw after her return from Paris was the Provincetown Players' revival of O'Neill's *Emperor Jones.* With a group of D.P. students she met the Provincetown staff—James Light, Eleanor Fitzgerald, and the designer, Cleon Throckmorton. The production's luminescent onstage dome mesmerized the audience and surely brought back memories of Medgyès. The sectioned plaster set, polished until its interior curves reflected light in all directions, created an illusion of deep space in which the actors loomed, especially Charles Gilpin, who as the runaway black prisoner became a larger-than-life silhouette against the glowing sky. But watching demons and nightmares pursue Gilpin through the jungle made Elizabeth feel so tense that she took an early train home and went to bed.

Since discussions with Florence ended in quarrels, she turned instead to the set of monthly diaries she had brought home from Paris—as if primitive

emotions could be more readily disclosed to an imaginary confidante. After overindulging at a party with the D.P. group, she confessed (while keeping much hidden): "Bubbles! Bubbles!—they take too many things away at once.—unknowingly—and cigarettes,—cocktails! dope—there'll be a smash up soon." "Bubbles" (champagne), along with cigarettes and "dope" (marijuana), were temporary means of blunting her inner turmoil as she ran back and forth between Poughkeepsie and New York.

Plays dealing with social outcasts deepened Elizabeth's sense of imminent "smash up." The Theater Guild's controversial production of Franz Werfel's *Goat Song* treated the play as an allegory. In this tale of revolt against the old order, an aristocratic couple keep their half-beast, half-human offspring locked up until a group of peasants release the monster. At Romany Marie's, where the D.P. gang repaired after the performance, people said that *Goat Song* staged the conflict between the Apollonian and Dionysian forces. When Elizabeth tried to explain the play's enactment of primitive urges to Florence, who must have felt its resonance, their talks ended in the usual argument.

Ibsen's view of modern life was equally disturbing. The Actors' Theater 1926 production of *Hedda Gabler* presented the heroine as an alarming example of modern womanhood. Hedda's attempts to control those around her through force of will made her a "fiend," a reviewer wrote, even though she "never quite succeeds in guiding the destiny of a man." If *Hedda Gabler* was a warning to headstrong women, Ibsen's *Ghosts,* also at the Actors' Theater, raised the issues of social hypocrisy about venereal disease. *Ghosts,* staged as "a mystery play of sex," urged creative freedom but ended by visiting the sins of the fathers on their sons. It would have been a painful reminder of Elizabeth's condition. Nearly every play that season dealt with sex, although few as darkly as Ibsen.

Despite their differences, Hallie Flanagan recognized her special student's promise. She encouraged Elizabeth to continue in stage design and had her invited to events with Vassar dignitaries—President MacCracken and his guest George Baker, then the head of the Yale Drama School and, she learned, the teacher of her beloved Eugene O'Neill. But while Baker's dinner speech was amusing, Elizabeth felt "uncompromisingly bored" by academic chitchat. She longed to leave "P'ok" to work in an experimental theater of the kind she had discovered in Paris.

That spring, Elizabeth spent as much time as she could with the Provincetown Players, who welcomed her as a neophyte designer. Although the Players no longer ran their theater as a cooperative, the group still refused what they called the crass commercialism of Broadway. The Playhouse, a few steps south of Washington Square at 133 MacDougal Street, retained the sloping floor from its earlier days as a stable. The walls had just been painted a tawny orange brown, and the low ceiling, indigo; cushions were strewn on the

wooden benches in a concession to comfort. While the Players still staged experimental work—commedia dell'arte, plays from the Moscow Art Theater, "negro drama"—they tried hard to meet expenses with revivals.

After performances, Elizabeth went upstairs to Christine Ell's restaurant over the Provincetown Playhouse to discuss staging with the set designer, Cleon Throckmorton. Although his name suggests a stage villain, "Throck" was by training a Carnegie Institute engineer. His sets for *The Emperor Jones* had been so successful that he had given up engineering in favor of the theater. (In the 1930s, he would serve under Flanagan as technical director of the Federal Theatre Project.) Throck was artistic yet practical—like her father, or Medgyès.

Like many young women of her time, Elizabeth wanted the social and sexual autonomy reserved for men. Though frowned on in Poughkeepsie, this kind of "free" thinking was rife in Greenwich Village, where psychoanalysis, free love, and self-expression were taken for granted. She spent hours in the cafés frequented by Village celebrities like Jane Heap, Edgar Varèse, and Bobby Edwards, peered into Patchin Place to see where E. E. Cummings lived, and one day at Romany Marie's, teased Edwards into singing all the verses of his off-color "Village Epic." Strumming his ukulele, he crooned, "Way down south in Greenwich Village / There they wear no fancy frillage, / For the ladies of the square / All wear smocks and bob their hair," then intoned, as if specially for her, "Way down south in Greenwich Village / In the Freud and Jung and Brill age / People come with paralysis / For the balm of psychoanalysis." The contrast between New York and Poughkeepsie was obvious.

Elizabeth found some comfort in the privacy of her 1926 notebook, but even there, she still felt the presence of an inner critic. Having partially expressed the "awkward, swollen feeling" from childhood, she wrote, "You who read this may well marvel at lack of emotion," then confessed that she had recopied her first draft because the original "was too laden with excitement to be legible." This process, the recopying or reframing of material "too laden with excitement," would take a different form in photography, where her choices of subject and composition became the means to convey the tensions she felt between depth and surface, inside and outside.

Analyzing the pages of her notebook as an amateur graphologist, she decided that her different styles of writing revealed her contradictions. "Why does my handwriting vary with my mood," she wondered. Did it imply that she was overly imaginative, mentally sloppy, or the sort of person "who never becomes exactly settled in one run of living and thinking?" (Her normally left-leaning hand inclined to the right in these bouts of self-criticism.) The hand

revealed the inner self, she thought: "Is it not ironic that I, who expend so much attention on hands and handwriting, should be endowed with this irregular script."

The act of keeping a notebook also concerned her. She used its pages to spare others her "supreme egoism," she wrote, but also to acquire self-confidence—"since there is no opportunity in my daily contacts." Because she found fault with most of her acquaintances, she wondered about her capacity for love. She was romantic, "but sentimental, never." Yet she looked back on her emotional life with regret: "always there has been some ugly animal attachment." (This conviction would have been reinforced by the recurrence of gonorrhea and the treatments required to keep the symptoms under control.) Agreeing with Freud that "all sentimental relations have sex at the bottom," she wished it were otherwise. "I long to be loved, just once, somewhat purely and chastely," she went on, but feared that it was "too late . . . to be anything but an animal with unhealthy desires."

Whatever her shortcomings, Elizabeth believed that she was "different." Yet despite contemporary talk at Vassar and in the press of brilliance in women, she feared that genius was masculine, that "there is none in the feminine sex." Her own gifts lay in some as yet unspecified "artistic-emotional field." "My fingers feel empty with the longing to create," she continued in the purple prose of adolescent diarists. "Void—yet full of yearning," she wondered whether she would ever "attain harmony with the infinite," or instead keep finding that she must "throw my puny self against the inevitable power of things that are."

Despite Elizabeth's success with the Experimental Theatre she had no wish to be remade in the Vassar image. Her time at the college had not inspired her to pursue learning for its own sake—although in later life, Lee often said that she regretted her lack of formal education. Despite her adventures in Paris and New York, she remained a willful, talented, and extremely beautiful young woman with an uncertain future.

In April 1926, Elizabeth persuaded Theodore to pay for training of a practical kind: dance lessons in New York. The decision paid off. The following month she was hired to dance in the chorus of George White's Scandals. With her father's help, she rented a hotel room for late-night rehearsals.

White's revue was known to be faster and livelier than Ziegfeld's Follies, since the Scandals girls performed the latest steps in costumes that stopped just short of nudity. A few years before, the press had made much of their glittering attire, stitched in Paris from designs by Erté: "There were large quantities of gorgeous costumes," a critic wrote, "much of them on the girls of the chorus from the neck up and the shoes down." That year, seventeen-year-old Louise Brooks had been the youngest chorus member and the only trained dancer. At nineteen, Elizabeth fit in, though, like Brooks, she was probably

bored by the other chorus girls "mooching around from dressing room to dressing room, talking about men and sex."

Dancing in the chorus of a revue was not the sort of creative activity that put one in touch with the infinite, yet it was a start. Martha Graham had performed in the Greenwich Village Follies before founding her own company; Louise Brooks's nightly appearances in the Scandals had led to film roles. (Showgirls were courted by bachelors who, "finding debutantes a threat, turned to pretty girls in the theater," Brooks recalled.) For those who knew how to capitalize on their natural resources, invitations to Park Avenue parties might lead to lavish wardrobes, screen tests, and financial rewards—or, for the less enterprising, a job modeling something more substantial than a Scandals costume.

To her parents' relief Elizabeth did not follow this course of action. The Millers visited several times a week, often staying the night in her hotel. They worried about her health as well as the somewhat louche atmosphere of the Scandals. In June, when she became ill and spent several days in bed, Theodore enlisted two of her friends to join him in persuading Elizabeth to come home.

After a few weeks' rest she felt well enough to see friends. Harold was good company despite his lack of intellectual powers; there was still a sexual charge between them. They went rowing in Upton Lake on a hot July day. Wanting to show off, perhaps, Harold dove off the side of the boat, then disappeared. Elizabeth went into shock. She waited with her family while the authorities dragged the lake until his body was recovered; efforts to revive him were to no avail. Theodore entered the date in his diary, but said nothing about the effect of this tragedy on Elizabeth. The shock would have reactivated buried feelings of guilt about being sexual, especially when Harold's mother implied that her son's death was Elizabeth's fault.

Elizabeth coped with her emotional distress by looking for another job in New York. Taking the first one she found, she moved back to the city in August to start work as a lingerie model at Stewart & Company on Fifth Avenue—an occupation that was only slightly less risqué than dancing the shimmy in sequins. Florence helped her settle into a rented room on East Fifty-fourth Street. Her obliging parents, resigned to her determination to leave home, accepted the break but did not quite believe in it.

Art Students League class, New York, 1926 (Lee is third from the left in the front row)

Chapter 4

Being in Vogue

(1926–29)

Although Elizabeth was now a New Yorker, her parents oversaw the practical side of her life. Florence visited frequently. Theodore paid the rent and examined her expenses on "bill days," when the Millers often stayed in town to take Elizabeth to the theater. Together they saw the Broadway version of *Gentlemen Prefer Blondes*—whose Lorelei left the stage to wed a tycoon, a case of an actress who kept on playing her role after the show had closed. But unlike her heroine, Elizabeth showed no interest in marriage. Theodore indulged her wish for independence while keeping her on a long leash.

At the end of the summer, reverting to the strategy that had served her in Paris, she told him that she hoped to complete her training in stage design. Since John was to spend the year in New York earning his engineering degree at Pratt Institute, the Millers found them an apartment in a brownstone on West Forty-eighth Street, near Fifth Avenue. From then on, brother and sister led separate lives, meeting at night or on weekend trips to Poughkeepsie. John spent his days at Pratt and after classes with a group of aviators who met in a speakeasy to relate their exploits in the Great War. Elizabeth continued to model while looking for art courses with practical applications.

∞

In 1926, the Art Students League of New York was considered the most pro-
gressive school of its kind in the United States. While most American painting
academies were nearly as formal as their model, the Académie des Beaux-Arts
in Paris, the League attracted young painters interested in modern art. The
faculty's preference for representational treatments of American scenes did
not blind them to the merits of Cézanne, Matisse, and Picasso: teachers there
included Maurice Sterne, Max Weber, and the director, John Sloan, whose
canvases throbbed with the rhythms of his favorite subject, Manhattan. Sloan
emphasized the basics—line, color, composition, perspective—while warning
students against too much devotion to technique. Rather than imitate reality
they should paint the idea of it.

Elizabeth began classes in October. Each morning she walked uptown
and west along Fifty-seventh Street to the League's gray stone Renaissance
building, arriving just in time for Life Drawing and Painting for Women. She
returned in the afternoon for Antique Drawing, followed by George Bridg-
man's Constructive Figure Drawing class, where students drew the live model
and learned nearly as much anatomy as if they had been at medical school. In
successive classes Bridgman lectured on the head, neck, shoulders, hands,
forearms, hips, thigh, knee, and foot, then examined the whole figure. Since
Elizabeth considered the hands the most expressive parts of the body, she con-
tinued to study handwriting as if it revealed one's inner nature.

During a weekend visit to Poughkeepsie in October, Theodore asked Eliz-
abeth to pose for him. Having seen her model lingerie at Stewart's, he thought
that she would be the perfect subject for a new photographic series. They
drove to Oak Ridge, found a secluded spot in the woods, and set up the ste-
reoscope camera. Elizabeth took off her clothes. The idea was that he would
portray her as a woodland nymph in a modern version of *September Morn*.
Judging by the results, she felt uncomfortable. In some photos, she covers her
face with her hands; in others she stands stiffly and shields her genitals. After
trying different poses—backbends, a frontal stance that offers her body to the
camera—she turned to her father with her arms bent behind her head and
looked away.

They drove home to continue indoors. Elizabeth stood before a mirror,
placed her hands behind her back, and looked at Theodore as if willing herself
to be his partner in this enterprise. Later, with him in the darkroom, she would
have experienced the sensation of seeing double: herself as aesthetic subject;
her body as object of scrutiny for the man in whose eyes she saw herself mir-
rored. And if she studied these arresting images through his stereoscopic
viewer, the distancing effect would have been multiplied by the startling depth

One of Theodore's many stereoscope art studies of his daughter, annotated by her
"me, Lee Miller," Poughkeepsie, 1928 (Theodore Miller)

of field. Perhaps observing her body with detachment gave her a sense of control over the uses to which it had been put—though it also meant experiencing not her inner states but the camera's objectifications.

To us, Theodore's "art studies" are disturbing. While their collaboration indicates a deep trust between father and daughter, his interest seems obsessive, and her stance oddly compliant. Seeing these images, we cannot help asking whether Lee's career was not marked by the need to protect herself against the camera. "This ravishing young woman," a critic writes, "used her camera as a defence against the potentially crushing force of the narcissism pressed upon her." We wonder why a father would take such pictures, why a mother would not intervene, and what long-term effects such sessions would have on a moody nineteen-year-old whose early sexual experience still haunted her.

While there is no evidence apart from these images of what we would call, at best, an overly intimate relationship, it is apparent that Elizabeth coped with the situation by dissociating. In each of these photographs, she distances herself from the use of her body to which her love for her father bound her—a set of responses that look back to her childhood and forward to what would become her way of dealing with those who sought to capture her image, her body, and her trust. Yet at the same time, in these peculiar sessions Elizabeth

worked out a compromise: evaluating the modus operandi of those for whom she posed, starting with Theodore, she took what was to be gained and stored it away for future use.

∞

At the League Elizabeth met a number of lively companions, including the sculptor Isamu Noguchi and a young woman who earned her living as a model, Tanja Ramm. The daughter of Norwegian immigrants, Tanja was a year older than Elizabeth but far less worldly. A slender brunette with a piquant expression, she felt awkward about her modest family background and her lack of education. While Tanja admired Elizabeth's insouciance about having been expelled from nearly every school she attended, she was often shocked by her behavior, especially her casual attitude toward alcohol and sex (although Elizabeth's diary ended abruptly before her move to New York, one can assume that the inoculations were a success).

The two women became close despite their differences. To Tanja, her new friend was more like the artists at the League than someone from Poughkeepsie. Tanja's shyness compensated for Elizabeth's boldness: "I was so pure I gave her a good reputation," she remarked years later. Tanja was not so much prudish as cautious, while Elizabeth, who meant to throw caution to the wind, sometimes felt the need to look respectable. Tanja enjoyed the well-mannered college men who took them out—including several Yalies in love with Elizabeth. "Her admirers were legion," she recalled. "One besotted young man told me that she was a cross between Marlene Dietrich and Greta Garbo."

The League failed to hold Elizabeth's interest. Painting required more discipline than she could muster; from her perusal of art history it seemed to her "that all the paintings had already been painted." Most artists looked to the past for the means to depict the present day: what she wanted was a medium that was fast-paced, mechanical, and modern. Elizabeth gradually understood that she lacked the dedication to become an artist. Life in Manhattan had made her lighthearted and streetwise. She was more interested in the city's promise of "fantastic success and eternal youth" (as Fitzgerald wrote in *The Crack-Up*) than in the pursuit of Art.

Elizabeth would have gone on "circulating around," she told an interviewer later, but for an accident—which itself sounds like fiction or Hollywood fantasy: one day she was "discovered" when she stepped into the path of an oncoming car and was pulled back onto the sidewalk by a well-dressed stranger, into whose arms she collapsed. Her rescuer proved to be Condé Nast, the founder of the publishing empire. Elizabeth happened to be wearing an outfit bought in Paris the year before and in her shock began babbling in French. Nast had a closer look, invited her to his office, and asked her to think about working for *Vogue*.

At the time she did not know that Nast, who dressed like a banker, was said to be obsessed with sex, or that his headquarters was "both an escort service and a feudal village." While he preferred women with quick minds, they also had to have "the intangible quality of chic" that in his view characterized his magazines. Edna Chase, *Vogue*'s understanding editor, was accustomed to finding work for the comely amateurs who turned up at Nast headquarters after meeting her employer. By chance, Elizabeth came along at the precise moment when Chase was pondering a new look for the magazine, one that would portray the modern woman's independence and élan.

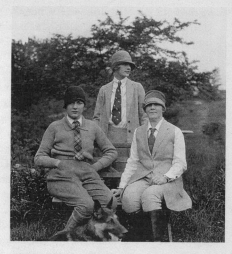

A *1928 portrait of Tanja Ramm, Lee, and Florence Miller in similar outfits hints at Florence's ongoing rivalry with her daughter. (Theodore Miller)*

What was chic at *Vogue* in the winter of 1927 included short hair, Art Deco, cloche hats, and Cubism, but above all New York itself—"the crowding of Fifth Avenue with motors flashing in the sun, the tumult of the smart restaurants, the anguished haste of dressmakers and modistes, and the sandwiching of picture exhibitions and special matinees for the illuminati between luncheons at Marguery's and first nights of the luscious and glittering . . . reviews." Elizabeth looked as if she were one of the smart set, someone for whom modistes stitched and matinees were arranged. Her features would suit the March issue, on the new Paris fashions. She would make her first appearance in *Vogue* on its cover.

In the twenties it was not yet the practice for magazines to use photographs as cover art. Condé Nast publications featured the work of well-known illustrators like Georges Lepape, who earned as much as $1,000 per drawing. Before the war, Lepape had become famous in Paris for his work on Paul Poiret's fashion albums. His sylphs, garbed in sinuous silk and swirling lamé, had decorated *Vogue* for the past ten years, but their poses now looked too languid to illustrate Nast's belief that times had changed. About this time, *Vanity Fair* announced emphatically: "Women don't faint at the slightest provocation. Most girls, before they are twenty, become interested in the world in general and in some work in particular!"

Lepape's cover presents Elizabeth as one of these "girls"—but also as the

spirit of the city that had become her theater of operations. Against the background of Manhattan's night sky she looks straight ahead, a determined figure in a helmetlike cloche. His depiction of her short bob and purposeful gaze brought out an androgynous quality, one that was often present in his illustrations but until then had not found its subject. Unlike the willowy figures of earlier *Vogue* covers, this twenty-year-old is not only interested in the world but prepared to meet it head-on. The image of Elizabeth as unflappable flapper evoked all that was "moderne," the term in use for streamlined furniture and free-spirited behavior alike.

The March *Vogue* actually appeared a month before Elizabeth's twentieth birthday, like an announcement of her emancipation. The issue featured a "confidential guide" to the new French fashions, in which the American reader learned that the Parisienne's approach was not so different from her own. *Vogue* also promised to simplify the job of shopping in Paris by explaining the rituals of its spring season. "It is far better to be too informal than too formal," it told the perplexed. Lepape's image of Elizabeth implied that Paris chic could be naturalized in New York provided one had the right spirit—a blend of determination and insouciance.

Suddenly Elizabeth was in demand with the best-known photographers in New York, all of them Europeans. Nickolas Muray, a Hungarian whose celebrity portraits also earned as much as a thousand dollars a page, had worked freelance for *Vanity Fair* before becoming *Vogue*'s official color photographer. Muray befriended Elizabeth and later helped her start her own career as a studio photographer. In a fashion shot from one of their first sessions, she wears a fur-lined coat that would have suited a Park Avenue matron. Her hands, resting protectively on her hip, say more than her impassive features— appropriately enough for someone who believed that hands reveal character.

Arnold Genthe, a founding member of Alfred Stieglitz's Photo-Secession movement, had photographed many women artists—Isadora Duncan, Ruth St. Denis, Pavlova, Garbo. Genthe was close to Theodore's age when Elizabeth sat for him. Perhaps for that reason her features softened in his presence. He discerned in her something that others failed to see. His portraits of her show not the forthright flapper but the dreamy, vulnerable girl. Elizabeth liked to visit Genthe in his studio. He gave her roses and told her tales of his youth in Germany, where he had studied archeology, languages, and music. From Genthe she learned the range of interests that one could bring to photography and the difference that a trusting relationship made to the final product.

Of the photographers with whom Elizabeth worked after her *Vogue* debut, Edward Steichen was by far the most celebrated. Before the war, Steichen had

been a painter. After giving up art for photography, he won fame first as a pictorialist and a member of the Photo-Secession, then as an modernist whose tightly cropped images showed the influence of his Paris friends—Matisse, Picasso, and Brancusi. (He had brought their works to the United States, to hang at 291, the gallery he founded with Alfred Stieglitz.) Because Steichen had served as a U.S. Army photographer during the war, *Vogue* staffers referred to him as the Colonel. In 1923 he became chief photographer for Condé Nast, with an annual salary of $35,000, to which he added another $20,000 after taking the job of art director at the J. Walter Thompson advertising firm.

When Elizabeth began posing for Steichen, he was the wealthiest artist in America and a celebrity whose glossy portraits of other celebrities summed up the period's love affair with glamour. As photography replaced illustrations in ad campaigns, the public began to think of photographers as heroic figures. They were a new breed of aesthete whose work was practical, and the Colonel was the most admired of all *because* he earned so much money. At work he could be arrogant. "He managed to give the impression that a photographic session in his Beaux Arts studio was the equivalent of an investiture at Buckingham Palace," a *Vanity Fair* editor wrote. Those who sat for him were often awed, but some Condé Nast staffers made fun of "this the-Master-is-creating atmosphere."

Steichen liked to present himself as a man of the people. "Big, rugged and bony in build, dressed in a rough tweed suit and a soft blue shirt," a reporter wrote, "he somehow symbolized the simplicity and democracy that is so much a part of him." He had abandoned painting, he explained, to make art that was "of so much greater use than a canvas in a parlor." Living proof that it was productive to embrace modernity, he opined, "we are living in an age in which all things have to stand the test of usefulness."

It was a philosophy in keeping with Elizabeth's own—in so far as she had one, an amalgam of her father's belief in facts, her own interest in how things work, and Medgyès's machine-age vision of art. At that time, Steichen's approach to design was being hailed as revolutionary. *Vogue* printed Steichen's shots of his fabric patterns under the banner "The Camera Works Out a New Theory of Design." In one photograph, matches arranged in irregular fan-shaped swirls recall Cubism; in another, a shimmering abstraction proves to be made of metal tacks. These designs were "satisfying and effective," *Vanity Fair* observed. Readers should buy the new fabrics "if only to see that good art, when entrusted to the right man, is often inspired by the simplest and most everyday subjects."

For the most part, Steichen's fashion shots rejected the everyday in favor of glamour. He often photographed in Nast's duplex, a thirty-room penthouse on Park Avenue that looked like a stage set. Its gilt-framed mirrors, French antiques covered in pale green damask, and gleaming parquet floors created

an opulent background for Steichen's photos of Elizabeth. In one, she turns to reveal the deep V back of an evening dress: posed in front of a costly Louis XV table, she seems to belong in this setting. In others, taken outside to show off her summer frock and picture hat, we see her as the sort of girl who spends her afternoons at garden parties, but in a summery image that ran in the June *Vogue* in 1928, she looks uncomfortable in a broad-brimmed hat and Art Deco dress, perhaps an effect of the "Master-is-creating" atmosphere.

Despite (or because of) the luxurious surroundings in which Steichen worked, Elizabeth often seemed detached from the fantasies to which she lent herself. She became one of his favorite models nonetheless, perhaps because she paid attention to their work together. Photography sessions resembled theater rehearsals, with the Colonel as designer and director. When he worked on advertising campaigns for firms like Jergens and Packard, technicians set up the lights and adjusted the cameras; the cameraman took the picture when Steichen snapped his fingers; darkroom assistants printed from the big glass plates; and the Master chose the final product.

It was Steichen, Lee explained years later, who "put the idea into my head of doing photography." A man of her father's generation, the Colonel carried himself with self-assurance and through his commercial work combined Theodore's own passions, business and art. Lee also observed ironically—but with pride—that "she had practically been born and brought up in a dark room." In this account, Theodore's parenting gives birth to her vocation. The "upbringing" begun in her father's darkroom continued in sessions with the Colonel—the most recent in the series of confident, creative men after whom she modeled herself.

In this respect as well, she was a girl of the twenties, who—the *New York Times* argued—liked to "take a man's view as her mother never could." A modern woman preferred men to her own sex, essayist Dorothy Bromley argued in 1927, because "their methods are more direct, . . . their view larger, and she finds that she can deal with them on a basis of frank comradeship." Bromley describes the new feminists as Fitzgerald heroines seeking to reconcile work, self-expression, and marriage. Taking several more steps along this radical path, Elizabeth also adopted a man's view in her dreams of creative and sexual freedom, which at this point meant liberation from the creeds of Poughkeepsie in particular and puritanism in general. "I wish I had been born a man," wrote a contributor to a feminist symposium published that year in *The Nation*. "I *was* my father," another asserted. Elizabeth would have agreed.

∞

Following her appearance on the cover of *Vogue,* she moved effortlessly into café society—the self-regarding group of artists, patrons, and publishers

"which sets the pace in fashion, in genteel living and entertaining," according to the *New York Times*. At Condé Nast's, Elizabeth met the celebrities profiled in his magazines—all those said to be clever, gay, and amusing. What counted in this world was a light touch and some familiarity with cultural fashions, from "modernist" art to the writings of Gertrude Stein and the new dance craze, the Black Bottom.

Since it also helped to be beautiful, Elizabeth and Tanja were always welcome. "We went to many parties at Condé Nast's," Tanja recalled. "He loved to mix the social, business, and theater communities, adding a few young things like Lee and me." At his soirées one saw George Gershwin, Bea Lillie, the Vanderbilts, Fred Astaire, Cecil Beaton, and Steichen. Elizabeth again met Frank Crowninshield, the dapper, knowledgeable editor of *Vanity Fair*, whose magazine conferred celebrity status on Nast's guests—for the most part, people who knew how to present themselves in the influential new media that coincided with the rise of photography.

Nast had been divorced from his wife since the early twenties. A wealthy man, he had his pick of debutantes and professional beauties. The gossip columnists chronicled his appearances in smart restaurants with a different companion each night. Young women whispered that he could be generous to protégées. Elizabeth, already accustomed to overtures from nearly every man she met, dismissed him affectionately as "a harmless old goat"; laughing over her New York adventures one weekend at home, she warned Minnow that in tête-à-têtes, "you had to keep the desk between yourself and Mr. Nast."

Nast often looked uncomfortable at his own parties. The person whose role it was to create the scintillating atmosphere that surrounded him was Crowninshield, who relished the offbeat and the unexpected. Known as "the man-who-knows-more-celebrities-than-anyone-else-in-New-York," he and his reserved employer were opposites. *Manners for the Metropolis,* Crowny's tongue-in-cheek etiquette book, purported to help the newly rich avoid panic "at the mere sight of a gold finger bowl, an alabaster bath, a pronged oyster fork, or the business end of an asparagus."

Crowny's feeling for modern art set the tone for *Vanity Fair*. In its pages he introduced Marie Laurencin, Jacob Epstein, Matisse, Maillol, and Picasso to America. He published new writers like Dorothy Parker, Edna St. Vincent Millay, E. E. Cummings, and Edmund Wilson, and championed some who were already known, including Fitzgerald and Anita Loos—a favorite of his, whose latest book, play, or film *Vanity Fair* always plugged. Crowny also appreciated witty women. He remained friendly with Dottie Parker even after firing her as the magazine's drama critic; they lunched together at the Algonquin Hotel, known to the circle of wits who made it their headquarters as "the Gonk."

Elizabeth met Dottie at the Algonquin group's unofficial annex, Neysa

McMein's painting studio in a dingy brick building on West Fifty-seventh Street. After classes, the more adventurous League students gathered there to drink bootleg gin and mingle with Neysa's bohemian friends, many of them people one read about in the gossip columns. They rehearsed Dottie's latest quips and toasted her *Vogue* captions (e.g., "brevity is the soul of lingerie"). But judging by her recent verse, Parker's reputation as the wittiest woman in New York had not brought happiness. Her subjects—the cynicism of the flapper; the fate of unmarried, divorced, and "career" women; rejection in love—did not inspire younger women to follow in her footsteps.

Elizabeth preferred Neysa McMein, an illustrator whose portraits often appeared in Nast's magazines. Her talent for amusing herself in unusual ways, such as riding in a parade on an elephant, made good copy. One day Neysa, a statuesque blonde, would be judging bathing beauties at Coney Island; the next she might be "opening a new movie house in Toronto or swimming impromptu in the Marne," wrote Alexander Woollcott, another regular at the Gonk. A confident woman with a talent for self-promotion, Neysa had done war posters and fashion drawings, but now specialized in pastels of famous women—Parker, Edna Millay, Helen Hayes. Née Margery, she had changed her name "because some seeress had assured her in sibylline accents that it would bring her luck." Her studio was crowded and noisy, but the guests liked the confusion. Charlie Chaplin might be rehearsing a bit of slapstick while Irving Berlin played the piano; Neysa, her short hair streaked with pastel dust, might suddenly decide to improvise with Chaplin or join Berlin at the keyboard. Unexpected things happened to her, Woollcott thought, because she had "an insatiable, childlike appetite for life."

Neysa, who in some ways resembled Elizabeth, adopted the young woman as her protégée. Elizabeth must change her name as she herself had done, Neysa explained, to ensure the continuation of her good luck. They went over her childhood nicknames before choosing the slightly androgynous Lee—an abbreviated, updated version of Li Li. Her career dated from the day she changed her name, she told Minnow—who recalled years later that "we all started using *Lee*, but it was difficult. We had to think of her as this new person." Once she began working as a photographer, the name proved to be useful. Prospective clients were unsure whether she was male or female—an advantage, she thought, in the early days of commercial photography.

Neysa also explained the lay of the land to Elizabeth during their visits to Long Island's north shore, known as the Gold Coast. So many members of the smart set had weekend houses there that the *New Yorker* illustrator John Held Jr. drew a map showing the residences of local luminaries. Neysa's Port Washington cottage was down the street from Chaplin's grander dwelling and across Manhasset Bay from Fitzgerald's. If Held's tongue-in-cheek Who's Who charted the fluid social worlds on which Fitzgerald had modeled *The*

Great Gatsby, Nast lived in the style of the novel's title character. Soon Eliza-
beth (the transition to her new name not yet complete) was spending more
weekends at Neysa's or at Sandy Key, Nast's mansion in Stony Point, than in
Poughkeepsie.

By 1927, when Nast bought Sandy Key, his magazines' circulation had
risen, along with the worth of the parent company, and *Vogue's* European edi-
tions had extended his fame. That year, Nast crowned his success by purchas-
ing a country home whose grounds extended from his colonnaded porch to
Long Island Sound. His famous guests sipped cocktails, played tennis, wan-
dered in the gardens, and swam in the huge oval pool while Nast courted
Leslie Foster, the *Vogue* staffer a few months younger than Elizabeth whom he
would later marry.

After her appearances in *Vogue,* Elizabeth had no shortage of beaux. A
rotating crew of suitors took her dancing, sailing, to polo matches, and up in
their two-seater planes—a pastime that earned the approval of her brother.
John, with whom she still shared the apartment, was impressed when she
dated Grover Loening, an aeronautical engineer twenty years her senior. The
U.S. Army had adopted Loening's treatise on military airplanes during the war;
the engineer had recently patented his designs for seaplanes, including the
five-seat Flying Yacht sent on the army's recent Pan-American goodwill flight.
One wonders how he coped with Elizabeth's need for independence, and
whether she saw the similarities between Loening and her father.

That summer she also met Charlie Chaplin. His reputation as a lover of
young women preceded him, as did reports of his superior physical endow-
ment. Two years earlier, when *The Gold Rush* premiered on Broadway, Chap-
lin had begun an affair with Louise Brooks, who at eighteen was half his age.
Elizabeth's friendship with Chaplin came at a shaky time in his life. When his
"child bride," Lita Grey, sued for divorce in California, threatening to name
prominent actresses with whom he had had affairs, he fled to New York.
Despite the scandal, the public loved him, socialites sought him out, friends
like Neysa helped revive his spirits. In August, after he agreed to pay Lita a
million dollars, the press called him a hero and artists rallied to his defense.
Chaplin took comfort in the news that in Paris, André Breton published a
protest on his behalf entitled "Hands Off Love," signed by artists and intellec-
tuals like Louis Aragon, René Clair, and Man Ray.

Not all of Elizabeth's suitors were older than she. Alfred De Liagre Jr., one
of the Yale men who took Elizabeth and Tanja on double dates, was the son of
a European business executive. Dellie was warm, witty, and imaginative;
within a few years he would become a well-known Broadway director. Although
Elizabeth cared for him, their love affair was punctuated by arguments about
other suitors. They worked out an agreement by which they remained intimate
while she also went out with his friend, a Canadian aviator named Argylle—

another male companion whose independence mirrored her self-image as a free spirit.

In 1927 millions looked to aviators as a new breed of hero—modern-day explorers whose flights enacted the aspirations of the earthbound. In May, as Charles Lindbergh prepared for the first nonstop transatlantic flight, the news galvanized the world. Several aviators had already tried to make the trip, in vain. Lindbergh, the twenty-five-year-old dubbed "the flying fool," hoped to advance the cause of aviation by attempting this difficult flight. On May 20, John and Elizabeth joined the crowd at Roosevelt Field in the early morning. They watched the small silver plane race down the runway in the dark, lift into the mist, and clear the obstacles—a tractor and telegraph wires—at the end of the field.

When the news of his landing at Le Bourget reached the United States, the press renamed him "Lucky Lindy." A hundred thousand Frenchmen welcomed the aviator; the press hailed him as a new type of American. On his return to the United States, President Coolidge awarded him the Distinguished Flying Cross, and on June 13, all New York lined up for his reception. Waves of cheering greeted the cavalcade's slow progress up Broadway beneath a snowstorm of confetti. Lindbergh was the most admired person in the world in an era of intense hero worship.

At the same time, the *Little Review*'s Machine-Age Exposition became the sensation of the New York art world. Students at the League flocked to Steinway Hall, one block west of their school, to see the exhibit celebrating "the great new race of men in America: the Engineer." It was vital for modern civilization that this new hero "make a union with the artist," declared Jane Heap, the organizer. She had planned the show, she continued, because machinery had already inspired some artists to turn "the realities of our age into a dynamic beauty."

Steinway Hall in no way resembled an art gallery. Bare posts and girders framed the large open space. Actual machines (a tractor, a machine gun, an airplane engine) and photographs of machines were displayed next to images of grain silos and skyscrapers or juxtaposed with works by artists like Man Ray, Marcel Duchamp, Charles Demuth, and Charles Sheeler. The catalogue used a Fernand Léger design on the cover; the *Little Review* ran his tribute to machines as "the most beautiful spectacles in the world." Heap's landmark exhibition illustrated her belief that machines were the icons of modern life.

From this perspective, photography was clearly *the* modern art. "The moving picture and the snapshot mark the tempo of our time," wrote a *New York Times* critic. A publicity campaign that year claimed that photography could be trusted to deliver the truth, or a version thereof. "Photographs mingle romance

and reality; present your wares exactly as they are; yet with a captivating charm that leads to bigger, quicker sales," the Professional Photographers of America told prospective advertisers. While an illustration might be dismissed as "the fanciful dream of an artist," the camera was objective—telling its story "as an unprejudiced eye witness." It was an exhilarating time to think about becoming a photographer, as Elizabeth did while continuing to study art, model for *Vogue,* and conduct her life as actively as if she were a man.

∞

Looking back on her New York years decades later, Lee told an interviewer, "I looked like an angel, but I was a fiend inside." At the time, it distressed her that her life was full of contradictions. A proud young woman whose radiance made people stare when she entered the room, she felt that her inner nature belied what they saw. By 1928, she had all but left Poughkeepsie—having taken a new name, learned the rudiments of art, and assumed the right to sexual freedom. Yet as Lee's remark about the gap between her angelic and fiendish selves implies, she remained in the grip of childhood trauma. Deeply held fears about inside and outside as contradictory realms of experience continued to haunt her. Only in later life did she become aware that she had internalized aspects of the puritanism she claimed to despise.

While Lee did not tell the interviewer about Theodore's passion in those days, she may also have been thinking of the way she was pictured in the many stereoscopic photographs he took of her on weekend visits. It is difficult to contemplate these "art" nudes with equanimity. Just before her twentieth birthday, Theodore photographed Elizabeth gazing at her reflection in a mirror, a pose in which she is both subject and object. She stares at her naked body and at the same time at her father, who is taking the shot. While her expression is vacant, as if her mind were elsewhere, she also participates—gaining some measure of control by helping to stage these scenes with her father. Other shots show her facing the camera with her hands behind her back—a provocative pose but one that diminishes her agency. In still others, she daydreams naked on the living room couch, a lace antimacassar placed anachronistically behind her boyish head.

However *we* respond to such images, whatever we make of Theodore's love for his daughter, and hers for him, we cannot know what happened. Just the same, if their intimacy was unconsummated (as seems likely), a transgression of the boundary that should protect a child from incestuous wishes did take place. A father's expression of his desire—of which he may be unaware—harms a child in a different way, perhaps as much as if the act were committed. The evidence of this harm, which multiplied the effects of Elizabeth's rape at the age of seven, can be seen in Theodore's photographs. Whether or not he was conscious of his motivation, they exploit his knowledge of the rape

by putting her on display. Yet it is also true that, over time, Elizabeth became complicit in their sessions and may have taken pride in her dual role as object and collaborator.

Oddly—to us—Theodore continued to do these private studies while also clipping and pasting into his diaries every account of her appearances in *Vogue,* as if there were no contradiction between the two kinds of poses. "June Vogue Contains Two Artistic Photos of Elizabeth Miller," the *Poughkeepsie Star* announced on the society page a month after her birthday—adding, in case anyone didn't know, that she was the daughter of Mr. and Mrs. Theodore H. Miller. The wayward girl who had been expelled from nearly every school she attended had become a celebrity.

By the end of the decade, advertising campaigns with endorsements predominated in women's magazines. Steichen's photographs for Jergens lotion had evolved from images of homemakers peeling potatoes to scenes of upper-class women pouring tea, the implication being that Jergens raised one's social status while softening one's hands. Steichen also used portraits of titled beauties to promote Pond's cold cream as the secret every woman could afford. In the first of this series, the duchesse de Richelieu, who had lived in Baltimore before marrying into one of the oldest aristocratic lines in France, was photographed like a film star combining Old World status with a New World fortune.

It was one thing to associate one's prestige with Pond's and another to appear in the "whisper" campaigns depicting the consequences of failing to use hygienic products. Admen for the mouthwash Listerine produced the slogan "Even your best friend won't tell you"; a copywriter for Absorbine Jr., a liniment company, coined the phrase "athlete's foot"; negative campaigns about the new social sin, body odor, promoted Odorono. Typically, such ads showed one woman whispering to another about the ignorance of a third—the sort who was often a bridesmaid but never a bride because she failed to mask her natural functions.

Madison Avenue presented the female body as a terrain for the projection of fantasized needs. On the one hand, this attention made consumers more health-conscious; on the other, it projected a sanitized image of bodies anxious not to offend. The ad campaign for another new product, Kotex, became the test case for what a critic calls this "WASP vision of a tasteless, colorless, odorless, sweatless world." As an alternative to cloth devices, nurses in French hospitals during the war had used "cellucotton" bandages made of wood fiber. Their innovation, ads claimed, now available commercially, eased the strain caused in "better" households by the postwar shortage of servants. By 1928, Kotex ads also stressed the embarrassment factor. At tea, two women discuss

"this grave social offense," while a third seems unaware that Kotex gives "peace of mind under trying conditions."

When Elizabeth's image unexpectedly graced the advertising campaign for the "new, improved" Kotex, she was outraged. The ad, which ran in different versions in *McCall's* and other women's magazines, used a Steichen portrait taken at Nast's penthouse. Her gleaming pearls and columnar white gown seemed to support the claim that "correct appearance and hygienic comfort" could now be combined, thanks to Kotex; readers could assume that she was one of the unnamed consumers quoted saying that the pad could be worn "under the sheerest, most clinging frocks." De Liagre's protest to Condé Nast and Elizabeth's letters to the agency made no difference. She had signed the release form. By 1929, when the ad appeared for the last time, she reversed her position and took pride in having shocked family and beaux alike.

Poughkeepsians, who had long been scandalized by Elizabeth, would have been even more shocked to learn that the notorious spokeswoman for Kotex was also a participant in Theodore's new pastime: group nude shots of his daughter and her friends. Tanja and Minnow were both persuaded to sit for him, with Elizabeth or with other young women, in pairs and trios. "Theodore was always begging us to pose for him in different stages of undress," Tanja

Kotex ad, Delineator, *March 1929*

"I warn women
when they have gowns fitted

says a famous
MODISTE

Sanitary protection can make for embarrassment if the lines of a gown reveal awkward bulkiness beneath . . This new way solves a difficult question

MANY a smart costume has failed in its effect; many a perfect evening has been ruined because of certain outstanding flaws in grooming. Women who have been aware of awkward bulkiness in sanitary protection now welcome the Improved Kotex, which is so rounded and tapered at the ends that it fits with an entirely new security. Now there is no break in the lines of a costume, no need for unhappy self-consciousness.

*Kotex deodorizes completely**

And another hindrance to fastidious grooming is finally removed; Kotex deodorizes thoroughly and safely—by a patented process*. Greater softness of texture, marvelous absorbency; instant disposability; the fact that you can adjust the layers of the filler—these things are of great importance for comfort and good health. Cellucotton absorbent wadding, which fills Kotex, actually takes up 16 times its own weight in moisture. That is 5 times more than cotton itself. Kotex scientists have tried every new way to achieve perfection in a sanitary pad. Improved Kotex is the result of their research.

Buy a box . . . 45c for twelve . . . at any drug, dry goods or department store. The Improved Kotex is also available in vending cabinets of rest-rooms by West Disinfecting Co.

**Kotex is the only sanitary pad that deodorizes by patented process. (Patent No. 1,670,587.)*

Use Super-size Kotex
Formerly 90c—Now 65c

Super-size Kotex offers the many advantages of the Kotex you always use *plus the greater protection* which comes with extra layers of Cellucotton absorbent wadding. Disposable in the same way. Doctors and nurses consider it quite indispensable the first day or two, when extra protection is essential. Buy one box of Super-size to every three boxes of regular size Kotex. Its added layers of filler mean added comfort.

K O T E X
The New Sanitary Pad which deodorizes

recalled. Minnow felt pressured, albeit politely: "If you didn't do it, you'd feel prudish," she explained, adding that Florence watched over the proceedings. In some photos, Tanja and Lee recline on the sleeping-porch sofa, warming their limbs in the sun. In others, they tell stories by the fire, or, more provocatively, Lee's head rests on Tanja's thigh. The boldest image in the series treats the two friends as a study in light and dark: arms linked, they strike hip-shot poses on a Navajo rug that looks "moderne," like the arty display of their naked bodies. As a group, however, Theodore's nudes hark back to the prurience of the stereoscope.

While posing for her father's ongoing series, Elizabeth was simultaneously absorbing Steichen's approach to the craft. The Colonel justified "faking," his term for interventions in the photographic process such as marking, shading, or otherwise manipulating negatives, as a means to capture the truth. He had recently renounced art by taking his canvases into the garden and burning them—the sort of gesture that appealed to Elizabeth. After two years of modeling, she announced her intention to become a photographer, to stand behind the camera rather than in front of it.

For a New Yorker, the obvious place to start was the Clarence White School. White, an early member of the Photo-Secession, had taught photography since the 1910s. Although he first taught a soft-focus aesthetic, his students were now learning the modernist idiom. Some, like Paul Outerbridge and Ralph Steiner, "acquired a formal rigor and technical brilliance that served their ideas well," a historian writes, "while others learned only a handsome stylishness." Instructors at the school stressed design. The choice of subject, one's feelings about it, or what larger purpose the exercise might serve, were not important. How to fill the picture space mattered more than what went into it, an approach suited to the dynamics of advertising.

By 1929, one former student had already acquired a reputation. Like Elizabeth, Margaret Bourke-White, who was her age, learned a reverence for both machines and photography from her father, a printing-press designer. Bourke-White had also gone to college to study science. After refining her photographic technique at the White School, she chose the new medium as the means to realize her ambitions: "I want to become famous and I want to become wealthy," she wrote in 1927. Her timing was excellent. Bourke-White's images of Henry Ford's factories, Cleveland's steel mills, and Niagara Falls' generators expressed Ford's (and the decade's) view of machinery as the new messiah. "Her personal passion," Bourke-White's biographer notes, "ran in perfect synchrony with the nation's interests."

Elizabeth went about learning what she wanted to know in her own way. Lacking the disciplined habits that may result from an advanced degree or professional training, she picked up her knowledge as she went along. To her apprenticeship in theater lighting and design, she added the imagery of the consumer culture that embraced her. White's students approached images as

design; Elizabeth saw them as shifting scenes in the theater of her mind—to be held and framed by means of the camera. But to earn her living as a professional photographer, she would need training.

The issue was indirectly addressed in *Vanity Fair* when the magazine ran a tongue-in-cheek "Modern Art Questionnaire" by the young critic Alfred Barr. His questions might seem dated, Barr wrote, because they included "no spellbinders such as, Name four important artist-photographers whose names begin with St—." The correct answer to this spellbinder, Steichen, Stieglitz, Steiner, and Strand, formed a roll call of photographers working in the "recent manner," but included no women. In the twenties, one apprenticed oneself to an established professional or attended his school (whether or not his name began with St—).

Steichen told Elizabeth about the inventive, well-paid photographer whose work reflected art's affair with the machine: the futuristically named Man Ray. A New Yorker, he had invented the rayograph (a photographic image made without a camera) before going to France in 1921. Since 1925, when he covered the Art Deco exhibition for *Vogue,* his fashion work had appeared in Nast's magazines, along with his portraits of French aristocrats. The *Little Review* had published some of his most abstract images; others in the 1927 Machine-Age Exposition had enthralled art students and mystified critics. Elizabeth could introduce herself to him as a prospective student provided she could get back to Paris—an idea that had, for some time, obsessed her.

New York's excitements were no longer satisfying. She had won fame as a model, consorted with the smart set, and had more love affairs than Lorelei Lee (or perhaps as many as Louise Brooks). Having recently seen Medgyès on his visit to New York, she wanted to return to the life he had shown her in Paris. Steichen promised to write Man Ray on her behalf; Condé Nast planned to introduce her to George Hoyningen-Huene, the head of photography at French *Vogue;* a fashion designer gave her a job illustrating vintage patterns in Florence, where she would spend the month of June. Tanja, also at loose ends, decided to accompany her on the *Comte de Grasse,* which was due to sail on May 10, two weeks after Elizabeth's twenty-second birthday.

Elizabeth's compliant lovers flipped a coin to decide who would see her off. With the Millers, De Liagre, the victor, watched her ship sail down the Hudson in the morning sun while Argylle followed in his biplane, then swooped close to the sundeck to let loose a cascade of roses in Elizabeth's honor. She had come of age with the decade when New York became the world's most powerful city, yet she was turning her back on its cocksure mood of self-celebration.

Part Two

Miss Lee Miller

Lee and Man Ray, c. 1930, Paris (Man Ray)

Chapter 5

Montparnasse with Man Ray

(1929–30)

Whil it is tempting to think that Elizabeth became Lee while crossing the ocean, the psychic shifts that accompanied this name change took place more gradually. She was still her parents' daughter; her "angel" self was still at odds with the "fiend" inside. One night at the ship's bar she surprised Tanja by admitting "that the reason she liked me was that I gave her a false feeling of respectability." Despite herself, she still cared about other people's opinions.

By Poughkeepsie standards, Elizabeth lacked the "finish" that the Old World could confer. She and Tanja were to spend the summer doing Europe like the heroines of a Henry James novel—though they more nearly resembled Anita Loos's flapper duo. From Paris they went to Florence with letters of introduction to the fin-de-siècle expatriates in residence there. Their chaperone, an English art dealer, took them to tea at Bernard Berenson's villa, a coveted stop on the grand tour for connoisseurs. The famous critic impressed Tanja but failed to interest Elizabeth.

Her job required her to spend hours in the city's museums drawing Renaissance ornaments—cuffs, laces, belts, and buckles—as inspiration for current New York fashions. The work was painstaking. It occurred to her that

she could make better copies by taking photographs, even though the light was bad and she had only a folding Kodak. Drawing on the Miller ingenuity to solve these problems, she satisfied her employer's needs while strengthening her resolve to abandon art. In June, after a short stay in Rome, Tanja went to Germany and Elizabeth returned to Paris to look up Man Ray. She could learn more from him than from the English art dealer and Berenson combined.

Lee went back to France in 1929, she explained, "to enter photography by the back end." Until then, she had stood in front of the camera: she had been intensely looked at but not looked into—as if her being stopped at the surface of her skin. And it intrigued her that no two photographers made her look the same. Since she could seem romantic, flapperesque, or conventionally middle class, she hoped to explore this "mystery" by going around to the other side of the camera—to see how the photographer's vision affected the outcome.

Entering photography from the back end also meant changing its power dynamic, since male photographers usually looked at female models. By the end of the twenties, Margaret Bourke-White, Berenice Abbott, and Germaine Krull were reversing this scenario. Yet it is unlikely that Lee would have chosen a female mentor had she known one. Adept at establishing a rapport with men whose work she admired, she learned best in situations of intimacy.

To our ears, "entering photography from the back end" is a suggestive way to describe her decision: since Lee's childhood, the photographic apparatus, the experience of posing, and the darkroom itself were all charged for her with sexual meaning. Becoming a photographer would make it possible to explore much unfinished business. Lee often told the story of meeting Man Ray as a turning point in her life. In each version of this encounter, she is the protagonist—reversing the dynamics of her "discovery" by Condé Nast.

Once in Paris, she made her way to Montparnasse and, after knocking on the door of Man Ray's studio at 31 bis rue Campagne-Première, learned from the concierge that Monsieur Ray had left for the summer. Disconsolate, she crossed the Boulevard Raspail to the corner café, climbed the narrow iron staircase to the second floor, and sat down to sip Pernod with the owner.

Suddenly Man Ray appeared before her. "He kind of rose up through the floor at the top of the circular staircase," she recalled. "He looked like a bull, with an extraordinary torso and very dark eyebrows and dark hair. I told him boldly that I was his new student. He said he didn't take students, and anyway he was leaving Paris for his holiday. I said, I know, I'm going with you—and I did." Another version of their first meeting underscores her boldness: "I asked

him to take me on as a pupil. He said he never accepted pupils, but I guess he fell for me. We lived together for three years and I learned a lot about photography."

Becoming Lee Miller and entering photography occur simultaneously in "My Man Ray," the most extended version of this pivotal tale. When the café owner introduces them, she declares without hesitation, "My name is Lee Miller and I'm your new student." This version continues: "He said he was leaving for Biarritz the next day, and I said, 'So am I.' I never looked back." Ironically, the meeting that sealed her identity also led to her becoming, as the French said, "Madame Man Ray."

In the twenties, Man's reputation spread throughout Europe. To be "done" by him meant that you were someone. His portraits of writers, artists, and socialites, many of them published in *Vogue,* allowed him to lead a life of luxury. He wore custom-made suits, drove a sports car, and spent his holidays with the wealthy patrons who financed his experimental movies, which had, until recently, featured the previous Madame Man Ray, the high-spirited Kiki de Montparnasse. Kiki had left Man the year before, but he described their breakup as his decision. "Having terminated a love affair," he remarked, "I felt ready for new adventures."

Going to Biarritz for the summer with his young American "student" was the start of an adventure for both. Given Lee's attraction to older men, the age difference—nearly seventeen years—worked to Man's advantage; while she was a head taller, his energy was compelling. "If he took your hand or touched you, you felt almost a magnetic heat," she recalled; his hands, "square and even workmanlike," were soft. Moreover, Man had style. He sported white flannels and loose Breton shirts during the summer and wore a beret long before his compatriots adopted this headgear as a symbol of insouciance. The most striking thing about Man was his economy of motion. "He never seems to hurry," Lee explained, "but he always gets there."

It is easy to imagine how Lee affected Man. Everything about her—deep-set blue eyes, graceful long neck, lean, supple shape—was full of promise. She was the incarnation of that provocative French figure, the *garçonne*—an independent young woman who plans to enjoy her freedom. The term came from Victor Margueritte's best-selling novel of the 1920s, *La garçonne,* whose heroine's emancipated ways were read as a protest against bourgeois standards. The bob, or *"coiffure à l'allure garçonne,"* had become a postwar focus of cultural anxiety about the destabilization of gender roles. To the French, Lee looked like the sort of hoyden whose willfulness threatened the fabric of society. Man was used to women living alone or with lovers, but until Lee, none had gone so far as to model themselves on the *garçonne*. Lee's seductive manner made her all the more alluring.

At first, in deference to her new mentor, she went along with his plans. He

took her to visit Rose and Arthur Wheeler, the American couple with whom he spent part of each summer. They had become friends in Paris when Rose sat for her portrait. After seeing Man's experimental movies, Arthur had insisted that Man devote himself to the cinema and offered both financial backing and the use of his estate in the Basque country, near Biarritz.

Lee and Man drove south through the countryside in his stylish Voisin sports car. Before coming to Paris in 1921, he had not dreamed of owning an automobile, but after becoming a success, he took up fast cars and dancing, another of "a series of accomplishments," he wrote, "which had seemed beyond me." Yet Man was not the sporty type, Lee recalled: "He liked to fiddle around in the water at the beach if the weather was good, but, as he said, he swam like a typewriter." Nor was her mentor moved by nature. The clichés of art—sunsets, panoramas, flowers—bored him, unless the flowers could be photographed as designs or evocations of the female sex. "I do not photograph nature," he observed. "I photograph my fantasy."

Man's snapshots of Lee on the road show a reserved young woman in a long linen jumper, white blouse, and beret—the counterpart of his darker one—posing demurely on the way to Biarritz. Another set shows her looking mischievous, as if about to escape from the car and take off into the countryside. Perhaps she already sensed that she would often go her own way.

During the long drive together, she would have disarmed Man's reserve with questions about his life in New York. If they told each other about their families, the class differences would have been obvious. His father was a tailor from Kiev who had made his way to the United States in steerage; his mother a blue-eyed beauty who stitched elegant clothes for her children but could be harsh and overbearing. He had shortened his name from Emmanuel to Man at twenty-one, at about the time the family changed Radnitsky to Ray—when anti-Jewish sentiment in the United States made this a practical decision. Signing his first artwork as Man Ray, he had, in effect, reinvented himself, as she would do by becoming Lee Miller.

On the journey south, it would have been clear to Man that his companion was nothing like Kiki, whose languid forms suggest the ideals of the nineteenth century. One of Man's best-known photographs, *Violon d'Ingres*, shows a naked Kiki wearing a turban and, superimposed on her back, the curlicue "f" holes of a violin. His title for this image, a witty tribute to Ingres's odalisques, is a pun on the French phrase for an artist's hobby (for Ingres, his violin; for Man Ray, Kiki). Man's many portraits of Lee, which also celebrate her body as an instrument of pleasure, do so instead in the vocabulary of modernism— perhaps because they hold the muted awareness of his new muse as a *garçonne* with a style, and a mind, of her own.

∞

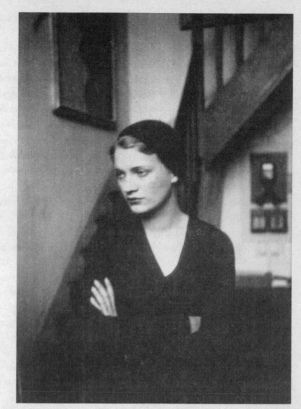

Lee at Man Ray's studio, 31 bis rue Campagne-Première (Man Ray)

Soon after their return from Biarritz, Lee informed Theodore that she was staying in Paris to study photography. Since Tanja would return for a month in September, she took rooms for them in a hotel on the Boulevard Montparnasse, a few minutes' walk from Man's studio and, in the opposite direction, from the expatriate cafés at the Vavin crossroads, the hub of Montparnasse.

Man's Art Nouveau building, a neighborhood landmark, dates from 1911, when this area replaced Montmartre as the city's artistic center. As the Boulevard Raspail was extended to the south, speculators built hundreds of live-in studios, of which Man's was one of the most desirable. The same frieze of ochre ceramic tiles still adorns its façade; the Art Nouveau muses framing the doorway seem to usher visitors inside. In 1929, a plaque with Man's name identified his ground-floor studio, which combined a large, well-lit salon with a small bedroom and an even smaller darkroom on the balcony. Man's oils and photographs hung on the walls; his objects—chess pieces, wooden cubes, pyr-

amids, and artists' mannequins—decorated the furniture like so many little worlds assembled by their creator.

Each day Lee walked around the corner to the rue Campagne-Première, a block-long monument to modern art. She passed Chez Rosalie, where, before the war, Modigliani had traded drawings for meals. Man's friend Mina Loy, a poet and painter who supported herself by designing Art Deco lamps, had lived in a studio at number 17 (where Rilke also resided), then, more recently, at number 11. Americans often stayed two steps from Man's at the Hotel Istria (where, according to legend, Hemingway's Brett Ashley and Jake Barnes pursued their frustrated love). Louis Aragon lived next door at 31 with his companion, the Russian novelist Elsa Triolet, who eked out a living by stringing bead necklaces.

The neighbor whose work had the greatest impact on Man's was the photographer Eugène Atget, who, until his death in 1927, arose at dawn to record aspects of old Paris. Man had bought a number of Atget's images and offered to print his work on stable paper, but Atget said that he was too set in his ways for modern techniques. Yet in Man's view, the old man's images were Surrealist in spirit. (Man showed Atget's photographs to Breton, who ran one on the cover of *La Révolution surréaliste*, the movement's polemical magazine.) Atget's influence was palpable in Man's images of Paris and, indirectly, in the Surrealists' view of its crooked streets as a veiled map of the psyche.

Although Man kept his distance from the Surrealists' political squabbles, he was, in Breton's view, the one photographer who expressed the movement's vision. It was gospel among the Surrealists that reality could be transformed by freeing repressed libidinal energies. To illustrate his beliefs, Breton used Man's photographs in *La Révolution surréaliste* and his 1928 novel *Nadja*, which tracks the narrator's affair with a woman encountered in a Paris street. (Nadja goes mad at the end of the novel, but her disappearance is of no concern to the narrator, since their affair has deepened *his* process of self-discovery.) Man's erotic portraits of women seemed to confirm the Surrealists' hope that through sexual ecstasy the creative imagination would be unleashed.

As part of the group's ongoing research into sexuality, Breton asked the Surrealists to name the "essential" encounters of their lives and say whether these had been "fortuitous" or "necessary." Man replied enigmatically, "Any encounter I rejected was fortuitous; any I accepted and continued was necessary." After his return from Biarritz, he fell deeply in love with Lee. In the early stages of their affair, they hardly left the studio. Lovemaking alternated with picture-taking. For the first time, perhaps, Lee felt the intoxication of a love that takes itself as the center of existence, and Man, the implications of an encounter that would become more than necessary.

Decades later, Lee looked back on this time with detachment. What mattered were the details of her apprenticeship with Man. To the biographer, what

she did not say is just as interesting. Her recollections, while hinting at the tangled interweave of personal and aesthetic matters, downplay her role in the transformation of their rapport into a partnership whose intimacy can be detected in the photographic record of their years together.

Man often said that photography was not an art but a way to paint with light. In the same way, technique was just a means to an end, that of isolating a subject in its particular aura. Most of the time, he would rather paint than photograph, but portraiture and advertising paid the rent. Lee offered to print for him so he could return to his easel. But first, he had to teach her his approach to the art that wasn't one, whose first principles, he said, were calm and control.

Man had everything in place before a sitter arrived. During a session, he gave simple directions, worked quickly, and photographed from a distance (ten to twelve feet), knowing that he would crop the negatives and enlarge the results. This procedure, which limited interactions with subjects, suited both his temperament and his aesthetic. Man's portraits were formal, in keeping with period expectations of a dignified likeness. "He dislikes the 'candid camera' attitude in portraiture," Lee explained. Yet his images, whether of people or of objects, were all expressions of "his personal mood."

This mood, a blend of reserve, inventiveness, and practicality, was as much a function of his working methods as a reflection of his engagement with the avant-garde. Man hoped "to extend the field of this newest of mediums to the limits of artistic expression," he explained. While in his opinion, photography was a matter of "light and chemistry," it also created "a new element of social contact." For those who had eyes to see, the distance between photographer and sitter was minimal: "As far as desires go, there is really not such a great gulf between the one who creates and the one who appreciates."

Man also liked to say that equipment mattered less than the person who pushed the button. Any camera would do. Man and Lee often photographed outside with their viewfinders. Although some photographers dismissed these small cameras as toys, their advantages included simplicity, low cost, and a final product that approximated what one saw through the finder, which was held at eye level. When indoors, Man often used a Graflex or a small studio camera with glass plates, although by 1930 this technology was on the way out. While plate cameras were cumbersome (one focused the lens by moving it on a track), their large negatives, which could be retouched, made them appropriate for portraiture.

Man taught Lee to work with his half-plate camera; its plates, which measured four by five inches, "had to be unpacked very carefully and loaded into the chassis," she recalled. When it came time to print, she went up the narrow staircase to the darkroom. Although it "wasn't as big as a bathroom rug," Man arranged his equipment as neatly as his objects: he was "absolutely

meticulous." He showed her how to insert the glass plates into their holders, dip them into the basin, then rinse them once they had been fixed. He taught her to use the enlarger under mercury light and, when printing on his favorite eggshell paper, to retouch with a "Jenner," a triangular blade that scratched out wrinkles. The work, as painstaking as her stint as a copyist in Florence, was more gratifying: "You have something in your hand when you're finished— every 15 seconds you've made something."

Man shared all of his secrets with Lee. By the end of their first year together, she recalled, "he had taught me to do fashion pictures, he'd taught me to do portraits, he taught me the whole technique of what he did." He used colored backgrounds, white, gray, or silver, "which gave off different colors and reflected whatever was in the room or wherever you walked," she went on. "One of the things he taught me so carefully was how to photograph silver objects, because where you think a silver object is very bright it actually isn't, it's just reflecting what's in the room." Man obtained a brilliant light by putting a low-voltage bulb into a higher-voltage circuit—an early version of the photoflood. His true medium was light. Using it to model the sitter's face as a painter used a brush, he obtained "that very fine, delicate drawing that's so Renaissance-looking."

Lee also acted as Man's receptionist. She welcomed sitters—a cross-section of the French and expatriate art worlds, and the trendsetters known as le Tout-Paris—on whom she often made an indelible impression. The American composer George Antheil remembered her as "a sylphlike creature . . . a decor by herself." A visiting *Vogue* editor thought her "a vision so lovely" that one forgot the purpose of one's visit. But to the novelist Henri-Pierre Roché, Man's new companion was "pretty, perverse . . . and somewhat lacking in the bust." (About this time, a glass manufacturer with a different opinion designed a champagne glass modeled after her shapely breast.) To Cecil Beaton, whose sexual imagination made her into a nubile youth, Lee resembled, rather, "a sunkissed goat boy from the Appian Way." "Only sculpture could approximate the beauty of her curling lips, long languid pale eyes and column neck," he said.

Lee dressed becomingly in velvet trousers and jersey tops that set off her long neck and shining bob. In 1930, when the *garçonne* look came to dominate fashion, its mannish lines brought out her androgynous side. "Her athletic figure made the simplest thing seem elegant," recalled Jacqueline Barsotti (later Goddard), who modeled for Man and who, despite some ambivalence about Lee, befriended her. Women who could wear the new style gained confidence, Jacqueline thought: "The men of our circles were astonished by the change in us." Lee had no qualms about reaping the advantages of her looks, she added. And while Jacqueline had mixed feelings about her new friend's self-centeredness, she envied her ability to get what she wanted.

Before Lee talked her way into his life, Man had had several assistants who, like her, developed, printed, and retouched photographs according to his specifications. Man had hired the sculptor Berenice Abbott because she knew nothing about photography; after three years with him, she opened her Paris studio, and they became friendly rivals—even photographing the same people: James Joyce, Jean Cocteau, and Peggy Guggenheim. By the time Lee arrived, Abbott had gone back to New York to document the city in the spirit of Atget, whose negatives she bought to preserve and take home as inspiration.

Man's next assistant, Jacques-André Boiffard, a Surrealist poet, had taken up photography after abandoning his medical studies. He photographed some of the Paris street scenes in Breton's *Nadja,* and often dropped by Man's studio when Lee was there. Bill Brandt, Man's other assistant at the time, worked with him until 1930, when he settled in England. Like Abbott, Boiffard, and, eventually, Lee, Brandt turned from studio work to documentary studies and photojournalism.

An indoor person by nature, Man relaxed by going out with friends. "He took me to wonderful restaurants with people who knew all about food and wines, and lunches that lasted from 1 to 7," Lee recalled. In the evening, they strolled down the Boulevard Montparnasse to dine at the Trianon or drink at the Jockey, "where you'd find James Joyce, Hemingway and all those people with their coteries around them." Other nights they joined the group at Le Boeuf sur le Toit, Jean Cocteau's jazz club near the Faubourg St. Honoré, or, once the Boeuf lost its cachet, Le Grand Ecart in Montmartre—a "narrower and smaller and more snobbish" place, Lee said, where one had to dress well to get in. Since Man was proud of having learned to dance, they practiced the latest steps at Bricktop's, the American-style nightclub whose unflappable owner crooned Cole Porter songs between glasses of Rémy Martin.

Man's pleasure in escorting Lee to all the spots where formerly he had taken Kiki was not lost on their friends. They went to cabarets to hear Kiki sing and often saw her at the Coupole, where she reigned over the habitués gathered in the narrow bar. Lee was delighted to meet the woman who had inspired the Broadway play, but "when [Kiki] realized that I had moved in with Man, she was a little piqued," she recalled. "She used to eye me and I used to eye her and finally I met her and we got along fine because I admired her very much." While the Surrealists treated Lee as Kiki's replacement, it was clear to friends that she was nothing like her predecessor.

Some said that Man had "created" Kiki by designing bizarre makeup and painting it on her—even shaving off her eyebrows and replacing them with new ones at odd angles. Lee needed no embellishment, nor would she submit to being redesigned. Paradoxically, Lee's belief in herself boosted Man's ego. While he still looked morose on occasion, he seemed more alive with her beside him. Kiki's friends were fascinated by Lee's self-absorption—a large

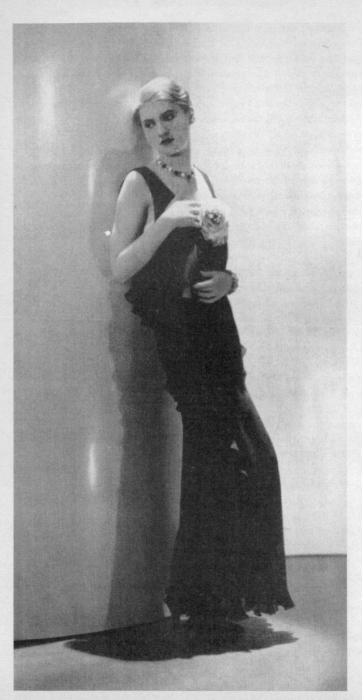

*Lee
modeling
Patou
gown
(Hoyningen-
Huene)*

part of her seductive aura, they thought. Watching Lee trade shamelessly on her beauty, they felt sorry for Man. "He loved her without restriction," Jacqueline Barsotti Goddard explained. "For the first and last time in his life, Man had to surrender. To have this fascinating, intelligent woman as his mistress was fatal."

To others in Montparnasse, they were opposites. People stared at them not only because of the differences in age and height but because Lee's radiance contrasted with Man's reserve. Yet they were complementary. Both were snappy dressers and liked to craft their images for their own amusement. On the Boulevard Montparnasse one day an acquaintance noticed a striking couple linked to each other by a golden chain. "The woman was taller than the man and strode along in spite of being tethered," she observed. As they drew closer, she recognized "the well-known photographer and his new assistant— he more attached to her than she to him."

∽

On October 23, 1929, news of the Wall Street crash hit Paris. Within a few days, foreigners dependent on remittances began to decamp. Jewelers on the rue de la Paix, antique dealers, and art gallery owners saw their clientele vanish. Tourists stopped boasting about the superiority of the dollar. But unlike Tanja, who went back to New York, Lee saw no reason to leave Paris.

In the meantime, Man worried about the future. Fewer sitters came for portraits; Arthur Wheeler could not sponsor more cinematic experiments. Man's anxiety deepened as the Depression spread to France and his New York supporters turned their backs on avant-gardism. The art critic Henry McBride, one of his early advocates, observed tartly, "If an American artist must live in Paris for his soul's good, that's his affair, but in doing so he automatically becomes French and must gain French support rather than live, parasitically, upon funds from home."

To augment her own funds, Lee went to Paris *Vogue:* Michel de Brunhoff, the editor, welcomed her as Steichen's model and Condé Nast's protégée. It may have seemed ironic that the October issue, appearing just before the crash, illustrated the new fashion "consecrating the triumph of muscular young woman" with three shots of Lee in streamlined tweed and jersey ensembles—as if she epitomized what the magazine called the "aristocracy of elegance." For the rest of the year, French *Vogue* ("Frogue" to its staffers) existed in a parallel universe. The crash went unmentioned, luxury thrived, and occasions for its display—garden parties, costume balls, competitions of expensive automobiles—were chronicled in its pages.

The photographer in charge of Frogue's studio, which sent the U.S. and U.K. editions their fashion pages, was George Hoyningen-Huene, a tempera-

mental Estonian baron. His father had been chief equerry to the tsar; his mother, the child of an American ambassador to Russia. After the revolution, the family fled to France. Man had taught Huene the rudiments of photography; together they produced a portfolio of Paris beauties for an American department store. Huene admired Man but revered Steichen. Like his idol, Huene wanted fashion to represent women "in their normal surroundings, pausing for a moment during their daily activities." Although he was known to terrify models, he showed Lee respect as Steichen's friend and Man's lover—and soon for her own sake.

Huene's portraits of Lee emphasize the relaxed stylishness that typifies his vision of the modern woman. In one, she turns to reveal the marcelled coiffure and jeweled evening gown that provide the photo's raison d'être, while her pose—arm resting on a fur draped over her chair—shows off her back and shoulders. In a variant, seated on one of the classical pedestals that Huene used as props, she wears an almost backless Lanvin dress called "Baghdad" and displays her "good profile." Huene sensed that Lee's contradictions made her more versatile than other models. She could look virginal in a white evening dress, her figure framed by calla lilies on a low table, or vamp unseen admirers in a black satin robe. For the first time, the magazine listed "Miss Lee Miller" in the photo credits, as if she were a celebrity.

Lee's apprenticeship with Huene began in 1930, she recalled, when she and a young German art student named Horst Bohrmann (later known only as Horst) "joined the *Vogue* studio to be [Huene's] slaves." Their workplace resembled a stage set. Models posed on platforms lit by brilliant lights that threatened to melt their makeup. Assistants wheeled the large studio cameras into position, raised and lowered them on their wooden frames, then turned a wheel to move the lens in or out. During the time it took for the elements of the picture to come together, the photographer entertained the sitter. Compared with working with Man, Lee observed, "that was an entirely different kind of photography." The baron's slaves absorbed their mentor's advice while struggling with the cameras and readjusting the tungsten lights, since light meters did not yet exist.

As Horst and Lee became Huene's collaborators, a triangular relationship developed among them. Three blue-eyed blonds who were vain of their appearance, they could have been siblings—with Huene in the role of older brother and, soon, protector where Horst was concerned. Their intimacy is reflected in Huene's studies of Horst's athletic torso and his "Hellenic" poses—an allusion to same-sex love. However Lee felt about Horst—there is a hint of a rivalry between them—Huene saw his assistants as counterparts. The same age and physical type, they complemented each other.

Huene's beachwear series for Frogue became the vehicle for his feelings about them. These striking scenes, which resemble snaps of a summer holiday

for members of the leisure class, are marked by a redistribution of sexual ener-
gies. In one, Lee slouches in what must be the first pair of high-fashion over-
alls. In another, she lounges in a deck chair placed in front of a striped canvas
cabana: the composition emphasizes her jawline, short hair, and apparently
boyish chest. In yet another from this session, she gazes at a male companion
shot from behind, the better to show his muscles; a companion portrait of
Horst's torso accentuates the phallic vertical of the pole clasped in his muscu-
lar arms.

Swimwear by Izod, the best of this series and a hallmark of modernist pho-
tography, shows an athletic couple seated, judging by their garb, on a diving
board. As we seem to gaze past them to the sea, the two figures all but merge
into a single form. They share a pair of legs, the woman's; the verticals of their
necks and trunks, their cropped coiffures and contrasting costumes form an
androgynous whole. Like much of Huene's work, the image reflects the thir-
ties' turn to Neoclassicism, but there is a Surrealist note. Huene photographed
his sporty pair on the roof of the *Vogue* building; seated on a stack of boxes,
they were gazing not at the sea but at the parapet above the Champs-Elysées.
While studies of Huene's work identify the man as Horst, the woman is
unnamed, but to those who know Lee's neck, torso, and place in Huene's
imagination as Horst's "twin," she is instantly recognizable. *Friends,* as this por-
trait of Huene's favorites is also called, combines the seductive allure of
androgyny with the desire for an elsewhere.

Horst, a shy man with limited English, began modeling himself on his
patron. In time, the baron's self-assurance would rub off on his lover, who
gradually took charge when Huene gave him assignments. "It used to intrigue
me," Horst wrote, "to have power over my lovely sitters, to realize that they
were reluctantly entrusting me with the task of rendering a likeness that would
encourage a wavering faith in their own looks." One day he persuaded Lee to
pose for him. The portrait captured her soft side. Holding a sprig of lily of the
valley, she looks more like a romantic heroine than a *garçonne.* But when Horst
showed her the print, Lee pronounced it "a howl." After looking up the word in
the dictionary, Horst concluded that she was making fun of him. He decided
not to repeat the experiment. "With strong-willed girls," he wrote, "you let
them do it, you don't suggest."

∞

Lee moved easily from the family atmosphere of Frogue to the café life of
Montparnasse, where she was accepted, if not welcomed, as Man's lover. Few
understood the intensity of their relationship. After working side by side with
Man for a year, she had become necessary to him. Their bond, based in part on
her absorption of his approach, transcended words. It was sometimes hard to

say who took which image, Lee recalled. Photographs attributed to him might have been taken by her: their work overlapped. He set the scene and pushed the button; she took the image through the stages of development, retouching, and printing. The final product reflected their collaboration.

Man's portraits of Lee reveal the intimate dialogue that may occur between artist and muse. "What can be more binding amongst beings than the discovery of a common desire?" he asked in his 1934 collection, *Photographs by Man Ray*. Its many "autobiographical images" (including portraits of Lee) were not experiments, he wrote, but the residue of experience, "seized in moments of visual detachment during periods of emotional contact." Man's gift, Breton wrote in an accompanying essay, was to capture female beauty at the point "where it reaches its full power: so sure of itself as to appear to ignore itself!" His portraits of Lee depict what he saw as their common desire. His job was to capture the power of her beauty; hers, to seem to ignore herself.

Like a true portraitist, he began with her head. "The head of a woman is her complete physical portrait," Man wrote. "The more daring poets who have seen in a woman's eyes her sex, have realized that the head contains more orifices than does all the rest of the body; so many added invitations for poetic, that is, sensual exploration." He explored Lee's head from every angle, showing her full-face and staring at the camera, her uncertainty masked by her makeup; veiled by a wavy pattern of stripes that likens her to a wild animal (*Leebra*); childlike in sleep, with one finger at her lips (*La Dormeuse*); three-quarter face, both profiles, and each of her features as fragments. One of his favorite images shows her touching a manicured hand to her mouth as if inviting further intimacy.

While Lee's poses reveal a complicity of the kind she exhibited when sitting for her father, it is difficult to detect in them *her* sense of her relations with Man. Enacting his dream of a compliant femininity, she may have gained a measure of power. Perhaps she also sensed in these photographs projections of Man's feelings about the fluctuating dynamics of their rapport.

In his enlargement of her lips, half closed in a smile, it is easy to see another metaphor for the woman's sex. This image would haunt him, Man wrote, until he completed the large painting of red lips afloat in a blue sky entitled *Observatory Time—the Lovers*, which he used as the background for a series of photographs in the 1930s. "The lips because of their scale, no doubt, suggested two closely joined bodies. Quite Freudian," he added coyly. Lee's lips became his shorthand for the image of "two bodies fitting together in perfect harmony," he wrote, yet "when these lips break into a smile, they disclose the menacing barrier of the teeth." Beyond the dream of shared ecstasy lay its other face, the female sex as specter of castration.

The portrait of a loved one was not "just an image at which one smiles but also an oracle one questions," Breton observed. In Man's images of women, he

continued, "we [men] are given to see the most recent avatar of the Sphinx." Lee as Sphinx may seem far-fetched, but it was through the Surrealists' "Freudian" readings of myth that they saw the real women to whom they turned for inspiration. Man took two "oracular" portraits of Lee's face seen upside down, one with her eyes closed, the other with them open. In the second, the image is cropped to emphasize the inversion (chin on top, hair below). The uncanny angle of vision and positioning create Medusa-like images as disturbing as Magritte's contemporary canvas, *Le Viol* (Rape), where the woman's naked torso replaces her features.

Like his fellow Surrealists, Man devised images of women's bodies to subvert the long tradition of the nude as raw material of art. One of his early photographs of Lee assimilates her to sculpture. Her forearms disappear into the diagonals formed as they bend behind her head; her torso, draped below the navel, suggests a modern Venus de Milo to whom the head and partial use of the arms have been restored. Lee also posed nude from the waist up for a series of shots taken as she gazed out a window, where, in turn, a mesh curtain, iron grillwork, and dappled reflections cast patterns on her torso. Man kept the series for himself, releasing only the variant that shows Lee's torso minus her head—the image cropped at the neck and pubic region. Paradoxically, when this variant is compared with the original, his symbolic beheading enhances her determination. The pose seems forceful, as if *she* is in charge.

In the Surrealist imagination, seemingly fixed categories like "male" and "female" were reversible. ("I wish I could change my sex as often as I change my shirt," Breton is said to have remarked.) Yet enactments of this reversal provoked anxiety, which was part of their allure. Man also took several photographs of Lee's neck and upper torso and entitled them, suggestively, *Anatomies*. In them, she takes an extreme backward bend. Because her head is obscured, the tense, columnar shape of her neck suggests an erect penis. (A variant of this image, cropped just below the clavicle, focuses even more tightly on her throat.) It is easy to see *Anatomies* as an ambivalent appropriation of the female form, or as an anxious allusion to the power of the "weaker" sex.

Another image of Lee's neck, shot from below, included her profile. Displeased with the negative, Man threw it in the trash. Lee printed it anyway and claimed it as *her* work. They quarreled over her appropriation; she left the studio and returned to find *her* image on the wall with red ink streaming from the throat. Man had slashed it with a razor. That he continued to resent her insubordination is evident from his *Le Logis de l'Artiste,* painted the following year. The contested image of Lee's neck, again slashed with scarlet, dominates the neat arrangement of objects in the artist's studio. Antony Penrose comments: "The reduction of Lee's head to an object and its inclusion in this visual context reveal even more perhaps than Man Ray intended."

One of the things it revealed was Man's difficulty with Lee's need for independence. He wanted her to be his *chose* (his thing)—like Kiki, Jacqueline observed. Gradually, Man came to understand that Lee's compliance was a pose, or a series of them. He liked to photograph her asleep, when she offered no resistance. In one such image, shot from above, she lies fully dressed and spread-eagled on a dark coverlet, which contrasts sharply with her white trousers rolled to the knee. The position and angle direct the eye to the veiled V of her crotch, as if her long legs had involuntarily opened to allow a better look.

Man also played with the shape of her legs in an amusing series taken with three female midgets who were in Paris with a vaudeville show. In one, a tiny harem dancer stands between Lee's legs; in another, a pair of twins in bathing suits admire her as she balances above them. The composition juxtaposes the midgets' limbs with her much longer ones, but cuts them off at the thigh— another V shape pointing to what, this time, is absent rather than veiled. Although fragmentation is a commonplace of Surrealist art, one may suppose that by shooting Lee this way, Man felt that he was breaking her into pieces, the better to hold on to her.

Man's focus on Lee part by part may be seen as the visual equivalent of the Renaissance poet's praise for his mistress feature by feature. But it can also be understood as the recourse of an artist whose resentment of his beloved's power expresses itself in symbolic violence. The sadistic charge of these images is hard to ignore, especially given the Surrealists' worship of the Marquis de Sade and Man's enthusiasm for this banned author. In an image suggesting a Sadeian source, Lee poses like a supplicant, one leg folded beneath her, the other stretched out on the floor. Her head tilts back; her hand touches her throat like a sacrificial victim. Man called this nude *Suicide* and gave it to her as a present.

La Prière, one of his best-known photographs from this time, is even more disquieting. Inspired by Sade's predilection for sodomy, it shows a nude bent forward on her knees, her feet beneath her buttocks and her hands cupped to shield her anus. Man's ambiguous title, *Prayer,* hints that she offers what is hidden as an orifice for exploration. As in much of Man's erotica, the image plays with ideas of cruelty and worship while raising questions about whose desire is on display—the subject's or the artist's. It is impossible to identify the sitter (kneeler?) since only her extremities and posterior are visible. However, given Lee's desire to shock, the date of the photograph (1930), and Man's gift of it to her, it is likely that she also posed for this daring "portrait," which uses the woman's body to stage fantasies of domination and submission, along with their entanglement in the sexual imagination.

Some photographs, Edward Weston's biographer writes, reveal "not the personality of the sitter; and not the personality of the photographer." They

affect us, rather, by showing "an invisible, indefinable interaction of the two." Man's portraits of Lee are often of this kind. In their case, as in Weston's portraits of his sexual partners, "what we see, what we respond to, is the dialogue between subject and artist, unspoken, unspeakable." In actuality, however, this dialogue was one-sided. Man took hundreds of portraits of Lee. Only three of him by her survive.

Man sometimes made up the difference by speaking both parts. In a staged self-portrait, he stands next to a bed in a terry-cloth robe that seems about to fall open. Behind him is a small portrait of Lee looking down while the light of a tanning lamp called a Sunray—Man's stand-in—plays over her hair, breast, and thigh. Man's expression is melancholy; he seems to be pleading. The composition invites his lover to resume their intimacy but makes her part of the décor, her image subservient to the swirling Art Deco pattern on the wall behind him. Man's strategy vis-à-vis his muse, containment and miniaturization, bespeaks desperation more than it does dialogue.

"You are so young and beautiful and free," Man wrote Lee during a separation, "and I hate myself for trying to cramp that in you which I admire most, and find so rare in women." "My affection can stand an awful lot," he continued, "more than I can myself." He admired her insistence on doing things her way and wanted to defend himself against the charge that he was cramping her style.

Since the start of their affair, he admonished in another letter, "I promoted every possible occasion that might be to your advantage or pleasure, even where there was danger of losing you." She had grown tired of his "intensity," he worried. But was it intensity, or "sustained enthusiasm, whether in work, play, or love-making, or rather all three inseparably joined." Man could not voice his fear that Lee held more cards than he did. Despite his reputation, he was short, unattractive, and, socially speaking, her inferior. His success as an avant-gardist had erased neither his desire for respect nor his need to control the woman he loved, even while admiring in her that which caused him pain: her independence.

Against his inclination, Man encouraged Lee to find her own path. He sent her to work for firms that wanted a Man Ray but would accept the work of Madame. Among the more bizarre assignments he gave her was a stint as a photographer at the Sorbonne medical school, a job that appealed to her love of the macabre. One day Lee walked from the Left Bank operating theater to Frogue headquarters carrying a breast on a dinner plate, covered by a cloth. Having retrieved it from a mastectomy with the intention of taking a picture, she placed a knife and fork on either side, then added salt and pepper shakers

to this morbid still life, a true *nature morte*. Her bravado shocked Frogue editor de Brunhoff and scandalized Horst. What Man made of her dark humor—a reply in Surrealist terms to his obsessive focus on her body?—is not recorded.

Despite her provocative lapse in taste, de Brunhoff encouraged Lee to work as a photographer. Soon she was taking Huene's place in the studio on minor assignments. New York *Vogue* published her Steichenesque shots of luxury items arranged like miniature still lifes. To set off Chanel's new perfumes, she arranged their glass bottles with several modernist props: African masks, bits of classical architecture, a chessboard that might have come from Man's studio. In the most original of this group, a silhouetted hand reaches toward the flacons of Patou's perfume bar, whose essences let the owner concoct her own scent. The caption for Lee's shot of Elizabeth Arden's new perfume—"l'Elan d'Elizabeth, which blends sweet and spicy"—may have seemed like another "howl." One can imagine her pride when images of Patou gowns such as she had modeled ran in the magazine above the credit "Lee Miller, Paris."

Frogue provided relief from the intensity of life with Man. De Brunhoff, a portly, talkative tease whose brother created the *Babar* series, was also a trained actor. His dramatic flair convulsed his collaborators, especially when he did one-man renditions of silent movies—acting all the parts while quivering uncontrollably to indicate the flickers. De Brunhoff was "a brilliant mime," a friend recalled; "he could act a feature as well as draw it; and over his squat little body he would cunningly twist the lapel of his ill-fitting jacket to indicate the subtlest new line." De Brunhoff considered Lee a kindred spirit, whose sense of the ridiculous matched his own.

One could say that Lee's feel for the incongruities of daily life made her a Surrealist, though she never joined the movement and no doubt laughed in private at Breton's pomposity. Too pragmatically American to adopt his view of photography as a path into the unconscious, she nonetheless sympathized with the Surrealists' wish to shock society by whatever means possible. Even as an apprentice, she had an eye for unsettling moments and used the camera's framing capacity to capture and re-present them. Her knowledge of art, drama, and lighting came together in the unstudied Surrealism of her early Paris images—a mature body of work for a young photographer. Having trained with the masters—Steichen, Huene, Man Ray—she had absorbed their authority along with their "personalities."

By 1930, when Man had abandoned his flirtation with Paris as a subject, other photographers—André Kertesz, Germaine Krull, Ilse Bing, Brassai—were documenting its street life in the spirit of their common precursor, Atget. Like them, Lee walked around the city looking for scenes that spoke of their own accord. Working out of doors with a simple viewfinder gave her the freedom to capture the unexpected. In some of her earliest images, odd angles accentuate the humor implicit in the scene. In one, a canted vision marks her

delight at spotting four small rats seated side by side with their tails draped over their narrow perch. In another "found" image, three painted carousel cows eye the camera as they rise, fall, and spin by: her composition leads the eye past these tethered creatures to a patch of sky—the beyond to which they will never escape.

The urban landscape yielded many surprises. In a tilted image of a man standing near a swatch of asphalt, the bottom of his legs and his shoes (all that is seen of him) seem to be endangered by the encroaching substance. Lee's handling of light and texture—dull fabric, shiny leather, hard pavement, viscous asphalt—turns an ordinary street scene into a quirky view of the shrinking interval between human and nonhuman. Another arresting image called *Exploding Hand*—one of a series of hands standing in for faces—illustrates Breton's idea of "convulsive beauty." As a woman reaches toward a glass door marked by a tracery of scratches, her hand seems to explode just before its manicured fingers grasp the knob; the tilt of the door, a natural frame inside the picture, heightens the drama. Having mastered the camera's framing capacity, Lee used it—less programmatically than some official Surrealists— to enhance the strangeness in the everyday.

Other images from this period play with presence and absence. In one, the idea of something missing is implied by a silhouetted hand reaching toward an almost abstract pattern of grillwork. In another, of birds in cages, the alternation of the cages' bell-shaped wires and the spaces between them suggests ideas of escape. An implicit irony or dark humor—one of her persistent notes—emerges when we see that the birds are shot against patterned grillwork that imitates their natural habitat, the forest, in its leafy curves. Similarly, a pair of wooden shoes found on a patch of earth imply the marginality of their absent owner. In an image that harks back to Atget, Lee photographed the entrance to Guerlain's headquarters on the oblique, as if looking askance at the luxury trade to focus instead on the trees reflected in the plate-glass window. With each of these shots, familiar scenes and objects are made new by re-presenting them at odd angles.

Given Lee's apprenticeship in the arts of vision, her approach to photography as "a mechanical refinement of the art of perspective" is not surprising. She had studied perspective, lighting, and composition with the best; she knew how to compose the image in her mind's eye, turn the lens in relation to the scene, and let the play among shapes speak for itself. Her sense of subjects positioned relationally in space aligns her with other modernists for whom "one of photography's fascinations has been to propose psychological connections between forms and figures in space." The gaps between the shapes defined by the varieties of grillwork in her Paris photographs, for instance, attest to her feel for spatiality—both the shifting dynamics of inside and outside, and the gaps between figures in relationship.

One wonders how Man responded to Lee's outdoor shots, found as she

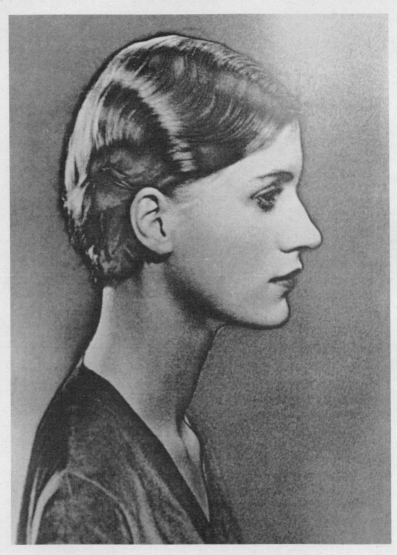

Lee solarized, c. 1930 (Man Ray)

strolled around Paris in search of surprises. She may have reflected on the difference between working outside and in the studio's controlled atmosphere while printing Man's portraits, including the many studies of her own person. Perhaps the relative absence of the human figure in her early work (hands and feet stand in for bodies) was not accidental. Photographing the nonpersonal, the other-than-human, would have offered relief from Man's use of her as his material, just as controlling the distance, angle, and composition may have reversed feelings of complicity she experienced as his subject at a time when she was struggling to establish herself.

Their discovery of a mysterious technique in some ways illustrates their symbiotic, yet conflicted, relationship. While printing one day in the tiny darkroom, Lee turned on the light, forgetting that twelve negatives—nude studies of a sensational blond singer named Suzy Solidor—hung in the developing tank. Fearing that the work was ruined, she turned off the light and called Man, who barely curbed his anger. Since it was impossible to redo the session, Mlle. Solidor having left Paris, they plunged the negatives into the developer to see what would happen.

The result, a partial reversal of the blacks and whites, was startling. A delicate line detached Suzy's torso from the rest of the image. "The unexposed parts of the negative, which had been the black background, had been exposed by this sharp light," Lee recalled, "and they had developed, and come right up to the edge of the white, nude body." It was the first example of what she and Man would call "solarization"—a tribute to the charms of Mlle. Solidor (whose name means "sun giver") and a code name for their discovery. In the controlled experiments that followed, they exposed negatives for different lengths of time "so that you wouldn't lose too much of the goings-on in the shadow," Lee said, "or have the hair come out all despondent and gray . . . or melting." In time, they worked out how much overexposure was needed and learned to use "this quality of melting to enhance or give volume to the images." Yet solarization remained chiefly a matter of chance.

Once one gave up the idea of control, knowing that each solarization would turn out differently could be seen as an advantage. "You wanted to get different effects," Lee explained, and the approach suited some subjects more than others. In Man's 1930 portrait of Duchamp, one of a series of solarized portraits of artists, the fine line chiseling his friend's profile alludes to Duchamp's skill as a draftsman. "But somebody else's profile who was just as good-looking might have been completely coarsened by the technique," Lee remarked. Solarization worked according to its own laws. And despite Man's gradual mastery of it, material reality kept reasserting itself in the form of accidents, some more pleasing than others.

The female body could be approached afresh from this perspective. The subtle "goings-on" in the shadows, the "melting" quality enhancing its vol-

umes, gave the nude greater dimensionality, and the silvery aura emanating
from the body externalized its inner life. One day Lee and Man photographed
a naked model as if she were asleep in midair, then solarized the result. The
print's floating quality became emblematic to the Surrealists, who courted
such states of being. Man's title, *Primat de la matière sur la pensée,* gives pri-
macy to matter over thought—perhaps an ironic gesture since the solarized
line surrounds and contains the naked body. It was the sort of joke that devel-
ops in intimacy. Decades later, Lee wondered which of them should take
credit for the image. "I don't know if I did it but that doesn't matter," she
remarked. "We were almost the same person when we were working."

In the next few years, as Man used solarization to turn bodies into dream
anatomies, Lee remained his favorite subject. The technique stood for her
presence in his life. His inclusion of her solarized profile in his autobiography,
Self Portrait, connects her to the rebirth of creative energy he experienced in
the 1930s, when solarization was hailed as an invention that elevated photogra-
phy to fine art. In this famous image, her "good" profile is delineated by a black
line that softens as it moves out from her body, paradoxically suggesting both
the emanation of her energy and its containment. "In either case," notes a
critic, "her body and the solarization process join forces here with the result
that Miller's flesh becomes essential to the rhetoric of Man Ray's invention."

If her body was essential to his creative vision, Lee's lips remained an
emblem of her power. Greatly magnified and on their own in another solariza-
tion, they pursued him, Man wrote, "like a dream remembered." The image
held still other meanings: lovers entwined, but also the engorged genital lips.
One wonders to what extent Lee, whose sexual repartee was often vulgar,
accepted Man's view of her—whether she saw such images as erotic puns or
as the latest version of familiar desires. (Or both?) Her solarized portrait of
Man shaving wittily compares his sudsy profile with her own, and in the
process, dissolves the pose's allusions to high art: the head turned as in Renais-
sance portraiture of notables. Here the noted photographer is trying to remove
the traces of masculinity, her portrait suggests—pulling his (invisible) leg in a
good-natured manner.

The enlargement of detail expanded the possibilities of photography, Man
believed, by loosening the medium's ties to realism. What he did not say was
that it also allowed him to explore his obsessions. *Photographs by Man Ray,* his
1934 retrospective in book form, includes a solarized image of calla lilies, one
of several taken while living with Lee. The lilies' formal beauty is enhanced by
the artificial light and the process of solarization: isolated on a pale back-
ground, the lilies resemble so many white, nude bodies. It does not take much
imagination to see in the form of the pistil emerging from the flower another
sexual metaphor, nor is the French word for *lily* (*lys,* to an American ear pro-
nounced like *Lee's*) coincidental. Like the image of her lips, Man's lilies spoke

covertly of his desire—of the fusion of energies he simultaneously feared and yearned for.

What Lee made of this photo one can only guess. Horst's portrait of her holding a sprig of lily of the valley had made her laugh. Man's allusions to her in the calla lily series may have given her pause. Much later, she recalled that in the process of solarization, "the background and the image couldn't heal together. . . . The new exposure could not marry with the old one." Metaphors often say more than is intended. Photographic development resembled psychological growth, but in neither had the healing taken place that was needed for "marriage," or wholeness.

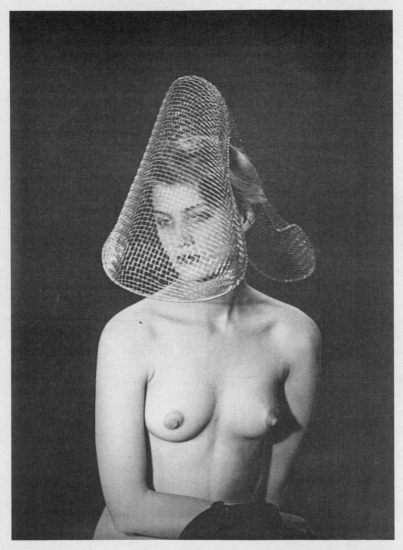

Lee as "la femme surréaliste," *1930 (Man Ray)*

Chapter 6

La Femme Surréaliste

(1930–32)

Lee began the decade by moving to a duplex that was larger and more luxurious than Man's. He may have hoped that with this new arrangement, their bond would deepen. He had respected her wishes by helping her find her studio, and since it was just a few minutes from the rue Campagne-Première, they could go on living and working together. The move was commented upon at the Coupole once they were seen walking back and forth between Man's studio, their daytime headquarters, and Lee's, where they spent nights together.

Her building still stands opposite the Montparnasse cemetery on the rue Schoelcher, a street lined with artists' studios whose façades range from curvilinear Art Nouveau to the streamlined Art Deco of her own, at the corner of the rue Victor Considérant. Coming from Man's, they went past the concierge's loge into the courtyard, where a white parterre and cobalt-blue tiled fountains create the geometric look of the period, before taking the tiny elevator to Lee's duplex. Together, they hung one wall with gramophone discs set like bright lozenges against the diagonals of the wallpaper and others with silver panels to reflect light. They set Man's handmade lamps on pedestals, turned a carpenter's bench into table, and hung spectrum curtains. As a fin-

ishing touch, Man placed a hanging based on a Cocteau sketch behind the low, spacious bed. The look was "moderne" with a difference—"he liked the effect of the shimmering light and the changing as you moved about the room," she recalled.

How did Lee respond to having a place of her own, albeit one that had been found, decorated, and perhaps leased by her lover? (The record does not say whether Theodore paid the rent, or Man, or whether Lee earned enough to cover expenses.) "You should have seen my studio in Paris," she told a reporter, adding that she had decorated it herself.

Lee's architectural studies from this period focus on her building's spare geometry. Almost constructivist in their emphasis on form, they convey her feeling for the play of fullness and void, interior and exterior. In one, a canted view from an upper story plunges us down into the tiled courtyard while at the same time patterns made by the parterre, the quoins at the building's corners, and the shadows thrown onto the balcony complicate our orientation. Depth is simultaneously suggested and denied; perspective is diminished by the diagonal lines leaning outward in opposite directions. It is hard to say where we are.

A companion image looking out one of Lee's windows seems more conventional. Pattern does not flatten space as dramatically; the angle of vision seems straightforward. Yet the gaze is blocked by the background: the opposite wall and another window, itself impenetrable. What looks like a familiar device—a window used as an internal frame—contains a reverie on what can and can't be seen through such an opening, where the ironwork separating the small panes inside the frame segment the composition.

The most atmospheric of these formal studies, a shadowy image of a walkway topped by the alternating darks and lights of an ironwork railing, similarly complicates the contest between surface and space that is the hallmark of modernist photography. The eye, disoriented by the deep shadows, darts about in search of an exit, but is unsure which way leads out. The brooding quality and the railing's delicate tracery recall Atget, as if she had absorbed his aesthetic into her new perspective.

Not all of Lee's Paris photographs are unsettling. An image of rattan chairs plays their interwoven darks and lights against the shadows they cast on the pavement; in another, the Eiffel Tower becomes an overlap of metallic circles and spokes. These early photographs surprise the viewer with familiar shapes seen out of context or from odd angles—as if for the first time.

∞

Lee's spirits improved once she moved to her studio, Jacqueline Barsotti observed. She often strolled down the Boulevard Raspail to the Coupole and made her way to the bar, where Kiki's group clustered in the musky atmo-

sphere of American cigarettes, turpentine, and perfume. But despite her over-
tures, the group did not warm to her. Kiki's friends crowded together on the
banquette to dissect the latest exhibitions and love affairs, but when Lee
walked in, conversation ceased. While the usual response to a new arrival was
to squeeze together more tightly, they never made room for her. Lee did not
grasp the codes of bohemia, nor did it occur to her to buy drinks for all—
although (they thought) she could afford to do so. "What was hers was hers
alone," Jacqueline observed much later.

Kiki's circle resented Lee's "American" qualities, but Jacqueline—herself
something of a *"femme moderne"*—found them fascinating. A statuesque
beauty with a mane of blond hair, Jacqueline had modeled for her father
before being discovered by Montparnasse. Foujita and Kisling had painted her
portrait; Man photographed her with her hair streaming out behind her like a
blaze of light. She was considered a *lionne*—a woman who sets the style—
despite her chaste home life. A regular at Jules Pascin's costume parties, where
guests disported in states of undress, Jacqueline lived with her mother. Man
flirted with her during sessions, but behaved respectfully: the reputation of a
jeune fille had to be maintained—even in bohemia.

Jacqueline's status changed after she fell in love with a painter, and Kiki's
circle adopted her. As a member of this closely knit group, she criticized Lee's
arrivisme while studying her modus operandi. Lee made use of her beauty,
Jacqueline thought. "A phenomenon, even in Montparnasse," she asked for
and was given the clothes she modeled, the photographs she sat for, the recog-
nition she craved. Calling on Lee one day in her studio, Jacqueline found her
filing her nails. When she admired her manicure kit, a large box with a hun-
dred colors, Lee did not offer to share her bounty; Jacqueline felt that she was
too self-centered to think of pleasing a friend. Pondering Lee's success years
later, she added, "Everyone had to please her, but she was never pleased with
herself."

Lee found her closest friend in the social circles to which, in Jacqueline's
view, she had always aspired. Tatiana Iacovleva, a Russian émigrée known as
Tata, resembled Lee both physically and temperamentally. A tall blonde who
"strode into a room like a tribal war goddess," Tata was the daughter of St.
Petersburg intellectuals who claimed descent from Genghis Khan. Her force
of character made others take her at her own valuation. Shortly after her arrival
in Paris in 1925, she began posing for hosiery ads that showed off her long legs,
then modeling for *Vogue* under Huene's direction and declaiming Russian
verse with Elsa Triolet, Man's neighbor. Tata soon acquired legendary status
among the émigrés as Mayakovsky's muse. The Russian poet had fallen in love
with her during a trip to France and tried to take her back to Russia. Tata's
refusal to leave, some said, had been the cause of his suicide.

Like Lee, Tata caused a stir when she entered a room. A tale went round

Paris about the night when, finding herself across a crowded bistro from her friends, she walked the length of the room on the tabletops to join them. It was the sort of thing that Lee did, and admired in someone brazen enough to carry it off. Soon people pointed to Lee and Tata as the two most beautiful women in Paris. Though one wonders how each coped with the other's need to be the center of attention, they became friends. What Tata wanted was a title—a goal she achieved by marrying Bertrand du Plessix, the son of a French viscount. What Lee wanted was less clear. It involved not marriage but recognition by the overlapping worlds of art, fashion, and privilege she shared with her counterpart, the Russian "phenomenon."

In this sense, Frogue had more to offer than the Coupole. Huene's friend Solange d'Ayen, the fashion editor, brought to the magazine her prestige as the duchesse de Noailles. The duchesse handled temperamental couturiers and socially prominent models with the same courtesy. When Huene blew up at Horst in photographic sessions she took the young man to a café to sip champagne and discuss German poetry. Staffers said that she spent her life trying to make people forget her title.

In these years, the bolder members of the French aristocracy mixed with artists and writers. The new social rites—costume balls, experimental films, artistic soirées—thrown by this privileged group were regularly reported in Frogue, whose photographers were welcome at such events provided they dressed properly. Huene was at ease everywhere. After learning the Black Bottom from Bricktop, he taught it to his circle, who then rushed to see the lighting Huene designed to set off the red and black decor of Bricktop's new club. It became the fashion for young French aristocrats to meet there, at Le Boeuf sur le Toit, when Kiki was singing, or to create their own versions of the amusements found in such places.

It is easy to see why *le gratin révolté* (the rebellious upper crust) liked to rub shoulders with the avant-garde—Man Ray, Cocteau, Schiaparelli, Chanel, the dancer Serge Lifar, and the illustrator Christian Bérard. They were the stars of a new universe. While prestige and pleasure motivated this group's enthusiasm for private spectacles, some adhered to the old idea of patronage. The alliance between visionary artists and progressive members of society produced entertainments whose brilliance was made more poignant by their brevity, since each performance lasted just one night. And if some members of the aristocracy had doubts about their appropriateness in depressed times, for most, occasions for the display of wit and imagination were their own raison d'être. Hosts vied with one another in devising themes. Guests were to dress as Louis XV's courtiers or, for the Bal Proust, as characters in the book that dissected their class. They might be told to come as someone famous—politicians, writers, one another—or "as you were" when the hostess's limousine arrived at the door.

Man's entrée into French society had come through his success as a pho-

tographer. The Count de Beaumont, one of his first patrons, invited him to photograph his guests and said to wear a dinner jacket so that he would not look "professional." This evening led to invitations from the Comtesse Greffulhe, one of Proust's models, and the vicomte and vicomtesse de Noailles, Charles and Marie-Laure. (At Marie-Laure's futurist ball, Man photographed her sharkskin gown while guests in silver spacesuits glared at his outfit: a clothes bag with holes for his limbs and a cap topped by a propeller.)

Unlike Huene, whose background paralleled theirs, Man was never comfortable with these wealthy eccentrics. For Marie-Laure's 1929 Bal des Matières, guests were to devise clothes made of materials like cardboard, straw, raffia, or cellophane. The writer Maurice Sachs arrived in a suit of pebbles (uncomfortable when he sat down), the publisher Paul Morand wore Gallimard book jackets, Huene's friend Nimet Eloui Bey, a Circassian beauty, dazzled everyone in a robe made of triangular pieces of mirror, which *Vogue* featured the month before Lee made her début in its pages.

In June 1930, three years after Condé Nast introduced Lee to café society, Man introduced her to high society at the most beautiful soirée held that year—the best costume-ball season, all agreed, since before the war. The 1930 balls were "frequent, fast, and mostly foreign," Janet Flanner wrote in *The New Yorker,* and for this reason, represented "the true spirit of their time." Of these, the most ethereal was the Bal Blanc, hosted by Anna-Letizia Pecci-Blunt, the niece of Pope Leo XIII. The Pecci-Blunts asked their guests to wear white, to match the décor. Man was enlisted to do the lighting and film show, with Lee as his assistant.

The ball took place in the formal gardens of the Pecci-Blunt residence. Since everything was white—including the dance floor constructed on a platform over the pool and the outdoor stage—Man decided to use the scene as a backdrop on which to project images, including some hand-colored film by the French cinematographer Meliès, which he had found at the Paris Flea Market. He and Lee practiced throwing random frames on a sheet, and a few days before the ball set up a 35-millimeter projector in a room overlooking the garden. Taking care to appear more soigné, Man wore tennis whites and helped Lee select her outfit, a tennis dress and shorts by Mme. Vionnet, who often lent her clothes as a means of free advertising.

The evening was magical. Imagine a spacious garden lit by hundreds of lanterns and filled with pale, graceful figures gliding on the surface of a white platform. Upon this scene Man and Lee threw images, first the hand-tinted Meliès scenes, then a sequence in black and white. The effect on the white costumes was "absolutely stunning," Lee recalled, but it shocked some of the participants, on whose limbs "rude letters" suddenly appeared. "You'd reach up and grab an 'e' or an 'i,'" she added, while people tried to decipher the messages from on high.

Guessing the identities beneath the disguises was less difficult than read-

ing the moving script. Arthur Rubenstein was recognizable as an oriental prince, the Baroness Rothschild and friends as the Empress Eugénie and her court. The most memorable costumes appeared later, when five guests resembling statues appeared. This mock-classical *tableau vivant* grouped Marie-Laure, the Prince and Princess Faucigny-Lucinge, Princess Nathalie Paley, and the couturier Lucien Lelong in white masks and wigs devised by Cocteau and Bérard. Their entrance was deemed a success, especially when the group plunged into darkness as the lights went out.

But from Man's perspective, the evening was a disappointment. Lee spent most of the time on the dance floor. "I was pleased with her success, but annoyed at the same time," he recalled, "not because of the added work, but out of jealousy." Man's account is more telling than he knew. "As the night progressed," he continued, "I saw less and less of her, fumbled with my material and could not keep track of my supply of film holders. I finally ceased taking pictures, went down to the buffet for a drink, and withdrew from the party. Lee turned up now and then between dances to tell me what a wonderful time she was having; all the men were so sweet to her." It annoyed him to watch her début, made, in a way, at his expense.

Man had another reason to be jealous that spring, when Lee agreed to act in Cocteau's new project, a film to be called *La Vie d'un Poète*. One night at the

Enrique Rivero helps Jean Cocteau paint eyes on Lee's lids for The Blood of a Poet.

Lee in The Blood of a Poet

Boeuf sur le Toit, the poet stopped at their table and asked if they knew any-
one who wanted to take a screen test. Having toyed with the idea since child-
hood, Lee said that *she* did. Man disapproved (the Surrealists condemned
Cocteau's politics along with his ingratiating ways), but thought it best not to
oppose her. Her test went well. She had the look Cocteau wanted for the
Muse—as if she had just stepped out of the Grecian tableau at the Bal Blanc.

Moving pictures were as much in vogue as costume balls among the aris-
tocracy, who were then agog about the presence in Paris of Louise Brooks. It
didn't matter whether the films they sponsored were commercial. As in the
weeks of preparation for a ball, the important thing was to work closely with
artists like Cocteau or Man Ray. Charles de Noailles, whose ballroom housed
a private theater, had lured Man back to filmmaking in 1928, when he pho-
tographed the viscount's guests performing mysterious rites at his home in
Provence. (The film, *Les Mystères du Chateau de Dés,* combines Mallarmean
ideas of chance with shots of gymnasts in striped swimsuits.) But despite de
Noailles's enthusiasm, Man declined his offer to back another film. In 1930,
the viscount embarked on two different projects, the first with Luis Buñuel,
the second, a "talkie," with Cocteau. Regret over his decision to forgo film-
making may have tinged Man's fury at Lee: she would be working closely with

the Surrealists' bête noir at a pastime that he, Man, had abandoned in order to spend more time with her.

Lee went ahead with her plans nonetheless. Each day at the film studio brought surprises. The mattresses lining the walls to keep out sound were full of bedbugs, which fell onto the set and bit the actors. The crystal chandelier, an important part of the decor, arrived in three thousand pieces and had to be assembled by hand. The script changed daily to accommodate the accidents of production. Enrique Rivero, the Brazilian who played the poet, had a scar on his back ("He'd been shot by his mistress's husband," Lee explained), which Cocteau covered with one of his trademark stars. When Féral Benga, the black dancer who played the angel, twisted his ankle, Cocteau declared him a limping angel. The director "liked it better that way," she added, "but people have read all kinds of things into it." Cocteau believed in working with chance: when the cleaners began sweeping up the studio, he told the cameraman to film the last scene through the dusty light.

Cocteau's talent for improvisation was less obvious in relations with the crew. "Elegant, shrill, and dedicated, [he] knew exactly what he wanted," Lee recalled. "He electrified everyone who had anything to do with the film." Few understood what it was about, however, except that the images showed where poems came from. In the first scene, the poet stands at an easel and draws a face, whose mouth starts to speak, then takes up residence in his hand. After a charged autoerotic moment—he uses the lips to caress his torso—the poet transfers the mouth to the plaster statue that comes to life as his muse, Lee's part. Like the Venus de Milo, she lacks arms yet sends him on a voyage through a mirror and into the hotel of "dramatic follies," where he observes a series of nighmarish scenes before returning to his room to smash the statue. The muse reappears as a woman in evening clothes at a card game played before a group of well-born spectators. In the final scene, she reverts to her former state and glides away while the poet's stand-in bleeds to death on the floor.

Whatever ambivalence Lee may have felt about the sinister side of her role she kept to herself. She had more to say about its discomforts: "My 'armor' . . . didn't fit very well: they plastered the joints with butter and flour that turned rancid and stank." To make her garments cling to her body, she was covered with a pomade that cooked under the lights. Cocteau painted dark eyes on her lids to turn her face into a mask and made her walk with her eyes closed, to give her performance a trancelike feeling.

The Blood of a Poet, Cocteau's definitive title, is a classic often seen in film courses. To us, it is an evocative period piece, an example of creative cinema on the theme of artistic identity. To Cocteau's peers, the film was either a revelation or a clever appropriation of avant-garde motifs. "It was the remarkable *Sang d'un Poète* that showed me that cinema could exist in Europe," Charlie

Chaplin told Cocteau. To de Noailles, the title of the last section, "The Profa-
nation of the Host," struck an irreligious note, especially since Cocteau had
edited the film to show him and his friends applauding the death of the boy on
the floor beside the card players. Cocteau reshot these scenes at the viscount's
insistence.

To the Surrealists, the film remained a scandal, though for different rea-
sons. From their perspective, Cocteau had used Surrealist motifs—chance,
dream states, the descent to the unconscious—in a pale imitation of their
efforts to subvert society. Man had particular reason to take offense—had he
not painted false eyes on Kiki's lids four years earlier in his *Emak Bakia?* Worse
yet, Lee had gone along with Cocteau's use of her as *his* material. From Man's
perspective, her "armored" torso belonged to him. "You don't lend out your
mistress, do you?" he remarked on another occasion.

For Lee, the decision to dispose of her talents as she pleased was liberat-
ing, as if she too had gone through a looking glass to a place where all the ele-
ments of art flowed together. She had not betrayed Man in lending herself to
Cocteau's vision. Rather, she had taken part in something that transcended
the merely personal. "In a state of grace," she wrote years later, "we partici-
pated in the making of a poem."

∞

Man was annoyed with Lee for yet another reason. About the same time that
she began work on *The Blood of a Poet*, she was collaborating with him on a
project that was half erotic play, half home movie. This film, to which he gave
the title *Self Portrait*, remained in Man's possession until his death. Its
themes—identity, improvisation, the relations between artist and muse—
resemble Cocteau's, yet are treated quite differently, except that both artists
assumed their right to the muse figure as their material.

In this context, Man's anger at Lee's disloyalty is understandable. Their
relationship was the most important of his life. Too reserved to entrust to
words the feelings she aroused in him, he expressed them instead in the
dreamlike sequences of his private cinema, where the female's dual role as
stimulus to the imagination and the means of its expression links a heightened
sexual charge to artistic innovation.

Before meeting Lee, Man had made Kiki's sexuality a central element in
his scenarios. Light reflected from a window in *Le retour à la raison* (1923)
caressed a headless torso—Kiki's—with shadowy stripes; the sequence of
sleeping beauties in *Emak Bakia* (1926) ended with Kiki's eyes opening to show
the second pair on her lids. In *L'Etoile de mer* (1928), inspired by Robert
Desnos's poem on an artist's meeting with a *mystérieuse*, she played the myste-
rious woman: Man's fears about Kiki's role in his life—she left him after the

film's completion—are reversed in the hero's dismissal of the woman. Yet anxiety about the female sex pervades *L'Etoile de mer* in the recurrent image of a starfish, whose predatory ways evoke that queasy male myth, the vagina dentata. Man said that he had abandoned film in 1929 because with the advent of sound, it needed serious backing. What he did not say was that Kiki's desertion removed the impetus from his engagement with the medium.

About that time, Man's feelings found expression in fantasies from which much may be gleaned. In 1928 Breton invited the Surrealists to a series of discussions entitled *"Recherches sur la sexualité"* (research into sexuality). The participants (mostly male) pondered such things as female orgasm and whether it mattered (Breton said it didn't), the number of orgasms achieved in a session (counts varied from two to twenty-seven), masturbation, impotence, and the relations between sex and love. Man joined Breton, Aragon, Boiffard, and the writers Benjamin Péret, Jacques Prévert, and Raymond Queneau at the second session, where voyeurism, homosexuality, fetishism, and sadomasochism were addressed. He kept quiet until Breton asked the group which sexual positions they preferred. Man said that he had no preferences, but added in an afterthought, "What intrigues me most is fellation of the man by the woman, because that's the thing that has happened to me most rarely."

Man said little until the group began recounting their sexual memories. He confessed that as an adolescent he had tried to penetrate "a little girl of ten" to whom he had promised a picture book "if she would show me her sex." The attempt failed when she complained that he was hurting her. His younger brother, who accompanied him, was more successful; the girl preferred him to Man. For those who knew how to listen, he had said enough. The conjoining of sex and pictures, of intercourse, pain, and failure, and of the wish for the thing that most intrigued him would be replayed in the private language of his objects, photographs, paintings, and cinema.

The following year, Man collaborated with Péret and Aragon on a pornographic book entitled *1929*, to which he contributed four images—one for each season—of a couple making love. Péret, a militant anticlerical, began the year with a poem in praise of "little girls who lift their skirts / and diddle themselves in the bushes." He extolled each sex's genitalia and the minor perversions before ending with an orgiastic vision of Parisians, animate and inanimate, engaged in rampant fucking—the baker's wife replaces him with a baguette while the Eiffel Tower buggers the Trocadéro. Since the speaker presented himself as a well-endowed cocksman, Man's photo for Spring shows a male torso positioned on top, the better to display his equipment.

Visually, things heat up in the second half of the year. Inaugurating Summer, Aragon's fairy tale for adults invokes full autonomy for *"la belle et la bite"* ("beauty and the prick"). These sexual parts come together in every possible location—"in a confessional at the Church of Saint Augustine . . . / before the

eyes of a boarding school for young ladies . . . ," and in the full-scale orgy that ensues, where multiple couples enjoy fellatio in a profane version of the sacrament. This Bosch-like fantasy is introduced by Man's image for Autumn, a startling close-up of the woman's heavily rouged mouth performing the thing that, for Man, happened most rarely.

That autumn *1929* was printed in Brussels, then seized at the border in December due to its pornographic, anticlerical, and generally antisocial nature. The image for Winter depicts the darker aspect of taboo sex, buggery of the woman. The couple cannot be identified, but given the dates, it is possible that Lee posed for these pictures, which were taken in mid-1929—soon after the start of her liaison with Man. If this is the case, his obsessive interest in her rouged lips takes on yet another layer of meaning.

Lee *is* recognizable in *Self Portrait,* Man's erotic home movie begun about the same time and destined, presumably, for an audience of two. The fragment's alternative title, *Ce qui manque à nous tous (What We All Lack)*, hints that what "we" all wish for is the activity featured in Man's image for the Autumn section of *1929.* After setting the scene in his studio, Man filmed Lee lounging naked in bed—blowing bubbles through a long-stemmed pipe. Next, he passed the camera to her, put the pipe in his mouth, and began blowing smoke into the bubbles, which swell and explode. Visibly excited, he exposes himself to her, and to the camera. In another sequence, they trade the camera back and forth in an erotic peekaboo. Man spies on Lee as she removes the covering from a large object, Brancusi's *Princesse X*—a sculpture known for provoking rude comments, since despite its title it resembles an erect penis. Following Man's directions (or improvising?), Lee caresses the sculpture and smiles, baring her teeth.

A few years later, Man gave solid form to this suggestive image—a ceramic pipe with bubble attached—to which he also gave the title *Ce qui manque à nous tous.* Although he often exhibited this object, he never mentioned its earlier, cinematic version, or his collaboration on it with Lee. Like her red lips afloat in *Observatory Time,* the pipe symbolized an aspect of their relationship—in this case, her sexual daring. His collaborator in more ways than one, she too enjoyed indecent images and lewd language. Man would have learned from Kiki, and Lee from him perhaps, the slang meaning of *pipe* and the infinitive, *piper—fellatio,* or, to put it vulgarly, a blow job. The most telling thing about Man's cinematic self-portrait is not that it stages the woman's reverence for the penis but that she appears to share his fantasy.

Despite Man's declaration that one did not lend out one's mistress, he was not averse to enlisting Lee in the staging of other people's fantasies. He introduced her to an American named William Seabrook, then enjoying some notoriety in the press. Seabrook's interest in the exotic—he had described what purported to be experiences of voodoo and cannibalism—extended to unusual

sexual practices. He appointed Man his agent in dealings with the Surrealists, who hoped to publish photos of his African masks, and suggested costumes for the models in their photographic sessions. These included high heels, a black leather mask for the head, and a priest's outfit concealing "a wasp-waist hour-glass corset finished either in some glittering fabric that looks like polished steel, or in black leather-like material to match the mask." After locating these items, Man took a series of shots to suit Seabrook's taste for pictures of the women he hired as sex slaves—with the resigned acceptance of his wife, Marjorie Worthington.

Seabrook was so pleased with Man's grasp of his fantasies that he asked him to design a high silver collar for Marjorie. Man outdid himself. The collar, hinged so that the wearer had to keep her chin up and studded with silver knobs, looked more like a choke collar than a piece of jewelry. Man photographed both Marjorie and Lee wearing the collar—Marjorie looking like an angry schoolmistress, Lee positioned below Seabrook with her eyes closed. At one level it was playacting, but at another, Seabrook's penchant for keeping women in chains made Man feel awkward, especially when he took Lee with him to babysit for one of them in the Seabrooks' hotel. The young woman, naked except for her loincloth, was to eat on the floor, Seabrook explained. Room service would bring whatever they wanted.

When dinner came they freed her, invited her to dine with them, and listened to her tales of kinky clients. Lee told Man that she knew about such things, having met a man who liked to whip women. "It was nothing new for her," Man recalled. "Nor for me either. I had whipped women a couple of times, but not from perverse motives." While Man recognized Seabrook's penchant for fetishism, he may not have understood his own.

Man's images of women bound, constrained, and missing their heads or other body parts bespeak his motives nonetheless. One of these was the exercise of power over his models. One day he asked Lee to pose for him with a new prop, an orthopedic mesh cast designed to immobilize the arm and shoulder. Knowing his habit of cropping negatives, Lee undressed to the waist, put her arm in the metal cast, and glared at Man. He had her pose for other pictures with the cast placed over her head like a mesh veil, to soften her expression. This series shows none of the quality of touch that informs his best portraits. Rather than intimacy, it registers the discord implied by the prop: another piece of metal jewelry, or armor, that restrains while protecting.

Like other men excited by the idea of lesbianism, Man had long been intrigued by scenarios with several women. Soon after his arrival in Paris, when a meeting with the couturier Paul Poiret led to a visit to the mannequins' quarters, he watched "beautiful girls with every shade of hair from blonde to black, moving about nonchalantly in their scanty chemises." Man longed to photograph them but they seemed "cool, almost forbidding." A few weeks later, he talked a model into bringing a friend to pose with her—explaining

that he wished "to make some compositions for myself that had a little more variety." The women understood perfectly. "At my suggestion," he went on, "they took some intimate poses with arms around each other, making for rather complicated anatomical designs."

He may have been thinking of such designs when shooting another home movie at Lee's studio a few years later. He called it *Two Women*—hinting at a lesbian theme through his use of Gertrude Stein's title for her word painting of close female relationships. But unlike Stein's portrait, Man Ray's *Two Women* is pornographic. The women strike the kind of intimate poses thought to titillate a male audience. One stimulates a dildo, recalling Lee's caress of the Brancusi sculpture in *Self Portrait*; in another sequence, the women smile knowingly while taking positions for oral sex.

It is likely that Lee helped Man during the filming of *Two Women*, since the action takes place on the bed where she and he slept together. About this time, Man also photographed her mouth to heavily lipsticked mouth with another woman. It may have been exciting to capture such scenes from the other side of the camera. Perhaps she enjoyed seeing through masculine eyes.

Man's interest in female intimacy would also have been piqued when Tanja returned to Paris in 1930 to live with Lee—an arrangement that meant living with him as well. Tanja found work as a model and had her hair cut short, a coiffure that set off the gowns she wore on the runway and borrowed from the couturiers. Man would have been stimulated by the sight of these beautiful girls moving about the studio in their chemises. They posed for him dressed and coiffed alike. At one session, each wore the same satin gown with her hair parted in the middle and eyes heavily shadowed—like two priestesses of an obscure cult, two *belles dames sans merci*. Man left this portrait of Tanja unretouched, but traced lines across Lee's forehead, nose, and chin, as if defining his control over her features. A more informal study of the two young women dwells on their closeness—posed with their torsos spoon-fashion and hair sleeked back, they face the camera like complementary visions of the *garçonne* whose ambiguous allure inspired Man's fantasies.

Tanja had brought news from home. The Depression had dampened everyone's spirits, yet some were thriving despite the economy. Alfred De Liagre was making his mark on Broadway. Margaret Bourke-White, who had become famous overnight with her industrial photographs for the new glossy, *Fortune*, was having an affair with De Liagre's father. Condé Nast had lost much of his fortune in the crash, but found happiness with his young wife and their baby; Neysa McMein, having married, now spent less time riding elephants and more in her Long Island retreat.

Lee's parents, still comfortable despite the crash, were preoccupied with

their health. In accordance with the diet advocated in Dr. William Hay's *Health via Food,* they ate only certain foods at each meal. They also made regular trips to Dr. Hay's sanatorium in the Poconos and underwent colonic irrigations in the hope of increased vigor. Florence recommended the diet to Lee even though she was unlikely to follow it in France, and sent her a copy of *Health via Food*—which told readers to avoid wine and worry.

Lee's brothers were following their respective paths. John, based in New Jersey, was an aviator at Teterboro Airport, where Lindbergh kept his plane; he often helped him bring it out of the hangar. (John would soon make the first cross-country flight in an autogiro, a precursor of the helicopter.) While still at school, Erik had helped his brother rebuild a wrecked plane formerly owned by a flying circus—a pastime that interested him more than his studies. At twenty, Erik planned to start as a freshman at Antioch, despite John's opinion of the college, but before settling down, to enjoy a visit to his sister—a gift from Theodore.

On his way over that summer, Erik fell in love with a lively brunette named Frances Rowley, known as Mafy, who planned to join him in Paris after her European tour. Toward the end of July, Lee and Man drove to meet Erik at Le Havre in Man's car; the oak-framed Warsaw sedan made as great an impression on the exuberant young man as his first French meal. Although Man decamped to the rue Campagne-Première while Erik stayed with Lee, Erik understood that they were lovers.

Like his sister, Erik was more interested in photography than in art. He was thrilled when Man demonstrated his recent inventions, a primitive tripod that was raised and lowered with a crank, and an improved version of his photoflood prototype—controlled with a rheostat to avoid burnout and arranged in banks to turn at different angles, which cast multiple shadows, like overlapping waves. Watching Lee develop Man's negatives or replace him on assignments, he saw that his sister had become a highly competent professional.

One day she took Erik to lunch with Huene, to his eyes the epitome of sophistication. When they ordered champagne, Erik was surprised to see the baron cut a piece of cheese into cubes and drop them one by one into the glass, to banish the bubbles—apparently without harming the champagne. They went back to the *Vogue* studio, where Huene photographed Erik, then brother and sister in a relaxed double portrait. Mafy met Man and Lee when she arrived in Paris. He seemed rather old and serious for a woman of twenty-three, she thought, but said nothing at the time.

Man and Lee often went their own way socially. Her friends from New York visited when in Paris. Henry Rowell, one of the Yale men, passed through in September on his way to an archeological dig. When Tanja met him at the door wearing red silk pajamas, she made such an impression that Rowell spent the

rest of his time with her; they planned to marry after his return from Syria. That autumn, Huene introduced Tanja to the Russian émigrés, who were pleased to act as escorts for an engaged model. Tanja went out with Tatiana Iacovleva's friend, the decorator Zizi Svirsky—a concert pianist whose nerves kept him from playing in public. Svirsky in turn introduced her to Aziz Eloui Bey, an Egyptian aristocrat with an eye for spirited women. His wife, Nimet, the languid beauty who sometimes posed for Huene, had caught movie fever. (Nimet obtained a screen test with Ernst Lubitsch, but having calmed her nerves with a number of drinks, ended her film career before it began.) Tanja visited the couple at their villa, and one evening, brought Aziz to Montparnasse to meet Lee—who

Lee with and without makeup (Hoyningen-Huene)

asked after he left what Tanja saw in him.

That autumn, while Lee worked on the final scenes of Cocteau's film and did occasional fashion shoots, Tanja began modeling for Frogue. Her piquant looks suited the new fashions. (The caption beneath her image in the November issue notes her "youthful charm" in a Chanel gown.) Huene photographed Lee and Tanja together for a feature on the art of makeup. "Every woman can be the artisan of her own beauty," it began. To illustrate this claim, Huene shot each of them with half her face made up and half untouched—the fair and dark versions of "refined womanhood." In October, de Brunhoff ran a feature on Cocteau's film, with photos of the poet painting false eyes on Lee's lids and of the controversial last scene. He selected a photograph of Lee for the editorial page, as if she typified his ideal, "the difficult art" of elegance.

A woman who is photographed often may look with detachment on images of the female form. In reaction to her years of modeling and Man's obsession with her person, Lee took few self-portraits. One day in her studio she draped a dark scarf around her neck to contrast with her light blouse and the darker background. After setting the shutter release, she sat opposite the camera, looked to the side and, at ease, took her picture. This reflective self-

portrait must have pleased her: she signed it in French, "Lee Miller *par* Lee Miller"—not, for once, by someone else.

Given her close collaboration with Man and his continuing influence, it is instructive to compare Man's portraits of Tanja with Lee's during the time of their ménage à trois. In one, Man shot a tight close-up of the young woman with her hair flowing back from her head and solarized the negative, making her one more in a series of solarized women. Lee took a different approach. She enveloped her friend in a large swath of fabric, arranged the lighting to deepen the shadows, and took the picture of her head and torso from below. The result shows a woman lost in thought, troubled, perhaps, by her dark reflection.

Lee asked Tanja to sit for her again. The pose she had in mind was unusual—quite possibly an idea devised with Man, since Lee's sketches for the pose were found among her papers. Tanja was to stand behind a chest of drawers on which were placed a volume and a bell jar. Only her head would be visible. After putting her chin on the book, Tanja closed her eyes and waited while Lee photographed her behind the bell jar. The pose made her uncomfortable; the result, more so. Her head seems to float in the glass container like a specimen, something captured on an expedition. In another shot from the same session, the eerie quality is enhanced by the blindfold placed around her eyes: the woman can be seen but cannot return the gaze. Her encased head, which has Sadeian overtones, became another in the series of images—like Lee's lips—to which Man would return and make his own.

In the meantime, Man met regularly with the Surrealists, whose complicated schisms were fracturing the movement. That year, Breton purged twelve of his apostles for failing to toe the party line. While Man kept his distance, he supported Breton's attempt to align Surrealism with the Communist International in his new magazine, *Le Surréalisme au service de la révolution*—a mixture of "paranoia criticism" by Salvador Dalí, anticlerical and antisocial poems by Aragon, Eluard, and Péret, images of women (hysterical or ecstatic) from postcards and movie stills, homages to such diverse writers as Lewis Carroll and the Marquis de Sade, and Man's latest photographs.

The inaugural issue, appearing in July 1930, featured Breton's declaration of solidarity with Moscow. His second contribution, a Surrealist fable entitled "Once upon a (Future) Time," seemed to contradict the first: it pledged the movement's fealty to the imagination, in his view a vast mental palace where visions arise to "lead the world forward." Breton imagined this palace as a chateau outside Paris where men could come and go at all hours and where *jeunes filles* who had "distinguished themselves in some scandal . . . or by the

strangeness of their spirit or beauty" were invited to live, although sexual activity was forbidden. Like so many storage batteries, these girls were the raw material for creativity. To illustrate the fable, Breton ran Man's photo of Lee's head in the orthopedic cast above a caption identifying her as one of the *jeunes filles*. The image implies her acquiescence in the role of stimulus to the male imagination—at a time when the idea of her "belonging" to Man heightened the tensions between them.

The magazine's October issue, an homage to Sade, would have fanned the flames of their disagreement. It included a letter by the marquis, essays on his work, and passages from Sade that, to the Surrealists, proved his stature as the seer of absolute freedom. Breton ran the photo of Tanja under glass as illustrative material, with the title *Hommage à D. A. F. de Sade* and the credit to Man. In this hyperexcited context, the photograph took on meanings that go beyond Surrealist fantasies about women's complicity in their own subordination. It hints at the woman's imprisonment, but also her decapitation: so much for females who tried to use their heads. Lee noted years later that her images sometimes appeared under Man's name. Whatever the nature of their collaboration, this use of Tanja's image made the point that it was meant to depict. Beautiful girls, however distinguished, were so much material for masculine fantasy.

In September, when the Sade issue of Breton's magazine was being put together, Man was still angry with Lee about her work with Cocteau, who was then completing *The Blood of a Poet*. It would have been some comfort when the movie was shelved after becoming entangled with the scandal that erupted over *L'Age d'or*, the de Noailles's other film project. This subversive classic provoked riots at its first showing—an outcome foreseen by Breton, who prepared inflammatory program notes and decorated the lobby with art by Dalí, Arp, Ernst, and Man. But the response was more than he bargained for. Right-wing gangs, the "Patriots' League" and the "Anti-Jewish Youth Group," came to the screening armed with crowbars. After they threw ink at the screen, attacked the audience, and slashed the art, the conservative press denounced the film as the work of Jews and Bolsheviks. Within a few days, it was banned. De Noailles faced excommunication due to the film's sacrilegious nature and had to resign from his club. *The Blood of a Poet* would not be shown for two years, until outrage over *L'Age d'or* died down.

The Surrealists soon published a tract in the film's defense, to which Man gave his signature. It warned about the consequences of compliance with right-wing tactics: "Is not the use of provocation to legitimize an intervention by the police a sign of fascistization [sic]," the authors asked; the film's suppression in the name of family, religion, and country had as its aim "the destruction of all those forces against the coming war." Lee understood the reasons for Man's concern: as an avant-gardist, a foreigner, and a Jew, he was a

target. But there is no trace of her involvement in the "affaire" over *L'Age d'or*. Her mind was on other things.

In December, as the scandal was reaching its height, Theodore telephoned to say that he was in Sweden and asked Lee to join him. They had not seen each other for a year and a half. Lee arrived in Stockholm on December 17 when (Theodore's diary notes) the thermometer registered minus three degrees centigrade. They spent the day at the Grand Hotel, then arranged for him to move to a room adjoining hers. His diary records dinners with business associates, evenings at the opera, and a party where thirty guests were invited "on account of Elizabeth." There are also entries about photo sessions. Judging by the images from this time, Lee slipped into her familiar role. In one of Theodore's nude studies, she is again the nymph and her father the observer, gazing down at her as she sits, or poses, in the gleaming bathtub. What Sweden meant to her at this point is not known, nor can much be said about their relations except that she looks at ease in Theodore's photos.

After celebrating the new year, they traveled to Hamburg, where (Theodore wrote) they shared room 231 at the Atlantic Hotel. Back in Paris they dined with Tanja; Theodore arranged to have Lee's teeth recapped, bought her a taffeta gown at Mainbocher's, and returned with her for fittings. A few days later, Man returned from Cannes, where he had been organizing a show of his work. The two men reached an understanding, no doubt because each respected the other's scientific bent. Man invited Theodore to use his studio, where they took each other's portraits. Theodore persuaded Tanja to pose; he joined Lee and Man in a photographic session with two hired models ("Selena, a blond Italian and Rita, a brunette Russian," he noted). Within a short time he, Lee, and Man were taking their odd triangular relations for granted.

Theodore relished the opportunity to do as many nude studies as he could schedule. During his two weeks in Paris he had more sessions with Tanja, several with Lee nude or in her Mainbocher, and one with Natasha, Man's new assistant. He also liked scenes of the kind that Man favored, with two or three women. On January 20, after several nudes of "Te Te, Tanja, and Tytia" (a model) cavorting on Lee's bed, he shot one of Lee and Tytia in a position that stops just short of lesbian sex. (He also photographed Lee and Tanja in pajamas having breakfast in bed, and Lee's Martiniquaise maid, Caroline, in her uniform.) Nearly sixty, Theodore was so much at home in bohemia that he accompanied Lee to Kiki's latest performance, had lunch with Tristan Tzara, and enjoyed a reunion with Medgyès.

One wonders what went through Man's head as he watched Lee and her father. It was obvious that they were close; her trust in him was implicit. In Theodore's nude studies of Lee in her bedroom, even the most contorted poses—she arches back over the bed or lies with her legs up the wall, pubic

region exposed—did not cause her difficulty. Man made the best of things by turning their intimacy into a series of portraits in which Lee's feelings for Theodore are enacted in her pose. She sits on his lap with her arms around his neck, nestles on his shoulder, gazes tenderly at him, and rests her head on his as if she felt utterly safe. Allowing Man to see her this way may have answered any questions: it implied that there was nothing to hide.

Man's portraits of their relationship also show the generous side of his nature. He may have been moved to witness the softening of her features as Lee sat with her father. Perhaps, accepting that he would never be as close to her as he wished, he took comfort in the thought that he had the regard of the man who held the central place in her affections—whose position he occupied in some respects as her mentor and support. One can imagine the welter of emotions on January 22, 1931, when Tanja, Man, and Lee drove to St. Lazare station with Theodore to put him on the boat train to Cherbourg.

The winter of 1931 marked a turning point for both women. In February, Tanja married Henry Rowell at the American Cathedral of Paris, with Lee as her attendant and a Yale classmate of Rowell's as best man. While Tanja's departure for the United States left a vacuum, Lee saw no reason to leave. Her photographic career was taking off: sitters now came to *her* for their portraits, and she was about to start work at Elstree Studios, the British branch of Paramount Pictures, a position that would mean frequent trips to London over the next six months.

Having absorbed as much as she could on Cocteau's set, she felt ready to go round the other side of the camera in *Stamboul,* a drama set in the Middle East. The first version, based on a French novel, had been filmed at the Joinville studios outside Paris. Paramount planned an English version with the director, Dimitri Buchowetski, a Russian who made the switch from silents to talkies that year with this tale of love in exotic places. (The plot justified the Turkish locale by having the heroine, a German countess, fall for a French officer on a trip to Istanbul; when her husband tries to catch the lovers, the officer kills him to protect the countess.) The film crew was as international as the plot. Margot Grahame, the countess, was a pouty siren known as "the Aluminum Blonde"—Britain's answer to Jean Harlow. The most intriguing cast member was Abraham Sofaer, the Burmese actor who played Mehmid Pasha, the potentate. After *Stamboul,* Sofaer would play more Turks, Arabs, Jews, and Indians in his long career; offscreen, he behaved like an old-school-tic gentleman.

Lee worked closely with the director, filming backgrounds, stand-ins, and images to be edited into the movie later. She also took publicity shots of the

principals. Her portraits for *The Bioscope,* a film revue, show the Aluminum Blonde looking reflective and Mehmid Pasha in uniform. Although *Stamboul* in no way resembled Cocteau's celluloid poem, it had a charm of its own. "I love extravagant and gorgeous 'historicals'—melodramas, ambiguity, inaccuracy and all," Lee wrote, "as long as the heroes are close-up close and the background has panoramic splendour." Such films were lovable for their "strident nonsense."

Wanting to have her cake and eat it too, Lee relied on Man for long-distance emotional and professional support. In response to her first letter from London he answered technical questions, then told her about his dinner the previous night, by the Seine. "I haven't been so romantic since my teens," he wrote, "with the moon shining on pale green row-boats moored to the shore, I got away from the crowd for ten minutes and walked with you arm in arm along the edge of water." He "adored" her for writing to him so soon. "How big and empty the bed is," he continued. "I throw my arms and legs in every direction."

Man rushed to renew his passport after Lee asked him to visit. But on replaying their phone conversation, he grew suspicious. Was the "old pal" she mentioned casually keeping her company? Was she telling half-truths about this man's date of departure? She must tell the truth "down to the slightest detail"—even if it would hurt. "Bringing everything out in the open is the one real test of endurance," Man went on. This strategy—accepting Lee's affairs (real or imagined) as long as he knew about them—would come to seem like a desperate move, but for the time being, he promised, he would "try to be everything you want me to be toward you, because I realize it is the only way to keep you."

Lee returned to Paris when her schedule permitted. In some ways nothing had changed, except that Man was worried about finances. His Cannes exhibition had not been a success, the Depression had cut into business, and although he had several propositions, nothing was definite. The one bright spot had been a visit from the New York art dealer Julien Levy. Levy had married Mina Loy's daughter, Joella, in 1927 and with her help started the first American gallery to feature avant-garde photography. He was taking some of Man's images to New York for upcoming shows, including one on Surrealism, but Man would not see much in the way of returns until the following year. In the meantime, it was hard for him to accept the change in relations with Lee. "I've had only one fear all these last months," he told her, "that your wanderings might be dulling your emotion for me, while mine has been growing."

On her return to England, Man told her that he would let her "go through with your job in peace." But his deeper wish, to hold on tight, put him in an untenable position. More than his letters, Man's erotic images of Lee from this

period express his desire to end the "dissipation of forces" her independence caused him. He could hold on to her in art if not in life. That spring, a commission let him give shape to his feelings for Lee while improving his finances. The Compagnie Parisienne de Distribution d'Electricité, a municipal utility, hired him to produce an illustrated brochure about electricity—a limited edition for their best customers. Man could treat the theme however he wished as long as his images extolled electric power. A short poetic text by the writer Pierre Bost would accompany his photographs.

During one of Lee's breaks from filming, Man enlisted her in the project as muse and as second-in-command—perhaps to show that they were still a team. But while Lee was his partner, she was also the raw material for his images. He planned to treat electricity as a strong but invisible current—like erotic energy, though more easily tamed. For the first image, *Electricité*, Man photographed Lee in a Venus de Milo pose. After cropping from neck to pubes, he made a second, enlarged image to put beneath the first, photographed them together, then drew undulating white lines across her torso— the *rayons*, or rays, emanating from their source. The pun would have been obvious, as would Bost's allusions to Electricity as a "dangerous Goddess," but also a "Beast" whose power is captured in Man's photographs, if not in his life. Another in the series, *Salle de Bain*, superimposes a white line connected to a cylinder on Lee's headless torso; the image shows the lady of the house at her toilette—tamed, yet radiating the energy that makes her so alluring.

The brochure, also called *Electricité*, was a collaboration in which "curious things happened," Lee recalled. "I think the use of a nude—that was me— was a little tough for the officials," she explained. "We were pretty shaken because we went and took a beautiful picture one night of the Place de la Concorde (I borrowed someone's roof to do it from) and discovered the whole thing was lit by gas! There was no end to th[e] complications."

The complications Lee did not discuss included her attraction to other men. Tanja's friend Zizi Svirsky invited her to his parties, where Russian émigrés mingled with artists, models, celebrities, and aristocrats. Zizi had been in love with Tatiana Iacovleva. After her marriage, he transferred his attentions to Lee and courted her with the promise of introductions to important people. Resorting again to half-truths, she took Man to one of Zizi's soirées as if it were just another party. Quick to sense the current between them, Man went on the attack. Zizi was too old, he argued (ten years older than he was), and though he had "enormous experience [and] marvelous Russian brains," he was interested neither in her work "nor in any new developments." (The irony of having as a rival a man of "enormous experience" whose name meant "penis" in French slang would not have been lost on Man, whose references to his own name and diminutive stature run throughout his oeuvre.)

Zizi's motivation was "selfishly human" compared with his own, he contin-

ued. "You started off on a different career with me," Man told her, "and now all the simplicity of it has been ruined." Barely able to contain himself, he asked:

> Would you like to know how my attitude compares with his? I have loved you terrifically [sic], jealously; it has reduced every other passion in me, and to compensate, I have tried to justify this love by giving you every chance in my power to bring out everything interesting in you. The more you seemed capable the more my love was justified, and the less I regretted any lost effort on my part. . . . I have tried to make you a complement to myself, but these distractions have made you waver, lose confidence in yourself, and so you want to go by yourself to reassure yourself. But you are merely getting yourself under someone else's control.

A powerful man's companion may find it hard to accept the idea of herself as his complement. At twenty-four and forty, Lee and Man were in different stages of life. Loath to remain in his shadow, she was unwilling to accept a relationship unless it indulged her wishes. While Man was planning their return to New York as a photographic team, Lee worked to establish herself as a portraitist. Sitters were now knocking at her door. She had "a run of royalty"—the Maharanee of Cooch-Behar, the Ranee of Mandi, the Duchess of Alba—then the literary set, actors, and socialites. She was not about to waste this opportunity.

During one of her trips to London, Man wrote in despair that they would have to separate—unless she gave him her preference and stopped worrying about "the material problem." "We have already managed together for a long enough period," he went on. "It hasn't been so bad if you are willing to adapt yourself to our limits. . . . I ask nothing better in the future than to pool everything with you." If she meant to continue in movies, he pleaded in another letter, "you must arrange to do work for Joinville if possible in the future, and you must arrange to live as my wife, married or not. I cannot see you in any other way."

That Lee could not see herself this way must have been obvious on her return in August, when she spent most of her time at work. Distinguished Americans in Paris came to have their portraits done: the New York publisher Donald Friede, the actress Claire Luce, who posed with her Siamese cats, and Charlie Chaplin, who lay down on the floor after posing beneath a large Art Nouveau chandelier that, in her striking image of him, seems to spring from his head. Given Lee's taste for an energetic sexual life, she may have joined him on the floor after taking his picture. Both of them enjoyed the session. Thinking about it years later she burst out laughing: "Charlie said he had never had such a good time in his life as he had with what he called my *surréaliste* photography," she recalled.

In December Lee joined Chaplin and his friends at Saint Moritz, the most fashionable ski resort in Europe. Each year *Vogue* devoted several pages to the celebrities who went there to recover from their social lives. For those who were not content to ski, skate, sled, or toboggan, a more relaxed version of Paris nightlife could be pursued in the jazz clubs and restaurants at the top of the vertiginous ski runs. Stars like Gloria Swanson and Gary Cooper vacationed there, the Prince of Wales was seen on the slopes, the ski instructors were ingratiating. Intrigue and romance flourished. Through Huene (who was on assignment in Saint Moritz), Lee became reacquinted with Aziz Eloui Bey and his wife, Nimet—who prided herself on her friendships with Rainer Maria Rilke and, more recently, Chaplin. The actor's stunts kept their group in stitches. Having just completed *City Lights,* he ate dinner as if he were blind, wrapped Nimet's head in a table napkin and proceeded to extract an imaginary tooth (a sugar lump) from her mouth, then posed for Huene before a snowy replica of his alter ego, the Little Tramp.

Had members of the group known what was happening, they would have been surprised to learn that Eloui Bey was falling in love with Lee, who found that she could, after all, see something in this cultivated Egyptian. Nimet— whom *Vogue* interviewed that year about her beauty regime—spent mornings accentuating her eyes with kohl and making her hair gleam, the better to resemble her heroine, Garbo. Lee photographed Nimet as *"la belle Circassienne";* coolly beautiful in her turban, pearls, and velvet robe, she stares at the camera, unaware that the woman behind it is her rival. Lee's affair with Aziz would destabilize his marriage and her relations with Man—whose request for the truth, down to the slightest detail, she failed to honor. Perhaps she felt that under the circumstances, it would have been disastrous to bring everything into the open.

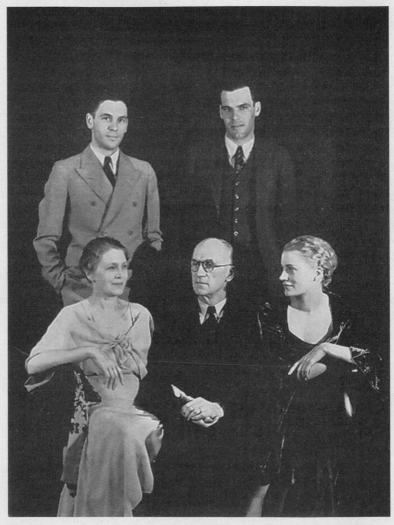

The Millers, Thanksgiving 1932. Standing: Erik and John; seated: Florence, Theodore, and Lee (Theodore Miller)

Chapter 7

The Lee Miller Studio in Manhattan

(1932–34)

The new year marked the end of Lee's apprenticeship. But while it seemed that she *could* make her way as a photographer, the overlapping social and artistic worlds from which she drew support were closing in on her. Her private life was a tangle of conflicting alliances. Her liaison with Aziz called for discretion; more than a few half-truths were required to keep the peace with Man while she moved back and forth among the émigré set, the Frogue family, and the influential Americans abroad wanting to be "done" by Lee Miller.

Representatives from all of these worlds converged at the Théâtre du Vieux-Colombier on January 20, 1932, for the long-delayed première of *The Blood of a Poet*. While a cross-section of fashionable Paris—including the writers Julien Green, André Gide, and Jacques Maritain; Serge Lifar; and Cocteau's bartender from Le Boeuf sur le Toit—were in attendance, Breton's decision to boycott the evening put Man in an awkward position, since he was close to Breton but Lee was officially his mistress.

Tensions ran high as Cocteau, his hair artistically disheveled, made his way to the stage. His aim, he stammered, had been to capture creativity on celluloid. Following the example of Hollywood (Cocteau pronounced it

"Olioude"), he had used tricks to create what they were about to see. One such trick, he said with a nod to Lee, required his leading lady to close her eyes and walk as if blind: "This unreal way of walking," he explained, "adds to the unreality of her character." Moments later, Cocteau turned again to "Mademoiselle Miller," whose acting was "admirable." Indeed, while all his actors were admirable, he had chosen them not for their looks, "but for their moral attitude, since in a movie, the faces are huge and the eyes reveal all." As Cocteau summed up the muse's effect on the poet—"the statue comes to life, takes revenge, and involves him in ghastly adventures"—Lee may have wondered how much her own eyes revealed.

While Cocteau's film was dividing the Paris art world, another work appropriating Lee's vision was on display in New York in Julien Levy's new exhibit, "Surréalisme"—"a bewildering and splintering sense of conglomerate nonsense," according to the New York Times. Levy's choice of paintings, photographs, and collages by such artists as Ernst, Dalí, Picasso, Cocteau, Atget, Boiffard, and Man Ray provoked dismay in the gallerygoers, but the "objects" included in this controversial show (by Man, Marcel Duchamp, and Joseph Cornell) puzzled them even more. Man's Boule de Neige, the most disquieting of the lot, was a glass paperweight in which a cut-out image of Lee's eye, much enlarged, floated, then disappeared in a flurry of snowflakes when the ball was shaken. The Blood of a Poet had enhanced her "unreality" by making her walk with her eyes closed, but Boule de Neige removed that which a photographer needs even more than her camera. "Perhaps the 'eye' of Lee Miller was the photographer's eye," Man's biographer writes; "by separating it from her body, Man Ray was reclaiming authority over her sovereignty as an artist."

To New Yorkers, works like Boule de Neige produced the psychic "splintering" said to result from Freudian raids on the unconscious. To Parisians, Surrealism was an assault on the body politic. In the uneasy climate of the early 1930s, as France succumbed to economic depression and antirepublican groups espoused fascist tactics, even the nonaligned could not ignore the growing hostility to foreigners, Jews, and Communists. Man followed these developments closely. "It is some time now that the crisis has hit me," he told his sister. "I make it a point never to complain as everyone else around here does plenty," he went on. But his spirits were low, especially after Arthur Wheeler's death in a car crash.

While Man pondered the idea of returning to New York with Lee as his partner, she had other things on her mind. Her romance with Aziz, who spent half the year in Paris and the other half in Cairo, offered a way out of the impasse in which she found herself. Unlike Man, her new lover did not try to control her. Aziz was supportive and broad-minded. He was also good-looking and spoke English fluently, having studied engineering in Liverpool. His father, a well-known ophthalmologist, had run the Cairo Board of Health; his

mother's father had been the Egyptian commander of expeditionary forces. He and Nimet lived together while maintaining a de facto separation, made possible by their not having children. And since Nimet's well-being required baths in Vichy water, walks in the Bois de Boulogne, and naps before soirées (as well as facials, manicures, and pedicures), she may not have noticed the change in her husband's spirits after their return from Saint Moritz. When friends mentioned her reputation as one of the world's great beauties, Aziz often replied, "She should be; she spends all her time painting her face."

Much can be gleaned about Aziz's feelings for Lee from his letters, which combine a lover's passion with a parent's tenderness. Nearly twenty years older than she, Aziz accepted her contradictions—the vulnerability beneath the surface, the need for a secure base from which to stray. Temperamentally, she was Nimet's opposite. While his wife held court on a chaise longue, Lee dashed all over Paris on assignments. Nimet ate one meal a day to control her weight; Lee enjoyed life's pleasures. Aziz may have supposed that she would bear him the heir he lacked. It is not known when he told Nimet of his wish for a divorce. Judging by the tales of suicide threats passed down in their circles, she probably made attempts on her life.

By spring, when Aziz returned to Cairo, he and Lee were in love. Man was furious: all Montparnasse seemed to know that she had left him. According to Julien Levy, who arrived in April on a gallery scouting trip, Man, already "half-dead with sorrow and jealousy," had gone on a liquid diet to purify himself but was said to be packing a gun—with which "in default of the Egyptian, [he] was threatening any other rivals." Since meeting Lee the year before, the young art dealer had wanted to know her better: "Her spirit was bright," he wrote, as were "her mind, her photographic art, and her shining blond hair."

Earlier that year, Julien had included Lee's work in his Modern European Photographers show, along with images by Man, Kertesz, Ilse Bing, Florence Henri, and Moholy-Nagy. As a group, their work challenged the belief in American art circles that photography was an art suited to realistic depictions of the industrial age but little else. Unexpectedly, the *New York Times* praised both Man's solarized portrait of Lee and Lee's shot of a woman's manicured hand grasping the curls at the back of her head; in the critic's opinion, these images transcended the purely "virtuoso" nature of the exhibition. Another critic described Man's profile of Lee as if she were his material, then added that she had, nonetheless, contributed "two of the most striking pictures in the show, the Greek statue with its dramatic spotlight effect and the study of a pink-nailed hand embedded in curly blonde hair." However matters stood between them, Man and Lee were linked by their work and their relations with Julien.

Just before sailing, Julien lent prints by both photographers to the Brooklyn Museum's spring show, International Photographers. This comprehensive

summary of contemporary camera work included both European experimentation (photograms, images turned upside down, and negative prints by such artists as Henri, Moholy-Nagy, and Maurice Tabard); American industrial studies by Abbott, Bourke-White, and Walker Evans; fashion shots by Steichen, Huene, and Beaton; and work by Tina Modotti and Imogen Cunningham. That month, as Lee turned twenty-five, New York seemed to beckon. Thanks to Julien, the way was being paved for her return.

Julien had hoped to shock New Yorkers into accepting modernist photography with Man's first American one-man show in April. The exhibition produced some tart coverage by *Time*, which called it an assortment of "nuts and nudes" (the "nuts" included portraits of Lee, Brancusi, Picasso, and Nancy Cunard). *Time*'s critic pooh-poohed Man's Paris reputation, called him "a kinky-haired photographer" whose real name was "Emmanuel something," and judged his work "not quite worth all the furor that friends have raised." As if these slurs were not enough, he made innuendos about Man's relations with Lee: "Also exhibited were assorted sections of his favorite model, Miss Lee Miller, known as 'Lee-girl' to her intimates, widely celebrated as the possessor of the most beautiful navel in Paris."

Lee was outraged. It might have been amusing to make her return to America piecemeal—first her eye, then "assorted sections," and now, her navel. But at this point, as her own work was becoming known, *Time* had exposed her to ridicule. It was one thing to see one's midsection displayed in Montparnasse and quite another to have it mentioned by unknown persons

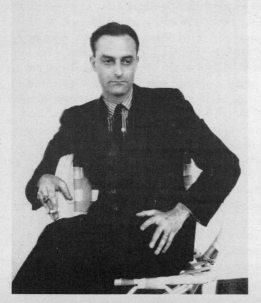

Julien Levy, c. 1930

claiming to know about her private life. "Lee suddenly became very proper about her navel," Erik Miller recalled.

Man, more distressed for Lee than for himself, insisted on the need for an apology. Lee's reputation was safe because she came from a good family, he told Julien, but the unwanted publicity *could* damage her career. At the same time, Theodore went into action. He cabled Lee, consulted a lawyer, and sued for libel. By May, Joella, representing the gallery, and Theodore, representing the family, were at war with *Time*. The magazine agreed to run Theodore's response to the "offensive and quite untruthful reference" in their review and extended to "Miss Lee Miller, and her family, an apology for the inconvenience caused by the erroneous publication." The apology did not mention the financial settlement. "It was a chance to make some money," Erik noted though he could not recall the amount. "Lee was very happy."

It was also a chance to get out from under Man's shadow. That spring, as cables from Julien, Theodore, and Lee flew back and forth across the Atlantic, it was clear that her dealer was taking more than a professional interest. Julien, who was Lee's age, was mesmerized by the "bold, bright aura" surounding her. Lee was the kind of woman about whom "one would hope to sing '*Auprès de ma blonde . . .*,' " he mused, the ellipsis suggesting what he had in mind.

On his second day in Paris, Julien spotted Lee on the Boulevard Raspail. They made a date to meet later at the Jockey Club. "It promised to be a most pleasant evening if I could charm her," he recalled. "And so it proved," the passage concludes. In May, while coping with Man's wrath and the *Time* brouhaha, Lee began an affair with Julien. Honored to be shown "the Paris that all artists and very few tourists then knew," Julien savored their evenings together, which often included drinks at the Café Flore (where she sipped *menthe à l'eau*), dinner at an out-of-the-way bistro, followed by more drinks at the Jockey, the Boeuf sur le Toit, and, in the early morning, Zelli's in Montmartre.

During the day, Lee went with Julien on buying trips and introduced him to artists. When they called on the illustrator André Dignemont, a surreal music emanating from his antique music boxes greeted them. Their host brought out his collection of old photographs—Nadars and Atgets—and choice examples of nineteenth-century pornography. After Julien filled three suitcases with his purchases, Dignemont gave him a bonus: a volume attributed to Pierre Louys, whose erotic vocabulary included "various *argots* and incredible improvisations" hitherto unknown to the young New Yorker. Years later, Julien boasted in private about trying some of the improvisations with Lee.

Julien's published memoir fails to say how he handled matters with Man, what Man knew of his relations with Lee, how the situation affected their business dealings, or whether he said anything to Joella. Perhaps he too professed the Surrealist disdain of monogamy, or simply behaved like other men

when their wives are across the ocean. And although Mina Loy might have been expected to upbraid him on Joella's behalf, his mother-in-law (with whom he stayed when in Paris) condoned his affair with Lee—reasoning that he had married young and, consequently, needed to sow some wild oats.

Over the course of the summer, Lee and Julien socialized with Mina, Lee took her portrait for Mina's upcoming show at Julien's gallery, and Julien—following in Man's footsteps—made home movies of both women. Mina, whose rivalry with Joella and affection for Julien would undermine their marriage, saw Lee as a surrogate daughter—a female artist of the younger generation and as such the antithesis of Joella, whose managerial skills made it possible for Julien to play at being a Surrealist but did not extend to creative work of her own. Characteristically, Lee took the complex bond between Julien and his youthful mother-in-law as lightly as she took their own relations, while counting on him to support her career.

Julien, excited to find himself in such racy company, took care to keep Lee amused. He had an artistic temperament and, from a European perspective, unlimited resources. (That he had recently come into the trust fund that underwrote his gallery was not lost on Lee's circle.) That summer, while shooting a series of cinematic portraits, he was a stimulating companion. After filming Mina at the Flea Market and capturing Lee's aura in a Cocteauesque sequence, he also filmed Ernst, Brancusi, and Léger in their studios. At the same time, he was looking to buy experimental movies like *The Blood of a Poet*, which he hoped to show at his gallery in homage to Cocteau and to the muse who inspired both men, though for different reasons.

When Julien learned that the still banned *L'Age d'or* would be screened at a small cinema in Vincennes, he invited Lee and Mina to the clandestine showing. "The surreptitious presentation added excitement to the performance," Julien wrote. Some of the right-wing extremists who had attacked the film two years earlier began brawls as soon as the projection started, shouting slogans like "down with the Surrealists" and "shit on the Sorbonne." Surprised to see that art could generate a furor, Julien decided to buy *L'Age d'or* as well. Seeing this scandalous film with the two women he most admired enhanced his sense that he was taking part in epoch-marking events, that avant-garde art "might be considered a moving factor in immediate politics."

Julien's Paris holiday, a heady blend of illicit love, banned art, and political passion, ended in September, when he sailed for New York. Along with his purchases—paintings, movies, flea-market finds, and erotica—Julien took a group of Lee's photographs. He planned to give her a one-woman show and place her work in other venues. One imagines that he encouraged Lee to join him in New York now that she had the settlement from *Time* and two prospective partners: Cliff Smith, Claire Luce's husband and heir to the Western Union fortune, and Christian Holmes, a Wall Street broker, had volunteered

to finance her studio. Given her recent success as a celebrity portraitist, New Yorkers would seek her out; Dr. Mehmed Agha, the new art director of *Vogue*, was interested in her work.

But Lee was undecided. There was her understanding with Aziz, although it was on hold (from her perspective) while he was in Egypt. Arrangements had been made for her participation, with Man, in two European exhibitions that fall. (As planned, their photographs were shown at the Brussels Exhibition of Photography, with images by Germaine Krull, Moholy-Nagy, and Atget; this selection then traveled to Ghent for an exhibit organized by the Circle of Socialist Studies.) And she was about to make her debut in a new Surrealist magazine, *Le Phare de Neuilly*—probably due to Man's connections. To an observer of the photographic scene, her work had his imprimatur. It had developed under his aegis, in tandem with his own.

By September, it must have been clear to Lee that her mentor saw her as a threat. The violence implicit in the many works of art that cut her in pieces became explicit in another of Man's objects on the theme of vision. Some years before they met, Man had attached an image of an eye to a metronome; he called the work *Object to Be Destroyed*. During the summer of 1932, after her affairs with Aziz and Julien, Man replaced the image with Lee's eye, cut from one of his portraits, and gave the work a new title: *Object of Destruction*. As if warning her, he published a drawing of the object with instructions for its use: "Cut out the eye from the portrait of one who has been loved but is seen no more. Attach the eye to the pendulum of a metronome and regulate the weight to suit the tempo desired. Keep going to the limit of endurance. With a hammer well aimed, try to destroy the whole at a single blow."

Man reached the limits of endurance in October, when Lee booked her passage to New York on the *Ile de France*. Drawing her face in his notebook, he outlined her eyes and mouth, covered the page with her name—"Elizabeth Elizabeth Elizabeth Elizabeth Lee Elizabeth"—then printed on the reverse, "Accounts never balance one never pays enough etc. etc. Love Man." In case she missed the point, he folded the page around a second cutout of her eye— on the back of which he wrote in red:

POSTSCRIPT: OCT. 11, 1932

With an eye always in reserve
Material indestructible. . . .
Forever being put away
Taken for a ride. . . .
Put on the spot. . . .
The racket must go on—
I am always in reserve.

Man dated this adieu the day of Lee's departure. After posting it, he walked to the Dôme in a downpour. Perhaps intending to prove that he no longer held himself "in reserve," he sat down beside Jacqueline Barsotti. "He seemed to have shrunk and not know where he was going," she recalled. When he hit the table with a gun and moaned, "I wish I were dead," she knew that he was desperate. Jacqueline took him outside; they walked round the Montparnasse cemetery in the rain for a last look at Lee's studio, then went back to Man's. Her account of what followed is worth quoting in full:

> He got out a pistol, a rope and other objects and started to arrange them for the now famous photograph of him in utter despair. In order to set the photograph up he asked me to pose in his place so that he could focus. Then we switched positions and he sat there with the gun pointing at his head and the rope round his neck. I was terrified because I had no idea if the gun was loaded or if he was actually going to shoot himself. Anything could have been possible, he was so distraught and I, myself, was upset. Anyway I took the picture and looking back on it, I felt it summed up the moment. He was utterly destroyed by her leaving him. He had lots of women but she was the one he wanted most. That might have had something to do with the fact that he couldn't have her.

Lee arrived in New York on October 17, 1932, to find reporters awaiting her. Looking pensive in a dark beret and fur coat, she smiled sweetly for the *World Telegram*, whose reporter called her the most photogenic of the "cargo of celebrities" on board. To a journalist who spoke of her early success as "one of the most photographed girls in Manhattan," she quipped that she would "rather take a picture than be one." Photography, she added, gave her "the joy I wanted from my work." The medium matched "the tempo and the spirit of today"—and, she implied, her idea of herself.

Erik and Florence greeted her at the pier; Theodore was away on business. They had arranged for her to stay in a Park Avenue hotel while she looked for a working and living space. In November, she rented a double studio at 8 East Forty-eighth Street, and with Erik, who was to be her assistant, drew up plans for a darkroom equipped with cypress sinks big enough for large format (8-by-10-inch) plates and, for the studio, remote-controlled lights rather than the cumbersome equipment in general use. Erik built everything to measure while Lee reactivated her contacts.

Being a celebrity had advantages, one of which was free publicity. Lee's appearance in the November *Vogue* reminded readers of her fame as an icon of elegance. Her sequined Lanvin dress, the copy gushed, was "smartest worn as

Paris, New York, Egypt

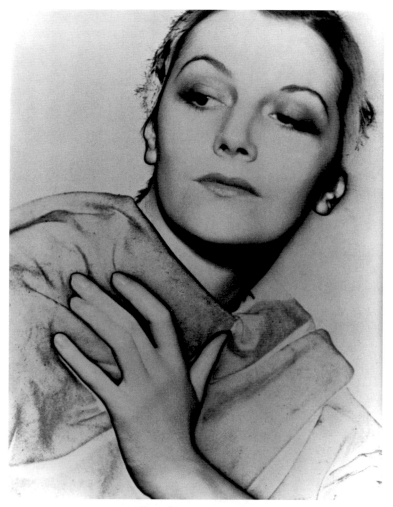

Solarized Portrait. Paris, 1930

Exploding Hand. Paris, c. 1930

A Strange Encounter. Paris, c. 1930

Joseph Cornell. New York, 1933

From the Top of the Great Pyramid. Giza, Egypt, c. 1938

Bus in street. Egypt, 1937

Mafy Miller. Cairo, c. 1937

Portrait of Space. Near Siwa, Egypt, 1937

Miss Lee Miller wears it in the photograph, without a single ornament." The following month, in an interview with a journalist from the *Evening Post,* Lee explained that she wished "to settle down in her native land and photograph the American great . . . because everyone here is so good looking." Europe had its beauties, she continued, but American bone structure was "much better." The journalist wagered that her sitters would learn to be as *photogénique* as Miss Miller and said that her portraits could be seen at the Levy Gallery's current show—along with work by Abbott, Genthe, Huene, Steichen, Steiglitz, and Man Ray. Lee's reflective self-portrait ("Lee Miller *par* Lee Miller") illustrated the interview.

Lee also ran ads promoting her studio as the American branch of "the Man Ray school of photography." In a highly qualified account of her apprenticeship, she explained, "What you mostly do is absorb the personality of the man you are working with. The personality of the photographer, his approach, is really more important than his technical genius." While Lee had no qualms about dropping Man's name, he was outraged by her opportunism. Although averse to legal action, he told his sister that he would soon take steps to disconnect his name "from all these publicity-hunters."

Lee's name stayed in the news while she and Erik prepared the studio. Julien did his best to advance her career by linking it to his own. The nature of their friendship changed once Lee began socializing with both Levys and acting as the gallery's unofficial publicist. In November, she photographed Joella and Julien installing Max Ernst's exhibit for *Town & Country* and shot several portraits of Joella. One wonders what ran through the two women's minds during these sessions. "I really liked her," Joella said much later, then added, "She never really meant to hurt the other woman."

Lee also renewed her friendship with Tanja Rowell, who was working for Anton Bruehl, a pioneer color photographer. Tanja was amused to watch Lee's reputation soar once her studio opened in November. Prospective sitters spoke with awe of her talent, and how difficult it was to get an appointment. Lee booked one sitting a day, she told a reporter, since each session took several hours. Clients were served lunch and invited to relax; to avoid "an audience complex" or a "gallery smile," friends were not welcome. "It takes time to do a good portrait," Lee went on. "I must talk to the sitter, find out what idea of himself or herself he had in mind."

Moreover, male and female sitters behaved differently: "Young men never know whether they want to look like a pugilist or Clark Gable. . . . Older men often want you to catch the twinkle in their eyes, a certain angle of their profiles or their 'Mussolini jaw' that some woman has told him she loves." Men were more self-conscious than women, she observed, "because women are used to being looked at." As a profession, photography suited her sex. "Women are quicker and more adaptable than men," she believed. "I think they have an

intuition that helps them understand personalities. . . . And a good photo-graph, of course, is just that, to catch a person not when he is unaware of it but when he is his most natural self."

Yet sitters who cared more for their public image than their natural selves—socialites, theater people, and professional beauties—sought her out because of her reputation. Clients came through the Levy gallery, Condé Nast, and her backers. Soon she was photographing New York's artistic elite: the publisher Donald Friede, literary critic Lewis Galantière, museum director Chick Austin, and actors and actresses of the day, such as Claire Luce, Selena Royale, Lilian Harvey, and Gertrude Lawrence. Her command of lighting in their portraits recalls that of Steichen or Huene: these theatrical shots repro-duced well in magazines like *Vogue,* which preferred high gloss to naturalness. Lee's portraits from the early 1930s demonstrate her professionalism and her sense that despite the Depression she might make her way by following in her mentors' footsteps.

But judging by Lee's photographs of friends, she felt more relaxed with noncelebrities. When Tanja posed for a bridal shop ad, Lee softened the light-ing to enhance her friend's thoughtful gaze at the other woman in the picture, a seamstress adjusting the waves of tulle at her feet. Two portraits of Tanja in a dark evening gown bring out her sensuous side through the deployment of the subtle gradations from white to black. Tanja's friend Dorothy Hill asked Lee to take her wedding portrait: the result, a solarized likeness of this stunning brunette, evokes her character in a composition recalling some of Lee's mod-eling stints with Man. For another portrait that harks back to Lee's past, she draped a dark cloth around the neck of her friend Mary Taylor. This striking composition, *Floating Head,* treats her sitter as a masklike visage and a mane of hair. Photographing these women allowed Lee to rethink her time as a model, to recall what she had felt on the other side of the camera.

About this time, she occupied both positions for an unusual self-portrait—for a fashion article on hairbands. Due to its commercial nature, this image does not reveal the self, but uses it by aestheticizing her person. Artfully coiffed, made up, and dressed in a dark velvet gown with elaborate ruching, Lee photographed herself in profile, facing a chair whose pale upholstery con-trasts with her garments and sets off the light on the shot's raison d'être, the hairband. More deliberately stylish and cooler than *Lee Miller* par *Lee Miller,* the image displays her command of the medium.

Not surprisingly, portraits free of economic pressures show a greater emo-tional range. Lee's friendship with Joseph Cornell, which dates from this time, moved each artist to depict the other. Julien, who was Cornell's dealer, may have mentioned the eccentric collagist to Lee during their affair in Paris, when he was combing the Flea Market for the antique boxes he brought back to encourage Cornell's homegrown Surrealism. After his return to New York,

Julien surely told Cornell, who admired women from a distance, of his relationship with Lee. Cornell began squirreling away scraps of information about Lee, starting with Huene's photograph of her in the October *Vogue*. While it is amusing to think of Julien introducing the shy Cornell to his former lover, their friendship shows his talent for bringing together like-minded people.

Cornell's shyness around women did not keep him from expressing his feelings for them. Lee complied with his request for stills of her as Cocteau's muse and answered his questions about *The Blood of a Poet*. One can imagine what the starstruck Cornell saw in his beautiful new friend. Three years older than Lee, the dreamy young man had grown up in Nyack, on the Hudson, and, like her, taken part in amateur theatricals. Enchanted by the bric-a-brac of popular culture, he saw Surrealism as an innocent magic. Cornell was no doubt awed by Lee's acquaintance with Ernst, whose collages had inspired him, and pleased by her interest in his own early creations, which expressed his emotional yearning.

Perhaps Cornell, too, saw Lee as a muse—the feminine side of his persona. One day he brought his latest creations to her studio to be photographed for his one-man show at Julien's gallery. It is difficult to know how she felt as she focused on his glass bell series, which shelter small objects—a mannequin's hand, a doll's head, a metronome recalling Man's *Object* (minus the eye)—and whether she saw Man's shots of Tanja's head under the bell jar as a dark precedent for Cornell's naïve counterpart.

Cornell also sat for a group of portraits that reveal this unlikely pair's artistic sympathy. One of his first objects, a toy boat topped with a butterfly and a mane of floating hair, was both a self-portrait—"a synthesis of voyager and ship, male and female, brought together in Cornell's ambiguous guise"—and an emblem of his guileless response to Surrealism. As if he had set sail in his imagination, Lee posed Cornell with the ship and turned his profile so that the blond mane cascading from the mast becomes his own. Cornell's exhibit ran at Julien's through December, with a group of etchings by Picasso. (Relegated to the back room, his objects were dismissed by the press as "toys for adults.")

On December 30, after taking down the Cornells, Joella and Julien hung Lee's photographs and sent out the announcement for her one-woman show. Stylishly printed on maroon paper, it contained an endorsement by Frank Crowninshield. Lee had left America four years before, he began, "a girl in her earliest twenties. She has now returned . . . an accomplished artist." Commending her apprenticeship "with the artistic radicals of France, the Surréalistes, and their photographic leader, Man Ray, as well as her gift for seeing artistic possibilities in all sorts of subjects, he felt sure that in Lee's new studio, she would "go on exercising her sensitive and rounded talent in an art in which she has shown herself naturally and peculiarly adept."

Judging by the announcement, which lacks a checklist, Lee's show included

most of her work from Paris—street scenes, architectural studies, still lifes—and a number of portraits. Her celebrity status was underscored by the recent publication of her portrait of Claire Luce in *Vanity Fair*, just as her friend began her starring role on Broadway as Fred Astaire's partner in *The Gay Divorce*. The publicity for Lee's show was carefully planned. In an interview published the day of the opening, she again mentioned her apprenticeship with Man. But that was in the past, she told the reporter, who noted, "She can do the same mysterious stunts herself now, getting a third dimension by 'solarization,' spoofing pebbles that they are Alps, and presenting people as 'cold' or 'warm' all by manipulating her lights and lenses." Indeed, many of her shots were seen first in her imagination, then "assembled," as one would a painting. Julien told the crowd of well-wishers at the opening that "the new light on the horizon of photography is Miss Lee Miller." (Joella voiced her reservations in private: "We just opened the Lee Miller show. . . . We don't think her photos are very good but they make a surprisingly good show.")

Fortunately for Lee, the critics agreed with Julien. Edward Jewell remarked in the *New York Times* on her ingenuity: unlike other experimentalists, "her photographic work," he wrote, was "free from disconcerting tricks of overstatement, evasion and palimpsest." Though influenced by Surrealism, about which he had doubts, Miss Miller was more interested in "compositions featuring highly contrasted light and dark masses." It was to her credit that given this feel for abstraction, she did not try "to conceal a healthy affection in subject matter as such—an affection that many modern artists have pretended was unworthy of them." Among her portraits, he praised those of Gene Tunney, Claire Luce, Charlie Chaplin, Selena Royale, and Man Ray.

"Lovely Lee Miller has opened a studio in New York," *Creative Arts* gushed. "That seems the natural way to speak of her," the review continues, "as for three years she kept many folk in Paris arguing as to whether she or Greta [Garbo] was the more fascinating. She was generally considered more beautiful, but a proof of her ability as an *actrice* is to be found in Jean Cocteau's film." Mixing admiration of her person and her celebrity subjects, it concludes, "The number of famous people whom she has 'done' is extremely large and includes all of the nobility of India who have been in Europe in the last few years." Surprisingly, few images sold. Julien kept most of them for his own collection.

Before the exhibit's close on January 25, 1933, Julien put four of Lee's portraits in Bergdorf Goodman's Exhibit of New York Beauty. Although the show was chiefly a tribute to the store's most attractive customers, one reviewer noted, it was nonetheless distinguished by Lee's presence among "the sixty most." Julien claimed to take the event seriously. The camera alone could identify beauty, he wrote in the announcement: "a relatively impersonal judge . . . [it] offers an interpretation, so that you shall see yourself as others see you." Lee could be seen as *Vogue* photographer André Durst saw her, but

also as she saw herself in her elegant subjects—Eden Gray, Renée Hubbel, Mrs. Donald Friede, and the ubiquitous Claire Luce. They were in good company. Portraits by Genthe, Steichen, Edward Weston, Toni Frissell (a contemporary of Lee's who worked for *Vogue*), Cecil Beaton, Horst, and Man also adorned the walls at the department store.

The Millers, a little disappointed at seeing so little of Lee since her return, came to New York on January 13 to see her one-woman show and the Bergdorf exhibit; typically, Theodore's reaction to her success is not recorded in his diary. Lee no doubt attended Julien's next opening, on January 28, for Mina Loy's Cocteauesque paintings. She also posed for an elaborate fashion sequence taken by her loyal assistant, Erik, who, seeing her fatigue, noted that it was due "to not taking care of herself."

Toward the end of the month, Theodore proposed a plan combining a restorative holiday and time with his daughter. On February 5, they drove to the Pocono Mountains for an eight-day "cure" at the Hay-Ven sanatorium. Like others obsessed by diet (in a time of bread lines and soup kitchens), the Millers had tried several regimens that held out the promise of enhanced health. New food fads kept sweeping the country. The Hollywood Eighteen-Day Diet emphasized grapefruit. "Two-food" diets promised fast weight loss through the consumption of paired foods: depending on the plan, pineapple and lamb chops, baked potato and buttermilk, raw tomatoes and boiled eggs, or, for the diehards, coffee and doughnuts.

Lee's parents still followed the philosophy of natural living detailed in Dr. Hay's *Health via Food*. This diet, variants of which are still popular, advocates "compatible food combinations": starches and proteins are not eaten together; fruits and vegetables may accompany either of these but only in accordance with Dr. Hay's directions; caffeine is eliminated from the diet. The Millers also drank Pluto Water, a "physic" in a distinctive green bottle that helped dieters cleanse themselves during the daylong fasts that were part of the regimen. One wonders what Theodore told Lee about its more challenging features, "hi-colonic irrigations" and the avoidance of sex unless its aim was procreation—advice she may have considered after several of her love affairs resulted in pregnancy, terminated by abortion. (The problem with "a too free indulgence in the sex life," Hay wrote, was not so much venereal disease as "the physical deterioration that is the direct result.")

Those who followed his diet, Dr. Hay claimed, would "get well and stay well through the detoxication and through inner cleanliness of the body." The food at Hay-Ven could not have been less like French cuisine. Spirits were forbidden; sugar, salt, and pepper were not recommended; one was not to eat when tired or "when nerve stresses may interfere with digestion." The record does not say whether Lee felt invigorated by her stay. Theodore's diary notes that they had adjoining rooms and makes no mention of photographic ses-

sions. Perhaps that expression of their intimacy became a thing of the past. On her return to New York, Lee resumed her hectic pace—paying no further heed to Dr. Hay's recommendations.

∞

Within months of her return to New York, Tanja recalled, Lee was "THE photographer to be photographed by." Although the luxury trade was feeling the effects of the Depression, advertising agencies commissioned shots of perfumes and cosmetics, Saks Fifth Avenue and Helena Rubenstein hired her to publicize their wares, and Condé Nast featured her work. Lee became so well known that Macy's commissioned her to choose, then photograph, the new "Macy twins" (the store used twins as models). Old friends like Nickolas Muray sent assignments when work was slow; new ones, like Dr. Walter Clark, Eastman Kodak's head of research, explained the complex procedures of color photography before the advent of Kodachrome.

Lee refused to compromise even when times were hard. Having hired a lively young woman named Jackie Knight as her business manager and an unflappable black maid named Georgia Belaire, whose cooking pleased clients, backers, and friends alike, she kept them on salary even when uncertain she could pay the rent. Erik ran the darkroom and did most of the developing. "Lee could be intolerably lazy when she wanted," he noted, "but when the chips were down, she just would not quit."

Erik emerged from the darkroom at all hours to get her opinion of prints. "Lee was very insistent on getting the highest quality," he recalled: "She would grab hold of any that were even slightly defective and tear the corners off." Working together, they intensified dark areas with the warmth of their breath or fingers during development. Since Lee knew enough chemistry to fortify the solutions then available, "the resulting brew sometimes became quite deadly," Erik continued. They coughed and choked over the developing tanks; his nails turned brown. Years later, he still marveled at her eye for composition, "the way she could pick out what was wrong with a print, maybe something that had completely escaped my notice."

Lee's commercial work from this time is marked by precision, but also by its reserve—as if this sort of work held little interest. Sometimes she found creative ways around routine assignments: her decision to solarize the gleaming lid of a grand piano—essentially a high-class ad—lets one "hear" the silent music. For a shot of Elizabeth Arden perfumes, Lee aligned her subjects diagonally on a mirrored base, in whose depths the glass bottles, like self-obsessed starlets, seem to see their reflections.

Lee decided to use color, a complex three-step process requiring three separation negatives, in a more prestigious, and expensive, perfume ad. She

and Erik surrounded the flacons with gardenias and, as their petals drooped, "ended up rushing the gardenias straight from the refrigerator, spraying them and then gently placing them on the mirror," Erik recalled, to keep them from moving during the time it took to complete the exposures. "We would hit the lights, make the first exposure, then bing, bing, change the film and filter for the second and third time." Despite these difficulties, the photograph was "very, very successful." Challenges of this kind brought out the best in Lee by providing antidotes to routine and boredom.

Lee's rise to fame coincided with that of her fashion mentors, Huene, Horst, and Beaton. These highly paid celebrities had a symbiotic relationship with the new media—magazines, advertising, public relations—that required a constant supply of high-quality images. While in their orbit, Lee had little contact with the practitioners of a new kind of lyrical realism, Berenice Abbott and Walker Evans, who by the 1930s were photographing New York in the manner of Atget. (Evans praised the Frenchman's "understanding of the street, trained observation of it, special feeling for patina, eye for revealing detail, over all of which is thrown a poetry which is not 'the poetry of the street' or 'the poetry of Paris,' but the projection of Atget's person.") Rather than follow Atget's lead, Lee avoided such projections, since commercial work had to convey the values of its audience.

Artistically, she had reached an impasse. Without meaning to do so, perhaps, she had abandoned the experimentation of her Paris years. And in any case, despite Julien's efforts, Surrealist-influenced photography did not go over well in the changed economic climate, when American photographers were moving toward a local focus. Invidious distinctions between native and foreign perspectives were not unusual. Of the Brooklyn Museum's 1932 Modern European Photography exhibit, a critic wrote that while the American school was "realistic, objective, and reverently attached to its native place," European artists "concerned with explorations of the medium's expressive range" often produced images that were "disconcerting and arbitrary"—not what the country needed during a depression.

It is not surprising that in this context, Lee's New York images lack the passion of her Paris work. Since commercial photography did not excite her, she put her energy into her social life—joining the guests at Condé Nast's, renewing ties with Crowninshield and the *Vogue* staffers, and forging new ones with Dr. Agha, Edna Chase, and Henrietta Malkiel, a writer who had worked at German *Vogue* (which failed before acquiring a nickname, like Frogue or Brogue, the British edition). Lee was now on equal footing with Genthe, Muray, and Steichen, and a peer of Bourke-White and Toni Frissell, with whom she shared a preference for informal fashion pictures resembling snapshots.

Lee also socialized with theater people—Gertrude Lawrence, Ira Gersh-

win, Lewis Galantière and his writing partner, John Houseman. Actors, direc-
tors, critics, and members of fashionable New York gathered after hours at her
studio to play poker and enjoy Georgia's cooking. Erik watched Georgia baby
Lee, letting her stay in bed when she was tired or when business was slow; to
his dismay, the late-night poker games turned into all-nighters. By May, they
were again doing well, he noted, but Lee was "ill or tired most of the time"—a
fatigue he attributed not to work, but to bootleg booze and irregular hours.

John Houseman became a regular at the ongoing poker game—drawn, he
wrote, "less by passion for gambling than by an unrequited lust for my host-
ess." He saved enough money to take her dancing one night in Central Park, to
no avail. Still lusting and "bitterly jealous," Houseman watched Lee flirt with
her admirers. He had a low opinion of the one who became her constant com-
panion, a literary agent named John Rodell. (In Lee's portrait of Rodell, he
looks like an elegant Humphrey Bogart, his face shadowed by a slouchy hat
and his gloved hand dangling a cigarette.) Lee became "ugly, fat & bad tem-
pered" while with Rodell, Joella told Mina with a touch of satisfaction.
Although Lee spent a few weekends in Poughkeepsie with him, she was too
busy to go home for her twenty-sixth birthday.

In May, Julien screened *The Blood of a Poet* at the New York Film Society,
which he ran like a club. Committed to finding a New York audience for exper-
imental film after seeing *L'Age d'or* with Lee, he had enrolled an enthusiastic
group of backers (Crowninshield, Dos Passos, Sherwood Anderson, George
Gershwin, and Nelson Rockefeller, among others) after his return from Paris.
The film society had already shown *Ballet Mécanique* and *L'Age d'or,* along
with Disney cartoons and Harold Lloyd silents. On May 17, 1933, the
cognoscenti gathered in the society's rooms on East Fifty-seventh Street to
watch *The Blood of a Poet,* preceded by Robert Benchley's *Sex Life of a Polyp.*
To change the mood after this intriguingly titled short, Julien discoursed about
Cocteau. For the Frenchman, film was another experimental medium, he said,
and *Blood* "the visual transcription of a poem." The film had the right kind of
artiness for connoisseurs. Lee was "extremely good, playing with . . . rapt
intensity," a reviewer wrote. Houseman, mesmerized by her lips' migration
onto the poet's torso, continued to dream about her sex life.

In June, the Millers became involved in wedding plans for their sons.
After Catherine Sague, the daughter of a former Poughkeepsie mayor,
accepted John's proposal, they were married beneath a floral pergola on the
Millers' lawn. The newspaper noted the presence of "Lee Miller of New York
City, widely known art photographer." Erik and Mafy waited for Lee's return
from a vacation in Maine with Rodell to solemnize their vows in August; then,
after a trip to Niagara Falls, Erik went back to work with his sister on a group
of theatrical portraits—the kind of work that came her way now that she was
the most stylish photographer in town.

∞

Lee's gift for remaining on good terms with ex-lovers, unsuccessful suitors, and assorted admirers resulted in her being involved in the most exciting event of the 1933–34 drama season. Through her old beau De Liagre and new friends like Houseman, the theater world adopted her. That she was a sought-after participant in avant-garde ventures became all the more apparent that autumn, when *The Blood of a Poet* began a two-month run at the Fifth Avenue Playhouse. Lee's photographs decorated the foyer; according to the program, the muse-turned-artist had been the source of inspiration for "Monsieur Cocteau."

The film became a topic of conversation at Kirk and Constance Askew's "at homes"—where one met the trendsetters who supported Julien's film society, the Museum of Modern Art, and the couple's new project, the world premiere of the Virgil Thomson–Gertrude Stein opera, *Four Saints in Three Acts.* Each Sunday at five some of the most innovative New Yorkers gathered in the Askews' drawing room to drink, flirt, and make contacts. After joining the regulars there, Lee met or remet such people as Thomson, Aaron Copland, Carl Van Vechten, Henry McBride, Lincoln Kirstein, Agnes de Mille, George Balanchine, Joella, Julien, and the Levy gallery artists—Dalí, Tchelitchew, Campigli, and the two Bermans, Leonid and Eugene. Everyone knew that their hosts were aligned with old money that could be called on in a good cause, provided it.was also amusing.

When Thomson sailed to New York from Paris in October, he meant to capitalize on Gertrude Stein's unexpected fame in the United States after the recent publication of her *Autobiography of Alice B. Toklas.* Intending to mount *Four Saints* that winter, he persuaded Houseman to direct. Houseman's European manners, he insisted, made up for his lack of experience. The Wadsworth Athenaeum in Hartford would provide the venue; an Askew-backed group called the Friends and Enemies of Modern Music offered a budget of $10,000. Within a short time, Houseman engaged Florine Stettheimer to design the sets, Frederick Ashton to choreograph, and Lee to be official photographer. Since Thomson believed that American blacks would embody the opera's spirituality, Houseman also engaged the best singers and dancers in Harlem. This production is now part of theater history. In the winter of 1933, however, it was not obvious that an idiosyncratic modern opera would be taken seriously, let alone draw crowds. To the press, Stein was a joke—the mama of Dada, a literary Cubist, or, as the *Boston Globe* put it, "the high priestess of the cult of unintelligibility."

The press also seized on the novelty of an opera performed by Negroes. Thomson, who was not immune to the prejudices of his time, told Stein that

Four Saints in Three Acts (*White Studios*)

he wanted black singers because of their rhythm and style but did not intend to produce "a nigger show." Rather, he hoped to achieve the opera's note of "solemnity and grandeur" with an ensemble of dark bodies. (If necessary, he added, they could be painted white, to reflect the transparent light demanded by Stettheimer.) In the 1930s, black actors *were* seen on Broadway, but as mammies, minstrels, pickaninnies, or prostitutes. In Stein's opera, they would sing the kind of music reserved for white performers and play roles that went beyond clichés about "Negro life."

Thomson and Houseman found their singers through Eva Jessye, a classically trained teacher and choir director. Jessye, who had worked in Hollywood on King Vidor's *Hallelujah,* called *Four Saints* a breakthrough "because up to that time the only opportunities involved things like 'Swanee River,' or 'That's Why Darkies Are Born,' or 'Old Black Joe.'" With this opera, she explained, they were "on fresh ground." Shocked by the poverty in Harlem, Houseman took the unusual step of paying the cast for rehearsals, at a time when discriminatory hiring meant that black performers regularly earned less than whites.

Rehearsals began in December at St. Philip's Episcopal Church, on 137th Street. One cold day toward the end of the year, Lee went to Harlem to take photographs. After arranging her cameras in the warm, stuffy basement, she posed the cast—eighteen principals, twenty choristers, and six dancers—one by one. Eva Jessye faced the camera with the same self-assurance she showed

in dealings with Thomson's attempts to authenticate her singers' diction (she explained that she had been a black person longer than he had). Similarly, Lee's portrait of Bruce Howard, the woman who played Saint Teresa II, brought out her force of character. Head shots of Edward Matthews (Saint Ignatius) and Embry Bonner (Saint Chavez) reveal the men's softer side, in the same way that her photographs of Houseman, Thomson, and Ashton suggest their creative vision. As a group, Lee's portraits are empathetic. The participants are seen not as professionals preparing public selves but as friends engaged in an unusual venture.

Four Saints opened on February 8 in subzero weather. The biting cold did not keep art-world movers and shakers from descending on Hartford "by Rolls Royce, by airplane, by Pullman compartment," the *Herald Tribune* quipped, "or for all we know, by specially designed Cartier pogo-sticks." (The New Haven Railroad added special parlor cars for the less adventurous.) It is not known whether Lee joined the stylish crowd that night but her work was present in the much-admired program—now a collector's item—which featured her portraits of the company.

It is likely that Lee attended *Four Saints'* New York opening on February 20, when Houseman took the opera to Broadway. In the audience that night were her old friends Neysa McMein, Dorothy Parker, Henry McBride, and other arbiters of café society. *Four Saints* became the hit of the season. Through its run of sixty performances—the longest for any American opera—guests at cocktail parties debated Stein's libretto, people waved the program at one another in the street, and George Gershwin found inspiration in the opera for *Porgy and Bess,* produced the following year with Jessye as choral director. By Easter, Gimbel's was displaying spring fashions as "4 suits in 2 acts," and Stein's enigmatic phrase "pigeons on the grass alas" had entered the American vernacular. Constance Askew spoke for her circle when she recalled, "It *does* stand for the best part of our lives."

One wonders whether Lee's work on *Four Saints* prompted *Vanity Fair* to name her as one of the seven "most distinguished living photographers" in May. (The list also included Huene, Beaton, Muray, and Genthe.) To the magazine's request for "pictures of the girls whom they consider the most beautiful they have ever photographed," Lee sent her image of Renée Oakman, a blonde of the Jean Harlow type whose features suggest a more reserved version of herself. Beaton chose his portrait of the well-dressed Mrs. Harrison Williams, and Huene a close-up of Nathalie Paley, of the Paris *bal masqué* crowd. "Thus do tastes differ," *Vanity Fair* mused, "and thus is the world saved from dullness." Bourke-White's shots of the new NBC radio tower, which ran a few pages before this feature, may have given Lee pause. While her portraits were said to be distinguished, judging by their restraint, her heart was not in them.

Toward the end of the month, Lee surprised her family and friends by

turning her back on the stylish life in which she had become a fixture. After hearing from Aziz, who was on his way to New York on behalf of the Egyptian Railway, she closed her studio and went to a "fat farm" (Hay-Ven?). "She disappeared for a week," Houseman recalled, "and returned having lost about fifteen pounds, radiantly beautiful; she went out and bought or got someone to give her a few glorious dresses so that by the time he arrived, she was in prime condition."

A few days after Aziz's arrival in June, Lee took him to Poughkeepsie for the weekend. Theodore showed him around DeLaval, where he studied the separators, especially those used to purify oil; one engineer to another, they discussed ways to irrigate the Egyptian desert. Aziz celebrated Theodore's sixty-second birthday by presenting him a box of the best cigars. In July, when they returned to Poughkeepsie, Lee and Aziz went driving and swimming with Theodore but said nothing of their relations. Her parents accepted him as they had Rodell and other friends. It must have come as a shock when Lee asked Florence's opinion of Aziz. After hearing him deemed acceptable, she told her mother, "That's good—because I married him."

The wedding had taken place in Manhattan on July 19, in a civil ceremony with an official who warned Lee about marrying a foreigner who was also "black" (she became so angry that their paperwork was expedited). Later that day, they were also wed according to Muslim law at the Egyptian consulate. According to the marriage contract, Aziz could have up to four wives, divorce Lee when he pleased, and refuse to let her leave the house without permission. Contrary to custom, the bride had no dowry. Perhaps none of this mattered.

Of Lee's many friends, few made her husband's acquaintance. After she introduced him to the Levys, Joella told Mina that Aziz "although not distinguished is really very nice and much better than Man Ray," and added that Lee would "give up photography to go to Egypt." To some, the age difference was telling: Aziz was forty-three, and Lee, twenty-seven. But for most of her friends, Houseman recalled, Aziz was "a sort of mystery figure, out of the Arabian Nights, this man who was coming to claim her, and he did, and she vanished."

Lee's vanishing left several people in the lurch, including Erik. Although he and Mafy had closed their apartment for the summer and moved to her family's, he was out of work unless the studio could reopen in the fall. No doubt Lee also waited to tell the family her news because she felt guilty about deserting her brother. Casting about for a solution, Lee had Jackie Knight cable Man "to ask if he wanted to avail himself of her organization." When Man did not reply, she turned to Julien, who said to tell Duchamp of this opportunity for Man to return to New York. "The year seems propitious," Jackie wrote; Man's book had been well received; Lee would be glad to turn

over "her many and profitable accounts." "My acquaintance with the field leads me to believe that he could command the best of the photographic business at the highest prices," the letter continues—in a shameless attempt to keep the "organization" going. But Man, who had long since ceased to hold himself in reserve for Lee, cabled by return, PULL YOUR OWN CHESTNUTS OUT OF THE FIRE.

A large party, including friends, family, and the Egyptian consul, came to the Italian Line pier on September 1, to see Lee sail in state on the *Conte di Savoia.* "Lee Miller a Bride," the *New York Times* announced a few days later. The article, probably dictated by the Millers, notes that the happy couple would live in Cairo and Saint Moritz. It also gives a highly selective account of Lee's life thus far: "Mme. Eloui Bey, whose father is works manager of the DeLaval Separator Company here, has been a commercial photographer in New York."

Part Three

Madame Eloui Bey

Lee and Aziz Eloui Bey, Egypt, c. 1935

Chapter 8

Egypt

(1934–37)

Lee embarked on marriage as if it were a holiday. Aziz had booked her on the *Esperia,* one of the Mediterranean's most luxurious steamships. At Genoa, passengers from the Paris-Rome Express, for whom the trip was an occasion to display their wardrobes, came on board in high spirits. For the next four days, as they cruised the Mediterranean, ladies exchanged their morning clothes for tea gowns, then, at night, robes suitable for dining at the Ritz. Lee had ample time to ponder her decision. She was now the wife of the generous man who would meet her in Alexandria. The struggle to maintain her studio was behind her; Aziz would take charge.

By 1934, Lee's modus operandi—spurts of activity followed by periods of exhaustion—had become self-defeating. She often regretted her lack of education, despite having learned more with Medgyès, Flanagan, and her teachers at the Art Students League than most did at college, and despite her professional training with the masters.

Her impulsive decision to leave New York also expressed her discontent with glossy magazines. In the 1930s, American photography was enmeshed in the country's ideals, its love of speed, machinery, and consumerism. More than before, ads featuring celebrities encouraged ordinary people to identify

with their privileges; modernist techniques put to commercial uses urged them to accept the truths of the surface; Steichen was still turning out images that reflected the materialism of the day. This was "photography off its track," Walker Evans wrote, an aesthetic of "technical impressiveness and spiritual non-existence." Feeling the limits of this approach, Lee abruptly turned her back on the premise that what mattered was the sheen of metal and the glow of skin tones.

Before Egypt, she had lived on the surface of things—as if her childhood traumas had never happened. Aziz told the Millers that his fondest wish was to "bring peace to her heart." "I would like to impress upon you not to worry for her," he wrote in the first of the many letters that tell the story of their marriage from his perspective. As his wife, Lee would find the serenity that had thus far escaped her. If she did not like Cairo, he would arrange a transfer to London. "We have no secrets one for the other & we will get along in this difficult life quite well & despite our much troubled souls," he concluded.

Judging by the course of their life together, Lee kept more than a few secrets, and Aziz never fully grasped the nature of her trouble. Perhaps she did not understand it herself.

∞

Lee saw Egypt for the first time as her ship neared Alexandria. Ships approach the coast through billowing waves of color, the blue wash of the Mediterranean turning green, purple, or turquoise as the wind sends it crashing against the fortress at the harbor's entrance. The Bride of the Sea, the local name for Alexandria, is a place haunted by ghosts—Antony and Cleopatra, the great library, the ancient lighthouse of Pharos. In the 1930s, Alex (as it was called by expatriates) was popular with the Egyptian royal family, the upper class, and resident foreigners, who fled the heat of Cairo for their villas along the corniche. After Aziz guided Lee through customs and past the throngs of beggars, her holiday began with a rest at his beach house before the long drive south to Cairo.

Travelers new to Egypt need time to adjust to the landscape. It would take months before Lee picked up her camera and focused on the interplay of unfamiliar shapes and colors. At first, as she gazed out the window of Aziz's car, it may have seemed that there was little to see. When the sun came out, she would have noticed the silvery irrigation canals flickering across the alluvial plains, the clover and wheat bristling with red poppies, the fields where children in pink and yellow toiled with their blue-shirted fathers and mothers in head scarves—the fellahin, or Egyptian peasants. Perhaps she noted, too, how compositions appeared of their own accord in the villages—a minaret's spire forming a contrast to the low mass of peasant

huts, or, in the distance, sandhills turning ochre, gray, and mauve toward sundown.

The delta depended on irrigation from the Nile, which had been flooding since August. By September, the floods had turned low-lying plains into an Egyptian Venice. Aziz surely explained that in winter, when the water receded, the fellahin would again wield their ancient implements—the *shaduf*, a bar attached to a bucket that swiveled and dipped into the Nile, and the *sakia*, a waterwheel turned by blindfolded oxen plodding in circles. But now, as the floods threatened the railway tracks, the problem was too much water rather than not enough.

Aziz had just held a meeting with his superiors at the Ministry of Railways. They were now obliged to confront a situation "which makes them look as if they had something to do," he wrote the Millers. (Government jobs offered educated Egyptians prestige and political influence: they were seen as sinecures.) It distressed him "to see this valuable water wasted into the Mediterranean," he went on, since with modern technology, it might be diverted to the desert for large-scale reforestation—which would change the climate and "make Egypt a more pleasant country." Having invested in the local branch of Portland Cement, he gave Lee the bulk of his shares as a wedding gift and earnest of his belief in the future.

Europeanized members of the elite like Aziz looked to technology as the means to bring Egypt into the twentieth century. But while the Nile might eventually be tamed with a series of dams, the fellahin were another matter. Nationalists and foreigners agreed that they had changed hardly at all since the pharaohs. These stalwart peasants were the guardians of traditional values, "the sinews of national strength," as Lee's *Baedeker* put it—their character "a product of the soil itself."

The myth of the eternal peasant was a source of both pride and concern among the Egyptian elite, in part because they relied upon the millions of peasants at the base of the social structure for their own comfort. (Labor was incredibly cheap; middle-class households had complements of servants.) The Wafd Party, a group of progressive nationalists, had for years focused on the "social question"—the huge gap in standards of living. Yet most fellahin would not have imagined their lot differently. Foreigners, especially those from the United States, often concluded that Egypt was a land of the past rather than part of the modern world.

Lee's first impressions of her new home and its contradictions have not survived. She may have been too disoriented by the heat, the flies, and the difficulty of travel to concern herself with the peasants as Aziz and she drove past their sodden fields. One wonders whether she took in the slow-moving traffic on the embankments, whether she noticed the women with water jars on their heads or bearing loaves of bread. Later, she would see in the fellahin photo-

graphic subjects combining the strange with the familiar. For now, she approached her new life as Aziz's bride.

Baedeker's Egypt began by cautioning foreigners against "intercourse with Orientals." ("The average Oriental," the guidebook warned, "regards the European traveller as a Croesus, and sometimes too as a madman—so unintelligible to him are the objects and pleasures of travelling.") Travelers like Lee were unlikely to meet Egyptians other than servants and the Europeanized elite, who had, for generations, been attuned to such pleasures; but while their degrees and titles were listed in *Le Mondain Egyptien,* the Who's Who of Egypt, no guide to the expatriate colony existed. If one had been written, the author would have had to describe the many national and religious groups that made up the large foreign community.

To the entrenched British residents, Egypt was an outpost of the Empire—like India but closer to home. The British had established a protectorate in 1914 after decades of occupation; Egypt remained a de facto dependency. The British high commissioner, Sir Miles Lampson, was a favorite with King Fuad, but his impressive bearing (Sir Miles was six feet six) had not endeared him to the Wafd Party, whose campaign for nationhood would soon inspire widespread social discontent. Just as Sir Miles oversaw the administration of Egypt, British managers supervised their local counterparts, a situation that underlay Aziz's reservations about the British. (He nonetheless maintained membership in the Gezira Sporting Club, where members watched British military parades while sipping gin and tonic.)

Despite, or because of, his years in England, Aziz was a Francophile. To belong to the French-speaking elite, a contemporary wrote, "was to think of Cairo as home, but to believe that Paris was the navel of the world." In French-speaking Cairo, Lee's Paris years enhanced her glamour. And since members of the Francophone community, which included Greeks, Copts (Egyptian Christians), and Christian Arabs, spoke with a variety of accents, her Yankee twang was of no importance. Speaking French marked one as an educated person. The language of the courts, banks, and cotton houses, it was also the lingua franca in department stores, hotels, brothels, and among the well-to-do—Muslims, Copts, and Jews alike.

Within a short time of her arrival in Cairo, Lee's efforts to adjust were complicated by the hazards of life there, among them a plague of mosquitoes and the collapse of the sewer system—both consequences of the floods. Fearing for her health, Aziz took her back to Alexandria. They lounged in their beach cabin, played bridge, and visited the nightclubs, often with the Wissa family, prominent Copts with cotton plantations up the Nile, or with members

of King Fuad's entourage. Lee became friendly with vivacious Gertie Wissa, a champion bridge player a few years younger than she, and met the king's chamberlain, Ahmed Hassanein Bey, a distinguished explorer. One can imagine the Oxford-educated Hassanein stirring her imagination with tales of his treks across the Libyan desert, and of the intrigues surrounding his post as tutor to Fuad's heir, Prince Farouk.

Lee looks relaxed in a snapshot taken about this time; one hand rests on Aziz's hand as she strokes his knee with the other. "Lee is happy," he wrote the Millers, then added, "It is not easy to settle down smoothly considering her much troubled soul" (a recurrent phrase in his correspondence). She might not be able to tolerate the discomforts endemic to Egypt—dust, flies, mosquitoes (nets over the bed were the only protection), and typhoid injections. But worse than these, the lack of stimulation made her restless. "Her brain must work to occupy Lee's time," Aziz went on. "When she is rested from the strenuous life of New York, she will be much better."

After their return to Cairo, Lee met more of Aziz's friends, whose wives took turns inviting her to their homes. She became an object of curiosity. As a foreigner and a non-Muslim, she was not required to follow the code that confined the women to their quarters, the *haramlek*. European women were known to be less inhibited than local ones, who had their reputations to think of (as well as their health, since syphilis was widespread). Cairenes gossiped about the few foreigners married to Egyptians: Vicki Sadik, a Jewish beauty said to have been the mistress of Iraq's King Feisal; the ex-barmaid Katie Osman Pasha, the wife of an influential Wafd leader; and Madame Abboud Pasha, a Scot married to one of the richest men in Egypt. Since marriage was normally a business enterprise, the alliance of clans rather than of individuals, Aziz's marriage to Lee was seen as a rich man's caprice.

Unlike Aziz, most men of his class kept their female relatives in *haramleks*. "None of their wives had seen a man since they were twelve years old—except for their fathers, brothers, and husbands," Lee recalled. "The harem wives would spend their time behind the grillwork on balconies playing brilliant bridge and poker and watching the men's parties in the room below where I, of course, as a foreigner would be allowed." Yet despite their isolation, these women knew "more of what was going on behind the bushes and in the shadows. . . . I became their Scheherezade, telling them stories which were as fantastic to them as the Arabian Nights were to me," she continued, "what it was like to work for a living, to be with men all the time, to travel with them." Their questions made her reflect on freedoms she had taken for granted.

Soon after her arrival, she and Aziz drove to Assyut, a Coptic market town in Upper Egypt, to stay with the Wissas. "We had a marvelous time except for an attack of mosquitoes, which made Lee very miserable," and the drive, Aziz wrote, which "nearly ruined our beautiful friendship." When not battling mos-

quitoes, they watched the river traffic—feluccas loaded with scrap iron and vegetables, paddleboats taking tourists to Aswan, river barges carrying fellahin and their goats from one bank to another. Perhaps they stopped to admire the local pottery, the silver and gold scarves made by the Copts and the dam across the Nile. Aziz would have explained Assyut's importance at the crossroads of caravan trails leading west to the desert and south to the Sudan.

They spent the next few days at the Wissas' estate at Beni Korra, where Gertie's brother Victor ran the family cotton business. The Wissas' fortunes had grown with the success of Egypt's prime export, the long-staple cotton prized around the world. Writing to Theodore after the trip, Aziz reported that Lee had played bridge with Gertie rather than inspect the mills and that both of them had enjoyed the Wissas' largesse. "We ate so much that we must have gained at least a pound," he added.

The photographic record shows that at Beni Korra, Lee began trying to know Egypt by photographing it—a process that would include reframing the scenes she had gazed at through Theodore's stereoscope. Some of these Egyptian images show her desire to comprehend her husband's country. Others reflect on her vantage point: her position as an independent woman is implied in their odd perspectives and hints of stasis or escape.

Lee roused herself from her bridge game to visit the Wissas' mills on at least one occasion, when she photographed piles of cotton sacks whose contents seem about to burst out of their containers. A latent sexual energy, here leavened by a teasing humor that associates woman and nature, informs what may be her first Egyptian landscape. As stand-ins, or cover-ups, for feminine anatomy (the sacks resemble breasts with pointy nipples), these suggestive shapes point toward their ethereal counterparts, the cottony clouds above them in the sky. A companion image, *Cotton Struggling to Escape from Sacks to Become Clouds,* conveys the same sense of restlessness along with an idiosyncratic perspective on Egypt's national crop.

Toward the end of 1934, Aziz was still thinking about leaving Egypt. Although the details are not known, it is likely that during her first year of marriage, Lee suffered a miscarriage, an event that colored their life together from then on. Though it was too soon "to decide whether Lee will definitely like to stay here," he told the Millers some time later, she was "happy & will be even better in the future." There was "nothing to worry about," he continued—reassuring himself as well as her parents.

∾

Over the next two years, Lee pieced together Cairo's social geography. At first, she and Aziz rented an apartment while the mansion he had shared with Nimet was being renovated. The Villa al Beit, which would be Lee's new

home, was in Dokki, a residential section on the west bank of the Nile across from fashionable Zamalek, and near the Gezira Club. Like Heliopolis, to the northwest, and Maadi, to the south, these areas had been developed for Cairenes wanting to escape the dust and donkeys of old Cairo. English residents clustered in Zamalek's comfortable villas, shaded by scarlet flame trees and mauve jacarandas. Americans generally preferred the tidy garden villas of Maadi.

Although houses in these areas often copied the "Modern Style" buildings of Paris, their interiors warred with their façades. "With this new pretentious architecture," a Cairene wrote, "came a plague of cabinetmakers and agents for reproduction antique furniture from Paris, London, and Milan, all vying with each other to fill spacious halls with imitation Hepplewhite, Sheraton and Scottish Baronial." The prevalence of French copies prompted jokes about a local style called "Louis Farouk." Aziz's compatriots were "diseased by French bad taste," he told the Millers. Because Lee disliked the Villa al Beit's dark wood paneling and old-fashioned armoires (which had suited Nimet), Aziz planned extensive repairs, including American closets to replace the "ugly wardrobes" and the refitting of the top floor as Lee's studio.

While renovations dragged on, Aziz and Lee lived with his brother Kemal, the director of the Egyptian National Airlines. Scions of one of the Turko-Circassian families that had run the country for centuries, the Elouis were local aristocracy. Their father, Dr. Mohammed Eloui, had supervised the Cairo Board of Health, run the Egyptian National University during the Great War, and been the personal physician to King Fuad's sister. (A street named for him still exists near the Cairo Bourse.) Nicknamed the God of the Blind, Dr. Eloui made it his practice to visit villages where peasant children were losing their eyesight; he persuaded them to use the ointment he brought by calling it magic. While Aziz's father had been close to the royal family, he also maintained good relations with the Wafd Party.

Little is known about Aziz's politics. He belonged to the Mohammed Aly Club (which recalled the atmosphere of London's St. James's Club), but was also close to political figures like George Antonius, a Cambridge graduate who became a spokesman for the Arab cause. Like Aziz, Antonius bridged several worlds. When Lee met him, Antonius was in the process of writing *The Arab Awakening*. His wife, Katy, was the daughter of Dr. Fares Nimr, the publisher of a leading Arabic newspaper. Lee also met Katy's sister, Amy, a painter who had studied in Europe before her marriage to Walter Smart, the British diplomat known as "Smartie." While these worldly couples met regularly at the Smarts' house in Zamalek, Lee did not warm to Amy, whose taste seemed too obvious (her rooms displayed her fine china, Persian rugs, and English novels, all covered with gold or silver paper).

Intellectuals like the Nimrs and their spouses were the exception in Lee's

circle. The frivolous set with whom she often socialized were members of the Greek-Levantine elite that lived on inherited wealth or the proceeds of their cotton works. They wore French clothes, shopped at Vuitton and Christofle, and vacationed in Europe. When at home, they preferred tennis and gambling to serious pursuits. Women of Lee's cohort, the "black satin and pearls" set, spent their days shopping, gossiping, and seeking out new arrivals who could bring excitement to their lives. Lee soon absorbed the thirst for novelty that afflicted Cairenes in winter, when the city became a stop on the Grand Tour.

For newcomers to Cairo, French *Vogue* explained the expatriate's typical day: "Before lunch, one drinks cocktails at Shepheard's, where you will meet travellers coming from Syria, India, and the East." (Lunch was to be taken at the hotel grill.) Shepheard's, founded in 1841, had begun as the Middle East

Rosezell Rowland, Baron Jean Empain, and Dianne Rowland in Cairo

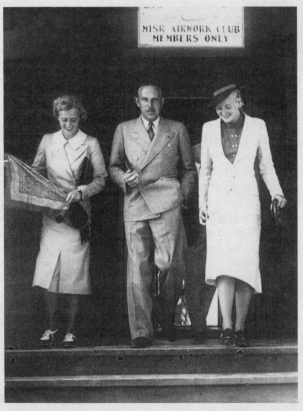

headquarters for Cook's tours. From its shaded terrace the cognoscenti watched the hubbub on Ibrahim Pasha Street; inside, the Moorish Hall offered refuge from the heat. Habitués, lounging on antimacassared chairs, sipped Pimm's cups or tangoed across the ballroom, whose lotus pillars, it was said, were inspired by Karnak.

Shepheard's was not to everyone's taste. Its decor was "Eighteenth Dynasty Edwardian," a visitor quipped; another thought that it looked like the British Museum. But if you wanted to find someone, one of Lee's friends explained, "you'd call Shepheard's and ask the operator, who would say, she's playing bridge at so and so's." (Men headed for the hotel's Long Bar—where Joe, the Swiss barman, heard but did not repeat their secrets.)

Groppi's, an Art Deco café near the department stores, bookshops, and galleries, offered an alternative to Shepheard's. In the late afternoon, the black-satin-and-pearls set gathered beneath the glow of the pâte de verre lights or under the umbrellas in the café's garden. Waiters in white galabias and red sashes glided from table to table with trolleys of decorated cakes. Affairs of state and of the heart were dissected while patrons savored Groppi's chocolates or, for the weight-conscious (weight was increasingly a concern of Lee's), their sugar-coated almonds.

During the winter season, the same women displayed their pearls at the Royal Opera House (where harem wives hid in screened boxes) or at the Comédie Française, whose repertory company purveyed Racine and Molière to the Francophiles. Jazz lovers congregated at the Café de Paris; cinema buffs watched movies in English or French with Greek, Arabic, and Italian translations on the side. The well-to-do drank champagne at charity balls; the most attractive newcomers were invited to dine with the immensely rich Baron Jean Empain, who was said to own Cairo's tram and electric networks, half the Belgian Congo, and all of Heliopolis.

Cairenes speculated about what went on in the baron's residence, the Palais Hindou, which resembled a surreal Angkor Wat. Baron Jean, a cross between a playboy, a showman, and a debauché, was known to surround himself with comely young women, most of them foreign. People said that guests ate from gold plates while footmen stood behind them, that dinner ended when the baron blew ear-splitting blasts on his French horn, and that alcohol flowed before, during, and after these repasts.

Lee joined the festivities at the Palais Hindou the following winter, when Rosezell Rowland, a young American dancer known as Goldie, became the baron's favorite. (Goldie's nickname came from her dance routine, an elegant striptease in which she appeared nude except for a few veils and the gold paint covering her body—a performance that had caught the baron's eye when he saw her onstage in London.) During Lee's first Egyptian winter, her social calendar was restricted to invitations by members of le Tout-Cairo. Although she

had not yet formed close friendships, "everybody Lee meets likes her," Aziz
told the Millers. Renovations at the Villa al Beit would be done early in 1935,
he hoped, when they would start repaying their invitations now that he was
being considered as undersecretary of state.

In the meantime, Aziz engaged household help—some fifteen servants,
including a personal maid for Lee, a Yugoslav woman named Elda. Lee's pas-
sion for cooking in later life, she explained, began when their Italian-trained
cook refused her access to the kitchen. (He had adopted as his culinary bible
the French cookbook *Ali-Bab,* chiefly due to the title.) Lee took pleasure in
the local food—the round flatbread, charcoal-grilled lamb, mint and yogurt
sauce, okra and melokhia (the leafy green that makes Egyptians homesick),
and sweets made of apricots or scented with rosewater. Their cook's dishes—
the antidote to Dr. Hay's diet, in which food groups could not mingle—
were an alchemy of tastes. "I was delighted," Lee recalled, "by the wonderful
Near Eastern dishes he prepared, such things as cheese and cucumber
salad . . . and meat balls with cinnamon and cumin."

Like other foreigners, Lee learned enough "kitchen Arabic" to get along.
Unlike most, she began the study of the language at the American University
of Cairo. (The AUC attracted mostly Greek, Jewish, and Levantine students;
Muslims enrolled at the National University.) The university, which held
classes near Aziz's ministry, had the advantage of requiring her presence in
town; she enrolled in chemistry as well, to gain control of the solutions used in
photographic processing.

By the end of June 1935, when the temperature registered one hundred in
the shade, Lee and Aziz agreed that they needed a change. While Alexandria
was twenty degrees cooler, the prospect of life there was not appealing. "Both
Lee & myself feel we should be perched on a mountain for at least 6 weeks,"
he told her parents, even though she had "stood the test of a summer with
great courage." To please her, he was planning a flight to Palestine with Kemal,
who hoped, with Aziz, to create an association between the countries' trans-
portation systems, as part of the government's plan to increase foreign rev-
enues.

In July, they flew to Jerusalem and spent the day before going on to Cyprus
to fulfill Lee's desire to see the crusaders' castles, and to swim, Aziz wrote,
"where Richard Coeur de Lion got a headache from thinking whether he could
break his habit & take a bath." Traveling in the footsteps of these childhood
heroes motivated her to take more photographs, framing the perspectives they
had seen through the castles' doors and windows. "I . . . got sort of inspired,"
she told Erik, "and did about ten swell ones."

A week later they drove to Alexandria, put the car on board, and sailed to
Europe, where they would spend the next two months, starting in Saint
Moritz. Once settled at the Villa Nimet, Lee developed back pains—"a show

of sensitiveness considering the sudden change of weather," Aziz thought. Aspirin made the pains disappear, but after joining him for her first game of golf, Lee told her parents, in one of her few surviving letters to them from this period, that she felt "very stiff, lame & old" (she was twenty-eight). She and Aziz played bezique, cooked, and walked vigorously uphill, but were so dispirited by the outlook of the summer residents and the shopkeeper mentality of the Swiss that Aziz decided to sell the villa.

In September, they visited Basel and Berlin, then spent a month in London, where Aziz bought a British car. On their return to Cairo in November, Aziz learned that someone in the upper echelons had taken advantage of his absence to have him demoted—in order to make his post available for a relative. When he tried to resign, his superior talked him into staying on. "The atmosphere is charged with electricity," he wrote.

Following Italy's annexation of Ethiopia in 1936, the political atmosphere was also full of tension. Although Egypt's support of Britain was initially popular, it was soon undermined by Italian propaganda. Students disillusioned with the country's leaders took to the streets by the thousands; when soldiers killed several of them, the government resigned. "Only the presence of a large British army on account of the coming war prevented a revolution," Aziz told the Millers. Yet he had little to say for the occupiers: "They failed shamefully when they wanted to take advantage of their actual increased power." Aziz felt so strongly anti-British that he planned to sell his new car in protest.

The political instability disturbed Lee chiefly during AUC's closure in December. One day she was trapped in a crowd of demonstrators; flirting with their captive as the police surrounded them, the students led her through a narrow passage to safety. "You can be perfectly quiet about her," Aziz told her parents. Apart from such disturbances, Lee was "fit and happy," he reassured them. "She looks healthy & feels devilish," and when not in riots was "becoming a chemist." Now that she had a license, she drove the car to town—though her command of it gave him "the jitters"—a term he picked up from Lee, for whom it meant the periods of nervous agitation that had assailed her since childhood.

∞

While Lee had, for the time being, found ways of occupying herself, Erik had been unemployed since the closing of her New York studio. He and Mafy had been living with the Millers in Poughkeepsie, where Erik set up a darkroom for the rare assignments that came his way. "It was a good thing I didn't have to support myself on that kind of income," he recalled, "or I would have starved to death." It had broken his heart, Aziz told the Millers, to have caused Erik's difficulties: "I will try & find something for him," he promised, "maybe in the

cement factory or [as] agent for an air cooling firm." Creating a job for Lee's brother in Cairo would assuage Aziz's guilt and provide her with company. Aziz studied the situation, but with the change in his own prospects was unsure how to use his influence.

Lee still hoped that Erik and Mafy would join them. In a letter probably written in 1935, she explained that the cost of living was low: "An apartment in the middle of the town costs about 5 pounds and a servant about 3 pounds. Food is much cheaper than in America, and the foreign colony is so enormous that any number of congenial friends should be available. Mine for instance are all gambling. Aziz's are all sport. It never rains—so there is permanently tennis, golf—swimming—sailing—squash and even cricket—god help us!—as well as duck shooting—snipe in winter—fishing in Suez and desert expeditions to make. The language is no problem because no foreigner ever learns more Arabic than the first ten days and English is spoken generally." (By then she had abandoned Arabic in favor of "rotten detective stories.")

Wondering whether Erik was still keen on photography, she added that she had gotten over her temporary "loathing" for the art, completed a roll of film, and found a printer. "I'm taking an interest again," she continued, now that a Kodak representative had come to Cairo to set up a Kodachrome plant. She had recently driven him to a nearby village to take photographs, she continued, but the trip was marred by an accident: "Unfortunately I ran over a man or something—you see if you hit anyone here in the country, you are expected to beat it—in fact the Consulates always say HIT AND RUN—and report afterwards—so it spoiled the trip and Aziz won't let me go again unless I have a sort of guide with me—but the pictures are swell."

Aziz's jitters had been premonitory. By the next summer, his nerves were frayed after trading his old job for two new ones. He was now chief technical adviser to the National Bank of Egypt and codirector, with Kemal, of Carrier air conditioning. For the bank, he devised projects to stimulate the economy—a marble-and-granite works, a power station, a button factory, and a plan to air-condition local hotels and cinemas. Demonstrating the Miller ingenuity, Lee came up with a plan for a glass factory, since all the materials were available. Unexpectedly becoming "an ace in business," Aziz told the Millers, Lee had prepared studies for the project and talked friends at AUC into writing technical reports.

What was more, due to Aziz's efforts to promote air-conditioning by installing it at home, Lee was no longer miserable during the summer: it was now so cool that friends came to the villa every day to play poker. After two years in Cairo, he wrote, she had put on weight (which pleased him) and

developed "an Egyptian complex, which means being a spectator." As the most convincing publicist for his plan to install Carrier equipment in the Parliament and other government buildings, she was, he added, "having the time of her life."

Both Lee and Aziz felt that the time was right for Erik to train with Carrier in the United States and come to Cairo in 1937. "We have had you in our minds ever since we came here," Lee told him, "and although there have been several jobs that you could have done fine—they none of them had a future like this one." Erik's lack of credentials was no obstacle provided he took the course, which Aziz would finance.

Their letters say little about local politics. In 1936, after the death of King Fuad, the Wafd Party returned to power and negotiated the Anglo-Egyptian Treaty, ending Britain's occupation of Egypt and granting support for the country's admission to the League of Nations. But many felt that Britain had gained more than Egypt had. British forces would continue to supervise local troops and the Suez Canal; Egypt would provide military aid in the event of a European war—which seemed likely, given the German occupation of the Rhine and the civil war in Spain. While the government called the Anglo-Egyptian Treaty a triumph of national honor, most Egyptians felt that the British had too much power.

Seeing the world from her new Middle Eastern perspective, Lee also worried about the instability among the Arabs of Palestine. "I get so bitter when I even think of it," she told her parents, "all the money my good Jewish friends have sunk into it—and how wrong they were. You only have to take a good look at the blasted place to be completely floored as to why everyone from the time of Moses has been screaming for that rotten country." That autumn, she spent two months in bed "sulking and just too damn tired to bother with anyone," and in November she underwent a course of glandular treatments in Jerusalem with a specialist, despite her opinion of Palestine.

Feeling sufficiently refreshed to prepare for the arrival of Erik and Mafy, she asked for items that could not be found in Egypt, "a great deal of popcorn" and a popper, Golden Bantam corn seed, buttermilk tablets, Cape Cod lighters for the fireplace, and her raccoon coat for European winters. Aziz had them purchase a Chevrolet sedan in his name, fill its trunk with shotgun shells, and put the car in the hold. (This illegal cargo, Erik recalled, caused them as much distress as the rough winter crossing.)

After their arrival in Alex on March 4, 1937, Aziz shepherded Erik, Mafy, and the Chevrolet through customs by the traditional means: drinking many cups of coffee with the customs official and paying a bribe. Intrigued by this lesson in local business practice, Erik fell in love with Egypt. "I loved the dryness and the smells," he said, "the pungent odour of the smoke from cattle dung and cooking and mules and donkeys and camels." The two-lane road

south seemed well engineered, though it was disconcerting to learn from Aziz that the British had built it to speed up the delivery of troops in case of an Italian invasion. Arriving at last in Dokki, he was deeply moved by the sight of Lee, "with her blond hair and her blue eyes and her arms tight around us, crying and carrying on and then all of a sudden very calm." The Villa al Beit expressed Aziz's position, Erik thought, as did the presence of servants "all over the place."

In a few days, Aziz took Erik to the ultramodern Carrier office and introduced him to the staff: a group of American-trained engineers; their supervisor, a Scot who had installed cooling systems in South African diamond mines; and the Egyptian foreman. After a short time, he and Mafy moved to their own apartment, taking with them their favorite servant at the Villa al Beit, a man named Mohammed, who became their cook, factotum, guide, and, in time, their friend.

Their compatriots, most of whom were with Standard Oil, were "impossible," in Mafy's opinion. They lived outside Cairo in Maadi (where they had their own country clubs), and "might as well have been in Kansas." The American University, which Lee had by then abandoned, was slightly more cosmopolitan, but the American Mission, a blend of Presbyterians, Baptists, and Evangelicals, was of no interest. While Mafy investigated the expatriate scene, Erik worked six days a week with Carrier, whose first assignment was to install air-conditioning in the House of Parliament in time for King Farouk's inauguration.

Left to her own devices, Mafy became Lee's partner in escapades, the foil in whom she saw her own predicament mirrored. Lee's photographs of her sister-in-law's encounters with Egypt bring out her impish spirit as well as her piquant good looks. A cinematic sequence of street scenes and close-ups of Mafy and a friend in the Khan el-Khalili bazaar show her first at the arched entrance to the maze of carpet merchants and trinket vendors, then inside an antique shop gazing at the display while the friend looks up at her from below. Lee's composition positions Mafy as a woman reflecting on her foreignness: shot through the plate-glass window, it frames an arresting moment of self-knowledge.

Residents loved to gossip about "the American girls," as Lee and Mafy were called, whose undefined social status allowed them to defy local custom. One day after an afternoon of shopping, rather than resort to Groppi's they made their way to a bar where they behaved like men in their clubs. Despite his anger at Lee's behavior, Aziz knew better than to interfere. ("He tried to be possessive with her," Mafy explained, "but it didn't work.") Emboldened, Lee and Mafy invaded the Long Bar at Shepheard's. By local standards, they were loose women, but excuses were made for them as Americans, and as Aziz's protégées.

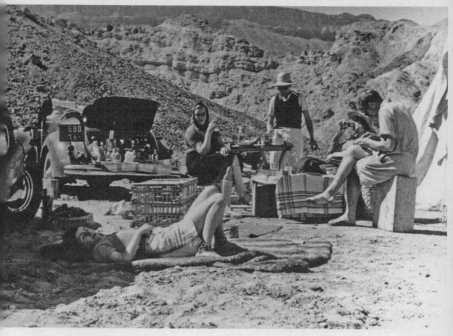

Desert picnic, Lee sitting in the center, Egypt, 1938

Like Lee and Mafy, the women in Baron Empain's circle were among the most liberated in Egypt, though some said that they formed a European harem. The baron surrounded himself with beautiful women because their jealousy of one another made them behave, he insisted, but he had the sense to see in Goldie a mistress who accepted him as he was. Lee, Mafy, and Erik often dined at the Palais Hindou, where the festivities sometimes lasted through the night. In the early morning, guests were called to breakfast and urged by their host to shake off their hangovers with a ride in the desert.

Goldie survived better than most because she did not drink, took easily to riding, and did her best to learn Arabic. These years were, she recalled, an education, but one that had little to do with real life. Members of the black-satin-and-pearls set gloated over the details of the rival pregnancies in the Palais Hindou. When Goldie and another of the baron's companions became pregnant at the same time, he promised to wed the one who bore him a son.

Lee's conduct made her almost as notorious as the baron's lovers, yet she could not help being indiscreet, Gertie Wissa thought. It was no use trying to

change her, she observed years later: "I took her as she was; she behaved like a man." Gertie recalled her dismay when Lee declared, "If I need to pee, I pee in the road; if I have a letch for someone, I hop into bed with him." She added, "This was natural to Lee. She had no morals." Nor did she have any use for the prevailing sexual hypocrisy.

Despite the sultriness of life in Cairo, sex outside marriage was unthinkable for Muslim women, though some of their husbands visited the brothels on the rue Clot Bey. Few risked their position by having affairs. While they indulged themselves in other ways (eating sweets, playing cards, gossiping), a shared sexual timidity kept women from venturing outside the *haramlek*. This fear, along with the mentality of bourgeois Cairo—where neighbors noted whose car was parked outside whose abode—created an atmosphere almost as claustrophobic as Poughkeepsie's.

In the spring of 1937, Lee organized the first of what would become her preferred means of escape, expeditions into the desert. Her plan, to visit the Coptic monasteries of Saint Antonius and Saint Paul, near the Red Sea, required careful preparation. After engaging a guide and a Sudanese soldier whose vehicle was equipped with a sun compass, she talked four carloads of friends into joining her. They were to bring supplies; Lee would provide drinks. Late in the day, as the guide went on to check the road while the group set up camp, Lee brought out a large thermos—which proved to be full of martinis. Everyone laughed, but hours of drinking alcohol made them so thirsty that they downed the guide's water supplies when he reappeared that evening.

Within a short time, Lee was planning desert expeditions with the skill of a military tactician. Treks to distant sites became the antidote to boredom, and taking photographs of them, a way to evoke and transcend her "Egyptian complex." As she moved from spectatorship to knowledge of the country—capturing it, piece by piece, with her camera—photography allowed her to say how she felt as an expatriate and reawakened her eye for incongruities.

She began by photographing sites of the kind that she had seen through her father's stereoscope viewer—the bazaars, pharaonic monuments, and ruins that for most Westerners typified Egypt. Along with such scenes, often taken from odd angles, she also photographed people at work—not as ethnographic subjects but as people like herself. In time, her camera became a means of transport, a way to escape from elite Cairo. Many of her images from this time seem to lack a human presence. Yet if one looks closely, an emotive quality may be implied in the framing, or in the details that shape meaning and show the acuteness of the eye that saw in the desert vast dimensions of shape and light.

Sand Track, taken on a trip to the Red Sea, is perhaps the first of Lee's Egyptian photographs in which space becomes tangible. The image is composed of wavy lines in the sand, not paths that one might follow but tracks

made by the wind. There is no horizon, and in a sense, no frame—these patterns, the photograph implies, continue beyond its borders. The sense of unbounded space is further dynamized by the erotics of the image. *Sand Track* makes a subtle link between creative energy and the oddly lush landscape— here seen not as empty but as a plenitude to which she would escape with chosen lovers and friends.

If *Sand Track* conveys Lee's deepening response to the desert, an architectural study entitled *Stairway, Cairo* hints at the impasse from which she longed to escape. In this melancholy shot of a stairway leading nowhere (the picture edge edits out hopes of arrival), diagonal lines focus the eye on details that suggest confinement. Beyond the stairs a window crisscrossed with metal bars is obscured by a large black cloth. The inhabitants cannot look out, nor can we see in. This composition stages a "no exit."

Seeking a broader perspective on her life in Egypt, Lee went to the top of one of its most famous monuments, the Great Pyramid at Giza. Early one morning, she climbed its craggy footholds step by step with her equipment to take the bold shot that is one of her best-known images—one in which her presence is felt like an invisible signature. While the Great Pyramid is unseen, its mass is implied in the huge triangular shadow cast over nearby fields to the Western Desert, as if the monument points the way toward some new destination. With this theatrical photograph, she met her jitters head-on and defied them.

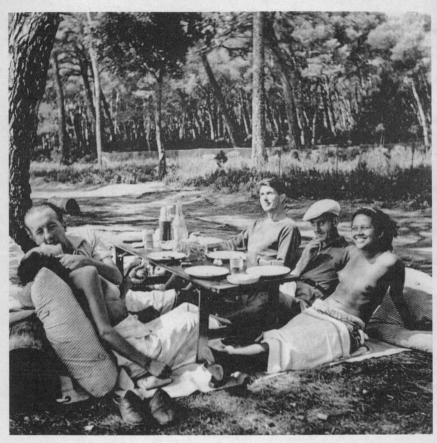

*Nusch and Paul Eluard, Roland Penrose, Man Ray, and Ady Fidelin, Mougins, 1937
(Lee Miller)*

Chapter 9

Surrealist Encampments

(Summer 1937)

Lee began planning her escape in May. For the next four months it would be too hot for desert treks; the prospect of another summer at home, playing cards while the air conditioner hummed, was not inviting. Aziz agreed to her spending the summer in France and with his usual generosity underwrote the trip. Her maid, Elda, would keep Lee company until he could join her there later. The two women sailed to Marseilles, took the train to Paris, and checked into the Hôtel Prince de Galles.

One of the first people Lee contacted was Julien Levy, who asked her to join him at a fancy dress ball that night. After unpacking, she changed into a dark blue evening gown—it was too late to devise a costume—and set off to the party. At first, she watched from the sidelines. The guests seemed to have stepped out of a Surrealist painting. Max Ernst, disguised as a bandit, had dyed his hair bright blue; Man Ray, whom she had not seen for five years, was equally eccentric. The women had gone in for displays of pulchritude. One was draped in ivy; others wore little more than scarves and bangles. Lee's elegance set her apart.

Ernst had brought with him Roland Penrose, a wealthy English artist and collector who was sloughing off his Quaker upbringing in the company of the

Surrealists. Like Ernst, Penrose came as a colorful bandit. His hair was green, his right hand blue, and his pants the colors of the rainbow—a costume that made him feel awkward, until, catching sight of Lee, he felt instead as if he had been hit by lightning.

The groundwork for this *coup de foudre* had been laid by the Englishman's awareness of Lee as muse: she had been the model for Man's most erotic images (Penrose had seen her lips in *Observatory Time* the year before in London), as well as Cocteau's statue and Julien's lover. Others at the party also found her entrancing. Georges Bataille and Michel Leiris agreed that they had never seen a more beautiful woman; Man embraced her as if the bitterness between them were forgotten. Lee stood before Penrose like Surrealist royalty. Delighted when she warmed to him despite "the abysmal contrast between her elegance and my own slumlike horror," the Englishman recalled, he persuaded Ernst to invite her to dinner.

The following night at Ernst's, Lee talked about Egypt, drank liberally, and flirted with Penrose. She awoke the next morning in his bed. For the next two weeks, they were inseparable; Lee returned to her hotel only to change her clothes. It is likely, given Penrose's worship of Picasso (whose work he collected), that they went to the Palais de Chaillot to see the artist's monumental *Guernica,* painted after Germans in Franco's employ bombed the Spanish town. While they delighted in seeing mutual friends, much of their time was spent alone. On his return to London at the end of the month, Roland wrote, "I have slept and woken at last from a dream—shall I ever dream again anything so marvellous?"

Included in his letter was an invitation to join him and some friends in Cornwall for July. Lee accepted immediately. She crossed the Channel with Man and Ady Fidelin, his Martiniquaise lover; Roland drove them to his brother's farmhouse, Lambe Creek, where they were joined by Paul and Nusch Eluard, the English artist Eileen Agar and her companion Joseph Bard, Max Ernst and the young artist Leonora Carrington, the Belgian painter E. L. T. Mesens, and later Henry Moore and his wife, Irina. Guests were urged to shed their inhibitions along with their clothes. "It was a delightful Surrealist house party," Agar wrote, "with Roland taking the lead, ready to turn the slightest encounter into an orgy. I remember going off to watch Lee taking a bubble-bath, but there was not quite enough room in the tub for all of us."

Roland's house party was also a celebration of the newly formed British branch of Surrealism. The year before, he, the critic Herbert Read, and the poet David Gascoyne, who at twenty had published a *Short Study of Surrealism,* conspired to launch the movement in England by rounding up recruits, including Paul Nash and Henry Moore, for an exhibition at the New Burlington Galleries that June. Breton, Eluard, and Man chose works to be sent from Europe; Penrose, Nash, and Read scoured London for British exemplars. On

their visit to Agar's studio, which resembled a mermaid's grotto, they adopted her at first sight. "One day I was an artist exploring highly personal combinations of form and content," she recalled, "and the next I was calmly informed that I was a Surrealist!"

The exhibition—some four hundred drawings, paintings, sculptures, and objects (including Man's *Observatory Time* and Agar's fishnet bath curtains)—caused a sensation when it opened on June 11. "A nation which has produced such superrealists as William Blake and Lewis Carroll is to the manner born," Read declared. During its three-week run, T. S. Eliot stopped to stare at Meret Oppenheim's fur-lined teacup, Augustus John left the hall when Eluard called the Marquis de Sade a martyr for freedom, and a nearly suffocated Salvador Dalí had to be freed from his diving helmet, part of the suit he donned to speak on the depths of the unconscious. The critics' dismissal of the works only strengthened the group's resolve. That autumn, Penrose traveled to Barcelona in support of the Republicans, and the next spring, shortly before meeting Lee, he showed his paintings in the Surrealist section of an international anti-Franco exhibition.

By the summer, he and his friends were ready to celebrate the year's accomplishments—their recognition as the artistic vanguard and their invigorated love lives. The woods surrounding Lambe Creek let in the sun while ensuring privacy; the nearby tidal creek inspired nude bathing. Looking at the snapshots Roland took that summer as Lambe Creek's impresario (which he arranged in albums like still versions of home movies), one feels the group's mutual delight—including their love of al fresco romps and erotic poses. In one group of snaps, Max Ernst, dripping with seaweed, emerges from the creek as the Old Man of the Sea to fondle the breasts of his mermaid, Leonora; in others, Lee greets Roland from their bedroom window, revealing her form without allegorical justification. In still others, she sprawls seductively across the laps of Ady and Nusch while her lover moves in for a close-up.

Lee's jitters all but disappeared in the company of these unconventional friends, whose relaxed sensuality also helped Roland forget his Quaker past. For the time being, while reassuring Aziz with vague letters about her trip, she could live as if she were on her own. Like Lee, the other women at Lambe Creek were full of mischief. One day Ady, Nusch, Leonora, and Lee, all stylishly dressed, sat for Roland's group portrait with their eyes closed (but holding demitasse cups) in a satire on ladylike behavior. Women Surrealists, Agar wrote, dressed "with panache." "Our concern with appearance was not a result of pandering to masculine demands," she continued, "but rather a common attitude to life. Juxtaposition by us of a Schiaparelli dress with outrageous behavior or conversation simply carried the beliefs of Surrealism into public existence." What Agar did not say was that it also excited their partners.

From our perspective, their antics may not seem revolutionary, but at the

time, the group's indulgence in shared fantasies felt like Surrealism in action. Sex, it was understood, nourished the imagination; it was obvious that the currents among them proved Breton's credo—that the lifting of inhibitions meant freedom for all. It would be hard to overstate the group's delight in playing at life rather than having to take it seriously, at a time when war seemed imminent. Eluard, having canceled plans to attend the International Writers' Conference in Spain to join Roland, said he preferred friendship to politics—in the company of those who (like Agar) saw Surrealism as a movement "bent on opening hilarious new avenues to free thought."

Agar also noted that despite Surrealism's liberatory stance, women did not enjoy equal status. A Surrealist's partner "was expected to behave as the great man's muse," she wrote, "not to have an active creative existence." And when it came to sexual freedom, men took the lead. Nusch did not object when her husband offered her to those he admired, a gesture he called an *hommage*. Eileen—for whom the poet was "a fountain of joy and faith in life"—converted to his cult of erotic freedom when they took the lead in what would became generalized partner-swapping. Her partner did not object, she recalled, "because he was himself enjoying a liaison with Nusch."

The group also encouraged exhibitionism, especially in women. In this context, Lee's penchant for unveiling her bosom may have seemed like an emancipatory gesture (as if she were Delacroix's Liberty leading the people), as well as confirmation of her fame as the woman with the most beautiful breasts in Paris. Breton thought of women as *"femmes-enfants,"* childlike repositories of sensuality or magnetic conductors whose sexual energy opened the dreamworld of desire. Reflecting on this fantasy years later, Leonora Carrington remarked that Surrealist women functioned like "talking dogs—we adored the master and did tricks for him."

In the group mythology, Leonora, then a twenty-year-old with wild black hair, personified the *femme-enfant,* and Lee the full-blooded female muse whose erotic freedom inspires creativity. Roland had, until their meeting, a limited knowledge of heterosexual passion. His first affair had been with a man; his marriage in 1925 to the French poet Valentine Boué had remained unconsummated due to her unusual anatomy, which prevented penetration. Roland rejoiced in Lee's air of barely contained recklessness. "You have given me something new, something so potent," he told her with the gratitude of one who doubts his amatory abilities, then finds that he is more than satisfactory. They amused themselves by painting a bare-breasted ship's figurehead—one of the sirens Roland called "cuties"; he began a series of works on the theme of a sailboat filled with wavy blond hair—in which friends saw his pleasure in sharing his fantasies with a cooperative muse. ("The blond season is favourable to my caresses / Your blond hair opens to me the boat of your body," Eluard wrote in "The Last Letter to Roland Penrose.")

Lee's "blond season" also fascinated Eileen Agar, who watched her closely. Lee was "a remarkable woman, completely unsentimental and sometimes ruthless," she believed, yet at the same time *l'élan vital* personified. The photographs and collages Lee and Eileen made of each other in 1937 reveal the ways in which each woman saw herself in the other. Lee took her most striking portrait of Eileen on a trip to Brighton, when both women brought their cameras: she caught Eileen's shadow silhouetted against a curved pillar in the Brighton Pavilion at the precise moment when the Rolleiflex hanging from her neck made it seem that she was pregnant with her apparatus.

About this time, Lee also posed Eileen next to one of her "poetic objects," an antique figure of a household god that she had painted and adorned. As if illustrating her views on the equal importance of dress and art, Lee's photograph makes the artist's patterned blouse part of the composition. Another of Lee's photographs of her friend, facing the camera, appears in a collage portrait of Agar as creative artist. Neither woman played the *femme enfant,* nor did they go along with the double standard. "The men were expected to be very free sexually," Agar wrote, "but when a woman like Lee Miller adopted the same attitude, the hypocritical upset was tremendous."

Reading Lee's letters to Aziz, one learns that she took pains not to upset him. When she told him that she had gone to Cornwall to be with friends, he replied that she was like "a thoroughbred who has been kept in stables too long." In the dark about the nature of the exercise she was taking, Aziz agreed to her request for more money and asked her to join him for a holiday in Alex at the end of August. "Amuse yourself my darling but not too much," he continued. "Cairo is pretty boring as you can imagine, which makes me support the idea that you should be away for your own sake even though it makes me feel lonesome and dejected to be without you."

He would be without her for the next two months. Before the party at Lambe Creek broke up, the key couples (Roland and Lee, Paul and Nusch, Man and Ady, Eileen and Joseph) agreed to reconvene in Mougins, the Provençal village where Picasso was spending the summer with Dora Maar. Lee and Roland went first to Brussels to meet the Belgian Surrealists Magritte and Delvaux, then drove south down along the Rhône to the Riviera, stopping on the way at Hauterives, whose postmaster, Monsieur Cheval, had built a naïve structure he called le Palais Idéal. His Ideal Palace testified, the Surrealists claimed, to the instinctual creativity in free spirits.

In mid-August, the group converged on Picasso's summer quarters, l'Hôtel Vaste Horizon. The view from their rooms looked past the vineyards below the village to the rooftops of Cannes and, in the distance, the Mediterranean. Life there was even more pleasurable than in Cornwall. Mornings were spent sunbathing, swimming, and doing gymnastics at the Plage de la Garoupe, near Antibes, or at Juan les Pins. At noon, the group repaired to the hotel's vine-

covered terrace to wash down the robust Provençal cuisine with local wines. Each meal was a celebration. The photographers—Man, Lee, Roland, Eileen, and Dora—took turns capturing one another on film, as if their intimacy were a kind of artistic collaboration. Picasso, in his role as *"le Maître"* (the Master), urged the party to work after lunch. Those who were less disciplined, or driven, retired to their rooms to rest and make love.

As at Lambe Creek, the air crackled with erotic energy. "I think if love comes your way you should accept it,"'Agar mused. After ending her fling with Eluard, she decided that theirs was a companionship of minds and befriended Nusch, "a delightful being who could never be permanently tamed." Lee photographed the poet with his arm wrapped protectively around Nusch against a background of ruins; in Roland's portrait of the couple, the poet, in a suit and tie, caresses his ecstatic wife, whose blouse is unbuttoned to reveal her torso. Nusch was the daughter of a circus performer, a past that endeared her to the Surrealists. In their act together, she was chained up first by her father, then by members of the audience, after which she freed herself—"a career," Agar wrote, "which was to prepare her well for later life with Eluard."

That summer, Roland, whose fantasies included similar scenarios, persuaded Lee to let him tie her up during lovemaking. He practiced bondage, he believed, because he had been plucked from his mother's breast and given to a wet nurse: "RP suffered," he wrote (as if he were someone else), "from an obsessive desire to make sure, so he thought, that the object of his desire would never escape him. . . . He longed to make sure of his girl . . . possess her in an imperative manner which would not offend her." Valentine had felt "honoured" when tied to a pine tree during his courtship of her but became angry "because the resin stuck to her tender skin." While Roland's memoir does not say whether Lee, too, felt honored by the manner in which he possessed her, their charged rapport gave birth to an intense artistic partnership.

Outsiders rarely have access to pacts made in the privacy of the boudoir— even when, as at l'Hôtel Vaste Horizon, friends stage them for one another in games and artworks. Like Lee, each woman worked out a different accommodation to her lover's desire. The many works of art showing these women's "submissiveness" assume their complicity, since the point of view is usually that of their male companions, but rarely hint at a particular woman's decision to play the *femme-enfant,* or femme fatale, in the unfolding scenario of sexual relations.

Having secured his object of desire (Lee was in love with him and he with her), Roland felt free to enjoy others. Judging by his photos of Ady Fidelin, which vibrate with sensuality, her relations with Man enhanced her appeal as the only dark-skinned woman in the group. Man and Roland took turns photographing each other with Ady on a boat, she swam nude for Roland's camera (in one shot, posing in the arms of her naked admirer), and let him photograph

her as a water sprite in a remote coastal inlet. Their enjoyment of these romps did not change Ady's rapport with the other women. Together, she, Lee, and Nusch pose like fashion models for Roland (then perform a bump and grind), an exuberant Lee brandishes an octopus speared on a fishing trip, and Eileen dances on a rooftop after a party, her breasts visible beneath her diaphanous gown.

The best-known photographs from this golden summer record the *déjeuner sur l'herbe* attended by Man, Ady, Paul, Nusch, Roland, and Lee. The picnic's sylvan setting gives a sense of plenitude, as do their expressions, but it is the women's dress—or undress—that creates the racy mood. While the men are clothed, the women are topless, as if sexual abandon were contagious. In two images by Roland, a rakish Lee ignores the camera's focus on her torso. In Lee's voluptuous and narratively complex shot of the group, Paul embraces Nusch as she bends backward, Man looks slyly at Lee while Ady grins, and Roland has "the appearance of a liberated Englishman freed from the burdens of his puritan past." Lee's photographs celebrate the group's elective affinities while documenting her own role as catalyst.

In addition to the emotional bonds among the couples, the glue that held them together was their Picasso worship. Eluard often said "that he was happy to be alive in the 20th century if only to have met Picasso," while for Agar, the Spaniard was "le Peintre Soleil . . . his thoughts and moods somehow setting the ruling temperature." Unlike Eluard, he was not flirtatious yet he dominated both sexes through his powerful presence. Penrose, too, was struck by Picasso's "small, neat, well-built physique." "His well-bronzed skin," he wrote, "his agile controlled movement, his athletic figure and small shapely hands and feet seemed to belong to the Mediterranean scene as though he were the reincarnation of the hero of an ancient myth."

The artist wore his authority as if by divine right, but as group ringleader, he amused himself with games that were playfully transgressive. One day he told the group to exchange identities. He became Don José Picasso, Eileen's partner became Pablo Bard to match her Dora Agar, Man answered to Roland Ray—a revealing choice under the circumstances. One wonders whether Roland reciprocated by becoming Man Penrose, and how Lee, Ady, and Nusch handled the situation. It is unfortunate that their thoughts about the game went unrecorded.

Picasso also appreciated playfulness in others. He complimented Agar on her collages of flotsam and invited her to see his marine treasures—pebbles, shards, and shells—which he often made into jewelry for the women he loved. Dora wore a heavy African bracelet on which he had carved his emblematic minotaur cavorting with a group of maenads, and Nusch, a bone shard engraved for her. Gifts of this kind were marks of his affection.

Since Picasso's many portraits of Nusch mingle tenderness with reserve,

there has been speculation about their rapport. Decades later, friends were still unsure what they felt for each other. At the time, their relations were complicated by Eluard's offer to lend Picasso his wife to express his love for both of them. The artist later told Françoise Gilot that his tryst with Nusch was merely "a gesture of friendship." "I only did it to make him happy," he added, yet later insisted that theirs was not a carnal affair. While it is impossible to know what happened, Eluard's gesture seems like an oblique avowal of homosexual desire—a tense subject among the Surrealists, for whom love between men was taboo, yet a recurrent urge that found expression in the exchange, real or fantasized, of their women.

It is clear from the portraits Picasso painted in Mougins that he was aware of this undercurrent. In contrast to the monochrome violence of *Guernica,* he chose acid yellows, greens, and pinks for a set of paintings of his friends as "Arlésiennes," the women of Arles whose picturesque dress had inspired van Gogh. Having already used their headdress as an intriguing shape in his Cubist period, Picasso returned to the theme in these fantastic portraits, based on the artist's idea of his subjects rather than on actual likenesses.

He began with Eluard. When he produced his portrait of the poet at lunch, members of the group were shocked: he was shown with large breasts, giving suck to a cat. "One could distinguish in the strong features and sparkling eyes a certain resemblance to the profile of Eluard," Penrose recalled, "but it was disconcerting to see his head surmounted by an Arlesian bonnet and that the poet had changed sex." Evoking the summer of 1937 years later, Penrose called the Eluard portrait a "joke," another instance of "the triumph of nonsense" that made Mougins so exciting. At the time, the likeness was troubling, the art historian William Rubin surmises, because it was "not only a transvestite but a transsexual image"—moreover, one that implies Picasso's sense of the poet as "a repressed homosexual, employing his wife as a means of entering vicariously into a sexual relationship."

Following Eluard's lead, Penrose told the Maître that he was welcome to enjoy Lee's favors. "Just as Eluard had made his wife, Nusch, available to Picasso, Penrose offered up . . . Lee Miller to the artist," writes John Richardson, Picasso's biographer. Surrealist women were, in a sense, interchangeable, to be traded as tokens of affection among men whose feelings for each other could not be expressed otherwise.

What Picasso made of Lee's charms may be deduced from his six portraits of her as an Arlésienne—one who is joyfully, unproblematically female. He began this series the day after painting Eluard. Lee's torso, naked from the waist up, appears against a gay pink background. Roland's description transmits his pleasure in this "astonishing likeness," which vibrates with sensuality: "Lee appeared in profile, her face a brilliant yellow like the sun with no modeling. Two smiling eyes and a green mouth were placed on the same side of

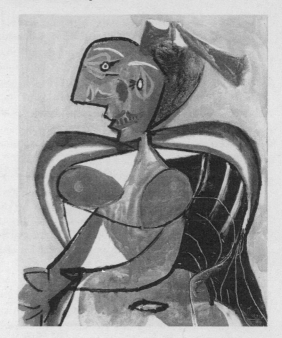

Picasso portrait of Lee Miller as an Arlésienne, 1937

the face and her breasts seemed like the sails of ships filled with a joyous breeze."

Picasso used the same loose brushwork and playful colors for the next five portraits. In the best of these, a playful tribute from one artist to another, Lee's torso is pink, her face and breasts a deep sky blue. But what distinguishes this version from the others more than its coloring is the presence of her lower body, including a vagina that resembles an eye—a witty detail in the portrait of a photographer. Lee said years later, "You do not sit for Picasso, he just brought it to me one day having painted it from memory." That day, in his mind's eye, she had looked back at him from her source of energy—which opened and closed like the lens of a camera.

Lee's role as Picasso's muse made her even more precious to Roland. She was an *inspiratrice d'oeuvres,* he told her later, in a letter. During their euphoric weeks at Mougins, he began a series of works inspired by her, the most original of which are collaged arrangements of postcards forming patterns of color with strong personal associations. Lee's solar presence is evoked in one of these, *Soleil de Mougins,* which Roland began one morning when she was still in bed. (She roused herself to photograph him fitting the pieces together on the floor.)

In another, *Real Woman,* a cut-out of Lee's body emphasizing the round-

ness of her breasts recalls Man's images of her light-dappled torso—perhaps an allusion to her place in her former lover's imagination. Lee would have gotten the joke in the name of the technique Roland chose for this image—*frottage*, from the French *frotter*, to rub: Roland claimed her form as his own by outlining it on a paper he placed on a wooden surface, then rubbing with a pencil in the artistic equivalent of lovemaking. "The work and the title point to a new and very different relationship in Penrose's life from the one he had had with Valentine Boué," a critic notes. "Valentine was fey, introspective and intellectual. Lee, on the other hand, was sensual and voluptuous—a 'real woman.'"

Picasso often said that his art was his diary. Roland's postcards, born in the creative rush of his affair with Lee, chronicle their rapport and assume her role in his discovery of the medium, which he would make his own. At the same time, his excitement sparked hers. Lee photographed Roland fitting pieces together into bright blocks of color; they drove along the Riviera to find cards with stimulating themes; he sought her advice about form, background, and composition.

During this time, Lee also made several accomplished collages, including one of Mougins, which she gave to Roland, and a montaged photo portrait of Agar that is her *hommage* to another woman artist. Lee placed her Brighton shot of Eileen pregnant with her camera (an image that made Picasso laugh) against a mottled background, then set an enlarged white cut-out of the artist's profile from the same image opposite its darker twin. The composition shows both sides of Agar floating above a bird's-eye view of the Riviera, as if she were surveying their artistic playground.

These collages surely amused the group at l'Hôtel Vaste Horizon, who understood their connotations. Before the war, when Braque and Picasso first played with collage, the word—which comes from *coller*, to paste or glue—had carried a meaning that reinforced their works' visual shock; in slang *collage* means an illicit love affair, one in which the lovers are "pasted" together. With Lee as catalyst, Roland had reinvented the form in the racy atmosphere of the group's affinities, using it to imply their delight in dalliance.

Breton, always adept at summing up character, called Roland a Surrealist *dans l'amitié* (in friendship) and Eileen a Surrealist *à l'accent ludique* (with a playful touch). One might use his terms to evoke this joyful summer, when the group's shared unleashing of desire produced a sense of mutual liberation. To be part of a group whose creative energies spilled into one another's lives at a time of impending social disaster would have been irresistible, and ties formed under such pressure, all the more binding. Appropriately, these affinities became tangible in combinations of disparate materials—objects, costumes, portraits, collages—that evoke the gleefulness with which people and materials came together when unconstrained by convention.

For Lee, the summer of 1937 was also the antidote to Cairo—where such "goings-on" (her term for risqué gestures) were unthinkable, even in the crowd around Baron Empain. Summing up their rapturous holiday in a draft of her memoir, *A Look at My Life* (1988), Eileen Agar thought it inevitable "to confuse the delights of being young with the place and the time one was young in; the south of France that summer, Surrealism on the horizon, Stravinsky in the air, and Freud under the bed." "The world was small then," she continued, "the freedom of the intellectuals and the pleasure loving twenties and early thirties were the privilege of those few with avant-garde ideas. . . . In spite of the increasing Teutonic fury," her memoir concludes, "we could still bathe and ignore it, bask in the sun, eat and have a merry heart."

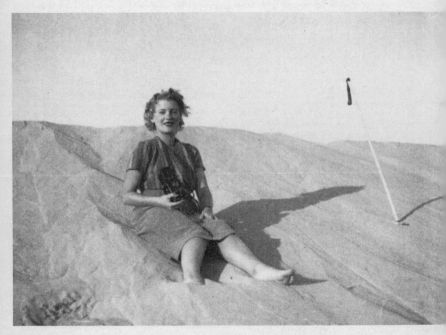

Lee on sand-skiing expedition, 1938 (Mary Anita Loos)

Chapter 10

The Egyptian Complex

(1937–39)

The merriment ceased in mid-September, when Picasso returned to Paris and the others set off in different directions. Lee and Roland spent some days in the capital before her long-delayed return to Cairo. As tokens of his love, Roland gave her several etchings by Picasso, his own *Soleil de Mougins* (the collage she had inspired), books on Surrealism, and an antique necklace. They hoped to be together the next summer, but agreed that it would be foolish to forgo other loves. En route to Marseilles, Lee composed a note to Roland:

> *It's cold in the train—I'm alone with the noise*
> *—and my tears, unlike your chains*
> *—bind me—*
> *it was true—it is true*
> *—I'm leaving—I love you*
> *and I'll return.*

∞

On board the *Mohamed Ali el-Kebir,* she began what would become a long correspondence with her lover, emphasizing their bond in sensual and painterly language. Shipboard life, she wrote, brought back all she disliked about Cairo: "the heat—the bad food—the mutual suspicion & hostility." Swimming, drinking, and sunbathing naked did not calm her sense of disjointedness. The different parts of her life resembled "a water soaked jig-saw puzzle, drunken bits that don't match in shape or design." And while she was trying to rearrange them, she went on, "I get nervous and jerk at them & wonder if I ever was meant to fit together."

During their separation, Roland was to tell her everything. "Cuties [will] fall in love with you," she wrote, "now that you find it's so easy, as with me." ("Cutie" was the right term for a bedmate, she teased, "tho I find Q.T. better, as it means in Yankee slang 'on the sly.' ") In a letter to Man inviting him to Cairo she wrote that she had never felt "so miserable leaving or going anywhere—It seemed that all the people in the world that I love were together."

To neither did she mention one exception to the awfulness of shipboard life: a fresh-faced English officer named Wingate Charlton. Having noticed her before they set sail, Charlton was thrilled when she sat down at his table. They spent the crossing in the bars and at the prow, watching dolphins. Lee became fond of the young man, who may have reminded her of Roland. She was the most beautiful woman he had ever seen, he recalled, and "frightfully jolly . . . a bit raucous at times but there was always tremendous fun with her."

Aziz met their ship in Alex on October 12. The next day, they began an expedition across the Western Desert to Siwa with Henry Hopkinson, a British diplomat, and his wife, Alice. At Marsa Matruh, where they stopped for the night, the coastal town's reputation as a trysting spot for Antony and Cleopatra put Lee in mind of her amours. She noted "five shades of blue as the water changed depth," she told Roland, "and when I was in it the surface reflected the palest and tenderest of pinks—the sky all dappled and Belgian Magritte." After peering through the curved glass bars of the lighthouse's prismatic lens, she noticed some of them lying shattered on the ground. One wonders if she saw in this image the hope of fitting together the parts of her life like compositions glimpsed through her viewfinder.

Marsa's other attractions included Cleopatra's Bath, a rock formation with three rooms hollowed out by the sea. In one, Lee discovered "a sort of sunken pool tub which fills and empties with high and low water in which she used to sit all day long during the heat of the summer." A modern Cleopatra like herself could watch "infinite variations of blue and curious wave[s] and sand worn rocks, all of which have an even more weird surface, as if they had been heavily painted in violet gray, which is now dripping and melting." From this point on, Lee's letters dwell on the painterly aspect of her treks as if by this means she could continue her collaboration with Roland while taking possession of Egypt in a new medium, the written word.

The next day, the party crossed a landscape of eroded hills and sand seas. (Until 1932, when the road to Siwa was finished, this remote oasis had been unreachable except by camel.) Approaching Siwa at sunset, they made out the ruins of a fortress—"skyscraper towers built of mud, disguising themselves to look like the upjutting rocks all around," she told Roland. "In the distance the rocks look like savage thatched huts—with the hard surface thrusting out over the worn soft rock below." The oasis seemed like a mirage. Lee awoke the next day to the sounds of the Siyaha fantasia, a celebration of male friendship whose trancelike rituals, she went on, "brought me to life." As a foreign woman (or honorary man) she was allowed to watch the circles of dancing Siwans, Arabs, and Bedouins. When a local man jumped up to join a veiled belly dancer who appeared unexpectedly, "they outdid in sexual suggestion anything I've seen," she continued, though both were "covered in mountains of clothing."

But when she tried to photograph the Siwan women in their veils, they ran away "spitting and cursing, and making signs against the evil eye." While the women, who married young, could speak only to male relations, the men, she was told, were "all pederasts and even tho some of them marry . . . keep a boy on the ground floor and the woman on the top floor." The government had just banned same-sex unions to "stop the goings on"—the sexual escapades that sparked her libido and Roland's.

Near the end of October, she and Aziz went to the Red Sea to fish with the Hopkinsons: "rather a flop," she told Roland, "not especially from the fact that I caught no fish—but the combination of people." She feigned outrage when Henry declared his love and practiced forbearance with Aziz, who was sulking—perhaps because they were not sleeping together. "You can imagine what my nerves and temper are like," she continued. Although Aziz was irritable, she was trying "to be patient and unquarrelsome because he has so often been like an angel with me." Nonetheless, she suffered from "the jitters," as well as "an upset sex life."

What was worse, she distrusted her own emotions. "When I got married after fifteen years of fiddling around I really did it for better or for worse—I really thot that at last I was going to settle down and be consistently attached to someone—With that little idea blown to hell by the summer, and you, it makes me cynically suspicious of any attachment I might make,—of my love for you—of living with you and being always with you—my 'always' don't seem to mean much, do they. And yet I love you so much that I'm in a sort of ecstasy of agony most of the time." Her condition was that of "the flagellant saints or hysterically repressed nuns who make a mystic marriage." "I'm like a condemned person in a cell," she went on, "full of self pity, misery and sexual excitement."

Despite the tensions among them, Lee, Aziz, and the Hopkinsons set out again in November to the Wadi Rish Rash ibex preserve, an oasis surrounded

by bloodred cliffs. "It was like being in the bottom of God's bathtub," she told Roland, but while the site was spectacular, she longed to be in Cornwall "or some place green with you." The only trips she did not describe in detail were those taken with Wingate Charlton—to the Sinai, the Suez Canal, and the Coptic monasteries at Wadi Natrun, known to expats as the Troon. They packed picnic lunches and, occasionally, gear for the night; the young officer introduced Lee to medieval romances, which he read aloud in their tent. During the day, he accompanied her as she photographed the rounded buildings from arresting angles. In one shot of the ancient retreat, the sensuality denied inside its walls is evoked in the breastlike curves of the roof.

Lee's jitters returned in Cairo when Aziz asked about her restlessness. "I do so want to seem well and happy after my long vacation," she told Roland, "so as to give a precedent of its being a good thing for me . . . but I'm afraid that I'm making a sorry job of it." While busy with golf, cocktails, and dinner parties, she felt "quite devoid of any inspiration." Drafting letters in their private language—a salty mix of innuendo, vanguardism, and left politics—and doing things that recalled their time together were her only forms of comfort. "Either I like doing things because they have some remote . . . relation to you," she wrote, "or I hate everything because it has no contact, or inside thought of you."

Becoming the local spokeswoman for modern art gave her another way to nourish "inside thoughts" of Roland. The right frames for the artworks he had given her, which to her eyes both concealed and revealed their relationship, became a preoccupation. Roland's *Holy Ghost* (her name for one of his watercolors) would be framed in two pieces of glass with a black border, she wrote, "so that if one day you make me a companion piece it can go on the back, and become reversible"—like a mirror image of their love. "Your two beautiful montages," she went on, would have "the simplest and narrowest of black frames—so that they have no interference" (a state she desired for herself). Her Picasso etchings were being framed in Republican red, to shock her "Fascist friends"—the English officers and diplomats who were pro-Franco.

One wonders what Aziz made of Lee's plan to hang Roland's collages opposite her bed, whether their placement on either side of the door suggested dreams of escape. ("The light is perfect on them and they are brilliant like jewels under the glass," she told Roland.) With her mind on "inside thoughts," Lee also equipped her camera with a remote shutter release to send him shots of herself in her studio, gazing at the typewriter on which she wrote to him and at objects that he alone would recognize—a pair of diving glasses, books by Ernst, and other items from their shared life. "I particularly wanted you to see my permanent state of disorder," she wrote. "This is my own little air-conditioned sitting room." With a remote, she added, "I can take as many pictures of myself as I want for you, only I expect you to do the same," as if by this means they could post themselves to each other.

Roland replied that she already shared his house in Hampstead through the artistry of Picasso, whose portrait of her (one of the six from Mougins) he had recently bought on a trip to Paris. He too was hunting for the right frame with which to secure Lee's image and wanted her permission to hang her portrait in a Surrealist show at Cambridge, after which he would send it to her. "You should mark it Portrait of Mme. X," she answered. "I've always wanted to be the mysterious and beautiful lady in a picture."

That autumn, Lee's portrait presided over Roland's hearth, "fill[ing] my room with your adorable presence," he told her. "It is so gay, contains all Mougins, all the summer, the sea and your laugh." Lee was everywhere present in his new collection, which included twelve Picassos from his Cubist period and a number of works by Miró and de Chirico, all purchased that year. He explained their location and effect. Picasso's *L'Arlésienne* and his *Young Lady with Mandolin* dominated the living room; Lee's Mougins collage hung on the mantelpiece with Man's portrait of her sun-dappled torso, his gift to Roland. "I wish that I were to see the house all stuffed with treasures, overflowing with all the new pictures, and overflowing with me too," she wrote, adding in an afterthought, "I'm so bored here! I think that I am slowly going mad."

Lee tried whatever Cairo offered in the way of distractions. She would go to the Hopkinsons' circus party as "the tattooed woman," she teased, "provided I can find someone to paint me in amusing designs." Others would be bearded ladies, lion tamers, strong men, trapeze artists, and animals with their trainers. "If I were a man," she continued, "I'd go as an orderly with a dust pan and a broom, to follow the animals around—and I'd love to annoy everyone with some live snakes as a serpent charmer or let loose a lot of white rats."

Roland was excited by the idea of Lee tattooed. "You will look marvellously beautiful all written over with fishes, dragons, lions, sailors and hearts," he wrote, adding, "Why aren't I there to draw them!" "I imagine you nearly naked," he went on, "bricks painted all up your legs, moss growing on the tops of these towers, a serene blue sky for your body with two cotton white clouds as your breasts, two black pigeons as your hands and the sun itself as your face." Since he knew that she wouldn't actually appear this way, Roland painted this vision of Lee, called it *Night and Day,* and after sending Picasso's portrait of her to Cairo, replaced it with his own.

Roland longed for her "physically," he explained, but also "in lots of other ways. Your way of seeing things when we are out together is a thing I miss all the time." He wished that she could collaborate with him on his next venture, a show of Surrealist objects at the London Gallery, and sought her advice about the ready-made "cutie" he planned to exhibit, using a shopwindow dummy's head adorned with a blond wig and hung upside down. Unsure what to put in her open neck, he saw several possibilities but felt that Lee would "as usual have a much brighter idea."

By return mail, Lee suggested a glass lens arranged to magnify several

objects, "flat brass gearwheels all toothed together like a complicated time bomb . . . a wax model of an ear drum or a hand and arm reaching up from inside the head—with a bleeding sacred silver heart such as they leave at Lourdes." Roland adapted her first idea by putting six small glass funnels filled with tacks, shells, and seeds in the neck of his construction, which he called *Dew Machine.* Later that year, he included the inverted head of a woman whose waves merge with the ocean in his canvas *Seeing Is Believing,* another work linking his new muse to the truths glimpsed in dreams.

By dint of these exchanges, their imaginations remained in sync. Lee proposed a contribution to the show of objects provided he could make it for her: "It is a very beautiful wax hand, like in manicurists' windows standing up from the wrist, vertically, and on it I'd like a bracelet made of false teeth mounted in particularly false pink colored gums." He might also paint the fingernails with false eyes (shades of Man) or "have fur tipped fingers" (shades of Meret Oppenheim).

Roland rushed to carry out Lee's instructions. "I shall choose a hand as nearly like yours as possible," he wrote, "and decorate it with teeth as nearly like mine." They might call this suggestive object *Le Baiser (The Kiss).* After purchasing a wooden hand (wax ones were unavailable), he painted it "with great care inspired by your hands which I can still see with some accuracy." For the teeth, he had located a dental technicians' workshop where two old men in white coats manufactured "the most rosy pearly false jaws I've ever seen."

Lee's object was finished in time for the opening, at midnight on November 24. It appeared beside Roland's *Dew Machine,* a piece by Eileen Agar, and one by Ernst—all labeled "objects for everyday use." The show caused more of a stir than Roland had anticipated. The critics were unsure whether to call the objects arty Christmas presents, bad dreams, or Surrealist leg-pulling. Lee was in good company, albeit vicariously.

Unable to keep her love affair a secret, Lee told Mafy, who was sympathetic. A month later, she confided in another young American who had the distinction of being Anita Loos's niece. Mary Anita Loos, a sprightly Californian, would soon follow in her aunt's footsteps as a screenwriter; in 1937, she was making her grand tour before settling down in Los Angeles. When the attractive brunette was introduced to Lee by their mutual friend Charles MacArthur, of the Algonquin Hotel Round Table set, it was as if Lorelei Lee's confidante Dorothy had unexpectedly turned up in Cairo.

Mary Anita, a Stanford graduate and an amateur archeologist, was not about to succumb to the Egyptian complex. As they drove around Cairo visiting the mosques and museums, Mary Anita told Lee about the American Southwest, where she often went on digs. The subject piqued Lee's imagination. With Mary Anita, she discovered the fascination of Egypt's past: "I walk around for hours on end, even went to the Pyramids, the Sphinx, the Museum

and the mosques," she told Roland. She was at last "finding amusing things to do." In December, these included a duck hunt on a private oasis, a trip to Luxor (where she stayed with Abboud Pasha and his wife), and a fantasia (a mock combat on horseback) at night in the desert.

Lee enlisted Mary Anita in one of her most amusing activities that winter: skiing on sand dunes. Convinced that *Vogue* would push the sport as the latest fad, Lee organized the party. Mary Anita would model; Robin Fedden, a writer friend, would write the article; and Lee would take photographs. Carrying their skis, camera, and tripod, they climbed the dunes barefoot—hard work because the sand avalanched almost as fast as they could climb. Robin, in his pith helmet, positioned himself a little way below. Mary Anita stripped to her two-piece floral bathing suit, skied for a few seconds, and fell on her duff. All three roared with laughter until Lee and Robin shouted at Mary Anita to get up. An asp was lurking near her foot. "Skiing in Egypt lasted twenty minutes," she recalled, "the shortest potential sports event in history." Before returning to Cairo, Mary Anita photographed Lee sitting on a dune, her Rollei-flex around her neck and a ski beside her—a portrait of the photographer on location.

In Cairo, their amusements included rounds of cocktails at Shepheard's, where Mary Anita studied Lee's set—"a thoughtless group," she concluded, "who had inherited money but not recently enough to enjoy the novelty of it." They drank Pimm's cups while watching the magicians in long robes who pulled canaries out of their ears to entertain the tourists. The more politically aware debated the impending war in Europe, whether, as the British thought, a victorious Franco might be made to end his pact with Hitler to side with them, and whether the Italian presence in Libya threatened Egypt. Mary Anita, who had watched Hitler and Mussolini drive through Munich that autumn, told them about the papier-mâché milkmaids that lined the streets there, like a Hollywood film set.

When she visited the Villa al Beit with Lee, Mary Anita could not help noticing that despite Aziz's kindness, "Lee would do anything to get away." She also saw that Aziz and Lee were not well suited. Gentle and hospitable, he adored her but was often moody and prone to worry, especially about Lee. He was, Mary Anita thought, a product of the old school, while Lee "was a free spirit and made it plain to all." "Her blonde beauty blazed among the elegant women of Cairo," she went on, "but unlike them, she was a live wire." Since Mary Anita was another, Lee talked to her about Roland, explaining that she missed him but meant to console herself with others.

After two years of marriage, Lee flouted as many conventions as she could manage. Surrealism was a guaranteed shocker in Cairo. Some friends had gone so far as to read the books she lent them about the movement, but "they still don't believe it's true," she told Roland. When an English acquaintance

exclaimed over newspaper accounts of "a so-called art exhibition" of Surrealist objects at the London Gallery, Lee replied that she had contributed one of them. "You should have seen her face," she crowed, as if she had scored a point.

The long-awaited arrival of her Picasso portrait offered the chance to unsettle le Tout-Cairo at a combined unveiling and cocktail party. Thirty of her friends assembled before the canvas, which Lee had covered with a large piece of velvet. When she removed the cover, there was a shocked silence. After she insisted that it *did* look like her, Gertie Wissa replied, "Yes, it has a roving eye." Some mystified guests thought that Lee had shown it "as a deliberate insult," she told Roland, "and were convinced that it was all tongue in cheek . . . you see I am in Exile."

While her friends muttered that any child could paint that way, Lee planned her revenge. Two days later she produced art supplies, then invited her dinner guests to have a try. The party became a Surrealist soirée: "two boys who knew what we were doing after dinner arrived in Surrealist costumes—which included gas masks—pisspots full of flowers etc.," she told Roland. "I had my mouth painted in green make-up and my nails their usual blue green—everyone got very tight and painted beautiful pictures, except that they were all very realistic and very dirty minded."

While shocking the bourgeoisie let off some of the pressures bottled up inside, Lee also nourished private thoughts of rebellion. She aired her sexual fantasies in letters notable for their frankness after Roland began writing about the "cuties" replacing her in his bed. She had been celibate since her return from France, but in December, developed "a letch for a boy who can't be had, because there is neither opportunity nor place in the construction of our respective lives." (The "boy" was Henry Hopkinson, whose declarations of love finally produced a response.) "I hoped that I could transfer my troubles to a desire for someone else," she went on, "but even that is out, so I practice hydraulics [masturbation] from time to time and try to remember."

In addition to "hydraulics," she was reading an English version of the Marquis de Sade's *Justine,* which she had begun in Paris with Man. At that time, she recalled, she had been impressed by "a great deal of intimate goings-on" that seemed to be lacking in the English edition; she asked Roland to check the original. By reading Sade together they could meet in their imaginations if not in the flesh.

In the meantime, Lee took stock of her situation. She was often sad, she wrote, "altho I spend all my time in a wild burst of gaiety . . . then suffering from fits of depression, or just tiredness, or reaction until I'm suicidal and then cured of that by resting and sulking." She knew what was wrong: "I want to make love. I suppose that being in love makes love-making more interesting, even with someone else." And despite Surrealist dogma, she had "pangs of jeal-

ousy" about Roland's amours—"not because you are making love with other people, but because I can't also."

A trip to the Red Sea coast with Aziz and Henry brought relief. The Sinai mountains, like a "Max Ernst painting in Turner's colors," set the scene, and Henry's acute stomach cramps provided the opportunity. Though "plastered on rum," Lee drove him to the French hospital in Suez, where the doctor ordered him to stay in bed. "We had been looking for a bed for months and finally to find it filled with fevers, opiates and worry," she wrote, "but we did anyway, and made love to the accompaniment of two green hot water bottles and summonses to the telephone for all the long distance calls I had put in for Cairo to his wife and doctor. It was like a French comedy." At the same time, she could not stop thinking of Roland, "and the luck we had—to be independent, unattached, and certain of each other."

On Christmas morning, despite a bad hangover, Lee convinced Aziz of her need for "a certain fixed holiday every year as a bachelor." He gave her his blessing but said that she must visit her parents next summer and teased that if she married someone else, he would insist on being her lover. "Further than that I have never gotten even in an approach or thought of my own on the problem," she confessed. "All I know is that I couldn't possibly leave him—or hurt him, or open him to any sort of humiliation." As an afterthought, she mentioned his Christmas present to her, a beautiful gray Packard that she would have to drive carefully since, unlike her, "it's not allowed to go fast."

January brought a bad case of the jitters and a new malady, insomnia, both linked, Lee thought, to "those depressing Egyptian gray days when the world seems to have ended, and one senses the preoccupation of this country with death." Her mood was dark. The usual distractions—drink, desert trips, "French comedy"—were to no avail. "[Egypt] is just tombs, ruins, and embalmed bodies," she told Roland, "generations of people, dead people doing exactly the same thing, in the same way." She was becoming like everyone else: "The only thing that seems alive is the hope that I can get out of it."

Lee's gloom was not unusual among expatriates. "Many people find exile in Egypt difficult out of all proportion to the trials which at first appear to be tangibly involved," Robin Fedden wrote. The climate unhinged Europeans due to the lack of seasons "and the recurring stimuli they offer," he continued, but also because the landscape was "boneless and unarticulated"—except for the desert. The realization that Egyptian fields "are not soil but bone-mould and excrement" was known to produce "claustrophobic panic." Only Egyptologists or Muslims could appreciate the country. The isolation of the expatriate was deepened, he thought, by the "nightmarish unreality" of Cairo, where "the

Lee snake charming, 1938
(Guy Taylor)

black satin and pearls are complementary to rags and tatters"—the situation he described as "Levantine unreality."

Lee struggled with this unreality, she told Roland, by "spend[ing] a great deal of time doing extremely silly things." During another stay at Abboud Pasha's she behaved like "a Wild Western Novel Heroine." Although "neither a jockey or a rodeo girl," she insisted on riding a bad-tempered horse called Renown, who bucked, bit, frothed at the mouth, fell to the ground with her in the saddle, and was shot by the groom: "Evidently I'd driven him crazy."

For her next adventure, she became "the Sister of all the Serpents." In preparation, she took lessons from a snake charmer who made her promise that she would never harm a reptile, then draped her with vipers and cobras. "I have a perfect passion for snakes," she told Roland. They were "clean like jewels." The vipers had "wonderful eyes" but wiggled; "the cobras are gentle and come when you call." Once she had finished snake charming, she arranged to have the Aswan train stop for her to board, as if she were "the visiting queen of

what not," then drank and "played love games" with a Viennese passenger before visiting the temple of Horus. "It was an exciting and satisfying adventure," she told Roland. "[M]aybe you're right, and I'm just another girl looking for trouble."

Roland paid no attention to the self-doubt that punctuated Lee's accounts of her adventures. "Your letters read like the most incredible news, real thriller[s] with all the colour and incidents required, snakes, mad horses, lovers in train-de-luxe, temples and champagne," he replied. He felt "small and gray by comparison." The only thing he looked forward to was a trip to Paris for the International Exhibit of Surrealism at the Galerie Beaux-Arts in January. Yet even there he would miss Lee. The organizers wanted to show Picasso's portrait of her, but it was too late. He had sent it to Cairo. "I'm sorry that your radiant face shouldn't be in the centre of it," he wrote, "that you should not illuminate the whole affair with your presence."

Lee's presence was felt in Paris just the same. Her torso, as depicted in Roland's *Real Woman,* hung behind one of the satin-lined double beds in the main room, her lips floated above the gallery in Man's *Observatory Time,* and for those who knew, their past together was evoked in his mannequin with soap bubbles, one of the fifteen window dummies revamped by the contributors to exemplify the Eternal Feminine. She also figured in the catalogue, an *Abridged Dictionary of Surrealism,* in which Man's shot of her in the orthopedic cast illustrated the section entitled *"Femme Surréaliste."* "Why the devil aren't you here?" Roland asked. At dinner with Picasso, Dora Maar, and the Eluards, everyone spoke of her: "Picasso asked after you a lot and wanted to know when you are coming back."

Lee replied that she had nearly run away to join him but after a stormy talk with Aziz decided to leave "peaceably" in the spring. In the meantime, she had taken up camel riding. "My current ambition is to have my own racing camel—do it up very fine in my own colors and ride it around wearing a galabiya." It was fortunate that Roland had filled her requests for various items, more Surrealist books and magazines, and the Tampax she would need in the desert—"on account of what you can't ride a camel and wear a Kotex." Despite her jaunty tone, Lee was depressed. "Are you forgetting how difficult and discontented I always am," she asked. "I think that a double life is what I was meant to live," she continued, "dividing my heart up into little bits. I've spent so much of my life having it torn—between this and that—between one or one hundred men—and still loving them all." What was more, she had been drinking too much: "I could easily and with pleasure become an alcoholic."

Since Roland heard from her irregularly in the new year, he surmised that Lee, like the rest of Cairo, must be "busy bedding your little queen" (English newspapers that winter featured the plans for King Farouk's marriage) and wondered whether she was "getting any fun out of it." Lee's letters from the

spring of 1938 mention neither the royal wedding nor other sources of fun. They also fail to mention Giles Vandeleur, a captain in the Scots Guards with whom she began an affair after the departure of the Hopkinsons for Athens. She also went to Heliopolis to see Rosezell Rowland, who had recently returned as the new Baronne Empain. During her absence in Budapest, jokes had gone around Cairo about the Baron *"en panne"* (in trouble); true to his word, he married Rosezell after the birth of their son in November. But the goings-on at the Palais Hindou had ceased to be amusing. Lee's mind was on thoughts of escape.

Having persuaded Aziz to let her take a spring vacation in Greece, she hoped that Roland would join her. After telegraphing him about her plans, Lee sailed to Athens with Gertie Wissa, who was disturbed to learn that Vandeleur would accompany them. The other passengers could not help noting his visits to Lee's cabin since, accidentally or on purpose, she left the door open. Her behavior was scandalous, Gertie recalled, and worse when they reached Athens, where she came to a party in the nude. She continued her fling with Giles, who shared her penchant for practical jokes: they cabled Gertie in Greek characters that encoded four-letter words for those who knew English. Lee was nonetheless "hard hit" when a letter from Roland explained that he could not join her due to obligations in London. "By virtue of writing to you," she replied, "I'm in a state & will go practice hydraulics."

On her return to Cairo, Lee met Bernard Burrows, a handsome young diplomat who began work that year at the British embassy. Burrows, a product of Eton and Oxford, was interested in art, archeology, and letters as well as politics. He found Cairo society superficial and disdained the Empains' "totally empty way of life." While Lee struck him as very American, her beauty and mischievous humor were alluring. "With her looks and background she was of course sensational in that milieu," he recalled. "Her behaviour was often seen as excentric, but others too did as they pleased." She cared for Aziz in her way, he added, "did not always misbehave and was careful about her affairs"— except on foreign soil. And while Lee fretted about the narrowness of life in Cairo, "she did what she could to accommodate herself."

Unlike Burrows, Lee took little interest in the political scene. Throughout 1938, as Franco and Mussolini consolidated their power in Europe, Egypt's strategic position preoccupied her British "protectors." The Italians were reconnoitering in the desert from their base in Libya; Cairo was said to be full of spies (including Laszlo Almasy, the double agent whose expeditions inspired *The English Patient*). Lee went on desert treks for her own reasons, Burrows felt. These trips were her way to escape constraints by focusing on logistics— getting the expedition fitted out and organized. In this way she was her father's daughter, he added. It was technique, whether travel-related or photographic, that held her attention. She made up for her lack of education with sheer dar-

ing: on a trip to the Red Sea, she stripped off her clothes and swam naked despite the presence of sharks.

As a classically trained scholar, Burrows may not have fully grasped Lee's attraction to the desert, her sense that out there the past had fallen away. Some are terrified by the desert's emptiness. For those for whom the desert mirrors back the self, its vastness may be exhilarating. For Lee, the desert became the place where she could see more clearly who she was—and see herself seeing. From time to time, she abandoned the "extremely silly things" that amused her and went to the desert for refreshment—one might even say, for spiritual renewal, though the word *spiritual* was not part of her vocabulary. In its reaches, she glimpsed a place beyond technique, where the pieces of her life momentarily came together.

Lee's best-known Egyptian image, *Portrait of Space,* stages this kind of seeing as a moment of transcendence. The viewer, positioned inside a desert shelter, looks through the torn opening of a fly-screen door to the high plains on the horizon. Because this chance opening functions like an eye—or the aperture of a camera—a feeling of spaciousness opens in the body as one peers into the distance. Here the lucidity of her composition captures a split-second insight into another way of being. Although some of Lee's Egyptian photographs portray her response to the country while exploiting modernism's concern with the medium, in *Portrait of Space* she touched another dimension, joining the ranks of the few photographers, who, a critic writes, "understand this correspondence between outer and inner state, read the world as if it were an allegory and pass through it as if they were pilgrims on a journey, looking for signs."

Roland begged Lee to choose their reunion site. "I look to your arrival as the signal for a change," he wrote. Once she made up her mind, "we will be off to Iceland, Paris, Mexico, Dutch East Indies or wherever you like." The plan she presented to Aziz seemed plausible. In June she would sail to Athens with Arabella, her Packard, to tour the Aegean, then explore mainland Greece and Bulgaria with friends. She did not say that Roland was the only friend joining her, nor that she was packing a camp bed, blankets, and other essentials for the Eastern European equivalent of a desert trek. In the meantime, she told Roland to bring a driver's license, "some infra-red film, lots of hormones, and good humor."

Roland had many reasons to be happy. In June, on his way through Paris to meet Lee in Greece, he visited the Eluards. At Paul's urging, he bought the poet's art collection—including forty Ernsts, six de Chiricos, Picasso's portrait of Nusch, and work by Klee, Arp, Chagall, Dalí, and Man Ray. (The inclusion

in the lot of Man's painting of Lee with her throat cut, *Logis de l'Artiste,* may have seemed like a sign, although an ambiguous one.) Thinking back on that moment, Roland mused, "Sometimes, almost never, an invitation arrives to explore distant countries with a girl with whom one is in love and, should this happen, one would be an obstinate fool to refuse."

Soon after their reunion they sailed to Mykonos, whose voluptuous goddess figures had long fascinated Roland, then, on a boat filled with honey, grain, and nuts, to Delos—where the huge stone phallus at the sanctuary of Dionysus hinted that chthonic powers still ruled the land. Judging by the photographs in *The Road Is Wider Than Long,* the "image diary" Roland kept of their trip (and later published), these ancient sites were inspiring. The image of biomorphic rocks on page 1 evokes the release of pent-up energies; the accompanying lines note with awe the harmony of landscape and emotion. To Roland, their trip was a journey through a "world become fertile," and they themselves, "Lovers who escape, who are free to separate / free to re-unite leave their tongues / plaited together hidden in the dry grass / folded in peasant made cloth / embalmed in the green memories of desire."

Nonetheless, they could not help feeling "the menace of approaching doom" as Hitler strengthened his alliance with Mussolini over the summer. Of their next stop, the oracle at Delphi, Roland wrote forebodingly, "Vapours escape from the rocks / writing tomorrow's news in the sky." They gleaned scraps of information on the drive to Bucharest. In Prague, the Czechs were temporizing with the Nazis; in Bulgaria, rearmament had begun. In Bucharest, they met Hari Brauner, the musicologist brother of the Surrealist Victor Brauner, who invited them to hear Maritza Lataretu, a Gypsy singer, and to join his recording sessions of folk celebrations in the Carpathian Mountains. Lee bought an embroidered costume to move among the peasant women; unlike the Siwans, they let her take photographs and, through Brauner, talked about their lives.

Some years later Lee described this leg of the trip with the recall of an anthropologist. "Magic to bring on rain or to fertilise the bride or the fields [is] traditional," she wrote:

> In the gypsy rites to produce rainfall, a boy and a girl are dressed in leaves arranged like Hawaiian skirts. They prance around singing a primitive prayer ditty while the adults throw buckets of water over them. The peasants' ritual harks back to a ceremony as ancient as the oldest of Greek literature. The pure children (under the age of 10) fashion a moist clay doll in relief on a board. Gentians make blue eyes, and a scarlet petal the mouth. The sex is well defined. The offering is trimmed with blossom, laden with fruits and carried by child pall-bearers to the nearest remaining water on the parched plains. Bearing lit candles and suitable prayers

the sacrifice, symbolic of one of themselves, is placed on the water where
it floats away to death by drowning.

She photographed these scenes and others—the children in leaf skirts, a dead
child, crosses carved in trees in a cemetery—to record their journey, but also
to document folkways about to vanish.

In September, after Roland's return to London, Lee volunteered as driver
and photographer on Brauner's recording expeditions. They spent several
weeks attending Gypsy weddings and exorcisms and, at night, fending off the
fleas that lurked in the peasants' featherbeds. "We drank quantities of hard
liquor and gallons of Lapte Batute buttermilk," Lee recalled. "We made docu-
mentary photographs of all the frescoes painted on the outside of the ravishing
steep-steepled churches of the Budkovina province, and accepted for [Hari's]
institute the under-glass ikons which the churches might not destroy but were
discarding in favour of chromos, oleos and plaster statues of saints *en grande
serie* from mail order catalogues."

She was having an adventure a day, she told Roland, with "angry peasants,
murderous cart drivers, armed bandits, etc.," not to mention a valley where a
gas mine burned night and day, driving the peasants mad. "It's been going on
for a year now and I think it is the most exciting thing I've ever seen," she
added: daily life "on the brink of hell." Despite the outcome of the Munich
conference, which gave the Sudetenland to Hitler, and the prospect of war in
the Balkans, Lee felt oddly calm—even after foreigners were told to leave and
she was declared missing. Reluctantly, she sailed to Egypt at the end of Sep-
tember.

Soon after her return, Lee told Aziz that she had had an affair with Roland
in 1937, and that they remained close although unsure about the future. "He
doesn't want to divorce me unless he is sure that I'm going to be happy," she
told Roland. "I told him that I'd had enough of marriage for the moment and
didn't want to marry you until I had at least sufficient adjustment to make up
my mind." Her mutually contradictory plans included living with him in Lon-
don, spending the winter in Switzerland with Aziz, and returning to the United
States in case of war. In the meantime, she said that she would spend some
weeks in Syria but did not name her traveling companion, Bernard Burrows.
Judging by Lee's letters to Bernard, her confusion deepened with each new
plan. Immersing herself in lists of travel gear (snake serum, flea powder, oint-
ments for the eyes and stomach) did little to calm the jitters that, increasingly,
beset her.

Lee met Bernard in Beirut at the end of October, then traveled with him
through Transjordan and Syria, photographing all the way. At some point,
Robin Fedden joined them to start work on a travel book. A letter to Roland
omits any mention of Bernard but gives their itinerary—Palmyra, Baalbeck,

Jerash, Kerak, Sergiopolis, the Tigris and Euphrates, Homs, Hama, Aleppo, Damascus, and Antioch—and says that she took "some quite startling pictures" out in "all the great empty spaces." (Fedden's *Syria*, published in 1956, reproduces Lee's shots of Palmyra, Lebanon's mountain, a weaver, and two intimate portraits of Bedouin women, one on a camel and the others in their encampment—people like her, or her as she wished to be.)

Alone in Beirut, Lee took stock of her situation in a letter to Aziz. Having gone through "as many changes of scenery & weather here as there are kinds of religions & races of people," she had to conclude that "all of them [were] vaguely disappointing because of my own state of mind." "There is no further way of escaping some sort of plan, no way of pretending there isn't a problem & worst of all I am such a coward that I'd rather solve it from a distance. [It] ought to be much easier from here for me to say & know about coming back or about going any place else . . . it's too 'shymaking' to talk about it face to face." Wanting Aziz to initiate the break, she supposed that the solution was divorce: "I feel that you want most of all to be excused from further trouble for & about me & of course to feel absolved & in all good conscience free of responsibility & preoccupation with me. But either from tender-heartedness or misplaced faith in my possible reform[,] you are blinding yourself to my worthlessness as your wife."

As for herself, she did not know what she wanted, "unless it is to 'have my cake, and eat it too.' " Yet she *had* gained insight. "I want to have the utopian combination of security and freedom," she wrote, "and emotionally I need to be completely absorbed in some work or in a man I love." Given these desires, she would have to decide for herself. "I think the first is to take or make freedom, which will give me the opportunity to become concentrated again & just hope that some sort of security follows & even if it doesn't the struggle will keep me awake and alive." She would come home to discuss "yours, or my or our plans, for the future" if he wished. Otherwise she would go to Europe or America. While waiting to hear from him, she would keep on traveling.

From Palmyra, Lee wrote to Mary Anita of her interest in archeology and asked whether they might tour the Southwest together if and when she returned to the United States. Taking or making freedom was one thing; contemplating ruins while imagining oneself a refugee was another. Lee's Palmyra photographs are well composed archeological studies. At the same time, their desolate architecture—colonnaded temples eroded by sand, once-impregnable towers open to the winds—evoke a malaise. One feels almost viscerally the contradictions of this moment in her striking image of a blocked doorway: an impasse, a no exit, a dead end (the rounded shape above the lintel suggests a head, or an eye, for the door as body).

In January 1939, Roland asked for a decision. "All I want is to have everything taken out of my hands," she replied, "to wake up one morning and find

myself already launched in my life with you." Ironically, while not up to fitting the pieces of her life together, she was dividing her time between jigsaw puzzles and losing herself in travel books about places she had visited or longed to see written by women explorers (including the work of Freya Stark and Alexandra David-Neel's *With Mystics and Magicians in Tibet*).

New acquaintances offered some distraction. George Henein, an Egyptian poet who had met Roland in Paris, took an interest in her. He hoped to start a magazine along the lines of the American left-wing review *The Masses,* with the aim of uniting Marxism and Surrealism in an Egyptian context. "Our gang of misfits are starting a semi surrealist magazine next month," she told Roland. She would help them despite her doubts—in between expeditions, parties, and card games. In the meantime, she asked Roland to help her choose a costume for Amy Smart's next event: guests were to come as their latest dream or nightmare. Veering between defiance and depression, Lee was energized by Kemal Eloui's sudden denunciation of modern art—after which she moved all her paintings to her studio in protest.

While Lee's social life was not uninteresting, she told Roland, her sex life was nonexistent. "In a fit of longing for you yesterday morning I played hydraulic games with myself," she wrote. "It's neither the first nor the last time." The effect of this letter was immediate. By return, Roland announced his departure for Egypt to document peasant dances with a friend who needed him as her photographer. Lee replied that she was thrilled by the news and his arrangements, which would "give me endless opportunities to be with you if you want me to be." But it was too late for her to change her plan to start a weeklong desert trip on January 30, the day of his arrival. Morever, she wanted to play it safe: "Aziz knows that I had a love affair with you," she wrote, "and I told him it was over and we were just friends." Canceling the trip "would look too suspicious," she went on, "and spoil any plans we have here."

Lee set out at dawn with Bernard Burrows, Amy Smart, Gertie Wissa, and a couple named Pereira to tour the oases of the Western Desert—known as the desert of all deserts because of its treacherous dune fields, which had swallowed whole armies. She was now following in the footsteps of Ahmed Hassanein, whose *Lost Oases* surely went along as their guide, at a time when the political situation made desert travel even more hazardous. (In 1939, when Laszlo Almasy was mapping the Western Desert for the British-run Survey Department, the Italians were on maneuvers there. It was not unreasonable to think that war might break out soon.)

Their trip went well despite the general anxiety. At Bahariya, a lush collection of villages known for their wine, they were received by the sheik, who plied them with sweets. Driving from oasis to oasis, they found much to admire. At Farafra and Dakhla, the Bedouins' mud-brick houses and luxuriant crops—dates, olives, figs, and oranges—formed patterns of color against the

jagged pink escarpments. More than anything, it was the desert that held Lee's attention, the volcanic mountains of the Black Desert, the chalk statues carved by the wind—hawks, camels, sphinxes—in the White Desert, a Surrealist's dream. As seasoned travelers, they would have camped in the desert to see these shapes turn gold, then purple at sunset.

Lee was anxious to complete the trip. The last leg took them to El Kharga, a stopping place on the ancient forty-day caravan route from the Sudan, then to the Wissas' house near Assyut. Unable to wait any longer, Roland went to Assyut to surprise her. He brought as gifts the first edition of *The Road Is Wider Than Long* (inscribed "to Lee, who caught me in her cup of gold") and a pair of handcuffs made of gold from Cartier's ("pieces of sentimental jewelry," he believed, were "the symbolic equivalent of an orgasm"). One must imagine their reunion as "friends," and the discretion needed to bring it off.

On their return to Cairo, Lee introduced Aziz and Roland, who realized that they were already acquainted, Roland having visited the Villa al Beit in 1925, when Nimet was in residence. While it would have been reassuring to see that the two men liked and respected each other, it may also have seemed that one protector was handing her over to another. Yet in part of herself, this was what Lee wanted.

She was now free to travel with Roland provided they went in a group. As the political situation worsened, the authorities placed restrictions on travel by foreigners; it took Aziz's influence in high places to obtain the necessary permits. They set off for Siwa on March 12 with Mafy and George Hoyningen-Huene, who had come to Egypt to take photographs for a book on the classical past. The local sheiks welcomed them and showed their enthusiasm when, despite the rules for Siwan women, Lee and Mafy bathed topless in the hot springs. An active sex life rekindled Lee's love of mischief. Photographing the nearby rock formations with Roland, Lee saw them with a Surrealist's eye—as in *Cock Rock*, where a boulder stands at attention like an erect penis.

By the end of the trip, she had made up her mind to join Roland; he begged her to come to London, now that war seemed imminent. However, while Erik had also decided that he and Mafy would return to the United States, Lee was still unsure about leaving Aziz. Driving back to Cairo with Mafy (Roland had gone on to Alexandria with George), the two women "discussed our futures and our ficklenesses in a way only possible in the dark," Lee wrote, "not looking at each other, but fascinated by the diminishing lines of the road." At Marsa Matruh, they encountered a long convoy of army trucks, which Lee passed one at a time with her hands glued to the steering wheel. "It was like being very sick drunk in a nightmare," she told Roland. Although the Egyptian War Office had begun canceling permits for civilian travel, the next weekend Lee took Mafy and Erik to the Red Sea, to make up for not seeing much of them of late.

In April, as the couple packed their belongings, Lee came up with a plan. Since her brother and sister-in-law would be spending time in London on the way home, Roland should persuade Mafy to stay on. Lee could then set up housekeeping with her after Erik's departure. "My plans are maturing," she continued. "Everything will be smooth if there isn't a war." But she had to proceed with caution, having already gotten into trouble by going on another trip with Bernard. (She did not say that Bernard had fallen in love with her even though he knew about her relations with Roland.) Lee and Mafy had been "the last white women to visit Siwa," she wrote: "Anyone putting foot in the Western desert gets six months prison." What was more, Georges Henein was now under surveillance. "Don't send me any books with communistic leanings," she added. The War Office looked with suspicion on socialist and fascist tracts alike.

Lee should settle things at her own pace, Roland counseled from London, "but through all your plans don't forget that you *are* coming to me." Aziz had been "quite extraordinarily charming to me," he added. "I appreciate him very much but I love you." By May Roland was desperate for a decision. "If it's war scares that make you hesitate," he wrote, "all I can say is that here everyone is so used to them that they are beginning to treat them as weather forecasts, never to be relied on. . . . So don't let wild rumours upset you unduly—not that they ever would."

In a letter written about this time, Lee announced that she had booked passage to England on the *Otranto*, a "swell" ship sailing on June 2, with stops in Naples, Villefranche, and Toulon. Yet despite this decision, she felt too jittery to sort through her photographs. She would "bring the whole lot to London in a suitcase." Roland should find her a furnished flat, "as I might not be able to stay with you unless Mafy is there—altho also I might anyway." She would leave their summer plans to him.

Under the impression that Lee was taking a bachelor holiday, Aziz took her to Port Said and kissed her goodbye. On board the *Otranto* Lee avoided the "British bourgeoisie" and spent her time reading inspirational volumes: Vita Sackville-West's *St. Joan of Arc* and Negley Farson's *Way of a Transgressor.* "I'm not writing you more intimately of my thots & intentions," she told Roland from Naples. But in her "sick muddle of indecision," one thing was clear. "I'm never returning to Egypt," she wrote, "unless the ultimate in disasters & dejection overcomes me. . . . I'm glad that finally I'm coming back to you."

Part Four

Lee Miller, War Correspondent

Lee outside British Vogue *studio in London, c. 1943*

Chapter 11

London in the Blitz

(1939–44)

In a journal begun on her way from Egypt to England, Lee described her state as "uneasy & nervous." Despite Aziz's generosity, she was unsure how to live once she made up her mind to leave him for good, or what to do in the event of war. Her finances were "ugly," she told Roland in a letter from Toulon, "so unless I go back . . . to the family or husband etc. or someone keeps me or I get a job it looks very depressing."

Lee was also corresponding with Bernard Burrows. Dismayed to learn that he had reached Cairo one hour after her departure, Bernard declared his love, admitting that until then, he had been "too timorous & undecided to press any alternative." He would soon move to London to join the Federal Union, a scheme for an anti-fascist alliance launched by the American journalist Clarence Streit. "Would the idea of doing something like that bore you to distraction?" he asked. "I rather fancy it's too much of a generalization. My benevolent instincts are strong for the mass of people, weak for individuals—yours I think the other way round."

"Altho these nice idealistic societies have to try & try again," Lee replied, the "gangsters [Hitler and Mussolini] have several years more practice." Moreover, she was "not very convinced about Federal U" and had no faith in an

alliance led by "Perfide Albion," whose record in Palestine, Spain, and Czecho-slovakia aroused her scorn. Bernard risked being a "champion of lost causes" if he moved to England for her sake. "I don't want you to do anything 'all for love' as I won't marry you," she wrote, "I won't live with you and I can't be depended on for anything."

∞

After a week of pondering the future while sunbathing, Lee arrived at Southampton—where Roland waited impatiently. One can imagine the joy of their reunion, although its full celebration was delayed until that night at Roland's house in Hampstead. A more conventional woman might have found it odd that his other houseguest was Man Ray. Apparently untroubled by the situation, Lee took up residence at 21 Downshire Hill, Mafy having followed Erik back to the United States.

The next day, Roland took her to the West End, London's center of mod-ern art since the establishment there of the Cork Street "triumvirate": the Lon-don Gallery, the Mayor Gallery, and Guggenheim Jeune. It was another homecoming. At the London Gallery, run by E. L. T. Mesens and backed by Roland, she saw Picasso's portraits of Dora and Nusch, both from Roland's collection. At the Mayor Gallery, where his own work was displayed, she met new images of herself, reinvented in her lover's imagination. His 1937 *Night and Day,* which had replaced Picasso's portrait of Lee on his mantelpiece, fore-grounds her role as muse. Two birds replace her hands, her creative powers; three funnels drain water into the ground beneath her, evoking her lover's sense of loss after their first summer together.

In contrast to *Night and Day*'s allegory of longing, Roland's two most recent paintings were overtly erotic. *Bien Visé* poses Lee's naked torso beside a chain and against a bullet-pocked wall; her arms, in the pose taken by prison-ers of war, frame the landscape that replaces her head. Sadeian "goings-on" are implied by the chain and the figure's resemblance to the victims of firing squads; the low-slung garment over her pudenda is a visual echo of the girdle Lee wore in Man's headless image of her at a window. As in much Surrealist art, the composition's frontality makes the female subject complicit in seeming to offer herself to an implied male viewer.

A companion painting, *Octavia,* a critic writes, exhibits "morbid under-tones." Here, the Sadeian themes underpinning *Bien Visé* take shape in the spikes protruding from the inverted figure—the woman's neck and shoulders, the long arms on which she balances, and the braids that become chains, anchoring her to the ground. *Octavia* disturbs the viewer "due to the ambiva-lence of the woman's arms, which can also be seen as a man's legs, the head then taking on a sexual meaning linked to the phallic spikes on the crenellated body." While Lee's journal does not mention Roland's fantasies, these paint-

ings hint at his feelings about the cost of relations with her, and with women in general.

Roland had written to Lee about the American heiress Peggy Guggenheim—one of his bedmates in 1938. The founder of Guggenheim Jeune, she hoped to start a U.K. museum of modern art: as such, she was also Roland's colleague, one of London's small band of modernist pioneers. Their affair, in his view, had been "rather indifferent." Roland made up for his lack of passion with charm, Peggy recalled some years later, but he had a notable eccentricity: "when he slept with women he tied up their wrists with anything that was handy. . . . It was extremely uncomfortable to spend the night this way, but if you spent it with Penrose it was the only way."

It was also true that the only way to start a museum of modern art in London was with Roland's support. Peggy and Herbert Read had tried to enlist him in her project, but that spring, Roland, Paul Nash, Henry Moore, and most of the British Surrealists were making plans for a museum of their own—since Peggy's fortune gave her a power that provoked the London art world's distrust. One can imagine Lee's mixed feelings about her compatriot, who, having urged Roland to go to Egypt in pursuit of Lee, liked to take credit for their reunion. On June 22, unaware that local movers and shakers were mobilizing against her, Peggy threw a closing-night party at her gallery. A huge crowd came to see Gisele Freund's portraits—among them Joyce, Breton, and T. S. Eliot—and to help themselves to drinks at the well-stocked bar. Within a few weeks, Peggy abandoned her plan for a museum and went to France despite the mounting political tensions.

By June, when Lee arrived, Hitler had annexed much of Czechoslovakia, forged his "Pact of Steel" with Mussolini, and forced nonaggression treaties on Estonia, Latvia, and Denmark. In July, a peace effort by an Anglo-French mission to Moscow failed to enlist the Soviet Union in opposition to Germany. One could hardly overestimate the sense of dread felt by all those (avant-gardists included) who saw the coming war as a threat to civilization—despite their critique of its values. Paradoxically, Lee felt "vastly amused," she told Bernard. "They've got the world war fixed for the week of July 25th"; friends were planning to hole up "in country cottages, or on lordly well-provisioned estates." Thinking that she would join him later, Aziz suggested a month in Saint Moritz, adding that on their return home, he would rent an apartment which Lee could decorate without interference from Kemal.

Toward the end of July, Lee and Roland set off to see Picasso in Antibes; she told Aziz to write her there care of general delivery. On the way, they stayed with Max Ernst and Leonora Carrington in their farmhouse in St. Martin d'Ardèche. Max had sculpted fabulous birds and fish on the exterior walls; Leonora had decorated the interior with creatures from her private bestiary. In this magical space, the couple painted each other's portraits, Leonora wrote a book entitled *The House of Fear,* and with kindred souls (Leonor Fini was visit-

ing when Lee arrived) lived as if untouched by the world. Lee photographed the couple, their house, and what was perhaps the last Surrealist picnic, at which Man and Ady joined them. Leonora's title proved to be prescient. Soon after Lee's departure, the authorities took Max to a camp for aliens, and Leonora suffered a nervous breakdown.

In Antibes, where troops were guarding the port, Picasso joked that the war was a plot to keep him from working. A man of disciplined habits, he swam every day and, in the evening, met with friends and his nephews, Fin and Javier Vilató, who had escaped from Spain after the defeat of the Republicans. "Their irrepressible high spirits helped temporarily to disperse the increasing gloom," Roland recalled. (Fin demonstrated an innate Surrealism by shaving his legs in horizontal patterns.) Lee's photographs—the group at the beach, the Maître holding a tame monkey—document a vanishing way of life.

On August 21, after the Germans announced a nonaggression pact with Russia, foreigners rushed to get visas and plan their escape routes. On September 1, when Hitler invaded Poland, Roland and Lee drove north to Saint-Malo, where they caught the last boat to England. They reached London on September 3 in time to hear the first air-raid sirens and watch the silver gray barrage balloons rise in the sky. The western powers had declared war on Germany. At Roland's house, Lee found a letter from the American Embassy telling her to take the next available ship home. She tore it up, events having decided what she had been unable to decide for herself. On September 5, she cabled Theodore: "staying Roland love Lee Eloui." The next day she informed Aziz that she would be waging her war from London.

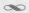

One kind of waiting had ended, another had begun—the period known as "the phony war." As they waited for the Blitzkrieg to begin, reserved Londoners talked to one another in public places, and war preparation—gas masks, blackouts, bomb shelters, evacuations—became a way of life. Then, the period from September 1939 to April 1940 was called the "Bore War," the "funny war," or, as wits said after months of anticipation, the "Sitzkrieg."

Throughout September, refugees from the Continent turned up in London. Eileen Agar invited Roland, Lee, and Herbert Read to the last of the Surrealist banquets, in honor of Walter Gropius, Marcel Breuer, and Moholy-Nagy, who were passing through on their way to the United States. Eileen decorated her Ping-Pong table with Surrealist objects—the strangest being the centerpiece, "a pedal-operated fretsaw hung with fruit and flowers"—and cooked oddly colored dishes, including pink potatoes. "The complexion of the dinner party was rather more abstract," she recalled, "but our guests took it all in their stride."

By October, Londoners were taking the increasingly surreal aspects of the Sitzkrieg in their stride. They covered windows with brown paper strips, installed "Anderson" shelters (named for the minister of home security) in the garden, if they had one, and, if not, prepared for the Blitz with government-issue earplugs. Signs saying TO THE TRENCHES showed the way to dugouts in Hyde Park. By November, when fog blanketed the city, flashlights were scarce; cigarettes gave a welcome source of light. People collided with one another; pedestrians found their way home by means of the white lines painted on the curbs and gateposts.

Fashion adapted to this state of affairs. For the first time, women went to work in slacks, with gas masks dangling from their necks. "Siren suits"—hooded coveralls, for nights in the shelters—made their appearance in Bond Street shops along with uniforms for the women's auxiliary forces—the Wrens (Women's Royal Naval Service), ATS (Auxiliary Territorial Service), Waafs (Women's Auxiliary Air Force), and the women of the Fire Service. ("The smartest seems to be the dark blue and scarlet of the fire service, faintly recalling a musical-comedy Zouave," *The New Yorker* noted.)

Lee found herself in a strange position. She had chosen to stay in England but as an alien could not join the thousands of Englishwomen enlisting in the auxiliary forces. Nor was she the type to stay at home and knit. "Learn to cook," U.K. *Vogue* urged readers who, like Lee, were at leisure. "Sew or knit something, preferably not too complicated. This is not to put your dressmaker out of work but to give you something to do." Not a good candidate for these activities (Roland's housekeeper kept order at Downshire Hill), Lee was at loose ends. Brogue's photographic studio did not require her services. Perhaps for this reason, she kept writing to Bernard and Aziz, who both hoped that she would return to Cairo soon, or when the war was over.

In the meantime, Roland joined the ARP (Air Raid Protective Corps) while Lee prepared for "siege, starvation, invasion." "I figured that if it were coming to . . . a diet of potatoes, field mice and snails," she told Erik, "I might as well make them taste nice, so the only hoarding I did was truffles—pimentoes—spices and all things nice," including tins of corn and clam chowder from Fortnum and Mason's, where she also bought a display basket full of dried seasonings. Roland installed an air-raid shelter, painted pink and blue, in the garden, with a Barbara Hepworth sculpture near the entrance. Like the rest of London, they listened to the radio at night (broadcasts by Lord Haw-Haw, the Nazis' English-speaking propagandist, were popular). By winter, nightspots were again packed with Londoners trying to cope with their discontent—the war of nerves having become "a war of yawns."

In December, the Royal Academy asked a number of painters, including Roland, to contribute to their "United Artists" exhibition—an unprecedented effort by this conservative bastion to boost morale. Due to the language ("sex," "flesh," "arse") with which he annotated one of his canvases, the committee

asked him to replace it with something less vulgar. Roland followed Lee's nose-thumbing suggestion. "What I did," he wrote, "was . . . get a card in deaf and dumb sign language from which I chose a four-letter word S-H-I-T, and painted a row of hands saying this." The committee hung this work opposite a portrait of King George, where it remained until a deaf and dumb cleaner "started hooting with laughter, and gave away what it said."

The winter of 1939, the coldest in forty-five years, gave few opportunities for laughs. The Thames froze, pipes burst, snow fell until March. Not normally one to put up with hardships, Lee shivered with the rest of England. When several Brogue photographers left on war work, Lee joined the staff after Harry Yoxall, the managing editor, wangled a work permit for her. Condé Nast cabled his delight that her INTELLIGENCE FUNDAMENTAL GOOD TASTE SENSITIVENESS [AND] ART VALUES were again being mobilized on behalf of the magazine, but wanted to wait before naming her head of the studio. KNOWING MILLER INTELLIGENCE INDUSTRY FEEL MUST HAVE PATIENCE ARRANGE LONG PERIOD EXPERIMENTATION, the New York office's art director counseled.

For one of her first assignments, Lee posed a model wearing a leopard-trimmed suit in front of the map of Europe and beside an array of helmets, boots, and satchels—as if she were about to trade civilian garb for military gear. That winter, as paper rationing went into effect, the staff struggled to make their trimmed-down issues relevant. Debates about which shade of lipstick complemented khaki and endorsements of Harrod's luminous headgear were accompanied by "must" lists for the wartime *élégante*. These included a gas mask bag resembling a camera case, a white umbrella, and another item to enhance visibility: "not a life preserver but a nerve preserver in the guise of a white waterproof dickey, with tape shoulder straps and side ties."

For Lee, employment was itself a nerve preserver. Throughout 1940, while photographing haute couture, celebrities, dress patterns, and bargains, she befriended members of the staff—with the exception of her bête noire, Cecil Beaton. Lee grew fond of Sylvia Redding, the studio head; Roland Haupt, an Anglo-Indian printer whom she taught photography; and Doreen Impey, whom she took to taste wine nearby in Soho's Italian restaurants, apparently unconcerned that after these lunches, they returned to work "a little less efficient."

In time, Lee also formed a close working relationship with Audrey Withers, the Oxford-educated socialist who was Brogue's editor. Withers struck the note for the magazine in wartime: "Women's first duty is to practise the arts of peace," she wrote, "so that, in happier times, they will not have fallen into disuse." A woman of integrity and taste, she had the foresight to look beyond the ephemeral aspects of fashion while putting them to good use under the circumstances. Government officials sought her support on matters affecting civilian life; as the war progressed, she maintained that women's new roles

were both a matter of style and a major social issue.

Brogue's offices on New Bond Street became Lee's second home. After work she often met Roland at the Barcelona Restaurant, a Surrealist haunt. Their Soho dinners, Eileen Agar thought, were good for morale, "for English artists are notoriously self-contained. . . . Some meetings were stormy, some merely cloudy, all lively and tempered by Spanish wine." On April 11, 1940, three days after the Germans invaded Norway, Mesens called a meeting. The Sitzkrieg had come to an end. Winston Chur-

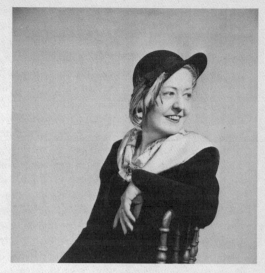

Lee's portrait of Audrey Withers, her editor at U.K. Vogue

chill's call to action had roused the country. Surrealists must stand up for their principles, Mesens argued—by which he meant refusing to support, show with, or write for non-Surrealist institutions. Despite some resistance, the group was stirred to action.

In May, as the Germans swept through the Low Countries and the British narrowly escaped from Dunkirk, Mesens organized an exhibition entitled *Surrealism Today*. In the current context, Lee's photographs from St. Martin d'Ardèche, before Ernst's internment and Carrington's breakdown, testified to the fragility of the creative spirit. The exhibition opened on June 13, the day the Nazis marched on Paris. Its window display, an armchair upholstered as a Negro mammy and a bed whose rumpled sheets were pierced by a dagger, provoked some critics to deplore the group's taste, while the *Studio* asked "whether the surrealists did not instinctively sense whither the European society in which they lived was tending, and whether their movement was not, in fact, a criticism of that society."

At the same time, the Surrealist-inspired *London Bulletin* published an issue on the theme of war. Because "the enemies of desire and hope have risen in violence," page 1 declared, artists were obliged to combat Nazism "wherever it appears." Contributions included poems by Breton, Eluard, Mesens, and Péret, work by Agar, Moore, Penrose, Tanguy, and Delvaux, and two of Lee's most striking photographs: *Portrait of Space* and *The Native* (aka *Cock Rock*).

Although she was not an official Surrealist, these images were "an integral part of the movement," in the view of art historian Michel Remy. Moreover, the dilemma of the group as a whole—its self-perception as "an open movement, never fully *satisfied* with itself"—echoed her own.

Soon London would offer scenes such as card-carrying Surrealists could not have imagined. After the fall of France, Britain carried the full weight of the war against Hitler. Brochures entitled "If the Invader Comes" arrived in the mail. By July, weeping families crowded the stations as the authorities began sending children to Canada and the United States. Lee persuaded the Millers to take two young refugees, who sailed on the first ship. "You did so well," she told her parents, "in just removing them from here that I don't think anything that happens to them after is of much importance."

The Nazis' night raids on London began on August 22 and increased in fury until September 2, when seven hundred German planes bombarded the city. People went to their shelters at the sound of the sirens; there was little panic. In his "This Is London" broadcasts to the United States, Edward R. Murrow praised the courageous "little people" in the hard-hit working-class districts, who dug live bombs out of their gardens and chatted through paneless windows after the explosions. "About an hour after the 'all-clear' had sounded people were sitting in deck chairs on their lawns, reading the Sunday papers. . . . There was no bravado, no loud voices, only a quiet acceptance of the situation."

From the heights of Hampstead, Roland and Lee watched the fireworks—searchlights piercing the night sky, antiaircraft beams tracking bomber squadrons, fiery clouds rising from the East End and the docks. Even at that distance, Roland recalled, fear "could seize a person and make him crawl like an animal." He felt calmer with Lee, who, he wrote, "innocently enjoyed the stimulus provided by danger."

Fear was less likely to take hold of those who kept busy. The War Artists' Committee, under Kenneth Clark, commissioned artworks from thirty artists, but no Surrealists were included. For the next few years, when British art favored morale-boosting tableaux, Roland's circle felt doubly isolated, since they were also cut off from Paris. One way to continue avant-garde pursuits was to adapt them to defense, an activity that engaged Roland from 1940 on, when he began teaching camouflage to the Home Guard. The following year, he organized the Industrial Camouflage Research Unit and published a book on the art of concealment, *Home Guard Manual of Camouflage*. (The manual, which treats of "deception, misdirection, and bluff," would have pleased Picasso, who claimed that the Cubists had invented camouflage in time for World War I.)

About the same time, Lee's first published prose, "I Worked with Man Ray," appeared in *Lilliput*, a review that featured photography. Although it had

been drafted on the boat from Egypt to England, when published two years later, the piece seemed to celebrate the creative spirit that England was fighting to defend. (Man's iconic solarized profile of Lee was featured in the illustrations.) After detailing her modernist pedigree, the contributor's note concluded: "Has a wandering spirit, pre-war liked to go wherever opportunity offered. . . . Came to England when war was declared, says she wouldn't be anywhere else."

A photo-essay in *Picture Post,* Britain's counterpart to *Life,* showed Lee at work on a fashion shoot resembling the production of a play, "for which actors, producer, stage hands must all be experts." As producer, Lee is shown contemplating the set she designed to signal glamour, showing the pose to her model, and experimenting with the lights. "Why all this fuss about a photograph," the journalist asks rhetorically, "when the country is fighting for its life?" Lee's meticulous care was necessary "because now standards are more important than ever," the article concludes, because fashion "maintains Britain's position as the world's greatest exporter of fabrics," or, to put it bluntly, "fashion pays for planes and supplies."

Another way for artists to participate in the war effort was by documenting the Blitz. Cecil Beaton went to photograph St. Giles' Church, in the City, after one of the first German raids. "I marvelled at the freaks of air raid damage and the unfathomable laws of blast," he observed. "Scattered cherubs' wings and stone roses were strewn about—whole memorial plaques of carved marble had been blown across the width of the church and lay undamaged. The entire frontage of the deserted business premises opposite was wrecked. . . . Yet the lamp-post was standing erect with no pane of its lantern broken."

To a Surrealist, the laws of blast were not so much unfathomable as liberating. By wrecking some targets and sparing others, the bombs created wonders in the midst of chaos—as if Magritte or Dalí had remade the landscape. Lee was in her element. By day, odd juxtapositions in the wreckage spoke to her; at night the tension of air raids energized her. There was no reason to be bored with such strangely beautiful sights occurring daily: silver barrage balloons gleaming in the sunset, the stars visible in the dark sky, London spread out like an enormous stage in the moonlight.

One night, an unfamiliar noise awakened her. When she pulled back the blackout curtain, a mysterious substance filled the room—part of a barrage balloon that had landed on the house. It took all night to corral the balloon's silvery mass and hand it out through the front door. Coming across another grounded balloon in a park one day, Lee photographed the huge shape as if it were a giant egg—the offspring of two geese unexpectedly posing in front of it. The title, *Eggceptional Achievement,* is characteristic of her quirky response to life in the Blitz. From the first, Roland noted, "her eye for a surrealist mixture of humor and horror was wide open."

Lee captured some of the firestorms' most startling effects on the way to and from work. One day she photographed a smashed typewriter balanced on the remains of a pedestal: the image, *Remington Silent,* speaks mutely of loss and damage. A companion piece, *Piano by Broadwood,* shows a piano crushed by debris—an eloquent testimony at a time when wailing sirens and droning dive-bombers composed London's nightly music. One of her most poignant images of a fallen culture shows the shattered dome of University College reflected in a pool formed by the rain that has cascaded through the roof. On a lighter note, a wooden board promoting a newspaper proclaims LONDONS NO NIGHT RAID, ONE NIGHT OF LOVE.

Although Lee had felt "like a soft-shelled crab" at the start of the Blitz, she told her parents, like most Londoners, she grew a thick skin in the "three months of solid hell at night" that followed. Brogue's offices were hit by incendiary bombs, yet "it became a matter of pride that work went on. The studio never missed a day, bombed once and fired twice—working with the neighbouring buildings still smouldering—the horrid smell of wet charred wood—the stink of cordite—the fire hoses still up the staircases and we had to wade barefoot to get in." Staffers took prints at home at night when they had "the sacred combination of gas, electricity and water." Lee also took her models home. In one shot, two of them pose in front of the pink and blue shelter wearing protective eye shields, as if masked for a macabre costume party.

Artistically, Lee came into her own in these months, hitting the disquieting note of glamour mixed with dread that, in many of her best images, reflect on each other. Impressed with her feel for the laws of blast, Audrey featured Lee's pictures of Brogue's headquarters—the shattered roof, the staff at work in rooms full of broken glass, the studio in the wine cellar—in the November issue, which also ran her shots for an article entitled "Still Smart Despite All Difficulties."

Lee's spectacular images also caught the attention of Ed Murrow's friend Ernestine Carter, an American married to an Englishman in the Ministry of Information. "We saw eye to eye on the oddities and awesome beauty, as well as the horrors of the Blitz," Carter recalled. They began work on a book based on Lee's photographs, a project "conceived (and given a paper allocation) as a propaganda effort aimed at the U.S.A." Their project could not have been more timely. To continue the fight against Hitler, Churchill needed Roosevelt's support at a time when the United States was strongly isolationist. Their book would complement Murrow's broadcasts and perhaps help shift the tide in favor of intervention.

After each raid, Lee photographed the most arresting sights amid the debris—the Burlington Arcade's transformation into a Piranesi, the angels of St. James' Church raising their trumpets to the sky, once proud Knightsbridge homes joined by a bridge of sighs above their missing stories. While such shots reveal the city stripped bare, they also find humor in the wreckage. Store dum-

mies take to the streets naked except for their top hats; the sign pointing the way to an establishment called Fifth Avenue reads, THE AMERICAN DRESS SHOP CARRIES ON! Lee's Blitz scenes plunge the viewer into a city turned theater of war. They show the new ways of understanding forced on its people.

Ernestine quickly compiled a book whose title, *Grim Glory: Pictures of Britain Under Fire,* echoed Churchill's description of England's spirit in 1940, a mix of "grim" and "gay." The publisher, in congratulating its authors, referred to them as Americans "whom matrimony and *Vogue* respectively have impelled to share with other Londoners their ordeal by fire." As for the images, they testified "to a quality which it is easy to admire but very difficult to analyse." The book was dedicated to Winston Churchill—"the embodiment and the inspiration of that indomitable spirit of the common people."

What could not be said in print was that for some the devastation unleashed on London was also energizing. It depended on one's point of view. One day, Lee found a damaged statue of a classical figure asleep in the ruins, a metal bar across her neck and a brick on her breast. She focused close-up and took the shot on the diagonal: the canted perspective heightens the drama of the statue's downfall. In the context of *Grim Glory,* where the image was featured, this female icon represents a civilization brought low. At the same time, Lee's sardonic title, *Revenge on Culture,* hints at personal themes. An emblem of femininity whose profile resembles her own has been overthrown, yet set free by destructive energies within the culture that first placed her on a pedestal.

Non-Conformist Chapel, another striking shot from *Grim Glory,* may not immediately appear to be a companion image to *Revenge on Culture.* This theatrical photograph of debris falling out the door of a Protestant church plays with the formal and thematic evocations of blockage figured in Lee's earlier photos of impassible doorways. Here, a congregation of stones leaves the chapel in a rush—an eccentric spirituality emptying out from its home, a body turning itself inside out. While such images faithfully record the laws of blast, Lee's compositions also seem to express personal issues: ideas of stasis and release, a sense of the blockage, or liberation, of body and soul.

∞

At times, talk of Britain's indomitable will seemed like so much propaganda. Lee's letters from the early days of the Blitz had been "hopelessly false," she told her parents later, "the reflection of a very temporary mood of fright, bravado, indifference, anger or as often as not just plain drunk and sentimental." By November 1940, she felt tough enough to join Ernestine and a group of American journalists at the BBC for a Thanksgiving Day broadcast to the United States. They had twenty minutes to write about life in the Blitz, "just like at school," Carter recalled. To their surprise, the person in charge chose

Carter and Lee for the program, since their essays were "the only ones that didn't start with 'through shot and shell and bursting bombs this correspondent made his way here.'"

Toward the end of 1940, the Germans let up on the bombing. "We've been having the most extraordinary lull in the blitz since before Xmas," Lee told the Millers. "It's given us all a chance to catch up on being human a bit—instead of just hanging on to the edge of the precipice." Friends who could not get home at night or were bombed out of their homes stayed with Lee and Roland, playing cards, doing crossword puzzles, and drinking. Guests came and went constantly. "It was an agreeably relaxed household," one of them wrote. "There was no demur should two luncheon guests decide to take an afternoon nap in their double bed." In their circle of friends—artists, writers, journalists, and politicians—it was the way to be human rather than just hang on.

One of the first to take up residence was Valentine Penrose, who was stranded in London. Uneasy about contacting Roland after their divorce, Valentine made a date with him at the nearby pub—where she got into conversation with Lee without knowing who she was. After Roland found the two women chatting amiably, Lee invited Valentine to live with them. "Downshire Hill," a poem written in 1941, voices the "great fear" Valentine felt in her attic room during bombardments, but also her admiration for "the lovely woman" who "does what must be done" and keeps "her taste for life"—a tribute from one brave woman to another.

"We eat fine, but it's a career to manage it," Lee told Erik. "We have a field day with the cheese rations," she continued. "Everyone brings theirs along and we have a big toasted cheese and beer party." Rationing was introduced gradually (bacon, sugar, and butter, then meat, tea, and fats, and, in 1941, eggs and milk). The Ministry of Food urged housewives to cook grains and vegetables. Dinner might consist of lentil sausages, mock goose (a gratin of potatoes and apples), and victory sponge (potato pudding with carrots). A soup for air raids could be made from root vegetables, the ministry explained: "A hot drink works wonders in times of shock." On less stressful days, one could top vegetables with mashed potatoes—the infamous Woolton pie, named for the minister of food, went through many variations, the best being the one served at the Savoy Hotel. In 1941, Lee began a nonstarch diet on the advice of her doctor, who said that her system had been poisoned by the national mainstay, wholemeal bread. (She told Erik that she longed for the United States, where she hoped to "eat a lot of butter" after the war.)

In December 1941, when unmarried women were called for military service, the housekeeper announced that she was leaving to work in a munitions plant. "Xmas won't be much of a party as leave is impossible to co-incide," Lee told her parents. "Someone has promised me a goose—a bird, not a rude poke—and I've wangled a pudding—tho no brandy to burn on it, yet. . . . I'll have to cook it myself." "It seems pretty silly to go on working on a frivolous

War Years

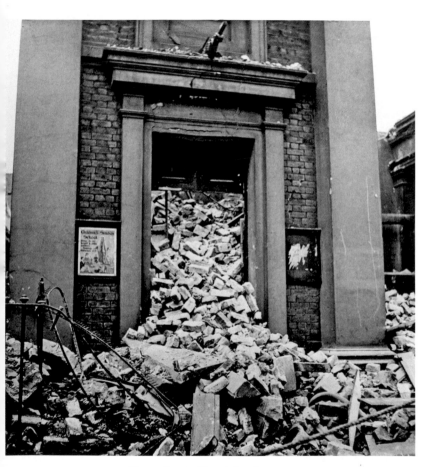

Nonconformist Chapel. London, 1940

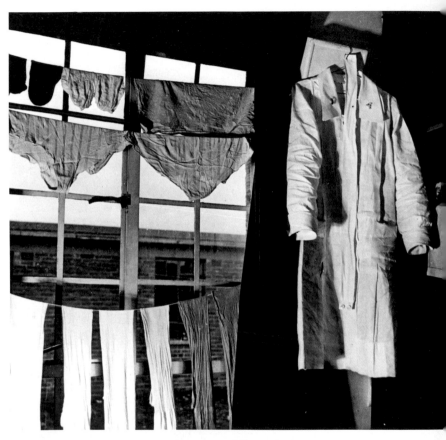

U.S. Army nurses billet. Oxford, 1943

Ordnance Wrens. England, 1944

Liberation scene, children celebrating. Paris, 1944

U.S. infantry advancing. Alsace, 1945

Alfred Freyburg, the Bürgermeister of Leipzig, with his wife and daughter. Town Hall, Leipzig, 1945

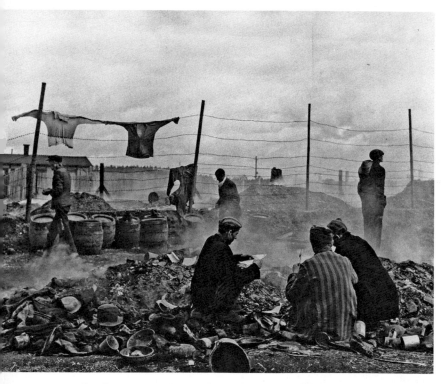

Freed prisoners scavenging the rubbish dump. Dachau, 1945

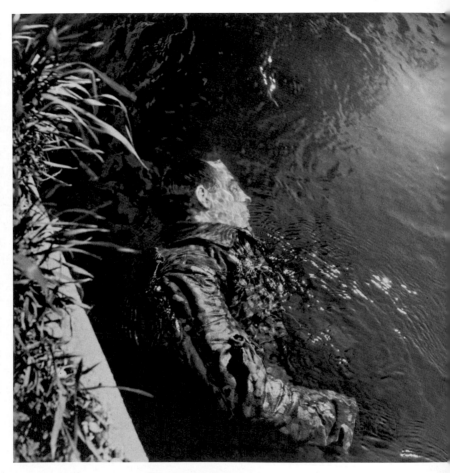

Dead SS prison guard floating in canal. Dachau, 1945

paper like Vogue," she continued, "tho it may be good for the country's morale it's hell on mine."

Since the outbreak of war, fashion magazines had maintained that keeping up appearances helped morale. In 1941, when clothes rationing came into effect, Brogue faced a new challenge: to support limitations on the use of fabrics (given the need for uniforms) while convincing readers that they could still dress well. "If the new order is to be one of sackcloth and ashes, we think some women will wear theirs with a difference," Edna Woolman Chase, U.S. *Vogue's* editor, declared. In the same spirit, Audrey Withers asked Lee to take pictures for a series of articles on the new Utility designs, factory clothes "with a tough chic of their own." Such styles, the October editorial claimed, illustrated "our belief that fashion is *of* its period, not superimposed upon it."

By the end of the year, the tailored look prevailed. To compensate, women wore their hair long, à la Veronica Lake—a style that proved hazardous to those employed in factories. In response to the minister of labor's plea to ban long tresses, Withers ordered features on hair-concealing hats and the short coiffures said to be chic in Paris. Lee's photographs—turbans, draped cloches, sleek hairdos—helped launch the movement toward smaller, neater heads. "Within a few months . . . accidents had disappeared from our workshops," Harry Yoxall recalled with pride.

For Lee's next assignment, Withers sent her and staff writer Lesley Blanch to Greenwich, to photograph the women of the Royal Naval Service. Blanch assured readers that the Wrens took care to look "pretty and feminine"; Lee's shots of these competent women on the bridge of their ship, tracking planes and conferring with their male counterparts, stress their seriousness while confirming the widespread belief that of all the auxiliaries' uniforms, the Wrens' (two well-cut suits in navy, a matching coat, and stockings) was the most becoming.

December, already an eventful time due to female conscription, became even more tense with the loss of two of England's biggest ships in the Pacific—an incident that had greater impact in the United Kingdom than the news of the Japanese attack at Pearl Harbor. (Some were heard to say that it "served the Yanks right" for having refused to join Britain.) And while the American journalists who gathered at the Savoy were jubilant over Roosevelt's declaration of war, most people took the news calmly. "For me," Lee told her parents, "the declaration of war is a sort of anticlimax . . . as I've felt so much in it from the beginning."

Increasingly, she sought out other Americans who had been "in it" from the start. Since autumn, a lively group of Time-Life journalists had been reporting on the war from their base on Dean Street. At a dinner party in December, Lee met the group's catalyst, David Scherman, a wisecracking New Yorker who, at twenty-five, had already established himself as one of *Life's* most inventive photographers. He drove her home; she invited him in for

drinks. Overwhelmed by the Picassos on the walls, and even more so by his hostess—whose work he knew from *Vogue* and *Grim Glory*—Scherman became a regular at Downshire Hill soirées.

By February 1942, Lee was thinking about sharing a flat with Scherman and two friends from Time-Life, since Roland was often away and people thought that the Germans would invade Britain by spring. After discussing the plan with Roland, Scherman instead joined their household, where his education in art, food, wine, and Surrealism began. It is easy to see what Davie (Lee's nickname for this intense young man) saw in his hostess, who was nine years his senior. Educated at Dartmouth, a puritan stronghold, he considered Downshire Hill a crash course in the kind of sophisticated living he had only read about in *The New Yorker*. And while his colleagues enjoyed London on their American salaries, Lee's guests outdid them in worldliness—especially where sex was concerned. It amazed him to learn that in his new family, open relationships were the norm. Soon Dave was sleeping with Lee when Roland went on assignment. "It was a ménage à trois," he explained, "but Roland was in the army, so it soon became a ménage à deux."

Their ménage functioned well, due to the mutual respect between Dave and "Rollers," the young man's name for Roland. "I was very fond of Dave and admired him greatly," Roland said, though he recalled his pique on coming home to find their friend's pajamas under his pillow. The trio's intimacy is palpable in a contemporary photograph, Dave and Roland each in uniform on either side of a barefoot Lee. For a time, Dave's absorption in Lee blinded him

David Scherman photographing, c. 1942, (David E. Scherman)

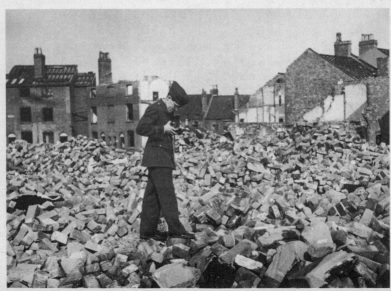

to the situation, in which he was, in a sense, being exploited, while Roland was pleased that Lee had company. She would be less likely to stray, and Dave would look after her during the bombing.

It is also easy to surmise Lee's feelings for Dave, in whom she gained a brother, a mentor, and a friend, as well as a rapt though inexperienced lover. Judging by his portraits of Lee in her nightgown, gazing at her image in a mirror, the seductive older woman seemed like a goddess. While her poses recall those she struck for Theodore and, later, for Man, the power was now on her side. Yet as well as being Dave's lover, she was also a friend with a sense of humor like his own. "There was no chi-chi about Lee," Scherman recalled, "no nonsense, but great fun." (Lee called him her pal—the substitute for the faithful playmate she had had in Erik.)

In exchange for Lee's lessons in the pleasures of life, her compatriot taught her his approach to photojournalism as a story—"pictorialism with a meaning." Scherman had learned his métier from *Life* photographers Margaret Bourke-White and Alfred Eisenstaedt. While he endorsed the "exact instant" approach to photography, as in Robert Capa's famous shots of the Spanish Civil War, he also believed that if one missed the instant, one might convey its meaning by reframing the shot, or, better yet, faking it. "You invent a good picture," he explained, often some time after the fact.

The idea of staging a complex image or a narrative sequence appealed to Lee's sense of the theatrical. Between fashion assignments, she helped Dave "invent" pictures for *Life*—a "photo-dramatization" of a novel about love in wartime, grimy chimney sweeps posed to dramatize the shortage of soap, scantily clad dancers auctioning lemons to demonstrate the rigors of rationing. This sort of "one-page quickie," Dave told his brother Bill, was designed to be a *Life* picture of the week. For the lemon auction, he and Lee "cooked it up, painted sign, bought fish-bowl for raffle, etc. . . . This sort of fakery I have no conscience about." Most recently, with Lee as lighting expert, he had shot Piccadilly Circus at night from atop a tall building.

Lee also traveled with Dave on two assignments in the country, "England in the Spring" (it rained every day) and "The Horrors of Wartime England"— often climbing up church towers for the best vantage points. (In a shot taken from the balcony of a burned-out Bristol theater, a tiny Lee curtsies onstage, beneath the remains of a safety curtain.) That autumn, Dave did a feature essay on the Home Guard's capture of a mock French village, staged with Roland's help. They amused themselves by calling the village brothel "Chez les Nudistes" and writing in French script on a wall the names Picasso, Miró, Matisse, and Utrillo, as if French villages naturally honored artists.

As Dave's pal, Lee joined the hard-drinking Time-Life crowd—photo editor John Morris, reporters Mary Welsh, Charles Wertenbaker, and Lael Tucker, photographers Robert Capa, Eliot Elisofon, and Bob Landry. When not at the

Savoy bar, the group met at their Soho headquarters, the White Tower, whose Greek proprietor served unobtainable items like fresh corn and wrote the scores of their ongoing gin rummy game on the wall. Through this network of high-powered journalists, Lee met other American women engaged in war work.

Lee spent the day with Margaret Bourke-White, the first female photographer accredited to the U.S. Army Air Forces, after she came to London to photograph Churchill, then flew to a secret U.S. airbase to name one of the long-range B-17s that were about to start the offensive against Germany. Lee showed her chatting with army personnel, taking pictures of the bomber crew, next to the engine christened "Peggy," her nickname, and beside "her" bomber, the "Flying Flitgun." Bourke-White posed as one colleague for another. One can imagine their conversation during the shoot. Both women liked the Rolleiflex's square format; Bourke-White was annoyed that despite her fame, the air force would not allow her to fly missions.

Lee also photographed the equally glamorous Martha Gellhorn, a reporter for *Collier's* and the wife of Ernest Hemingway—who caused a stir in London when he took up residence at the Dorchester to report on the war. In a composition reflecting Lee's sense of the gap between public image and private persona, Gellhorn, her back turned, stares at the camera from her dressing-table mirror. Within a short time, Gellhorn ended her marriage to Hemingway. The Time-Life crowd were not surprised, since they had been watching Hemingway's flirtation with Mary Welsh, who had set her cap for him, at the White Tower.

Welsh's memoir, *How It Was,* depicts the charged atmosphere in their circle. "Bob Capa came to photograph the war," she wrote, "and one could . . . hear the upswing in female heartbeats around the office." When Lee appeared, Welsh continued, "her crusty, cool intelligence, smoothed down the office airwaves, but not the heartbeats." Lee's ménage à trois was not the only triangular relationship in the group. While Dave was living at Downshire Hill, he befriended Cynthia Ledsham, an English researcher at *Time,* and later courted her. Ledsham, a friend of Lee's despite her hold on Dave, recalled "the atmosphere changing when she walked in, because of her joie de vivre. It's funny how someone so self-absorbed can buck up others," she added, "even while she got them to do just what she wanted."

At the same time, "Wert" Wertenbaker, *Time*'s foreign editor, began an affair with Lael Tucker, who worked under his direction—as did her husband. Sex in wartime carried "the demand to be casual," Wert wrote, since no one knew if he would be alive the next day. The war "made the English promiscuous," he believed, but kept "the deepest emotions for itself." Going to bed with someone could be intensely private but also "an irresistible expression of the forces around them . . . a gathering together of primitive passions and noble aspirations for the final orgasm of war."

Given their backgrounds, it is not surprising that the men at Time-Life took their female partners for granted. Although women worked as auxiliaries, they were unlikely to bear the hardships of military service. And while journalists like Lee and Lael were exceptions, the men considered reports from "the distaff side" (Scherman's words) less important than their own dispatches. What Lee thought of this attitude is implied in her portrait of Lael, whose mischievous smile hints at their complicity.

As the American "invasion" of Britain stepped up, Lee watched her friends at Time-Life become U.S. Army correspondents, a status that smoothed the way toward more exciting stories while also opening the doors of the well-stocked PXs—the source of cigarettes, Scotch, and other coveted goods. "The two phenomena, no-Kleenex-in-the-midst-of-plenty and the threat of being left out of the biggest story of the decade, almost drove poor Lee mad," Scherman recalled, "until I suggested that she too, a perfectly bona fide Yank from Poughkeepsie, apply for accreditation."

Though accurate, this explanation underestimates Lee's desire to see action as a photographer. Looking back on this period, one appreciates Audrey Withers's different sense of women's capabilities. She could see beyond reports of the hostilities to the social transformations taking place at home, which became the magazine's new focus. With her backing, "Mrs. Lee Miller Eloui" earned accreditation as U.K. *Vogue*'s correspondent on December 30, 1942. Unlike Scherman, Withers saw nothing odd in Lee's visit to Savile Row to order her uniform, since this was what all smart women did on receiving commissions.

"Now I wear a soldier suit on account of what I'm war correspondent for the Condé Nast press," Lee told the Millers. "You ought to see me all done up and very serious like in olive drab and flat heeled shoes," she teased, disinclined to admit that she *could* be serious. A month later, Lee posed in her new gear with five other writers—Mary Welsh, Dixie Tighe, Kathleen Harriman, Helen Kirkpatrick, and Tania Long—each wearing the triangular green WAR CORRESPONDENT badge on her jacket. The first official portrait of women journalists in the European theater, it implied that their presence there, contrary to popular opinion, mattered far more than their tailored uniforms and flat-heeled shoes.

As all realms of society mobilized in the war effort, fashion became serious business. Government officials sought Withers's support before launching the Utility clothes scheme, a system of rationing to save fabric; Brogue did its best to convince readers that austerity need not mean dowdiness. To this end, Audrey assigned Lee to photograph the tailored styles designed for the star of a film about a Wren in love with a Russian, and for the women diplomats

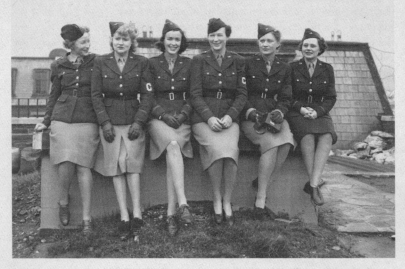

U.S. women war correspondents, 1943. Left to right: Mary Welsh, Dixie Tighe, Kathleen Harriman, Helen Kirkpatrick, Lee Miller, and Tania Long

posted to the British Embassy in Moscow (Russia having been England's ally since 1941). The illustrations for this article, "These Clothes Are News," bear a generic resemblance to Davie's "photo-dramatizations" but draw on Lee's long knowledge of staging and her sense that the women were as newsworthy as their outfits.

Throughout 1943, Brogue documented changes in British women's lives. Perusing these issues, one discovers Lee's commitment to being "in it" by chronicling the social upheavals wrought by the war, the first in which millions of women took part. Before she was accredited as a war correspondent, her assignments on women in the military were mainly domestic in emphasis. After accreditation, they treated the war as an opportunity for women, demonstrating her respect for the auxiliaries while giving her the chance to step into their shoes—in her imagination.

For the May issue, Lee photographed members of the Women's Land Army, a large-scale experiment that took women of different classes to be farm laborers: they drove tractors, thatched roofs, and reshaped hedges, activities that piqued her own interest in machinery and crafts. Among their few compensations for this backbreaking labor, the "land girls" received an ample wardrobe, including breeches, dungarees, and gum boots—indispensable for mucky farmyards. Lee's dissatisfaction with the layout and captions accompa-

nying her photos dates from this period, when the studio staff assembled arti-
cles without realizing that she had shot a story.

Lee's first piece of photojournalism, "American Army Nurses Pho-
tographed and Described by Lee Miller," appeared in the same issue. Evoking
the presence in Britain of these "blue-uniformed young girls with silver offi-
cers' bars on their shoulders," she outlined their training in hospital units
designed to be airlifted abroad. "The Presbyterian Hospital of New York," she
wrote, "has taken over the Churchill Hospital in Oxford which was a gift of
America to England. . . . There the patients range from G.I. Joe, who got out
too far on the big apple tree, to a lad back from too close attention in bombing
the Continent; but mostly men suffering from frostbite of high altitudes, expo-
sure in open boats, and wounds of just plain heroism."

Her illustrations show the nurses performing physical therapy, prepping
for surgery, and eating "American food" in the mess hall. "They are not forbid-
den, but not encouraged, to marry," she observed thoughtfully. "They may not
serve in the same unit as their husbands nor stay in the Service . . . if they start
a baby." Reading between the lines one senses her empathy—for the GI who
fell from the tree, the men with frostbite, women who "start a baby." From this
point on, while recording the changes in her subjects' lives, her images imply
her presence, as if she registered their experiences while peering through her
lens. (In some shots, clothes substitute for their wearers, as in a playful image
of nurses' panties framing the view from the window of their billet while a
starched white uniform stands guard beside them.)

Lee occasionally took up her old position on the other side of the camera.
One summer day when Roland was on leave, he decided to test an ointment
recommended by a cosmetic firm to camouflage members of the Home
Guard. The experiment, conducted in a friend's garden, began as the latest
variant on Lee's role as Surrealist muse. She stripped and covered herself with
the ointment, a thick green paste. "My theory," Roland wrote, "was that if it
could hide such eye-catching attractions as hers from the invading Hun,
smaller and less seductive areas of skin would stand an even better chance of
becoming invisible." Dave photographed the group, Lee painted green, Roland
in his shorts, and their friends taking tea on the lawn—a parody of English life
in wartime.

The following year, for a photo-essay on a stylish revue inspired by the
career of Cecil Beaton, Dave staged a mischievous Beaton-at-work photo with
Lee as Beaton's model: she reclined languidly on a couch while Beaton
focused on her from his perch high above on a mantelpiece. Judging by her
wary look, her opinion of him had not changed. One guesses that she went
along with the gag for Dave's sake, and as a joke for those who knew about the
lack of sympathy between the celebrity photographer and his skeptical sub-
ject.

Increasingly, Lee collaborated with Dave. Their partnership gave her prac-

tice in shooting a narrative sequence and confirmed her sense of métier. Though she relied on him for technical support, they collaborated as equals. Her photos sometimes appeared under his name; several of his were attributed to Lee. (Exchanging cameras or using each other's images was not unusual. When under pressure to submit pictures as fast as possible, photographers often pooled their work, helping themselves to the most suitable images.) In another *Life* "photo-dramatization" of a London beauty contest, Lee told the Millers, "some of the pix are mine, done on a co-operative job and fun with Davie." To show his gratitude, Dave told his brother to deposit his U.S. funds in a New York bank for himself and Lee, since "if I croak or if she goes to her home in America she would need some dough."

While neither would have used such a term, one could call them soul mates. Both were driven and practical. Like Lee, Dave had to be immersed in whatever he was doing. They had an unspoken pact to take things lightly. He liked to talk tough, as if they were characters in a Damon Runyon story. Both loved words like *hooligan, rubberneck,* and *boondoggle,* which made them laugh. As photographers, Scherman explained, "we were looking for odd juxtapositions—like Lee's title, *Grim Glory.*" Lee had "something unusual in a woman," he went on, "the soul of a tinker." She loved the technical side of their craft and shared his dislike of those who called it art. As Yanks, they reveled in popular culture, the wit of Irving Berlin and Cole Porter, and wartime humor. (Since the simultaneous appearance in Britain of Utility clothes and GIs, a joke had been circulating about Utility knickers: "One yank & they're off.") Their partnership relied on an ironic stance toward things others took seriously.

Given Brogue's mission to support the war effort, there was little room in its pages for irony. The subhead for "Night Life Now," a June 1943 article, reads in bold: "Lee Miller photographs, Lesley Blanch reports the after-dark drama of the work of the Women's Services." The piece gave Lee the chance to put light and shadow to narrative use. With Dave, she went to an ATS (Auxiliary Territorial Service) defense site at Hendon, north of London, to photograph the all-female regiment that lit up the night sky with searchlight beams. Arriving in the midst of operations, she posed two of them silhouetted against the searchlight. The shot, a kind of reverse solarization, creates a halo around the women who work to illuminate the dark. (One of them, Nina Hamilton, recalls coming under enemy fire as soon as the photo was done.)

With this striking chiaroscuro image, Audrey ran Lee's shots of Wrens maintaining boats, Waafs bedding down barrage balloons, ATS gunners, and the full ATS crew against the diagonal streak of their searchlight. Style no longer mattered, Blanch wrote, now that night life was a matter of "scrubbing, polishing and perfecting each apparently insignificant cog in this vast war machine of ours."

On her next assignment, Lee spent two weeks in Scotland at an undis-

closed location where the Wrens were honing their skills—from navigation, Morse code, ship maintenance, and "a certain amount of engineering, or mechanics," to repairing submarines that called into their station from the North Atlantic. Shadowing them at their labors, she photographed each aspect of their work, from the physically demanding, like climbing down rope ladders in thirty seconds, to the highly technical, servicing depth charges and regulating torpedoes. To get shots of Wrens racing down a ladder, crossing a boom, and clambering to a boat, she "nearly drowned," she told her parents, "or at least got damn wet stepping back to get a wider angle," another of her "Perils of Pauline style situations." She could not tell them about security measures, nor explain that some of her Wrens photos were being held by the censors.

In the same letter, she mentioned Dave's forthcoming books, two collections of photos due out in the United States in 1944. Building on a photo-essay for *Life* the year before, he had assembled his images of famous sites (King Arthur's castle, Charles Dickens's house, Canterbury Cathedral) under the title *Literary England*. "Davie says it's my idea," Lee told them. "It was the kind of book I wanted to read and see for a long time." His other volume, *First of the Many*, combined reportage and propaganda on behalf of the U.S. Eighth Air Force, whose bombers had been making strategic raids on Germany for the past year.

Watching Dave prepare these manuscripts inspired Lee to do a book of her own on the Wrens, using the "censored" pictures and the many shots not published in Brogue. As its title, *Wrens in Camera,* implies, it shows the women in private, but also at work—through the lens of one whose solidarity with them is apparent. Starting with a profile of their commandant, the Duchess of Kent, *Wrens in Camera* shows the women working as signalers, boarding officers, meteorological experts, cooks, and mechanics—mastering the kinds of techniques that piqued Lee's interest. She photographed them welding, servicing planes, testing radio equipment, and casting gears in the glowing furnace of a submarine depot—another chiaroscuro image of women in touch with pure energy. The book fulfills its function as a morale booster while honoring, by formal means, its subjects' engagement with power.

The time was right, Audrey felt, to show war artists at work. Lee's shots of Henry Moore sketching in a dimly lit tube shelter during the Blitz, Paul Nash seeking inspiration in a salvage dump, and Stanley Spencer, in the shipyards, illustrated an article on a new film called *Out of Chaos* that was intended to show the impact of chaos on the creative spirit. The artists agreed that "war turned them from abstract and surrealistic tendencies towards a more personal expression of their mind's eye"; the film, *Vogue* hoped, would "draw painter and public towards a closer understanding." Of the group, Lee's shot of Moore guarding his sleeping subjects while he draws conveys her empathy with the artist and the huddled bodies seeking repose.

That spring, Lee convinced Audrey to let her photograph and write about

Ed Murrow, whose comments were being cabled back to London for their authoritative overview. "You in the United States know why because you hear him," Lee told her compatriots in the version of their interview published in U.S. *Vogue*. "A radio prophet is a man without face in his own country," she said. Few knew that he was "literally tall, dark, and handsome."

After describing Murrow's accidental entry into broadcasting and the cramped office from which he electrified listeners, Lee explained his "seat of the pants" approach—as dazzling as that of any fighter pilot. "[Murrow] wing-talks with his right hand, pointing, circling his forefinger and putting in commas with steep left banks and right chandels [sic]," she wrote. "All the verbal 'hamminess' that some newscasters have is sublimated by Ed in these inaudible calisthenics. There are no crescendos, diminuendos, largos, or pizzicatos marked in on his script. There is no more writing on his page than meets the ear."

Lee's account of her friend "honestly writing what he honestly wanted to say" expresses her own ideal for prose. Murrow was her model, but when it came time to photograph him, she took charge. He was to sit at his desk and type, as if working on a story. "Lee says there is a difference between theory and practice," he wrote. "When Lee comes to take pictures she also straightens out the wiring."

In a note to Audrey accompanying the final draft of her article, Lee worried that the wiring still showed, that her idea—to write about a writer—had been a mistake. "I've spent fifteen or so years of my life learning how to take a picture, that thing that is worth ten thousand words," she fretted, "and here I am cutting my own throat." Writers were not, as she had thought, *démodé*." She had been naïve to think that she could master the "technique" of prose. But unlike Lee, who lacked confidence in her writing, Audrey was bowled over. The article showed "how the acutely observant eye of the photographer was transformed into the words of a reporting journalist."

From February to April 1944, the time of the Little Blitz, Lee persevered with routine assignments—society portraits, film stars, celebrities' grooming secrets—while also photographing women in the news and learning new trends in color photography. The year before, using Kodachrome film sent from the United States by Bill Scherman, she had "cornered the color racket for Vogue," Dave told his brother, with full color pages in each issue. The June 1944 issue ran a color shot of hers on the cover. Although conventional in terms of composition, it showed Lee's mastery of the process, much of it acquired that winter through her friendship with the Russian photographer Planskoi, whose expertise and supplies she exploited while he was in England.

With the rest of London, she dealt with the return of German planes bearing bigger, more destructive bombs. Once again queues formed outside tube stations, people slept in shelters, nights were pierced by ear-splitting raids and

defensive gunfire. It was "a bit dreamlike to hear broken glass being shovelled out of the gutters," *The New Yorker* noted, "to see a display of fluttering rayon stockings in a shattered shop window being guarded by enough policemen to make a Hope Diamond feel reasonably safe"—a scene one wishes Lee had photographed. At the same time, the rumble of military traffic produced talk of a brighter future, especially when the tide turned against the Germans and in favor of the Russians on the eastern front. In March, Roland left for Italy, where the Allies were fighting their way north, to study camouflage techniques for use in the European invasion, whose date was a matter of speculation now that General Eisenhower had taken command of SHAEF (Supreme Head-quarters Allied Expeditionary Force), based in England.

While the buildup of troops and supplies made it clear that the Allies were organizing a second front, the authorities took pains to keep its location secret. Londoners stopped betting on invasion dates, pretending to themselves that "this is just another spring, instead of the spring everybody has been waiting for since Dunkirk." With all of southern England become a military camp, the Time-Life staff lobbied New York headquarters for resources to cover the campaign. John Morris, *Life*'s head of photography, mobilized his own troops, including Capa, George Rodger, Ralph Morse, David "Chim" Seymour, and Scherman. *Life*'s cult of the "photographer-hero" was at its height; staffers' nerves were on edge despite the pretense of normality.

Lee's letter to her parents on May 29, 1944, mentions her "second-front nerves—which is affecting everyone—me particularly." After thanking them for their packages containing precious items like Kleenex, she asked for more food (canned corn, lima beans, Nescafé, "swell chocolates with soft insides"), and gave news of Aziz, whom her friend Henry Hopkinson had seen recently in Cairo. Aziz was "desperately ill," Lee wrote, "but I have no way of going there." Turning over in her mind the "shoulds," she wrote, "I ought to go—from human and moral obligation—and I ought to stay as my work would then be completely thrown away. So I dilly-dally around and am too cowardly even to find out whether there might be transport."

In the next sentence dilly-dallying gives way to insight. "All the reasons for which I left in the beginning come into play again—and the five years of making a new life would be thrown away. Not that Roland wouldn't understand but that selfishly I don't want to lose the grasp I have on work at the moment—I couldn't pick up another chance, and work is what I need for the rest of my life."

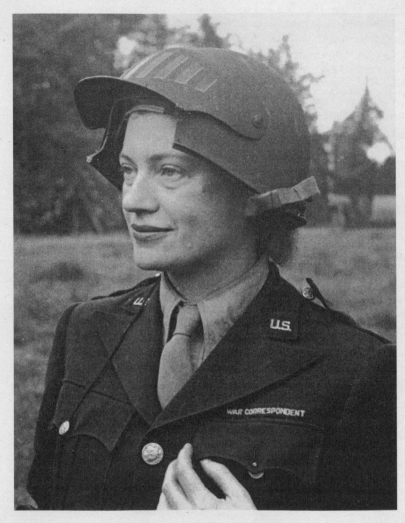

Lee in customized U.S. Army helmet, Normandy, 1944

Chapter 12

Covering the War in France

(1944–45)

On June 6, 1944, D-day, the Allies invaded Normandy. After photographing the onslaught from a U.S. Navy ship, Dave returned to London twenty-four hours later to find Lee preparing her own invasion. This was the work she wanted. She did not intend to miss her chance.

Nearly sixty years later, it is hard to imagine the constraints under which women journalists operated, even as they were becoming glamorous figures in popular culture. *Life* publicized the exploits of Bourke-White, who posed like a film star in her flight gear after gaining permission to fly with the air force. Hollywood churned out movies about "girl photographers"—romances in which the heroine's calling placed her at odds with the promptings of her heart. But newsworthy female journalists knew that they were unlikely to see combat. SHAEF protocol did not allow them to travel alone or visit press camps in a theater of operations. Nor were they assigned jeeps and drivers. As if they too belonged to an auxiliary corps, they were to stay behind the lines with the nurses. On D-day, Lee and her women colleagues were told that they must remain in England and file their stories from the invasion bases in the south.

During the next weeks, Lee suffered through several rounds of vaccina-

tions and, with the rest of London, coped with the new German missiles—the pilotless V-1s known as robots, doodlebugs, or buzz bombs. People ducked for cover at the sound of the V-1, which resembled the drone of a badly maintained motorcycle. Since it was hard to tell the start of a raid from its conclusion, nerves soon frayed from the sirens' constant wail. The weather—cold wind and driving rain—added to the strain. Lee coped by drinking the gin that came in the mail from Roland. "[It] saved my sanity," she told him on August 2. "See if you can do a deal for further supplies."

In July, SHAEF ruled that women journalists could report on the battle for France as it unfolded rather than return to London after each trip. Mary Welsh went on an official tour to cover the Medical Corps; on her return to the Dorchester, she related her experience to Hemingway, who was preparing to leave for France as *Collier's* war correspondent, Gellhorn having flown to Italy to cover the fighting. Iris Carpenter resented being assigned to an Allied hospital, but found that ambulances could be exciting when bombs fell all around her, shattering her eardrum. It was useful to have the backing of a major newspaper, a general, or both: Helen Kirkpatrick, the London bureau chief for the *Chicago Daily News,* convinced Ike to send her to France.

While it was not clear that Brogue needed a war correspondent, Audrey Withers tried to make each issue topical. "It was all very well encouraging ourselves with the conventional patter about keeping up morale," she recalled, "but magazines—unlike books—are essentially about the here and now. And this was wartime." Toward the end of July, as the Allies struggled to take the German strongholds along the Normandy coast, she sent Lee to report on the American nurses' postinvasion duties.

Lee's sense of the trip's strangeness pervades her published account: "As we flew into sight of France I swallowed hard on what were trying to be tears, and remembered a movie actress kissing a handful of earth. My self-conscious analysis was forgotten in greedily studying the soft, gray-skied panorama of nearly a thousand square miles of France—of freed France. . . . Cherbourg was a misty bend far to the right, and ahead three planes were returning from dropping the bombs which made towering columns of smoke. That was the front."

The sensuous particularity of this first paragraph would characterize her dispatches, along with her ability to focus the story with her photographer's eye. She regularly saw what others missed. "When you think that every situation she covered was completely outside her previous experience," Audrey reflected, "it makes the sheer professionalism of her text even more remarkable." In some ways Lee was winging it, inspired by Ed Murrow's seat-of-the-pants approach. Yet the many drafts in her archive attest to the care she took to

get the story right. Reading these different versions, one is struck by her ability to go to the heart of the matter.

After landing, Lee took quick, painterly notes while her convoy drove to the 44th Evacuation Hospital, near Omaha Beach, and later, to a hospital near the front. France looked familiar—"the trees were the same with little pantaloons like eagles, and the walled farms, the austere Norman architecture." Yet it was also full of strange juxtapositions. Strands of barbed wire "looped into each other like filigree." A skull and crossbones on a board in a hedge barred the way to fields of poppies, daisies, and land mines. Signs at crossroads bearing American code names—Missouri Charlie, Mahogany Red, Java Blue—stood beside those of Norman villages.

Camera around her neck and notebook in hand, she toured the tents where the wounded awaited treatment. Following the same pattern as in photo shoots, she surveyed the scene from a distance, then moved in for close-ups: "In the shock ward they are limp and flat under brown blankets, some with plasma flasks dripping drops of life into an outstretched splintered arm, another sufficiently recovered to smoke or chat to see if he's real. A doctor and nurse are busy on the next with oxygen and plasma. The rest are sleeping or staring at the dark brown canvas—patient, waiting and gathering strength for multiple operations on unorthodox wounds."

Lee zeroed in on one of the most unorthodox: a man whose entire body was swathed in bandages, with slits for his eyes, nose, and mouth. "A bad burns case asked me to take his picture as he wanted to see how funny he looked," she wrote. Complying uneasily with his request ("It was pretty grim and I didn't focus good"), she showed the man as a grinning white mask. The "grimness" of the case is betrayed in the shot's blurred focus—a trace of the shock she felt in this first encounter with a badly damaged body.

Moments later, a surgical patient watched her take his picture. "In the chiaroscuro of khaki and white I was reminded of Hieronymus Bosch's painting 'The Carrying of the Cross,'" she wrote. "I didn't know that he was already asleep with sodium pentothal when they started on his other arm. I had turned away for fear my face would betray to him what I had seen." That day, she learned that one could photograph horror, but at a cost.

Arriving at a field hospital closer to the front, she focused instead on technique, the use of "the magic life-savers"—sulfa drugs, penicillin, and blood transfusions. Yet even then, individual cases suggested larger themes. Others felt the need to record the mayhem, she noted: "Without looking up from his snipping a surgeon asked me to write down for him what exposure he should use if he wanted to take a detailed picture of an operation in that contrast of white towels, concentrated light and deep shadows." The next day, watching a doctor "with a Raphael-like face" treat a badly wounded man, Lee saw the scene in her mind's eye as an archetype of compassion.

Her response to suffering often troubled her. She sympathized with the hardworking American nurses whom she photographed off-duty. But trying to sleep that night in a tent recently vacated by enemy staff, she recalled, "I entangled myself with distaste in the blankets of the German nurses"—an intimacy that disturbed her as much as the gunfire. Then, watching German and American doctors work side by side, she wrote, "I stiffened every time I saw a German, and . . . resented my heart softening involuntarily toward German wounded."

On the road to the collection station, where cases were assigned to treatment, she spotted many odd sights—behind the Utah Beach hospital, "roly-poly balloons with cross-lacing on their stomachs like old-fashioned corsets," children in pinafores and soldiers' caps directing traffic, "fields with whole, transplanted trees sharpened into spikes against our landings"—some of which she captured on film. But the bulk of her images from this first trip show the most urgent cases, the "dirty, disheveled, stricken figures" and those who cared for them.

Before returning to London, Lee posed for her own portrait. In it, she stands with her hand at heart level, just below her war correspondent badge, and wears a metal helmet borrowed from Don Sykes, the army photographer who took the picture. (His customized headgear had a striped visor that had been cut away so he could wear it to shoot movies. "Sykes had painted on the stripes for fun," she noted.) Though Lee's expression belies thoughts of "fun," U.S. *Vogue* ran this portrait in her "U.S.A. Tent Hospital in France" on September 15, along with her shots of medics at work, the bad burn case, and the trees with pantaloons. A helmeted Lee also appeared in ads announcing, "VOGUE has its own reporter with the United States Army in France"—as if the portrait's mix of decorum and eccentricity conveyed her unique perspective.

This story also appeared in the September Brogue as "Unarmed Warriors." Publishing Lee's reportage was "the most exciting journalistic experience of my war," Audrey declared, and a source of pride for the entire staff: "We were the last people one could conceive having this type of article, it seemed so incongruous in our pages of glossy fashion." Lee's article not only thrust the magazine into the here and now; it showed that high gloss and seriousness were not antithetical.

∞

Throughout the summer, V-1s bombarded London. Reports of a crisis in Germany after a failed attempt on Hitler's life filtered back, but there was little optimism about the war's ending soon. In August, Lee wangled an assignment in Brittany—to cover the U.S. Army's efforts to maintain order in Saint-Malo after its liberation from the Germans, another behind-the-lines job. She

crossed the Channel on an LST, one of the large landing ships that had been ferrying troops to France since D-day. During the trip, she beat the captain at poker and talked with the crew about their adventures. Her own began when the LST ran aground at Omaha Beach and a sailor carried her ashore.

On her way to Brittany, Lee saw the devastation at Isigny, Carentan, and Sainte-Mère-Eglise. She reached Saint-Malo on August 13 to learn that, contrary to intelligence reports, the town had not been secured. The 83rd Infantry Division of the Third Army had arrived there a few days earlier to find minefields, antitank devices, and rows of steel gates meant to block their advance. The Germans, under Colonel Von Aulock, still held the heavily fortified citadel at the top of the bay, where they commanded positions around the port. In old Saint-Malo, the infantrymen who came in after the tanks were battling house to house with German snipers.

The head of the division's Civil Affairs unit (CA) took Lee to a hospital where U.S. medics were spicing their C rations with German herbs, then to their post at the once chic Hôtel des Ambassadeurs. "The wicker furniture tried to look gay and brave under the burden of machine guns and hand-grenades," Lee noted. "Instead of a chattering crowd of brightly-dressed aperitif-drinkers, there were a few tired soldiers." From a window facing the port, Lee shot views of the old city, the citadel, and the Grand Bey fortress. Amused to find a pair of GIs artillery spotting from a bed in the honeymoon suite, she took their picture—an action shot in which the cold gleam of their guns contrasts with the decorative curves of the window rail.

For the next five days, while the Americans attacked the enemy's positions, Lee had Saint-Malo to herself. "I had the clothes I was standing in, a couple of dozen films, and an eiderdown blanket roll," she wrote. "I was the only photographer for miles around and I now owned a private war." After crowds of panicky French prisoners left the citadel during a truce, she helped the CA keep order: "Kept busy interpreting, consoling and calming people—I forgot mostly to take pictures." She watched mangy pets escaping, women taking morphine for hysteria, "a tottering old couple with no shoes, an indignant dame in black taffeta . . . a pair of pixie twins, exactly like the little imps at the bottom of the Sistine Madonna"—whom she photographed picnicking in the midst of chaos.

That night, Lee slept well despite the bedbugs. In the morning, she washed in her helmet and ate K rations. Nothing in this life resembled her old one. The urgency of the tasks at hand drew on her gift for meeting events as they arose; the excitement of combat fired her imagination. Screening female civilians for the CA, she talked to a female collaborator who begged for protection against the patriots who were punishing women like herself by shaving their heads. Another collaborator posed for Lee with her children. They stared at her with "big sullen eyes. . . . They were neither timid nor tough," she wrote, "and I felt like vomiting." There was no way to observe with detachment.

To report the facts, the number of bombs deployed and targets damaged, she needed to get close to the action. Major John Speedie, the 329th Regiment's handsome commander, took her on a tour of observation posts. In one, the sun streamed through the floor-length windows, making it hard for her not to be seen by the Germans (who were only nine hundred yards away), "especially with such shiny things as binoculars." At another post, in the Hôtel Victoria, she lay on the floor to watch the artillery, her binoculars in the shadows. The GIs were pleased to see her, she thought, "mostly because I was an American woman, partly because I was a journalist and they wanted to be in the papers."

That evening, Lee moved to a nearby CA office with a phone connection to military command. "They are cooking up the final assault on the citadel," she scribbled in a note to Roland. "I'm going down to an OP inside the bomblines—to watch and take pictures,—naturally I'm a bit nervous as it'll be 200 pounders from the air—ours—I know nothing will happen to me as I know our life is going on together—for ever—I'm not being mystic, I just know—and love you." Lee's account of the assault brims with the sort of details that animate her photographs. A company files past, "ready to go into action, grenades hanging on their lapels like Cartier clips." The next section conveys her excitement as the planes arrive:

We heard them swelling the air like I've heard them vibrating over England on some such mission. This time they were bringing their bombs to the crouching stone work 700 yards away. They were on time—bombs away—a sickly death rattle as they straightened themselves out and plunged into the citadel—deadly hit—for a moment I could see where and how—then it was swallowed up in smoke.

Lee photographed this explosion not knowing that she had captured the Americans' first use of napalm. (Most of her shots were confiscated by the censors.) In one, in which the gaze passes through an inner frame formed by the curtain and railing, theme and composition merge. The contrast between the patterned foreground and the explosion catches the release of energy at the decisive moment.

Lee followed the GIs' ascent to the fort as if she were one of them. "I projected myself into their struggle," she wrote, "my arms and legs aching and cramped. The first man scrambled over the sharp edge, went along a bit, and turned back to give a hand in hauling up the others. . . . It was awesome and marrow freezing." But Von Aulock wouldn't surrender. At headquarters, "everyone was sullen, silent, and aching," including her. Before Saint-Malo, she had been a partisan observer. Now she was experiencing the war viscerally.

Later that day, when taking cover during a burst of gunfire, Lee stepped into one of the town's underground vaults, which by then "stank with death and sour misery." What follows gives a precise sense of war's horror: "I sheltered in a Kraut dugout, squatting under the ramparts. My heel ground into a dead, detached hand, and I cursed the Germans for the sordid ugly destruction they had conjured up in this once beautiful town. . . . I picked up the hand and hurled it across the street and ran back the way I'd come, bruising my feet and crashing in the unsteady piles of stone and slipping in blood. Christ, it was awful."

The GIs who rushed up a moment later were a benison. They joked and laughed with her, "asking me to talk American." Lee's spirits revived when they unearthed supplies in a nearby wine cellar ("bin after bin of sauterne, vouvray, magnums of champagne, Bordeaux, Burgundy"). She chose sweet wine for the soldiers, then joined Major Speedie and the officers at the hotel: "He opened a bottle of champage, aiming the cork at a helmet about as accurately as the bombers had done on the fort, and we drank from crystal glasses which I had polished on a bedspread." From this point on, the personal and public sides of war would be intertwined in her dispatches.

Dave Scherman turned up in Saint-Malo on August 17. After covering the battle from nearby, he wanted to see the results. Some of the most unexpected were the changes in Lee. She looked like "an unmade, unwashed bed" in her olive drabs and boots, he recalled. He photographed her seated on rubble while displaying her good profile, and beside a steel pillbox, while two soldiers from the 83rd peer at their tired, squinting mascot. Dave and Lee made plans to pool their shots, sending some of hers to John Morris and his shots of her to Audrey Withers.

When they reached the Hôtel de l'Univers, the best vantage point for the next assault, white flags appeared. Von Aulock had surrendered. They rushed to see the Germans emerge from their stronghold. The first to appear, a tall, erect man wearing gray gloves, a camouflage coat, and a monocle, was Von Aulock. As Lee ran to take his picture, he hid his face and cursed—he could not bear to have his defeat witnessed by a woman. "I kept scrambling on in front, turning around to take another shot of him," she wrote. It was a small victory, but an ambiguous one. She empathized with the man in spite of herself: he "seemed awfully thin under his clothes."

As Lee moved closer to the Germans with another group of GIs, those who looked carefully were amazed to find a woman among the cameramen. "She looked tired; she was covered with dust and dirt but she kept on taking pictures," one soldier recalled. (In Lee's shot of this scene, a German smiles at her, and the GIs watch without hostility, pleased that the battle is over.) When she saw Von Aulock later, his dignity restored after a change into uniform, she photographed him again from a respectful distance.

Her own dignity was deflated a few days later when SHAEF exiled her to Rennes after the news reached headquarters that she had been in the combat zone. (A memorandum dated August 20 recommends that henceforth "No female correspondent be permitted to enter forward area under any circumstances.") Lee moved into the Hôtel Nemours, U.S. press headquarters, where Dave joined her. She spent the week "in the doghouse for having scooped my battle," she told Audrey. "I'm mad about the 83rd Division," she went on. Her application to be attached to them had been turned down, but soon, she added, "I plan to rejoin them."

In the meantime, Lee bathed, slept, and caught up with colleagues. (Catherine Coyne of the *Boston Herald* followed her nose to Lee's room to find her rubbing cologne on her flea bites.) While Lee wrote up her private war, Dave wrote Audrey to ask whether *Life* could publish her historic shots of Saint-Malo: "Lee was the only reporter, and only photographer, let alone the only dame, who stayed through the siege with the infantry outfit that finally took the Port. She was exposed to small arms, machinegun, mortar, and artillery fire, as well as our own bombing," he bragged, "more than any girl journalist." He promised to keep her in the room until she finished the story—an improvement on the Normandy one, he thought, since it was "100% more exciting, and about 200% closer to the front line, in fact slightly ahead of it." What he did not say was that it was also ahead of most reportage in its courage and its quirky precision.

That week, Paris rose up against the Germans and on August 25 celebrated its liberation by the Free French and the Americans—though partisans and snipers were still battling in the streets. The women at the Nemours waited for SHAEF to issue travel orders. "It is very bitter to me to go to Paris now that I have a taste for gun powder," Lee wrote Audrey on August 26. "There they are already wearing swell uniforms like London—and I have only battle dress." (She asked for her new uniform, at her tailor's.) "I've just sat on my tail here in Rennes writing," she continued. But the day had not been a dead loss. She came across some female collaborators with shaved heads who stared as she ran ahead to take their photographs. "In that I was leading the parade," she explained, "the population thought a *femme soldat* had captured them." "I won't be the first woman journalist in Paris," she added, "but I'll be the first dame photographer, I think, unless someone parachutes in."

When Lee arrived, the capital was in the throes of a three-day celebration. "Paris had gone mad," she wrote. "The long, graceful, dignified avenues were crowded with flags and filled with screaming, cheering, pretty people. Girls, bicycles, kisses and wine, and around the corner sniping, a bursting grenade

and a burning tank. The bullet holes in the windows were like jewels, the barbed wire in the boulevards a new decoration." She photographed GIs flirting with Parisiennes, children in torched vehicles, sandbags at Notre Dame, barbed wire around the Place de la Concorde, and women cycling in the full skirts they wore to defy the Germans' fabric rationing. One vibrant shot returns the gaze of the models waving from the windows of Maison Paquin; its diagonal pattern of lights and darks heightens their shared sense of joy.

Lee reported to the Hôtel Scribe. The elegant old hotel near the Opéra— until a few days before, the Nazis' press bureau—had been requisitioned for the Allied journalists converging on Paris. Making her way past the bedrolls in the lobby, she went to room 412, on the fourth floor. Dave joined her next door. Over the next year and a half, he watched Lee's room turn into "a cross between a garage sale and a used car lot." The chambermaid did not appear to mind. She took it for granted that Lee, her *petit lapin,* and "Monsieur David" were lovers. The door between their rooms remained open.

The Scribe staff adjusted to their new guests. The cable setups and broadcast studios were still functioning, daily briefings outlined recent events, the press bar in the basement served K rations, coffee, and champagne. Lee set to work. AFTER TREMENDOUS THREE DAY WELCOME AND HAND WAVING, EVERY ONE EXHAUSTED, she cabled U.S. *Vogue.* TOWN LOOKED LIKE BALLROOM MORNING AFTER, FOUNTAIN BASINS STREWN WITH CIGARETTE BUTTS, BUT NONETHELESS BEAUTIFUL. A medium requiring compression, the cable spurred her to paint the scenes imprinted on her mind's eye: IN ONE STREET FLAG WAVING AND KISSING; NEXT STREET, DUEL SNIPER VERSUS PARTISAN. . . . CIVILIANS TOOK WHOLE THING AS TERRIFIC PARTY WITH LIFE OR DEATH STAKES LIKE BACCARAT GAME.

Life was topsy-turvy. Most of Paris lacked water, gas, and electricity; only the Scribe had power and heat. Everyone walked, cycled, or took the Métro when it was running (there were no buses); Lee wangled rides in official vehicles through Herb Saal, the Scribe's dispatcher. Outside official circles and the black market, gasoline was unavailable. Paris was quiet, except for the jingle of bicycle bells and the clip-clop of wooden clogs, the only footgear available since the disappearance of shoe leather. "Everyone's feet hurt due to the ill fittingness of the sabots," Lee told Audrey. "No one . . . can kneel, on account of bruises and skinned knees from bicycle accidents. Everyone has neuralgia from wet hair, and if they had any tea, coffee, soap and tobacco they'd think heaven was here. So would I," she added.

Despite the confusion, life at the Scribe was an ongoing party. Lee hung out in the bar with the Time-Life crew—John Morris, Ralph Morse, Capa, and "Wert" and Lael Wertenbaker, now married—where they were often joined by Irwin Shaw and William Saroyan, who were making a film for the U.S. Signal

Photographers and friends at Michel de Brunhoff's after the liberation of Paris.
Seated at lower right: Lee Miller, de Brunhoff. First row, from left: unknown
woman, Cynthia Ledsham, Robert Capa, unknown man, David "Chim" Seymour,
unknown man, Henri Cartier-Bresson. Second row: John Morris (behind Capa),
Charles Wertenbaker (raising glass)

Corps. Others who came to drink champagne with them included Ed Murrow,
William Shirer, and Hemingway, who made forays from the room at the Ritz he
shared with Mary Welsh. The press bar became such a hot spot that *Life* pub-
lished a caricature of its denizens, including Dave with his camera around his
neck and Lee in uniform.

Links between French and American journalists were also forged there.
Henri Cartier-Bresson introduced Morris to members of the Resistance group
Photo Presse Libération, who provided shots of the first wild days for *Life*.
When Lee realized that she had lost some of her film, Michel de Brunhoff
arranged for both *Vogue*s to receive images from Photo Presse, as well as shots
of his own: de Gaulle's triumphal march down the Champs-Elysées, patriots
firing at German snipers, a Resistance fighter who resembled a Picasso. While
the substitute photos made up for Lee's loss, she felt "sick with rage and ill
with jealousy," she told Audrey, "to have been the only woman photographer
and then to muck it." And without directives from London, which were slow to
arrive, she didn't know what approach to take.

Reunions with old friends soothed her. De Brunhoff gave Lee an affectionate welcome; Solange d'Ayen, who looked like a wraith, embraced her. They told her the outlines of life at Frogue. He had suspended publication rather than work under the Nazis and used his office as a mail drop for the Resistance; tragically, a few days before the liberation of Paris, the Gestapo murdered his only son. Solange had herself been in prison; her husband was in a German concentration camp. Lee arranged transport for Solange to her chateau, which had just been vacated by the Nazis. "S. seemed very pleased to have me as an escort," Lee wrote, and was herself pleased to again be taken for a *femme-soldat*.

"This is the first allied soldier I have seen, and it's you!" Picasso exclaimed when she entered his studio. Lee was so changed that he wanted to paint a new portrait of her. With Dora Maar, they celebrated their reunion at a nearby bistro, which produced a chicken, wine, and brandy. Picasso asked whether the English artists had kept painting despite the bombs and chortled at the idea of Roland working on camouflage. Lee's shots of the three of them show their joy at finding one another, and their friendship, alive. "From the point of view of art in Paris," she wrote, "the most valuable contribution has been the fact that Picasso stayed here under the occupation as an inspiration to others." He had used what came to hand—vegetable juices as paint, corners of the tablecloth as paper. On a return visit, Lee ate a tomato from the plant that had been "his favorite model." "It was a bit moldy," she teased, "but I liked the idea of eating a work of art."

The Eluards had not fared as well. Seeing Lee's uniform, Paul flinched when she caught up with him, but Nusch grinned with pleasure when she walked in the door of the apartment where they were hiding. She was still beautiful, but had suffered so much under the Occupation that there was little left of her. The couple had moved eight times in the past six months to avoid the Gestapo: they were on the wanted list because of Paul's work with the clandestine publishing house Editions de Minuit. Lee photographed them in front of Picasso's *Night Fishing at Antibes,* the canvas he had been working on when they were last together. On another visit, Cartier-Bresson snapped a picture of Lee sitting on Paul's lap and smiling at Nusch, which captures their joy in one another's company.

It was reassuring to learn that some wounds had healed during the war. Picasso, Eluard, Aragon, and Cocteau had set aside their quarrels to work together in secret on books, films, and other projects. Cocteau was no longer the group's bête noire, although his contacts with the Germans had caused suspicion. Lee visited the poet in the apartment he shared with Jean Marais, the star of his new film, *Beauty and the Beast.* Cocteau seemed "younger than I thought possible," she told Audrey, "less nervous and not mournful or whining which was so much his style when I left Paris." She photographed him

standing beside the wall on which he had written the names of the artists he admired, and then with Frogue artist Christian (Bébé) Bérard, who picked her up in his arms. Later, Lee went to the Coupole in uniform—"very large, padded all over," an acquaintance recalled. When she took off her helmet, the group saw that this was "the girl they'd known a decade before: she became the symbol of freedom, the Statue of Liberty walking into the Coupole."

After checking up on friends, Lee wanted to learn how others had fared. It was moving to meet the family of the playwright Tristan Bernard. French Jews, they had survived with the help of friends who obtained his release, because of his age, from Drancy, the Nazi camp near Paris. Throughout the war, they had had to wear the yellow star: it was "six pointed satinette," Lee informed Audrey, "overprinted in black ink. Not only must it be worn at all times, but they had even to give [ration] tickets for it." Mme. Bernard prepared a wartime meal for Lee: potato pancakes that were half cooked because the gas ran out, salad without dressing, a dessert of raw grain. Lee covered her recurrent gagging by claiming to have a hangover but realized that her "indisposition" was, in the main, emotional. Her angle, she decided, would be to recount the Occupation's effect on creativity by interviewing artists, writers, actors, and designers.

From this perspective, her next assignment—the rebirth of haute couture—could be the way to show that fashion, too, had been "part of the passive and active resistance." For the past four years, while English women conserved fabric, the Parisiennes defied the occupiers by dressing extravagantly. This was especially true of their headgear. In August, women still sported hats resembling cream puffs. At the millinery shows, Lee photographed models in foot-high chapeaux—soft helmets, flowerpots, and one that combined cabbage roses with sables. (For fun, she put her army cap on top of a mannequin's head and took a shot that testifies to her presence among the hatboxes.) Hats were "coming back to sanity," she told Audrey, but like the Parisians, they were "still gay and a little mad."

What was true of millinery also applied to clothing. It was chic to dress more moderately, yet "an unsuppressible exuberance still express[ed] itself in folderols." Lucien Lelong (whose clothes Lee had modeled in the thirties) brought her up-to-date in meetings to plan *Vogue*'s coverage of the new season. As president of the Syndicat de la Couture, Lelong had stood up to the German officials who planned to transfer the industry to Berlin. Arguing that *la mode* depended on the French spirit and a large group of skilled workers, he had managed to keep it in Paris. But a tight system of rationing had been imposed. That January, the Germans had closed Grès and Balenciaga for exceeding their fabric quotas; in July, they threatened to put an end to haute couture—which was saved at the last minute by the liberation.

Lee grew bored with waiting around while the fashion houses prepared their October openings. Audrey's praise of her Saint-Malo reportage ("good girl great adventure wonderful story") sharpened her desire to follow the action—provided SHAEF would renew her permit. In the meantime, Paris made her impatient: "I want to go to the wars again," she told Audrey, "before the collections tie me down."

In mid-September, Lee caught a ride to the Loire district, where the 83rd Division had gone after Saint-Malo. Arriving in time to watch them round up over ten thousand Germans, she recorded their surrender outside Orléans—a ritual arranged by Lieutenant Colonel John Speedie (who had recently been promoted) to suit enemy protocol. Lee photographed columns of German soldiers trudging in battle gear toward the field where they were to pass review. "They were armed but impotent," she wrote, and wary due to the presence of the newly formed French Army, which was eager for revenge. She and the Signal Corps were the only witnesses: "I am getting to be the surrender girl," she joked.

After promising Speedie copies of her Saint-Malo pictures, Lee went to Orléans—"scene of the triumph of Jeanne d'Arc," she recalled (visualizing the deeds of her heroine in silent movies?). It was a shambles: "Old ruins and new associate together; the statue of Jeanne d'Arc is askew on its pedestal." She photographed the damaged Beaugency bridge, which had been hit by both the Germans and the Allies, and a row of heavily laden prisoners clambering up the steps beneath it. The shot's perspective literalizes her position of superiority and underscores their "impotence." (Taking advantage of their plight, she liberated a pair of field glasses from a German officer.)

In the next few days, as she hitchhiked around the country, Lee began to feel that "life had somehow adjusted itself. The earth and the vegetation had healed the war wounds." In villages just freed from the Germans, people asked travelers to formalize their liberation. "Someone has to receive the champagne, the speech, the keys of the city," Lee told Audrey. "Sometimes it was me—for no reason except that it is a ceremony, and no other business of the municipality can function until that duty is done."

Returning to Paris with her taste for gunpowder satisfied, she looked up Helen Kirkpatrick, who invited Lee to share her apartment. On September 28, as Dave, Catherine Coyne, and Lee gathered in her room for drinks, a telegram arrived from Roland. He would soon be in Paris. Lee stripped off her clothes, Coyne recalled, "and said, 'I'm going to have a good clean bath for this!'" She was not the only one struck by Lee's aplomb. The night before, when John Morris came to room 412 for a drink, he found Dave in bed, reading. When John ran into Lee the next day, he wrote, "she again invited me up for a drink. There, reading in the same bed, was Roland Penrose."

Later that day, Lee and Roland went to Picasso's studio for a reunion, dur-

ing which she took a formal group portrait: the Maître, the Eluards, Aragon and Elsa Triolet, with herself and Roland in uniform. They posed solemnly, aware of the moment's historic aspect. The night was full of joy and tears, Roland recalled: "They were all in tremendously high spirits, their enthusiasm hid at first glance the signs of strain they had been through. . . . My surprise was that any should have survived."

It is easy to understand Roland's response to Lee's new life. His role as "a home-bound instructor," he wrote, "gave me a sense of inferiority when I compared my own efforts to the immensely daring exploits of Lee." What was more, Dave's presence at the Scribe had changed the balance of relations. The young American spent more time in her bed than Roland did. And throughout his brief visit, Lee was organizing *Vogue*'s fashion coverage, which meant hitchhiking all over town for illustrations, harassing others for their reports, and arranging to send photographs. She felt torn between doing her own "reportages," she told Audrey, and meeting *Vogue*'s needs, which made her "schitzophrenic [sic]." Dave complained to his brother that Lee was exhausted from "trying to be the up and coming girl war photographer, reopening Paris office and generally knocking herself out."

The long-awaited openings began on October 1. Parisians saw the revival of haute couture as a labor of love since there were no foreign buyers. "They regard it in the nature of an art exhibition," Lee noted. "The whole thing has been done in good faith," she continued, "just as they gave the last resources of their larders to the liberators. Each dressmaker wanted to express some sort of *joie*." Joy was evident in the details. Sashes set off hips, armholes accentuated bosoms, and basques flaring out behind slim suits emphasized wasp waists. Jersey knits, ersatz wool blended with angora, and velvets stitched with sequins cheered the spirit as well as the body.

Lee took several models to pose outside, at the Chamber of Deputies, the Ministry of Justice, and the Place Vendôme, where bullet holes pocked Van Cleef's windows. One model strides past a flag-bedecked building in Schiaparelli's black "wool" coat, her hair tucked into a matching turban—wet heads still needed protection after hours at the coiffeur's. Another, wearing a nipped-waist "woolen" dress by Paquin, essays a dance step at the Place de la Concorde; another leans on her bicycle to set off Schiaparelli's fur culottes, fur-crowned helmet, and fur-lined windbreaker. Lee also photographed inside the couture houses. A shot of Paquin models relaxing on the floor between shows, she wrote, "reminded me of the between party scene in Gone with the Wind."

Lee's reportage is detailed and informed. For a fashion insider like her, the language of couture—its tucks, pleats, and bias cuts—held no mysteries. Yet it is the acuity of her cultural analysis that stands out as one reads her fashion writing, especially its levelheaded response to the charge of frivolity made

against the industry. While she agreed that "seductive clothing has little to do with the starving bodies behind the scenes," she pointed out that it had "a lot to do with the starving souls." For the past four years, the situations of England and France had been different. The English had mobilized from top to bottom: "one hoped that a percentage of what one saved would reach the war . . . whereas here they were afraid it might. . . . Whatever they saved, it wouldn't help their own people."

On the last day of the shows, a telegram came from Audrey: EDNA CRIT-ICAL SNAPSHOT FASHION REPORTAGE AND ESPECIALLY CHEAP MAN-NEQUINS URGES MORE ELEGANCE. Assuming that Lee's pictures were not typical of haute couture, Chase asked whether more WELLBRED WOMEN might be persuaded to model. Lee's reply was understated. "I find Edna very unfair," she told Audrey. "These snap shots have been taken under the most difficult and depressing conditions, in the twenty minutes a model was willing to give of her lunch hour most of which was being taken up with further fittings for unfinished dresses or after five o'clock in rooms with no electricity. . . . Any suggestion that *dames du monde* could and should have been used is strictly out of this world. Edna should be told that . . . there is a war on."

Increasingly, Lee tried to grasp the war's impact on civilians—the story that as a longtime expatriate she was qualified to tell. The French were now looking to the British system of rationing, she explained: "They realize that there are going to be several millions of political deportees, war prisoners and refugees from the battle areas to clothe properly, to feed, to rehabilitate. These millions will be detraquee [disoriented] to a much greater extent than any returning British prisoners." Through the autumn and winter, she alternated between stories about celebrities and reports on the political scene. "I want more than anything," she told Audrey, "to be able to follow the war to the finish over here, and more important, to watch the reconstruction or whatever of Europe."

But *Vogue* needed news of celebrities. In September, Lee supplied both editions with shots of Marlene Dietrich in a satin evening gown, Fred Astaire signing autographs for Folies Bergères dancers, and Maurice Chevalier being charming—after Aragon, who brought her to the press conference, said that the singer had not been pro-German, as some claimed, but had helped the Resistance. Now Audrey wanted her to assemble a scrapbook of cultural luminaries. Again playing impresario, she wrote captions for shots obtained from colleagues: Aristide Maillol had just died, Pierre Bonnard and Henri Matisse had gone on painting in the south of France, Albert Camus—who had edited the clandestine newspaper *Combat*—would soon make a name for himself. With these portraits, Lee sent her own of Bébé Bérard on his studio floor, Tristan Bernard representing the French theater, and Eluard admiring a Picasso

with Communist Party leader Marcel Cachin. Lee squeezed in a visit to the Maître's exhibit at the Salon d'Automne, where policemen protected his work from its admirers. Paris still lacked the necessities, but cultural life was reviving, and with it the city's spirit.

In October, Lee jumped at the chance to go to Luxembourg. The Allies, hoping for a quick end to the war, had tried in vain to cross the Rhine the month before in an assault on the Siegfried line, the three-hundred-mile-long fortification that ran along the old Maginot line. Since then, there had been protracted fighting in the forests south of Aachen, in Lorraine, and in the Vosges Mountains. On October 18, Eisenhower ordered the next phase of the campaign to break the German defenses with combined operations from Arnhem in the north to Basel in the south. Luxembourg, halfway between these two points, had been partly freed by the Allies, but its border with Germany was not secure.

Lee knew little about her destination: "The Duchy of Luxembourg, traditionally tidy and neat," she wrote, marking time, "peaceful and neutral as the Ruritania of musical comedy." The first part of the long article that resulted from this trip recounts Luxembourg's recent past: the population's response to the Germans' embrace of them as Aryans, their efforts, postliberation, to resume normal life, and the U.S. Army's attempts to help with the transition by herding cattle, harvesting crops, and escorting grandmothers through the rubble.

Lee's prose came alive as she recalled an unexpected reunion: "A jeep hove in sight. I recognized the numbers. In a few seconds I was in the street peering at the mud-splashed identification marks of all the cars and trucks which passed. I found one I knew and stuck my hand out. . . . It was Doc Berger and the chaplain of the 329th, 83rd Division. I was home again. Colonel Crabhill said, 'We consider you've been AWOL since Beaugency.' The Sergeant said, 'Lady, every time you turn up something's bound to happen.' "

Things began happening a few days later. Lee made her way to the 329th's post above Echternach, on the border. With Lieutenant Colonel Speedie, she walked through the forest overlooking the valley below, and eastward to Germany: "The Siegfried Line was just landscape to the unaided eye. Through the glasses I could see luscious flat lawns like putting greens. They were the fire areas between the black mushrooms which were gun emplacements—a tank trap accompanied by a gun was at a crossroads and on the horizon was a village which they said was housing two divisions of retreated Huns." A shift in narrative voice shows her emotional reintegration. When a German came in sight, Lee wrote, "I hoped we'd shoot him. . . . We could have slugged him with a

machine gun but that would have given away a new position we were saving for tomorrow."

At dawn the next day, Lee slogged through the mud with Colonel Crabhill while he showed her the plans for actions along the front. Heavy mist hindered picture taking that day ("my cameras wouldn't be able to see any better than I," she wrote), but the gunfire was loud: "the whole valley echoed with the boom, bark, tattoo and cough of different styles and sizes of weapons." They patrolled the surrounding area in a jeep with a mounted machine gun, looking for civilians "who didn't match the landscape, as they could easily be and often were disguised Krauts."

Disappointed not to find any, Lee noted examples of the GIs' language. Since D-day, "to liberate" had acquired new meanings. One could "liberate" a bottle of wine by knocking down the price, or "liberate" a girl by eluding her chaperone. Being the only woman made things lively: "I keep my ear cocked to be told: 'It beats the . . . out of me, Mac,' followed by an apologetic 'oops, sorry, I mean Ma'am.' " Lee was proud of her rapport with the soldiers: "Some Tank-Destroyer men said they'd been talking and thought it was very good to have me around, as they minded their four-letter language. Thinking of some of the refinements of my own vocabulary I was deeply touched by their concern, which was reciprocal—I'd reformed for their sake."

At her billet in town with a veterinary surgeon, Lee learned to churn butter and make cream cheese with his wife; in the evening, they sat by the stove, drinking the local fruit brandies. Now and then German buzz bombs rattled past in retaliation for the 329th's attacks on the border towns. During the day, Lee photographed refugees praying, GIs herding pigs, and a woman known as the Blonde Bombshell, who turned up everywhere in her role as the CA's multilingual interpreter. Lee admired the Bombshell's ability to make villagers obey orders: "I don't know what she was saying, but it was violent and bitter; and she made it stick."

On the way back to Paris, Lee drove past "fields of purple cabbages like porcelain funeral flowers, long rows of biggish pink radishes for cows to eat, gold and scarlet autumn trees and factories cuddling into earth." Thinking of the homesick GIs who had pointed out this land's resemblance to the eastern states, she named them like a litany—Carolina, Virginia, New York, Maine, New Hampshire—and ended her Luxembourg piece with an admission: "Even I was homesick."

Since Helen Kirkpatrick's apartment was no longer available, Lee decided to stay at the Scribe for the duration. By winter, room 412 overflowed with guns, camera equipment, crates of cognac, and items looted on assignments; on the balcony, jerry cans of gasoline awaited the offer of a vehicle to take her on her next adventure. Dave photographed Lee's atmosphere: her Baby Hermes typewriter surrounded by half-filled glasses, a bottle of cognac, knick-

knacks, and ashtrays. This creative disorder was insufficient by itself. Lee also relied on Dave in his roles as taskmaster, lover, and friend, which he performed by turns during her all-night writing sessions.

It did not occur to either that Lee had become a journalist under unusual circumstances. While her knack for description and analysis are evident in her correspondence, she had picked up what she knew about writing as a sideline. In France, she worked without editorial feedback. Long delays between submission and publication meant that she had no idea whether her work was suitable until the magazine, having appeared months later, made its way to Paris after further delay. As if this were not enough, she heard from few readers other than Audrey.

Prone to feelings of abandonment (her "persecution complex"), Lee told Audrey that she found herself "coming to full, unnecessary stops in work because you never comment." After the Luxembourg trip, she wondered how to proceed. Although she kept detailed accounts of all she felt and saw, writing was torture: "Every word I write is as difficult as tears wrung from stone." She felt depressed, suicidal, or, less dramatically, in need of a new career.

One imagines that these difficulties were on her mind when she interviewed Colette. It had been hard to get an appointment. The celebrated writer, nearly seventy-two, was bedridden and very deaf. One approached her, as one did Cocteau, her neighbor at the Palais Royal, with the reverence due to *monstres sacrés*. When Lee arrived in uniform, Colette was amused to find Cocteau's statue become a soldier. From the depths of her fur-covered bed, she illustrated the story of her life with the books and photographs she asked Lee to fetch as she spoke: "I was an extension of her body and she stretched her hand on my arm to reach an envelope of pictures high on a shelf," Lee wrote. "Colette, the siren, the *gamine,* the lady of fashion, the diplomat's wife, the mother, the author."

The note of admiration for a woman who had led so many lives is apparent in Lee's reflections on the author. Approaching her profession as a craft, Lee asked what sort of implements she used. Different pens for different purposes, came the reply; hard ones for "digging," soft ones for first drafts. And what sort of paper? Blue sheets for drafts, their pages "scratched out, rewritten, rescratched and arrowed," Lee noted. "When the bright blue page will bear no more torture, she copies it over with larger spaces between, and starts the scraping and polishing again." Lee felt despondent on learning that even after fifty years, "a brilliant professional writer . . . suffers the same anguish for every paragraph."

Colette's husband, Maurice Goudeket, was the antidote to her anguish. Seventeen years younger than his famous wife, he spoiled her. Lee photographed the couple quarreling about his behavior during the liberation. After slipping into the Tuileries to watch the fighting, he had hid for two days in a

shelter until it was safe to come up. "It was a favorite scene they like replaying," Lee observed; "her pointed elfin face was fifty years younger." The couple's rapport is palpable in her portraits. The nattily dressed Goudeket sits at Colette's side while she glances at him flirtatiously; he smiles as she touches a favorite pen to her mouth.

Moved by her visit, Lee left something of herself in the apartment. Colette was working on a tapestry: "I did a few stitches in the piece, like wielding a crowbar, and wrote my name along the side while Colette leafed through an old botany book from the case behind her to show me the watercolors and engravings she had taken for patterns. . . . Her fingers are so 'green' that the pictures came alive." Lee's portraits of Colette convey her zestiness in old age, and her own delight in their entente. "It was fun to tease her by talking very low," she wrote, "to get the flash of defiance and pique which daggered at us . . . greedy for everything that went on." She might have been speaking of herself.

Soon after their interview, Lee flew to Brussels. The city "was now more British than London," she wrote. Everything was done to feed, house, and entertain U.K. forces on leave. Following what was, by now, her journalistic formula, Lee told the history of the Belgian Resistance, discussed the fate of Belgian art treasures, and interviewed friends—Magritte (having abandoned Surrealism, he was painting "like a streaky Renoir") and Delvaux (his wartime skeletons had been replaced by warmer subjects). For British readers, she spent time with Hardy Amies, the London designer who was a liaison officer to the Belgians. She would have liked to write a piece on the British women's services, she told Audrey: "The Army of occupation is going to include a lot of dames." "I like the town in a way I never thought possible," she went on. "It's still bourgeois, polite, and reticent," virtues one would not associate with Lee under more normal circumstances.

About this time, Audrey asked Lee to describe the process of liberation. "This is a very difficult piece," she replied. "If I could find faith in the performance of liberation I might be able to whip something into a shape which would curl a streamer and wave a flag." Making shapes with words was harder than framing images in her lens. While Lee's eye for detail was acute, she had less feeling for verbal structure. Moreover, the relation of particular details to overall shape—an issue for all writers—was not obvious. Yet, she believed, truth resided in the details. "I'll try to put it all together for you into some sort of visual piece," she went on. Some of her colleagues were addressing Europe's future: "I, myself, prefer describing the physical damage of destroyed towns and injured people to facing the shattered morale."

At night, after copious amounts of morale-boosting cognac, Lee sat down to write. "The pattern of liberation is not decorative," she began. Along with "the gay squiggles of wine and song," there were "disappointed hopes, and bro-

Lee in jeep with model, Paris, 1945 (David E. Scherman)

ken promises." After four years of simply surviving, "there is grogginess like after a siesta, a 'sleeping-beauty' lethargy. The prince has broken into the cobwebbed castle and planted his awakening kiss. Everyone gets up, prepares a banquet, dances a minuet and lives happily ever after."

The next paragraph focuses on daily life to make a larger point, about matters dismissed as collateral damage:

> The story does, but shouldn't end there. Who polished the verdigrised saucepans? Who replaced the rusted well chain? Were the shelves dusted? The cupboards clean? . . . Did they start their quarrels and gossip where they left off? Did they ask what the neighbours had been saying about them all this time? Had the milkman left rows and rows of bottles on the sill? Had the tradesmen tried to collect their bills? Were there fresh lettuces and eggs in the larder? Maybe the prince solved all these problems and brought all these things too, or was liberation enough?

For Lee, the answer was no, it was not enough to heal Europe's shattered morale—or, one suspects, her own. The specter of Europe in pieces served,

obscurely, as an emblem of her fragmentation, the scattered parts of her private jigsaw puzzle..

∞

When not engaged in "stone-wringing" (as she called her writing process), Lee liked to play word games. American soldiers knew only two "decent" French phrases, she told Audrey: " 'C'est la guerre' for T.S. and AH! OUI! (pronounced AWI), for pauses, exclamations, and as a variant on 'oh yeah?' " Residents of the Scribe had their own patois—the bilingual puns invented by Lee's friend Herb Saal. To amuse journalists waiting in the transport queue, he told the adventures of his imaginary friends, the boxers Jake Coote (*j'écoute*) and Nicky Taypar (*ne quittez pas*). "The winner of their forthcoming contest will fight the winner of the bout between two characters known as Sammy Tegal (*ça m'est égal*) and Harry Kovair (*haricots vert*)," Lee explained. "These mugs are always having girl trouble, and the quarrels between Jenny Saipa (*je ne sais pas*) and Elsa Mackie (*elle se maquille*) are usually caused by jealousy of the lovely Countess Mary de Billancourt (*Mairie de Billancourt*), who really only loves a certain party—Jerry Veyandré (*je reviendrai*)." To flesh out the dramatis personae, Lee invented a Scribe war staff—General Nuisance, Colonel O'Truth, Major Calamity—and some foreign correspondents: Lowering, of the *Evening Standard,* and Hitching, *Post.*

Friends (real ones) were another distraction. Lee fretted to Audrey about the long-deferred visit of Harry Yoxall, Brogue's managing editor. It was the coldest December in memory; nonmilitary billets were unobtainable: "The number of people sleeping on the floors of 'old residents' exceeds the 'stay-where-you-dine' sleepers in London during the Blitz." Yoxall arrived bearing twenty pounds of coffee and with a billet at the Ritz, both of which made him popular: "When the hotel had hot water," he recalled, "I could give a bath to a woman from the office, or to phrase it better, I could provide her with facilities for taking a bath." *Vogue* staffers worked in hats and coats; they slept in their clothes. "Whereas in England we had . . . all the necessities but no luxuries, in France they had all the luxuries but no necessities," he said. "There was plenty of *foie gras* but no toast to put it on; plenty of champagne, but no milk."

Lee enjoyed the Scribe's champagne with Janet Flanner, who stayed at the hotel when in town. Having just returned from America to resume her correspondence for *The New Yorker,* Janet was "slightly scratchy in places," Lee told Audrey, but like herself, "violently francophile." They agreed on the reasons for misunderstandings between France and America. Both feared for the future now that the French were settling old scores in the guise of postwar reprisals. The winter was harsher than the previous four; morale was plummeting. Explaining the situation one day to Carmel Snow, who was touring Europe as

editor of *Harper's Bazaar,* they defended the ability of the French to endure hardships, like the heavy snowfalls. Carmel managed "a couple of semi-cordial compliments" on Lee's work for the U.S. edition of *Vogue* while feigning ignorance of Brogue. After she left, Lee vented her anger by throwing snowballs at Janet—however scratchy, she had a sense of humor.

Lee's spirits revived at Christmas—a luxurious reunion with Roland at Downshire Hill, where Dave joined them and helped consume the four turkey dinners put on by their cook after efforts to obtain one bird by placing multiple orders produced an unexpected bounty. On Lee's return to Paris, she found the city snowbound and the population acting like urchins—"the flics [cops] have battles in the driveway of the Opera, distinguished SHAEF officers feel the ammo shortage when the snow on their balconies runs out." She amused herself with shots of snow-draped street fixtures—a Joan of Arc statue in a mantel of ermine, the ubiquitous Wallace drinking fountain nymphs under their white cupola, a snow-topped pissoir adorned with posters urging one to give blood, so many quasi-surreal transformations of the city. While this unusual weather held, the snow kept producing surprises—coiffing the statues in the Tuileries, etching patterns on café windows, cooling the champagne on her balcony.

About this time, Bérard enrolled her in a project intended to put the French fashion industry in a new light by showing the next season's styles in miniature stage sets, with wire dolls instead of live models. The most prominent artists in Paris would be involved in the exhibition, *Le Théâtre de la Mode.* Bérard was to direct; Kochno, Cocteau, and some young designers and decorators would participate; Lee would be their photographer.

But staying in Paris made her edgy. Toward the end of January, despite the frozen ground, massive snowdrifts, and bone-chilling winds, the Allies moved to close the holes in the Siegfried line—the next step in the campaign to cross the Rhine. As the U.S. First and Third Armies pushed on in the Ardennes and the First French Army battled to expel the Germans from the Colmar region to the south, Lee went to Alsace.

Strasbourg was "frightening," she wrote; people were in hiding. The city had been liberated in November, but the Germans, encamped across the Rhine, threatened the population with their return: "They promised to collect ten heads for every Allied flag they found and to pass out other suitable punishments for people who had smiled in their absence." Lee took in the area's complicated history. Having been German soil since the Franco-Prussian War, it became French after the Great War and remained so until its annexation by Hitler in 1940. Some believed the Alsatians were German at heart. "They are like the children of divorced parents whose marriage was never a love-match," Lee wrote. "They are the children for whose custody the spectacular law-suits are conducted—these exhibitions which are selfish excuses for vengeance."

The French Army's liaison office in Strasbourg made arrangements for Lee to tour the area in a requisitioned jeep. Alain Dubourg, the young second lieutenant who accompanied her, was surprised that she planned to visit Struthof, a concentration camp in the mountains where the Nazis had kept thousands of slave laborers, often working them to death. At lunch in the village below this remote stronghold, Lee told Dubourg about her life in Paris with Man Ray, Cocteau, and Picasso. She was twice his age, but the young man was curious about her: "My sense was that she had been around."

It struck him as odd that she had heard of Struthof, the only camp of its kind in France. Since its liberation in November, it had housed hundreds of German civilians: only the gallows at the top of the hill reminded visitors of the recent past. The Allies would find more such places, Lee told Dubourg as she photographed the site. She mentioned one in Germany called Dachau, but had little knowledge of what went on there. On their visit she insisted on stopping for a bottle of Kummel, a caraway-flavored eau-de-vie. She said little during the long, cold ride. Dubourg found her "hard to decipher," especially when she said that having taken many perilous drives, she would return to Strasbourg on her own.

About this time, Lee joined a group of GIs who were liberating the contents of a distillery. Spying a Red Cross jerry can meant to hold sterilized water, she filled it with framboise (raspberry brandy) and painted the can khaki. From then on, she took this "gasoline can" wherever she went. At a time when gas was more precious than gold, people were not surprised by this precaution, but some were taken aback when they saw her drink from it. When the "gas" ran out, she filled the container with whatever came to hand, making unimaginable new cocktails and keeping herself in good spirits.

A few days later, following a French division through the frozen plains, Lee saw a crossroads sign pointing the way *"Vers l'ennemi."* While the Americans were synchronizing attacks on the fortified villages in the Colmar pocket, General de Lattre de Tassigny's Legionnaires trudged through the knee-deep drifts in their snow gear, providing Lee with several strongly marked chiaroscuro compositions. They bore no resemblance to the heroes of *Beau Geste* films, she wrote, but were hospitable. A group of them served her coffee in a sawed-down shell case, and after she photographed them cooking an al fresco stew, shared their bounty. "The hell with K-rations," she continued. "This is the way to live."

Compared to the light-fingered Legionnaires, Lee found the infantry "sullen." She sensed their fear as they watched the return of the wounded. "I'll never see acid-yellow and gray again like where shells burst near snow," she wrote, "without seeing also the pale, quivering faces of replacements, gray and yellow with apprehension. Their fumbling hands and furtive, short-sighted glances at the field they must cross. The snow which shrouds innocent lumps

and softens savage craters covers alike the bodies of the enemy and of the other platoon which tried before." Death and snow were the great levelers.

The closing of the Colmar pocket, one of the bloodiest campaigns of the war, became the occasion for some of Lee's finest work thus far. She joined the U.S. command while they coordinated infantry, artillery, and engineers with French units for each day's battle. She photographed fortified villages where the GIs fought in hand-to-hand combat, extension bridges thrown across rivers to continue the advance, civilians putting out fires in their blazing towns. One of them, Neuf Brisach, she wrote, was taken after "a citizen with a candle led them through the mined moats, through bunkers and caves and secret passages into the impregnable town" while other infantrymen scaled the walls. She photographed an eerie scene in the ruins: a doll with its arms raised as if to surrender to the men sitting in what had been its home.

Picturesque Jebsheim, another fortified stronghold that was taken, lost, and retaken several times over the course of two days, reeked of death: "There were a great many German deaths in these streets," Lee noted, "and the stink of exploded shells was a taste in the mouth that matched the greenish coats and the strange faces of the newly dead for the Führer." That night, though she was "irreligious" by nature, Lee took comfort in the GIs' voices singing a hymn: "no one who has opened his heart to the sky in front of a fellow stranger, even though the words are not of his choosing or his meaning, can ever feel quite as alone again, quite as mistrusting as if he had not participated in this ritual."

She reached Colmar just after its liberation by de Lattre de Tassigny, who had been told that she was coming. As relations between the French and the Americans were shaky, de Lattre told his assistant, Edmonde Charles-Roux, to give "Lee quelque chose" free rein. Charles-Roux was astonished to learn that this important journalist was a woman, and even more surprised that she was the *"lionne"* of Paris in the thirties of whom she had heard so much from their mutual friends, Bérard, Kochno, and Cocteau—"the symbol of all that had been destroyed by the war, the Surrealists' blonde Venus. Now this living statue was among us," she said, "extraordinarily beautiful, against a background of ruins, in her strict khaki uniform."

As they toured the devastated region together, Charles-Roux took care to impress Lee with the role of women in the French Army. After meeting the *ambulancières,* the women ambulance drivers, Lee photographed them at their hospital while smoke billowed up from artillery fire in the background. They visited the civilian wounded lodged in gutted churches; a white-coiffed nun wept as Lee took her picture; others peered at her from their ruined sanctuary. They stopped for a moment in a field where evacuees huddled around smoking logs. In this "nightmare bivouac," Lee told Edmonde about the *Théâtre de la Mode* project and the roles of their mutual friends. "The circumstances as much as the setting of our conversation gave an almost surreal character to Lee's descriptions," Charles-Roux recalled.

By the end of their time together, the young woman (who would become a novelist, editor of French *Vogue,* and a member, then president, of the Académie Goncourt) was won over by her charge. "Lee was fearless, she had the soul of an adventurer," Charles-Roux remarked fifty years later—still amazed at her transformation into "a reporter of a kind we no longer have." Lee wrote as she lived, inventing her own brand of first-person journalism. "The muse of artistic Paris, the beauty among beauties," Charles-Roux reflected, "had become a writer."

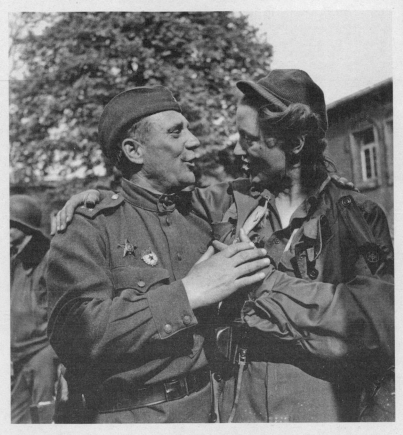

Lee with Soviet soldier, Torgau, April 26, 1945 (David E. Scherman)

Chapter 13

Covering the War in Germany

(1945)

Vogue published an issue on the liberation while Lee was at the front. "One essential fact strikes those who are waging war," the editorial began, "which will strike its historians—women's contribution in all areas, social, medical, and military—their full participation in the immense effort that each nation is making." By thrusting women "into the terrifying spotlight where nothing stays hidden," it went on, the war had revealed their strengths. Lee Miller and Helen Kirkpatrick were singled out as exemplars— "great friends of France" whose work showed "an inspired understanding of our country."

It may have surprised Lee to learn that she was one of those journalists whose work mattered. That winter, her piece on Colette appeared in U.S. and U.K. *Vogue*s, as did her reports on Luxembourg and Brussels. All were well received; the New York office gave her a bonus. Yet once back at the Scribe, her anguish about writing returned. Getting her through the process she called stone-wringing meant putting himself through an emotional meat grinder, Scherman recalled. In his role as writing coach, he kept her at her desk; as lover, he offered sex, comfort, and, when needed, more cognac; as partner, he wired funds to their U.S. bank account for the future. Their relationship kept him in thrall—but he could not imagine life without her.

The Allies began their drive toward Germany's heartland in mid-February. Lee and Dave wedged into the press room for Eisenhower's briefings on the engineering miracles needed to cross the Rhine—pontoon bridges topped with linked wheel tracks, oddly named duck and buffalo flotillas. Both longed to return to the front, but authorizations were not forthcoming. They talked of the work they would do after the war; Lee covered the spring fashions and wrote about Alsace while helping Dave with two photo-essays for *Life*. The first showed exhausted Allied soldiers on leave in the Grand Hotel, the second followed an army team investigating the black-market trade in U.S. supplies—soap, cigarettes, trucks, and gasoline. "What's wrong with this picture?" *Life* captioned his café scene, where the heads of embracing lovers are obscured by the cognac glass in the woman's hand—probably Lee's. (The answer: their black-market Chesterfields.)

For fun of a different sort, Lee wrote a piece on slang, with examples. To a GI, *with it* meant "elegant" or "hot stuff"; to army nurses, *weave* meant "promote" or "scrounge." "You can weave a person or a thing," she explained. "Perhaps you want a lift to Paris, so you 'weave' someone you know who is assigned to transport. Or you want a pal's extra coat or his second German helmet souvenir, so you 'weave' them. It has something to do with spinning a web." While it amused her to spin webs with words, such pastimes seemed like boondoggling compared with time at the front. After switching her accreditation to the air force when their press bureau arranged for male and female journalists to work under the same conditions, Lee awaited her orders.

∞

Once authorized to travel, Lee drove to "Krautland" in mid-March. At Aachen, which had been bombed by the Allies the year before, she photographed the Gothic cathedral and some surreal sights: a Magritte-like wall peeled away to reveal the bricks below, a statue made by a GI with artificial limbs for legs and a teddy bear's face. Townspeople picked their way through the streets in furs and silk stockings. They were "arrogant and spoiled," Lee thought, "a prideless population who hoarded selfishly, cheated in food queues and had more money than objects to buy." Countless bodies lay beneath the rubble. When she climbed up some wreckage to take photographs, parts of it came loose and she fell to the ground: "The tightly packed earth surface opened, foul tomb smells swelled forth. Half-buried, putrefying flesh had turned over in its grave and clung to my hands, elbows, and bottom." The once proud city, she wrote with distaste, "smells and looks like a sepulchre."

From Aachen she went to Cologne, where she shared quarters with Janet Flanner, Marjorie "Dot" Avery, and Catherine Coyne. (They were joined later by Bourke-White and a young *Herald Tribune* reporter named Marguerite Hig-

gins.) Unlike Aachen, Cologne had been flattened by three years of Allied bombing. Its population still lived like troglodytes. Emerging from their basements to meet their captors, they looked to Lee like so many worms, "well nourished on the stored and stolen fats of Normandy and Belgium." Their attempts to curry favor with journalists enraged her: "How dared they?" she raged. "Who did they think were my flesh and blood but the American pilots and infantrymen?" What kind of detachment could they find, she went on, "from what kind of escape zones in the unventilated alleys of their brains are they able to conjure up the idea that they are liberated instead of conquered people?"

Over the next few days, Lee interviewed many civilians. No one admitted to being a Nazi; no one claimed to have supported Hitler. "They were all party members because they would have lost their jobs otherwise, but no one ever believed in any of it," she wrote scathingly. "And the number of Germans who suddenly are confessing to Jewish relatives, and remembering how they sponsored and saved the lives of accused Communists and Anti-Nazis, is growing to ludicrous proportions." They were unwilling, or unable, to tell the truth.

With a group of journalists at the Kingelputz Gestapo prison, Lee watched the survivors stumble into the courtyard and fall to the cobblestones. Some were too crazed for speech; others, like a tall Dutchman who shouted, "We must never forget!" still made sense. She photographed two emaciated young Belgians: a woman jailed for aiding RAF pilots and a Resistance fighter who had just buried his father in the prison's open grave. All bore the marks of their suffering. "It was good that a half dozen of us American journalists viewed them together," Janet Flanner wrote, "so that our eyewitness reports would be unanimous."

Some prisoners told Lee their stories: "Often the jailor would torture the suspect to unendurable pain, order him to be shot, and forget to sign the papers. The next day the same hideous routine would be replayed." The prison symbolized Nazism, she felt, and its acceptance by the population. "This went on in a great German city, where the inhabitants must have known and acquiesced or at the very least suspected and ignored the activities of their lovers and spouses and sons."

At this point, Lee became viscerally anti-German. After leaving the prison, she told Audrey, she was beside herself. Moments later, when an old woman dropped her bag in the street, Lee bent to retrieve it, then stopped: "It hurt my stomach muscles to catch my gesture midair, but it hurt my feelings more to realise I had forgotten for an instant what I had just seen a thousand feet away." It felt "eerie" to be in Germany, "where the adrenalin, stimulated by hate, boils in the blood." She planned to analyze the German character, but felt "confused" by contradictory impulses—to see them as people like herself, to dismiss them as a nation of "schizophrenics." Until the Allies secured

Frankfurt and journalists received permission to follow, there was "nothing to write home about on Germans." What she could not say was that she was struggling with her own response—the adrenaline that fueled her outrage, the displaced anger at what had been done to her.

Taking pictures gave some relief. She photographed Cologne's cathedral not, as most did, from afar, contrasting its Gothic spires to the flattened city, but from inside its cavernous body. For this reason, the gaze is drawn into the soaring presbytery; one feels a sense of spaciousness, an attunement with the architecture. When this image is compared with Bourke-White's contemporary shot of GIs praying on the cathedral floor, Lee's focus on its ribcage of pillars suggests not a religious rite but a survival of the spirit. It is instructive to compare the two women's views of the same scenes. While Bourke-White's sometimes seem stagey (perhaps because they were taken for *Life,* but also because of her controlled aesthetic), Lee's convey a sense of intimacy. One seems to be inside such shots rather than standing at a distance.

Some of Lee's images of monuments embody both ruin and survival. A wrecked bridge across the Rhine projects the eye through its arches' metal tracery to the sky. In others, an ironic effect is created through the juxtaposition of contradictory elements. In Bonn, Beethoven's birthplace, she photographed the bombed-out music stores named for him around a devastated square, which was still being watched by a larger-than-life statue of the composer. Seen through her eyes, this site is an eerie tribute to the corpses in the air-raid shelter beneath this monument to civic pride. Seconds later, Lee found herself sharing a foxhole with two "home town boys" and their commanding officer. "I confirmed that Wappingers Falls and Poughkeepsie really do exist and that I spent all my American life exactly halfway between them."

After the Allies completed their Rhine crossings, the U.S. First Army extended the bridgehead at Remagen into Nazi territory; the Third Army pushed into Hesse to take Frankfurt on March 27. Lee, Helen, and Marguerite arrived a few days later to find fires raging and bodies in the streets. Dazed civilians came up from their hiding places; mobs of freed slave laborers raided their supplies; women carrying bouquets of lilac picked their way over corpses. Goethe's birthplace was "as messy and hollow as Cologne and Aachen," Lee told Audrey. While the town's façades had been wrecked by fire, carved statues framed cornices and doorways—"saints, heroes, bishops . . . calmly surveying a sea of dusty bricks."

In April, when the end of the war seemed imminent, it was still hard to find the front. The situation became hazardous. Troops lurched forward, unsure whether they had outrun the action or fallen behind. Cities raised white flags but no one came to accept their surrender. "The war has become so fluid," Lee went on, "that I can't keep up with my own ideas." She was using the Frankfurt press camp as her base for trips to nearby towns, but did not

know what to emphasize: "I still haven't sorted out my impressions of German people enough to make a piece out of it."

Settled in Frankfurt, it would have been hard not to think of her Hessian ancestor, the Müller whose name she inherited in Anglicized form, and of her resemblance to the blond German *mädchen*. It was too disturbing to admit that she resembled the "schizophrenics" whose denial of the truth grated on her nerves. "I don't like Germany at all except it's too pretty to believe," she told Roland. "I'm getting a very bad character from grinding my teeth and snarling and constantly going around full of hate." Her anger revived as she toured the countryside: "I glare at their blossoms and plowed fields and undestroyed villages and work myself up into such a state that I have no human kindness in me when I talk to their victims."

When her knotted feelings became too painful, she thought of those she loved. At Lee's urging, Lieutenant Colonel Speedie had looked up Roland while on leave in London. He had written to say that she should spend the rest of her life with this fine English gentleman. Lee's letter to Roland ends with her teasing confession: "I guess I'll take his advice."

It was with mixed emotions that Lee recorded Frankfurt's smashed factories—where jet engines, rubber tires, and tanks had been built for the Nazis. In one warehouse, the GIs found a half-track in working order and drove it away: "After weeks of seeing nothing but charred walls and beaten up machinery," she told Audrey, "we all got [the] giggles." A tour of nearby Ludwigshaven offered equally strange sights. The ruined industrial center was "a nightmare of great vats tossed into odd positions by tanks of nitric acid leaking vapor to poison the already stinking air." Lee's photographs of steel compressors looking like huge spark plugs and liberated female laborers in babushkas convey almost palpably the devastation and, for the laborers occupying the factories, the unexpectedness of their freedom.

Heidelberg was intact, but the town's air of self-satisfaction enraged her. Escaped laborers camped in trolley cars; hungry refugees roamed the streets; the inhabitants grinned down at her from their windows. Returned German soldiers in civilian clothes strolled around "looking so cocky," she wrote on April 5, "and there is nothing to do about it." On a visit with a bourgeois family, she noted their up-to-date electrical equipment. "They live well," she continued, "like everyone else in krautland." Here too the inhabitants insisted that they were not Nazis: "All these people claim entire ignorance of the treatment of slave labor—of deported Jews etc. They hide very neatly behind what we always say of them, that they were kept in ignorance by their press."

Lee returned to Frankfurt with quantities of film and a liberated genera-

tor—widespread looting having become a "legitimate" response to German abundance. While she could now work at night, she felt she could grasp the situation only in its particulars. A few days later, she joined a press trip to Bad Nauheim, where a refuge for the Nazi high command had been built below a camouflaged castle. What remained of its tunnels and catacombs after Allied bombings made good copy, she thought, even if the place gave her "the creeps": "For the next hundred years we're going to have Hitleriana like Napoleona." Hitler and his inner circle had houses nearby, with "magnificent tiled bathrooms, marvellous kitchen equipment." (A note of outrage about the Germans' access to electricity recurs in her letters.) Tracking the "master criminal" to his lair, did not, however, explain Nazism. "I'm taking a lot of kid pictures," she added. "They are the only ones for whom there is any hope, and also we might as well have a look at who we're going to fight twenty years from now."

While it is difficult to pinpoint Lee's travels from this point on, the outline is clear. "Things move very fast, as you may be noticing," a letter to Audrey in mid-April explains, "and Lee, here, is either moving when she wants to stay put, or planted when she has itchy feet. . . . Since I'm wearing the same trousers I wore when I left Paris six weeks ago—and my other shirt is lost, the only thing to do is to keep moving forward. However, I never finish a story at that rate—as you may have noticed."

Horrifying news reached the press camps about this time. South of Gotha, at a camp called Ohrdruf in the Thuringian Forest, Third Army soldiers found rotting bodies—inmates gunned down by the SS before they fled the site—and the bewildered survivors of the massacre. On April 12, Generals Eisenhower, Patton, and Bradley toured the camp, the first of its kind to be liberated in Germany. Eisenhower later observed, "I have never felt able to describe my emotional reactions when I first came face to face with indisputable evidence of Nazi brutality. . . . I have never at any other time experienced an equal sense of shock." (Patton, said to be tough as nails, threw up.) After inspecting Ohrdruf, Eisenhower cabled London and Washington to send journalists immediately, to counter claims that Nazi brutality stories were propaganda.

Those arriving at the camp over the next weeks learned that it was named for the nearby village where Bach had studied. Some noted the irony of the phrase above the gate, *Arbeit Macht Frei*, as many inmates died digging underground tunnels for secret munitions plants. Lee, too, felt an unparalleled sense of shock: she put down her camera. "I don't take pictures of these things usually," she told Audrey later, "as I know you won't use them. . . . I won't write about this now, just read the daily press and believe every word of it."

Articles on the successive discoveries of death camps—Nordhausen-Dora, Buchenwald, Bergen-Belsen, Dachau—appeared in U.S. and U.K. papers throughout April. The *Illustrated London News* showed a grim-faced Ike at Ohrdruf staring at bodies in the not yet familiar striped pajamas. The *Boston Globe*'s account of Belsen conveys the shock of unmediated vision: "I saw these dead," their reporter wrote. "I saw the living beside these dead. . . . I saw children walking about in this hell." Struggling to describe Nordhausen, where General Courtney Hodges made the residents bury the dead with their hands, Ann Stringer of United Press wrote, "You really had to grit your teeth to put what you'd seen into words." For most, language was inadequate.

In the same way, taking pictures of atrocities, in some ways simpler than writing about them, required a composure that few possessed. When asked how she could photograph such things, Bourke-White replied that she worked with a veil over her mind: "In photographing the murder camps, the protective veil was so tightly drawn that I hardly knew what I had taken until I saw prints of my own photographs. . . . I believe many correspondents worked in the same self-imposed stupor." Judging by Lee's images from the camps, she too worked in a stupor, but without a protective veil.

∞

Lee reached Leipzig soon after its capture by the First Army on April 18. In the old city, women and children with spring bouquets cheered and waved at the troops, while around the corner, street battles continued. Over the next days, Lee photographed an enemy ambush at the town's Napoleon monument, a soldier playing his accordion, and some American POWs being housed in the apartment that was now the command post for Captain Charles MacDonald's Company G. She interviewed him at length because his recent experiences, she thought, showed "the consistent fashion in which comic adventures and opportunities for heroism presented themselves." The day before, when the chief of police tried to surrender the city to him, the captain had imprisoned the entire force for their own protection. Seeing MacDonald with the police, whose uniforms resembled their own, several enemy units surrendered, "causing a lot of trouble because there were not enough Americans to capture them."

MacDonald asked Lee to stay. "We were one of the few rifle companies in the US Army who could boast of having an American girl spend the night in its CP in such forward positions," he recalled. He liked her style and her American accent: it "sounded good in the strange surroundings." Lee enjoyed her time there but was troubled by the health of the POWs. They had been put on a starvation diet by the Germans, who hated Americans, she thought, "in a different and more intense way than other nationalities."

Lee's increasingly visceral hatred of the Germans found expression in the photographs she took at one of the strangest sites in Leipzig. Tales of mass sui-

cides were circulating among the press corps. A factory director had invited a hundred guests to dinner; when the GIs took the city, he set off an explosion by pushing a button below the table. Top officials lay dead in Leipzig's town hall. Bourke-White rushed to document the suicides for *Life*. The city treasurer, his wife, and their daughter, in her Red Cross uniform, reclined on the heavy leather furniture of his comfortable office, their family papers arranged on the desk next to an empty bottle of poison. Bourke-White shot the scene from above, at a distance.

The treasurer and his family still lay on their deathbeds when Lee reached the site hours later. She photographed them not from above but on the same level, the macabre scene formed by the women in the background and the man in the foreground, his allegiance signaled by the portrait of Hitler opposite his desk. (Before taking this shot, Lee positioned the Führer's portrait, which is absent from Bourke-White's photograph.) Her close-ups of the dead women are more intimate. Standing on the Persian rug on which their own well-shod feet repose, she photographed the mother and daughter as if asleep, then moved close to the daughter, who seems to swoon luxuriously across the leather sofa, her mouth half open. She had "extraordinarily pretty teeth," Lee noted in her Leipzig captions.

What she did not say was that this blond Aryan beauty looks like a younger version of herself. Perhaps it was too disturbing to admit their resemblance. Perhaps her hatred allowed her to keep some psychic distance from the "Krauts." Yet the scene's unnerving intimacy betrays Lee's fascination with its blend of beauty and horror. Standing in her shoes, the viewer is drawn into the picture. Similarly, her photograph of a member of the treasurer's staff shows the dead man sprawled diagonally across the floor; his head and arm nearly slash across the frame separating subject and viewer.

Each shot in this sequence is informed by Lee's complicated feelings about her subjects. She could record violent death when the corpses were Nazis, but unlike Bourke-White, she could not keep her distance. More than Lee's dispatches, the photographic record suggests that she was aware of her tangled emotions—the mixture of outrage and empathy that mark these photographs. This disturbing blend is conveyed through her staging of highly scenic compositions that implicate the viewer, and the act of viewing, in their charged emotional spaces.

One little-known shot from the Leipzig sequence links the camera to deadlier weapons. In this image, the eye alights on a U.S. Army photographer taking an aggressive stance to "shoot" the dead man. By framing him as her (and our) stand-in, the composition connects the living across the bodies of the dead. It arouses the viewer's penchant for voyeurism, however uneasy.

∞

"Buchenwald is beyond all comprehension," one of the first reporters there observed: "You just can't understand it, even when you've seen it." Journalists and photographers toured the site in disbelief in the weeks after its liberation on April 11, when the inmates rose in revolt hours before Patton arrived to take charge. Helen Kirkpatrick and Marguerite Higgins went in the same day; Lee and Bourke-White arrived somewhat later.

Journalists were met by former inmates offering to show them the sights; consequently, their accounts follow a similar pattern. The first thing they noticed was the stench. Walking around the main camp they saw the charred corpses inside the crematorium; beside it lay stacks of bodies that had not been burned because the coal ran out. After their liberation, some survivors had taken revenge on the guards. Others remained there as prisoners in a strange role reversal. What struck those who had seen small camps like Ohrdruf was Buchenwald's scale. Fifty thousand inmates crammed into barracks meant to hold one-third that number had worked as slave laborers. As the population swelled, subsidiary camps proliferated around the original site—in the forest where Goethe used to compose poetry. In the infamous "Little Camp," Jews, Gypsies, and those too ill to work had been kept in sub-human conditions. "Their eyes were sunk so deep that they looked blind," a reporter wrote. "If they moved at all, it was with a crawling slowness that made them look like huge, lethargic spiders."

Bourke-White forced herself to record the camp's most shocking scenes: preserved organs, shrunken heads, tattooed skin used for lampshades. For many, her well-known photograph of skeletal survivors behind a barbed wire fence typifies Buchenwald. Under such conditions, she wrote, "using the camera was almost a relief. It interposed a slight barrier between myself and the horror in front of me."

Lee focused on some of the same scenes without this barrier. Her close-ups of corpses piled in a heap force the viewer to look each person in the eye, as if by this means the camera could deliver the dead from anonymity. Survivors are shown as agents rather than victims. They study the map of Europe or construct effigies of Hitler to stage mock executions for the "tourists"; those who are strong enough march in a funeral service or confront the piles of bodies as the spectators' stand-ins. In another sequence, Lee photographed five men contemplating a heap of bones and later cropped the shot to focus on the foreground; the composition formed by the men's striped trousers and the remains enlists the viewer's eye in a composition emphasizing survival.

"The ex-prisoners have found and recognized a certain number of their former torturers," she wrote. "If they catch them they give them a thorough working over and bring them back to the camp jail house." She photographed several "former torturers" as if condemning them with her camera. A highly constrained shot of two bloody-faced guards kneeling inside a tiny cell seems

to restage their beatings as an act of vengeance. Another, of a guard who had hanged himself, transmits her pleasure at seeing the tables turned: "He was taken out on a stretcher," she wrote, "stripped and thrown on a heap of bony cadavers where he looked shockingly big, the well fed bastard."

Lee photographed the residents of nearby Weimar when Patton ordered them to tour Buchenwald. Some fainted when they saw the camp; others remained aloof. Since many had worked in factories with the inmates, the issue of their responsibility is implicit in these shots. They were "not like the rubberneckers of the blitz," she wrote. "They are not a funeral procession nor are they holiday-makers." What were they? Lee continued to believe that Germany was a nation of schizophrenics.

In an intriguing reversal, Bourke-White's shots of these tours bridge her usual barrier to show Germans weeping, while Lee's hold them at a distance. One image underlines the indifference of a woman in a dirndl by foregrounding her escort, a black GI with a wary expression: "Even after the place was ninety-five percent cleaned up," Lee noted, "soldiers who are used to battle casualties lying in ditches for weeks are sick and miserable at what they see here." Using both "tourists" and GIs as part of the composition, her images restage the tour, eliciting the viewer's response by formal means. As in her shots of the captured guards, she made quick decisions about distance, point of view, and edges that mark these images as close-up and vengeful, or distanced and reflective.

Throughout the last weeks of April, massive columns of displaced persons trudged through Germany as civilians fled the advancing Red Army and the Allies prepared to link up with their Soviet counterparts—a meeting that would signal the division of Germany. On April 25, having spotted a Russian cavalryman on the bank of the Elbe, members of the U.S. First Army's 69th Regiment crossed the river to greet his unit and radio news of their encounter to headquarters. "I found it comic that the great symbolic joining of great modern armies should be thus," Lee noted, "the Americans catching crabs in rowboats across a swift river to meet Russians who operated horse-drawn artillery."

The next day, racing to the scene in a jeep mounted with machine guns, Lee watched the chaos along the road. Taking them for Russians, villagers hid at their approach; others welcomed them as an advance party of the U.S. occupation. She reached Torgau, the ruined town on the Elbe held by the Soviets, at about the same time as her colleagues—Dot Avery, Iris Carpenter, and Catherine Coyne—and the mob of reporters who turned the linkup into a media event. Both sides took part in ritual exchanges—black bread and onions

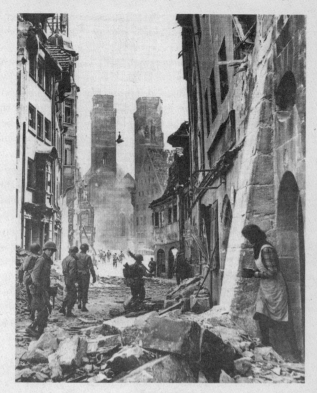

Nuremberg, April 1945: GIs search for prisoners. (David E. Scherman)

for K rations, endless toasts to friendship with Soviet vodka and German wine; the men compared weapons and admired one another's insignia. Everyone cheered as the Russian women climbed into the Americans' tanks; some of them took Lee aside to compare the merits of their differently engineered underwear. "My entire ideological exchange with the Russians suffered a language impediment due to new methods of drinking Vodka," she observed.

When Scherman arrived later that day, few remained sober. The Russians sang raucously to entertain their guests, who returned the favor with renditions of "Birmingham Jail." Journalists joined the officers at an al fresco lunch under portraits of Stalin and Roosevelt hung from fruit trees. The Russians heaped the tables with ham, cheese, and sausages; the Americans contributed eggs and chocolate; they toasted one another all over again. "There was more food than any of the Americans present had ever seen on any table at any one time," Iris Carpenter noted, "and more liquor." The celebration ended when the participants fell asleep on the grass.

In Scherman's photos, Lee flirts with two Russian officers, holds hands with another who clearly enjoys the contact, and grins at the attractive Russian blonde who turns up in many of these shots. When not fraternizing with her new friends, Lee photographed Dave comparing cameras with his Soviet counterpart and, to commemorate the occasion, in front of signs pointing to Torgau with *Life* photographer Johnny Florea and another Russian (Scherman included this image in *Allies,* a book he coedited with a Russian colleague to mark this hopeful moment in U.S.-Soviet relations). "There was a terrible rat race of photographers," Lee wrote. In their efforts to scoop the story, "they were funnier than the main event."

From Torgau, Lee and Dave drove south into Bavaria in his Chevrolet, painted olive drab, following Patton's push to Munich. Stopping at Nuremberg, which had been leveled by the RAF, Lee's anti-German feeling abated: "This is the first German city or possession of any kind I feel sorry for having wrecked." A note of respect colors her account of conversations with the women there: "[They] cling to their ruins and personal possessions, preferring living in air-raid shelters to evacuation, and cook carp caught in local rivers over open fires." She talked with one who had "dirty ankles . . . [an] intellectual, speaking French, Italian, and English," for whom she felt an unexpected regard: the woman had worked in an underground factory as punishment for listening to the BBC. Unlike her shots of civilians elsewhere in Germany, Lee's snaps of these women do not judge them. They, too, are surviving the collapse of the Third Reich.

Lee and Dave caught up with Dick Pollard, a former *Life* photographer stationed at the Nuremberg press bureau. He gave them a tip: divisions of the Seventh Army were heading for Dachau, a village ten miles north of Munich, to free the inmates of the nearby work camp. They set off in pursuit.

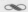

"How is it every time I arrive somewhere to cover a story you and Lee are just leaving?" Marguerite Higgins complained to Scherman. On April 29, she beat them to one of the last big stories of the war—under circumstances that still provoke controversy.

While Lee and Dave drove south toward Dachau, Higgins, journalist Peter Furst, and General Henning Linden of the 42nd Division raced there in their jeeps. Having heard rumors that major political figures—Léon Blum, Stalin's son, and the former Austrian chancellor—were held there, Linden hoped to rescue them, and Higgins to get the scoop. Once there, they learned that the 45th Division's 157th Infantry Regiment, under Lieutenant Colonel Felix Sparks, had already arrived by a different route. Sparks was trying to keep order, a task that was threatened when Higgins ran to the gate, nearly causing a riot.

To this day, each division disputes the other's claim to have freed Dachau, but both agree on the horrific scenes there.

"It was one of the most terrible and wonderful days of the war," Higgins wrote. "It was the first and the worst concentration camp in Germany." Built in 1933 to house Communists and others who opposed Hitler, Dachau became a hub through which slave workers were shipped in such horrendous conditions that many died before arrival at their ultimate destinations. In April, as trainloads of evacuees from camps near the Allied advance arrived in ever greater numbers, the extermination system—crematoria and mass graves—broke down. By the end of the month, Dachau was full of neatly stacked bodies, some of whose eyes were still blinking when the GIs appeared.

The long freight train parked on the railway line next to the camp that day held other horrors. On discovering the source of the stench that emanated from its open cars—thousands of bodies smeared with blood and excrement in the remains of their prison garb—many battle-hardened veterans wept. Others became angry. "It's haunted me . . . for 36 years," one recalled. "I mean, who are they? What's their name? What nationality are they? What is their religious faith? Why were they there?"

The sun shone the next day as Lee and Dave drove through the town of Dachau, where white sheets hung from the windows, and past the sumptuous villas along the railway to the camp. The train, still full of bodies, was surrounded by flies. Beside the track lay the corpses of those who had tried to escape. More than five thousand inmates of Buchenwald had been crammed into the transport earlier in the month. Only a few remained alive.

Lee documented the scene with deliberation. Closing in by stages and shooting from different angles, she photographed the train lengthwise from the siding, then (it appears from a shot in which two medics gaze in disbelief at a corpse) from a partly cleared car—an image that makes the viewer adopt a stance next to the dead man. Moving still closer to the bodies lying on rotten straw, she captured the sheer misery of "unaccommodated man": a naked corpse with boots on beside two empty tin bowls.

Her photos of the train are different from those taken by others that day in their consistent use of witnesses—medics and GIs—whose bodies register their shock and mediate our responses. In one masterful shot of two soldiers stepping up to a car full of corpses, their sturdy forms reframe the scene, shaping the mind's attempt to grasp the incomprehensible. (Scherman's image of the same scene lacks the elements of tension and balance due to the absence of this interior frame, since the second GI is missing.)

Looking at composed images of the unspeakable disturbs those for whom formalist composition and horrific content are at odds. While such viewers are right to be disturbed, their discomfort may result from concerns that did not hamper photojournalists at the time. Working at top speed and in chaotic con-

ditions, Lee brought to her work a passion for justice and a mind's eye that saw arrangements of significant form even before they registered in her camera. After twenty years of experience in theater, film, and photography, she instinctively used the resources of the medium to draw the gaze into the picture— composition mobilized not for aesthetic reasons but as a momentary container for strong emotions.

What is even more disturbing to some is the thought that these images were taken by a woman. At the time, Lee's colleagues saw her as a professional who kept working under unspeakable conditions while experiencing, as they did, a jumble of emotions—rage, grief, disgust, and a queasy fascination. Jacques Hindermeyer, a French Army doctor sent by the Catholic Church to document the camp, was shocked to see a woman photographing the soldiers at the freight car. When bodies began tumbling out, he felt too ill to go on: "Lee took the pictures I could not take," he said decades later. As the only woman photographer at the camp, Scherman recalled, Lee was "in seventh heaven, shooting a scoop of tremendous magnitude. She never stopped to think about what she was seeing." But, he added, the shock went underground.

Inside the camp, Lee and Dave were mobbed by cheering survivors. Some were loading the dead onto carts for disposal. Others, too weak to leave their barracks, tried to smile at her from the three-tiered bunks where two or three lay together—another of her shots in which the tight photographic space enhances the scene's alarming intimacy. "In the few minutes it took me to take my pictures," she wrote, "two men were found dead, and were unceremoniously dragged out and thrown on the heap outside the block. Nobody seemed to mind except me." The rabbits at the prison farm were well fed, she noted with anger; the stables housed "fat-bottomed beasts which shocked the eye after so many emaciated humans."

The healthier survivors kissed the GIs, paraded them around on their shoulders, and waved the American flag with their own banners, stitched together in secret from scraps of fabric. Lee photographed some scavenging in the dump, others lining up for bread—anger, relief, and pleasure on seeing her apparent in their faces. After documenting Dutch inmates gathered in the square to mark their princess's birthday while their comrades raised their fists in victory from the top of a building, she put a new roll of film in her camera to capture their celebration. Ari Von Soest, a former inmate, recalls their shock at seeing a woman in uniform, and their gratitude when she asked to hear their stories: "She was the only one of the liberators who stayed with us; she went into the prison hospital where prisoners were sprayed with DDT; she joined our celebrations." The Dutch women asked Lee to sign her name on the commemorative cloth they were embroidering; it reads "Thank you for all you have done for the Dutch women."

The five hundred women laborers sent to Dachau during the evacuation of other camps were healthier than the men, but many had typhus and some had gone mad. In an effort to document the whole camp system, Lee photographed with equal objectivity the recently arrived prisoners who worked in the camp brothel to shorten their sentences, a distinguished Viennese doctor who also had a law degree, and the crazed Gypsy woman under her care. Dachau was a microcosm of the outside world. It reflected as in a distorted mirror the system it re-created.

Unexpectedly, Lee's shots of captured Dachau guards are not possessed by the anger that marks her similar photos from Buchenwald. Over a hundred SS had been killed by the soldiers and prisoners the day before she arrived: "The violence of Dachau had a way of implicating all, even the liberators," historian Robert Abzug observes. Perhaps that was enough in the way of retribution. Her job was to chronicle the suffering of the dead and the survival of the living. Her contact sheets include shots of captured guards disguised as prisoners, and several document a strange scene at the canal outside the camp— "a floating mess of SS, in their spotted camouflage suits and nail-studded boots," she wrote, "they slithered along in the current" while the soldiers tried to fish out their corpses.

Lee framed the scene at the canal from a distance before moving in for the close-up known as *German Guard, Dachau*—another image that meets reality on its own ground. The guard floats in his uniform, a strong diagonal mass in the dark water that will be his grave; his features blur as he starts to sink below the surface. This elegant composition provides objective testimony while using light, shadow, and reflections to hint that the guard's death, although justified, is somehow redemptive. Its mysterious beauty implies the issues— grief, responsibility, memory—that would haunt Lee long after the war was over.

A letter to Audrey after her tour of Dachau evokes the complex emotions that Lee felt there. "Dachau had everything you'll ever hear or close your ears to about a concentration camp," she wrote. "The great dusty spaces that had been trampled by so many thousands of condemned feet—feet which ached and shuffled and stamped away the cold and shifted to relieve the pain and finally became useless except to walk them to the death chamber. I fell on my knee once and the pain of tiny sharp stone on my knee cap was fierce; hundreds of Auslanders [foreigners] had fallen like that every day and night. If they could get up they could live, if they hadn't the strength, they were left to be hauled off to an unidentified end, just another unknown soldier." She and Dave left for Munich that afternoon, "gulping for air and for violence." The front would seem like "a mirage of cleanliness and humanity. . . . If Munich, the birthplace of this horror, was falling we'd like to help."

They arrived to learn that units of the 45th Division had taken the city. A

doddering guide showed them Munich's Hitlerian shrines: the sites of the 1921 Beer Hall Putsch and the attempt on the Führer's life, the wrecked Hofbrau House, where Lee forced herself to taste the beer hauled up from the dank cellar.

Next they went to the house at 16 Prinzregentenplatz where Hitler had lived since the 1920s. In one of the war's macabre ironies, it was now the command post of 45th Division's 179th Regiment, whose CO told Lee and Dave to move in. "There were no signs that anyone more pretentious than merchants or retired clergy had lived there," she observed. "It lacked grace and charm, it lacked intimacy, but it was not grand." After buying the building in 1935, Hitler had made the ground floor into quarters for his guards, and the subbasement into a bomb shelter. His own apartment, on the second floor, included a private suite. Lee peered at his "mediocre" art collection, inspected cupboards full of china initialed A.H., and sat at the table where the German high command had plotted the Final Solution.

"Here was Hitler's real home," she continued. "Munich was his physical as well as spiritual home, and I started immediately to track down what went on here." The staff who remained in the building did not express remorse. "No Germans, unless they are underground resistance workers or concentration camp inmates, find that Hitler did anything wrong except to lose," she concluded. "I know that I will never understand them. I'm just like the soldiers here, who look at the beautiful countryside, use the super modern comforts of their buildings, and wonder why the Germans wanted anything more."

Among the modern comforts she and Dave tried that night, Hitler's bathroom was perhaps the most enjoyable, since neither had bathed in weeks. Before taking turns in the large tiled tub, they set the scene for the series of photos that mark the occasion. In the best of these, Lee's pensive, almost unreadable expression as she reaches to scrub her shoulder contrasts oddly with the objects around her, which look like props. On the rim of the bath, a photograph of Hitler surveys the scene; a classical statue of a woman stares back at him. Beneath this statue, Lee's crumpled uniform sits on a chair; her boots stand at attention on the soiled bathmat; a shower hose is looped behind her head. In this deliberately staged setting, her look suggests, it was impossible not to think of those who died in Dachau's "bathhouse": "the elected victims having shed their clothes walked in innocently. . . . Turning on the taps for the bath, they killed themselves."

News of Hitler's suicide came over the BBC at midnight. "We've all speculated where we'd be," she told Audrey in a letter describing this moment, "what city and friends we'd choose in the way of celebrations for the end of the war, or the death of Hitler. . . . We couldn't celebrate any more than we were already." Yet her expression, which acknowledges that Dachau will not wash off, is hardly jubilant. While the "machine-monster" was dead, "he'd never

Lee in Hitler's bathtub, Munich, 1945 (David E. Scherman)

really been alive for me until today." He seemed less unreal "and therefore more terrible" after touching what he had touched, rather like "an ape who embarrasses and humbles you with his gestures, mirroring yourself in caricature." "There but for the grace of God walk I," she added. This distorted mirror showed the potential monstrousness in all humans.

In perhaps the most telling irony in a photograph full of ironies, Lee saw herself in both Hitler and the statuette—which recalls her modeling career and role as muse for Man, Huene, and Cocteau. Having placed this miniature Venus, armed but cut off at the knees, opposite Hitler's portrait, she turns toward her counterpart, whose raised right arm echoes her own. This sly jab at cultural clichés about the eternal feminine is complicated by Lee's knowledge that as a blue-eyed blonde, she met Hitler's aesthetic standards—which concurred with the prewar period's return to classicism. This rapidly composed scene includes her recognition that she would have been considered an Aryan, one of the hated "Krauts."

Lee and Dave staged other photographs while in Munich. Some were serious: Lee, dressed but still pensive, posed next to a kitschy statuette on the Führer's desk; Dave in the Konigsplatz Mausoleum, whose strict Doric colums frame him while he photographs the tombs. Others were gags, like Dave's shot of a GI reading *Mein Kampf* on Hitler's bed. On May 1, Lee toured the apartment of Eva Braun, Hitler's mistress, in her attempt to grasp the heart of Nazism. Braun's small villa gave no clues: "Part of the china was modern peas-

ant and part was white porcelain dotted with pale blue flowers. The furniture and decorations were strictly department store like everything in the Nazi regime." And her cosmetics—Elizabeth Arden—were the sort that anyone might buy. Lee took a nap "on Eva's bed," she told Audrey, as if she were on intimate terms with those she detested: "It was comfortable but . . . macabre, to doze on the pillow of a girl and man who were now dead, and to be glad they were dead."

Following another tip from Pollard, Lee and Dave raced to Salzburg, where units of the Seventh Army's 3rd Division were planning their assault on Berchtesgaden, Hitler's "Eagle's Nest." On the way, Dave liberated a Mercedes convertible from some GIs who ceded it in exchange for pictures of them posing with Lee for their local papers. With two soldiers and a driver, she and Dave wound their way up the steep mountain roads. They arrived at sunset, in time to photograph Hitler's house going up in flames, the SS having set fire to the Führer's residence before retreating into the forest.

Returning from the village below the next morning, they found the site full of soldiers and journalists, all happily looting. The champagne, whiskey, and cigars from Hitler's cellars disappeared immediately. "Everyone hunted for souvenirs of Life with Hitler," Lee wrote mockingly. "The main excitement was inside the mountain. Miles of library, dining rooms, cinema machinery, living rooms and kitchen space. . . . Cases of silver and linen with the eagle and swastika above the initials A.H. found their way into the pockets of the souvenir hunters." Dave chose a set of Shakespeare with Hitler's bookplate on each volume; Lee took an ornate silver tray engraved with his monogram. "It was like a very wild party," she observed, "with champagne corks whizzing over the flagpole, and the house falling down over our ears."

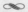

The Germans surrendered a week later, on May 8. Lee was typing her story in the Rosenheim press camp when a soldier said that the war was over. "Shit! That's blown my first paragraph," she exclaimed. Before sending her story to London, she cabled: I IMPLORE YOU TO BELIEVE THIS IS TRUE. Another wire states, NO QUESTION THAT GERMAN CIVILIANS KNEW WHAT WENT ON. RAILWAY SIDING INTO DACHAU CAMP RUNS PAST VILLAS, WITH TRAINS OF DEAD AND SEMI-DEAD DEPORTEES. I USUALLY DON'T TAKE PICTURES OF HORRORS. BUT DON'T THINK THAT EVERY TOWN AND EVERY AREA ISN'T RICH WITH THEM. I HOPE VOGUE WILL FEEL THAT IT CAN PUBLISH THESE PICTURES.

Lee's story, which appeared in the U.S. and U.K. victory issues in June, begins: "Germany is a beautiful landscape dotted with jewel-like villages, blotched with ruined cities, inhabited by schizophrenics." After describing

fairy-tale vistas, hills crowned with castles, birches and willows along tranquil streams, she continued in the same vein: "The tiny towns are pastel plaster like a modern watercolor of a medieval memory. Little girls in white dresses and garlands promenade after their first communion. The children have stilts and marbles and tops and hoops, and they play with dolls. Mothers sew and sweep and bake, and farmers plough and harrow." The Germans, in other words, behave like real people. "But they aren't," the passage concludes. "They are the enemy."

In the U.S. version, entitled "Germans Are Like This," the New York studio ran three-quarter-page shots of the Torgau linkup and Dave's photo of Lee between two Russians. Her text followed, punctuated by sets of juxtaposed images—"German children, well-fed, healthy" next to "burned bones of starved prisoners"; "orderly villages, patterned, quiet" opposite "orderly furnaces to burn bodies"—then some of her most disturbing shots from the camps. "There are millions of witnesses," she wrote, "and no isolated freak cases." For readers who harbored doubts, *Vogue* ran Lee's cable below the headline in extra bold: BELIEVE IT.

U.K. *Vogue*'s victory issue ran a longer version of the article but only one photograph from the camps: the pile of corpses at Buchenwald. Reflecting on this decision decades later, Withers remarked, "The mood then was jubilation. It seemed unsuitable to focus on horrors." Instead, she featured one of Lee's shots from Frankfurt, the statue of Justice brandishing her sword and scales next to the cathedral. This image conveyed "the Christian and cultural heritage which the Nazis aimed to destroy," she wrote. "Now they are themselves destroyed. But statue and spire remain, symbols of justice and aspiration."

In this spirit, women's contribution had to be recognized. "Where do they go from here," Withers asked, "the Servicewomen and all the others . . . how long before a grateful nation (or anyhow, the men of the nation) forget what women accomplished when the country needed them? It is up to all women to see to it that there is no regression." In her view, *Vogue*'s war correspondent was one of those who pointed the way—a sentiment that could not have been farther from what Lee herself felt as she, Dave, and their colleagues tried to decide what came next.

Lee at trial of Marshal Pétain, Paris, August 1945 (David E. Scherman)

Chapter 14

Postwar

(1945–46)

By June 1945, most American journalists were on their way home. Once settled, Margaret Bourke-White wrote a book urging the United States to take on the role of postwar moral leader, Catherine Coyne returned to the *Boston Herald,* Helen Kirkpatrick became a traveling correspondent for the *New York Post,* Mary Welsh gave up her career to live with Hemingway in Cuba, and Janet Flanner continued her "Letter from Paris" for *The New Yorker.* They were among the fortunate. "A number of correspondents of both sexes joined the great postwar fraternity of the psychically displaced," a historian observes.

∞

Lee had no intention of leaving Europe. She and Dave could go on working as a team. They would cover the aftermath of the war in Eastern Europe, under the Soviets. But he was of two minds about the plan, which would keep him in thrall to her. He needed time to reflect.

Soon after their return to Paris, Lee drove Jemima, Dave's Chevrolet, through Germany to Denmark, "encased," she wrote, "in a wall of hate." She

was tense with rage: "For several months I had held my eyes so rigid and my mouth so frozen that I could scarcely manage a smile. . . . I had to learn to relax, to go from war to peace." But at the Danish border, as she watched "arrogant German officers whisking around in super-charged cars," her anger flared, and on her trip north, columns of German soldiers plodding homeward "margined the panorama of peace [she] had expected." Their presence framed the edges of her vision.

Arriving in time to see the end of five years of German occupation, Lee took pleasure in documenting Denmark's denazification. One of her shots redresses the balance by formal means: laughing Danes massed on a bridge form the backdrop to a handover of power by German officials. There had been no collaborationist government as in France, she noted. Danish businesses had protected their own from conscription into forced labor. Women had mobilized at all levels: "The National Women's Council and the National Householding Organization doubled their energies in binding the women of the country together by extending their teaching facilities and establishing preserving, mending, and cooking classes. This not only encouraged food and clothes economy but legally broke the law forbidding crowds."

It was heartening to learn that the Danes had taken their Jewish compatriots to safety in Sweden, often by devious means: "Prominent citizens announced the death of a relative and kept hearses and flower wagons, complete with top-hatted pall bearers, wandering around the streets from house doors to cemeteries with the hunted people hidden under wreaths on the floor. Taxi drivers and pushcarters and dressmakers and barbers transformed and transported the Jews. Wedding parties took them to ports for lobster dinners, and fishermen and sailors buried them under their nets until they reached midstream, and a friendly Swedish pilot boat." Once in Sweden, many joined the Danish forces of liberation.

Copenhagen's euphoric mood lifted Lee's spirits. "The Danes are drunk on laughter and fun and freedom," she wrote—despite the lack of electricity and other essentials. The populace had retaken their city. The Tivoli amusement park had replaced its war-damaged pavilions with cardboard façades; joyriders pushed the roller-coaster cars uphill before careering down; couples strolled through the gardens; old people dozed in the sun. Lee climbed high above the crowds to photograph their celebration, a daring composition that spills over its borders. As far as the eye can see, citizens form "a conspiracy of gaiety"—with no margins.

The royal family had also served as a unifying force during the occupation. Stories circulated about the defiance of the current ruler, Christian X. When told by the Nazis that Jewish Danes would have to wear yellow stars, he insisted that he and his family would also wear them. Lee obtained an interview with the crown princess and her daughters, who played unaffectedly

while she took their portraits. But however much she admired the courageous Danes, her own transition to peacetime remained on hold pending her return to England.

Lee's homecoming was a public event. She was now a celebrated figure—the only female photojournalist to see combat, the one whose dispatches gave a visceral sense of the war. A British movie-news team wanted to film her return. The scene of her reunion with Roland at Downshire Hill required prior planning since he had to take leave from his post in Norwich. On the appointed day, they dressed in their uniforms. The crew filmed a smiling Lee being greeted by Roland, who kisses her, gives her a welcome-home gift, a kitten, and shows her some new paintings, a domestic scene suggesting the drift to peacetime.

Brogue welcomed her with a gala luncheon. "No correspondent has displayed a greater versatility," Harry Yoxall's postprandial speech began. "Who else has written equally well about G.I.s and Picasso?" he asked. "Who else can swing from the Siegfried line one week to the new hip line the next?" Praising her empathy and courage, he continued: "She has shown herself a good soldier, and my only regret . . . is that the British authorities are so slow and ungracious in recognizing how good a soldier a woman can be." Lee's articles embodied the "quintessence" of *Vogue* for the last five years, he maintained: "A picture of the world at war, an encouragement to our readers to play their part, with no flinching from the death and destruction; but with a realization that these are not all, that taste and beauty represent the permanent values, that a pretty and well-dressed woman (as we see indeed in the person of today's heroine) can serve the cause better than a slovenly virago." The guests then toasted their heroine—whose reflections on viragos were not recorded.

Audrey Withers gave a more realistic appraisal of Lee's state of mind. "She was reluctant to abandon the adventurous life in which she had found her true vocation," Withers recalled, "and sensed, rightly, that she would never again have the opportunities it had given her." They discussed ideas for new assignments in the United States. After learning that Lee would like to work in New York, Edna Chase replied, "We would be delighted to have her come home, at our expense, of course, whenever she wants to make us a visit." Lee filed an account of her expenses and pondered the idea of being "base[d] in America for the same kind of thing I've been doing here but for other countries."

Dave's sporadic residence at Downshire Hill that summer did not help relations between Lee and Roland, since by this time she was, in many ways, closer to Dave. They discussed joint projects for Brogue until Roland put an

end to the plan by asking Sylvia Redding, the head of the photographic studio, to quash it. He worried about splits among the English Surrealists over whether to join the Communists, as Picasso had done, or to follow Breton's endorsement of Trotsky; struggling with his jealousy of Lee's success, he wondered whether he should return to painting. He wanted her to stay in London; she wanted to chronicle the war's aftermath, the dislocations of ordinary lives that needed to be set right.

In Dave's view, the much-delayed publication of *Wrens in Camera* in July confirmed the importance of Lee's work. Although she had all but forgotten the book, *Wrens* was attractive and timely, since it demonstrated that women *were* good soldiers. Dave hoped to sell a book of Lee's war pictures to a New York publisher: "She has written thousands of words of text and taken enough pix for 6, also is only dame who did," he told his brother. "I think it would be pretty good as her press suddenly became good in the US thanx to Vogue's handling." He might even publish the book himself: "She's a lazy bastard like me and would never do it."

About this time, Bernard Burrows wrote from Cairo to announce his engagement and to ask whether Robin Fedden might use some of Lee's shots in his book on Syria. "I found the pictures of our oasis trip the other day," Bernard continued, "& had quite a lump in the throat. . . . I wish I could see you. Come out here as official photographer for the Americans." Aziz, who had tried to keep in touch with Lee during the war and sent money whenever he could, also asked about her plans. He had been ill for the last two years and now felt his age. Having followed "the hiking thru the ravaged Europe of Lee Miller, the stranger," he hoped to settle their affairs—since they were still married and most of his holdings were in her name. Once again she was at a crossroads.

Coincidentally, Lee had come home in time for the elections that would determine England's future. Millions pondered the rival claims of the Conservatives and Labourites. It was disheartening to learn that Churchill had sunk to warning the country of the Gestapo tactics that would ensue if Labour implemented plans for nationalization. On July 26, after the Labour landslide, he resigned. In the meantime, the Potsdam conference partitioned Germany into four occupation zones and ratified Soviet spheres of influence, deepening the impression that the postwar world was one of shabby compromise. In August, after the United States bombed Hiroshima and Nagasaki, most in England reeled at the news of the slaughter committed by their allies.

In a climate of public alarm and private confusion, the conflict between Lee and Roland erupted in a violent quarrel. "I'm not Cinderella, I can't force my foot into the glass slipper," she told him. In mid-August, she left for Paris to join Dave, who had returned to the Scribe, after promising to keep Roland informed of her whereabouts.

Before leaving, Lee went up the hill to Hampstead Heath one clear night while a fair was in progress. The photograph she took high above London, of light squiggling across the landscape in a vivid release of power, recalls her panorama of Danish crowds celebrating the end of the war. Both record the present from the widest possible vantage point. But the Hampstead image hints that despite her intentions, it was too soon for peace, too difficult to relax for more than the seconds needed to take a picture of the world around her—and of the jagged energies inside.

Lee reached Paris in time to attend the trial of Marshal Henri-Philippe Pétain, whose lack of remorse for his deeds as head of Vichy France left as great an impression as the guilty verdict. Daily life was still taxing. The "coffee" had the bitter taste of its chief ingredient, acorns; the Métro was running but so many stations were closed that one had to guess where to get off; the electricity came and went unreliably, leaving the unwary trapped in the city's small, shaky elevator cages. Although gasoline was scarce and the price of food had doubled since the year before, there were compensations. There was little traffic except for bicycles, and the air was balmy.

"I've spent a lethargic and useless week in Paris," Lee told Roland, "doing nothing just like London only less to drink. . . . We celebrated vj day several times before we finally gave up and decided we'd invented atomic bombs ourselves and dreamed up the jap surrender. The room and my affairs are a hopeless mess," she continued, "and I'm incapable of sorting them out." Their friends—the Eluards, Picasso and Dora—were away: "The whole town is closed down." She was organizing a solo trip to Austria, Hungary, and perhaps Russia, but doing so "with a great deal of dread and boredom." Dave was waiting around to see her off, after which he would return to New York.

By the time Lee set off for Austria in the third week of August, her methods of dealing with depression were mutually contradictory. She needed benzedrine followed by cups of bitter coffee to rouse herself in the morning, and rounds of drinks followed by sleeping pills to calm her nerves at night. Sporadic efforts to go on the wagon met with little success. Nonetheless, she had Jemima, official backing, and letters of introduction. ("This is to introduce Lee Miller, our famous war correspondent," a Frogue staffer told a friend in Budapest. "You will find her absolutely charming.")

She reached her first stop, Salzburg, at the height of the music festival normally held each summer in Mozart's birthplace—an event meant to mark the war's end, as the fashion shows had done after the liberation of Paris. But the Europe carved out at the Potsdam conference looked quite different than it had the year before. Austria was divided into four zones, under the jurisdic-

tion of the occupying powers. The truckloads of soldiers—French, Russian, British, and American—pouring into Salzburg for the festival, Lee wrote, created "a babel of foreign voices." It had taken the skills of Barbara Lauwer, a former spy, to organize the event. The musicians, many of whom were Jewish, were coaxed out of hiding; the conductor, Reinhardt Baumgartner—who had spent the war in Switzerland—was retrieved at the border, and on arrival received a rousing welcome from the Russians invited there by U.S. General Mark Clark. Music brought potential enemies together; Mozart's harmonies bridged misunderstandings.

Lee became acquainted with a new dramatic form, opera, while in Salzburg, starting with *The Abduction from the Seraglio*. Mozart's theme of forgiveness was timely; the female leads befriended her when she took their pictures. Rosl Schwaiger, who stole the show as the soubrette Blondchen, took her to see director Max Reinhardt's bombed-out residence and sang for her in front of the derelict castle. On another occasion, when Maria Cebotari (Constanze in *The Abduction*) drove with Lee to a well-known inn, she began to thaw: "I'd always thought opera stars babied their voices and gargled at unsociable intervals, but she paid no attention to her flying hair and the whirling dust."

Later, Lee joined the crowds at the marionette theater, where singers hidden beneath the floorboards sang in English for the soldiers. Backstage she photographed the puppeteers looming over the set as they manipulated their miniature characters. In a comic opera about space travel, the little rocket that took the hero to Mars blasted across the tiny stage "with a bang and a shower of sparks, all too redolent of the Vis we were on the receiving end of last year," she wrote. Before reaching Mars, it landed on a planet with insectlike natives and squawking reptilian creatures whose ribs stuck out. "It's a comedy," she continued, "but I didn't laugh. The rocket is serious and the lizard beasts were like Dachau."

Salzburg proved to be a rehearsal for Vienna, where a fifth zone, under international control, deepened the confusion. On the way there through Russian-occupied territory, the mix-up of languages at checkpoints created a semantic babel. "The few road signs necessary for the limited traffic were painted white on infantry badge blue in cabalistic letters," she wrote, "candelabras, bedsteads and an assortment of our letters and numbers upside down or backwards like a witch's looking glass." The Russians waved red and yellow flags then saluted; the Americans wisecracked about her driving. The smartly uniformed bellboys at the Hotel Weisser Hahn, where she took a room, looked like members of the chorus.

Vienna was a cross between a comic opera and a puppet show, but one in which bureaucrats held the strings. Permits in quadruplicate were needed to move around the city, which kept two times: Viennese, for daily life, and military, based on the hour in Moscow. The press worked on local time but had to

rise with the military. Soldiers who had Viennese girlfriends went to bed late and woke up early, "so they are losing weight and getting circles under their eyes," Lee wrote to Roland on September 30. There was a thriving black market. She photographed enterprising Russian soldiers fishing for carp in the ornamental pond at the Belvedere Gardens, and, like the other hotel guests, pocketed leftovers for friends. "Nothing ever happens to schedule," she complained, "and none of my reform acts ever works, such as being orderly, on time or respectful to my elders."

"Lonesome and not amused" by the omnipresent music, Lee felt too distracted to write. "Arpeggios give me the shudders," she said; waltzes annoyed her. "Now I do nothing but go to operas and concerts . . . and associate with coloratura sopranos." While Vienna's Opera House had been gutted, it made a dramatic setting for her photograph of Irmgard Seefried, captured in silhouette against the ruins while she sang an aria from *Madama Butterfly*. But at the performance (a reprised German-language version), Lee's mind kept returning to the war. Noting the resemblance between "Kraut" uniforms and those worn by the American sailors, she wondered which uniform Pinkerton wore. Soaring music and themes of doomed love failed to unlock her emotions.

Vienna depressed her because she saw in it a distorted image of her state of mind: "In a city suffering the psychic depression of the conquered and starving, the Viennese have kept their charming duality. *Gemütlich* as ever, they are drunk on music, light frothy music for empty stomachs." But in a city full of displaced persons and peasants bearing stacks of wood for fuel, music functioned like the old Roman games: "It keeps people's minds off their tightened belts and the failure of politics."

"This trip is working very slowly," she told Roland. "I'm not at all sure it's successful. . . . I seem to have lost my grip or enthusiasm or something with the end of the war. There no longer seems to be any urgency." Only individuals touched her. The great Nijinsky, whose mental deterioration had doomed him to a mercy death under the Nazis, miraculously survived with the help of his wife, Romola—also a dancer. On hearing Russian spoken by the soldiers, he had talked for the first time in years. "Shocked that the great Nijinskaya had no shoes," Lee told Audrey, they had "looted a red leather sofa from under the debris next door and cobbled her a pair of sandals." Lee brought the couple scraps from the hotel, apple strudel, a liver sandwich, and Nijinsky's favorite, white bread spread with peanut butter.

While most civilians suffered from malnutrition and related illnesses, the shortage of medical supplies was far more disturbing. Lee visited a hospital where children were dying for lack of drugs. "For an hour I watched a baby die," she told Audrey. "He was a skinny gladiator. He gasped and fought and struggled for life, and a doctor and a nun and I just stood there and watched. . . . This tiny baby fought for his only possession, life, as if it might

be worth something." Her shots of this infant and the girl in the next bed are heartbreaking. There were millions of such cases, she noted in a passage that echoes reports from the camps: "There are a thousand here—I saw them." Memories of the dead and dying returned involuntarily. The dying baby was "dark blue when I first saw him," she wrote. "He was the dark dusty blue of these waltz-filled Vienna nights, the same color as the striped garb of the Dachau skeletons."

What could be done for the people of Austria, she asked herself: "We can liberate them and set them up as a going concern, but liberty and freedom and independence are not gifts; they are the reward of struggle and sacrifice." Moreover, it was impossible to forget that the Austrians had embraced Hitler. "This is a silly, fatuous town," she scrawled in her notebook. "It's not evil, wicked or tragic. Tragedy is the fate of the undeserving, not the earned justice of the wicked Nazis."

One of the few Viennese to win Lee's sympathy was the scrawny kitten she found in a gutter and named "Varum" (in English, "Why"). Tucked inside her uniform, he kept her company as she made the rounds of the occupying powers to obtain clearance for Moscow—where things might run more efficiently—or should this effort fail, Hungary and the Balkans. But even with Varum near her heart, hours with bureaucrats deepened her frustration. Her timing was wrong, people said. Winter was approaching; life under the Soviets was unstable. Lee persisted in her attempt, largely to persuade herself that she had not lost her grip.

Another letter to Roland drafted about this time begins, "Please, darling, I haven't forgotten you. It's part of my boondoggling habits and a piece of my current frustrations which I've tried many times to explain to you. Every day I'm expecting to find the solution, the key to the code. Every evening when I could take the time and certainly have the interest to write you I think that tomorrow I'll know the ultimate answer or my depression will have lifted." But the answer never came. "Now I'm suffering from a sort of verbal impotence," she continued. "When Europe was yet to be 'liberated,' . . . when I had thought and burned with ideas for years and suddenly found a peg on which to hang them, I found work and transport and transmission and courage. This is a new and disillusioning world. Peace in a world of crooks who have no honor, no integrity, and no shame is not what anyone fought for."

Lee's depression mirrored that of many displaced persons, she believed. "Really great groups of humans are suffering from the same shock symptoms caused by peace that I'm combatting," she said. "I don't in the least mean the boys going back home to find that they've become dependent upon benevolent maternal army, that they have outgrown their wives or become unsocially unfit or drunks or misanthropes. It's just an impatience with the sordid dirt which is being slung around compared with the comparative cleanliness and the real

nobility of men in the lines, or men and women in lousy little jobs they thought were helping win the war, and the people who bought the bonds so that their disreputable government could continue after the war boom had been paid off, the families who are still on short rations so that a lot of grasping bastards with greedy gloating appetites should have enough schlag [whipped cream] on their coffee." She was sick of Vienna and its schlag-devouring residents: "A more disorganized, dissolute, dishonest population has never existed in the history books."

∞

In late October, accompanied by an Austrian broadcaster, a Hungarian soldier, and Varum, Lee drove to Budapest. Their adventures made "good cinema," she told a friend in Vienna. On the road to Bruck, the checkpoint, they were chased by Russian guards who hauled out Lee's passengers and stuck a gun in her side. At headquarters, Lee charmed the commanding officer: "He thought it sporting of me to give a lift to two strangers," she went on, but warned her to be careful in Hungary—Hitler's most enthusiastic ally until earlier that year, when Budapest fell to the Russians after a long siege.

Lee's first impression of the capital was positive. The Danube shimmered "like a mirage"; Budapest rose from its banks "like a jewel studded icon." But the civilians' hotel, the Bristol, reeked of rat turds, and by the time she found a room at the officers' billet, Varum was missing. Retracing her steps, Lee found the kitten lying dead outside the Bristol, "arched like when he's pretending to be a warrior." She gave way to bitter tears—a delayed response to "weeks of frustration bursting on the doorstep of my objective as well as [to] the loss of my pet." Later, since her bed lacked sheets, she put the red Nazi flag she used as a scarf on her pillow, she said, "so that at least it'd be my own dirt, and the color came off on my nose and eyes, from crying."

Breakfast at the U.S. mess (butter, coffee, and six eggs) improved her mood. General Geoffrey Keyes, the military commander, made her feel welcome; an officer told her to move to the Sisters of Mercy convent, where some journalists were living at the pleasure of the abbess, Margit Schlachte—one of the many in Budapest who made known their dislike of the Russians. Despite their complaints, Lee preferred the Hungarians to the Austrians. One felt a bustle in the air. After moving to the convent, she dined nearby at the Park Club, headquarters for the Allied missions, and downed palinca, Hungarian apricot brandy, at the bar, where a U.S. colonel grumbled about journalists using their status to junket around Europe.

Surprised to find *Vogue*'s war correspondent living next door to them at the convent, *Life* photographer John Phillips and *Stars and Stripes* reporter Simon Bourgin welcomed Lee—as much for the legend surrounding her as for her

fireplace, an asset as nights grew cold. (Their cells were far from monastic: the nuns provided palinca and foie gras in exchange for dollars.) Soon they formed a team of three, Lee in the role of sister to the two Americans. Phillips, a worldly expatriate who had begun his career as a society photographer in Nice, knew everyone; Bourgin, a fresh-faced young reporter from Minnesota, let Phillips arrange their appointments and map the terrain.

They were uniquely placed to watch the breakdown of Hungarian society, Phillips explained: it was taking place before their eyes. As for the future of Eastern Europe, he believed, it would be hard to get the Russians out of the areas they now occupied. Having known prewar Cairo, Phillips agreed that while life there had been pleasant for foreigners, most Egyptians wanted a German victory, to end British rule. They discussed politics into the night: Hungary's support of Hitler, the population's refusal to take responsibility for their defeat, the Russians' plans, which were, as yet, unknown, except that they backed the November elections, the first exercise of this kind in Hungary. "Lee was very aware of what was happening," Phillips recalled. "She had been to the college of life." One night she barged into their room with her bedroll and declared, "I'll be damned if I'm going to be excluded from this conversation because I'm a woman."

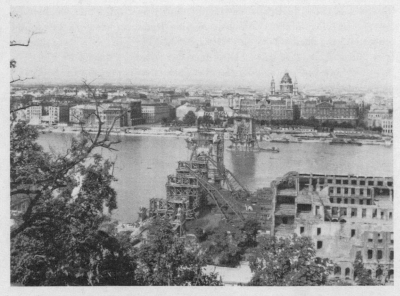

Panoramic shot of the Danube, a bombed bridge, and Pest taken while Lee and Simon Bourgin (the photographer) explored Buda together in October 1945

Remembering this time, Bourgin observed with a smile: "Lee and I almost lived together." Between appointments, they explored Buda, a romantic ruin across the river that was hard to reach since the siege, when the Germans blew up the bridges. Crossing the partially rebuilt Franz Joseph bridge was an adventure. One picked one's way past crowded trams, carts pulled by ancient nags, and homeless children who pilfered what they could in the confusion. After climbing the medieval streets to Castle Hill, Lee photographed the parapets of Fisherman's Bastion, an unlikely pastiche of Gothic and Romanesque built as a viewing platform over the fish market—where she framed Pest in the distance through the Bastion's doorways.

Street scenes in the more modern part of the city caught her eye for detail. She shot election posters pasted on the walls in decorative patterns, the outdoor market stocked "with abundant wonderful food at astronomical figures," she noted, and the geese she acquired and traded for a kilo of salt—but also the "freezing, starving returning deportees" and the few survivors of Hitler's last-ditch effort to eliminate Hungarian Jewry. "She hated the Fascists," Phillips recalled. "We were all anti-Nazi, but the strength of her hatred was unusual." He found it hard to fathom the depth of her anger.

Soon after her arrival, Lee met Robert Halmi, the son of a distinguished Hungarian photographer who was himself a cameraman. Halmi, who spoke good English, became her interpreter, assistant, and chess partner. "Our relationship was very basic," he recalled. He toted Lee's equipment, did setups, and translated at interviews. Soon he was also serving as her masseur, morning rubdowns being as necessary as the first shot of palinca to rouse her after the previous night's drinking. Lee was "absolutely fearless," Halmi went on: "she had a marvelous sense of humor." They became good friends, but the young man did not find her attractive. She drank too much and in her baggy army uniform looked "too masculine."

One day, Bourgin came into Lee's cell when Halmi was sitting astride her to massage her back. "Shake hands with Halmi," she told him. "He can get you anything you want." Once roused, Lee often joined Si and John at interviews or with Halmi's help photographed Budapest luminaries. Between engagements, she and Bourgin swam at the Gellert Hotel's Art Nouveau baths, where the guests strolled in their towels beneath the domed ceiling. The spa was maintained despite the hotel's extensive damage—proof of Budapest's taste for pleasure, Lee thought, like the nightclubs "flourish[ing] with champagne and girl acts, the latter being frequently padlocked as a reform wave strikes the government."

With her new friends, she spent evenings at the Park Club, which before the war had been the exclusive precinct of the Hungarian aristocracy. Former members were delighted to return as guests of Allied staff. She and Bourgin often took their well-connected English-speaking friends—Baroness Kati

Schell, who worked for Phillips, and Elizabeth Uhlman, the daughter of a Jewish baron and banker. The Park Club was "the mecca of all social Budapest," Lee explained for *Vogue* readers. It had excellent food, a famous Gypsy band, and the bar where "the Two Georges," musicians who had survived the camps, entertained while the waiters arranged sales of drugs or diamonds.

It became apparent to Lee that Halmi was not the only one who could get anything you wanted. Men in the street proffered cameras, binoculars, gold watches, and pistols; waiters had villas to rent or cases of champagne. "The American dollar is king," Bourgin began his report on Hungary for *Life*. "The dollar here can buy anything—all the luxuries and fineries that the rest of Europe only dreams about." With the collapse of the pengö following Hungary's despoliation by the Germans and the Russians, Americans were the new aristocracy. Working for Phillips at ten dollars a week, Kati Schell earned more than the foreign minister did in a month; a GI's monthly pay exceeded the prime minister's annual salary.

Kati explained the topsy-turvy social system to Lee and her friends. That spring, after the passage of the land-reform laws that ended the feudal system, the nobility had shown great resourcefulness. With whatever they could rescue from their estates—antiques, mink coats, the butler's gold buttons—they came to town to earn money. "The waitresses and nurse-maids trades union register of Budapest reads like the Almanach of Gotha," Lee noted. Baronesses worked as barmaids; a countess who was a famous horsewoman joined the team rebuilding the bridges. These women, she observed, had "learned courage and endurance and a long-term sense of values." Moreover, they knew "what good service should be like and weren't ashamed to give it."

Lee's ideas about the piece she wanted to write for *Vogue* seemed mutually contradictory. The political situation illustrated aspects of life in Eastern Europe under the Soviets, yet it was also peculiar to Hungary. The population's refusal to admit guilt for their pro-Nazi past enraged her, as did their treatment of the Jewish deportees who came home to learn that their neighbors had helped themselves to their property. "She had a strong streak of compassion for those caught on the wrong side," Bourgin recalled, "a political sense enlivened by an ethical feeling."

While Lee felt obliged to do a story on fashion, this was a joke, Halmi felt. Everyone but the aristocrats went around in rags. As in Paris, fashion showed the war's aftereffects: Lee photographed Kati Schell, a scarf round her head for warmth, at the Café Roszwurm in Buda and posed one of Halmi's friends in front of the Hungarian Parliament. She took a more original line by showing the nobility's efforts to turn hunting trips into a source of profit. "American and British officers (who have cars, travel permits and enough enthusiasm to batter against the rotten roads for a shot at a stag) transport the party," Lee explained. Since ammunition cost thousands of pengös, only the best shots

were invited. The nobility were "cockeyed but courageous," Phillips recalled of these weekends. "Who else would have thought of hunting with the Allies in their jeeps?"

At the other end of the social ladder, the inhabitants of many villages still wore traditional dress. Toward the end of October, Lee and Halmi drove to Mezökövesd, "a living folkore museum," she told Audrey, where even Elsa Schiaparelli might pick up an idea. About fifty miles north of Budapest, the village had catered to tourists since the folk revival before the war. In October, after the harvest, the unmarried women paraded in their embroidered costumes to attract suitors; they married in white dresses decked with flowered streamers and headdresses of cascading white fringe.

The story combined fashion with anthropology. In contrast to their gorgeous clothes, the peasants "live primitively in crowded houses with permanently closed windows, stinking outhouses . . . and muddy manure sloshing streets," Lee wrote. (Oddly, they had "elegant baby carriages.") One old woman, "a sort of show piece," drew embroidery patterns for the women in the region. Stitching the blossoms for which she was famous, she made a proud subject in her dark clothes and headdress of pink pompoms. As Lee photographed her, a Russian barged in, shouting, *"Davai, davai"* ("come along," a phrase that often preceded demands for one's watch), then detained her for taking pictures without the proper papers.

Lee and Halmi were taken to Miskolc, the provincial capital, and placed under guard for two days. "I sat in austere rooms under a photo of Stalin, to be interviewed, scrutinised, and asked to wait by officers of various rank, amiability, and branch of service," Lee told Audrey. "Everybody was very polite and patient and I was given deli-

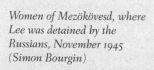

Women of Mezökövesd, where Lee was detained by the Russians, November 1945 (Simon Bourgin)

cious cigarettes." Although confined, she did not suffer. "I ate what I liked and was taken out walking or shopping when I was bored or sat in the cafe drinking palinca (I think it must be distilled paprika) and real coffee." She initiated the commanding officer into a variant of the Surrealist *corps exquis* by drawing imaginary monsters, section by section. But it was hard not to worry. "I couldn't think what I'd done wrong," she continued. "Was it enough for Siberia? Would my cameras be seized? Would I be exiled from Hungary?"

In the meantime, Lee and her captors toasted their respective governments and discussed "culture," for which the Russians showed respect. When she showed them copies of *Vogue,* they jeered, " 'Bourgeois,' pronounced 'boorjooey,' " which was "not a criticism of pink sheets and bed-lamps, crested silver, or heated motor cars but an implication that they were acquired by undemocratic means." The Russian colonel gave her new papers and sent her to tour the region, including the Tokaj vineyards and the fin-de-siècle spa of Lillafured. Her adventures made news in Budapest and soon, in the United States, when the New York papers published reports of her detention. (The Millers learned from the *New York Times* that she had been held by the Russians; since the invasion, her correspondence with them had been sporadic at best.)

Lee returned to the capital a few days before the elections. For weeks, she wrote, "Budapest had been seething with rumors about stronghanded methods and reprisals by the communists if the vote didn't swing to a left-wing majority." Yet on election day, November 4, "everyone voted exactly as they pleased"—resulting in a coalition government led by the Small Holder Party, which defended the landed peasantry while also attracting voters alarmed by the thought of a Soviet-style future. "The conservative elements of the country have [a] great interest in the failure of democracy," she continued. "Their publicized mistrust and dislike of the Soviet Union . . . results in the sabotage of sincere efforts on the part of modern minded people." While the Russians' plans for Eastern Europe are still a debated question, Lee thought that they should be given the benefit of the doubt.

Sister Margit Schlachte, who held the opposite view, found it increasingly difficult to accept Lee's modern-mindedness, even allowing for her nationality and profession. Halmi took her home at night when she was drunk and pleaded ignorance when she flouted the convent's rules—as if she were back at boarding school. Lee's presence was corrupting the nuns, Schlachte believed. She gave them silk stockings; a novice became hysterical on finding Halmi performing his morning massage while Lee lay naked in bed. "Schlachte told us, 'We don't do that,' " to which Halmi replied, "I'm sorry, I didn't know. I never lived in a convent."

One night, after Lee, John, and Si met some homeless refugees on their way to the convent, Lee gave them her cell and slept next door. In the morn-

ing, another sister berated them: "First we had the Nazis," she declared. "Now we have the Russians, but you people are the worst." They would have to leave; the convent could no longer tolerate such behavior. The trio moved to the Astoria, where the U.S. enlisted men's Hungarian girlfriends could stay until inspections at 4 a.m.

John and Lee remained at the Astoria after Si was posted to Belgrade. On December 22, she cabled Roland wistfully: WISH EYE WERE GOING TO HAVE AS MERRY A CHRISTMAS AS EYE HOPE FOR YOU STOP LOVE EVERYONE ESPECIALLY YOU STOP KISSES. She had, in a sense, become an eye—a courageous, highly esteemed professional. Unlike Bourke-White, Lee was "good company," Phillips explained: "Bourke-White just worked; Lee had a sense of humor." Although both knew what they wanted and went after it, they had "nothing in common." As for Beaton, Brogue's other "eye," John and Lee were in agreement. He was "a pure social climber," he recalled, "someone who would knife you in the back if it served his purpose."

John and Lee occasionally worked together on stories, such as the execution of Laszlo Bardossy, the premier during Hungary's alliance with the Nazis, who had been found guilty of war crimes. On January 10, they rose at dawn to document Bardossy's execution. Their photographs reflect their different perspectives. Leaning out of a window, Lee framed the scene as a theater of retribution: witnesses stand to the side as four soldiers take aim at the ex-premier, standing stiffly against a pile of sandbags. By contrast, Phillips's close-up of a priest kneeling over the body leaves the viewer in doubt. Few blamed Bardossy, he believed. His final words ("God save Hungary from these bandits!") were understood to refer to the Communists. That day, he recalled, "a pall of gloom descended on Budapest."

At Lee's hangout, the Café Floris, people said it was a disgrace to hang the premier like a criminal; they did not believe her when she said that he had been shot. "Next edition," she ironized, "he'd been shot and writhed in agony for forty minutes and neither his wife had been allowed to see him, nor absolution given. No women had been present and the press forbidden to take pictures. . . . Finally, one day I'd be walking down Bardossy Street to the executions of the present democratic leaders." The attitudes voiced in these remarks disgusted her: "I gave up, and left Hungary to its world of fable."

Taking stock the next day in a note to Audrey, Lee concluded that it had been "a mistake" to go to Eastern Europe. Her stubbornness, which had served her in the war, "turns out to be a bad peacetime habit," she continued, "and my bulldozing tactics tangle with the supple evasiveness which pervades this part of the world." In the current climate, she felt "as popular as a leper and as rational as a scattered jigsaw puzzle." Yet she wanted to keep on going. "I'd rather chew my finger nails right down to the elbow rather than retreat from here until I have something positive and convincing to say." At the

moment, "the octopus of dishonesty" prevalent in Hungary had forced her into "numb sterility and appalling self-examination."

During these weeks, Lee received several kinds of disturbing news. Harry Yoxall cabled on January 7 that he and Edna Chase would no longer bear the expense of her stay in Europe. He urged her, RETURN LONDON SOONEST POSSIBLE VIEW PROCEEDING NEW YORK. On January 23, Audrey cabled that she had not received Lee's Hungarian coverage. AFRAID CIRCUM-STANCE RENDER IT IMPOSSIBLE, Audrey continued, MUST ASK YOU RETURN QUICKEST ROUTE LEAVING MID-FEBRUARY LATEST. About the same time, Dave cabled John Phillips to tell Lee to return to Downshire Hill, where another woman was installed in Roland's bed.

Lee put the cables aside. She was going to Romania with John in spite of everything—the news, the weather, the political situation. "Before leaving," Phillips recalled, "we invited three quarters of the expropriated Hungarians to the Park Club. With the inflation, we could pay two weeks later in dollars so it cost nothing." They watched their friends smash glasses, drink themselves silly, and behave "as if this were the old days," then took their leave just before the first Hungarian republic came into existence on February 1.

Lee's return to Romania began with a false start. After crossing the Great Plain's grasslands in a convoy—John and his driver, Giles Schulz, in their jeep, Lee in Jemima—they were rejected by the Russian border guards and sent back to Budapest to secure the correct papers. One Russian unit did not always recognize another's authority, Phillips recalled: "We had no idea which Red Army unit we were dealing with, and by the looks of things, the authorities in Budapest didn't either."

Despite this contretemps, the chain of command in Romania seemed clearer than in Hungary. In 1939, the Germans had turned the largely agrarian country into a satellite of the Third Reich. After King Carol's abdication in 1940, General Ion Antonescu had established the fascist dictatorship that lasted until August 1944, when the Russians invaded, and the country changed sides. For the past year, Prince Mihai (Michael), whom John knew from pre-war days, had ruled under Soviet protection.

After obtaining credentials signed in red, John and Lee plotted a new route. They crossed the border with a few hours' delay and drove through the waning winter light to Arad, where curious crowds, for whom foreigners other than Russians were a novelty, surrounded their cars. The French-speaker who translated for them booked the one hotel room available and took them to a restaurant whose decor retained traces of Arad's past as an outpost of the Austro-Hungarian Empire.

It was the start of a long, cold night of misunderstandings. They exchanged drinks with an inebriated Russian officer named Andrei, who told the band to play American tunes, including "It's a Long, Long Way to Tipperary." Later, after failing to persuade his new friends to stay up all night, Andrei banged on their door while they shivered in their beds—under the pretext that the translator, who was sleeping on the couch, had the wrong papers. "Lee, my driver, and I put on our shoes without a word," Phillips recalled: if Andrei took the translator, he would have to take all of them. The fuss ended when the chief of police arrived and found the man's papers to be in order. Andrei marched out in a snit; the chief sighed, "These Russians."

In the morning, they drove to Oradea, a center of imperial elegance that became a backwater when Hungary lost Transylvania after the Great War. To their surprise, a grinning Andrei invited them to his table in the hotel dining room, where he and some officers were downing Wiener schnitzel, pickles, chocolate cake, and quantities of beer and wine. "While it was hard to reconcile the way he had grimly stalked out of our lives only to re-enter it wreathed in smiles," Phillips wrote, "he looked genuinely pleased to be with us." After many rounds of tuica, Romanian plum brandy, Andrei said that he was "Russian SS"—part of the dreaded NKVD. He then sang lustily, did Cossack dances, and fell asleep outside the room that John and Lee were sharing. Later, on their return, they noticed his badly gashed forehead and disinfected his cuts with tuica before sending him away.

It snowed the next day on the drive through Transylvania, John and Lee in Jemima, and Schultz behind. "Through eyelids squeezed against the brilliance," Lee wrote, "I peered at the showy expanse of white plains and mountains topped by blue skies." The province had long been politically "ambiguous," she explained for *Vogue* readers. After each war, it ended up on a different side of the border (having been ceded to Hungary by the Nazis in 1940, the region had just been restored to Romania by the Russians). Under heavy snowdrifts, it was also "anonymous." There were no road signs—the Hungarian place-names having been taken down and the Romanian ones not yet put up: "I might have been in Russia, or Michigan, or Patagonia."

On the icy road to Sibiu, Lee visualized this mysterious town, where large eye-shaped windows nestled beneath the rooftops. "In 1938 I was very impressed by the peering prying eyes of the architecture," she wrote. "At this time this province was being proselytized by the bigger and better Germany crowd as well as by the Nem Nem Shoha gang of Hungary [revisionists who said 'no, no, never' to the transfer of Transylvania to Romania]. I was there as a simple tourist but under great suspicion by all." Steering Jemima along the slippery road, she thought of "the way the buildings peered just like the hidden microphones in Bucharest listened."

Suddenly, her car skidded off the road and onto a slope, where it came to

a stop forty feet away. "I'm awfully sorry, John," Lee said calmly as Schulz rushed to their aid. By chance, soldiers from a Red Army unit that had been at the Torgau linkup drove up, asked their nationality, then shouted, "Yanks Goddamn sonavabich bastard okay!" After several failed attempts to dislodge Jemima, Lee, John, and Schulz drove to Sibiu in the jeep, then returned hours later to find that the car had been stripped by the bandits they had been warned about in Budapest.

The next day, on the road to Sinaia, a ski resort in the Carpathians, Schulz drove while Lee and John traded memories of prewar Romania. They hoped to see King Michael and the queen mother, whom John had met when photographing King Carol—an assignment that Carol saw as a chance to improve his image in America. (The king explained that as Queen Victoria's grandson, he had enlarged the royal residence to enhance its resemblance to Buckingham Palace.) While the current king had been unable to stop the deportation of Romanian Jews to Auschwitz, his recent coup d'état had realigned Romania with the Allies.

Michael and his mother, the former Helen of Greece, lived in a chalet but preferred to meet journalists in their official residence—which to Lee "looked like something Orson Welles might have chosen as the set for a Balkan mystery." Michael posed regally against the background of armor in his great hall. "A very satisfactory king he makes," Lee told Audrey, "an extremely astute clever cookie." He was respected by all: the peasants, the Russians, and the political parties. "In this moment of our side fostering all the wrong kings in the right countries," she continued, "it is curious to find that Mihai, with his coup d'état more or less on his own is the only outstanding post-war monarch." She approved of his hobbies—riding his jeep down the palace stairs, tinkering with machinery, taking photographs and printing them in his darkroom—though his contempt for the Rolleiflex (he had five Leicas) surprised her.

The queen mother, who joked about the "terrifying taste" of Romanian palaces, had

D-ra Lee Miller, corespondenta revistei „Vogue" în România

D. John Phillips, corespondentul magazinului „Life", la Bucuresti

Illustration for Poporul *(Bucharest) interview with Lee and John Phillips, February 9, 1946*

"great elegance and simple charm." Helen posed for Lee in a tailored frock and pearls against the swirling rococo stairway. "Even I recognized that the pearls were real," she told Audrey, "in spite of the fact that they . . . were worn in the simplest possible manner." It pleased her to bring Helen news of "what had happened to the various schlosses and castles various relatives of hers in Germany or Austria had been living in"—as if they shared a common past. Before leaving Sinaia, Lee photographed the graves of the American airmen who had died in raids on the Ploesti oil fields, their stark crosses in the foreground against the snow-covered mountains.

It was a short drive to Bucharest. The streets were full of oxcarts, barefoot peasants, and big American cars. After checking into the Athenée Palace, they learned that since the recognition by Britain and the United States of Romania's left-wing government, representatives from both countries were there making overtures to the state-owned oil company. In the new political climate, Lee and John were welcomed as the representatives of influential U.S. magazines. A reporter from the independent daily *Poporul* wrote about them as "guests" who had toured Romania before the war. During their interview, they reminisced about conditions in 1938. Lee, whose blue eyes and "beautiful hair, like freshly harvested corn," were much admired, the reporter wrote, waited patiently while John expressed his belief that a journalist was as much a combatant as a soldier—he needed "sang froid," but also "a sense of ambiguity . . . to participate not only with his heart but also with his mind."

On their travels, Lee listened to many observations of this kind. "Romania is a profession, not a nationality," John was fond of saying. Life in Bucharest was almost oriental, in that intrigue determined whom one could see or photograph. Lee still felt "rhapsodic" about the people, who were Latins: "The language was understandable, or at least readable," she explained. Moreover, the streets were a feast for the eyes: "Every shop had gay, primitive paintings by the door, of pork chops, sausages, hats, gloves, hammers, saws, and ploughs, whatever was stocked inside." And there were no shortages except for caviar. Nightlife had resumed. It was hard to distinguish the "nice" women from the professionals, since both dressed with equal flashiness. As in Budapest, she listened to Gypsy music while tossing tuica down her throat from a kind of bud vase, a custom dating to the time when riders knocked back the drink without dismounting—a trick she no doubt thought about trying.

While some aspects of peasant life were unchanged, the Gypsies who had wandered about Romania with their bears were nowhere to be seen. Before the war, the bears had danced for the villagers and walked up and down their spines to cure backaches. Eager to try ursine massage, Lee made inquiries. Her friend Hari Brauner, who had resumed his university post, explained the bears' fate. Under Antonescu, Gypsies had been forbidden to ply their trades, but after Michael's coup, they flocked to Bucharest. "Traffic

was blocked by mobs of excited children and rheumatic oldsters surrounding the beribboned, flower-garlanded bears," Lee wrote in a draft for *Vogue*. But when typhus began to threaten public health, the government reinstated the ban on Gypsy travel. Lee waited while Hari asked his informants about venues for bear massage.

In the meantime, Brauner brought her up-to-date on their friend Maritza. Now a national figure whose records were often heard on the radio, she still wore peasant clothes and refused to be chic. Hari took Lee to photograph the singer in her element, a bistro where visitors followed the Gypsy code: "The guest never gives money to the singer," Lee wrote, "but places it in a piggy bank in the belly of the guitar." While Maritza cooed and chirped, the music unwound itself like a spring: "The minor half tones are almost oriental and the nostalgic or passionate verses gather a terrible intensity, sustained above the scrambling, scraping patterns of the orchestra. They say that once you drink from a certain well and listen to the music, you will return to Romania. I've done both and returned twice."

Lee dutifully reported on Romanian society. "Thinking you might want personalities," she told Audrey, she went to lunch with the wife of Romanian Oil's general manager to photograph the newly influential. Later, the minister of justice's spouse took her to a picturesque part of town where whole streets were covered with carpets, and street vendors bore their merchandise on their shoulders. The peasants interested her more than the society ladies: "All the most beautiful dames in town are either tarts or are living more or less scandalously with our officers." Maritza, on the other hand, was "authentic . . . a great friend of mine and a lovely woman."

Lee enlisted Maritza's help in her efforts to find a bear hotel, an inn with a courtyard where the animals slept curled up beside their masters. When Hari's informants provided the address of a bear hotel less than an hour away, Lee hired a taxi and with Hari "rumbled forth into a mysteriously foggy country on frighteningly bumpy roads, squashed through snow and ruts." The village had thatched roofs and unkempt gardens full of sunflowers. The one remaining bear had to be awakened. "Sleepy and sulky, she snapped at her keeper," Lee recalled. After a few growls, she stood on her hind legs to dance—a prelude to massage.

Before lying down on a carpet, Lee taught Hari to use her Rolleiflex so he could capture the event. "The bear knew her business," she wrote later. "She walked up and down my back on all fours as gently as if on eggs. Each big paw felt its way until it found an area which wouldn't squash in, and the weight was transferred from foot to foot with very little change of pressure. As the music started again, she raised up on her hind legs and shuffled up and down my back. It was crushing and exhilarating. All my muscles clenched and relaxed to keep from being flattened. Then she was led off, to return, facing the other direction. She sat her great, furry, warm bottom down on the nape of my neck,

and with gentle shuffles, went from my neck to my knees and back again." Afterward Lee felt "marvelous . . . flexible and energetic. I discovered I could move my neck and shoulders in patterns I'd forgotten." The bear's owner reluctantly accepted payment, "the equivalent of a dollar and a half . . . all we had left with us at the end of a couple of months peregrinations."

One would hope that Lee was in this relaxed state when she read the missive from Roland that came near the end of her stay. He had heard from her once since August. Tired of loving someone who had become a "ghost," he was making a last attempt to reach her. "Our pact made from the whole bottom of my heart was one which gave you always your liberty," he

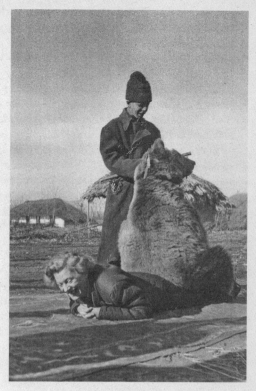

Lee being massaged by a bear, Romania, February 1946 (Lee Miller with Hari Brauner)

wrote. "Every hour spent with you was an hour of supreme happiness. Every hour without you was just too bad." But there had been too many of them lately, and no sign that the future would be different. "You asked me before leaving if I had some girl I loved as well as you," he continued. "Now I have. Someone you don't know, have never seen and who is here—real—no ghost." He would make his life with her unless Lee returned.

About the same time, Phillips recalled, officialdom caught up with him, in the form of an order from Allied headquarters to return to Vienna with his jeep and driver: "My task now was to make sure Lee got back to London." As long as she had Jemima, she had kept moving. But now, lacking transport and nearly broke, she had to admit that her plan to press on to Bulgaria seemed unlikely. They argued. John told her to go home to Roland: "That night Lee understood that Bucharest was the end of the line. Her war was finally over."

The next morning, Lee caught the train to Paris, then went to the Scribe.

She was exhausted. Her skin was covered with blotches; her hair was lank; her gums bled constantly. Living on her nerves for a year and a half had taken its toll. To *Life* staffer Rosemarie Redlich, who lived at the Scribe, "she looked very much the worse for wear." Redlich had been curious about the woman Dave Scherman had spoken of admiringly on his return to their New York office. While Lee had taught him about sex, he said, their affair was over: "He felt he had rescued her—but also himself—by sending her back to Roland."

On February 16, Lee ran into Roland, who had been celebrating his demobilization in Paris when he learned that she was on her way. He took her back to Downshire Hill, a burnt-out case. Not wanting to disrupt their longstanding relations, her rival, a blond art restorer named Gigi, moved out; Lee summoned the strength to make the commitment that Roland required. It was a compromise—and one that would include the continued presence in his life of Gigi, who was as charming and gentle as Lee was abrasive. (The niece of an art historian, Gigi shared Roland's values; unlike Lee, she drank, at most, a glass of sherry.) Lee accepted Roland's desire for another woman, she later wrote, "to prove that I loved you . . . the fact that your love for me was diluted and weakened was unimportant as long as you were happy."

One night he was massaging her feet, an experience that always gave her pleasure. "If only someone had massaged Hitler's feet like that there would have been no massacres," she murmured darkly. Despite Roland's efforts to reopen the London Gallery, the winter of 1946 was not a happy time in artistic circles. After seven years of mobilization, most felt demoralized and resented being told that they must choose between Russia and America. Food was still being rationed; shortages of staples increased in 1946 as supplies were redirected to the victims of the hostilities.

Lee's resumption of life at Downshire Hill was further complicated by the presence in London of Dave, who had returned from New York in January to do a photo-essay on Scotland Yard—but actually (he confessed to his brother Bill) to court an English researcher at Time-Life. He had taken a flat in St. James Place, near their office and far from Hampstead. But Lee's return was a major event. He felt responsible for her, he told Bill, because she was now "in bad odor with her office and home life." If she went to the United States, which seemed likely, he would write letters of introduction and lend her his car (not having been completely put off by the fate of Jemima). What he did not say was that Lee was interfering in his courtship, even though she was supposed to be patching things up with Roland. Reading between the lines, one senses Dave's abiding love for Lee, whose future he was trying to secure in spite of himself.

In March, as Lee alternated between rage and depression, Dave helped her with the *Vogue* article on Hungary; Timmie O'Brien, *Vogue*'s managing editor, extracted a final draft by locking herself into Lee's bedroom one night with

Portraits

Charlie Chaplin. Paris, 1930

Tanja Ramm. Paris, 1931

Eileen Agar. Brighton, 1937

Martha Gellhorn. London, 1943

Jean Cocteau. Palais Royal colonnade, Paris, 1944

Dorothea Tanning with her painting *Maternity*. Arizona, 1946

Pablo Picasso and Antony Penrose. Farley Farm, Sussex, 1950

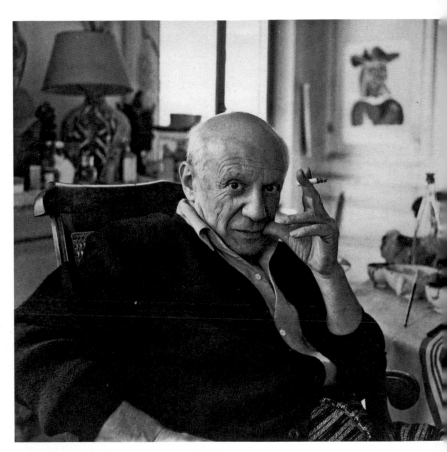

Pablo Picasso. Villa La Californie, Cannes, 1958

a bottle of whiskey. Lee told Audrey to use whatever parts she liked and promised to make her piece on Romania "non-scolding." Severely edited, both articles appeared in U.S. *Vogue* on May 15, an issue that also featured her advice for would-be photographers and a cover shot of a woman looking very much like Lee—photographed, ironically, by Cecil Beaton.

The issue, entitled "Travel and Camera, Charting Places and Clothes," sounded the note for postwar *élégantes*. "Now that everyone is camera-crazy," Lee wrote, the fashionable traveler's luggage should include two cameras (a Contax and a Rolleiflex), several lenses, a brush to remove dust, lens tissues, a photometer, and Scotch tape for accidents. Amateurs should remember to label exposed film, learn to say "Don't look at the camera" in the local tongue, and distract those who tried to interfere with "decoys and diversions." She warned of the medium's occupational hazards, ranging from "queasy stomach ulcers to mumbling jitters." (A stiff neck due to wearing too many gadgets on one's person could be dealt with by hiring "a small boy or a patient donkey.")

In the meantime, Dave lost patience with his Scotland Yard story and with London. He went to Paris on April 15 to start a book on literary France, but in his old room at the Scribe, gazing at Lee's jerry cans on the balcony, he wondered whether, as she had said, he was "a sucker." "I'm on my pratt," he told Bill, "no identity cards, no food tickets, no international touring club, no garage, no wife, no moustache, no expensive shops, no quaint little bistros in that little allee behind the Eglise de St-Simon-et-Ste-Eustache-de-chat-qui-puke." Lee was coming to Paris the following week to wind up her affairs. "Penrose almost gave her the run out," he continued, "but by herculean efforts I got her back in time, and after a touch and go month, maybe she's in the clear. . . . The best way to help patch things up is if they both go to America."

Lee felt sufficiently in the clear to celebrate her thirty-ninth birthday in Paris (Dave annotated his diary entry for April 23, "St. Lee's Day," though it was St. George's). They lunched with Michel de Brunhoff, saw Nusch Eluard, and parted on May 11, when Lee returned to London. Scherman's literary France project was taking shape with the help of Rosemarie Redlich: they had teamed up and would, in a few years' time, marry. The Scribe, Dave told his brother, was "very depressing, a few gnomes still hanging around from the war, nobody told 'em it's over." Lee, too, was finding the adjustment difficult. "She is having a tough time, largely through her own making," he reflected, "and sooner or later she is going to break all to pieces like a bum novel."

Part Five
Lady Penrose

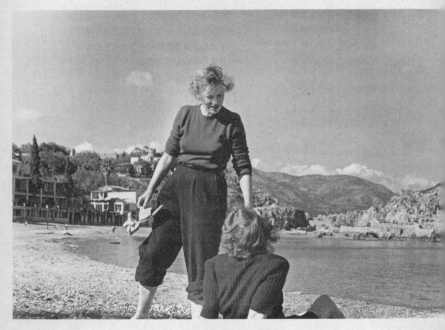

Lee in Corsica, late 1940s

Chapter 15

Patching Things Up

(1946–50)

L ee and Roland flew to New York on May 19. The trip began well. Julien
Levy lent them his apartment. Since they had last been together, he
had divorced Joella, married the painter Muriel Streeter, and made the
gallery into a salon for the Surrealists exiled in New York during the war. The
Condé Nast staff celebrated Lee's homecoming. The American Museum of
Natural History asked for her help with an exhibition on France. Old friends,
amazed by her metamorphosis from muse to photojournalist, welcomed her as
a heroine.

∾

After twelve years abroad, Lee was eager to see her parents. On the train to
Poughkeepsie with Roland, she pointed out the schools from which she had
been expelled as a prelude to his meeting with the Millers. Theodore made a
strong impression. Lee's father, Roland wrote, was "a highly skilled and inquis-
itive engineer" and a "benign atheist" whose educational theories had con-
tributed to Lee's becoming "a menace to discipline." Theodore noted Lee's
efforts to improve her spirits by taking Roland for drives up the Hudson and,

unexpectedly, by cooking. While at home, she sorted through her photographic equipment and the paintings stored at DeLaval during the war (including some of Roland's Picassos, Ernsts, and Mirós), which Vassar planned to exhibit before their return to London.

John Miller, his wife, Catherine, and their daughters, Patricia and Joanne, drove from their house in Long Island to greet Lee and Roland. Predictably, John and Lee quarreled. "She was not the same after the war," he recalled. "Her health had suffered and so had her looks," he continued, but more than her changed appearance, he noticed her irritability. During a visit to Bill Scherman, Lee felt so out of sorts that Bill wrote to ask Dave whether this was normal. "She is getting old and with it getting fat," Dave replied uncharitably, "and she won't face up to it." Gigi's presence in New York and Roland's trips to see her there would not have improved her temper. When in town together, Lee and Roland saw new friends like Alfred Barr and James Thrall Soby of the Museum of Modern Art, and Peggy Riley (later Rosamond Bernier), an elegant, vivacious writer who showed them around artistic Manhattan.

That summer, U.K. *Vogue* ran drawings of "those great war and post-war travellers, Lee Miller and Cecil Beaton." To the home office, she was a celebrity. Alexander Liberman, *Vogue*'s Russian émigré art director, had been thrilled by her accounts of the war: "She brought regular doses of reality, a commodity that had been lacking from *Vogue* until then." After persuading Edna Chase that Lee's coverage of the death camps had to be shown, Liberman had chosen the images, done the layout, and run the headline, "Believe It." Lee's report on the linkup at the Elbe was equally impressive, he thought: "She was an adventurer and a Surrealist—going to the front was a Surrealist gesture." But she was also very American, he added: "She went religiously to Poughkeepsie to find her nourishment."

In New York, Lee photographed a number of celebrities—among them Damon Runyon, whose stories inspired the musical *Guys and Dolls;* Wilfredo Lam, a Cuban Surrealist painter; and her old friend Isamu Noguchi, who posed bare-chested among his sculptures. Despina Messinesi, Liberman's assistant, liked working with Lee because of her humor. "When you were photographing luminaries," she recalled, "Lee got them to relax." Unlike Horst, Condé Nast's resident portraitist (who emerged from the camera's black hood with a scowl), Lee knew how to make her subjects laugh.

Her refusal to "dress" (in defiance of fashion, Lee wore trousers to work) shocked younger women at headquarters. Reflecting on Lee's career years later, photographer Frances McLaughlin-Gill remembered thinking that "she had everything—good looks, talent, and drive." "But Lee was a bit of a gypsy," she added, "which doesn't go with a career." She had made her way on her own, or with the help of male mentors, unlike the members of McLaughlin-Gill's generation, who were forming an association of women photographers.

Lee relied instead on members of the prewar *Vogue* family. Liberman had married Tatiana du Plessix after her husband's death in 1940. Since coming to the United States, Tata had been turning out whimsical hats for Manhattan-ites in her salon at Saks Fifth Avenue. "Tatiana had a past and Lee had a past," Liberman explained, "so they had a complicity about things that others didn't know" (including Lee's affair, in Paris, with Zizi Svirsky, who was often found playing the piano at the Libermans' apartment). Like Lee, Tata mocked bour-geois taste. "Diamonds are for suburbs," she liked to say. "Meenk is for foot-ball." But she too found it hard to understand Lee's disdain for fashion.

Between stays in Poughkeepsie, Lee and Roland looked up old friends. In 1941, with the help of the Emergency Rescue Committee (an organization backed in part by Peggy Guggenheim), Breton and his wife, Jacqueline Lamba, Victor Brauner, and others of their circle, including Max Ernst, had made their way to New York. After his release from internment, Max had gone to Lisbon, where Leonora Carrington was recovering from her breakdown in the company of a Mexican artist. He had joined the ménage consisting of Peggy, her ex-husband, Laurence Vail, and their two children, and Vail's four from his marriage to Kay Boyle—until plane seats were found for all. Max mar-ried Peggy in New York after the American declaration of war in 1941, when it seemed likely that he would be deported as an enemy alien.

Since then, Peggy's gallery, Art of This Century, had proved more success-ful than her marriage. Through Julien Levy, Max had met Dorothea Tanning, the high-spirited young artist whose canvases he selected for an all-women show there. The two fell in love. Soon Dorothea was attending parties in clothes decorated with snapshots of Max. Peggy vented her rage by dismissing her rival as someone who dressed in the worst possible taste—one of the many acid phrases in her memoir, *Out of This Century*.

Peggy's book, published in March 1946, had shocked members of the art world, who mostly took sides against its author, though some shunned Max and Dorothea (shortly after its publication, they moved to Arizona). When Lee and Roland arrived in May, people were still gossiping about Peggy's affairs and decoding her memoir's transparent disguises: "Florenz Dale" was Laurence Vail; "Ray Soil," Kay Boyle; "Beatrice," Leonora Carrington; and "Annacia Tin-ning," Dorothea Tanning. And while Roland ("Donald Wrenclose") did not object to Peggy's account of his taste for bondage, he *was* annoyed at being called a bad painter.

Lee and Roland planned to spend a week with Max and Dorothea on their way to Los Angeles to see Erik and Mafy, who had been there since 1941. They flew to Phoenix on July 23, then drove to Oak Creek Canyon, the artists' desert refuge near Sedona. "The surroundings were . . . like the most fantastic land-scapes Max had painted," Roland noted, "as though he had designed the great red mountains and canyons himself." It was blisteringly hot. The house, which

was still under construction, had no electricity or water; Dorothea cooked dinner outside on two stones.

For the next few days, they listened to Max chant exotic words like *sheetrock* and *two-by-four* while they coped with snakes, scorpions, centipedes, and the heat, which melted the tar on the roof. During a trip to the Grand Canyon, Lee was disappointed to see only "a large wet cloud filling it up to the brim," she told Bill Scherman, "so that it might quite easily have been a field full of sheep." On their return they watched the Hopis perform a rain dance and cooled off in the nearby creek. Lee recovered sufficiently to inspect the jagged desert shapes—Cathedral Rock and the suggestively named Cleopatra's Nipple.

On their last day, photographing nonstop, she used the building site to frame Surrealist interiors: Max and Dorothea through a just-completed window, the couple wiping dishes with Roland, Max cavorting in a Hopi mask. Other shots show group dips in Oak Creek, Max and his dog on a raft, Max sitting yogilike while hammering floorboards. Still others focus on the couple's highly self-referential art. Dorothea poses in front of a recent painting entitled *Maternity*, which shows a woman in a tattered gown holding a large, angry infant; in another shot, Max and Dorothea admire this canvas —a declaration, perhaps, of their decision to give birth to a life of shared inventiveness rather than have children.

For a composition that takes a more ironic view of their relations, Lee posed the couple in the rocky landscape—at the precise distance from each other that makes Max seem a giant and Dorothea a tiny figure shaking her fist at him. This wry image works on many levels. A comment on their respective status in the art world, it hints that even in a marriage of equals, the woman is diminished. "We cannot help . . . but read into this photograph a sense of protest," Jane Livingston notes. "At the very least, we glean from this image a feeling of feminine ambivalence in relation to a virile and creatively empowered man."

One would like to have been present while Lee and Dorothea discussed these matters. "A woman had to be a monster to be an artist," Dorothea mused years later, "and one who married another artist was branded—like a cow." (She also insisted that while there were many pitfalls for women artists, gender was not among them.) During her last day there, Lee staged two portraits on this theme, one of Max, the other of herself—both framed by an unfinished door. In one, Max stands bare-chested, gazing at the camera; in the other, an equally bare-chested Lee echoes his pose but presents her good profile. A portrait of the artist framed by his unfinished creation was a kind of joke, yet at the same time, Lee's composition sets herself up as equal to the "creatively empowered man" on whom she turned her gaze.

Lee and Roland landed in Los Angeles on August 17. Erik and Mafy did

everything to make them feel welcome; the couple's affection buoyed Lee's spirits. Their fortunes had improved since 1941. Erik had found his calling as a photographer of airplanes at Lockheed; they had settled into the easygoing rhythms of California life. "Everyone goes around cherishing the idea that they're all slightly looney and behave in a surrealist manner which isn't the case at all," Lee told Bill Scherman.

Man Ray, who had lived nearby, on Vine Street, since 1940, shared Lee's view of the locals. Visitors to this busy part of town were surprised to discover the calm of Man's duplex, which was shaded by palm trees. While its upstairs balcony may have reminded Lee of the rue Campagne-Première, his new muse, a dark-haired dancer named Juliet Browner, in no way resembled Lee. A gentle, graceful young woman, she did whatever Man wanted. Yet the many photos of Juliet on the walls recalled those he had taken of Lee and, before her, Kiki—since female subjects were, in a way, interchangeable while their erotic energy inspired him.

Man called his new home "a beautiful prison" and often said that while New York was twenty years behind Paris where art was concerned, Los Angeles was twenty years behind New York. He missed Paris, especially the paintings, photographs, and objects he had left with Ady. Even more, he missed being known as an artist, having returned to an America where collectors sought out not *l'américain de Montparnasse* but the publicity-conscious Salvador Dalí. As a way of re-creating his private universe, Man was reconstructing some of his favorite works, which he planned to show under the title "Objects of My Affection." These objects included a small version of *Observatory Time*, the painting in which Lee's lips float in the Paris sky. One wonders what she made of this reduced image of their relationship.

Lee was also keen to see Mary Anita Loos, who by 1946 was a successful screenwriter whose friends included Paulette Goddard, Joan Crawford, and Cary Grant. When Lee introduced Roland and told Mary Anita about the Hopi dances they had witnessed, her friend noticed a sadness in her face. "She seemed worn down," Mary Anita recalled. "It seemed to me that she had been drained. The weight of what she had been through showed in her glance when we spoke about the future." Lee had changed, she added, "except for her strong character."

Vogue had commissioned Lee to photograph some of the celebrities who made Hollywood their home during the war. Her portrait of Igor Stravinsky focuses on the composer's muscular hands and pensive gaze. She took a series of informal shots at friends' houses, some on a visit to the Dada patron and poet Walter Arensberg, who showed her and Roland his collection of works by Duchamp. At Man's duplex, she photographed Juliet playing chess with Man, using one of the sleek Art Deco sets he designed as a source of income: in a variation on the theme of the muse, Juliet looks at her partner, invisible except

for his hand, which is poised to take her pawn. Another shot, a double portrait of Man and Roland positioned at an angle to the oval mirror in which we see their profiles, parodies this classic pose, which Man had used for Lee's solarized profile.

Friends had arranged for Lee to visit a Francophile chef named M. F. K. Fisher, but their interview was canceled at the last minute when the producers of a radio show featuring visiting celebrities persuaded *Vogue*'s "real live lady war correspondent" to appear on the program. The interviewer, Ona Munson, the actress who played Rhett Butler's mistress in *Gone with the Wind*, met Lee and Roland in a Hollywood hotel. Munson's gushy tone dominates the interview. She began by saying that she hoped to interview Roland as well, since "two women need a man to balance the conversation." Promising to try "to sound like a fabulous character," Lee explained how she became Man's student, her "accidental" start as a writer, and her entry into war work. Minimizing her determination, she added, "I was very lucky."

When Munson asked how she had managed to photograph at the front, Lee replied coyly, "You can't blame a girl for that when she has a battle right in her lap!" The interview continued in this vein until Munson asked what Lee was doing in Hitler's bathtub. "I'd have to go back a bit," she began. Having long been fascinated by the Führer, she had gone to his house in Munich. "I took some pictures of the place and I also got a good night's sleep in Hitler's bed," she went on. "I even washed the dirt of Dachau off in his tub." *Vogue* had been right to print her atrocity pictures, Munson felt, because otherwise "most of us would think it had been a hideous nightmare." With unusual restraint, Lee replied, "Yes, here in America it does seem like that."

By mid-September, when she and Roland returned to New York, Lee knew that despite her love of the United States, she was too European to live there. They spent September seeing old and new friends. *Art News* sent a staffer to interview Roland about his collection. Having been brought up surrounded by Victoriana, he explained, he had formed a loathing for curios; he had been drawn through personal sympathy to the works that made up his collection. At the same time, his cordial relations with people like Barr and Soby of the Museum of Modern Art confirmed his desire to create its London equivalent, a strong modern collection that would build on his own.

∞

Lee and Roland flew to London on September 30. Energized by his time in New York, Roland threw himself into the project that would take shape as the Institute of Contemporary Arts (ICA). Herbert Read, E. L. T. Mesens, and Douglas Cooper, an art historian and collector who, like Roland, idolized Picasso, formed the fledgling center's nucleus until Cooper turned against

Roland and resigned. (Roland was heard to say that having Cooper as his enemy, he needed no others.) With Lee's consent, he continued to see Gigi after her return to London.

That autumn, surprising news came from Los Angeles. On October 24, Max and Dorothea were married by a justice of the peace; Man and Juliet formalized their union on the same occasion. Their unlikely double wedding, which sent up the institution, was described as surreal in the Los Angeles papers. (Man took pictures of Dorothea, who painted Juliet as a bride; both couples had fun with their respective roles by playing dress-up, Max and Man in dresses, Juliet sporting a black mustache.) Unsure of what her own future held, Lee reported to Brogue.

The change in her attitude was clear to Lee's friends on the staff. Alex Kroll, then U.K. *Vogue's* art director, believed that she was "bottled up" as a result of the war: "I felt a screen while talking to her," he explained. "I couldn't get through." Audrey was aware that Lee's assignments after her return failed to inspire her and wondered whether her talents might have been better employed with the photographic collective Magnum, then being set up by Cartier-Bresson and Capa, whose vision of photojournalism resembled her own. But for the next five years, Lee worked mainly as a *Vogue* photographer; the stories accompanying her images were often written by others.

That autumn, she spent three weeks in Ireland photographing Joyce's Dublin while rereading his work ("try reading Ulysses or Finnegan's [sic] Wake," she told her parents) and frequenting his favorite pubs. On her return, she photographed several "Bright Young Things," a new production of *Carmen*, middle-class children at the circus and working-class ones at a toy theater. In her shots of its miniature stage one senses a reduction of scope and imaginative response. In December, the news of Nusch Eluard's death deepened her sense of loss.

When Audrey arranged for Lee to go to Switzerland with *Vogue's* newly appointed arts writer Rosamond (Peggy) Riley, she summoned up her enthusiasm. In the new year, they would travel to Saint Moritz, "scene of Aziz's and my romance," she told the Millers, then Berne, Lausanne, Zurich, and Geneva. Before leaving, Lee and Roland inspected the house across the street. "The owners were looking for a smaller house," she went on, "so we sold to each other." She looked forward to having a workroom where "all my camera junk and things I never pick up at all can just be locked in and Roland can't complain anymore that there is no place for breakfast because of my typewriters, or to sleep because of my negatives are spread out, or to bathe because I'm rinsing prints in the bathtub." What was more, she was negotiating her divorce from Aziz. Now that they had become "a little more amiable," he would either meet her in Berne or come to London to settle things.

Lee was to photograph the beautiful people at Saint Moritz, then take por-

traits of Swiss celebrities. Despina Messinesi, by then Paris correspondent for U.S. *Vogue,* would join her to write up the winter season and Rosamond would do the luminaries. While Lee's return to Saint Moritz was uneventful, she detested the place, she told Roland, especially the "international crooks and exiled royalty" at their hotel. Carrying out her assignment nonetheless, she photographed socialites on the slopes in the new fashion, stretch pants. Since their après-ski chitchat revolved around "how awful the people are this season," Lee was soon drinking too much. Her ski gear didn't fit; she wanted her combat boots—which were by now an extension of her self. On learning that Aziz's villa was to be sold at auction, she told Roland, "I miss you very much and wish I were home."

In the next weeks, Lee and Rosamond crisscrossed Switzerland to interview artists and intellectuals: Jean Arp, Hermann Hesse, Albert Skira, Arthur Honegger, Jean Piaget, and C. G. Jung. Between portrait sessions, she did what she could to amuse herself. "I could not have had a more entertaining, though drunken, companion," Rosamond recalled of their time together. Lee was curious about everything, a spontaneous, thoughtful, generous friend. But she had "lost her delicate beauty" and showed "a total disregard for her dress"—an attitude with which her friend was not sympathetic.

Together they visited a children's village near Lake Constance, where orphans lived in homes run by "parents" from their own countries. Lee photographed a French girl feeding her doll, whose hair bow matched her own. The children at the Polish house were well dressed but obviously disturbed. One boy, who had promised his dying mother to watch over his sister, had to be persuaded that the pediatrician would not harm her. Another drew pictures of Warsaw in flames: Lee photographed him in front of his war tableau, drawn on a blackboard in colored chalks. Of the blond Polish children whom the Nazis had deported to be raised as Aryans, Rosamond observed, "even their identities are lost. Many of them are too young to remember who they were before they were given new German names."

Lee was waiting to confirm an appointment with the Swiss president when she made an unexpected discovery. At the age of thirty-nine, she was pregnant. Feeling "rather peculiar about it," she wrote Roland a few days later:

> Darling, This is a hell of a romantic way to tell you that I'll shortly be knitting little clothes for a little man. . . . So far no resentment or anguish or mind changing or panic, only a mild astonishment that I'm so happy about it. I've had to tell Peggy [Rosamond], as otherwise she couldn't understand my insistence on returning so immediately to London when the job isn't really thru.

So much of their time was spent trying to keep track of Lee's tripod, she joked, that they feared the baby might have three legs. The letter concludes: "There

is only one thing. MY WORK ROOM IS NOT GOING TO BE A NURSERY. How about your studio?"

When Lee returned to London in February, it was so cold that the pipes froze. Their supplies of coal and wood having run out, Lee and Roland burnt the base of a statue and two sets of bed legs to keep warm. "Just as I was eyeing some South Sea island sculpture in teak and mahogany, a neighbor lent us a sack of wood," she told the Millers. "Roland seems as impervious to the cold as he was to the heat in America," she went on. Oddly, this letter does not mention her pregnancy, but complains about having to sort negatives: "Every time I go on a story, I'm enthusiastic and bite off large hunks of stuff, and am mad with rage on return when I have to digest it all."

They moved to the new house, which had room for two studios and a nursery, at the end of February. While Roland wanted to legitimize his heir by marrying Lee once her divorce was final, some in their circle saw Lee's pregnancy as a last-ditch effort to hold on to him. In March, after summoning up the courage to tell her parents the news, Lee developed pleurisy, followed by pneumonia and a virus resembling the mumps. Nurses were hired after her confinement to bed—the warmest place to be, although not the best treatment for her back, which despite the bear massage had grown worse. "Due to all this illness I'm going to be all the more dependent on you for the things I'll need for the baby," she told the Millers.

"This baby business isn't all it's cracked up to be," Lee confessed soon after her fortieth birthday: "If anyone even ever mentions to me again how much I'm going to love it once I have it, I'm going to sock them in the nose." Roland was "angelic" when back pain made her miserable, but both were "depressed." As for the child's sex, it would have to be a boy, "so that it can use bad language becomingly, and I can play with engines and choo choo cars." She asked for knitting needles, wool for baby clothes, and fine white woolen fabric for nighties. While she had learned "to sew a fine seam" and would soon take up knitting, the lack of real work had reduced her to crossword puzzles: "It's very disappointing as it's the first time I've not been having work on my mind since 1939."

That spring, Aziz came to London to divorce Lee according to Muslim law. He and Valentine both stayed at Downshire Hill, forming an unusual but amicable household. Aziz entertained them with tales from *The Arabian Nights;* Roland, inspired by the acid colors of Picasso's portraits of Lee, depicted her as a goddess holding her globe-shaped belly, which shelters a rather reptilian fetus. Given a pregnant woman's prerogative, Lee made strange requests—an aquatic salamander called an axolotl (which may have inspired Roland's painting) and a family of hedgehogs, who were later set free on Hampstead Heath. After marrying Roland at the Hampstead Registry Office on May 3, Lee went back to bed.

Visitors were a distraction. In July, Jackie Braun, the former head of Lee's

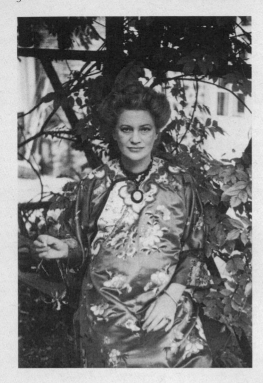

Lee pregnant, 1947
(Alexander Liberman)

New York studio, came to stay. She took over the household and organized the layette. "You'd think it was her child," Lee told her parents; "she's so interested in it, much more than me." When Alex Liberman called at Downshire Hill, he photographed Lee resplendent in a green silk Chinese robe, though she felt that she "look[ed] and weigh[ed] about the same as a hippopotamus." The photographer Clifford Coffin, whom Audrey had recruited from New York when it seemed that Lee had disappeared in Eastern Europe, shot a series of portraits of her in the same gown. She took her former model's poses, profile, three-quarter turn, head shot; at the end of the session, he took a relaxed close-up that shows Lee's amusement with the process—or perhaps her sense that she was a different woman from the one who had sat for Steichen, Huene, and Horst.

Lee felt "apprehensive" about the baby, she told the Millers. Since childbirth at her age was considered risky, she planned to have a cesarean. "I think of all the worst things, such as it being a girl, or twins, or having six fingers, or birthmarks or being an idiot. The rest of the time I'm plain scared of the oper-

ation, or tired and exhausted." Her parents outdid themselves with parcels of goods unobtainable in England: soap flakes, baby clothes, diapers, bed jackets, maternity smocks, dried milk, juices, and olive oil. Toward the end of the summer, Lee requested silk thread, name tapes, satin ribbon, and Fels Naptha for the layette, all required by the maternity clinic. Cesareans were performed at the last minute, she explained, "never just because of age and desire to have it that way." But taking into account her mental and physical state, her doctor had scheduled the operation for September 9. "So now I sleep much better," her letter concludes, "as I've got everything arranged."

In the last weeks of pregnancy Lee tried to take charge by making still more lists: for hospital, makeup, gin, cigarettes, playing cards, pen and paper, a typewriter and table, ear plugs, nail scissors, and knitting (her list specifies "pink"). In a semihumorous *Vogue* piece published the following year, she counseled expectant readers to create an "island of safety" around themselves while awaiting the event. It was wise to have things that made one comfortable—smart bed jackets, bras with hooks in the front, cosmetics that held up under bright lights, a radio, crossword puzzles, books that were neither long nor taxing, and "a written list with addresses and numbers of everyone who should be told the glad tidings."

Lee felt less jaunty than this account suggests. The night before the surgery, she wrote to Florence: "Dearest Mother, Tomorrow morning, almost without waking, I'll be a mother also. More than forty years ago you must have been waiting in somewhat the same way, curious, apprehensive and elated." Had Florence hoped that her baby would some day "understand all you did and dreamed?" Had she been disappointed "when a noisy stupid little brute appeared . . . who was insistent, demanding, uncooperative and ignorant after you'd felt such friendship and tolerance for many months?" Lee's fears became more obvious with each question: "Did you worry whether I'd be a monster? . . . Did you know you'd love me?" She wished Florence was there to tell her.

Early the next morning, she wrote instructions for Roland in the event of her death. Her finances were for his or Junior's use. Her cameras should go to Erik or else "someone with real talent," Cartier-Bresson or Berenice Abbott. Junior must not become a Germanophile, she warned, "or I'll come back to haunt him." Comparing childbirth with other times when she had awoken to realize that she was fully committed—plane flights, dawn attacks, marriage—she wrote, "and now a baby. This is like being a dumb beast, knowing something is happening, automatically house hunting and 'nesting,' but not quite realising the import of it."

The rest of Lee's dawn confession must be quoted at length: "I keep saying to everyone, 'I didn't waste a minute, all my life—I had a wonderful time,' but I know, myself, now, that if I had it over again I'd be even more free with

my ideas, with my body and my affection. Above all, I'd try to find some way of breaking down, through the silence which imposes itself on me in matters of sentiment. I'd have let you, Roland, know how much and how passionately and how tenderly I love you. Next week, if I'm here, I'll probably be as off-hand again as in the past, or, at least, seem to. Does it puzzle you? You know that I love you, don't you?"

It had been impossible to tell him this the year before, when she returned from Romania "inarticulate with shock." She hoped that her decisions to accept his relations with Gigi and, now, to have the baby were proof of her love. In recent months, she had felt relaxed—"without a trace of the old urge to be out and . . . embarking on adventures." But while childbirth *was* an adventure, the sound of the nurse's trolley as it approached resembled "the swish and rattle of doom."

Junior proved to be a healthy boy. During the operation, Roland waited at home with Eluard, who was recovering from a triangular love affair that he had hoped could reconcile him to the loss of Nusch. After seeing his son for the first time Roland told the Millers, "He is so ugly, snout like a pig, hands like a bruiser and the toughest looks ever known." A name had not yet been chosen: "Lee insists on Butch Roland Penrose. I say no but a compromise on the lines of Anthony seems preferable." The baby was being bottle-fed. Lee, who was still being stitched together, had not yet experienced "the joys of motherhood."

In good Surrealist style, Eluard commemorated the birth with a poem: *"La beauté de Lee aujourd'hui / Anthony / C'est du soleil sur ton lit."* In rhyming *Lee* and *lit,* Eluard no doubt intended a compliment that is lost in translation. Yet the gist is clear: Lee's new beauty, in the form of Anthony, shines like the sun on her bed. Named Anthony William Roland Penrose (he would later drop the "h" to become Antony), Butch and his mother went home after a week in the hospital.

∞

Lee's letters to her parents over the next year and a half, as she coped with motherhood, unreliable help, and continued rationing, show her reliance on their willingness to come to her aid. After her return to Downshire Hill, Lee's highly strung maternity nurse looked after the baby for a month, then returned to the clinic. Her replacement handled the situation briskly, but on her days off, she left Anthony in such a state that he screamed and vomited—whereupon Lee, too, became so distraught, she told the Millers, "that I'd get my old stomach spasms too and start shooting my cookies, and life was hell."

This state of affairs lasted until November, with the arrival of a calm, elderly nurse named Mollie Woodward. Nanny Woodward was set in her ways, which struck Lee as old-fashioned: infants required one nursery for daytime

and another for the night, with room for the nanny; they were to be fed on schedule and toilet trained as soon as possible. But she was willing to consider Lee's theories (one nursery, where the baby slept alone, feeding on demand, no toilet training for a year). Even more important, she did not object to her employers' unconventional household.

At two months, Butch had become "awfully cute," Lee told her parents. He giggled, followed his parents with his eyes, and gazed at a blue butterfly mounted under glass and at Roland's red necktie. (He might be a lepidopterist with communist leanings, she joked.) By December, he was smiling, cooing, and waving his limbs "like a real baby," she wrote, "and knows who Nanny is, and sometimes recognizes me or Roland as being at least familiar masses of flesh or color and noise." Since she was giving him a goldfish bowl for Christmas, she asked Theodore for the castle that had been in his fish tank since her childhood.

About this time, Audrey asked *Vogue*'s photographers to contribute one image that conjured up Christmas for the December issue. Lee took a portrait of Anthony, yawning beneath a tinsel-bedecked party hat. Her caption reads, "Gay tinsel and a brand new baby is my formula for a Merry Christmas this year. Maybe by the time he finds there isn't any Santa Claus this not so shiny world won't need one as badly as it does now." The portrait, which ran between Clifford Coffin's version of an English pantomime and John Deakin's shot of a diamond-encrusted Mae West, produced quantities of "fan mail," Lee told her parents, from acquaintances for whom it took the place of a birth announcement. "Poor little buggar, working for his living already," she teased. "Imagine your first pay check when you're six weeks old."

Before returning to Brogue in January, Lee had to solve the problem of disappearing supplies, which had plagued them since the arrival of their new housekeeper, who seemed to be feeding her adolescent son better than she was her employers. When the woman said that the work was too much for her, Lee fired her. "Of course that leaves me high and dry," she told her parents: she would have to do all the cooking during the Christmas holidays, when Rosamond and an American antique dealer would be their guests. "But I'd rather do it than see her sour face around any longer," Lee added, before requesting the culinary items—hickory-smoked salt, onion powder, grated cheese, ham, chocolates—that would help her through the holidays.

Unexpectedly, two Polish refugees, a mother and daughter, turned up the day that the thieving housekeeper departed. Since they didn't speak English, Lee used her own form of sign language—a method of communication whose humor was compounded by their dismay on being asked to cook shellfish, which they had never seen, and mushrooms, which, they believed, would poison the household, a fate they enacted in pantomime.

A large part of each letter home requested items unobtainable in Britain.

Given the postwar lack of staples like sugar, flour, and powdered milk, and the low standard of daily fare (Lee deplored the English tendency to boil vegetables into submission), her interest in cookery became a passion. Making an apple pie while waiting for the Poles was amusing except that having tippled while baking, she became "slightly tight," she told her parents. Cooking was a way to make the best of the situation while providing family and friends with good food in a time of culinary famine, but it was also an occupation that kept her in the moment, occupying her hands and mind in somewhat the way that photography had done, though in very different circumstances.

Lee hoped to use her furlough to shed the weight she had gained and strengthen her back. But despite attempts to limit her intake (except for alcohol), her clothes did not fit. And the treatment prescribed by her doctor—"agonizing girdles all strutted with steel bones"—protected her spine but poked "into every other part of my anatomy." These girdles did little for her libido, which had been low since childbirth. Since sexual relations no longer gave her pleasure, one assumes that Roland's feelings for other women—Gigi having ended their affair—were freely expressed. For those who had known Lee during the war, it would have been startling to visit the household over which she reigned in apparent tranquillity. "Am getting so fascinated by Butch," she told her parents, "that I'm considering not going back to work right away. As you say this will only happen once and I don't want to miss it."

After Christmas, catered in large part by the Millers' care packages, Lee began acting as Roland's secretary. He was "getting the dream idea of his life going," she told them: it was "a sort of thing like the Museum of Modern Art." After addressing several thousand invitations to the opening, she felt like the poor little match girl, she went on, or one of the children in stories "who addressed envelopes for thruppence a hundred with rheumatic hands, sitting in cold garrets." Rewarding herself after the completion of her task, Lee baked a pumpkin pie using ingredients sent by her parents: brown sugar, molasses, evaporated milk, and canned pumpkin. "I'll see that we drink a toast to you when we eat it," she joked.

The inaugural exhibit of the Institute of Contemporary Arts, "Forty Years of Modern Art," opened on February 10, 1948, in the basement of the Academy Cinema, on Oxford Street. Consisting of paintings and sculptures from private collections, including Roland's, it featured works by Picasso, Braque, Matisse, Dalí, de Chirico, and Magritte, as well as Lucian Freud, John Craxton, and Eduardo Paolozzi—who were included to encourage British artists. The show attracted attention to Roland's venture, but also resentment among those who felt that he had left the avant-garde and gone establishment. He should be asked to resign, Geoffrey Grigson wrote, "on the grounds that his position as a minor painter, buttressed by wealth and indeed by taste, and his sincere energy in furthering the ICA, does not outweigh his pursuit of compromise which is making the ICA ridiculous to those very artists it should help."

Unperturbed by criticism, Roland helped find a home for the ICA on Fitzroy Street. Ewan Phillips of the Courtauld Institute was chosen as the director; he was soon joined by a spirited young woman named Julie Lawson, whose organizational skills and languages were invaluable in the running of the institute. While Lee no longer had to address envelopes, she often lent her energy and talent to the furthering of the ICA: planning receptions, taking photographs, writing reviews, and inviting the artists and their spouses to stay in Hampstead. It was an ambiguous role, one that meant taking second place while sometimes feeling as if she were being paid thruppence a hundred— though she was rarely heard to complain.

There were other compensations. With Nanny Woodward in charge of Anthony and the Poles running the household, Lee and Roland could resume their travels. Ten years after their summer encampment at Lambe Creek, they stayed there again under calmer circumstances with Roland's brother Beacus. In the summer of 1948 they went to Venice for the Biennale, which Lee was to cover for *Vogue*—her first assignment in over a year. The Biennale's national pavilions had shown primarily academic art before the war. That summer, the presence in Venice for the first time of works by the masters of modern art and the outstanding postwar Italian artists was generating a buzz among the Serenissima's visitors.

Making the round of the British exhibits, Lee noted the contrast between their muted hues and the dazzle outside. Turner's canvases looked "almost Cubist in the subtlety of their colour after the bombardment of brilliance which makes up the Venetian scene," she wrote. In the same way, the contours of Henry Moore's sculptures were "reassuring" after hours in the sun. Like his statues, Moore was a familiar presence: "stocky, un-Latin, serious, and simple," he used his hands to communicate with his Italian counterparts and sipped Americanos (vermouth and soda) at the Piazza San Marco, where Lee took his portrait.

Of the five Italian artists whom she photographed beside their creations, Lee preferred those whose work showed a light heart, progressive leanings, or both. Renato Guttuso, "a vast, untidy, and charming Roman" whose scathingly anti-German drawings impressed her, blended abstraction with social themes, she noted, in the manner of Picasso's *Guernica*. Similarly, the Venetian Giuseppe Santomaso adapted modernist abstraction to scenes of daily life, "which assumed a sharper meaning during the terrible years of the war." Pleased to see that the art world had rediscovered the Metaphysicals—de Chirico, Morandi, Carrà—after a long period of neglect, she also admired Marino Marini's equestrian statues, which combined "the mysterious aura of Chinese dynasty art and the vitality of modern good humour."

While Roland may have had mixed feelings about seeing Peggy Guggenheim, Lee enjoyed their visit to her pavilion, the hit of the Biennale. Having moved her collection to Venice, Peggy intended to give it a permanent home

after acquiring a suitable palazzo. "Her selection of 136 paintings, sculptures, and objects makes a historical survey of the trends of modern art from Dadaism through Cubism, Abstraction, and Surrealism," Lee observed in her *Vogue* article. What was more, seen together, Peggy's Ernsts, Picassos, and Brancusis "point[ed] up the significance of each artist in relation to the others." They took part in the general excitement—which was so contagious that an eminent Italian critic had been seen playing with Peggy's Calder mobile. Lee photographed Peggy with her Lhasa Apsos, "who flip-flopped around the exhibition looking extraordinarily like the dogs of the Renaissance Venetians," she concluded, "making her spectacular show look very much at home."

After Lee's review ran in both the U.S. and U.K. editions, the Condé Nast office drew up a new contract for "Lee Miller Penrose . . . hereinafter called Lee Miller." She was to write and take photographs for eight features per year. The company would supply film, equipment, and an assistant; when work took her outside London, they would pay expenses. She was to receive fixed remuneration (fifty pounds for short articles, seventy-five for longer ones). Although others could not use her photographs without Condé Nast's consent, the contract allowed an important exception. The Magnum Agency and its clients could publish her work, "but it shall not bear Miller's credit line." At this point, Lee hoped to reactivate her connections with Capa, whose reports on the USSR she had been reading. (Recommending them to her parents earlier that year, she explained, "I gave up reading anything about Russia or the Russians unless I personally knew and respected the author.")

Presumably she discussed these matters with Theodore when he and Florence came to England that summer. They brought suitcases full of toys for their grandson (now called Tony), household supplies, and foodstuffs, including a once-frozen roast beef that survived the trip to London. Florence was glad to find that conditions were not as dire as she had thought them from Lee's letters; when petrol became more readily available, they visited Ely, Cambridge, Stonehenge, and Truro, where they stayed with Beacus before driving to Land's End. In September, they helped organize Tony's first birthday party, a picnic on the lawn. On October 6, Theodore met the staff at Brogue and later, Lee's physician, Dr. Goldman, who told him about "neuroses brought on partly by the war," without recommending treatment. During their four-month stay, Theodore inspected power plants, bridges, and factories, shopped with Lee for gadgets, and made himself useful by repairing faucets, window sashes, and doorlocks. Before leaving at the end of October, he told Roland, "Florence and I have considered everything very carefully, and we want you to know that this is all not half as bad as we expected."

After their departure, Roland assembled the next ICA exhibit, provocatively titled "40,000 Years of Modern Art." Its purpose, to show modern masterpieces next to the ethnographic works that had in some way inspired them, seemed shocking at a time when many dismissed non-Western art. But to the

young British artists in revolt against the social and aesthetic values that dominated the art world, the exhibit's nonhierarchical display broke down deep-seated distinctions between high and low, civilized and primitive, timeless and contemporary.

Welcoming any approach that turned authority on its head, Lee wrote a sprightly review. "In the time of our grandmothers," she began, "all primitive art was regarded as an ugly, beastly and sinful manifestation of idol worship." Taking *Vogue* readers on a vicarious stroll through the hall, she noted the "confrontations" created by the placement of a Henry Moore statue next to a prehistoric Venus, an elongated Modigliani beside a similarly shaped spirit carving from Gabon, Ibibio masks next to Picasso's *Demoiselles d'Avignon*. "Some of the confrontations are so gently allusive and subtle that they are to be sensed, not seen," she explained—like the affinity between the Ivory Coast carvings and Cubism. This exhibit would open visitors' eyes in the same way that ethnographic objects had "opened the new wider horizon to the artist."

When the show closed in January, Roland and Lee turned their attention to another of his dreams, life as a gentleman farmer. It made sense to have a country place where Tony could grow up in traditional surroundings; after the war, the price of rural property was low. Harry Yoxall informed them of a farm for sale in East Sussex, in the wonderfully named hamlet of Muddles Green, part of the parish of Chiddingly. It had the advantage of being near Lewes, which had good rail service to London, and Newhaven, where one could take the ferry to France. On the day they went to inspect, they could see only the house, which was large and well-proportioned. Farley Farm was blanketed by fog. Undeterred, Roland bought the property for £22,500—including the house, two hundred acres, three cottages, two barns, several sheds, and a malt house.

On their next visit, the sun shone brightly. Gazing toward the South Downs and the Channel, Roland spied the outlines of a prehistoric form cut into the turf to mark the solstice, the Long Man of Wilmington. The house's alignment with this spirit guardian, he later wrote, "gave Farley Farm a position in harmony with the sun, the moon and the stars in the heavens." The Long Man was an omen full of promise for the next phase of their life.

While Lee initially shared his enthusiasm, after months of struggling with the lack of creature comforts, especially heat, and the logistics of running two houses, she was heard to protest, "Fuck living in the country." In March, on Tony's first visit to the farm, the house was so cold that he, too, complained. Doors slammed, beams creaked, gale winds whistled through the cracks in the windows. The lack of carpets and curtains let in the Sussex mists; repairs were out of the question due to postwar shortages. Everyone huddled around the large Raeburn stove while Lee cooked for herself, Roland, Tony, and their guests.

Ironically, while attempting to make the farm habitable, Lee was writing a

piece entitled "Bachelor Entertaining," in which she disclosed the secrets of London hosts whose kitchens resembled ship's cabins. Her friend Fred Bartlett of the U.S. Foreign Service ("and therefore nomadic," she observed in an aside) regularly performed "a magician's act of making a salad dressing in plain view of the audience to distract attention." John Tillotson, a publisher, did not allow anyone in the kitchen. (His rules for entertaining included practicing new dishes on oneself and noting preparation times in the margins of cookbooks.) An acquaintance with one gas burner cooked ahead and kept meals hot in insulated containers; a scientist friend steamed asparagus in a beaker and fried eggs on his Bunsen burner. One senses that Lee imagined herself cooking under similar circumstances.

"Here is a partial diary of the past few months," she told the Millers. "Go every Friday to country, taking all food and clothes and leftovers, where I cook and entertain a minimum of four guests beside ourselves . . . garden and weed like mad, try to make curtains and things and come back to London on Monday bringing all leftovers and family and dirty clothes. Work all week until Friday, do marketing for food to take back to country and run for trains and god knows what." The Poles having departed, she did all the cooking while also shooting fashions for *Vogue* and *Picture Post,* the U.K. counterpart to *Life*.

That spring, Lee went to Sicily for a *Vogue* feature on "travelling at ease" with BOAC. On the way to the airport, she suddenly felt "all sorts of panic about leaving you & Tony," she confessed to Roland. Before leaving she had been unable to tell him "how much I love you & how terribly happy I've been this last year, so much that I'm scared that it'll have a horrible pay off"—as if sorrow would inevitably replace happiness.

Despite Lee's ambivalence about the assignment, a ten-page spread of her photographs (chosen from the hundreds on her contact sheets) documented the *Vogue* team's flight from wintry England. Included in the group is one of Lee's most evocative images from this time: a stylish traveler shot in profile, her coat a circle in the wind, her hand shading her eyes as she gazes, and directs our gaze, toward the silvery airplane wing behind her. (This image compares oddly with Lee's 1942 shots of Bourke-White kneeling in front of "her" bomber.) But once in Sicily, photographing the models sunbathing in shorts or legs covered by cinch-waisted skirts gave her no time to follow their example.

"Travelling at Ease" ran in the May 1949 issue, which also included shots of people in the news—Cecil Beaton's triple portrait of Edith, Sacheverell, and Osbert Sitwell, and Lee's photograph of a pensive Roland in front of one of his paintings. "Roland Penrose holds an exhibition at the London Gallery," the copy ran. "He is a collector and authority on the Surrealist School as well as a painter, and is married to Vogue photographer Lee Miller." Soon after Roland's opening, Lee's back pain became worse, and the new cook gave notice on learning that they planned to spend the summer in the country.

Running two homes was "too much for me," she told her parents. "With my job to do as well it's sort of a handful." Consequently they were renting a two-bedroom apartment on Hornton Street, in Kensington—"no stairs [and] central heating"—and putting the Hampstead house up for sale. With summer approaching, she hoped to make quantities of jam with the fruit at the farm, provided the Millers could send enough sugar. She and Roland would also spend a few weeks in France, at Rosamond's Paris apartment, then at l'Hôtel Vaste Horizon in Mougins, where they would revisit the scene of prewar frolics with Picasso.

Lee's letters ignore, as she tried to do at this time, the contradictory nature of her double commitment: to her career, on the one hand, and to Roland's bucolic vision, on the other. Attempting to save energy by turning the farm into a subject or a setting, she put their adventures in a humorous light. "Our first summer on the farm was a camping foray in a practically empty house," she recalled in a *Vogue* piece on getting weekend guests to work, à la Tom Sawyer. "We never stopped laughing and learning while dealing with crumbly brick floors, ice-less larder techniques and the construction of pelmets."

To her parents she confided the realities of country life. During one of the worst gales in history, they had to move the stove away from the rain pouring down the kitchen chimney. There was still no heating; to go to the bathroom, one went halfway down the stairs, across the landing, and up the other side, "usually slipping and falling on your coccyx." In the winter, she had linoleum installed in the nursery and the staircase carpeted, for warmth. Each improvement seemed like a victory.

Other assignments mirrored the pattern of her week. "Travel light," counsels a *Picture Post* article on trips to the country commissioned by her friend Timmie O'Brien. Lee posed her models in town attire at the local station, feeding cattle in the barnyard, and in front of the Chiddingly post office and general store—an important source of supplies, and gossip, on weekends. Photographing models engaged in pastimes for which she had neither the time nor the interest, she produced a number of uninspired fashion shots but few features. In April 1949, the *Vogue* staffer who was reviewing Lee's work informed Audrey that she did not think that they could get eight illustrated features a year from Lee and suggested alterations to her contract. Always diplomatic, Audrey encouraged Lee to go on holiday: "I know very well that you find writing a strain and that you need to be feeling fresh and rested to do it."

By summer, Lee's exhaustion was apparent to all. Brogue colleagues found her unapproachable, as if the war and its aftermath had created a wall around her. She drank to excess, burst into tirades, and complained of depression to Dr. Goldman. "There is nothing wrong with you," he is said to have replied, "and we cannot keep the world permanently at war just to provide you with

entertainment." This unsympathetic response expresses the doctor's—and the period's—failure to grasp the condition now known as post-traumatic stress disorder, which afflicted Lee as it did many combat photographers and journalists. But even those of her intimates who sensed what fed her sadness felt unable to help. She embraced the role of hostess as if she had chosen it deliberately, but her depressions proved otherwise.

Tony, on the other hand, was "enchanting." He talked "a mile a minute," she told her parents, and was "remarkably logical and mechanical," having demonstrated the Miller ingenuity in his mastery of locks, keys, and bottles. What was more, he took after Lee in his awareness of shadows, which to his way of thinking defined the presence or absence of light: "He shows you the sun," she explained, "by showing you where it isn't, like under a chair, or from his hand on the wall." A letter written toward the end of 1949 pronounces him "wonderful," requests finger paints for Christmas ("I think it comes in jars and I know it isn't dangerous to eat"), and boasts of her talent at turning sweet cream into butter: "This week I made almost a pound, which is four times our weekly ration."

Over the next few years, as Lee alternated between activities like butter making and photography, it became clear that she had lost what interest she once had in fashion. Features about eight different ways to tie a scarf or the return of the fitted coat were not inspiring. Dutifully, she photographed luminaries—T. S. Eliot, Claire Bloom, and, an assignment that must have given her pleasure, Max and Dorothea, who were in London for a retrospective of his work at the ICA and her stint designing sets for Covent Garden. (Lee posed the couple with Dorothea in the foreground and Max behind her—a more formal double portrait than those taken in Sedona.) Increasingly, Audrey turned to Lee as *Vogue*'s culinary expert, publishing her Christmas menus and original recipes, like Muddles Green Green Chicken, a savory concoction whose hue came from the herbs in the garden. "Lee took to cooking with all the passion and professionalism she had brought to her reporting," Audrey reflected before adding, "But still, it was not her life."

"Photography had been a passion for Lee," Roland wrote dismayingly in the section of his autobiography, *Scrap Book,* entitled "Lee the Hostess." "But after the war, photography became less important in Lee's life and instead she became absorbed in another art, cooking, which gave great pleasure not only to her gourmet friends but also to the flow of weekend visitors. She was by nature more at home in the flat in Kensington than in the country, but on arriving at the farm her consolation was to make straight for the kitchen."

Other consolations—drink, rages, bouts of tears—are not mentioned, nor are his own: the love affairs, casual and serious, to which he turned increasingly while Lee found solace in the kitchen. Nor does his memoir refer to his interference in her work, which, despite the grief it caused, had occupied her

for the past fifteen years. Roland believed that it was time for her to stop. After many stormy episodes when Lee became miserable because she could not meet deadlines, he begged Audrey, "I implore you, please do not ask Lee to write again. The suffering it causes her and those around her is unbearable."

Reluctantly, Audrey accepted the idea that her star photojournalist's life did not inspire her. "Lee came into her own during the war," she explained. "It had an extraordinary effect on her. Afterwards, nothing came up to it. She was not meant to be married, have children, or live in the country. She thought she wanted security but when she had it, she wasn't happy. She couldn't write."

Lee and Roland, London, c. 1946; in background is Roland's portrait of Lee,
Night and Day (*Roland Haupt*)

Chapter 16

A Double Life

(1950–61)

In May 1950, Audrey and Lee met to discuss her contract. She had fulfilled her quota of fashion shots but failed to produce the illustrated features that were her unique contribution. When Audrey suggested that Lee shift to freelance status, Lee reminisced about her long association with *Vogue,* then agreed.

Audrey's distress at the loosening of their ties is evident in a letter summing up this conversation: "I hope you will remember how very sincere I was in telling you of my unbounded admiration for your features, and my conviction that they have made a great impression on our readers. I asked you if you ever felt like writing articles, or doing illustrated features, that you would let me know, and give us, if possible, the first refusal. As you say, you are a very long standing member of the Vogue family, and have a great gift for seeing and handling subjects from the Vogue point of view. If ever the mood comes on you again, I hope we can know about it."

∞

The people Roland employed to restore Farley Farm gradually became Lee's alternative family. Realizing that he needed help, Roland hired a sage villager

known as Grandpa White along with his grandson-in-law, Fred Baker, who brought his brother to help with the cows. Determined to grow their own produce, Lee studied books on horticulture before directing Fred to turn a nearby field into a vegetable garden. "My first encounter with this extended family," Antony Penrose recalls, "was through Fred, who arrived with unerring timing at half-past seven every morning to bring fuel for the Raeburn, and deposit two quart bottles of fresh milk on the kitchen table." The following year, Roland hired Peter Braden to modernize the dairy operations, a job that sometimes brought him into conflict with Lee. (When Braden had the Ayrshire cows dehorned, Lee shouted, "I wish I could pull all your teeth out, then you would know how these poor animals feel.")

The requirements of the holiday season got the better of her sympathy for barnyard creatures. Just before Christmas, Lee spent "a most exciting Friday" learning to slaughter a pig, she told her parents—"saw it up, cure it, salt it for bacon, do the brawn sausages & everything." Plum pudding from Fortnum and Mason saw her through Christmas Day; a new cook arrived in time to help prepare for visits by the village carol singers and the local children on Boxing Day—festivities that Roland enjoyed as Chiddingly's unofficial squire. Since they also had six houseguests, she went on, "I was worked to the bone." (Both Lee and the cook retired to the kitchen in tears.)

One senses Lee's mixed feelings about country life from photographs of their first years at the farm. Affection is evident in her shots of Grandpa White and Fred Baker transplanting seedlings and a portrait of the Ayrshires making their way to pasture. A striking view through an upstairs window frame all the way to the Downs is more enigmatic. The image brings to mind *Portrait of Space,* but in this later gesture toward a far-off vanishing point, the shot is taken from within the interior that, increasingly, bounded Lee's horizons.

In the meantime, Roland remade Farley's in accord with his vision. He filled its rooms with French provincial antiques, arranged Henry Moore sculptures on the lawn, carved images on tree trunks, and placed Iris, the barebreasted ship's figurehead he had brought from Cornwall, beside the front door (according to legend, she had defended herself against charges of immorality by unveiling her charms). Next, he filled the dining room fireplace with an elaborate mural of cosmic harmony in which the sun, moon, and planets align themselves while voluptuously shaped female cornucopias offer their bounty—an invocation of nature as well as a premonition of the farm's opportunities for "goings-on."

At first, the farm's female population consisted of the various nannies who looked after Tony, guests like Timmie O'Brien and, starting in 1950, Valentine Penrose, who wintered there and became, in Tony's view, their resident witch. Soon Lee's friends began turning up as weekend guests. On their return from Egypt, Bernard Burrows brought his wife to meet Lee and Roland; Ernestine and John Carter, Timmie and Terry O'Brien, and Robin Fedden spent the

Christmas holidays there; Max and Dorothea came at Easter and again during the summer; John Craxton and John Golding, both painters, became regulars. Farley's was the place where the different parts of Lee's life converged, and weekends there were a continuation of the openings and soirées that took place in London once the ICA moved to a permanent home on Dover Street in April 1950.

Roland's new project "opened with a bang & good press," Lee told her parents. That spring, T. S. Eliot inaugurated an exhibition on James Joyce, and the group staged a performance of Picasso's play, *Desire Caught by the Tail,* with Dylan Thomas as the Stage Manager. (When one of the two main characters, the Tart, requested tea after telling her lover, "I am all naked and I am dying of thirst," Lee and others in the audience imagined more potent remedies.) She was busy all week helping Roland with "branch activities like lectures on the history of modern art, meetings between the critics, the public & the artists," she continued. Her latest task, archival research for the ICA film series (which included Charlie Chaplin silents), was so demanding that in the future, she planned to "just leave them to it."

As Audrey hoped, the writing mood came on Lee again once the ICA was up and running, and life at the farm more settled. In November, a surprise visit from Picasso, on his way to a Communist Party peace congress in Sheffield, moved her to pick up her camera, and later to unpack her typewriter. Roland met the Maître at Victoria Station and whisked him off to Farley Farm. "We practically had to go into hiding," Lee told her parents, "as all of social climbing and curious London was & is still ringing us."

Picasso found much to admire in Chiddingly. His enthusiasms included "Ayrshire cows, open log fires, a whiskey and soda night-cap, hot water bottles, cooked breakfasts and tea," Lee noted in a tribute written the following year. "He could scarcely know that besides modern pictures, an English farmhouse doesn't have rows of French sabots inside the back door, garlands of garlic, and furniture which lived its first hundred years in Gascony. But a tinned plum pudding on my menu, holly wreathed and flaming was indeed English, *very* English." Amused to learn that Picasso had been an Anglophile since reading of Lady Hester Stanhope's adventures among the Bedouins, and that he had hoped to meet such a woman, she continued, "We speculated on the result if he'd become an 'English' painter instead of 'French.'"

Picasso had joined the French Communists soon after the liberation of Paris, chiefly because Eluard was a member. He was now their star recruit, having attended the Party's 1948 Congress of Intellectuals for Peace, given large sums to charity under their auspices, and lent his work for use in a recent youth festival. "Desperately conscious that wars had never ceased in his lifetime," Lee explained, he came to England in the hope that the peace congress would curtail future conflicts.

When the anti-Communist Labour government thwarted the peace con-

gress by refusing to admit most of the foreign delegates, Picasso returned to Farley Farm. Lee's weekend guests having eaten everything in the larder, she scoured Brighton for supplies while Pablo shopped for souvenirs—postcards of the Pavilion, a toy double-decker bus, schoolboy caps for himself and his son Claude, one of his children with his new companion, Françoise Gilot. Throughout the Maître's stay, Lee recalled, "our three-year-old son Tony was in ecstasy." Picasso took him in his arms, spoke with him in a language of their own, and roughhoused on the floor. Soon Tony was wearing a beret, dipping his bread in the sauce, and in general behaving "just like Picasso."

The farm also fell under his spell. "The winter jasmine came in flower," Lee remembered, "the hateful stinging nettles disguised themselves with frills of hoar frost, even a great heap of trash and broken tiles produced a lovely form." Picasso, Roland wrote, "had the effect of charging one's emotional batteries." One senses Roland's deference in Lee's photograph of the two men in Roland's studio: Pablo stands in the foreground with Roland slightly behind, in his shadow. By contrast, her shot of the artist with Tony on his lap shows their mutual affection. Roland commemorated Pablo's visit with photographs of him, Lee, and Tony admiring their bull and Iris, the ship's figurehead, as if charging the batteries of animate and inanimate alike.

From 1950 on, Roland and Lee made numerous trips to see Picasso in France. With Tony, they spent a week in Paris in 1951 to choose pictures for the ICA's Picasso retrospective that autumn. His studio on the quai des Grands Augustins resembled an ongoing salon; visitors included Jacques Prévert and Tristan Tzara, filmmakers, critics, artists, writers, and Picasso's nephews, who entertained while Roland and Pablo worked their way through his limitless material. Although Roland knew Picasso's work "like a disciple," Lee wrote, "he was amazed at the treasures." Intrigued by the objects—a bat's skeleton, shells, pebbles, and snapshots—that collected themselves around him, she observed, "Even my own used flash bulbs are still in the corner by the stairs where I left them Liberation week."

One can imagine Lee's thoughts on this occasion, when the contrast between her life as a *femme-soldat* and her new role as Roland's helpmeet could not have been more striking. Her photographs of Pablo seated among his paintings show their ease together as well as her glee on finding traces of herself preserved in his studio. When Picasso visited them in London, a trick of the light streaming through the windows brought further revelations. As it threw reflections of paintings onto the windows, superimposing them on the world outside, a dancer swung from a tree; a collage replaced a windowpane. From this perspective, Lee wrote, "street lamps and the road-menders' red lanterns twinkled like Baedecker stars against masterpieces"—another instance of Picasso's magic.

In June 1951, Lee, Roland, and Tony traveled to Saint-Tropez in time for

Paul Eluard's wedding to Dominique Laure, his new companion; Picasso and Françoise Gilot came from Vallauris to serve as witnesses. After the ceremony, the Maître invited the group to an al fresco lunch and drew their pictures while Lee took photographs. Her shots recall those taken at their prewar *déjeuner sur l'herbe* at Mougins, but without their emotional abandon. Tony, stimulated by the chocolate biscuits fed him by Françoise, roughhoused with Pablo until the painter, tired of his biting, gave him a nip and exclaimed, "That's the first Englishman I've ever bit!" Eluard confided to Roland that after Nusch's death, he had felt unable to go on, but with Dominique at his side, he had restored his spirits during a visit to the USSR.

"Picasso, Drawings and Watercolours Since 1893" opened at the ICA on October 11, 1951, two weeks before the artist's seventieth birthday. "If Picasso is ever going to be a Grand Old Man he'd better start now," Lee wrote in a review for *Vogue*. The works shown ranged from a drawing done at the age of twelve to a "Bacchanale" executed while the French battled the Germans during the liberation of Paris. As she walked readers through the exhibit, an elegiac tone colored Lee's review: "There are contemplative lovers watching over sleeping partners . . . beauties like Fernande Olivier, Picasso's first girl friend, and Nusch, fragile, lovely Nusch who died—she was the wife of his great friend, the poet Paul Eluard." (Soon Lee and Roland would also mourn Eluard, who suffered a fatal heart attack the following November.)

That same year, a young woman named Patsy Murray came to Farley Farm for two weeks after the departure of Tony's latest nanny. Unlike the others, she stayed on, bringing calm and predictability to the little boy's life. Patsy became the heart of the extended family. (Years later, Roland recognized her centrality in their lives: "If it was not for Patsy," he said, "I would have never been able to keep Farley Farm.") Having been brought up in a communal household headed by a philosopher and philanthropist named Josiah Oldfield (a friend of Gandhi's), Patsy was unshockable. When her mother joined her as housekeeper, Antony Penrose recalls, "Farleys stopped being a transit camp for itinerant nannies and took on an air of permanence."

After Roland and Lee began leaving the little boy there during the week, Patsy became, in effect, his mother—a development that created complicated emotions for both women. Friends noted a touch of rivalry in their relations, especially as Tony grew older. Finding herself supplanted in her son's affections, Lee nonetheless relied on Patsy and turned to her in times of crisis, whether culinary or emotional. Roland, who took the situation for granted, appreciated Patsy's care for their son. Since he had been brought up by nannies himself, turning his son over to a woman of Patsy's abilities seemed normal, even desirable, since Lee claimed not to like children.

Despite the establishment of a settled routine, the writing mood came on her rarely. Audrey tried to give Lee assignments that were appropriate to

Vogue's renewed emphasis on feminine subjects, like cookery. "A great deal of the hash slung around by me would seem banal to an American no matter how exotic it appears in Muddles Green," Lee explained when asked for her culinary approach. She liked dishes that could be made in advance, with her own produce. Americans hated tripe but loved Yorkshire pudding, watercress sandwiches, and trifle, she said. "If we have overseas guests, I try to give them one of their national dishes but unfortunately the best need meat." Since rationing was still in effect, it took work to find the ingredients for steak and kidney pie. But the "rare and noble" roast of farm-raised pork or veal, Roland's favorite, was "not to be monkeyed around with."

In response to Audrey's request for recipes "from international hostesses," Lee provided a Sunday lunch menu consisting of Muddles Green Green Chicken and English Trifle. In autumn 1952, she put together a plan for the Christmas holidays that warned readers, "Remember, this time, Christmas is thirteen meals long; exasperating, as well as exhausting slavery unless the emergencies are given as much consideration as the scheduled events." (Her recipes included a Betty-Crockeresque "master mix," from which one could make scones, waffles, and dumplings; she recommended hangover cures like fruit salts and vitamin B_1.) Since Lee's contributions were sporadic at best, Audrey hired another cookery expert, Elizabeth David, whose monthly food columns entertained *Vogue* readers even when they could not find the ingredients for her recipes.

Roland made use of Lee's talents the following year to conceptualize and hang an exhibit that showed in its own way that the ICA was keeping up with the eclecticism of the organization's younger members, Reyner Banham, Tony del Renzio, Colin St. John Wilson, William Turnbull, and Richard Hamilton, who called themselves the Independents. Titled "The Wonder and Horror of the Human Head," it grouped a mixed-media collection of heads from widely different times and places. Roland, who wrote with difficulty and may have been dyslexic, nonetheless produced a scholarly catalogue. Dedicated "To my Wife, without whose help this essay could not have been written," it drew heavily on Lee's editorial skills and long-standing interest in phrenology.

To have a say in her own right, Lee sent *Vogue* a lively review of the show, which—read between the lines—offers advice for former head-turning beauties struggling with the knowledge that they had lost their looks. "The next time you find yourself hunched and miserable, threading your way through masses of other hunched and miserable creatures on some wretched quest," she advised, "bluff yourself and them by bouncing along with a large smile." Women whose charms had faded might also consider the transformations wrought by plastic surgeons, or, like their Egyptian sisters, dress as they pleased. Beauty was a matter of particular times, she continued: "If we can't be 'beauties' in our own period, let's forget it and have fun." Yet it was true that

"the free choice of a new head, with a new face; flashing carefree teeth; completely different and manageable hair" was as tempting as the thought of "escaping from oneself." Lee's sense of herself as one who managed by bluffing is evident in a sentence omitted from the final draft: "Humility, which is not one of the greatest attributes of the human, is quite a different thing when applied as a whip."

A few months later, Lee brandished a whip of her own in her last illustrated piece for *Vogue*. This tongue-in-cheek guide for weekend guests dismisses the conventional approach of the 1950s ("team-work on the part of husband and wife to make it seem that a bevy of pixies flits around doing the . . . chores") in favor of something like a Soviet workers' camp, whose motto would be "Joy Through Work." (One wonders if readers caught the echo of *"Arbeit Macht Frei."*) Her farm's assembly-line approach to meals, Lee wrote, offered companionship, discussions of art, politics, romance, and murder trials, and for those in need, occupational therapy. Moreover, it allowed her to enjoy "all the fun of being devious," assigning repetitive tasks to those who liked to be "free from the neck up," more demanding ones to "those who prefer to have their minds on the job." Having nearly completed her first five-year plan, Lee was planning the next one. She hoped to start a vineyard, to keep her friends, and herself, in drink.

Lee's Stalinesque tactics were illustrated with a series of staged photographs. Roland and Tony are shown clipping the grass; Henry Moore embracing his *Mother and Child*; Saul Steinberg battling a garden hose that threatens to turn into one of his drawings; Rosamond Bernier, Timmie O'Brien, and Cynthia Thompson (formerly Ledsham) shelling peas; John and Ernestine Carter filling worm holes in the furniture; H. D. Molesworth, keeper of sculpture at the Victoria and Albert, mending the chairs; and Alfred Barr feeding the pigs. (In a spoof on their labors in Sedona, Lee posed Dorothea as a master electrician and Max as a gardener planting borders of corn.) Despite her pleasure in orchestrating this story, Lee procrastinated, drank, and took out her distress on the household when she could not complete it on time—at which point Roland persuaded Audrey not to ask Lee for work. When Lee found out, she was furious.

The story, featured in *Vogue*'s July 1953 issue, recalls the layout and style of Dave Scherman's photo-essays for *Life* with an important difference: the strongly domestic emphasis of the 1950s. Above the title, "Working Guests," the magazine ran Lee's haunting shot from her upstairs window to the Downs, a hint that these were now the limits of her vision. In the final image, Lee naps on the sofa while the guests toil, a send-up of her role as slave driver. "She was not suited to country life," Audrey reflected, "but it became a point of pride not to complain about the choices she made when she married Roland."

∞

At the same time that "Working Guests" marked the end of Lee's career, another event with ominous implications took place as if with Eluard's posthumous blessing. Before his marriage to Dominique, he had formed a liaison with a tall, radiant blonde named Diane Deriaz, whose many charms included a stint as a *trapéziste,* a circus tightrope walker. The young woman's specialty act—hanging from a rope by her heels—displayed her courage, and her toned body, to advantage. Although sufficiently excited by Diane to tag along on her circus tour, Eluard came to feel that she was too self-centered to replace Nusch. He introduced her to others in Surrealist circles, including Picasso. ("Eluard's love of women was generous and enveloping rather than promiscuous," Roland opined.)

In 1953, Diane appeared at the ICA and introduced herself to Roland as "*la trapéziste de Paul Eluard.*" That July, they met again in Saint-Tropez, where Roland and Lee were staying with Dominique Eluard and her other guests, Man Ray and Juliet. The group often swam at Golfe-Juan, then dined with Picasso at his favorite restaurant. On one of these occasions, Diane recalled with satisfaction, Cocteau joined them but failed to recognize Lee. "She had been one of the most beautiful women in the world," the young woman wrote in her memoir, "[and] what was more, madly original, which made her all the more seductive. Unfortunately, she drank. She was a total alcoholic, which, little by little, destroyed her beauty." In Roland's photograph of the group at lunch, Diane smiles at the camera over Lee's shoulder.

Despite a severe case of shingles, a nerve disease, Lee invited Diane to stay with her and Roland in London that autumn to devote herself to fencing, another of her pastimes. The young woman moved into their Hornton Street apartment, foil in hand. She enjoyed ICA parties and weekends at Chiddingly but was shocked by Lee's drinking, especially when asked to bring her hostess a whiskey in her bath. (She also disapproved of Lee's habit of going braless, then peeling off her top in warm weather.) After Lee made inquiries about Diane's sexual life, the young woman realized that her new friends had plans for her: she was to be Roland's lover.

In the seduction scene recounted in her memoir, Diane defended herself so strenuously against his overtures that he fell in love with her—the only woman in his life to gain the upper hand and wield the whip with which he had sought to strike her. Lee then found herself in a ménage à trois that worked to her disadvantage—"the young beauty triumphed over the older woman," Diane reflected. Lee's affection turned to hatred, she thought: "Having tried to involve me in the perverse Surrealist game in which one lends one's partner to another, she had lost, and in her despair, held a grudge."

Roland announced that he wanted a divorce. Lee could return to the United States with Tony or leave him with Patsy. The crisis, temporarily defused after Diane's return to Paris, was still smoldering when she returned to Chiddingly at Christmas. Everyone's nerves were on edge. Housebound by the weather, the other guests—Max, Dorothea, Dominique, Valentine, and the O'Briens—dealt with the situation by playacting, making costumes from acid-colored felt, and parading around the house in their creations. Valentine read their horoscopes; the group scribbled New Year's greetings on a card to Picasso. When the emotional tension became unbearable, Lee took to her bed.

Valentine's "adoption" of her compatriot compensated for Lee's dislike, Diane believed: "We looked deep into each other's eyes. She said to Roland, 'Diane is beautiful. I like her very much.'" On Christmas Eve, after gesturing theatrically throughout dinner, Diane fell to the floor in a swoon. Valentine said that she was pretending, but Roland was too infatuated to see through her ruse. He became even more determined to marry her, and Lee, to banish Diane from the farm. Neither understood that the young woman, who valued her independence, did not want to cause a breach. "I ended up saying to Roland," she wrote, "I will never marry you and we will never be anything but friends."

For the next six months, after Diane's banishment, Roland made many trips to Paris to see her. His subjugation to the *trapéziste* was no less disturbing to Lee than if they had been lovers—even after Diane asserted her autonomy by becoming a flight attendant for Air France, which allowed her to indulge in another of her passions, foreign travel. Roland's infatuation let up sufficiently by June for him to go to Venice with Lee for the 1954 Biennale, where Max and Dorothea joined them. From Venice, they went to Vallauris to see Picasso and meet his new lover, Jacqueline Roque, who had moved in soon after Françoise Gilot's departure—yet another demonstration of the volatile nature of sexual relations.

One can only speculate about Lee's frame of mind as she boarded the SS *Olympia* at the end of July to attend her parents' fiftieth wedding anniversary. Their marriage had not been a model of fidelity, yet they had stayed together. Her brother John, his wife, Catherine, and their daughter, Joanne, met Lee on her arrival in New York on August 4 and took her to Vassar Hospital, where Florence was being treated for cancer. Her mother came home on August 9 and two days later felt strong enough for the party at John's house, where Lee photographed the extended family and the wedding cake that symbolized her parents' union. The next day they learned that the cancer had spread to Florence's liver and lungs. She returned to the hospital, underwent an operation, but died on September 11. Lee inspected the family plot and oversaw the burial preparations the next day, when Theodore left the room because, he confessed in his diary, he was "too emotional."

All that month, Lee looked after her father, who could not sleep. On September 22, they dealt with their grief by characteristic means: Theodore fasted and did a Pluto water purge, Lee made a batch of red-pepper marmalade. They watched a Hollywood romance, *Valley of the Kings,* whose Egyptian settings earned Lee's approval—the plot, in which an amateur archeologist (Eleanor Parker) explores Upper Egypt with a handsome guide (Robert Taylor), may have stirred up memories. She had some of Florence's clothes altered for herself, organized her mother's estate, and saw old friends, including Jackie Knight and Bert Martinson, who had studied photography with her in New York. Theodore's diary entry for November 8, when Dave Scherman drove to Poughkeepsie to see her, calls him "a pupil and old friend of Lee's now on Life"—suggesting that he remained in the dark about their relationship. She and Dave sorted through her photographic equipment; he took some of it home in memory of their partnership.

Lee renewed her local ties with visits to Agnes Rindge, the head of Vassar's art department, and began a new friendship, with John's liberal-minded daughter Patricia, a Vassar student who was keen on English literature, religion, and philosophy. Trish, who had the striking good looks of the Miller family, may have reminded her aunt of herself when young; Lee ordered copies of her textbooks with the idea of keeping up with her. Trish was fascinated by her aunt's "deep whiskey voice and free spirit" and impressed that Lee always spoke her mind, a bold move in a family prone to secrets. When Lee lamented her lack of schooling, Trish replied that her whole life had been an education, but she had the impression that Lee felt herself wanting.

Lee gave her approval to Trish's engagement to her beau because of his unconventional ideas, Theodore noted, but above all because he was Jewish. She counseled her niece about sex and explained how to cope with its consequences, especially cystitis (one should urinate after intercourse, she said calmly). There were two kinds of bodies, she explained, the straight up and down, or Nordic, sort, which as Millers they possessed, and the more curvacious Mediterranean type.

One night at a party where alcohol was unavailable, Lee badgered the hosts into opening the liquor cabinet, drank until she was tight, and danced with abandon—despite the fact that she wasn't wearing underpants. Lee was "unembarrassable," Trish said admiringly. "She spent her life trying for honesty; she was against hypocrisy and keeping things hidden." Yet during her visit, Lee mentioned neither her unhappiness nor Roland's infatuation with Diane—although she did ask her niece how she stayed calm under provocation.

Lee sailed on the *Queen Elizabeth* on November 27, to be at home for the holidays. Roland had missed her, but he was immersed in his new project, a biography of Picasso commissioned by the British publisher Victor Gollancz—

with which she could help him, since he doubted his ability to research and compose a lengthy manuscript. "They found they loved and needed each other, although they still found it hard to get on together," Antony Penrose recalls. "Their relationship settled into a fragile balance that alternated between affection and incomprehending strife. Lee accepted that Diane was part of Roland's life, but he was more discreet."

However much their son was protected from these events, it is hard not to ponder their effects on him. As a child, he found it difficult to accept change. Patsy did what she could to help him bear his parents' absences and Lee's mood swings. What bothered him most was her volatility. The little boy, who had inherited the Miller ingenuity, was happiest when learning the intricacies of the farm machinery. Like his mother, he loved taking things apart and putting them back together. In 1955, when he turned eight, Tony was sent to boarding school. Lee's American voice and manners intrigued his classmates during her visits, which made it clear to her son that she was nothing like more "proper" mothers. Whatever "the done thing" was, Lee didn't do it; what she did do was often embarrassing or alarming. (One weekend, when Audrey Withers showed Tony her house present, a pair of doves for Farley's dovecote, he begged her to hide them since Lee might put them in her freezer, one of the first in England.)

While other children adored Lee's subversive humor and practical jokes (she gave Tony fake puddles of vomit and papier-mâché dog turds as gifts), he found it hard to live with a mother who didn't care how she looked, what she said, or how her views affected others. It was bad enough that she wore scruffy trousers when other women did their best to incarnate the ultrafeminine New Look. What was worse, she sometimes appeared in public with a pink net toilet seat cover on her head, her preferred headgear in the kitchen, she explained, because it protected her hair from grease. "My chums thought she was the most enchanting and exciting person," Antony Penrose recalls. On visits, they saw Lee's flashing wit, far-ranging knowledge, and exuberance. Her angry outbursts were reserved for her son, whom she often dismissed as stupid. "I don't know what I represented to her," Penrose observes. "I may have reflected her own self-loathing."

Open warfare broke out by the time Tony was ten. "Please ask Patsy to meet me from the school train because if Mummy comes I am not sure if I will recognize her," he remarked, with an unerring sense of how to wound her. For the next two decades, he would alternate between being "deeply embattled with or icily indifferent to her," a pattern that in some ways replicated Lee's behavior with those she loved. One day when Theodore was at the farm on an extended visit, Patsy noted the strong family resemblance among the three generations of Millers. They shared not only their Germanic (or Nordic) genes but also their insistence on having things their own way. "Lee had a lot of

her father in her," she said; Tony, despite his unease with his mother, had a lot of Lee.

Given their embattled relations, the inclusion of Lee's photograph of Tony in Steichen's enormously successful 1955 Museum of Modern Art exhibition, "The Family of Man," may have seemed ironic. The result of her mentor's three-year search for the most evocative images of common human experience, it concluded with photographs of children that, in Steichen's view, affirmed life by transcending cultural differences. (The show would tour the USSR at a time of increasing tensions.) Displayed with similar images of children from France, England, Morocco, and Soweto in the concluding part of the exhibit, Lee's shot showed an overalled Tony gazing beyond the frame and, in the foreground, a tabby cat facing the camera. When the catalogue became a best seller, this tranquil image replaced Lee's scenes from the death camps in the public's mind.

During the mid-fifties, as Roland's star rose and Lee's declined, her deviousness expressed itself in subversive gestures not always grasped by others. While Roland coped with the Independents group—their proto-pop aesthetic incorporated the shapes and colors of postwar culture into forms ranging from collage to installations—he remained the mainstay of the ICA, often propping up its shaky finances by selling his paintings.

The 1955 season featured an Independents-sponsored exhibit called "Man, Machine and Motion," with talks by Reyner Banham on topics like the iconography of the automobile. The younger artists, Paolozzi, del Renzio, and Banham, gathered in the ICA bar, "usually decorated by Lee's presence," Colin Wilson recalled. "Mostly she drank," he said, since she had little interest in the debates between the old guard, for whom Surrealism was the defining moment of modern art, and the Young Turks like him. "Yet she was open-minded, in fact bloody-minded, enough to support us," he observed, at a time when Roland found it hard to move beyond Surrealism—a vision that, to the Young Turks, was "claustrophobic and kinky, especially where sex was concerned."

Partly in response to divisions within London art circles, Roland turned increasingly to his biography of Picasso. He decided to tour parts of Spain associated with the artist's youth. Having published books of her own, Lee agreed to help—at what personal cost one can only speculate. Even then, it would have been hard not to see Roland's new project as competitive and harder still to grasp Lee's decision to polish her secretarial skills so that she could serve as his scribe—a plan she contemplated but did not execute once he said that he wanted her to document the trip with her camera.

Lee, Bill Copley, Max Ernst, Dorothea Tanning, and Man Ray in Paris (Man Ray)

They traveled to Málaga, Picasso's birthplace, in the spring of 1955. Lee photographed, as they toured the port's Moorish citadels, Picasso's first art school, and the family home on the tree-lined Plaza de la Merced. In Barcelona, they visited the Quatre Gats café, the fin de siècle anarchist locale where a cosmopolitan group of artists and intellectuals had befriended the painter, and the rundown areas where beggars and prostitutes were still in evidence. "The company of Lee and her ability to record so much with professional skill was invaluable," Roland wrote. "All this helped me to gain an idea of the atmosphere that had, some fifty years before, produced the paintings of the Blue Period." Lee had little to say about the trip, except to tell Picasso that she had seen her first bullfight. "It was better than I had imagined," she wrote. She witnessed the event "with enthusiasm."

Lee returned to England in July in time to greet her father, who had come for three months, while Roland stayed in Paris. Although Theodore enjoyed the British Museum, at eighty-three, he found Farley Farm more restful, despite the late dinner hour (Tony had tea at 5 p.m. and disappeared, he noted). He helped Lee pick peas and freeze them, accompanied her to performances at the nearby Glyndebourne opera festival, and took walks with weekend guests (that summer he met Audrey and her husband, the O'Briens, the Burrows, the Thompsons, art critic John Russell, Lady Vera Barry, and others with titles, which impressed him). After Roland's return, they took excursions to Lewes, Brighton, and the Channel beaches. On one occasion, when Lee and her father repaired to the pub in Chiddingly, the regulars tried not to

stare. After Theodore became ill from eating Lee's green-pepper jam, he cured himself with a purge in time for Tony's birthday party.

Following Theodore's departure in October, Roland accepted a position with the British Council, the government's cultural organization, as its fine arts officer in France, in part because Roland and Lee's friends—Man and Juliet, Max and Dorothea, Miró, Braque, and Giacometti—had returned to Paris, in part because residence there would facilitate the completion of his book on Picasso. Starting in 1956, he would spend six months there each year, lecturing, organizing exhibitions, and promoting the work of British artists. Lee, who supported the plan, was "an essential asset," Roland wrote—as his hostess. Audrey took a different view. "One might think that, for Lee, that would be like going home," she reflected later, "but Paris, for her, was the city she had known in earlier days, when she was a free spirit—not a member of the Establishment; and when she represented nothing but herself."

For the next three years, Lee's life was shaped by Roland's status as a member of the establishment. He attended openings, wrote exhibition catalogues, traveled to Venice, Lisbon, Brazil, the United States, and Mexico on lecture tours, and took part in the effervescent life of the Paris art world, where he made new acquaintances—the writer Henri-Pierre Roché, painters Roberto Matta, Ossip Zadkine, and Yves Klein, and Princesse Jeanne-Marie de Broglie, of the Cordier Gallery. In addition to their longtime friends on the Left Bank (Man and Juliet had a studio on the rue Férou, near the Luxembourg Gardens), he was drawn to the elegant bohemians who gathered at the vicomtesse de Noailles's palatial Right Bank town house. Marie-Laure and Charles de Noailles had lived apart since the 1930s. The vicomte spent most of his time on the Côte d'Azur indulging his passion for horticulture. His wife, who possessed her own fortune, encouraged the eccentricities of those who frequented her salon—both to shock the aristocrats who had snubbed the couple since the *L'Age d'or* scandal and to perpetuate the idea that Surrealism was still outrageous.

One way to carry on in the old style was to revive the costume ball, where guests could act out their fantasies. At Marie-Laure's sumptuous *bals déguisés*, one might see Jacques Fath as a bear, Schiaparelli as a goat, the American ambassador David Bruce as a waiter in a dive, or Man Ray as a caricature of himself in a handmade mask. On February 14, 1956, Lee and Roland joined the vicomtesse's more than three hundred guests at a ball in honor of art and literature. Marie-Laure stood at the top of her grand stairway as they were ushered in by the servants. Resplendent in white satin and black velvet, she was impersonating Délie, the muse of poet Maurice Scève. Roland did not recall Lee's costume but wrote that he came as the clock "that disturbed at a crucial moment the father of Tristram Shandy in his pleasure with his wife." One wonders what thoughts went through Lee's head that night, whether she

thought of the ball where she and Roland had met in 1937 under such different circumstances.

"The erotic enticements of Parisian nights were still there," he recalled of this time. Roland saw Diane when she returned from trips, and other women when she was traveling. It was her hold on him that hurt Lee the most, a friend observed: "She couldn't digest Diane; she stuck in her throat." Nor did Lee follow the example of Marie-Laure by surrounding herself with admirers, mostly homosexual, who offered the stimulus of unobtainable love. (Conversation at the vicomtesse's table contrasted oddly with the surroundings. While she talked of buggery and dildoes, liveried servants stood discreetly behind the guests' chairs.) Women sometimes felt uncomfortable at Marie-Laure's, since she preferred the company of the male artists who enjoyed her patronage while reassuring her that she was not *démodée,* a concern of hers in middle age.

In the 1930s, when Lee and Marie-Laure first met, the vicomtesse was considered a *jolie laide* (an ugly woman who contrives to be chic). By the 1950s, both had gained weight and let themselves go, in the view of their friends from before the war. But unlike Lee, Marie-Laure coped with aging by befriending people who sparked her creativity. She had published a novel, experimented with lithography, collage, and most recently, neo-Surrealist oils—often featuring her cat—that hung in galleries with the work of Man Ray, Leonor Fini, and her latest lover, the painter Oscar Domínguez. But when Marie-Laure urged Lee to make a fresh start with photography, she was disappointed by her reply: that part of her life was over.

While Roland maintained a hectic schedule, Lee did little but cook, drink, and attend cocktail parties, often with her close friends Ninette and Peter Lyon—also intimates of Marie-Laure. Peter saw her through "some tough times" when Roland worked for the British Council, he recalled, "especially when he was with Diane or some other woman." Ninette, a painter and writer, inspired Lee to take cooking seriously, while her husband became Lee's confidant, chauffeur, and companion in her search for an apartment with a modern kitchen.

On such occasions, which included stops for drinks, Peter talked with Lee about her unhappiness, and his own: Ninette was having an affair with Roland, to which Lee turned a blind eye. One day when Ninette inquired about the letters NA on Lee's dressing table mirror, Lee replied, "It means Never Answer—and it is to remind me that I am expected to carry on without protest." Her defiance came out nonetheless in provocative jokes and pranks or at costume parties, where she might appear as Marcel Duchamp's gender-bending version of the *Mona Lisa.*

In 1957, Lee found an apartment with a satisfactory kitchen in the Place Dauphine, the eighteenth-century square on the Ile de la Cité, which became their home for the rest of their stay in Paris. Roland gave her a six-month

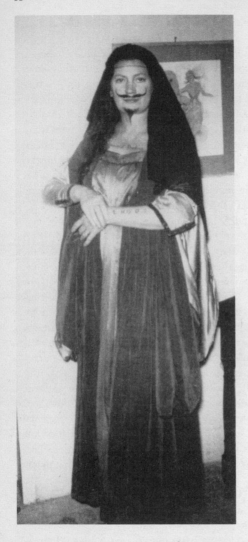

*Lee dressed for a
costume party as
Marcel Duchamp's
version of the*
Mona Lisa, *1955
(Dorothea
Tanning)*

course at the Cordon Bleu cooking school as a fiftieth birthday present, cook-
ery having become chic in their circle. Marie-Laure, whose chef habitually
served elegant dishes like lobster à l'armoricaine and figs in cream, was
charmed to dine at a country kitchen where Schiaparelli boiled spaghetti while
the hostess roasted chickens in the hearth. (The reverse snobbery of simple
cuisine had not yet reached more conventional circles, where the thought of

doing without one's staff was unthinkable.) Lee found the Cordon Bleu school unhygienic (if a fish "flew out of the chef's hand," she said, "he would simply pick it up and slam it back into the pan"), but she learned the essentials— browning, simmering, skimming, straining, and sieving—in their time-honored order: the techniques of French cuisine as a self-contained system.

During these years, when Elizabeth David was introducing French provincial cuisine to the English and Julia Child was mastering the art of French cooking, Ninette Lyon was also writing cookbooks, several of which were translated into English. Unlike these other women, Lee would not become a professional chef, yet her extravagant dinners, which required days of preparation, became legendary among their friends. The alchemy of the kitchen fired her imagination. While cooking, she could protect her autonomy by practicing an art that nonetheless enhanced Roland's status, though some of those who enjoyed it took her contribution for granted.

"Lee is still making remarkable dishes," Roland told Picasso in a letter announcing his visit to Cannes that autumn to check details for the Maître's biography. Starting in 1954, he made several trips a year to see Picasso, often with Lee. Her photographs make up a visual record of their relations, which were complicated by the presence on the scene of the collector Douglas Cooper: Cooper maintained that he, not Roland, was the English Picasso expert. Cooper's companion John Richardson, whose multivolume biography of the artist would one day expand on Roland's, sees Picasso as "a past master at dividing and ruling": "He would keep Roland . . . waiting for days at a time in Cannes, saying that he was busy with Douglas. Next time, Douglas would be reduced to begging Jacqueline to arrange an audience with the master. Whoever was the victim of these teases would usually be rewarded with a drawing."

While Roland was deferential, Lee teased Pablo with the intimacy of a former lover, Richardson recalled: "Roland, as Boswell, was always saying, yes sir, no sir; Lee did as she pleased." On these occasions, she took what constitutes an album of relaxed domestic portraits—Picasso with wives, lovers, and children; Picasso with Tony, Roland, and Patsy on visits to Cannes. Toward the middle of the decade, by which time he had become a global star surrounded by acolytes, her images of him focus on the exuberance that remained the basis of his creativity. A series taken at Picasso's pottery in Vallauris during a visit by his estranged friend Georges Braque catches the Maître at play—kissing the cheek of the ceramic infant he has just made for his *Woman with a Baby Carriage;* giving Braque a peace offering, a pottery dove. On another occasion, Picasso and his friend Sabartès don masks for her, and Sabartès cradles a nymph in his lap.

Picasso's ease with Lee is also evident in her images of the artist in the company of those whose vision complemented his own. Soon after his partici-

pation in *The Testament of Orpheus,* Cocteau's latest film, Lee photographed Pablo in conversation with the poet—an occasion that may have prompted her to rethink her prewar relations with both men, and her decision to take second place to Roland. In an image of Picasso with Jacqueline at their new home, La Californie, the couple's relative positions imply their emotional dynamic. Seated in a low chair, he stares at the camera while placing his hand on her knee; she turns edgily in the foreground, aware that despite his distance she is his support.

But it is in Lee's images of Picasso alone that their relations are most palpable. One particularly moving close-up all but erases the distance between them: Picasso gazes at his former muse as if recalling the history of their affections—an unusually intimate portrait at a time when, increasingly, he held himself in reserve. In another, a surreal double exposure, the two are literally superimposed on each other. As Pablo displays a drawing of a man looking at a nude model, Lee's white dress shadows the painter's face, and her sandal-shod feet appear at the place of his heart—an accident that mirrors their easygoing rapport.

In 1956, Roland organized an ICA exhibit called "Picasso Himself," including portraits of the artist by his friends—among them Beaton, Capa, Doisneau, Man, and Lee, some of whose shots were also used in Roland's catalogue *Portrait of Picasso.* Her portraits may be distinguished from those of other photographers by their focus on Picasso's gaze. Of a series taken in Picasso's studios a critic writes, "In these narrow and often heavily decorated spaces spirit is, as it were, put under pressure and forced into assertion—hence the power and urgency of those staring eyes. It is this prevailing condition in Picasso's art which is acknowledged by Lee Miller. . . . At one level they are documentary pictures, informative as to the look of this or that studio, but at another level they embody the artist's own way of working and show Picasso appearing in his own pictures, as though in a collaborative venture halfway between portraiture and self-portraiture." At the time, few noticed their collaborative nature, since her growing body of images of Picasso were not shown together.

Roland's biography, *Picasso: His Life and Work,* published in 1958, listed Lee among the artist's models and used one of her photographs. Soon after its publication, Roland accepted the invitation of the official U.K. funding body, the Arts Council, to curate a retrospective of the artist's work at the Tate Gallery in 1960, to which he devoted himself for the next two years. With the help of Joanna Drew, the exhibition organizer, he wrote the catalogue and cajoled collectors around the world to lend work from each of the artist's periods. In the lead-up to the opening, the ICA publicized the Picasso Party, its fund-raising gala at the Tate, by announcing that the guest of honor would be the Duke of Edinburgh, whose presence would compensate for the absence of Picasso.

During this time, Lee was seen chiefly as Roland's adjunct. With Audrey's retirement from *Vogue* in 1960, she had no outlet for stories should the writing mood return, of which she was doubtful. Nonetheless, having acquitted herself well on British television on the occasion of a show of Picasso's drawings, Lee was persuaded to compose a piece for the Picasso Party souvenir brochure. "Only Lee's family knew the agonies that were suffered in assembling those 500 beautifully crafted words," her son wrote of this effort. "The long nights hunched over the typewriter, 80 or 100 cigarettes a day and prodigious amounts of whiskey, the procrastination to build up the pressure against the deadline and the blackest weeping despair. Everyone associated with Lee breathed a sigh of relief when she announced she would never write again."

Reading Lee's "Picasso Himself," one would not suspect how much it had cost her. Lee began by evoking the artist's presence: "His flashing black eyes have fascinated everyone who has even only seen Picasso but those who meet him feel thrown into an exciting new equilibrium by the personality of this small, warm, friendly man." The piece combines intimate recollections with perceptive remarks on his attitude toward his work—while revealing much about her own. Picasso made sculpture from "lost and founds," she wrote, "a juggling feat which needs luck, observation and wit." Refusing to take his work seriously, he referred to it in "a gay and flippant way." To evoke Picasso's gleefulness, she described his wardrobe of false noses, beards, hats, and costumes. Finally, to explain his absence, she said that he could not be bothered. "He's too busy making new things to pay homage to the old," she wrote. "He's never been his own *aficionado*."

Lee also gave an interview to a *Daily Mail* reporter for whom both Picasso and modern art were incomprehensible. After mentioning the titled guests expected at the ICA gala, the insurance costs, and Roland's devotion to the artist ("I feel it is good just to be alive at the same time as a man like Picasso," he remarked, echoing Eluard), the reporter described her visit to Lee's apartment and her struggle to see the resemblance between the artist's 1937 portrait and its subject. Lee told her to relax and "feel" the painting. "Can't you see it's like me," she went on provocatively; "it's got my grin." The reporter noted that Lee loved Picasso because, she said, "you never knew how he would react." Like her, he hated "people breathing down his neck."

On the night of July 5, 1960, a huge crowd, many in satin and diamonds, downed sangria on the lawn of the Tate under a pink and white marquee before mounting a specially constructed staircase and filing past banks of flowers to take their places at table, where they washed down paella with quantities of Spanish rioja. While the guests craned their necks to catch glimpses of Princess Margarita of Yugoslavia, the Marchioness of Dufferin and Ava, and the Princesse de Broglie, the organizers kept watch over the guest of honor.

Despite some concern, Prince Philip had been seated next to Lee, who might have been tempted to misbehave by drinking too much rioja. They were relieved to see her and the prince enjoying each other's company. Perhaps for that reason, she curbed her outrageousness.

Some of the younger members of their circle were disappointed by her failure to express in public what they were saying in private. The writer George Melly lambasted Roland for using the Duke of Edinburgh as a drawing card: "Honestly, I find the whole concept an insult to a great painter. What are you after? A title? A ticket to the Royal Enclosure?" The event was, he said, an "opportunistic little marriage of art and the establishment."

Roland's unease with his success is evident in his account of taking the royals around the exhibition. "I was required to act as a guide who would pilot round the Tate, first Prince Philip at the opening and later the Queen herself," he wrote: on a separate visit some weeks after the gala, Her Majesty responded sympathetically to the artist's Blue Period subjects and demonstrated "that she could laugh at Picasso's jokes and enter into the many phases of his work with wholehearted spontaneous enjoyment. It was an unforgettable experience for me to visit an exhibition of this importance in the rare company of one who showed such genuine pleasure."

Lee was not invited on the occasion of Queen Elizabeth's tour. Despite her good behavior at the gala, no one knew when her subversive side might get the better of her, or how she might respond to the marriage of art and the establishment. Nor does the biographical record include her reaction to the news, the following January, that Roland had been named a Commander of the British Empire. "It's because of you," he told Picasso, adding that they need not worry, since the empire was a thing of the past. As for himself, he did not require honors; he was happy being known as "the Picasso man."

Lee lost enough weight to look almost girlish in the evening gown she wore to the ICA's next big party, for Ernst's 1961 retrospective. The gala was "the largest of its kind at the Tate since the memorable Picasso exhibition last year," the *Tatler* gushed. The magazine, which featured the doings of the social elite, published pictures of ICA stalwarts—Julie Lawson, Victor Gollancz, and Dorothy Morland, along with Peter Ustinov and a beaming Max. Tellingly, the caption beneath the shot of Dorothea and Lee subsumes the women under their married names—"Mrs. Max Ernst with Mrs. Roland Penrose, whose husband organized the exhibition."

Much of her time, Lee wrote her brother John from London, was spent "mouldering in my schizophrenic life between the farm and here"—though she had recently gone to Paris to see Picasso, who was ill, and revisit the paintings that she and Roland had loaned to an exhibition there, including Pablo's *Weeping Woman,* just before the French police nabbed the thief who tried to cut it out of its frame. Since then, the farm garden had been overflowing with

peas, beans, raspberries, and strawberries, which she preserved for the winter; consequently, she had not had time to find an electric typewriter to replace her Hermes. "But when all this double life I'm leading calms down," Lee promised, "I'll study the situation seriously"—to what end one can only imagine, the writing mood having abandoned her.

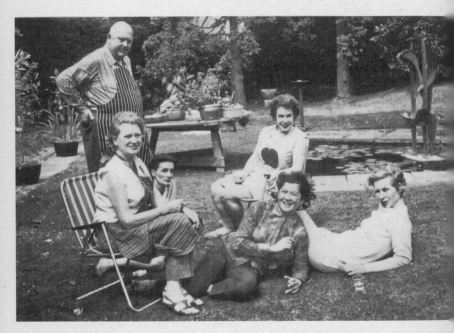

Foreground: Lee, Patsy Murray, Julie Lawson, Bettina McNulty; background: James Beard and Katie Laughton, in chair. Farley Farm, 1966 (Henry McNulty)

Chapter 17

A Second Fame

(1961–71)

"Lee's past was overshadowed by Roland's present," a friend observed on recalling their circle in the 1960s. She rarely mentioned her former life. In the climate of England's recovery—the time of "Swinging London"—her reticence seemed to suit the general need to forget the past and celebrate the present.

Because Lee rarely spoke of the war, her entourage thought that this chapter of her life was closed. Few knew that it had gone underground, to resurface late at night when she could not sleep, or when drinking with a female guest or relation—a younger version of herself. You must be careful, she warned them, you could get in over your head. During the day, the war seemed to have receded into the background. Yet its unfinished business never left her.

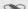

Despite the changing cast of characters at the farm, Lee's weekends were much alike. To cater lunches, teas, and dinners for twelve or more required advance planning—designing meals that could be made ahead and relying extensively on Patsy. Still, most of her time was spent at the stove. Guests who

wandered into the kitchen midmorning might find her breakfasting on fresh tomatoes and mozzarella while the more conventional ate kippers and toast. Those who stayed were given educational tasks, like fluting mushrooms; if talented, they were welcomed as sous-chefs. "I want to get some cooking out of you," she often told John Golding, who was invited to improvise with the exotic ingredients—Jamaican hibiscus or Egyptian saffron—he brought her from trips. "She was funny about cooking," he recalled; "she pottered around the kitchen laughing and swearing. Food amused her."

It also allowed her to be devious. Middle Eastern spices discomfited those who preferred plain English food. One night an eggplant dish was so hot that it caused Roland to leave the table. On occasion, guests who said that they did not eat such and such found themselves enjoying dishes in which the offending item was concealed. After the critic Cyril Connolly joined Roland in disparaging the American taste for marshmallows and Coca-Cola, Lee made a "bombe surprise" for dessert. "When they'd eaten every last mouthful," she recalled, "I was pleased to announce that they had just eaten my patriotic invention: marshmallow-cola ice cream."

Lee's "defiant" cooking (a friend's term for this subversive practice) was not incompatible with a more complimentary version of the art—her way of paying homage to people she liked. Lee invented meatless versions of dishes to suit Patsy's vegetarian diet, and with the help of Patsy's Polish friend Stan Peters, she perfected a sauerkraut stew called *bigos,* which improved on reheating. For Princess Jeanne-Marie de Broglie, whose ancestors also came from Poland, she prepared a complicated sauce from the southern part of the country after researching its cuisine. The princess wondered at Lee's immersion in cookery: "it was as if she had never lived in France, as if all she had done had never happened." One night, after the guests had downed more than the usual number of the stiff drinks Roland habitually poured, he stormed into the kitchen to ask when dinner would be served. Lee was preparing a blue fish in honor of a Miró painting, he explained on his return. "She had set her mind on the idea," the princess noted. "We just had to wait."

While some of Roland's friends took Lee for granted, she intrigued those who, knowing her past, did not understand how she had become the woman at the stove. The guests in Roland's orbit usually spent the weekend conversing with one another and following him around the farm. But for John Craxton, Lee was "the lure . . . an icon who represented the pre-war era, a time of utter freedom." Guests who were curious about her, like him, repaired to the kitchen—"a heavenly place always full of open bottles of booze and a potent cider anyone could swig at," he recalled. "She was an old soul," he continued, "a breath of fresh air in a country where people tended, even *tried* to conform; she collected all those who were deraciné, like herself."

When cooking with friends like Craxton, Lee was "in a world of her own,

yet totally in the present," a visitor noted, "since cooking is a pastime that makes one pay attention." It was also an excuse to indulge in her love of gadgets. Lee amused the guests who watched her clean spinach in the washing machine or cook a chicken by inserting six silver spoons, covering the bird with water and letting it boil, then turning off the heat after six minutes, to let the hot spoons finish the process. She devised alternative recipes—like the low-calorie mayonnaise concocted with Craxton's help, using carageen moss instead of olive oil. Other tricks included washing strawberries in sherry, using leftover salad in meatloaf, and shaping ground beef and onion into a no-dough pizza "crust." There seemed to be no end to her inventiveness, nor to her appetite for research in her collection of two thousand cookbooks—which threatened to take over the house until Roland built a special room for them.

There, late at night, when everyone else was asleep, she sometimes talked about the past with younger friends who knew of her prewar fame but loved her for herself. Roz Jacobs, a starry-eyed New Yorker who had fallen in love with Paris on a buying trip for Macy's, met Lee and Roland there in 1955. Visiting Farley's at Lee's invitation, she learned that her impression of the couple as "sedate Brits" was unfounded. Lee embraced her as a member of the family—one who was, moreover, American. She asked Roz questions about herself and said when her opinions were naïve. "She was usually correct, so I didn't mind," Roz recalled. "I was pleased and flattered to be her friend."

During one of Roz's buying trips, which often included stays at Farley's, she sat up with Lee. The alcohol and the lateness of the hour loosened her tongue. "Lee saw herself as one of the boys," Roz said. "Drink was no big deal, sex was no big deal. She had wanted, and assumed, the same rights they had." But when she recounted her war exploits, she did not mention the camps. "She talked about being held by the Russians and matching them drink for drink, of her illness after the war, when her looks went, but never complained. She took joy in the moment."

Priscilla Morgan, a theatrical agent, met Lee in Paris through their mutual friend René Bouché, a *Vogue* artist who lived in a penthouse at the Hotel Crillon. The young woman arrived at Farley's to find Lee drinking martinis while preparing lunch. Intrigued by her accent, Priscilla asked where Lee came from. They nearly "fell into her martini," she recalled, when Lee said Poughkeepsie, which was also her hometown. "It was the basis of our friendship; we had both escaped. Later, when I asked my mother if she knew of Lee, she said, 'Everyone in Poughkeepsie knew of Lee Miller.'" But when Priscilla brought up Lee's work for *Vogue*, Lee became evasive: "She had used up that part of her life. Lee was a hugely creative person who wasn't fulfilling her potential." A passion for cooking, whether complimentary or defiant, was not a way of life her new friend understood.

Similarly, few grasped the reasons behind Lee's equally defiant non-

walking. Roland's taste for country life included excursions in all weathers. While guests who wanted to walk off gourmet meals tramped across the fields in their Wellingtons, Lee cooked, napped, or curled up on the floor with her cookbooks. She purred when Craxton massaged her back, then slept off the aftereffects of early tippling. "She put her nose outside only to pick herbs in the garden," he recalled. One day when Audrey Withers returned from a walk to the nearby copse with a bouquet of bluebells, Lee confessed that she had never gone that far. Her rare excursions to the local pub, the Six Bells, were made in the car, often frightening her passengers as well as pedestrians on the short, winding road from Muddles Green to Chiddingly. Claiming to detest walks helped protect her realm, where Roland's eminence availed him not at all.

In the early 1960s, while completing her Cordon Bleu training at the school's London branch, Lee met several food professionals, including Henry McNulty, a wine and spirits expert, and his wife, Bettina, the *House and Garden* editor who became her cooking companion, co-conspirator, and best friend. Bettina's playfulness matched her own. Bettina and Henry, who represented the French Champagne and Cognac Federation in London, shared Lee's high-spirited, self-debunking American humor. The couple became regulars at the farm as part of Lee's orbit, which grew to include their friend James Beard and others who liked talking about food as much as preparing and eating it. (When Bettina invited Beard, Elizabeth David, and Robert Carrier to dinner with Lee and Roland, Beard concluded that the Penroses were "the maddest people in the world.")

Cooking was "pure therapy," Lee told Bettina, "and it's fun to work in a group like a sewing bee." She had "drifted into cooking," Bettina reflected later, for therapeutic reasons, but also to avoid the need for a career. She felt obliged to put her wartime experiences behind her, to the point of imposing self-censorship on the subject. Cooking was also artistic and practical. It allowed Lee to share the products of her imagination while stimulating conversation, "to guarantee a constantly renewing supply of this intoxicating elixir." But in her culinary endeavors, as in everything else, she required freedom. Lee thrived in the company of those who, like herself, "considered freedom an unalienable right and gave the same freedom to others." "A genuine original," Bettina wrote, she "abhorred manacles, whether political, social or domestic."

Like Lee, Bettina lacked a college education, but her curiosity and wit more than made up for it. She regaled Lee with tales of her years with Henry in France, sampling ten kinds of oysters with Jim Beard and picnicking with him and Alice Toklas; Lee told Bettina the story of her life. "I couldn't live without her," Bettina went on. "As well as planning menus, shopping, and cooking, we spent lots of time gossiping and giggling, talking about my travels

for *House and Garden,* which she enjoyed vicariously. We did things that people like ourselves didn't do then, like watching soap operas." They read English history on their own terms, seeing the kings and queens (as portrayed in popular novels) as if they too inhabited a soap opera—a "Grand Guignol" view of the past that made Mary, Queen of Scots, and Lord Darnley "the focus of a lively conversation almost as if they were currently making newspaper headlines."

The two friends also planned trips with culinary themes. On a tapas crawl through Spain in the early sixties, they deliberately ate only those small dishes that, served together, subverted the formal Cordon Bleu tradition of many courses each in the proper order (Lee's favorites included tapas made of mushrooms called nightingales, others of baby octopus and of "little sole the size of my big toe"). Treating a stop-off in Tarragona as a pilgrimage, she brought sprigs of tarragon to pay her respects, and in Barcelona, jotted notes about the tapas dinner they planned to serve on their return to London. It would mean trips to Jacksons of Piccadilly for green peppercorns, sesame oil, and tapenade; a long list of spices for seviche, celeriac, pine nuts, canned figs, and other items that were then hard to find.

Culinary trips helped Lee cope with the bitter cold of English winters. Over the years, Bettina recalled, she made herself comfortable by stocking her kitchen with ingredients and equipment, like the saffron and paella pans brought from Spain, and loading her freezer with homemade staples such as pesto from her basil harvest, tarragon-flavored oil, and snowballs—"in case a zany guest wanted to throw one in June." By the late sixties, the larder became "a combination of gourmet shop and country store."

In 1963, Lee "jumped at the chance" to join an ICA trip to Lebanon and Egypt, Bettina remembered, chiefly to see Aziz. The two women spent several days in Beirut, visiting archeological sites and sampling the Lebanese equivalent of tapas: olives, pickled turnips, hummus, tabouleh, baba ghanoush, and cumin-flavored boulettes. Lee went to find Aziz soon after reaching Cairo. Having lost most of his holdings under nationalization, he was living in straitened circumstances with their housekeeper, Elda, whom he had married. Aziz seemed old and tired, Bettina thought, yet despite his reverses of fortune, "as charming and elegant as Lee had said." Sitting around his gleaming mahogany table, they reminisced in a language of their own; Lee decided to stay on after the ICA tour to see more of him.

With the group, Bettina and Lee cruised up the Nile for the next week, visiting places she had known before the war—Karnak, Luxor, Edfu, Abu Simbel, and Aswan. On their return, she organized one last expedition: to Wadi Natrun, where thirty years earlier, she had photographed the suggestively curved roofs of the Coptic churches with Wingate Charlton. When a black-robed monk invited the women inside the monastery, they took note of a huge

dry bread loaf in a trough that had to sustain the inhabitants all week—a strik-
ing contrast to the freshly prepared meal they enjoyed in the shade of their
jeep after the tour. This time, rather than the martinis she had brought on an
earlier trek, Lee provided an infusion of hibiscus flowers called karkade to
wash down their meal of flat bread, hummus, tomatoes, boiled eggs, and
Egyptian brown beans. For Bettina, their picnic in the desert ranked as the
most exotic experience of its kind, while for Lee, it recalled more flamboyant
times, when such meals were preludes to nights with a lover.

After Bettina's departure, Lee spent more time with Aziz. One wonders in
what frame of mind she took the cure at Helwan-les-Bains, a European-style
spa near Cairo whose waters were said to help rheumatism. On her return to
London, the two friends began planning a reunion dinner, based, Bettina
explained, on "our own idea of what Egyptian food should be." As with English
history, they did it their way, inventing more fanciful dishes than actually
existed. The menu featured savory bulgur wheat; Golden Chicken "for
pharaonic cachet" (the chicken was stuffed with a rich farce and covered with
gold leaf); Walnut Lamb, a concession to English taste spiced with garlic,
coriander, and anchovies; and for the finale, Persian Carpet, a sensual compo-
sition on a silver tray spread with orange segments and rose petals, then strewn
with candied roses, orange peel, and rosewater—in Bettina's view, a treat
inspired by the romance of their trip.

The Egyptian dinner became the model for banquets based on their ideas
of piquant taste and relaxed conviviality. Trips to the nearby Glyndebourne
Festival provided the occasion for more picnics while reviving Lee's fascina-
tion with opera. On warm summer days, she served lunch outside. It might
consist of cold borscht, fish mousse, seviche, crudités from the garden, and
her own version of gooseberry fool, with whipped cream rather than egg
whites. Sometimes, while Lee, Patsy, and Bettina worked all day on feasts
including dishes from lands whose natives would never sit down together,
members of the family "grumbled," Bettina recalled; they preferred English
cookery.

Lee reverted to plainer fare when Theodore came to visit. During his
three-month stay in 1963, he spent most of his time at the farm. On Tony's
return from boarding school, the old man worked with his grandson in a wood-
working shop set up in a trailer—where Tony displayed the Miller ingenuity by
manufacturing tools of his own design. Theodore did minor repairs and visited
nearby sights, including an abandoned British Railways steam train, with Lee.
While suffering from a bad case of shingles, a recurrent ailment, she prepared
a festive meal for Tony's sixteenth birthday and baked a cake decorated with
sixteen grasshoppers—a tribute to his talent as a jack-of-all-trades. Before
leaving in October, Theodore gave Roland his Swedish razors in trust for Tony,
provided he learned to shave with both hands. "It's a great convenience instead

Theodore and Lee in Venice, 1961

of the contortions required with only one," Theodore noted in his diary, satisfied that his grandson would use these prized possessions when he came of age.

One wonders what he made of the tensions in the household at this time, when Lee's alcohol-induced panic attacks and bouts of self-pity were alienating many of her friends and family. Already in her cups at dinner, she would upbraid Roland for recounting the same stories, then repeat some of her own, or tell Tony that he was boring. Roland's hurt expressed itself in remoteness (he was again thinking of divorce); the coldness between Lee and Tony that had become entrenched in his early adolescence, when he took pains to avoid her, erupted in wounding remarks on both sides. "We hated each other," her son recalled, "and did it with such attention to the fine points that it became an art form. We constantly lurked in ambush and never missed a chance to

assassinate each other's emotions." Their hostility was often enacted before friends, the uneasy audience for these humiliating battles.

Trips abroad became another of Lee's means of coping with the sadness caused by her estrangement from those who were closest to her. In 1961, she and John Craxton toured the USSR with a small group organized by the ICA. In a huge hostel "miles from anywhere," Craxton recalled, "Lee broke down like a child in floods of tears. I was surprised that a tough girl from Poughkeepsie needed reassurance and company. It was immensely touching." He was also touched by her taste for the unfashionable when she fell in love with the "Cecil B. deMille–like" prints of medieval Russian battles—"it was typical that Lee, who lived in a house full of surrealist and cubist masterworks, was no doctrinaire slave to fashion."

In July, Lee and Julie Lawson flew to Rome to travel with Theodore in Italy. "Still magnetic," Julie recalled, Lee attracted people, including the policeman who put her in a cab when her feet became swollen after a performance of *Aïda,* and the Venetians who helped her push the wheelchair to which, increasingly, Theodore resorted, over the cobblestones. (When they went to Peggy Guggenheim's palazzo for drinks, Lee danced until 2 a.m.; Peggy lent them her gondola.) Throughout the trip, Julie noted the tenderness between Lee and Theodore. "It was a great love," she said, "nothing peculiar." Theodore spent the next three months in London and at Farley's.

In autumn 1964, after another trip to Venice for the Biennale, Lee and Roland flew to the United States. On her own in Poughkeepsie, she showed greater interest in her father's new discovery, the TV dinner, than in her brother John's arrest earlier that year in Manhattan for cross-dressing (his case was defended by the American Civil Liberties Union). Lee spent five weeks with Theodore, taking care of him after cataract surgery, seeing friends like Minnow, eating more TV dinners, and baking cookies for Dave and Rosemarie Scherman, who drove up to see her. She returned to England in time for Christmas.

In the new year, Ninette Lyon came from Paris on an assignment from *Vogue,* to interview Lee as a former-celebrity-turned-avid-cook. Lee's culinary interests had begun on desert treks, she explained, when she learned to doctor canned food with spices. (Water was not required to wash dishes, since sand would do—a tip few readers would have put into practice.) She became a serious cook during the war, she went on, because French cuisine reminded her of friends. Since her time at the Cordon Bleu, she loved talking with chefs—"the really enormous ones" (like James Beard). Her favorite dish was *truite au Chambertin;* her first original creation, Muddles Green Green Chicken, resulted from efforts to re-create the Belgian classic *waterzooi,* whose ingredients—celery, parsley, and leeks—Lee had included in such quantities that they became the basis for the new dish's rich green sauce. The article gave her

recipe for this fortunate accident, as well as for the chicken in sesame seeds she had served Miró after his recent retrospective at the Tate.

On reading Ninette's profile, those who knew its subject were astonished by the photograph of Lee looking tidy in a white apron—standing behind Roland's shadowy profile, which occupies two-thirds of the picture. Almost unrecognizable, she was wearing a wig and had had her front teeth replaced to close the gap between them. Although few ever heard her lament the loss of her looks—to which former admirers often alluded—it was clear to close friends that it mattered, especially when contemplating a return appearance in the magazine that had launched her career forty years earlier.

About this time, during one of Roland's trips abroad, Lee decided to take her own advice for fading beauties: a complete face-lift at the hands of Lady Claydon, a well-known plastic surgeon. "She was hellbent on having it done," Roz Jacobs recalled. "When I visited her in hospital, she said, 'Look at my chin!'" The operation removed the bags under her eyes and gave her face greater tautness; Lee regained some of her confidence. Her health improved and she felt happy, she told friends. But on Roland's return, she had to deal with his anger about the surgery, and his practice of seeking satisfaction elsewhere.

Theodore arrived in August 1965 for another three-month visit. At ninety-three, he was often confined to a wheelchair, which did not keep him from teasing and fondling the women who took care of him. "He was a dirty old man," Patsy said affectionately, "but harmless." (Her duties included bathing him once a week, when he stood naked before her to be dried.) Theodore also took a fancy to Anne-Laure Lyon, Ninette's eleven-year-old daughter, who stayed at the farm when not at her English boarding school. She walked him to the mailbox each day; he treated her with respect.

Moved by the girl's friendship with her father, Lee took Anne-Laure into her confidence. "Suddenly this scary adult, who drank to excess, became my friend," Anne-Laure recalled. When she got into trouble at school, Lee lied on her behalf. "She aided and abetted me," the young woman thought, "because she too had been a trouble-maker." In her teens, Anne-Laure sat up late with Lee and listened to her talk about her life. When she came to the subject of the camps, she broke down. Risk takers like themselves, Lee sobbed, sometimes rushed into situations unprepared. When she brought out her photos from Dachau to show what she meant, Anne-Laure could not grasp what she saw but felt nauseated. Lee went on sobbing. "She cried from loneliness as well as drink," her friend reflected, "from never really sharing that experience with anyone."

∞

Although Lee was rarely alone, few understood her solitude, or her reactions to village society. It hurt that locals rarely invited her to their homes, that some

villagers' perceptions of Roland as an eccentric lord of the manor were rein-
forced on visits to Farley's. Lee's "ingrained sociability," Roland wrote, "allowed
her to run her household as a family, abolishing for ever the last remnants of
my punctilious and puritanical upbringing." By this, he appears to have meant
that in addition to their many guests, she included the farm staff, the neigh-
bors, and local shopkeepers at events like the end-of-the-year bell-ringers'
party, when, for an evening, her innately democratic spirit dissipated other
people's class consciousness.

Christmas itself was reserved for the family, including Patsy and her
daughter, Georgina, Valentine, and the McNultys—who had become part of
it. The 1965 holidays were especially memorable for Bettina's five-year-old
daughter, Claudia. Arriving on Christmas Eve, she and her parents entered the
house by the old kitchen, renamed Aladdin's Cave. A giant tree reached the
ceiling; mistletoe and holly covered the walls. "Roland, in his surrealist holly-
king role," Henry McNulty wrote, "directed volunteer guests to hang, stick,
and nail box upon box of tinsel, stars, eggs, silver balls, strings of lights and spi-
rals of flashing silver paper into strategic positions until the sparkle and move-
ment in the Cave was dazzling." The *bigos* that Stan and Lee had been stirring
all afternoon was served at dinner. Breakfast the next day was "do-it-yourself,"
lunch a smorgasbord of herring, patés, salads, fruit, and cheese, "washed down
with champagne," after which presents were distributed. Those who felt up to
it walked with Roland, then returned to await dinner by the fire.

Combining invention with tradition, Lee might stuff the turkey with green
rice or make vegetable purées—carrots and parsnips or potatoes and turnips.
"I have to serve plum pudding," she complained, "but I refuse to eat the stuff,
so I have lemon sorbet as well"; she colored the brandy sauce blue, "to get
away from that relentless red and green of Christmas." The candied fruits that
arrived as presents became the basis for "Nesselrodish things"—desserts using
these sticky sweets as found ingredients. At the combined bell-ringers and
farmworkers party, a traditional buffet was served—sandwiches, sausage rolls,
deviled eggs, and cake, with gin punch.

Roland was at his most genial on such occasions. He wrote the Christmas
pantomime, featuring the children in papier-mâché hats that made them into
mice, cows, or rabbits. When Claudia began to doubt the existence of Santa
Claus, he took her outside to watch Santa's sleigh (shooting stars crossing the
night sky). During the 1965 holidays, when Valentine dreamed of seeing a
ghost who resembled a Victorian child, Lee and Bettina dressed Claudia in
old-fashioned clothes and sent her to bring Valentine down for tea. "Startled,
then charmed," Henry recalled, she regarded apparitions as part of the sea-
son's magic.

On New Year's Day 1966, the festivities were capped by Roland's accep-
tance of the knighthood conferred on him by Queen Elizabeth in recognition

of his service. He had not
renounced the tenets of
Surrealism, as his deci-
sion implied, but would
now be known as Sir-
Realist, he teased, making
light of the honor. The
joke amused friends but
failed to appease younger
critics, who for the next
few months regularly
denounced him as a trai-
tor to the avant-garde.

Lee had mixed feel-
ings about Roland's ele-
vation. She roared with
laughter on reading a
telegram from their friend
Bill Copley that read SIR

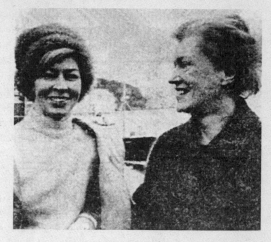

*Bettina and Lee in Stavanger, Norway, January 22,
1966*

ROLAND, WHO WAS THAT LADY I SAW YOU WITH LAST NIGHT? Later,
at the Ritz, she had herself paged to hear her title (Lady Penrose) and told
friends to call her "Lady Lee," which was technically incorrect but matched
"Sir Roland." For the next few months, telephone callers were surprised to
hear her answer "Lady Penrose here" in her deep-throated American voice.
"Hope you were gleeful about Roland becoming Sir R.," she wrote Roz.
"Doesn't that sound like King Arthur's henchmen?" she went on. "That makes
me Lady P. so I can look after the Round Table."

That January, Lee received honors of a different kind. Having decided a
few months earlier to enter the Norwegian government's tourist board's con-
test for the best *smørbrød*—open-faced sandwiches—she practiced at home,
concocting these small snacks for weeks. On the day of the contest, entries
were presented anonymously to the judges, who decided, on tasting them, to
give Lee first, second, and third prize. (First prize, a trip for two to Norway, was
awarded for her Penroses—poached mushrooms stuffed with paté, herbs, and
cheese, then set on buttered bread.) "I don't believe in drinking without eat-
ing," she told a reporter, though she might have put it the other way round. "A
selection of interesting *smørbrød* make marvellous snacks at a party," she went
on, though lately, her husband had "been complaining about being a little tired
of open sandwiches." In Norway, she hoped to meet artists and "ordinary" peo-
ple, visit a herring plant, and cook with the chef in a hotel kitchen.

Since Roland did not fancy more *smørbrød*, Lee took Bettina as her com-
panion. They arrived in Stavanger on January 21 to find a photographer await-

ing them. Their tour became a media event. The newspapers published arti-
cles on the activities of "sandwich queen Lady Lee Miller Penrose," with
recipes and notices of her war work. At Oslo, their next stop, the shapes of
statues outlined by the snow were "like a coincidence of nature," Lee told a
reporter (perhaps thinking of her Paris-in-the-snow photos); residents vied to
have the two friends to dinner. At Geilo, a ski resort, Lee worked in the hotel
kitchen, making trays of Jansen's Temptation, a potato, onion, and herring
gratin, while downing aquavit with the chef. She and Bettina reached Bergen,
their luggage weighted with tinned fish, in time for a reception in their honor.
To a reporter who marveled at the thought of "an English Lady" winning a
Scandinavian contest, Lee explained that she was American—"one of the
brave," the reporter wrote, then noted that Lee had "fallen in love with Nor-
wegian herrings," the vast variety of pickled and marinated fish that preceded
each meal.

After their return to London in February, Lee and Bettina produced an
eleven-course Scandinavian feast that featured herring, Jansen's Temptation,
and, for the less adventurous, Swedish meatballs. The trip fueled Lee's
appetite for culinary research. When family members asked why she compul-
sively clipped recipes and kept smuggling cookbooks into the farm, she replied
that cooking was her work. Friends like Bettina and Jim Beard knew that it had
become her modus vivendi.

That summer, when Beard was testing recipes for a cookbook, he often
spent weekends at Farley's with Lee and Bettina, concocting the informal
meals they all enjoyed, picnics being occasions for relaxed eating and Glynde-
bourne the preferred destination. Lee photographed Jim holding a just-caught
three-foot-long fish—the cover shot he chose for a new edition of *The James
Beard Cookbook*. Though not a professional, she participated as an equal in
the small world of cooking experts at a time before nouvelle cuisine, Bettina
observed, "when chefs were not yet like hairdressers and designers; only
Escoffier and Carême were famous, but everyone knew each other."

Lee's culinary reputation having grown since she became the sandwich
queen, the writer Shirley Conran interviewed her for an article, "Cook Hostess
in Action, Sandwiches *à l'américaine*." Lee's war reports, "though terse and
tough," Conran wrote, "bore a feminine touch"; while she had "the growly
voice and slightly toothy smile" of her compatriot Humphrey Bogart, she was
"efficient and sharp as a razor blade." Conran watched Lee's assembly-line
preparation of the open-faced sandwiches she served at informal suppers,
after a filling soup and before "a whopping rich dessert." Her approach was the
opposite of haute cuisine—which, Lee quipped, "has to be bloody haute to
make me gasp." Despite her title and Cordon Bleu training, Lee's attitude,
Conran implied, was American, the outcome of a democratic spirit. One thing
annoyed her: "people pinching my cooking wine. If I find that bottle has disap-

peared," Lee said, "I march into the sitting-room and replace it with a bottle of the best [Roland] has in the sideboard."

Lee also met Jim Beard's friend Chuck Williams, with whom she discussed recipes and ingredients. Williams, who came to Europe every year to purchase supplies for Williams-Sonoma, his San Francisco cookware store, was friendly with Rosemary Hume, of the London Cordon Bleu, and Elizabeth David, whose accounts of French, Mediterranean, and Italian cooking would inspire chefs on both sides of the Atlantic. In the company of these experts, Lee thought that she too might write a cookbook. But as she clipped, annotated, and filed recipes, the project grew to unmanageable proportions. In the same way that she couldn't be bothered to organize her photographic archive, she left the clippings in their boxes.

Lee's dislike for projects requiring long-term organization did not keep her from excelling in another kind of work: entering, and often winning, competitions staged by businesses to promote their products. When combing through magazines for recipes, she also clipped ads for slogan contests of the twenty-five-words-or-less variety still current in the 1960s. Theodore gave advice about how to install the electric range she won during his visit to the farm in 1967, when family members who had dismissed this new pastime had to recognize Lee's knack for snappy phrases. But apart from Bettina, few saw that she enjoyed the writing for its own sake, or that these contests stirred her delight in being devious by pursuing activities that to most seemed trivial, or worse—lowbrow.

Lee's pride in her winnings made sense to Theodore, whose American optimism she had, in many ways, inherited. At ninety-five, he was keenly interested in his grandson's future, noting with approval that after abandoning his studies in mechanical engineering, Tony, then twenty, was working as a farm student in East Anglia, a prerequisite for attending the Royal Agricultural College at Cirencester. Though arthritic, Theodore inspected the farm machinery and worked on an old project of his—the projection of images. His July 1967 diary records his idea for "a method of suspending a screen for projected pictures from a ceiling by means of an elongated or any shaped balloon which could be inflated by compressed gas." (It is not known whether the invention was tested.) While the villagers considered the inmates of Farley Farm people of dubious morals, they made an exception for Theodore, whom they saw as an emissary from another world. (The story went round about his shocking the nuns at the hospital where he stayed during an illness. On awakening from a coma, he proclaimed, "I want you to know that God does not exist!")

In the opinion of Chiddingly, then a parochial, "upright" village, the others at Farley's were artistic, foreign, or both—neither term being complimentary. Although English, Patsy was depraved because she didn't wear shoes; Valentine ("that Frenchwoman") wandered the country lanes to no apparent pur-

pose except to steal cuttings from gardens; a heathen figure with bare breasts and painted toenails (Iris) stood at the kitchen door. Roland achieved respect on being knighted, but his having two wives in residence remained suspicious. As for the current Mrs. Penrose, she was American, and what was worse, she served strange dishes at ungodly hours.

There were exceptions to the general disapproval. Jane Brymer, whose family lived in the cottage across the road, loved Farley's for the same reason that Chiddingly remained aloof: because nothing was done according to local standards. Jane was ten when invited there to play with Claudia McNulty. They turned the Henry Moore statue on the lawn into a den, swung on the garden gate, and did pretend-cooking with Patsy. At lunch, the child's first meal at someone else's home, Jane enjoyed the taste of unfamiliar foods (like olives), the high spirits and laughter, and being told to call her hosts Lee and Roland, which felt like "a grown-up privilege." Though the villagers said that Farley's was not a "proper household," it was one where the little girl felt at home.

"Lee was the house and the house was Lee," Jane Brymer recalled years later. Her presence or absence was "palpable." In the kitchen she was always in motion, smoking and gesturing nonstop. One day Lee took Jane into her sitting room to chat. "She wanted to communicate with someone who was not judgmental," Jane thought, "and she made me feel that what I had to say was important." Lee emphasized the need for an isolated child like herself to read, go out in the world, follow her desires. At other times, she spoke to her as if she were an adult. Noting Jane's interest in their paintings, Roland took her round the collection. Lee gave her a book on art history and, without knowing it, the sense that Surrealism was "a natural reaction to life."

As a young girl, Claudia McNulty took the creative ferment at Farley's for granted and saw Lee simply as her mother's friend. As she grew older, she wondered why Lee was fond of her. While she and her mother were both independent spirits, Claudia felt too well behaved, especially when Lee recounted her adventures on railroad trains or in the desert. "She was a figure out of a story-book," the young woman reflected later, yet she had treated her like a daughter. During the 1960s, when Lee wounded Tony with acerbic remarks and he retaliated with boorish behavior, her affections were transferred to Anne-Laure, Claudia, Jane, and Patsy's daughter, Georgina—the girls in her entourage whom she tried to protect and embolden.

"I think she felt trapped in the country," Claudia went on. "Later, when I was reading Flaubert, I remember thinking that there was a bit of Emma Bovary about her, such an energetic person in this environment, even if there was a tremendous mix of people at Farley's." Claudia noticed Lee's feeling for the underdog, her refusal to say "snobbish things" about social inferiors, and realized that she "had a dark side." When Lee talked about the war, the teenager was shocked to learn that she had bathed in Hitler's bathtub—the

story was "disturbing" as Lee told it. "She was someone who had wanted to do good," Claudia said. "When I was sixteen, she let me know that she would help should I become pregnant and not want to tell my mother. I was touched . . . that she wanted to be in a position of importance in my life."

In 1966, when Lee's niece Marnie, the daughter of Erik and Mafy, came to England with a friend after high school graduation, she decided that Lee was her own Auntie Mame. "I had been expecting to meet a lady," she recalled, "not someone who used coarse language and treated us like peers." During this "eye opener" of a visit, Marnie saw that like her mother, who drank in secret, Lee was an alcoholic. Yet her aunt's drinking did not keep her from "dashing off at the drop of a hat." And while she was not the motherly type, she loved frivolous escapades with the girls—taking them around London, to Carnaby Street and Mary Quant's to shop for clothes.

Later that summer, Marnie saw Lee again in Venice, where her aunt wanted to see a writer friend who had been imprisoned during the war for smuggling Jews out of Germany. Marnie and Lee were in St. Mark's Square when one of its many pigeons deposited a slimy white trail on Lee's hair— an event that gave both of them hysterics. "There is nothing I can do," Lee gasped between giggles. (When her hair dried, she combed it and went to her rendezvous.) If Lee had a touch of Madame Bovary when in Chiddingly, it vanished in places like Venice and New York; travel with kindred souls had the effect of a natural high.

∞

Lee's trips over the next few years took her to the United States to see family members and to old haunts like the south of France. She followed Theodore home shortly after his departure in 1967. In October, she divided her time between New York (Roland joined her to lecture at the Museum of Modern Art) and Poughkeepsie, where she helped her father sort through his possessions. In November, she met Erik, Mafy, and Marnie in Chicago, then flew to San Francisco, where she had dinner with Chuck Williams and discussed her ideas for a Lee Miller cookbook, a project that still fired her imagination. She returned to Poughkeepsie in time to celebrate Thanksgiving with Theodore, John, Joanne, Trish, and their families. Having turned sixty that spring, she felt the need to be with her kin.

Lee's annual visits to New York, where she often stayed with Roz Jacobs, Priscilla Morgan, or Rosamond Bernier, did not always bring out the best in her. At social events, some old friends avoided her because she drank heavily and became sentimental. "At her age," Priscilla noted, "Lee could have been an older beauty, but like most drinkers, she gave into it, which made her look worse. She had lived too freely; she hadn't protected herself." Rosamond lent

Lee in St. Petersburg, Florida, October 1969

Roland and Lee her apartment during one of their visits even though Lee was "epically untidy." While her affection for her friends did not waver, she was distressed by the chaos she found after their departure. Nor could she understand Lee's disregard for her appearance: "She made no effort to please, though she knew that Roland was sensitive to feminine beauty." The consensus in the art world, where appearances counted, was that Lee went too far in her disdain for convention and her desire to shock people, themselves included.

In 1969, Lee learned of Tanja Ramm's whereabouts when her daughter, Margit Rowell, ran into Roland in Paris. On a trip to New York that autumn, Lee and Roland visited Tanja and her husband, a professor at Johns Hopkins. From then on, the Rowells stayed with them when in England; Lee and Tanja took holidays together on the Riviera to make up for lost time. Moving in academic circles had not changed Tanja. When Margit showed her mother Man Ray's photograph of Lee's headless torso, she remarked, "You never forget the tits of the girl you room with"—though she professed a certain vagueness about Theodore's nudes of herself. The renewal of their relations brought Lee the comfort of being with a friend who had known her in her heyday but did not mind that she was no longer a beauty.

It also gave her another surrogate daughter in Margit, a curator and art historian. When Margit met Lee for the first time at the Rowells' fortieth anniversary party, "we became intimate immediately," the young woman recalled. From then on, they saw each other whenever Lee was in New York. Dressed in the white turban she often wore to hide her hair, Lee was still "very beautiful and very up front," Margit said. "She had lost neither her innocence nor her enthusiasm for life."

During Lee's 1969 visit to the United States, she spent much of her time with her father, then ninety-seven. Feisty but frail, he had decided after a

stroke earlier that year not to risk transatlantic travel. His diary entry for September 25 notes in his arthritic hand the arrival in Poughkeepsie of "Lee, Lady Penrose"—as if it were a state visit. (The next entry relates the sweetly risqué story he told her: "Young man being introduced to a girl in a very revealing costume said I am very pleased to see you & I shall look forward to seeing more of you in the days to come.")

In October, Lee and Roland went to Florida as the guests of Nelson Poynter, publisher of the *St. Petersburg Times,* and his wife, Henrietta Malkiel, Lee's friend from New York theater circles. The *Times* reporter sent to interview Roland, who was to lecture on Picasso, emphasized his knighthood while noting that since the 1920s, he had "lived in the vanguard of art." Whatever direction painting might take with the advent of computer technology and "concept art," these developments would not replace oils, Roland believed, since "a painting can seize a moment . . . and carry this moment of time with it"—a philosophy illustrated in the accompanying photograph, which showed Lee and Roland rapt in contemplation of an abstract sculpture.

A portrait of a reflective Lee with her Hasselblad accompanied the *Times* interview with her the next day. A backward look at her life, it attributes her experiences as "a top model, an actress, an Egyptian, a world-renowned photographer-correspondent and an author" to her discovery of Paris at eighteen, when she escaped from the chaperone who had taught her French. In this account, everything flowed from that fortunate accident. Noting Lee's nostalgic tone when recalling her time with Medgyès, Man Ray, and Cocteau, and in Egypt, the interviewer asked her about the courage it took to be a photojournalist. Or was it luck, Lee replied, "a matter of getting out on a damn limb and sawing it off behind you." Although her current passion was gastronomy, she disliked most domestic pursuits, like flower arranging. "I'm no good with my hands," Lee teased, "though I am good with a screwdriver—taking a camera apart. But sewing on a button? I could scream!"

After spending November in Poughkeepsie, Lee returned to London in early December, in time to accompany Roland to an Arts Council dinner at 10 Downing Street, where she behaved herself in accordance with her status as Lady Penrose. Increasingly, Lee accompanied Roland on the lecture tours to which he turned in his disenchantment with the ICA, where younger members saw him "as an old fuddy-duddy," someone who, despite his avant-gardist past, was now "firmly in the establishment's camp." By the late sixties, when happenings had supplanted the modernist retrospectives Roland favored, he felt out of touch with the organization he had founded. At the same time, the ICA's move to an imposing classical building on the Mall in 1968 required massive infusions of cash as well as the continued support of the Arts Council, which looked with disfavor on the provocative exhibits being mounted as the latest in revolutionary art.

What was worse, in Roland's view, were the new director's associates—"an

unruly clique, a 'mafia,' which began to defy and then openly to sabotage the instructions of the ICA Council." A break occurred following an event sparked by the new crowd's love of mischief. Invited by the "mafia" to stage a happening, an American performance artist named Rosalie filled the ICA auditorium with foam rubber tubes, took off her clothes, and invited the spectators, some of whom were on drugs, to join her. Lee disapproved of the event, which piqued the interest of the police and angered the Arts Council.

Another event linking art to notoriety further undermined Roland's sense of himself. In 1969, while Lee, Roland, and Tony, then in his first year at the Royal Agricultural College, were in Chiddingly, thieves broke into their London flat, ripped twenty-five of their paintings from their frames, and made off with them. Scotland Yard put its art squad on the case; Interpol was alerted; Roland went on BBC-TV in an appeal for information. The detective in charge of the case identified the thieves but not the location of the paintings—which turned up months later when some London workmen found what they took to be "an old pile of rubbish." Dusty but mostly undamaged, the priceless paintings were returned to Roland, who wept on seeing them. From then on, his son writes, "we lived among burglar alarms and security systems. The casual accessibility that Roland gave others to both the collection and his life was ended."

Roland made an exception when a vivacious young Israeli he met that year captured his fancy. Daniella Kochavi had made her way in London as a foreigner, and a Jew, with difficulty. Her outgoing nature, warmth, and dark beauty captivated Roland; her enthusiasm for modern art—she was then editing a film on Picasso—revived his sense of his importance in a lovely woman's eyes. Roland was enchanted with his young mistress. That he was seventy and she was twenty-two did not matter (except to friends who thought the affair silly). He told Daniella that sexual relations with Lee had ceased after Tony's birth, and that she agreed to his knowing other women. Since Daniella made Roland happy without posing a threat, Lee made her feel welcome at the farm.

Soon she began telling the young woman about her adventures at her age, treating Daniella like another surrogate daughter—who had the peculiarity of loving Roland. One evening when they were alone together, Lee asked Daniella what she saw in him. He had shown her the things that enhanced life, she explained—art, nature, good food (thanks to Lee), wine, and conversation—and made her feel comfortable in the company of the critics, artists, and writers who formed their circle. Lee and Roland were her English family.

"I adored Roland," Daniella remarked years later. "It was a Svengali-like relationship. He formed my taste, and Farley Farm showed me how to live." What he and Lee had created—the evening conversations, the flowers on the table, the mural over the fireplace, the Picasso in the kitchen—inspired and nurtured her. "You seem to be the initial source of . . . my pleasures and preoc-

cupations," she wrote Roland on his seventy-fifth birthday, "so how could I not love you with all my heart and think that you are the most wonderful person." Basking in the young woman's affection, Roland took her to Paris (where she met Diane) and, later, on a cruise to Sardinia.

Roland asked Lee, rather than Daniella, to visit Picasso at his isolated villa, Notre-Dame-de-Vie, whose location on a hill near Mougins brought back memories of long-ago summers. Although Lee rarely bothered to travel with her camera, she always brought it on trips to see le Maître. In June 1970, as part of the Avignon summer festival, his drawings and paintings filled several rooms in the Palais des Papes. Lee photographed the majestic palace and took al fresco shots of Picasso with friends and patrons, showing some of her zest for odd perspectives by shooting the group from above while they inspected a Gobelins tapestry based on his *Women at Their Toilette*. Tired of admirers and depressed about his work, Picasso canceled their next appointment, but two days later greeted Lee and Roland "with his usual equanimity and affection."

By December Lee was "in a tizzy," she told her father, who was then ninety-nine. After the usual holiday festivities, she flew to New York on January 3, 1971, to join him on a cruise to the West Indies. She hoped to see friends like Tanja, she went on, "but mostly to relax on the most perfect family holiday possible—can't think of a better way to see a lot of you, & I can rub sunburn oil on your bald pate, & you can scratch my mosquito bites." The cruise would take them to Dominica, Jamaica, and Puerto Rico—another return to the past, in that their trip there in 1923 had been the actual start of Lee's adventures, at a time when Florence Miller saw her and her father as the resident trouble-makers.

Nearly fifty years later, Lee's letter implies, she still felt like a runaway, but one who has acquired a position in the world. The passenger list for their ship, the MS *Gripsholm*, signaled the presence on board of Lady Penrose from Poughkeepsie—the most concise account of her career thus far.

Lee and Roland, Arles, 1976 (Marc Riboud)

Chapter 18

Retrospectives

(1971–77)

Theodore Miller died on May 5, 1971, two weeks after Lee's sixty-fourth birthday and a month before his centenary—an event he had hoped to celebrate with the family until pain undermined his will to live. Lee was left alone with her grief. Her father had loved her unconditionally, albeit too intimately, and she had returned his love. On June 3, his birthday, she cabled John Miller: THINKING OF DAD.

Nineteen seventy-one was a year of thinking back to earlier times. Having been superseded by the war, Surrealism was now being claimed as an inspiration for the social upheavals of the late sixties. The movement's outlook was not restricted to particular times, its apologists said; "surrealism" would persist after "Surrealism" (the official phase having ended with Breton's death). This view of the movement—as something like a religion—revived that year in London art circles with Eileen Agar's retrospective at the Commonwealth Institute and an exhibit, "Britain's Contribution to Surrealism," that emphasized Roland's role in the movement he had started.

Since the publication of Roland's book on Miró the previous year, he was again in demand as a speaker. Lee accompanied him on lecture tours to Ontario, Hartford, and New York, where they attended the opening of the Guggenheim Museum's Miró retrospective curated by Margit Rowell. About this time, Lee dined tête-à-tête with Man Ray, whose life Roland planned to write next, in time for the retrospective he was organizing for Man's eighty-fourth birthday, in 1974. Mutual friends remarked on the closeness between Man and Lee, an abiding love born of their artistic collaboration and intimacy—though Man remarked one day to Roz Jacobs, without a touch of irony, that Lee no longer excited him.

When not traveling, Lee brought together those she loved at the farm, where she entertained on a reduced scale. Though members of her extended family—the O'Briens, the Lawsons, the McNultys, Anne-Laure—came on weekends and holidays, the revels of earlier days had all but ceased, except for occasions like Anne-Laure's sixteenth birthday, an informal coming-out party at which Tony served as the disc jockey and Lee flirted with the young men, as if reliving her flapper days. New acquaintances also turned up—whenever she met people for whom she felt an affinity, she invited them to Farley's.

Lyn and Ed Kienholz met Lee and Roland in London when the ICA exhibited Ed's Surrealist-inspired assemblages. Lee took to Lyn, whose zest for life matched her own. The spirited young woman shared Lee's love of food and gadgets; when they sat up late drinking whiskey together, Lee encouraged her to explore her interests. Soon Lyn was sending her culinary supplies from Los Angeles: Cut-Rite wax paper (the English brand smelled odd) and, when Lee acquired a microwave oven, one of the first in England, recipes for her new "toy" and a Geiger counter to check radiation leaks. Lee asked about Lyn's basil crop and gave news of her own, sent recipes for butters made with herbs from the garden, and emboldened her friend after her divorce. She could do whatever she wanted, Lee insisted. She could live well on her own; she must follow her passions for food, art, and design. (Years later, Lyn reflected that Lee had not always taken her own advice.)

Following Tony's graduation from the Royal Agricultural College in 1970, Roland and he discussed plans for the future, his own and that of the farm, whose manager was not yet ready to retire. At Roland's suggestion, Tony decided to travel before settling down at Burgh Hill, the nearby dairy farm Roland had bought recently. In 1971, with a Penrose cousin and Robert Braden, the son of Farley's manager, he began what would become a three-year trek around the world in a specially fitted Land Rover named Que Sera. Valentine, then in residence at Farley's, read the expedition's tarot cards, which predicted their safe return, and Roland marked their travels on a map of the world.

For the first time in many years, Lee and Roland did not spend Christmas

at the farm. Lee's tolerance for what she called "this bloody English weather" being low at the best of times, they went instead to the Canary Islands—"all volcanos, dragontrees, rainstorms & rainbows," she told Lyn. She hoped that they would travel to Spain together soon, to sample recipes.

Bettina's long-standing plan to write about Lee for *House and Garden* came to fruition in the summer of 1972. The staff photographer arrived at Farley's when the vegetable garden was full of peas, beans, and artichokes, and the freshly mown lawn ready for croquet. Lee and Bettina set the table outside for an informal lunch—cold borscht, salads, fish mousse, rice salad, and her signature dish, the prize-winning Penroses—all enhanced with edible blossoms from the garden and displayed in bright, amusingly shaped dishes. Lee, neatly attired but less glamorous than in Ninette's *Vogue* piece, was photographed preparing dessert in the old kitchen, itself gussied up for the article, "How to Make an Art of the Happy Weekend."

Subtitled "The Personal Strategy and Beautiful Food of Lee Penrose," the full-color spread was a retrospective look at an approach developed over the last two decades, during which Lee had learned to amuse herself by entertaining friends. This "compulsive cook," Bettina wrote, retained the speed and flexibility of her years as a war photographer. She enjoyed rethinking her *plan de bataille* when extra guests arrived; she loved time-saving devices and ingredients made in advance—roux, clarified butter, toasted filberts. Before giving Lee's recipes, Bettina explained her strategy. Dishes must be easy to serve (no joints of meat), right for the guests (including vegetarians), and, if possible, surprising (summer pudding made in season, then frozen, to serve in winter). "I like one-implement desserts, simple things that keep the conversation going," Lee explained while the photographer snapped pictures of her at work on the pudding.

By the time the *House and Garden* piece appeared in 1973, the weekends depicted in its glossy pages no longer occurred as often as before. Family members objected that lunch at Farley's was never so elaborate, but Lee was delighted. The article "makes us look luxurious," she told Margit, and alerted friends to pick up copies. Now that she was becoming known as a cook, others requested interviews.

For a *Vogue* piece, "The Most Unusual Recipes You Have Ever Seen," Arthur Gold and Robert Fizdale featured Lee's "Surrealist surprises." Lee had invented culinary Surrealism, they wrote, by putting familiar ingredients in odd contexts. Her Mack Sennett cream pies were both cinematic and Dadaesque, she explained—"delicious to eat and fun to throw." Her food paintings (veal scallops encased in gold foil valentines, relish-stuffed lychees beside cherry tomatoes full of dark green mayonnaise) were "as amusing to look at as they are delightful to eat." Interspersed between recipes, they gave the highlights of Lee's past in art and photography, her marriages, and life as a

cook. Her love of contests ("Dada high camp," in their opinion) illustrated particularly well her "you-know-this-is-all-in-fun" spirit. The piece ended nostalgically with Tony's favorite, "Antonio's Sweet-Sweet" (a hazelnut meringue filled with apricot brandy cream), and Lee's tale of besting Cyril Connolly with her marshmallow-cola ice cream.

Henry McNulty's "Christmas at Muddles Green," published in *House and Garden,* struck an equally nostalgic note. "Christmas can be a gastronomic desert," Henry wrote, "bound and gagged as it is by tradition." But due to Lee's role as "mastermind, magician, [and] chef-gastronome," this had never been the case at Farley's. "Lee's Christmases are a memorable mix of personal nonconformity with custom," he continued. After describing the meals, rituals, and surprises of a typical holiday season, he ended with Claudia's recollections of Christmases past: "It was huge tree presents, being taught to ride a bike, loudness, fun—but Christmas really only began at lunchtime."

Each of these backward looks emphasized a different facet of Lee's culinary career. Together, they validated her postwar years from her current vantage point. About this time, Roland was also trying to depict the past in his book on Man Ray. Informative about its subject's work but reserved about his character, the book's attitude toward Man's relationship with Lee is puzzling, even though it is dedicated to her. She appears briefly as Man's "provocative assistant," the model for the lips in *Observatory Time* and the nude in *Electricité,* in which, Roland wrote, "sex and industry were subtly united"—the awkward use of the passive voice indicating some discomfort. While these well-known images are included in the book, Man's use of Lee's eye in *Object to Be Destroyed* is not mentioned. (After quoting his directions to destroy the eye of "one who has been loved but is not seen any more," Roland wrote that they "hide an inner rage.") The book notes Lee's "inadvertent" part in the discovery of solarization, but treats her as one of Man's muses—especially in the section where her profile and Juliet Man Ray's head, both solarized, are on adjoining pages.

In December 1974, Lee and Roland flew to New York for the opening of "Man Ray, Inventor, Painter, Poet," the New York Cultural Center's retrospective curated by Mario Amaya at which these iconic images of Lee were on display. One wonders what she made of Man's portraits of herself, whole and in pieces, as she toured the exhibition, which also included *Ce qui manque à nous tous,* the suggestive pipe and soap bubble assemblage that encoded the erotic charge of their relations. He had declined to come for the show, but mutual friends—Bill and Noma Copley, and Roz and Mel Jacobs, who lent works from their collections—reminisced with her about Man. Lee was, Bill Copley wrote, "his favorite of all models." Her presence in his life "marked his return to painting" with *Observatory Time*—a work "having a warmth and a naive erotic implication that was embarrassing even to some of the Surrealists."

Soon after the opening, their rapport was again evoked (for those in the know) at a Cultural Center party thrown as a re-creation of the Pecci-Blunts' 1929 Bal Blanc, at which Lee's admirers had sent Man into a jealous fit. John Loring, Amaya's assistant, asked Lee to help him cook an all-white dinner for the guests, one hundred celebrities and supporters of the arts. She accepted with glee. That afternoon, as they cooked and drank martinis, Lee was "ebullient," he recalled: "She had the presence of a woman who has always known she was beautiful." Starting with the first course, *brandade de morue,* they were soon "up to our ears in cream, olive oil, and codfish," Loring continued. Lee tasted the dish, then cried out, "More garlic! More olive oil! More martinis!" They took care to spice each of the courses—veal with cauliflower, rice, and endives, and vanilla ice cream with lychees. Lillian Gish pronounced theirs "the first acceptable meal" she had eaten, but Lee and John concluded that "food of one color made them uneasy."

When the retrospective came to the ICA the following spring, Man and Juliet flew to London for the opening, which featured a Man Ray–inspired installation instead of an all-white dinner. Feeling his age (almost eighty-five), Man accepted the wheelchair Lee hired for him and the attendant who wheeled him through the crowds in the long gallery. Meeting Lee by chance in the installation room, where large transparent plastic tubes lay on the floor in snaky patterns, he got up from his chair and crawled into one end of a tube while Lee crept into the other. They met in the middle and backed out laughing. Each day, Lee visited Man at his hotel. They sat side by side on the bed and didn't always talk, Man's assistant recalled: "There was great tenderness between them. Juliet seemed like a stranger when Lee was there; she seemed like his wife."

Lee's bond with Man was very much on her mind when Mario Amaya talked to her about their relationship. Amaya had acquired a certain notoriety in 1968, when a deranged Valerie Solanas shot him and nearly killed Andy Warhol. Since then, he had remade his reputation as an energetic art-world figure and a writer on subjects ranging from Art Nouveau to the fringe subcultures he frequented when in London. Charming and witty, he made Lee laugh. She agreed to a series of interviews with him, the first of which, "My Man Ray," appeared in 1975. Lee's "intense personal and working relationship" with the artist was one episode "in a colorful and varied career," Amaya wrote in the introduction, but one that had marked both artists' lives—as shown in "the two most interesting images that Man Ray ever created," the lips of *Observatory Time* and the eye of *Object to Be Destroyed.* The lips were "one of his fantasies," Lee said obliquely, the eye "something like a wax statue to poke needles into."

Amaya asked Lee to discuss her work with Man, to tell how, "besides learning all of his techniques, she accidentally invented one of the most

important of them . . . 'Solarisation.' " Describing her work as his printer, she acknowledged making "the initial mess" that led to their discovery, the image "that started this whole sequence off." (The sensuous feel of their work together is palpable in her metaphors: the black line coming "right up to the edge of the white, nude body"; the new exposure being unable to "marry with the old.") But it was Man who learned to control her discovery, she explained, "and make it come out exactly the way he wanted it to." During the interview, Lee did not discuss her own work as a photographer. What mattered was her long friendship with Man—that despite his stubbornness and her bullying, they fell "into each other's arms" each time they met.

Lee spent the summer of 1975 in "an orgy of freezing things," she told Lyn Kienholz. In her role as purveyor, Lyn brought her a new cookbook for her microwave, Freezettes to preserve produce, and cherry tomatoes in cardboard containers. By September, Lee had "not quite recovered from overdoing it in the heat," she wrote, but was still enamored of the microwave: "I'm very bold now and try anything"—her latest creation, a ham loaf made from leftovers in twelve minutes. By Lyn's next visit, "all those damn beans and zucchini will be over their season. No picking, no blanching, no packaging, labelling etc."

Meanwhile, her gadgets were living a life of their own. "My 'Toys' have been breeding," she told Lyn in another letter. "The oven and the Cuisinart got together I think and made me a Crock Pot, which I either haven't got the hang of, or had meat which hadn't been hanged as it took 18 hours to make a pot roast, and since I'm just recovering from acute muscular rheumatism and fever, my arm won't yet rotate easily enough for me to use my electric pancake maker, so I'm saving it for next week. Every week a new Toy, I hope!"

Her other news concerned Tony, who had come home from his trip around the world with Suzanna Harbord, the young ballet dancer he had met on his travels and married in New Zealand. Once the couple returned to England, having made their way through the Americas and Canada, Lee and Roland embraced Suzanne, who did all she could to effect the gradual rapprochement between Lee and Tony that took place over the next few years. "She would invite Lee to our home as often as possible," Antony Penrose writes. "Slowly we came to understand each other. We would never have a usual mother-son relationship, but we found that like many enemies who become friends we had a lot in common." Lee's drinking was under control; New York publishers were considering her cookbook proposal; Tony was, in his own way, by making films, pursuing the career she had abandoned.

Still other changes had occurred while Tony was away. Roland's differences with the ICA management had intensified. By 1976 there was "a bloody battle raging," Julie Lawson told Lyn. The new director ruled "with an iron fist & a teeny weeny mind." Roland, she said, "*can* get angry & outraged but cannot *fight*!" By then, Julie was doing most of the work on the exhibitions Roland

proposed, including a 1976 Ernst retrospective. The director's henchmen took advantage of the rift to sabotage their work for the show in petty acts of vengeance: removing Roland's office furniture and smearing the gallery walls with purple paint. That November, he resigned. "I no longer recognise in the present situation," he wrote, "the fundamental aspirations or the enthusiasm which have during the last thirty years caused me so willingly to give to the ICA all I could afford in time and money."

Roland was also grieving the loss of close friends. Picasso's death had been devas-

Lee with two hats, Arles, 1976 (Marc Riboud)

tating. "The news on the morning of Sunday 8 April 1973 that he had died at first seemed incredible," he wrote, "another of those diabolical jokes he delighted in inflicting on friends." Since then, Roland had been embroiled in the controversy surrounding the gift of Picasso's work to France in lieu of taxes—an onerous, and depressing, obligation.

Max Ernst's death on April 1, 1976, deepened the gloom. Lee invited Dorothea to Farley's in June. They found temporary solace at Glyndebourne in performances of *Così fan tutte* and *The Marriage of Figaro,* then returned to Paris together because Dorothea could not bear to be alone. "We never left the house it was so hot—played scrabble in our nightdresses for a solid week," she told her old friend Jackie Braun, although she made an exception to see Man, who received visitors on his sickbed; she later went to represent him at the Rencontres d'Arles photo festival. "The show was much appreciated by the 500 photographers present (and 2000 cameras)," she told Julien Levy, though, oddly, she failed to bring her own.

Other old friends were feeling their age. Julien sent sections of his memoirs for Lee to critique. What he wrote about her was "near enough," she replied, though she didn't recall their Paris trysts as he described them. "BUT," she continued, "I don't like you saying that Man Ray hit the bottle. . . . Man was never a boozer, even in his moments of drama he wouldn't have been drinking away his sorrow." Saying so would distress him. Since he was "very fragile, can't get out and about at all without considerable pain," she hoped that Julien would eliminate the hurtful passage. (He did.)

In the meantime, David Travis of the Art Institute of Chicago mailed Lee a questionnaire about her photographic career, in order to document the thirty-six Lee Millers Julien had donated to the institute and to catalogue his collection. Since Travis was also trying to reconstruct the photographic milieu in Paris in the 1930s, he hoped to learn more about her work. Lee replied that most of it had disappeared—"lost in New York, thrown away by the Germans in Paris, bombed & buried in the London Blitz," and recently "scrapped by Condé Nast." It was simpler, at this point, to dispatch her career as if the damage had been done by others than to sort through the trunks full of negatives stored in the attic—about which she maintained a kind of amnesia.

Despite Lee's reluctance to revive the past, filling out a questionnaire for Travis reawakened her sense of having had a career. She listed her one-woman show at Julien's gallery, New York studio contracts, *Vogue* articles, *Grim Glory* and *Wrens in Camera,* as well as her film career with Cocteau and at Elstree Studios. On the strength of this information, Travis wrote a biographical notice for the catalogue, which Lee corrected. Mario Amaya "wants to do a biography with and of me," she wrote on October 9, and a French art historian hoped to exhibit her work. "I've been delayed, by a variety of things, mostly inertia," she went on. "I haven't yet managed to take off on the project of digging around and thinking of the past."

Lee left for Paris the next day, to be with Man. Although he was usually in too much pain to see people, Lee found him in good humor. Sitting beside him, she asked questions on Travis's behalf about old acquaintances—his assistant Boiffard, who "knew nothing about photography & said so" when hired, Germaine Krull, Berenice Abbott, and Eugène Atget, whose work Man had tried to print on stable paper only to hear him express distrust of "this modern stuff." Despite his weakness, she told Travis, Man "was in a good mood & for once, didn't mind talking about the old days." This was the last time she saw him. On November 18, Juliet phoned Lee and Roland to say that Man had died in his studio, where he had spent most of the last year wrapped in blankets, contemplating the effects of age.

Suffering with depression following the loss of Pablo, Max, and Man, Roland found solace with Daniella. Lee bored him, he told a close friend. Increasingly, she sat by herself in her downstairs room, listening to music, sort-

ing her correspondence, and revisiting her cookbooks. While her passion for cooking remained, classical music became another "personal strategy." She cooked with the radio blaring until a new toy, one of the first Walkman devices to reach England, allowed her to listen in isolation. When the cassette player first arrived, she took it everywhere, startling Londoners who saw her walking around in headphones, humming to the inaudible tunes that filled her ears. Her favorites included Mozart and Beethoven; like her cookbooks, tapes of their compositions piled up everywhere.

In the mid-seventies, when Lee threw herself into her new passion, she attended concerts with a music-loving friend in London and listened to Antony Hopkins's music programs on the BBC, which she often recorded to hear over again. Many in their circle were astonished by her new interest. "There was something absolutist about her," a friend reflected. "With music, she was there, but not there, as if enchanted. For some, music is a kind of inner voyage." Although Lee professed a hatred of religion, especially its traditional forms, her feeling for music may have opened the door to a dimension akin to the spiritual—the vastness she had glimpsed through her lens in *Portrait of Space* and, later, across the reaches of the South Downs.

Visits by Miller relatives buoyed her spirits. Erik, Mafy, their daughter, Marnie, and her husband, Victor Ceporius, all came to England in 1975. When British immigration threatened to expel Victor, who lacked the correct passport, Lee phoned the head of the department to say that Lady Penrose would storm the gates if they did not let him in. That August, her niece Trish also stayed at the farm. She helped Lee with meals and made a blackberry pie. And they discussed one of their favorite topics, sex. Lee said that it was a privilege to initiate a younger man—thinking, perhaps, of Dave Scherman. She comforted Trish, who was going through a divorce. "Lee was tender-hearted and sympathetic," she recalled later. "Her bravado was a façade to deal with bullies and patriarchs, the Miller men and people like them."

By 1976, Lee was seeing few people. A local writer came to lunch to taste her new creation, elderberry-flower ice cream. He noted that she was not the sort of cook "of whom Swiss punctuality could be expected, but there were always endless Camparis and soda to pass the time." Nancy Hall-Duncan, a curator at the International Museum of Photography in Rochester, New York, wrote to ask permission to show Lee's work in an exhibit of fashion photography, but when she arrived at Farley's to choose images, Lee could find only one of her wartime shots for *Vogue*. Most of the time "she sat alone and desolate," Julie Lawson recalled with sadness. "You wouldn't dare ask what was wrong. She was unhappy, but she didn't want you to know."

The one bright note was Suzanna's pregnancy. Lee would be a grandmother by spring, she told friends proudly; she bought her daughter-in-law resplendent maternity clothes and basked in their mutual affection. In the

meantime, her own health had worsened. "I've been almost continuously away or ill," she told David Travis. While she was "trying to put order in and around the edges of the mountain" of her papers, she did not feel up to it. "I've scarcely recovered from the last horrible year with Man Ray, Max Ernst & so many others dying," she continued. "That nasty Indian Goddess Kali & the Chinese Dragon year really wreaked havoc. I'm beginning to believe in them."

∞

The new year brought little relief from her rheumatism, recurrent pneumonia, and a new ailment, a deep, persistent cough. "This is the last winter I'm going to spend in this filthy climate," she wrote Lyn, "so find me a civilized cabin in Calif. for next winter, near a nice market as I *have* to cook & want to learn all sorts of Mexican dishes." Having recently returned from Iran, where he was filming a documentary, Tony was exhilarated about future film projects and "even more exciting," he told Erik and Mafy, "the new sport of watching Suzanna grow bigger and bigger every day." Lee had "medical problems" for which she had been checked, he added. "It seems that there is a non malignant fungus growing on her lung—father claims it's a load of mushrooms." By mid-March, Lee was responding to treatment—"back on the party/dinner/etc circuit with all usual stamina"—while Roland spent every other week in Paris, "buzzing around with usual high energy."

About this time, Lee spent several days with Tanja Rowell, who had come to London on a theater tour. They had last been together in 1974, when Lee went to stay with her in Baltimore and spent all night reminiscing about their long friendship. On their last evening in London, Lee told Tanja that she had just been diagnosed with cancer but did not want to discuss it. (Lee also told Bettina and said that she was growing her own cannabis.) Writing to Lyn in April to thank her for more tomato seeds (which she "rushed into the ground"), Lee mentioned only the "medical high-jinks" about her sinus allergy—traceable, she thought, to dairy products. She still hoped to go to the United States and could "hardly wait" for Lyn's next visit.

On April 25, two days after Lee's seventieth birthday, Suzanna gave birth to a healthy girl, Ami Valentine—whose arrival in the world gladdened Lee's heart despite her official disdain for children. "Suzanna is radiant as a mother," she told Lyn, then gave her another shopping list: Mazola oil, refrigerator deodorizers, a cookbook called *The Taste of America*. Lee enjoyed a brief remission in May, when she found the energy to accompany Roland to Paris. He was to deliver a slide lecture on Man Ray at the American Center; they could stay nearby at the Lyons' apartment and she could see Dorothea, Juliet, and other dear friends.

On May 16, Lee and I met by chance. I went into the center's lecture room

at the rue du Dragon and sat down beside a woman who was noticeable because she was badly dressed by Parisian standards. Yet she seemed familiar, especially her profile—since I was immersed in research on Paris in the 1920s for a life of Mina Loy and had been studying Man Ray's portraits of women. "Are you Lee Miller?" I asked, to my surprise. Not the least disconcerted, she said that she was. We began talking. Our conversation continued after the lecture, when she asked me to join Roland and their friends at the Café de Flore, and the next day at the Lyons' apartment, where we sat side by side on the bed. What prompted me to write about Mina, she asked. What drew me to her?

My reply about the boldness of Mina's wish to live as a modern woman amused her. Mina was her mother's age, Lee said, but she hadn't thought of her as the previous generation. Age didn't matter, she went on. At seventy, she was now taking an interest in childbirth. Just before coming to Paris, she had held her first grandchild in her arms. Did I have children, she wanted to know. When I replied that my daughter was not quite three and learning French, she asked what it was like to have a girl. Then she looked me in the eye and said calmly, "I'm dying, you know; I have terminal cancer." I said, "I hope not; we've only just met." She asked me to come to Farley Farm, then changed the subject.

We talked about names, Mina's and her own. She had chosen Lee, she explained, because it was androgynous—an asset at a time when women artists were not taken seriously. It had been difficult to make her way as a photographer after being a model, all the more so while she was with Man. As for the Surrealists, she laughed, if you played it their way, you could have a good time, especially with Picasso. The war was another matter. She had done some work of which she was proud, "but," she confessed, "I got in over my head. I could never get the stench of Dachau out of my nostrils." Hoping to get to England by the end of the summer, I promised to send her Mina's childbirth poem, "Parturition," and noted the directions to Chiddingly.

"We are so looking forward to seeing you," Lee wrote to Lyn a week later. "Roland and I've just spent a week in Paris, where the weather was foul, but the friends were fine." She did not mention the seriousness of her condition, only "the compost heap" in her lungs and her allergy to dairy products. She had started using kosher margarine, which was tasteless: "The cows moo and glare at me as if I were a traitor. . . . The hell with them," she said; "they're ugly." As spirited as ever, she wrote that she was having "great games" adapting menus to her dairy-less diet. "Perhaps they're mistaken," she went on, "and it's wheat that is doing the damage, which is unfortunate, on account of whiskey, mm. Everyone awaits you."

Lyn did not get to England in time for more nocturnal whiskeys. By June, Lee was confined to her bed. Roland watched over her day and night. As her appetite waned, Patsy cooked her favorite meals, saw to her every wish, and

Lee after bedside picnic, July 20, 1977 (Bruce Bolton)

did her utmost to make her comfortable. Suzanna visited often with Ami, who
was said to resemble Lee at that age. Tony returned from another filming trip
in time for a long, intimate talk with his mother, the first in which she was able
to reveal her love and concern for him; she asked him to take care to nurture
Suzanna's creative spirit. Meanwhile, a team of nurses administered morphine
for the pain. "She was wonderful," Patsy said. "She didn't complain. The
nurses loved her, especially her wisecracks."

Lee faced dying as she had everything else, head-on and with courage—
often phoning friends to come down from London for a last drink. "She had
guts," John Golding reflected years later. Golding went to the farm in mid-July
to be with her despite Roland's warning that she was sometimes incoherent.
She summoned the energy to cook with him. They watched a nature program
while he massaged her feet. "I'm only going to do this once and I want to con-
centrate on it," she said, "but all I can think about is the next fucking pill!"

When Peter Lyon came to Farley's, he and Roland carried Lee down the
stairs in a chair and set her outside in the sun, to enjoy the garden. Bruce
Bolton, a cooking friend from New York, arrived a few days later. On July 20,
they had drinks and a bedside picnic. He took pictures of Lee, her hair
combed, lipstick neatly applied, a scarf tied jauntily round her neck that
matched the blue of her eyes. She smiled lovingly at her visitor—having gone
beyond the need to pose. On July 21, Lee died at dawn, in Roland's arms.

The next day, the *Times* announced the death of "Lady Lee Miller, beloved wife of Sir Roland Penrose." The *New York Times* obituary reduced her life to its essentials: "Lady Penrose Was Noted for Photos of the Blitz." The *Los Angeles Times* noted, "Model-Photographer Succumbs." Following the memorial service, the Agnus Dei from Bach's Mass in B Minor was played at top volume, in accord with Roland's wish that "it should resound." Two weeks later, on the night of the full moon, the family scattered Lee's ashes around the places she had loved—her herb garden, Henry Moore's *Mother and Child*, the lawn outside the parlor. Roland said almost inaudibly, "We must put some beneath the ash tree, for the joke of it," and burst into tears. "We walked back across the top lawn and he flung the last of the ashes widely," Antony Penrose recalls. " 'I want her to be HERE—ALL AROUND HERE,' he said with deep anguish in his voice."

Roland's massive grief surprised everyone. Of this time, he wrote, "Death had ploughed its furrow in my bed and was now to sit at my table. . . . Its dark presence in Lee's absence was overshadowing." Lee was mourned, and remembered with love by all who knew her. "What a remarkable personality," Bruce Bolton wrote to the Jacobses. "I wish she had written more of her life. . . . What was that book she was working on—I never got it straight whether it was a book on food or on her adventurous life."

By chance, a last interview with Lee appeared a few months later in the *Sunday Times*. Entitled "That Special Face," it paid tribute to her as "one of the first and the loveliest faces to acquire a name"—the prototype of the model "whose look is exactly right for its time." Eerily, its pages showed a radiant Lee in the deck chair where Huene had placed her for a fashion shoot, along with Man's backlit shot of her on the bed in her Paris studio, the light dappling her naked torso.

Years before, Man had given this portrait to Roland, as if to say "Take her, she's yours." It had been on their bedroom wall since then, but (he realized on seeing it in the *Times*) had lately gone missing. Its disappearance, and reappearance, seemed like a posthumous gesture. Lee had given it to the writer knowing that she would be dead when their interview was published, but also knowing, one suspects, that sooner or later, her adventurous life would be told, her photographs rediscovered, and her name—the one she chose with such deliberation—synonymous with a wholehearted way of seeing, and being in, the world.

Afterword

"Man Ray always used to say that one of the things Lee did best was make work for other people," Antony Penrose reflected some years later. "In her own mischievous way, that is what she did for me."

Lee's posthumous mischief, or legacy, came to light soon after her death, when Suzanna Penrose discovered the more than sixty thousand photographs and negatives Lee had left in cardboard boxes and trunks in Farley Farm's attic. Slowly, she and Antony catalogued her "lost" archive and sorted through some twenty thousand pieces of memorabilia she had also stuffed haphazardly into containers—documents, journals, cameras, love letters, Nazi souvenirs—while comparing the many drafts of her articles with the published versions.

Growing up, Antony Penrose had known little of Lee's past. When visitors like Man Ray or Max Ernst mentioned her accomplishments, he recalled, "the etiquette was to be condescending. Since the woman I saw before me was incapable of darning a sock, that view suited me." Now, poring over her images and touching the bric-a-brac of her life, Penrose felt that he had been "cheated out of knowing someone exceptional." Not long after Lee's death, Roland had suggested to him the idea of a book about her. Suddenly, the materials for one had appeared, and a publisher, Thames and Hudson, expressed interest. Pen-

rose began the voyage of discovery that would result in his pathbreaking biography, *The Lives of Lee Miller.*

The year after Lee's death, Valentine Penrose also died at the farm, deepening Roland's grief. He and Daniella Kochavi parted company about the time that Diane Deriaz came back into his life. They traveled together, and with Diane's encouragement, Roland returned to the postcard collage form that he had begun in Mougins with Lee. A retrospective of his work was held in Barcelona before coming to the ICA in 1980: "The grand old man who introduced Surrealism to the British in 1936 has finally been given a show to commemorate his 80th birthday," the *Evening Standard* wrote, echoing Lee's article on the exhibition there for Picasso's seventieth. Roland's "image diary" of his travels with Lee, *The Road Is Wider Than Long,* was reprinted that year, and his autobiography, *Scrap Book,* was published in 1981, with many images of, and by, her. He died at the farm on April 23, 1984—Lee's birthday—before their son could complete the book he had encouraged him to write.

In the meantime, Antony and Suzanna Penrose established the Lee Miller Archive at Farley Farm to make her images, papers, and memorabilia available to researchers, and, with the help of Carole Callow, the archive's curator and printer, to bring her work before an increasingly fascinated public. On a research trip to the United States, he learned from Lee's brothers about her childhood traumas and their aftermath, events she had never mentioned to Roland or to him. "Can you imagine living with a person, being married to a person, and not knowing that she'd been raped at the age of seven?" he asked an interviewer. "She kept that kind of thing in water tight compartments; nobody knew." By the time *The Lives of Lee Miller* was drafted, he had revised his sense of her: "I passed through the old enmities and understood how misunderstood Lee had been."

In these years, Penrose spent as much time as possible with Dave Scherman, who was also mulling over his relations with Lee and their significance for his later life. His close collaboration with Penrose—Scherman gave him the title for *Lives* and wrote the foreword for *Lee Miller's War,* Penrose's 1992 edition of her *Vogue* dispatches—helped both come to terms with Lee's contradictions. "A consummate artist and a consummate clown; at once an upstate New York hick and a cosmopolitan grande dame; a cold, soignée fashion model and a hoyden," she was, Scherman believed, "prodigious," or rather, her lives were. "She was the nearest thing I knew to a mid-20th century renaissance woman," he explained. "In the less grandiose but perhaps more appropriate pop culture patois of her native land," he went on, "she was a *mensch.*"

By the time Scherman's reminiscences appeared in print, shows of her work had begun their travels. "Lee Miller: An Exhibition of Photographs, 1929–1964," organized by Lyn Kienholz and curated by Jane Livingston, toured the United States in 1989–90, providing my first close-up look at her poignant, unflinching images; "Lee Miller's War" hung at the ICA in 1992 before touring

Britain and Europe. Since then, her work has been on display around the world in exhibitions on Surrealism, Picasso, art by women, fashion photography, war photography, and images from the death camps, and in the numerous shows circulated by the Lee Miller Archive.

Two recent exhibitions emphasized different aspects of her extraordinary range. "The Surrealist and the Photographer: Roland Penrose and Lee Miller," at the Scottish National Gallery of Modern Art in 2001, showed her images to maximum advantage, in comparison with which her husband's accomplishment seemed muted. "Surrealist Muse," at the Getty Museum in 2003, placed her work in the context of her creative exchanges with Man Ray and Roland Penrose, revisiting hotly debated questions about Lee Miller as a muse who is herself an artist.

Despite such attempts to evoke her gift for meeting, and capturing, her life's decisive moments, a museum is not the only venue in which to conjure Lee Miller's élan. A recent critical study, Richard Calvocoressi's *Lee Miller: Portraits from a Life,* has brought new perspectives. Two novels inspired by her have also appeared. Marc Lambron's *L'Oeil du silence* presents her as a woman who refuses to be entrapped by her legend; Robert Irwin's *Exquisite Corpse* explores the code of mad love through the narrator's pursuit of a woman whose panache recalls that of Lee Miller (herself a character in the book).

Lee's ways of being, and working, were highly theatrical, even cinematic. Because she looked for "the flash of poetry" she admired in the cinema, many of her own images seem like movie stills. Her life and work have inspired filmmakers: a recent documentary about Man Ray uses snippets from his home movies to convey Lee's seductiveness but, also, her participation in their filming; three documentaries have been made about her, most recently, the BBC's *Lee Miller: A Quirky Way of Seeing* (whose title echoes a remark by Scherman).

Building on the work of my predecessors, this biography tries to see through Lee Miller's eyes. Carole Callow writes that while printing from Lee's war negatives, especially those shot in the camps, she "had to detach [her]self from their content." Yet through this experience, she also felt "privileged to be a witness to many forgotten and hidden images, resonating with passion and energy, bursting to be released and acknowledged in their own right."

Similarly, this portrait of Lee, composed with an eye for the grain and texture of her life, acknowledges her passions in their own right. Writing it has been my way of keeping the promise I made to her, to stay in touch. It has felt like a privilege to resonate with the brave joy of this defiant spirit, who, like her friend Dorothea Tanning, sometimes felt that it was "monstrous" for a woman to devote herself to what she loved—but could not keep from trying.

Appendix

A Lee Miller Dinner for Eight

This menu has been assembled from recipes published in *Vogue* and *House and Garden*, and others found in Bettina McNulty's notes for a Lee Miller cookbook. It seemed appropriate to start with Lee's prize-winning *smørbrød* recipe and end with her "bombe surprise"—two of the unlikely culinary creations with which she delighted friends and startled food writers.

Penroses

*16 very fresh, closed mushrooms, about 2 1/2
 inches in diameter
olive oil
salt and pepper
Madeira or Marsala
mousse de foie gras or other delicately
 flavored liver paté
paprika
16 slices white toast
1 bunch watercress
thin strips or zests of carrot, for garnish*

Remove the stems from mushrooms by cutting carefully: do not pull them out, as the mushrooms will collapse in cooking. To retain juiciness, sauté open side down

first, then outside down. Add salt, pepper, and Madeira or Marsala to taste, and cook until tender. Cool.

Pipe or fill caps with a spiral of pale, pinkish mousse de foie gras or other paté; sprinkle paprika into the grooves.

Butter and carpet bread with watercress; arrange mushroom roses on top; sprinkle with a few strands of raw carrot. Serve two per person.

Goldfish

> *1 whole codfish weighing 5 or 6 pounds,*
> *including head*
> *4 1/2 pounds carrots, coarsely grated*
> *1 1/2 pounds onions, sliced*
> *8 ounces sherry, half to season inside of fish,*
> *half to sprinkle on fish*
> *juice of 1 lemon*
> *3 ounces butter*
> *3 tablespoons olive oil*
> *salt and pepper*

Put carrots through an electric or hand rotary-disk grater with large holes. Slice onions to approximately the same size. Sauté the vegetables in butter and oil until tender. Season with salt and pepper. Preheat oven to 350 degrees.

Season the fish inside and out with salt and pepper and 4 ounces sherry. Butter a pan to fit fish (if pan is too wide for the fish, lay foil, grease it, and pull up the sides to make a narrow foil pan).

Place some of the carrot-onion mixture on the foil. Place the fish on top and mound the rest of the mixture over the entire fish. Pour remaining 4 ounces sherry over the fish and sprinkle with lemon juice. Bake about 45 minutes, being careful not to burn the top; cover loosely with foil if necessary.

If you wish to expose the cod's head, after cooking push back some of the carrots, or garnish it with chopped parsley or watercress on the platter.

Sesame Chicken for Miró

> *4 1/2 pounds broiling chickens*
> *1/2 cup sesame seeds*
> *1 cup dry bread crumbs*
> *1/4 pound butter*
> *salt and pepper*

Cut the chickens in quarters, removing the carcass bones from the breasts. Remove the skin.

Heat the sesame seeds in small amounts in an ungreased skillet. When they

explode, remove to a bowl. When all are done, add bread crumbs to bowl. Season with salt and pepper.

Melt the butter and dip the chicken in the butter, then roll in the sesame-seed-and-bread-crumb mixture. Place in a roasting pan to fit, dot with butter or pour the remaining melted butter over it. Bake in a preheated 350 degree oven for 35 minutes or until crisp and golden, or broil under a hot flame for 10 minutes on each side.

Lee served this dish to the artist accompanied by corn on the cob, guacamole, and rice salad. "I wanted to amuse him by giving him dishes unknown in Spain," she recalled.

Burghul

1 cup finely chopped celery
1 cup finely chopped onion
5 tablespoons butter, divided
3 cups bulgur wheat
1 handful finely chopped parsley plus more
 for garnish
salt and pepper
grated rind of 1 lemon
juice of 1/2 lemon
6 1/2 cups fluid, half tomato juice, half water
chopped fried almonds or pine nuts

In a large skillet, sauté celery and onions in 2 tablespoons butter until limp. Add 3 more tablespoons butter and bulgur, parsley, salt and pepper, and lemon rind and juice. Add liquid, bring to almost a boil and simmer about 30 minutes. The liquid should be absorbed and the grains separate, well cooked but not mushy or sticky.

Sprinkle with chopped almonds or pine nuts and bake uncovered at 275 degrees for about 10 minutes to brown. Garnish with more chopped parsley.

Celery Purée

1 pound, 3 ounce can celery hearts
2 tablespoons parsley
1/4 cup chopped onion
3 to 4 tablespoons powdered potatoes
5 tablespoons butter

In a blender, purée celery hearts with their juice, parsley, and onion. Heat mixture in a saucepan. Add powdered potatoes, stir until excess liquid is absorbed, then add butter. Heat until fluffy and serve.

**Salad of Bibb Lettuce
with Nasturtium Blossoms or Fresh Garden Herbs**

Crusty French Bread

Marshmallow-Cola Ice Cream

24 marshmallows
1 can Coca-Cola (12 ounces)
juice of 1 lemon
pinch of salt
2 tablespoons rum
1 cup heavy cream

Dissolve marshmallows in half the Coca-Cola over low heat. Add remaining cola, lemon juice, and salt. Whip together; freeze in ice-cube tray.

When frozen but still mushy, remove, add rum and cream, and whip again. Refreeze until solid, whipping once again after half an hour for a smooth ice cream—a "flag-waving rebuttal to British critics of American cuisine" (Bettina McNulty).

Notes

Lee Miller's papers—personal documents, notebooks, drafts of articles, *Vogue* service let-
ters, and photo caption sheets—are held in the Lee Miller Archives, which also holds her
correspondence with members of the Miller family, Man Ray, Aziz Eloui Bey, Roland Pen-
rose, Bernard Burrows, David Scherman, and other close friends and associates. All
archival material referenced in the notes comes from this generous source unless otherwise
noted. Lee Miller correspondence in other collections is indicated by the names of the
recipients.

Published works for which full references appear in the bibliography are referred to by
the author's name in the notes or, for frequently cited sources, initials. When more than one
work by an author has been cited, the short title is also given. Correspondence and unpub-
lished works are referred to by the author's name, or initials in the case of frequent cita-
tions. All translations are my own.

Archives and private collections are abbreviated as follows:

AIC	Art Institute of Chicago
BMcNC	Bettina McNulty Collection
CBC	Carolyn Burke Collection
DSE	David E. Scherman Estate
GRI	Getty Research Institute. Man Ray papers
JMC	John Miller Collection. Theodore Miller diaries, correspondence
LKC	Lyn Kienholz Collection
LMA	Lee Miller Archives
MNP	Musée National Picasso, Picasso archives
RJC	Roz Jacobs Collection
SNGMA	Scottish National Gallery of Modern Art. Roland Penrose Collection
UKCNA	UK Condé Nast Archives. Audrey Withers papers

Frequently cited names are abbreviated as follows:

AEB	Aziz Eloui Bey
AP	Antony Penrose
AW	Audrey Withers
BMcN	Bettina McNulty
DS	David Scherman
EA	Eileen Agar
EM	Erik Miller
FM	Florence Miller
JBG	Jacqueline Barsotti Goddard
JL	Julien Levy
JM	John Miller
JP	John Phillips
LM	Lee Miller
MHF	Miriam "Minnow" Hicks Feierabend
MM	Mafy Miller
MR	Man Ray
PM	Patsy Murray
PMT	Patricia "Trish" Miller Taylor
PP	Pablo Picasso
RP	Roland Penrose
TM	Theodore Miller
TR	Tanja Ramm Rowell
WS	William "Bill" Scherman

Introduction

xii an American free spirit: Phillips, *Free Spirit in a Troubled World*, p. 401.

xii Who else has written: Harry Yoxall, unpublished talk, 1945.

xiv don't match in shape: LM to RP, Oct. 11, 1937.

xiv I feel about as popular: LM to AW, n.d. [Jan. 11, 1946].

xiv for therapeutic reasons: BMcN to the author, Jan. 20, 2002.

1. A Poughkeepsie Girlhood

6 driven by a dynamo: Platt, p. 234.

7 the orderly progress: William B. Rhoads, "Poughkeepsie's Architectural Styles," in *Dutchess County Historical Society Year Book*, vol. 72 (1987), p. 28.

7 the better for: Rhoads, p. 29.

13 a thrill-packed reel: LM, "What They See in Cinema," p. 46.

15 take things so natural: Astrid Kajerdt to FM, n.d. [1914].

16 as though she: Herman, *Trauma and Recovery*, p. 43. This response, known as constriction, produces a state of detached calm as a response to inescapable pain and may trigger other forms of dissociation that comprise the syndrome known as post-traumatic stress disorder, which afflicts survivors of sexual and combat violence alike.

16 the most sacred: Ulman, p. 117.

16 a breaking and entering: Maya Angelou, *I Know Why the Caged Bird Sings* (New York: Bantam, 1997), p. 78.

17 It changed: JM interview with the author, May 29, 1996.

17 Gonorrhea was: Prince A. Morrow, *Eugenics and Racial Poisons* (New York: Society of Sanitary and Moral Prophylaxis, 1912), pp. 12–13.

17 The flower: Dr. Abraham Wolbarst, cited in Brandt, p. 15.

17 Before sulfa drugs: E. T. Burke, *Treatment of Venereal Disease in General Practice* (London: Faber & Gwyer, 1927), pp. 121–23. The mysterious final sentence states that "in every female case detoxicated vaccines should be given."

18 damaged goods: The 1913 Broadway production of Eugene Brieux's *Damaged Goods* dramatized the social consequences of venereal disease through the story of a syphilitic who brings suffering on his wife, their child, and the wet nurse. The play became controversial because it treated VD openly, a consequence hailed by some and lamented by others. See Brandt, pp. 47–51.

18 *September Morn:* After Anthony Comstock, of the Anti-Vice Society, denounced *September Morn,* songs were written about the painting, versions appeared in the form of dolls, statues, and cane heads, sailors had the nude tattooed on their chests, and some seven million copies were sold at a dollar apiece.

19 He was the only: EM interview with the author, Dec. 13, 1992.

2. Never Jam Today

21 something to hand down: LM, 1926 notebook (misdated 1927).

22 Elizabeth had tantrums: TM diary, Jan. 21, 1918, JMC.

23 Bring your vacation home: Quotations from Kodak ads are from Strasser, pp. 102–5. On the Kodak girl, see West, passim.

23 the true stereoscopic effect: TM diary, Mar. 2, 1916, JMC. Information in this paragraph from EM interview with the author, Dec. 13, 1992.

24 That one, she: Miss Freer cited by PMT in interview with the author, Feb. 8, 1997.

24 At dinner the family: On Henry George, see Geiger. G. B. Shaw, who adhered to the social reform movement while under the influence of George, discusses Georgism in his *Intelligent Woman's Guide to Socialism and Capitalism.*

26 Dishevelled girls staggered: Unless otherwise indicated, all quotations in this and the next twelve paragraphs are from LM, "What They See in Cinema."

26 portended a change: *Poughkeepsie Eagle News,* Dec. 11, 1917.

27 as full of life: *Poughkeepsie Eagle News,* Dec. 7 and Dec. 8, 1917.

28 You will never hear: *Photoplay,* June 1921, p. 47.

28 were full of naked: MHF interview with the author, Nov. 3, 1999.

29 "A Song" and "Chinese Shawls": Both poems are in LM's 1926 notebook but were written c. 1922.

29 "Distributing Letters": dated Jan. 26, 1922, and signed Betty Miller.

30 vulgarity of some: *Poughkeepsie Star,* Jan. 23, 1919.

31 the King who suffered: TM to LM, May 2, 1922.

31 but being rather disturbers: TM to "My dear Sister," Oct. 26, 1923.

32 Elizabeth had misbehaved: TM diary, May 29, 1924, JMC.

32 where a great dent: TM diary, July 1, 1924, JMC.

33 It is at these ages: Brill, p. 164.

34 filled with the sorrowful: Marion McKay, "Plus Fours and Books" [n.d.], Lindmark file, Adriance Memorial Library.

34 sitting on a million: MHF interview with the author, Nov. 23, 1999.

34 Elizabeth made: Information from *Poughkeepsie Evening Star and Enterprise,* May 10, 1923, p. 8.

36 I do not want: Zelda Fitzgerald, "Eulogy on the Flapper," *Metropolitan Magazine,* June 1922, reprinted in Bruccoli, p. 78.

37 the accent [had] shifted: F. Scott Fitzgerald, cited in Frederick Smith, "Fitzgerald, Flappers and Fame," *Shadowland,* Jan. 1921, n.p., reprinted in Bruccoli, p. 79.

37 She refused: Zelda Fitzgerald, "Eulogy on the Flapper," in Bruccoli, p. 78.

37 An artist in: This and quotations in next paragraph from Zelda Fitzgerald, "What Became of Our Flappers and Sheiks?" *McCall's,* Oct. 1925, p. 30.

3. Circulating Around

39 merely applying: Zelda Fitzgerald, "Eulogy on the Flapper," in Bruccoli, p. 78.

40 It took my chaperones: LM quoted in Gold and Fizdale, p. 161.

40 I loved everything: LM quoted in Keenan, p. 63.

40 One look at Paris: LM quoted in Nancy Osgood, "Accident Was Road to Adventure," *St. Petersburg Times,* Oct. 5, 1969.

41 but it didn't matter: Ibid.

41 If you will roll: Frank Crowninshield, quoted in Flanagan, p. 276. For information on Medgyès in the next paragraphs, see Flanagan, pp. 275–78.

41 as gay, as sad: Medgyès, quoted in Flanagan, p. 278.

42 Like marionettes: Flanagan, p. 276.

42 Every once in a while: LM, 1926 notebook.

42 an appetite in which: Flanagan, p. 273.

43 all the various: LM, 1926 notebook.

43 Her teacher was "Maestro": Information from LM, 1926 diary, Mar. 8 and 21 entries.

44 Moreover, in 1926: Chafe, pp. 103–4. Information in the following paragraphs from Chafe, passim.

44 to play a part: Mary McCarthy quoted in Carol Brightman, *Writing Dangerously: Mary McCarthy and Her World* (New York: Clarkson Potter, 1992), p. 65.

45 more interested in Medgyès: LM, 1926 diary, the source of quotations in this and the next five paragraphs.

47 In one of these: LM, 1926 notebook.

47 inhibitions, repressions: LM's 1926 diary is the source of quotations from LM in the rest of this section. The diary includes references to a number of theatrical productions staged in the spring of 1926.

48 Hedda's attempts to control: Brooks Atkinson, "The Play," *New York Times,* Feb. 21, 1926, sec. 7, p. 1.

48 a mystery play: John Mason Brown, cited in *The Encyclopedia of the New York Stage, 1920–1930* (Westport, Conn.: Greenwood Press, 1985), p. 312.

49 You who read this: LM, 1926 notebook, the source of all LM quotations in subsequent paragraphs.

50 There were large quantities: *New York Times,* July 1, 1924, cited in Paris, p. 67.

51 mooching around: Louise Brooks, quoted in ibid., p. 64.

51 finding debutantes a threat: Louise Brooks, quoted in ibid., p. 68.

4. Being in Vogue

55 This ravishing young woman: Livingston, p. 27.

56 I was so: TR to AP, June 9, 1984.

56 that all the paintings: LM, quoted in Amaya, p. 55.

56 circulating around: Ruth Seinfel, "Every One Can Pose," *New York Evening Post*, Oct. 24, 1932, p. 10.

57 both an escort service: Seebohm, p. 156.

57 the intangible quality: Ibid., p. 181.

57 the crowding of Fifth Avenue: *Vogue* [1927], as cited in Seebohm, pp. 279–80.

57 Women don't faint: Seebohm, p. 162.

59 He managed to give: Helen Lawrenson, managing editor of *Vanity Fair*, cited in Johnston, p. 201.

59 Big, rugged and bony: Marguerite Tazelaar interview with Steichen, "Portrait of a Pioneer," in *Amateur Movie Makers* 2 (1927), cited in Johnston, pp. 128–29.

59 satisfying and effective: Johnston, p. 128.

60 In one, she turns: *Vogue*, Aug. 15, 1928.

60 It was Steichen: LM, quoted in Amaya, p. 59.

60 Lee also observed: LM, quoted in Osgood, "Accident Was Road to Adventure."

60 take a man's view: "Flapping Not Repented Of," *New York Times*, July 16, 1922, as cited in Douglas, p. 247.

60 A modern woman: Dorothy Bromley, "Feminist—New Style," *Harper's*, Oct. 1927, as cited in Showalter, p. 16.

60 I wish I had: Both writers are cited in Douglas, p. 247.

61 which sets the pace: As cited in Watson, p. 175.

61 We went to many: TR to AP, June 9, 1984.

61 a harmless old goat: MHF interview with the author, Feb. 9, 2000

61 the man-who-knows: Watson, p. 176.

61 at the mere sight: Crowninshield, quoted in Seebohm, p. 104.

62 opening a new movie house: Alexander Woollcott, quoted in "Neysa McMein," *Current Biography 1941* (New York: H. W. Wilson, 1941), p. 548.

62 we all started: MHF interview with the author, Feb. 9, 2000

64 Lindbergh was the most: Lindbergh's stardom was confirmed with the appearance of the latest dance craze, the Lindy Hop, which was named in his honor.

64 It was vital: In this and the next paragraph, Jane Heap and Fernand Leger quoted in *The Little Review Anthology* (New York: Hermitage, 1953), pp. 341–44.

64 The moving picture: as cited in Goldberg, *Bourke-White: A Retrospective*, p. 12.

64 Photographs mingle romance: Professional Photographers of America, cited in Lemagny and Rouillé, p. 160.

65 I looked like an angel: LM, quoted in Keenan, p. 63.

66 WASP vision: Fox, p. 101.

66 At tea, two women: The advertisement is reproduced in Fox, p. 143.

67 Theodore was always: TR to AP, June 9, 1984.

68 If you didn't do it: MHF interview with the author, Feb. 7, 268

68 acquired a formal rigor: Hambourg, p. 33.

68 I want to become: Bourke-White, cited in Goldberg, *Margaret Bourke-White*, p. 77.

68 Her personal passion: Goldberg, *Bourke-White: A Retrospective*, p. 8.

69 The issue was indirectly: Alfred Barr, *Vanity Fair*, Aug. 1927, as cited in Hambourg, p. 41.

69 With the Millers: Elizabeth learned much later that Argylle died in a plane crash that day, while teaching a novice to fly.

5. Montparnasse with Man Ray

73 that the reason: TR to AP, June 9, 1984.

74 to enter photography: LM, quoted in Osgood, "Accident Was Road to Adventure."

74 Since she could seem: LM, quoted in "She Found Art Too Long and Full of Melancholy," Dec. 30, 1932, clipping.

74 He kind of rose up: Brigid Keenan, *The Woman We Wanted to Look Like* (London: MacMillan, 1977), p. 136, as cited in AP, *Lives*, p. 22.

74 I asked him: LM, quoted in Gold and Fizdale, p. 186.

75 My name is Lee Miller: LM, quoted in Amaya, p. 59.

75 Having terminated: MR, *Self Portrait*, p. 291.

75 If he took: LM, quoted in Amaya, p. 58.

75 The term came: *La garçonne*'s publication in 1922 caused a scandal. Its heroine worked, drove a car, tried alcohol, drugs, and lesbianism, and supported progressive causes. The novel sold extremely well and by the end of the twenties had launched a new fashion.

76 a series of accomplishments: MR, *Self Portrait*, p. 198.

76 He liked to fiddle: LM, quoted in Amaya, p. 58.

76 I do not photograph: MR, cited in Schwarz, p. 228.

76 His title for this image: To French speakers, the title of Man's photograph also suggests the possibility of violence (*violon/violent*) and madness (*dingue*, crazy).

78 Any encounter I rejected: MR, *Minotaure*, nos. 3/4, p. 114.

79 He dislikes the "candid camera": LM, "I Worked with Man Ray," p. 316.

79 to extend the field: MR, "Man Ray: On Photography," *Commercial Art and Industry*, Feb. 1935, p. 66.

79 had to be unpacked: LM quotations in this and the following paragraphs are from Amaya, pp. 55, 58, 54.

80 a sylphlike creature: George Antheil and Madge Garland, as quoted in Baldwin, pp. 157, 156.

80 pretty, perverse: Henri-Pierre Roché, "Journal Intime," Feb. 9, 1930, LMA.

80 a sunkissed goat boy: Cecil Beaton in *Vogue*, c. 1960, as cited in AP, *Lives*, p. 29.

80 Her athletic figure: JBG interview with the author, Aug. 24, 1997.

81 He took me: LM quotations in this and the following paragraphs are from Amaya, p. 60.

83 He loved her: JBG, unpublished memoir.

83 The woman was taller: Pony Simon interview with the author, Feb. 7, 1998.

83 If an American artist: McBride, p. 293.

83 consecrating the triumph: French *Vogue*, Oct. 1929, pp. 76, 78.

84 in their normal surroundings: George Hoyningen-Huene, unpublished memoirs, as cited in Ewing, p. 98.

84 joined the *Vogue* studio: LM, quoted in Amaya, p. 59.

85 It used to intrigue me: Horst, *Photographs of a Decade* (New York: Augustin, n.d.), p. 9.

85 With strong-willed girls: Horst, cited in Lawford, p. 60.

86 What can be more binding: MR, "The Age of Light," *Photographs by Man Ray*, n.p.

86 where it reaches: André Breton, "The Visages of Woman," in MR, *Photographs by Man Ray*, p. 42.

86 The head of a woman: MR, "Inventory of a Woman's Head," in MR, *Self Portrait*, p. 393.

86 This image would haunt him: MR, *Self Portrait*, pp. 255, 393.

86 just an image: Breton, "Visages of Women," p. 42; his essay follows the image of Lee with her hand on her mouth.

87 The uncanny angle: Breton used a related Magritte painting on the cover of his 1934 *Qu'est-ce Que le Surréalisme?*, as if the enigma of the female sex-as-face offered a mocking answer to the question posed in the title.

87 The reduction of Lee's head: AP, *Lives*, p. 32. The image of Lee's neck continued to haunt Man. *The Necklace*, his 1965 collage made from a tightly cropped print of *Anatomies*, attaches a string arranged in overlapping coils around the base of the same powerful throat.

88 not the personality: Ben Maddow, *Edward Weston* (New York: Aperture, 1973), p. 55.

89 Man's strategy vis-à-vis: While Man's self-portrait could be seen to mock the genre, it wants to have it both ways—making fun of his supplicant position while also indulging in it.

89 You are so young: Undated MR correspondence in this and the next paragraph, LMA.

90 To set off Chanel's: *Vogue*, Dec. 8, 1930, and Sept. 15, 1930.

90 a brilliant mime: Yoxall, p. 87.

91 a mechanical refinement: Eugenia Janis, in Sullivan, p. 11.

91 one of photography's fascinations: Janis, in Sullivan, p. 17.

93 The unexposed parts: LM quotations in this and the next paragraph are from Amaya, pp. 56, 57; additional information from Baldwin, p. 158.

94 I don't know: LM as cited in *Atelier Man Ray*, p. 56.

94 In either case: Lyford, p. 233.

94 like a dream remembered: MR, *Self Portrait*, p. 255.

6. *La Femme Surréaliste*

98 he liked the effect: LM, quoted in Amaya, p. 58.

98 You should have seen: LM, "She Found Art Too Long," Dec. 30, 1932, clipping.

99 What was hers: JBG interview with the author, Aug. 25, 1997, the source of quotations in this and the next two paragraphs.

99 strode into a room: Francine du Plessix Gray, "Growing Up Fashionable," *New Yorker*, May 8, 1995, p. 54.

101 frequent, fast: Flanner, *Paris Was Yesterday*, p. 67.

101 absolutely stunning: LM, quoted in Amaya, p. 59.

102 I was pleased: MR, *Self Portrait*, p. 170.

103 The film, *Les Mystères:* The cast included Man Ray and Boiffard as men traveling to a destination chosen by a throw of the dice. The cubelike forms of the de Noailles' "chateau" (designed by Mallet-Stevens) made Man think of dice—hence the title.

104 He'd been shot: LM quotations in this and the following two paragraphs are from Steegmuller, pp. 408–9.

104 It was the remarkable: Chaplin, cited in Touzot, p. 336.

105 You don't lend out: Man Ray, quoted in Jan-Christopher Horak, ed., *Lovers of Cinema*. (Madison: University of Wisconsin Press, 1995), p. 127.

105 In a state of grace: LM, "What They See in the Cinema," p. 98.

106 What intrigues me: MR, in Pierre, p. 29.

106 a little girl: MR, in Pierre, p. 33.

106 little girls who lift: quotations in this and the following paragraph, Péret, Aragon, Man Ray, *1929* (Paris: Alyscamps Press, 1996 [trans. of 1929 edition]).

107 The couple cannot: The couple are identified as Man and Kiki by Klüver and Martin, p. 184; this seems unlikely, as Kiki left him early in 1929.

108 a wasp-waist hour-glass: William Seabrook to MR, cited in Baldwin, p. 166.

108 It was nothing: MR, *Self Portrait*, p. 193.

108 beautiful girls with every shade: MR, *Self Portrait*, pp. 123, 132.

109 He called it *Two Women:* Stein's "Two Women" was published in Paris, in Robert McAlmon's *Contact Collection of Contemporary Writers* (1925).

110 He was thrilled: Information in this and the following paragraph from EM and FM interview with the author, Mar. 16, 1996.

111 Every woman can be: French *Vogue*, Feb. 1931, pp. 72–73.

111 the difficult art: French *Vogue*, May 1931, p. 23.

113 To illustrate the fable: André Breton, "Il y aura une fois," *Le Surréalisme au service de la révolution* 1 (1930), pp. 2–4. Breton's 1938 *Dictionnaire abrégé du Surréalisme* uses this image of Lee as an example of *"la femme surréaliste."*

113 Is not the use: "L'affaire de l'age d'or," cited in Lewis, p. 94.

114 Lee arrived in Stockholm: Information in this and the next four paragraphs, TM diaries, Dec. 1930, Jan. 1931, JMC.

115 Having absorbed as much: *Stamboul Quest*, a World War I drama filmed in 1934, starred Myrna Loy as an American spy, capitalizing on the vogue for espionage plots crossed with love stories.

116 I love extravagant: LM portraits in *The Bioscope*, July 1, 1931, p. 19; LM, "What They See in Cinema."

116 I haven't been: This and other quotations from MR letters undated for the rest of the chapter, LMA.

117 curious things happened: LM, quoted in Amaya, pp. 56–57. It is possible that MR changed his mind about using Lee's image in *Electricité*. Comparing the nudes in the brochure with other shots by him of a different model, art historian Stephanie Spray Jandl concludes that he may have had photo sessions with this woman as well before selecting the images in *Electricité* (private communication, Mar. 13, 2001).

118 Charlie said he had: LM, quoted in Seinfel, "Everyone Can Pose."

7. The Lee Miller Studio in Manhattan

121 Tensions ran high: This account derives from Jean Cocteau, *Le Sang d'un poète*, in Touzot, p. 331.

122 a bewildering and splintering: *"Surréalisme"* ran from Jan. 9 to Jan. 29, 1932. The *New York Times* critic deemed it "one of the most entertaining exhibitions of the season" (Jan. 13, 1932, p. 27).

122 Perhaps the "eye": Baldwin, p. 169.

122 It is some time: MR to Elsie Ray Siegler, Feb. 12, 1932, Man Ray Papers, Getty Research Institute.

123 She should be: AEB, quoted in AP, *Lives*, pp. 39–40.

123 Judging by the tales: Although it was thought that Nimet committed suicide, she recovered sufficiently to sublet Djuna Barnes's Paris apartment in 1933, and after her divorce, to marry Prince Nicholas Metchersky. Nimet died on Aug. 4, 1943. See Jaloux.

123 half-dead with sorrow: Levy, *Portrait*, pp. 121–22.

123 Unexpectedly, the *New York Times:* "On View in New York," *New York Times*, Feb. 28, 1932, p. 11.

123 Another critic described: K.G.S. [Katherine Grant Sterne], "European Photography on View," *New York Times*, Feb. 25, 1932, p. 19. The show ran from February 20 to March 11; the Millers came to New York on March 8 to see Lee's photographs.

124 *Time's* critic pooh-poohed: "Rayograms," *Time*, Apr. 18, 1932. *Time* ran Lee's portrait of Man as an illustration.

125 Lee suddenly became: EM quotations in this and the following paragraph are from "Tea at Trumps" radio tape, Mar. 1989, LMA.

125 The magazine agreed: "To Miss Lee Miller," *Time*, Aug. 1, 1932.

125 Julien, who was Lee's age: JL quotations and information in this and the following paragraphs are from Levy, *Portrait*, p. 151, passim.

127 And she was about: The first issue of *Le Phare de Neuilly*, with illustrations by Man and Nadar, appeared in February 1933, with Lee's photograph of a lizard in a lilac tree on p. 3.

127 Cut out the eye: *This Quarter* (Sept. 1932), p. 55.

127 Elizabeth, Elizabeth: MR to LM, LMA.

128 He seemed to have shrunk: JBG interview with the author, Aug. 25, 1997.

128 Looking pensive: "Cargo of Celebrities That Was Brought Here by the Ile de France," *New York World Telegram*, Oct. 18, 1932, p. 3; LM, quoted by Julia Blanshard in "Other Faces Are Her Fortune," *Poughkeepsie Evening Star*, Nov. 1, 1932, clipping.

128 Her sequinned Lanvin dress: U.S. *Vogue*, Nov. 1932, clipping.

129 to settle down: LM quotations in this and following paragraph are from Seinfel, "Every One Can Pose."

129 from all these publicity-hunters: MR to Elsie Ray Siegler, GRI.

129 I really liked her: Joella Levy Bayer interview with the author, Oct. 2, 1991.

129 an audience complex: LM quotations in this and the next paragraph are from Blanshard, "Other Faces Are Her Fortune."

131 a synthesis of voyager: Dickran Tashjian, *Joseph Cornell: Gifts of Desire* (Miami Beach, Fla.: Grassfield, 1992), p. 48.

131 Lee had left America: Frank Crowninshield, "Lee Miller, Exhibition of Photographs," LMA. This was her only solo show in her lifetime.

132 Her celebrity status: LM's portrait of Luce appeared in *Vanity Fair*, Dec. 1932, p. 47. Lee and the popular blond actress resembled each other. The similarities in their backgrounds—Luce came from upstate New York, studied dance with the Denishawn School, and performed in Ziegfeld's *Revue* in 1926—would have amused them. Claire Luce is *not* the writer Clare Boothe Luce, who married Henry Luce, of *Fortune*.

132 She can do: LM, "She Found Art Too Long and Full of Melancholy," Dec. 30, 1932.

132 the new light: JL is quoted in the *New York Times* art section, Jan. 1, 1933, p. 8.

132 We just opened: Joella Levy to Mina Loy, Jan. 3, 1933, CBC. Lee's portrait of Mina was included in the show.

132 her photographic work: E. A. Jewell, "Two One-Man Shows," *New York Times*, Dec. 31, 1932, p. 18.

132 Lovely Lee Miller: William Gutman, "News and Gossip," *Creative Art*, Jan. 1933, p. 76.

132 the sixty most: "News and Gossip," *Creative Art*, Feb. 1933, p. 87.

132 a relatively impersonal judge: JL, "The Bergdorf Goodman Exhibit of New York Beauty," CBC.

133 to not taking care: EM diary, May 9, 1933.

133 Lee's parents still followed: Hay's philosophy is explained in his *Health via Food*, pp. 87–88, 289.

133 when nerve stresses: Hay-Ven "Compatible Food Combinations" card, CBC.

134 THE photographer: TR to AP, June 9, 1984.

134 Lee could be: EM, quoted in AP, *Lives*, p. 55.

134 Lee was very insistent: EM, quoted in AP, *Lives*, p. 45.

135 ended up rushing: EM, quoted in AP, *Lives*, p. 55. EM explained to the author the help Lee received in her early work with color from Dr. Walter "Nobby" Clark, director of research for Eastman Kodak, whose interests included color photography, specialized instruments like sensitometers, and aerial photography.

135 understanding of the street: Walker Evans, quoted in Hambourg, p. 49.

135 Of the Brooklyn Museum's: Katherine Grant Sterne, "American vs. European Photography," *Parnassus,* Mar. 1932, pp. 16–20 (as paraphrased in Hambourg, p. 54).

136 ill or tired: EM diary, May 9, 1933.

136 less by passion: Houseman, p. 96.

136 ugly, fat, & bad tempered: Joella Levy to Mina Loy [summer 1934], CBC.

136 For the Frenchman: JL, Film Society Program #5; Howard Barnes, quoted in "Praise Is Paid to Miss Miller," *Poughkeepsie Evening Star,* Dec. 5, 1933; John Houseman, NPR "Morning Edition" tape, Mar. 2, 1989, LMA.

136 Lee Miller of New York City: "Catherine North Sague Bride of John H. Miller," *Poughkeepsie Eagle News,* June 19, 1933, p. 4.

137 Lee's photographs: program quoted by Phil Rhynders, letter to the editor, *Poughkeepsie Evening Star,* Dec. 7, 1933.

137 the high priestess: *Boston Globe,* quoted in Eugene Gaddis, *Magician of the Modern* (New York: Knopf, 2000), p. 233.

138 a nigger show: Virgil Thomson, quoted in Watson, p. 213. My account of this production is indebted to Watson.

138 because up to that time: Eva Jessye, quoted in Watson, p. 245.

139 The participants are seen: Ironically, when the black actors asked Lee to lighten their skin tones, she experimented with a red filter that gave the desired effect. (AP to the author, private communication.)

139 by Rolls Royce, by airplane: Lucius Beebe, quoted in Watson, p. 265.

139 It *does* stand: Constance Askew, quoted in Watson, p. 6.

139 Thus do tastes differ: *Vanity Fair,* May 1934, p. 52.

140 She disappeared: John Houseman, NPR "Morning Edition" tape, Mar. 2, 1989.

140 although not distinguished: Joella Levy to Mina Loy [summer 1934], CBC; John Houseman, NPR "Morning Edition" tape.

140 To ask if he wanted: Jackie Knight to Marcel Duchamp [c. summer 1934]; MR cable to LM, cited in AP, *Lives,* p. 56.

141 The article, probably dictated: "Lee Miller a Bride," *New York Times,* Sept. 6, 1934, clipping.

8. Egypt

146 photography off its track: Walker Evans, "The Reappearance of Photography," *Hound and Horn,* Oct.–Dec. 1931; reprinted in Alan Trachtenberg, ed., *Classic Essays in Photography* (New Haven: Leete's Island Books, 1980), p. 186.

146 bring peace to her heart: AEB to FM and TM, Aug. 26, 1934.

147 which makes them look: Ibid.

147 the sinews: Baedeker, p. xxxvi.

148 The average Oriental: Ibid., p. xix.

148 was to think of Cairo: Magdi Wahba, "Cairo Memories," in Derek Hopwood, ed., *Studies in Arab History* (Oxford, U.K.: Macmillan, 1990), p. 107.

149 One can imagine: Ahmed Hassanein, a much-decorated fellow of the geographic societies of France, Britain, and the United States (and also of Bedouin descent), made the first major expedition to the interior of the Libyan desert in 1923. His account of this trip, *The Lost Oases* (1925), was the standard guide to the region.

149 Lee is happy: AEB to FM and TM, n.d. [winter 1934].

149 None of their wives: LM, quoted in Gold and Fizdale, p. 186.

149 We had a marvelous time: this and the next four paragraphs are from AEB to FM and TM, n.d. [winter 1934]

151 With this new pretentious: Wahba, "Cairo Memories," pp. 103–4.

151 diseased by French: AEB to FM and TM, n.d. [winter 1934].

152 Before lunch: "En Route vers les Pyramides," French *Vogue,* Nov. 1929, p. 56.

153 Eighteenth Dynasty Edwardian: Cooper, p. 37.

153 you'd call Shepheard's: Mary Anita Loos interview with the author, July 6, 1999.

154 everybody Lee meets: AEB to FM and TM, n.d. [winter 1934].

154 I was delighted: LM, quoted in Gold and Fizdale, p. 186.

154 Both Lee and myself: AEB to FM and TM, July 7, 1935.

154 I . . . got sort of: LM to EM, n.d. [1935]; AP, *Lives,* p. 65.

154 a show of sensitiveness: AEB to FM to TM, Aug. 8 [1935].

155 The atmosphere is charged: Quotations from this and following two paragraphs are from AEB to FM and TM, Dec. 30, 1935.

155 It was a good thing: EM interview with the author, Dec. 13, 1992.

155 I will try: AEB to EM and TM, n.d. [autumn 1934].

156 An apartment: LM to EM, n.d. [1935]; AP, *Lives,* p. 65.

156 an ace in business: AEB to FM and TM, July 7, 1936.

157 We have had you: LM to EM, n.d. [1936].

157 I get so bitter: This and the next paragraph, LM to FM and TM, n.d. [winter 1936]; AP, *Lives,* pp. 65–66.

157 I loved the dryness: EM interview with the author, Dec. 13, 1992.

158 Their compatriots, most: This and the following two paragraphs, MM interview with the author, Dec. 13, 1992.

158 Goldie survived: Baronne Empain interview with the author, Feb. 2, 2002.

160 I took her as she was: Gertie Wissa interview with the author, May 20, 1996.

160 In the spring of 1937: This trip is described in AP, *Lives,* pp. 71–72.

9. Surrealist Encampments

164 His hair was green: RP quotations in this and the next paragraph, R. Penrose, *Scrap Book,* p. 104. Breton's *L'Amour fou,* published earlier that year, hailed "mad love" as a revolutionary force, one generally lived outside of marriage.

164 I have slept: RP to LM, June 25, 1937.

164 It was a delightful: Agar, p. 133.

165 One day I was: Ibid., p. 115.

165 A nation which: Herbert Read, "Introduction," *The International Surrealist Exhibition* catalogue (London: New Burlington Galleries, 1936), n.p.

165 Women Surrealists: Agar, p. 120.

166 bent on opening: Agar, quoted in Simpson, p. 26.

166 was expected to behave: Agar, p. 120.

166 a fountain of joy: Ibid., pp. 132–33. Roland commemorated their affair in a witty profile shot of the couple joined and separated by a phallic megalith.

166 talking dogs: Leonora Carrington interview with the author, Dec. 28, 1999.

166 You have given me: RP to LM, Oct. 10, 1937.

166 The blond season: Eluard, quoted in AP, *Roland Penrose,* p. 78.

167 a remarkable woman: Agar, quoted in Chadwick, p. 56.

167 the men were expected: Agar, p. 121.

167 a thoroughbred who: AEB to LM [July 1937], quoted in AP, *Lives,* p. 75.

168 I think if love: Agar, pp. 133, 132.

168 RP suffered: RP, quoted in AP, *Roland Penrose,* p. 29.

169 the appearance of: AP, *Roland Penrose,* p. 80.

169 that he was happy: RP, *Flashart* 112 (May 1983), p. 31; Agar, pp. 135, 138.

169 small, neat, well-built: RP, *Picasso*, p. 312.

170 a gesture of friendship: Gilot, p. 137.

170 One could distinguish: RP, *Flashart* 112, p. 34.

170 Evoking the summer: Ibid.

170 At the time: Rubin, "Reflections on Picasso and Portraiture," in Rubin, pp. 78, 86.

170 Just as Eluard: Richardson, p. 25. AP writes, "The subjects of Picasso's best female por-traits tend to be the women he slept with, and Lee was no exception." (*Roland Penrose*, p. 80).

170 Roland's description: RP, *Scrap Book*, p. 109.

171 You do not sit: LM, quoted in *Daily Telegraph*, July 29, 1968, clipping.

172 The work and: Keith Hartley, "Roland Penrose: Private Passions for the Public Good," *The Surrealist and the Photographer*, p. 19. It did not occur to the Surrealists that intel-lect and sensuality could be found in the same woman.

173 to confuse the delights: Agar, quoted in Chadwick, p. 56.

10. The Egyptian Complex

175 It's cold: LM to RP, Oct. 5, 1937.

176 the heat—the bad food: LM to RP, Oct. 11, 1937.

176 so miserable leaving: LM to MR, n.d.

176 She was the most: Wingate Charlton interview with the author, Jan. 21, 2001.

176 five shades of blue: quotations in this and the next three paragraphs, LM to RP, Oct. 15, 1937.

177 rather a flop: quotations in this and the next paragraph, LM to RP, n.d. [Oct. 27, 1937].

178 It was like being: LM to RP, Nov. 8, 1937.

178 I do so want: LM to RP, Oct. 22, 1937.

178 so that if one day: LM to RP, Oct. 28, 1937.

178 The light is perfect: Quotations in this and the next paragraph, LM to RP, Nov. 9, 1937.

179 fill[ing] my room: RP to LM, Oct. 25, 1937.

179 I wish that I: LM to RP, Nov. 9, 1937.

179 the tattooed woman: LM to RP, Oct. 28, 1937.

179 You will look: RP to LM, Nov. 14, 1937.

179 Roland longed for her: RP to LM, Oct. 22, 1937.

180 flat brass gearwheels: Quotations in this and the next paragraph, LM to RP, Nov. 9, 1937.

180 I shall choose: RP to LM, Nov. 14, 1937.

180 with great care: RP to LM, Nov. 21, 1937.

180 I walk around: LM to RP, n.d. [Dec. 1937].

181 Skiing in Egypt: Quotations in this and the next two paragraphs, Mary Anita Loos interview with the author, July 6, 1999.

181 they still don't believe: LM to RP, Dec. 23, 1937.

182 The long-awaited arrival: Gertie Wissa interview with the author, May 20, 1996.

182 as a deliberate insult: Quotations in this and the next paragraph, LM to RP, Mar. 9, 1938.

182 a letch: Quotations in this and the next paragraph, LM to RP, Dec. 23, 1937.

182 altho I spend: Quotations in this and the next two paragraphs, LM to RP, Dec. 25, 1937.

183 those depressing Egyptian gray days: LM to RP, Jan. 7, 1938.

183 Many people find: Robin Fedden, "An Anatomy of Exile," *Personal Landscape* (London: Editions Poetry, 1945), pp. 7–11.

184 spend[ing] a great deal: Quotations in this and the next paragraph, LM to RP, Jan. 7, 1938.

185 Your letters read: RP to LM, Jan. 11, 1938.

185 Why the devil: RP to LM, Jan. 18, 1938.

185 peaceably: LM to RP, Mar. 9, 1938.

185 busy bedding: RP to LM, Jan. 18, 1938.

186 Her behavior: Gertie Wissa interview with the author, May 20, 1996.

186 hard hit: LM to RP, n.d., in reply to RP's letter of Apr. 2, 1938.

186 He found Cairo society: Information in this and the next two paragraphs, Sir Bernard Burrows interview with the author, Sept. 3, 1997.

187 understand this correspondence: Michael Lesy, *Bearing Witness* [n.p.], as quoted in Paul Hendrikson, *Looking for the Light* (New York: Knopf, 1992), p. 95. *Portrait of Space* is said to have inspired Magritte's canvas *Le Baiser*.

187 I look to your arrival: RP to LM, Apr. 18, 1938.

187 some infra-red film: LM to RP, June 18, 1938.

188 Sometimes, almost never: RP, *The Road Is Wider*, n.p., is the source of quotations in the next two paragraphs.

188 magic to bring on: LM quotations in this and the next paragraph are from "Romania," unpublished manuscript, quoted in AP, *Lives*, p. 87.

189 angry peasants: Quotations in this and the next paragraph, LM to RP, Oct. 15, 1938.

190 some quite startling pictures: LM to RP, Jan. 6, 1939.

190 as many changes of scenery: Quotations in this and the next paragraph, LM to AEB, Nov. 17, 1938.

190 All I want: LM to RP, Jan. 6, 1939.

191 Our gang of misfits: LM to RP, Jan. 23, 1939.

191 In a fit of longing: LM to RP, Jan. 6, 1939.

191 give me endless opportunities: LM to RP, Jan. 23, 1939.

192 He brought as gifts: Lee's copy of *The Road Is Wider* was full of innuendos, including a note stating that the memoir was "bound in gold handcuffs with 69 original inventions by the author." RP on pieces of sentimental jewelry: *Scrap Book*, p. 118.

192 discussed our futures: LM to RP, Mar. 23, 1939.

193 My plans are maturing: LM to RP, n.d. [Apr. 1939].

193 but through all your plans: RP to LM, Mar. 19, 1939.

193 If it's war scares: RP to LM, May 1, 1939.

193 a "swell" ship: LM to RP, n.d. [May 1939].

193 British bourgeoisie: LM to RP, June 7, 1939. That Lee failed to tell Aziz of her decision to leave him at this point is clear from his letters to her for the rest of 1939, which anticipate her return. On June 6 he asked her to join him in Saint Moritz for August; on September 4 and 6 he discussed his plan to rent them an apartment in Cairo that she could decorate as she liked; on September 20 he wrote, "you will have to postpone your arrival for a while, that is if you have decided to come right away."

11. London in the Blitz

197 uneasy & nervous: LM 1939 notebook.

197 Her finances: LM to RP, n.d. [June 1939]. Aziz continued to send money.

197 too timorous & undecided: Bernard Burrows to LM, June 2, 1939.

197 Altho these nice: LM draft of letter to Bernard Burrows, LM 1939 notebook.

198 *Bien Visé* poses: *Bien Visé*'s English title, *Good Shooting*, would be better translated

Well Aimed (*viser* means to fix in the line of sight). To an English-speaker (for whom *visé* sounds like *vissé*), it hints that the woman has been "well screwed down."

198 A companion painting: Remy, p. 185. AP calls *Octavia* an expression of Roland Penrose's struggle "to resolve whether to allow himself to be ruled by his intellect or his hormones" (*Roland Penrose*, p. 96).

199 rather indifferent: RP to LM, Oct. 25, 1938.

199 Roland made up: Guggenheim, p. 160.

199 Within a few weeks: Peggy's abortion influenced her decision at this time, see Remy, pp. 164–66, and Jacqueline Wald, *Peggy, the Wayward Guggenheim* (New York: Dutton, 1986), pp. 175–82.

199 vastly amused: LM to Bernard Burrows, June 27, 1939.

200 Their irrepressible high spirits: RP, *Picasso*, p. 323.

200 a pedal-operated fretsaw: Agar, pp. 145–46.

201 The smartest seems: Panter-Downes, p. 10.

201 Learn to cook: As cited in McDowell, p. 45.

201 siege, starvation, invasion: LM to EM and MM, Aug. 25, 1942.

201 a war of yawns: Panter-Downes, p. 15.

202 What I did: RP, quoted in AP, *Roland Penrose*, p. 99; cf. RP, *Scrap Book*, p. 126.

202 INTELLIGENCE: Condé Nast to LM, as quoted in AP, *Lives*, p. 98.

202 KNOWING: Dr. Agha to Betty Penrose, Mar. 1, 1940.

202 not a life preserver: As cited in wall note, Imperial War Museum, London.

202 a little less: Doreen Impey to AP, Jan. 18, 2001.

202 Women's first duty: AW, quoted by Drusilla Beyfus in obituary, *Guardian*, Oct. 31, 2001.

203 Their Soho dinners: Agar, p. 146.

203 whether the surrealists: T. McGreevy, "London's Liveliest Show," *The Studio* 120 (Oct. 1940), p. 137, as cited in Remy, p. 211.

203 the enemies of desire: Quoted in Remy, p. 212. The *London Bulletin* was edited by Mesens and Penrose.

204 an integral part: Remy, p. 171.

204 You did so well: LM to FM and TM, n.d. [1940].

204 "This Is London": Murrow, p. 145.

204 could seize a person: RP, *Scrap Book*, pp. 127–28.

205 Has a wandering spirit: "The Contributors to This Issue," *Lilliput*, vol. 9, no. 4 (Oct. 1941), p. 332.

205 A photo-essay: Anne Scott-James, "The Taking of a Fashion Magazine Photograph," *Picture Post*, Oct. 26, 1940, pp. 22–25.

205 I marvelled at: Beaton, p. 37. The War Office hired Beaton as an official photographer soon after the raids began; by 1941 he was with the Royal Air Force.

205 her eye for: RP, *Scrap Book*, p. 128. Murrow thought that the balloons resembled "queer animals with grace and beauty" (*This Is London*, p. 232).

206 like a soft-shelled crab: LM to FM and TM, n.d. [Dec. 1940].

206 We saw eye to eye: Carter, *With Tongue in Chic*, p. 36.

207 "grim" and "gay": As reported in Murrow, p. 215.

207 The embodiment: Carter, *Grim Glory*, Preface; Publisher's Note [n.p.], published in the United States as *Bloody but Unbowed: Pictures of Britain Under Fire*. Murrow calls the images "honest pictures—routine scenes to those of us who have reported Britain's ordeal by fire and high explosive" (Preface).

207 hopelessly false: LM to FM and TM in this and the next paragraph, n.d. [Dec. 1940].

207 they had twenty minutes: Carter, *With Tongue in Chic*, p. 64.

208 It was an agreeably: Barbara Skelton, *Tears Before Bedtime* (London: Hamish Hamilton, 1987), p. 26.

208 We eat fine: LM to EM, Aug. 25, 1942.

208 Xmas won't be: LM to FM and TM, Dec. 14, 1941.

209 If the new order: Chase, p. 291.

209 with a touch chic: "They Have Been Here Before," U.K. *Vogue*, Oct. 1941, p. 33.

209 Within a few months: Yoxall, p. 153.

209 For Lee's next assignment: Lesley Blanch, "W.RN.S. on the Job," U.K. *Vogue*, Nov. 1941, p. 92.

209 For me: LM to FM and TM, Dec. 14, 1941.

210 It was a ménage: DS interview with the author, May 28, 1996.

210 I was very fond: Cited in AP, *Roland Penrose*, p. 103.

211 There was no chi-chi: DS interview with the author, May 28, 1996.

211 pictorialism with a meaning: DS quotations in this paragraph are from Loengard, p. 113.

211 one-page quickie: DS to WS, Oct. 17, 1943, DSE.

211 Lee also traveled: "This Above All," *Life*, Jan. 26, 1942, pp. 68–77; "The Horrors," *Life*, July 20, 1942, pp. 53–57; "Death in the Village," *Life*, Nov. 2, 1942, pp. 108–10.

212 Bob Capa came: Welsh, p. 89.

212 the atmosphere changing: Cynthia Ledsham Thompson interview with the author, Sept. 5, 1999.

212 the demand to be casual: Wertenbaker, pp. 245, 244. After becoming pregnant, Lael divorced her husband and married Wertenbaker.

213 The two phenomena: DS, in AP, *Lee Miller's War* (henceforth cited as *LMW*), p. 9.

213 Now I wear: LM to FM and TM, May 3, 1943.

215 Lee's first piece: LM, "American Army Nurses Photographed and Described by Lee Miller," U.K. *Vogue*, May 1943, pp. 54–55, 88. A passage on p. 88, on the nurses' love of literary pilgrimages, reads as if the author were British: "They are brought up on 'English Literature'; but as they did not play pirates in Penzance or go to church in a cathedral, as we did, the geography of literature and history remain unreal"—a possible concession to the British readership?

215 My theory: RP, *Scrap Book*, p. 130.

215 The following year: "Speaking of Pictures," *Life*, Apr. 19, 1943, p. 13.

215 Increasingly, Lee collaborated: Information in this and the following paragraph from DS interview with the author, May 28, 1996.

216 some of the pix are mine: LM to FM and TM, Jan. 23, 1944.

216 if I croak: DS to WS, Feb. 23, 1944, DSE.

216 scrubbing, polishing and perfecting: "Night Life Now," U.K. *Vogue*, June 1943, p. 29.

217 nearly drowned: Quotations in this and the next paragraph, LM to FM and TM, Jan. 23, 1944.

217 war turned them: U.K. *Vogue*, Feb. 1944, p. 39.

218 You in the United States: LM, "This Is London . . . Ed Murrow Ready," U.S. *Vogue*, Aug. 1, 1944, p. 96.

218 Lee says there is: Edward R. Murrow, quoted in AP, *Lives*, p. 114.

218 I've spent fifteen or so years: LM to AW, quoted in AP, *Lives*, p. 116.

218 how the acutely observant: AW, Institute of Contemporary Arts lecture, 1992.

218 cornered the color racket: DS to WS, Oct. 9, 1943, DSE.

219 a bit dreamlike: Panter-Downes, p. 313.

219 this is just: Ibid., p. 320.

12. Covering the War in France

221 On D-day: There were exceptions. Martha Gellhorn crossed the Channel as a stowaway, joined a group of stretcher bearers, and filed a piece about the wounded but was confined to quarters on her return. Ruth Cowan and Iris Carpenter went to France several weeks later but were not allowed to cover the slow progress of the Allies against German strongholds along the coast. My account is indebted to Sorel.

222 It was all very well: Withers, *Lifespan,* p. 53.

222 As we flew: Quotations from LM in this and the next eight paragraphs from AP, *Lee Miller's War* (henceforth cited as *LMW*), pp. 15–26. Lee arrived in France when the battle of Cherbourg was still raging.

222 When you think: Withers, *Lifespan,* p. 92.

224 Sykes had painted: "Normandy Nurses" photo caption no. 88 reads: "Lee Miller wearing special helmet borrowed from U.S. Army Photographer Don Sykes."

224 VOGUE has its own: *New York Herald Tribune,* Sept. 11, 1944, n.p. The ad continues: "On D-Day plus 5, Lee Miller VOGUE writer-photographer, crossed the channel in the wake of the AEF. Her stirring article, *U.S.A. Tent Hospital in France,* appears in the current issue of VOGUE. In terse prose and unforgettable pictures, VOGUE shows the efficiency of the American Medical Corps, the devotion of American nurses under fire. Here is a straight-forward account of on-the-spot-surgery . . . field hospitals at the front . . . air evacuation of the wounded."

224 the most exciting: AW, quoted in AP, *Lives,* p. 118.

225 The wicker furniture: LM quotations in this and next nine paragraphs from AP, *Lives,* pp. 32–65.

227 an unmade, unwashed bed: DS, "Foreword," AP, *LMW,* p. 10.

227 She looked tired: Author interview with Raymond Perrussel, May 21, 2001. "We were happy the battle was over," Perrussel recalled, "and they were happy to be alive." He is the tallest of the GIs observing the Germans' departure.

228 in the doghouse: LM to AW, censor date Aug. 29, 1944, AP, *LMW,* p. 65.

228 Lee was the only: DS to AW, Aug. 23, 1944.

228 It is very bitter: LM to AW, dated Aug. 26–27, AP, *Lives,* p. 65; photo p. 64.

228 Paris had gone mad: LM, AP, *LMW,* p. 67. The date of Miller's arrival in Paris is not known. Given that the women journalists in Rennes were allowed to go there only after it was secured from the Germans, she probably arrived on August 27th.

229 a cross between: DS, "Foreword," AP, *LMW,* p. 11.

229 After tremendous three day: U.S. *Vogue,* Oct. 15, 1944, p. 148.

229 Everyone's feet hurt: LM to AW, service letter, (mis)dated August 18 [1944].

230 The press bar: This drawing is included in David E. Sherman, ed., *Life Goes to War* (Boston: Little, Brown, 1977), pp. 250–51.

230 sick with rage: LM to AW, service message, n.d.

231 From the point of view: LM, AP, *LMW,* p. 73.

231 younger that I thought: Ibid., p. 77.

232 very large, padded: John Houseman, quoting Joan Courtney, his wife, "Tea at Trumps" radio broadcast, Los Angeles, 1989, held at LMA.

232 six pointed satinette: LM to AW, service message, Oct. 12, 1944; see also AP, *LMW,* pp. 79–80.

232 part of the passive: Quotations in this and the next paragraph are from LM to AW, Oct. 13, 1944.

233 I want to go: LM to AW, Sept. 8, 1944.

233 They were armed: LM quotations in this and the next two paragraphs are from AP, *LMW*, pp. 87–91.

233 On Sept. 28: Catherine Coyne, as cited in Sorel, p. 226.

233 The night before: Morris, p. 89.

234 They were all: RP, *Scrap Book*, p. 104.

234 a home-bound instructor: RP, *Scrap Book*, p. 132.

234 She felt torn: LM to AW, n.d.

234 trying to be: DS to WS, Oct. 22 [1944], DSE.

234 They regard it: LM to AW, service message, Oct. 10, 1944.

234 reminded me of: LM to AW, service message, Oct. 4, 1944.

235 seductive clothing has: LM to AW, service message, Oct. 10, 1944.

235 I find Edna: LM, AP, *LMW*, pp. 83–84.

235 They realize that: LM to AW, service message, Oct. 12, 1944.

235 I want more: LM, AP, *LMW*, p. 93, censor date Dec. 7, 1944.

236 The Duchy of Luxembourg: LM quotations in this and the next six paragraphs are from AP, *LMW*, pp. 114–30.

238 coming to full: LM to AW, Dec. 7, 1944, AP, *LMW*, p. 92.

238 I was an extension: LM account of her interview with Colette is in AP, *LMW*, pp. 105–9.

239 was now more British: LM to AW, service letter, Nov. 30, 1944; see LM, "Brussels," U.S. *Vogue*, Mar. 1, 1945, pp. 132–35, 162, 164. "Brussels" is not included in AP, *LMW*.

239 This is very difficult: LM to AW, service letter, Dec. 4, 1944, and LM quotations in the next two paragraphs, AP, *LMW*, pp. 110–13.

241 American soldiers knew: LM to AW, service letter, Dec. 7, 1944.

241 To amuse journalists: LM to AW, service letter, n.d.; see U.S. *Vogue*, Apr. 1, 1945, pp. 102, 131.

241 the number of people: LM to AW, service letter, n.d. "Older residents" were those who had hotel rooms for some time, often since the liberation of Paris.

241 When the hotel: Yoxall, pp. 188–89.

241 slightly scratchy in places: LM quotations in this and the next paragraph from LM to AW, service message, n.d.

242 Strasbourg was "frightening": LM, AP, *LMW*, p. 150.

243 My sense was that: Quotations in this and the next paragraph, Dr. Alain Dubourg interview with the author, May 25, 2001.

243 Since its liberation: The camp at Natzweiler-Struthof was built in 1941 by German prisoners who were made to carry the materials up the mountains on their backs. Thousands died as a consequence of conditions there, which included medical experimentation. In September 1944, the prisoners (Poles, Russians, Dutch, French, and Norwegians) were transferred to Dachau.

243 About this time: LM told the tale of her "gasoline can" to Henry McNulty, whose version appears in "High Spirits from White Alcohols," *House and Garden*, Apr. 1970, p. 182.

243 A few days later: Information and LM quotations in this and the next three paragraphs, AP, *LMW*, pp. 135–45.

244 "Lee quelque chose": Information and quotations in this and the next two paragraphs, Edmonde Charles-Roux interview with the author, Mar. 3, 1998.

13. Covering the War in Germany

247 One essential fact: G.B., "Nous n'avions pas d'uniforme," French *Vogue*, Jan. 1945, p. 41. This issue includes Lee's shots of Dietrich, Astaire, Colette, Paul Eluard, Bérard, and the Wrens.

248 What's wrong with: "Paris Black Market Robs U.S. Army," *Life,* Mar. 26, 1945, p. 29.

248 You can weave: LM, "G.I. Lingo in Europe," U.S. *Vogue,* Apr. 1, 1945, p. 131.

248 arrogant and spoiled: LM, "I See Germany," U.S. *Vogue,* June 1945, p. 193; AP, *LMW,* p. 169.

249 well nourished on: LM quotations in this and the next paragraph are from U.S. *Vogue,* June 1945, p. 193; AP, *LMW,* p. 166.

249 It was good: Flanner, *Janet Flanner's World,* p. 95.

249 Often the jailor: LM, "Germans Are Like This," U.S. *Vogue,* June 1945, p. 102; AP, *LMW,* p. 166.

249 It hurt my stomach: LM to AW, service letter, n.d. [late Mar. 1945].

250 When this image: Bourke-White's image of Cologne cathedral ran in *Life,* Apr. 23, 1945, p. 31.

250 I confirmed that: LM to AW, undeveloped German film, photo captions, n.d.

250 as messy and hollow: LM quotations in this and the next paragraph, LM to AW, Apr. 5, 1945.

251 I don't like Germany: LM to RP, n.d. [c. Apr. 10, 1945].

251 After weeks: LM quotations in this and the next paragraph, LM to AW, Apr. 5, 1945.

252 the creeps: LM to AW, Apr. 9, 1945. Lee caught up with Dave Scherman about this time; his shots of Bad Nauheim appeared in *Life* on Apr. 30, 1945.

252 Things move very fast: LM to AW [mid-Apr. 1945], quoted in AP, *LMW,* p. 159.

252 I have never felt: Dwight D. Eisenhower, *Crusade in Europe* (Garden City, N.Y.: Doubleday, 1948), pp. 408–9.

252 I don't take pictures: LM, Jena photo captions, Apr. 25, 1945, p. 4.

253 I saw these dead: William Frye, "Thousands Tortured to Death in Camp at Belsen," *Boston Globe,* Apr. 21, 1945, pp. 1, 3, as cited in Zelizer, p. 67.

253 You really had: Ann Stringer, as cited in Sorel, p. 351.

253 In photographing the murder camps: Bourke-White, *Portrait of Myself,* pp. 259–60.

253 the consistent fashion: LM to AW, n.d. [c. Apr. 20, 1945].

253 We were one: Charles B. MacDonald, *Company Commander* (Short Hills, N.J.: Burford Books, 1947), pp. 258–59.

253 in a different: LM to AW [c. Apr. 20, 1945]; AP, *LMW,* p. 178.

255 Buchenwald is beyond: Percy Knauth, cited in Abzug, p. 45.

255 Their eyes were sunk: As cited in Abzug, p. 56.

255 using the camera: Bourke-White, *Portrait of Myself,* p. 259.

255 The ex-prisoners have found: LM quotations in this and the next two paragraphs are from LM, Buchenwald photo captions [c. Apr. 21, 1945].

256 I found it comic: LM quotations in this and the next paragraph are from LM, Torgau ms.; AP, *LMW,* p. 155.

257 There was more food: Iris Carpenter, cited in Sorel, p. 345.

258 There was a terrible: LM, Torgau ms.; AP, *LMW,* p. 155.

258 This is the first: LM, AP, *LMW,* p. 181.

258 How is it: Higgins quoted by DS in interview with the author, May 28, 1996.

259 It was one: Marguerite Higgins, cited in May, *Witness to War,* p. 91.

259 It's haunted me: Henry Dejarnette, cited in Abzug, p. 92.

259 Lee documented the scene: There is still uncertainty about which of the "death" trains taking inmates from Buchenwald to Dachau LM photographed: the first left on April 7, 1945, and arrived on April 28; the second left on April 9 and arrived on April 27. See Bertrand, pp. 49–69. My account relies on this authoritative source and my interview with Bertrand, Feb. 25, 1998.

260 Lee took the pictures: Jacques Hindermeyer interview with the author, Feb. 20, 1998; DS interview with the author, May 28, 1996.

260 In the few minutes: LM, AP, *LMW,* p. 182.

260 She was the only one: Ari Von Soest interview with the author, May 30, 2001.

261 The violence of Dachau: Abzug, p. 93.

261 a floating mess: LM, AP, *LMW,* p. 182.

261 Dachau had everything: LM to AW, AP, *LMW,* pp. 188–89.

262 There were no signs: Quotations in this and the next paragraph, LM, AP, *LMW,* pp. 191–93.

262 the elected victims: LM, AP, *LMW,* p. 182.

262 We've all speculated: LM to AW, n.d. [c. May 3, 1945]; AP, *LMW,* p. 188.

263 Part of the china: LM, AP, *LMW,* pp. 198–99.

264 Everyone hunted for souvenirs: LM, AP, *LMW,* p. 200.

264 Shit! That's blown: LM quoted in AP, *Lives,* p. 144; LM cables to AW, n.d. Cf. LM, "Germany—The War That Is Won," U.K. *Vogue,* June 1945, pp. 40–43, 84, 86, 89.

265 In the U.S. version: LM, "Germans Are Like This," U.S. *Vogue,* June 1, 1945, pp. 102–8, 192–93.

265 The mood then: AW interview with the author, May 5, 1996.

265 the Christian and cultural: AW quotations in this and the next paragraph are from U.K. *Vogue,* June 1945, pp. 45, 84.

14. Postwar

267 A number of correspondents: Sorel, p. 390.

267 Soon after their return: LM quotations in this and her next three paragraphs are from LM, "Denmark," U.S. *Vogue,* pp. 138–41.

269 No correspondent has displayed: Harry Yoxall, unpublished speech [July 1945].

269 She was reluctant: AW interview with the author, Oct. 6, 1997.

269 We would be delighted: Edna Chase quoted by AW, July 25, 1945, UKCNA.

269 base[d] in America: LM to AEB, n.d. [1945].

270 She has written: DS to WS, July 7 [1945].

270 I found the pictures: BB to LM, June 28, [1945].

270 the hiking through: AEB to LM, n.d. [1945].

270 I'm not Cinderella: LM, as quoted in AP, *Lives,* p. 147.

271 I've spent a lethargic: LM to RP, n.d. [late Aug. 1945].

271 This is to introduce: Bettina Wilson to "Mendy," Aug. 17, 1945.

272 a babel of foreign voices: LM quotations in this and the next two paragraphs are from LM, unpublished ms. on Salzburg, some of which is quoted in AP, *Lives,* p. 151.

272 The few road signs: LM, unpublished cable ms.; quoted in AP, *Lives,* p. 152.

273 so they are losing: LM quotations in this and the next paragraph are from LM to RP, Sept. 30, 1945.

273 In a city of suffering: LM, "Report from Vienna," U.K. *Vogue,* Nov. 1945, p. 40.

273 It keeps people's minds: LM, unpublished notes for Vienna ms.

273 This trip is working: LM to RP, Sept. 30, 1945.

273 Shocked that the great: LM quotations in this and the next paragraph, *Lives,* pp. 152–54. Unpublished cable draft, partially printed in AP, *Lives,* pp. 152–54.

274 We can liberate: LM Vienna notebook, partially printed in AP, *Lives,* p. 153.

274 Please, darling: Quotations in this and the next paragraph are from LM to RP, n.d., partially printed in AP, *Lives,* pp. 147–48.

275 Their adventures made: Quotations in this and the next paragraph are from LM to "Ralph," Oct. 25, 1945.

276 Lee was very aware: JP interview with the author, June 14, 1994; this is the source of all JP quotations unless otherwise noted.

277 Lee and I: Simon Bougin interview with the author, May 28, 2279; this is the source of all Bourgin quotations unless otherwise noted.

277 with abundant wonderful food: LM photo captions for Hungary.

277 Our relationship was: Robert Halmi quoted in letter from Simon Bourgin to AP, Apr. 8, 1994.

277 Shake hands with Halmi: Simon Bourgin to the author, May 26, 1999.

277 flourish[ing] with champagne: LM unpublished ms. on Hungary. Unless otherwise indicated, all LM quotations about Hungary are from this ms.

278 The American dollar: Simon Bourgin, "Inflation in Hungary," *Life*, 1946, clipping, p. 13.

278 The waitresses and nurse-maids: LM, "Hungary," U.K. *Vogue*, Apr. 1946, p. 92. Information and quotations from LM in this and the next seven paragraphs from "Hungary," original manuscript partially published in U.K. *Vogue*, pp. 52–55, 90, 92, 95–96; and in U.S. *Vogue*, Apr. 15, 1946, pp. 164–65, 197–98.

280 In the meantime: "Russians Hold U.S. Woman Reporter," *New York Times*, clipping; "Miller's Daughter Released After Detention by Russians," *New Paltz New Yorker*, Nov. 10, 1945.

280 Schlacht told us: Robert Halmi, quoted in a letter from Simon Bourgin to AP, Apr. 8, 1994.

281 First we had: JP, *Free Spirit*, p. 402.

281 Taking stock: LM to AW, undated [Jan. 11, 1946].

282 About this time: JP, *Free Spirit*, p. 413.

282 We had no idea: JP, *Free Spirit*, p. 407.

283 Lee, my driver, and I: JP quotations in this and the next paragraph are from *Odd World*, p. 211.

283 Through eyelids squeezed: LM, original ms. of "Romania," U.K. *Vogue*, May 1946, pp. 64–67, 98–100; U.S. *Vogue*, pp. 166–67, 208–9; AP, *Lives*, pp. 168–70.

283 In 1938 I was: LM, Romanian photo captions.

284 I'm awfully sorry: JP interview with the author, June 14, 1996.

284 looked like something: This and the next paragraph are from LM, Romanian photo captions.

285 beautiful hair: "Cu Jon Phillips Si Lee Milelr" [sic], *Poporul*, Feb. 9, 1946, p. 1.

285 On their travels: LM, original ms. of "Romania"; AP, *Lives*, p. 168.

286 The guest never gives: U.S. *Vogue*, May 15, 1946, p. 209.

286 Thinking you might: LM, Romanian photo captions.

286 rumbled forth: LM quotations in this and the next paragraph are from original ms. of "Romania"; AP, *Lives*, pp. 171–72.

287 Tired of loving someone: RP to LM, Jan. 15, 1946.

287 my task now: JP, *Free Spirit*, p. 413.

288 she looked very much: Rosemarie Redlich Scherman interview with the author, Sept. 26, 1999.

288 to prove that I: LM notebook, Sept. 9, 1947.

288 If only someone: LM cited in AP, *Lives*, p. 176.

288 in bad odor: DS to WS, Mar. 8, [1946], DSE.

289 Now that everyone: LM, "Travel and Camera," U.S. *Vogue*, May 15, 1946, pp. 123, 199, 200, 205.

289 I'm on my pratt: DS to WS, Apr. 20, [1946], DSE.
289 very depressing: Ibid.
289 She is having: DS to WS, July 27, [1946], DSE.

15. Patching Things Up

293 a highly skilled: RP, *Scrap Book,* p. 140.
294 She was not the same: JM interview with the author, May 29, 1996.
294 She is getting old: DS to WS, July 27, [1946], DSE.
294 those great war: U.K. *Vogue,* Aug. 1946, p. 29.
294 She brought regular doses: Alexander Liberman to the author, June 14, 1996; also the source of subsequent Liberman quotations.
294 When you were: Despina Messinesi, interview with the author, Feb. 22, 1998.
294 she had everything: Frances McLaughlin-Gill, interview with the author, Apr. 29, 1998.
295 Diamonds are for: Tatiana Liberman, quoted by Francine du Plessix Gray in interview with the author, Jan. 24, 1997. See also Gray, "Growing Up Fashionable," *New Yorker,* May 8, 1995, pp. 54–65.
295 The surroundings were: RP, *Scrap Book,* p. 140.
296 a large wet cloud: LM to WS, n.d. [July 1946].
296 We cannot help: Livingston, p. 96.
296 A woman had to be: Dorothea Tanning interview with the author, Feb. 20, 1997.
297 Everyone goes around: LM to WS, July 1946, a letter asking about DS's work for *Life.*
297 Man called his: Baldwin, p. 240.
297 She seemed worn down: Mary Anita Loos, interview with the author, July 6, 1999.
298 real live lady: Quotations in this and the next paragraph from LM and RP taped interview with Ona Munson, "In Town Tonight," Aug. 1946. When Munson asked Penrose whether he went "battling around Europe like our real live lady war correspondent," he said that his war experiences had been "dull in comparison."
298 Having been brought up: RP interviewed in "The Age of Picasso," *Art News,* Nov. 1946, p. 31.
299 bottled up: Alex Kroll interview with the author, Sept. 1, 1997.
299 try reading Ulysses: LM to FM and TM, Dec. 12, 1946.
299 In the new year: Ibid.
300 international crooks: LM to RP, n.d. [Jan. 1947].
300 I could not have: Rosamond Bernier interview with the author, Feb. 20, 1997.
300 even their identities: Rosamond Riley, "Children's Village in Switzerland," U.S. *Vogue,* Apr. 1947, p. 173. Lee's photographs illustrate the story, which also appeared in the U.K. Oct. issue, with fewer illustrations.
300 rather peculiar about it: LM to RP, n.d. [Jan. 1947].
301 Just as I: LM to FM and TM, Feb. 6, 1947.
301 Due to all this: Ibid.
301 This baby business: LM to FM and TM, May 2, 1947.
302 You'd think it was: This and the next paragraph, LM to FM and TM, July 31, 1947.
303 In a semihumorous *Vogue* piece: LM, "The High Bed," U.K. *Vogue,* Apr. 1948, pp. 83, 111, 112.
303 Dearest Mother: LM to FM, Sept. 8, 1947.
303 Early the next morning: This and the next two paragraphs, LM, London Clinic notebook, Sept. 9, 1947.
304 He is so ugly: RP to FM and TM, Sept. 11, 1947.

304 that I'd get: LM to FM and TM, Nov. 24, 1947.

305 awfully cute: Ibid.

305 like a real baby: LM to FM and TM, Dec. 11, 1947.

305 Lee took a portrait: "Vogue Photographers Interpret Christmas," U.K. *Vogue,* Dec. 1, 1947, p. 58.

305 The portrait, which ran: Quotations from LM to FM and TM in this and the next paragraph, Dec. 11, 1947.

306 slightly tight: LM to FM and TM, Dec. 18, 1947.

306 And the treatment prescribed: LM to FM and TM, Nov. 24, 1947.

306 Am getting so fascinated: LM to FM and TM, Dec. 18, 1947.

306 getting the dream idea: LM to FM and TM, Jan. 29, 1948.

306 He should be asked: Geoffrey Grigson, quoted in AP, *Roland Penrose,* p. 130.

307 almost Cubist: quotations in this and the next two paragraphs, LM, "The Venice Biennale Art Exposition," U.S. *Vogue,* Nov. 1, 1948, pp. 190, 191, 193, 195.

308 After Lee's review ran: Contract between LM and Condé Nast dated Nov. 15, 1948, UKCNA.

308 I gave up reading: LM to FM and TM, Jan. 29, 1948.

308 They brought suitcases full: TM 1948 diary; TM as quoted in AP, *Lives,* p. 186.

309 In the time: LM, "40,311 Years of Modern Art," U.K. *Vogue,* Jan. 1949, pp. 65–69, 82–83.

309 gave Farley farm: RP, *Scrap Book,* p. 163. For more about Farley Farm, see AP, *Home of the Surrealists,* on which my account relies.

310 "Bachelor Entertaining": U.K. *Vogue,* Mar. 1949, pp. 68–69, 114–16.

310 Here is a partial diary: LM to FM and TM, May 31, 1949.

310 all sorts of panic: LM to RP, n.d. [spring 1949].

311 Running two homes: LM to FM and TM, May 3, [1949].

311 Our first summer: LM, "Working Guests," U.K. *Vogue,* July 1953, p. 90.

311 To her parents: LM to Millers, n.d. [1949].

311 In April 1949: U.K. *Vogue* interoffice memo, Miss Hill to Miss Withers, Apr. 12, 1949; AW to LM, June 30, 1949, UKCNA.

311 There is nothing wrong: Dr. Carl H. Goldman, quoted in AP, *Lives,* p. 188.

312 Tony, on the other hand: LM to FM and TM, n.d. [1949].

312 A letter written: LM to FM and TM, n.d. [1949].

312 Lee took to cooking: AW, ICA talk, 1992.

312 Photography had been: RP, *Scrap Book,* p. 186.

313 I implore you: RP, quoted in AP, *Lives,* p. 193.

313 Lee came into her own: AW interview with the author, May 5, 1996.

16. A Double Life

315 I hope you will: AW to LM, June 2, 1950, UKCNA.

316 My first encounter: AP, *The Home of the Surrealists,* p. 68.

316 Just before Christmas: LM to FM and TM, n.d. [c. Feb. 1951].

317 Roland's new project: LM to FM and TM, n.d. [c. Feb. 1951].

317 We practically had to go: LM to FM and TM, n.d. [c. Feb. 1951].

317 Ayrshire cows, open log fires: Quotations in this and the next two paragraphs from LM, "Picasso," U.K. *Vogue,* Nov. 1951, pp. 113, 160, 165.

318 The winter jasmine: LM draft for *Picasso Himself,* 1956 ICA exhibition catalogue, cited in AP, *Home of the Surrealists,* p. 71.

318 had the effect: RP, *Scrap Book,* p. 208.

318 like a disciple: Quotations in this and the next paragraph from LM, "Picasso," p. 160.

319 Tony, stimulated by: This paragraph and next from LM, "Picasso," p. 113.

319 If it was not: RP, cited in AP, *Roland Penrose*, p. 145.

319 Farleys stopped being: AP, *Home of the Surrealists*, p. 77.

320 A great deal: LM to AW, n.d. [1953], BMcNC.

320 In autumn 1952: LM, "Plan for a Thirteen-Meal Christmas," U.K. *Vogue*, Dec. 1952, pp. 85, 114, 116.

320 To my Wife: RP, *Wonder and Horror of the Human Head* (London: Lund Humphries, 1953), p. 6.

320 The next time you: LM, "The Human Head," U.K. *Vogue*, Apr. 1953, pp. 146, 168, 170.

321 Humility, which is not: LM, draft for "The Human Head," quoted in AP, *Home of the Surrealists*, p. 82.

321 This tongue-in-cheek guide: "Working Guests," U.K. *Vogue*, July 1953, pp. 54–57, 90, 92.

321 She was not suited: AW interview with the author, June 14, 1996.

322 Eluard's love of women: RP, *Scrap Book*, p. 161.

322 She had been one: Quotations in this and the next four paragraphs, Deriaz, pp. 151–53, 237, 240.

323 too emotional: TM 1954 diary, Sept. 11 entry.

324 Trish was fascinated: PMT quotations in this and the next two paragraphs from PMT interview with the author, Apr. 26, 1998.

325 They found they loved: AP, *Roland Penrose*, p. 148.

325 One weekend, when Audrey: AW, ICA talk, 1992.

325 My chums thought: AP, "How I Learned to Love My Surrealist Mother," *You*, Aug. 19, 2001, p. 39.

325 Please ask Patsy: AP, *Lives*, p. 196.

325 deeply embattled with: AP, "My Mother, Me, and Hitler's Bathtub," *Mail on Sunday*, Mar. 14, 1999, p. 33.

325 Lee had a lot: PM interview with the author, May 10, 1996.

326 usually decorated by: Colin St. John Wilson interview with the author, May 20, 1996.

327 The company of Lee: RP, *Scrap Book*, p. 215.

327 It was better: RP and LM postcard to Picasso from Barcelona, June 21, 1955, MNP.

328 an essential asset: RP, *Scrap Book*, p. 230.

328 One might think that: AW, ICA talk, 1992.

328 Roland did not recall: RP, *Scrap Book*, p. 231.

329 The erotic enticements: Ibid., p. 230.

329 She couldn't digest: Quotations in this and the next two paragraphs, Peter Lyon interview with the author, Feb. 24, 1998.

329 It means Never: LM, quoted in AP, *Lives*, p. 196.

331 flew out of: LM, quoted in Gold and Fizdale, p. 187.

331 Lee is still making: RP to Picasso, Sept. 26, 1957, MNP.

331 a past master: Richardson, p. 234.

331 Roland, as Boswell: John Richardson interview with the author, July 28, 1999.

332 In these narrow: Jeffrey, n.p.

333 Only Lee's family: AP, *Lee Miller in Sussex*, p. 11.

333 His flashing black eyes: LM, "Picasso Himself," in *Picasso* (ICA Picasso Party brochure, July 5, 1960).

333 After mentioning the titled guests: Olga Franklin, "They've Even Insured Pablo for Ten Million," *Daily Mail*, July 1, 1960, p. 10.

334 Honestly, I find: George Melly to RP, June 23, 1960, cited in AP, *Roland Penrose*, p. 153.

334 I was required: RP, *Scrap Book*, p. 249.

334 It's because of you: RP to Picasso, Jan. 4, 1961, MNP.

334 the largest of its kind: "Party for a Painter," *The Tatler*, Sept. 20, 1961, pp. 596–97.

334 Much of her time: LM to JM, July 4, [1961].

17. A Second Fame

337 Lee's past was: Joanna Drew interview with the author, Sept. 30, 1999.

338 She was funny: John Golding interview with the author, May 20, 1996.

338 When they'd eaten: LM, quoted in Gold and Fizdale, p. 187.

338 it was as if: Princess Jeanne-Marie de Broglie interview with the author, May 29, 2001.

338 the lure . . . an icon: John Craxton interview with the author, Oct. 4, 1999.

338 a heavenly place: John Craxton interview with the author, June 26, 2000

338 in a world: Princess Jeanne-Marie de Broglie interview with the author, May 29, 2001.

339 She was usually correct: Roz Jacobs in this and the next paragraph, interview with the author, June 14, 1996.

339 Intrigued by her accent: Priscilla Morgan interview with the author, June 11, 1996.

340 the maddest people: James Beard, *Love and Kisses and a Halo of Truffles* (New York: Arcade, 1996), p. 331.

340 pure therapy: [BMcN], "How to Make an Art of the Happy Weekend," *House and Garden*, June 1973, p. 87.

340 drifted into cooking: BMcN, "Notes for LM Cookbook," unpublished, BMcNC.

340 I couldn't live: BMcN interview with the author, Aug. 8, 1997.

341 the focus of a lively: BMcN, "Notes for LM Cookbook."

341 little sole the size: LM to BMcN, n.d.

341 Over the years: Information and quotations in this and the next four paragraphs, BMcN interview with the author, Jan. 20, 2001, unless otherwise indicated.

341 in case a zany: [BMcN], "How to Make an Art of the Happy Weekend," pp. 66, 87.

342 It's a great convenience: TM diary, Sept. 26, 1963.

343 We hated each other: AP, "The Enigma of Lee Miller."

344 In a huge hostel: John Craxton interview with the author, June 26, 2000

344 still magnetic: Julie Lawson interview with the author, Jan. 21, 2002.

344 Lee's culinary interests: Ninette Lyon, "Lee and Roland Penrose: A Second Fame."

345 She was hellbent: Roz Jacobs interview with the author, June 14, 1996.

345 He was a dirty: PM interview with the author, June 12, 1996.

345 Suddenly this scary adult: Anne-Laure Lyon interview with the author, June 1, 1999.

346 ingrained sociability: RP, *Scrap Book*, p. 189.

346 The 1965 holidays: Quotations and information in this and the next two paragraphs from Henry McNulty, "A Christmas at Muddles Green," U.K. *House and Garden*, Dec. 1975, pp. 102, 106.

347 Lee had mixed feelings: Information from Roz Jacobs; LM to Roz and Mel Jacobs, Jan. 12, 1966.

347 I don't believe: LM quoted in "The Reindeer Meats Ball Lost the Battle of the Roes & the Roses," *Kensington Post*, Nov. 7, 1965, clipping.

348 The newspapers published: "To glade engelske damer til Stavanger i går," Jan. 22, 1966, *Stavanger Morgenavis*, p. 3.

348 To a reporter: "Bergensk slutt på historien om et smørbrød," n.d. [Jan. 1966], clipping.

348 when chefs were not: BMcN interview with the author, Jan. 20, 2002.

348 Lee's war reports: Shirley Conran, "Cook Hostess in Action, Sandwiches à l'améri-caine," n.d. [1966], clipping.

350 Jane enjoyed the taste: Quotations in this and the next paragraph, Jane Brymer inter-view with the author and AP, Jan. 23, 2002.

350 She was a figure: CMcN interview with the author, Oct. 2, 1999.

351 I had been expecting: Quotations in this and the next paragraph, Marnie Miller Cepo-rius interview with the author, Mar. 14, 1996.

351 At her age: Priscilla Morgan interview with the author, June 11, 1996.

352 epically untidy: Rosamond Bernier interview with the author, Feb. 20, 1997.

352 In 1969, Lee learned: Information and quotations in this and the next paragraph from Margit Rowell interview with the author, Feb 12, 1997. When Lee talked about Roland's girlfriends, she said that she had agreed to be accepting, but that there was one—"*la trapéziste*"—whom she could not stomach.

353 The *Times* reporter: Charles Benbow, "In Vanguard of Art," *St. Petersburg Times,* Oct. 5, 1969, clipping.

353 a top model: LM, quoted in Osgood, "Accident Was Road to Adventure," *St. Petersburg Times,* Oct. 6, 1969, clipping.

353 as an old fuddy-duddy: AP, *Home of the Surrealists,* p. 127.

353 What was worse: RP, *Scrap Book,* p. 263.

354 Another event linking art: AP, *Roland Penrose,* p. 160. The thieves were caught and jailed; Picasso repaired the painting they damaged, *Negro Dancer,* when they cut out his signature to send as a ransom note—but he did so only after telling Roland that there was no need for him to sign it again, since each brushstroke was his signature.

354 I adored Roland: Daniella Kochavi interview with the author, Oct. 1, 1999.

354 You seem to be: Daniella Kochavi to RP [Oct. 1975], RP correspondence, SNGMA.

355 With his usual: RP, *Scrap Book,* p. 247, illustrated by Lee's photo of the group inspect-ing the tapestry. Other shots from that day appear in the 1971 revised edition of RP's *Portrait of Picasso.*

355 By December Lee: LM to TM, Dec. 15, 1970, JMC.

18. Retrospectives

359 Lee's tolerance: LM to Lyn Kienholz, n.d., LKC.

359 Subtitled "The Personal Strategy": [BMcN], "How to Make an Art of the Happy Week-end," p. 87.

359 makes us look: LM to Margit Rowell, n.d. [c. May 1973].

359 Lee had invented: Gold and Fizdale, pp. 160–61, 186–87.

360 Christmas can be: Henry McNulty, "A Christmas at Muddles Green," *House and Gar-den,* Dec. 1975, pp. 102, 106, 107.

360 She appears briefly: RP, *Man Ray,* pp. 95, 99, 109.

360 his favorite of all: William Copley, "Man Ray: The Dada of Us All," *Man Ray, Inventor, Painter, Poet* (catalogue), New York Cultural Center, Dec. 19, 1974–Mar. 2, 1975; ICA, Apr. 11–June 1, 1975.

361 That afternoon, as they: John Loring interview with the author, Apr. 30, 1998.

361 They sat side by side: Lucien Treillard interview with the author, Oct. 8, 1999.

361 Amaya asked Lee: Amaya, pp. 55, 56, 57.

362 Lee spent the summer: Information and quotations in this and the next two para-graphs, LM letters to Lyn Kienholz, n.d. [c. 1975–76], LKC.

362 She would invite: AP, *Home of the Surrealists,* p. 131.

362 By 1976 there was: Julie Lawson to Lyn Kienholz, Jan. 25, 1976, LKC.

363 I no longer recognise: RP letter of resignation, Nov. 1, 1976, SNGMA.

363 The news on the morning: RP, *Picasso,* p. 479.

363 We never left: LM to Jackie Braun, June 28, 1976.

363 The show was much: This quotation and those in the next paragraph, LM to JL, n.d. [Aug. 1976].

364 lost in New York: LM to David Travis, June 28, 1976, AIC.

364 wants to do: LM to David Travis, Oct. 9, 1976, AIC.

364 Sitting beside him: LM to David Travis, n.d. [late Oct. 1976], AIC.

365 There was something: Jeanne-Marie de Broglie interview with the author, May 29, 2001.

365 Lee was tender-hearted: PMT interview with the author, Apr. 27, 1998.

365 of whom Swiss punctuality: *Wheeler's Review,* 1978, clipping.

365 she sat alone: Julie Lawson interview with the author, Sept. 29, 1999.

366 I've been almost: LM to David Travis, n.d. [Jan. 1977], AIC.

366 This is the last: LM to Lyn Kienholz, Mar. 14, 1977, LKC.

366 Having recently returned: AP to EM and MM, Mar. 16, 1977.

366 Writing to Lyn: LM to Lyn Kienholz, Apr. 17, 1977.

366 Suzanna is radiant: LM to Lyn Kienholz, May 25, 1977.

367 Are you Lee Miller?: Quotations and information in this and the next two paragraphs, LM interview with the author, May 16–17, 1977.

367 We are so looking: LM to Lyn Kienholz, May 25, 1977, LKC.

368 She was wonderful: PM interview with the author, May 13, 1996.

368 She had guts: John Golding interview with the author, May 29, 1996.

369 The next day: LM obituaries (clippings); RP note about funeral service, n.d.; AP to the author, Aug. 28, 2003.

369 Death had ploughed: RP, *Scrap Book,* p. 205.

369 What a remarkable: Bruce Bolton to Roz and Mel Jacobs, Aug. 2, 1977, RJC.

369 By chance, a last: Keenan, p. 63.

Afterword

371 Man Ray always: AP, quoted in "Mother in Her Own Images," *The Times,* Jan. 17, 1986, p. 11.

371 the etiquette was: AP, quoted in "My Mother, Me, and Hitler's Bath," *Mail on Sunday,* Mar. 14, 1999, clipping.

372 The grand old man: Carine Maurice, *Evening Standard,* Aug. 29, 1980, as cited in AP, *Roland Penrose,* p. 167.

372 Can you imagine: AP, NPR *Morning Edition* tape.

372 I passed through: AP, *Roland Penrose,* p. 169.

372 A consummate artist: DS, "Foreword," *LMW,* p. 13.

373 Her life and work: Documentaries include Mel Stuart, *Man Ray: Prophet of the Avant-Garde* (1999); AP, *The Lives of Lee Miller* (1986); Sylvain Roumette, *Lee Miller: Through the Looking Glass* (1995); and Sarah Aspinall/BBC, *Lee Miller: A Quirky Way of Seeing* (2001).

373 had to detach: Carole Callow, "Through the Eyes of Lee Miller," *The Surrealist and the Photographer,* pp. 135–36.

Bibliography

Abzug, Robert. *Inside the Vicious Heart*. New York: Oxford University Press, 1985.

Ades, Dawn. *Dada and Surrealism Reviewed*. London: Arts Council of Great Britain, 1978.

Agar, Eileen. *A Look at My Life*. London: Methuen, 1988.

Al-Sayyid Marsot, Afaf Lutfi. *A Short History of Modern Egypt*. Cambridge: Cambridge University Press, 1985.

Amaya, Mario. "My Man Ray" (interview with Lee Miller). *Art in America*, May–June 1975.

Angelou, Maya. *I Know Why the Caged Bird Sings*. New York: Bantam, 1997.

Anon. [Bettina McNulty]. "How to Make the Art of a Happy Weekend." *House & Garden*, June 1973.

Atelier Man Ray, Abbot Boiffard Brandt Miller, 1920–1935. Paris: Centre Georges Pompidou/Philippe Sers, 1982.

Aury, Bernard. *La Délivrance de Paris, 1924 Août 1944*. Paris: Arthaud, 1945.

Baedeker, Karl, ed. *Egypt*. Leipzig: Karl Baedeker, 1902.

Baldassari, Anne. *Picasso and Photography: The Dark Mirror*. Paris: Flammarion, 1997.

Baldwin, Neil. *Man Ray: American Artist*. New York: Clarkson Potter, 1988.

Ballard, Bettina. *In My Fashion*. New York: David McKay, 1960.

Baraka, Magda. *The Egyptian Upper Class Between Revolutions, 1919–1952*. Reading, U.K.: Ithaca Press, 1998.

Barker, Charles Albro. *Henry George*. New York: Oxford University Press, 1955.

Beaton, Cecil. *The Years Between: Diaries, 1934–1944*. New York: Holt, Rinehart and Winston, 1965.

Bertrand, François. *Notre Devoir de Mémoire, Convoi de Buchenwald à Dachau de 7 au 28 avril 1945*. Pau, France: Editions Héracles, 1997.

Blanshard, Julia. "Other Faces Are Her Fortune." *Poughkeepsie Evening Star*, November 1932.

Bourke-White, Margaret. *Dear Fatherland, Rest Quietly*. New York: Simon and Schuster, 1946.

———. *Portrait of Myself*. New York: Simon and Schuster, 1963.

Brandt, Allan M. *No Magic Bullet*. New York: Oxford University Press, 1987.

Breasted, James Henry. *Egypt Through the Stereoscope*. New York: Underwood and Underwood, 1905.

Brill, A. A. *Basic Principles of Psychoanalysis*. Garden City, N.Y.: Garden City Books, 1949.

Brittain, Vera. *England's Hour*. New York: Macmillan, 1941.

British Surrealism Fifty Years On (catalogue). London: Mayor Gallery, 1986.

Bruccoli, Matthew, ed. *The Romantic Egoists*. New York: Scribner's, 1974.

Burke, Carolyn. "Framing a Life." *The Surrealist and the Photographer*.

———. "Lee Miller in Hitler's Bathtub." *Heat* 12 (1999).

Burke, E.T. *Treatment of Venereal Disease in General Practice*. London: Faber & Gwyer, 1927.

Butcher, E. L. *Things Seen in Egypt*. London: Seeley, Service & Co., 1922.

Calder, Angus. *The People's War*. New York: Pantheon, 1969.

Callahan, Sean. *Margaret Bourke-White, Photographer*. Boston: Little, Brown, 1998.

Calvocoressi, Richard. *Lee Miller: Portraits from a Life*. London: Thames and Hudson, 2002.

Card, James. *Seductive Cinema: The Art of Silent Film*. New York: Knopf, 1994.

Carey, Gary. *Anita Loos: A Biography*. New York: Knopf, 1988.

Carter, Ernestine, ed. *Grim Glory: Pictures of Britain Under Fire*. London: Lund Humphries/Scribners, 1941.

———. *With Tongue in Chic*. London: Michael Joseph, 1974.

Caws, Mary Ann, Rudolf E. Keunzli, and Gwen Raaberg, eds. *Surrealism and Women*. Cambridge, Mass.: MIT Press, 1991.

Chadwick, Whitney. *Women Artists and the Surrealist Movement*. New York: Thames & Hudson, 1991.

Chafe, William Henry. *The American Woman*. New York: Oxford University Press, 1972.

Chase, Edna W. *Always in Vogue*. London: Victor Gollancz, 1954.

Chéroux, Clément, ed. *Mémoire des camps*. Paris: Marval, 2001.

Clarke, Graham, ed. *The Portrait in Photography*. London: Reaktion Books, 1992.

Cooper, Artemis. *Cairo in the War*. London: Hamilton, 1989.

Cord, Steven B. *Henry George: Dreamer or Realist?* Philadelphia: University of Pennsylvania, 1965.

Deriaz, Diane. *La Tête à l'envers*. Paris: Albin Michel, 1988.

Deutsch, Helen, and Stella Hanau. *The Provincetown*. New York: Russell & Russell, 1959.

Douglas, Ann. *Terrible Honesty: Mongrel Manhattan in the 1920s*. New York: Farrar, Straus, and Giroux, 1995.

Edwards, Julia. *Women of the World: The Great Foreign Correspondents*. Boston: Houghton Mifflin, 1988.

Eileen Agar (catalogue). Edinburgh: Scottish National Gallery of Modern Art, 1999.

Ewing, William A. *Eye for Elegance: George Hoyningen-Huene*. New York: International Center of Photography and Congreve Publishing Co., 1980.

———. *The Photographic Art of Hoyningen-Huene*. London: Thames & Hudson, 1986.

Fedden, Robin. *The Land of Egypt*. London: B. T. Batsford, 1939.

———. *Personal Landscape*. London: PL Editions, 1945.

———. *Syria: An Historical Appreciation*. London: R. Hale, 1946.

Flanagan, Hallie. *Shifting Scenes*. New York: Coward-McCann, 1928.

Flanner, Janet. *Janet Flanner's World*. New York: Harcourt Brace, 1979.

———. *Paris Was Yesterday*. New York: Viking, 1972.

Foresta, Merry, ed. *Perpetual Motif: The Art of Man Ray*. New York: Abbeville, 1989.

Fox, Stephen. *The Mirror Makers: A History of American Advertising and its Creators*. New York: William Morrow, 1984.

Frizot, Michel, ed. *A New History of Photography.* Cologne: Könemann, 1998.

Geiger, George Raymond. *The Philosophy of Henry George.* New York: Macmillan, 1933.

Gellhorn, Martha. *The Face of War.* New York: Atlantic Monthly Press, 1988.

Gilot, Françoise. *Life with Picasso.* New York: McGraw-Hill, 1964.

Gold, Arthur, and Robert Fizdale. "The Most Unusual Recipes You Have Ever Seen." U.S. *Vogue,* April 1974.

Goldberg, Vicki. *Bourke-White: A Retrospective.* E. Hartford, Conn.: United Technologies Corporation, 1988.

———. *Margaret Bourke-White.* New York: Harper & Row, 1986.

Guggenheim, Peggy. *Out of This Century.* Garden City, N.Y.: Anchor, 1980.

Hale, Nathan G., Jr. *Freud and the Americans: The Beginnings of Psychoanalysis in the United States, 1876–1917.* New York: Oxford University Press, 1971.

———. *The Rise and Crisis of Psychoanalysis in the United States: Freud and the Americans, 1917–1985.* New York: Oxford University Press, 1995.

Hambourg, Maria Morris. *The New Vision: Photography Between the World Wars.* New York: Metropolitan Museum of Art, 1989.

Harrison, Tom. *Living Through the Blitz.* New York: Schocken Books, 1976.

Hay, William. *Health via Food.* Aurora, N.Y.: Sun-Diet Foundation, 1929.

Herman, Judith Lewis. *Father-Daughter Incest.* Cambridge: Harvard University Press, 1981.

———. *Trauma and Recovery.* New York: Basic Books, 1992.

Hewison, Robert. *Under Siege: Literary Life in London, 1939–45.* London: Weidenfeld and Nicolson, 1977.

Houseman, John. *Run-Through: A Memoir.* New York: Simon and Schuster, 1972.

Hubert, Renée Riese. *Magnifying Mirrors: Women, Surrealism, and Partnership.* Lincoln: University of Nebraska Press, 1994.

Jaloux, Edmond, ed. *Rainer Maria Rilke, His Last Friendship: Unpublished Letters to Mrs. Eloui Bey.* New York: Philosophical Library, 1952.

Jeffrey, Ian. "Picasso's Gaze," *Lee Miller and Picasso* (catalogue). London: The Photographers' Gallery, 1984.

Johnston, Patricia A. *Real Fantasies: Edward Steichen's Advertising Photography.* Berkeley: University of California Press, 1997.

Keenan, Brigid. "That Special Face." *Sunday Times Magazine,* November 6, 1977.

Kirkpatrick, Helen. *Under the British Umbrella.* New York: Scribner's, 1939.

Kluver, Billy, and Julie Martin. *Kiki's Paris: Artists and Lovers, 1900–1930.* New York: Abrams, 1989.

Krauss, Rosalind, and Jane Livingston. *L'amour fou: Photography & Surrealism.* New York: Abbeville Press, 1985.

Lawford, Valentine. *Horst: His Work and His World.* New York: Knopf, 1984.

Lemagny, Jean-Claude, and André Rouillé, eds. *A History of Photography.* Cambridge, UK: Cambridge University Press, 1997.

Levy, Julien. *Portrait of an Art Gallery.* New York: Putnam, 1977.

———. *Surrealism.* New York: Black Sun Press, 1936.

Lewis, Helena. *The Politics of Surrealism.* New York: Paragon House, 1988.

Life Goes to War: A Picture History of World War II. Boston: Little, Brown, 1977.

Livingston, Jane. *Lee Miller: Photographer.* New York: California International Arts Foundation, 1989.

Loengard, John. *Life Photographers: What They Saw.* Boston: Little, Brown, 1998.

Lyford, Amy. "Lee Miller's Photographic Impersonations, 1930–1945." *History of Photography,* vol. 18 (1994).

Lyon, Ninette. "Lee and Roland Penrose: A Second Fame." U.S. *Vogue,* April 1965.

Malcolm, Janet. *Diana & Nikon*. New York: Aperture, 1997.

Marcuse, Harold. *Legacies of Dachau*. New York: Cambridge University Press, 2001.

May, Antoinette. *Witness to War: A Biography of Marguerite Higgins*. New York: Beaufort Books, 1983.

McBride, Henry. *The Flow of Art*. New York: Atheneum, 1975.

McDowell, Colin. *Forties Fashion*. London: Bloomsbury, 1997.

McNulty, Bettina. "Notes for Lee Miller Cookbook." Unpublished manuscript.

McNulty, Henry. "A Christmas at Muddles Green." U.K. *House and Garden*, December 1975.

Messenger, Charles. *The Chronological Atlas of World War Two*. New York: Macmillan, 1989.

Miller, Lee. Taped interview with Ona Munsen. "In Town Tonight." Los Angeles, August 1946.

———. "I Worked with Man Ray." *Liliput*, October 1941.

———. "What They See in Cinema." U.K. *Vogue*, August 1956.

———. *Wrens in Camera*. London: Hollis and Carter, 1945.

Morris, John G. *Get the Picture*. New York: Random House, 1998.

Morrow, Prince A. *Eugenics and Racial Poisons*. New York: The Society of Sanitary and Moral Prophylaxis, 1912.

Murrow, Edward R. *This Is London*. New York: Schocken, 1985.

Niven, Penelope. *Steichen: A Biography*. New York: Clarkson Potter, 1997.

Panter-Downes, Mollie. *London War Notes, 1939–1945*. New York: Farrar, Straus, and Giroux, 1971.

Paris, Barry. *Louise Brooks*. New York: Knopf, 1989.

Patten, Marguerite. *The Victory Cookbook*. London: Hamlyn, 1995.

Penrose, Antony. "The Enigma of Lee Miller." *A Propos Lee Miller*. Frankfurt: Verlag Neue Kritik, 1995.

———. *The Home of the Surrealists*. London: Frances Lincoln, 2001.

———. *Lee Miller in Sussex* (catalogue). Gardner Centre Galleries, May 1984.

———. *Lee Miller's War*. Boston: Bulfinch Press, 1992.

———. *The Lives of Lee Miller*. London: Thames and Hudson, 1985.

———. *Roland Penrose: The Friendly Surrealist*. London: Prestel, 2001.

Penrose, Roland. *Man Ray*. Boston: New York Graphic Society, 1975.

———. *Picasso*. Revised ed. Los Angeles: University of California Press, 1981.

———. *Picasso: His Life and Work*. 3rd ed. London: Granada, 1981.

———. *The Road Is Wider Than Long*. London: London Gallery, 1939.

———. *Scrap Book, 1900–1981*. London: Thames and Hudson, 1981.

Phillips, John. *Free Spirit in a Troubled World*. Zurich: Scalo, 1997.

———. *Odd World*. New York: Simon and Schuster, 1959.

Pierre, Jose, ed. *Investigating Sex: Surrealist Research, 1928–1932*. London: Verso, 1992.

Platt, Edmund. *History of Poughkeepsie, 1683–1905*. Poughkeepsie, N.Y.: Platt and Platt, 1905.

Prose, Francine. *The Lives of the Muses*. New York: Harper Collins, 2002.

Ray, Man. *Self Portrait*. Boston: Little, Brown, 1963.

———. *Photographs by Man Ray*. New York: Dover, 1979.

Remy, Michel. *Surrealism in Britain*. Aldershot, U.K.: Ashgate, 1999.

Rhoads, William B. "Poughkeepsie's Architectural Styles, 1835–1940." *Dutchess County Historical Society Year Book*, vol. 72, 1987.

Richardson, John. *The Sorcerer's Apprentice*. New York: Knopf, 1999.

Robbins, Ian, ed. *The Independent Group: Postwar Britain and the Aesthetics of Plenty*. Cambridge, Mass.: MIT Press, 1990.

Rodger, George. *The Blitz*. New York: Penguin, 1990.

Rubin, William, ed. *Picasso and Portraiture*. New York: Museum of Modern Art, 1996.

Sarlos, Robert K. *Jig Cook and the Provincetown Players*. Amherst: University of Massachusetts Press, 1982.

Schaffner, Ingrid, and Lisa Jacobs. *Julien Levy: Portrait of an Art Gallery* (catalogue). Cambridge, Mass.: MIT Press, 1998.

Schwarz, Arturo. *Man Ray: The Rigour of Imagination*. London: Thames and Hudson, 1977.

Seebohm, Caroline. *The Man Who Was Vogue*. New York: Viking, 1982.

Simpson, Ann. *Eileen Agar, 1899–1991* (catalogue). Edinburgh: Scottish National Gallery of Modern Art, 1999.

Showalter, Elaine, ed. *These Modern Women: Autobiographical Essays from the Twenties*. Old Westbury, N.Y.: Feminist Press, 1978.

Sontag, Susan. *On Photography*. New York: Farrar, Straus, and Giroux, 1997.

Sorel, Nancy Caldwell. *The Women Who Wrote the War*. New York: Arcade, 1999.

Stavrianos, L. S. *The Balkans Since 1453*. New York: Rinehart, 1959.

Strasser, Susan. *Satisfaction Guaranteed: The Making of the American Mass Market*. New York: Pantheon, 1989.

Steegmuller, Francis. *Cocteau*. Boston: Little, Brown, 1970.

Sullivan, Constance, ed. *Women Photographers*. New York: Abrams, 1990.

The Surrealist and the Photographer: Roland Penrose and Lee Miller (catalogue). Edinburgh: National Galleries of Scotland, 2001.

Tanning, Dorothea. *Birthday*. San Francisco: Lapis Press, 1986.

Toussaint, Yvon. *Les Barons Empain*. Paris: Fayard, 1996.

Touzot, Jean. *Jean Cocteau*. Paris: La Manufacture, 1989.

Train, Susan, ed. *Théâtre de la Mode*. New York: Rizzoli, 1991.

Ulman, R. B. *The Shattered Self: A Psychoanalytic Study of Trauma*. Hillsdale, N.J.: The Analytic Press, 1988.

Vatikiotis, P. J. *The Modern History of Egypt*. London: Weidenfeld and Nicolson, 1969.

Voss, Frederick S. *Reporting the War: The Journalistic Coverage of World War II*. Washington, D.C.: Smithsonian Institution Press, 1994.

Wahba, Magdi. "Cairo Memories," in Derek Hopwood, ed., *Studies in Arab History*. Oxford: Macmillan Press, 1990.

Watson, Steven. *Prepare for Saints*. New York: Random House, 1998.

Weber, Eugen. *The Hollow Years: France in the 1930s*. New York: Norton, 1994.

Welsh, Mary. *How It Was*. New York: Knopf, 1976.

Wertenbaker, Charles. *The Death of Kings*. New York: Random House, 1954.

West, Nancy Martha. *Kodak and the Lens of Nostalgia*. Charlottesville, Va.: University of Virginia Press, 2000.

Wineapple, Brenda. *Genêt: A Biography of Janet Flanner*. New York: Ticknor & Fields, 1989.

Withers, Audrey. *Lifespan*. London: Peter Owen, 1994.

———. Unpublished lecture. Institute of Contemporary Arts. London, 1992.

Yoxall, H. W. *A Fashion of Life*. London: Heinemann, 1966.

Zelizer, Barbie. *Remembering to Forget*. Chicago: University of Chicago Press, 1998.

Zox-Weaver, Annalisa. "When the War Was in *Vogue*: Lee Miller's War Reports." *Women's Studies*, vol. 32 (2003).

Acknowledgments

I have been fortunate to meet many remarkable people during the seven years it took to complete this biography, which would not have been written without their support. It is a pleasure to begin by acknowledging my profound indebtedness to Antony Penrose, Director of the Lee Miller Archives, who not only gave me full access to the work and materials of Lee Miller and Roland Penrose and introductions to their friends but generously read, reread, and commented upon my book, which builds on his invaluable studies of his mother's life and dissemination of her work through the Archives. I am also deeply grateful to the Archives staff, especially Carole Callow, Curator and Fine Printer, and Arabella Hayes, Registrar, for assistance of all kinds; to Roz Penrose for her warm hospitality; and to Patsy Murray for delicious meals and clear-eyed recollections of the Farley Farm household.

I can never fully express my profound thanks to Lee's family: John Miller, who helped me visualize the Poughkeepsie of his childhood and lent me his father's diaries, the late Erik Miller, the late Mafy Miller, Marnie and Victor Ceporius, Joanne Miller, and Patricia Miller Taylor, without whose generous hospitality and collaboration I could not have documented Lee's early years. Members of her extended family also contributed precious insights. David Scherman granted me an illuminating interview toward the end of his life, when he was still mulling over his relationship with Lee; Bettina McNulty filled out the picture of Lee's later years with anecdotes, recipes, and her unique perspective as Lee's closest friend.

I also take pleasure in thanking all those whose insights, introductions, references, and refuges made it possible for me to write this book. In Great Britain: Mary Banham, Jane Brymer, the late Sir Bernard Burrows, Phil Cairney, Wingate Charlton, John Craxton, Joanna Drew, Madge Garland, David Gascoyne, Sir John Golding, the late Jacqueline Goddard, Richard Hamilton, Eric Harbord, Sir David Hare, Tom Hawkyard, Doreen Impey, Dawn Jackson, the late Audrey Withers Kennett, Alex Kroll, Julie Lawson, Sarah Macdonald, Mollie Matthews, James Mayor, Claudia McNulty, James Mellor, Patricia Mitchell, Robin Muir, the late Timmie O'Brien, Jane Peyton, Miranda Preston, Lady Spender, Daniella Kochavi Stark, John and Cynthia Thompson, William Turnbull, Patricia Warner, Colin Wilson, and the late Gertrude Wissa.

In France: the late Hélène Azenor, Mihaela Bacou, Marie Balmary, Naomi Barry, Edwige Belorgey, Georges Bernier, François Bertrand, Pierre-Yves Butzbach, Catherine Chaine, Edmonde Charles-Roux, Georgiana Colville, the late Henri Cartier-Bresson, Diane Deriaz, Alain Dubourg, Princesse Jeanne-Marie de Broglie, Emmanuelle de l'Ecotais, Baron Edouard Empain, Baronne Jean Empain, Xavier Gary, Catherine Gonnard, Annick Gratton, Danielle Haase-Dubosc, Marilyn Hacker, Jacques Hindermeyer, Diane Johnson, Sylvain Labbé, Gentry Lane, James Lord, Gérard Messadié, Bernard Minoret, John G. Morris, Jean-Claude Moscovisi, Richard Overstreet, Raymond Perrussel, Marc Riboud, Sylvain Roumette, Jacques Serrier, Robert Solé, Edmonde Treillard, the late Lucien Treillard, Yvon Toussaint, Susan Train, and Arie von Soest.

In the United States, Canada, and Mexico: the late Richard Avedon, Timothy Baum, the late Joella Bayer, Susan Bedford, Gretchen Berg, Rosamond Bernier, Simon Bourgin, John Burnham, Leonora Carrington, the late Josephine Carson, Whitney Chadwick, Bill Cleveland, Noma Copley, Carolyn Crumpton, Betty Daniels, Mary Dearborn, Dan Dougherty, Warren Dunn, Jesse Effron, Donka Farkas, Miriam Feierabend, Harry Finley, David Friend, Francine du Plessix Gray, Robert Halmi, Nina Hamilton, Mike Harris, Shirley Hazard, Hedwig Herschop, Lisa Jacobs, Roz Jacobs, Stephanie Spray Jandle, Peter Kenez, Lyn Kienholz, Hans P. Kraus Jr., William Leiberman, Maya Lev, the late Julien Levy, Tom Levey-Galleguillos, Joel Leivick, Alexander Liberman, Mary Anita Loos, John Loring, Anne-Laure Lyon, M. C. Marden, Hank Massie, Frances McLaughlin, Despina Messinesi, Kats Miho, Sandra Mock, Priscilla Morgan, Weston Naef, Eugenia Parry, Marilyn Pearl, the late Oreste Pucciani, Nan Rosenthal, John Richardson, Tom Riordan, Jim Robinson, Ned Rorem, Naomi Rosenblum, Margit Rowell, Betty Jane Rowland, Naomi Sawelson, Ingrid Schaffner, John Scherman, the late Rosemarie Redlich Scherman, Tony Scherman, Pony Simon, Mel Stuart, Elizabeth Pathy Salett, Lee Eitingen Thompson, Dorothea Tanning, Marcia Taylor, Kim Vandervoort, Jeff Wales, Steven Watson, Charles Williams, and Annalisa Zox-Weaver.

In Australia: Carol and Tony Berg, Pam Brown, Rowanne Couch, Anne Deveson, Juno Gemes, Helen Greenwood, Margaret Harris, Robyn Johnston, Robert McFarlane, Drusilla Modjeska, Paul Patton, Tony Richardson, Gary Rogers, Erica Seccombe, and Jane Zemiro.

I have also been fortunate to have invaluable help with research and manuscript preparation from Jane Arons, Maria di Chiara, Renée Divine, Judy Foreman, Sylvia Gale, Natalia Lusty, and Rachel Servi, who will recognize their contributions in these pages. I am more grateful than I can say to my webmaster, Stephen Pollard, whose wizardry with images made it possible to imagine and prepare a book that would honor its subject's eye as well as her iconic beauty.

The staffs of the University of California, Santa Cruz library and the Santa Cruz Public Library went out of their way to find what I needed. To them I owe a profound debt of gratitude, as well as to the following institutions and people: Adriance Memorial Library: Myra Morales; Art Institute of Chicago: David Travis; Bardavon Opera House Archives: Annon Adams; Center for Creative Photography: Nancy Lutz; Condé Nast, London: Robin Muir; Condé Nast, New York: Stan Friedman, Charles D. Scheips Jr.; Condé Nast, Paris: Caroline Berton, Michelle Zaquin; Getty Research Institute: Susan M. Allen, Beverly Faison; Musée National Picasso: Anne Baldassari, Sylvie Fresnault, Laurence Madeline; National Museum of American Art: Merry Foresta, Linda Hartigan; Oakwood School: Kathy Meyer; Scottish National Gallery of Modern Art: Richard Calvocoressi, Jane Furness, Alice O'Connor, Ann Simpson; Tate Gallery: Sarah Fox-Pitt, Adrian Glew; Vassar College: Nancy MacKechnie, James Mundy, Dean M. Rogers.

The Florence Gould Foundation provided generous aid when I most needed it. Periods of residence at the Research Institute for Humanities and Social Sciences, University of Sydney, and the Columbia University Institute for Scholars in Paris afforded precious writing time, research support, and the chance to try out portions of this book with sympathetic audiences. I am grateful to the Division of the Humanities at the University of California, Santa Cruz for assistance of all kinds.

I would also like to thank my agents, Anne, Georges, and Valerie Borchardt, for their practical and moral support, and to express my deep appreciation for everyone I worked with at Knopf: Bob Gottlieb, for his sense of humor, tunafish sandwiches, and unparalleled editorial skills; Diana Tejerina, for gently unruffling me through all the phases of production; Iris Weinstein, for grasping the story through the photographs; Jon Fine, for sound advice; and the other exceptional people who worked on this book.

My deepest debt is to Poppy Burke, Terry Burke, and Valda Hertzberg, who made it possible, nourishing me, reading for me, sustaining me with their love and patience.

Index

Page numbers in *italics* indicate photographs.

Photo Credits

All photographs in the inserts are by Lee Miller.

Grateful acknowledgment is made to the following:

Harry N. Abrams: A Strange Encounter, by Lee Miller, from *Women Photographers,* edited by Constance Sullivan, appears courtesy of Harry N. Abrams (insert 1, page 3).

Artists Rights Society: Portrait de Lee Miller en Arlésienne, by Pablo Picasso, private collection, © 2005 Estate of Pablo Picasso / Artists Rights Society (ARS), New York (page 171). Photograph by Man Ray appears courtesy of Juliet Man Ray, © 2005 Man Ray Trust / Artists Rights Society (ARS), NY / ADAGP, Paris (page 77). Photograph by Man Ray appears courtesy of Dorothea Tanning, © 2005 Man Ray Trust / Artists Rights Society (ARS), NY / ADAGP, Paris (page 327). Photographs by Man Ray appear courtesy of Telimage, © 2005 Man Ray Trust / Artists Rights Society (ARS), NY / ADAGP, Paris (pages 72, 92, 96).

Beinecke Rare Books and Manuscripts Library: Photograph by White Studios appears courtesy of Yale University Collection of American Literature, Beinecke Rare Books and Manuscripts Library (page 138).

Simon Bourgin: Photographs by Simon Bourgin appear courtesy of Simon Bourgin (pages 276, 279).

Condé Nast: Photographs of Lee Miller in *Vogue* appear courtesy of Publications Condé Nast (pages 82, 102, 103, 111). Photograph of Audrey Withers from *Vogue* appears courtesy of Lee Miller/*Vogue* © The Condé Nast Publications Ltd. (page 203).

George Eastman House: Photograph by unknown appears courtesy of George Eastman House (page 23).

Harry Finley: Advertisement from *Delineator* appears courtesy of Harry Finley (page 67).

A Note About the Author

Carolyn Burke met Lee Miller while conducting research for *Becoming Modern: The Life of Mina Loy.* Burke has taught at Princeton and the University of California at Santa Cruz and at Davis; at the universities of Western Sydney and New South Wales in Australia; and at the Sorbonne and the University of Lille in France. Her many articles and translations from the French have appeared in *Art in America, The New Yorker, Heat, Sulfur,* and *Critical Inquiry.* Born in Australia, she now lives in Santa Cruz, California.

A Note on the Type

This book was set in Fairfield, a typeface designed by the distinguished American artist and engraver Rudolph Ruzicka (1883–1978). In its structure Fairfield displays the sober and sane qualities of the master craftsman whose talents were dedicated to clarity. Ruzicka was born in Bohemia and came to America in 1894. He designed and illustrated many books, and was the creator of a considerable list of individual prints in a variety of techniques.

Composed by North Market Street Graphics,
Lancaster, Pennsylvania

Printed and bound by Berryville Graphics,
Berryville, Virginia

Designed by Iris Weinstein